# THE ARTS

# THE ARTS

*a new, updated version*

*Written and Illustrated*

*by*

HENDRIK WILLEM VAN LOON

SOUVENIR PRESS

Copyright © 1974 by Henry B. van Loon and Gerard W. van Loon
Copyright © 1937 by Hendrik Willem van Loon
Copyright © renewed 1965 by Henry B. van Loon and Gerard W. van
Loon
New and updated version 1974
Published in the U.S.A. by
Liveright, New York

This British Edition published 1975 by
Souvenir Press Ltd, 95 Mortimer Street, London W.1 N8 Hp

All rights reserved
No part of this publication may be reproduced, stored in a retrieval system, or
transmitted, in any form or by any means, electronic, mechanical, photocopy-
ing, recording or otherwise, without the prior permission of the Copyright
owner.

ISBN 0 285 62185 8

15 AUG 1978

HERTFORDSHIRE
COUNTY LIBRARY

8847625

700·9

Printed Photolitho in Great Britain by
J. W. Arrowsmith Ltd., Bristol, England

*This volume is dedicated*
*to the memory of*
MAISIE ELIZABETH HUNT
*because, better than anyone else*
*whom it was ever our privilege to know,*
*she represented the Ideal*
*that all the Arts should have but one single purpose,*
*and should contribute as much as it*
*is within their own particular power to do so*
*to the highest of all the Arts—*
*the Art of Living*

# Table of Contents

ix

# CONTENTS

# *Illustrations*

# Foreword

I T WAS A TERRIBLE DAY and we were traveling through the dreariest part of our great and glorious republic, which on that particular morning was neither great nor glorious, but looked drab enough to suggest some circle that had apparently been overlooked when Dante gave us his description of the nether regions.

A few minutes before, the train had come to a halt. I don't know why. Nobody knew why. And nobody cared. The slush and rain would be just as bad a mile hence or a hundred miles hence. The fields with their desolate burden of brown, decaying cornstalks would present just as eloquent a picture of despair one mile farther along the road as a hundred or maybe a thousand.

Some two hundred yards away from the track there stood a house, a very plain and very ordinary house. It needed paint, but so did all the farmhouses we had seen during the past twenty-four hours. It also needed repairs. It had apparently been built by a carpenter who must have hated beauty as a deacon is supposed to hate sin, and with very much the same results.

Out of that farmhouse came two small children, a boy and a girl. They may have been twelve, and then again they may have been fourteen. It was hard to tell. They wore hideous woolen caps and mufflers—red woolen caps and mufflers and red woolen gloves, knit coarsely and carelessly, so carelessly and coarsely that even at a distance one could notice how little love had been worked into these garments. I dare say that they were practical and that they kept out the cold. But at no greater cost and with very little extra trouble they could just as well have been made pleasant to the eye.

The little boy and the little girl came slithering through the slush and then they stopped in the road to gaze at our train. That train was a thing of mystery to them. It was their only link with a world wherein people ate their griddlecakes from tables with small pink-shaded lamps, wherein women wore dresses made of all sorts of gaily colored materials, wherein men might sit and pleasantly idle away an hour or so discussing a book or a play, a world, therefore, wherein everything had not been ruthlessly sacrificed to the idea of utility.

For all I knew, those two children would never see that wonder-world with their own eyes. Yet—and on the other hand—and then again—a miracle might happen and that train might so fill their hearts with a holy curiosity for all those things that make life beautiful

and charming and interesting that at some time in the near or distant future they would definitely break away from the hideous place they called home, from the unnecessary ugliness of their hopeless surroundings, and go forth in search of something better and nobler and infinitely more satisfying to the soul.

But while thinking these thoughts and feeling very sorry for them, I noticed something that at first I had failed to observe. The little girl in the hideous red cap and muffler tightly clutched one of those blue portfolios in which children take their pictures to school on the day they have their drawing lessons, while the small boy, in his equally hideous red cap and muffler, carried a very shiny black fiddle case.

That was all there was to the incident which I have taken the trouble to describe to you in such detail. For the engine gave three long blasts, we waited a moment to pick up the brakeman, the wheels got hold of the slippery rails, and once more we were on our way, bound for more ugliness and for more desolation—for ugliness and desolation in a world that could be so sublimely beautiful.

I went to the observation car and I watched those two little red specks grow smaller and smaller. During the last twenty years I had been gathering material for a book on the arts, a book that should describe all the arts in a single volume. But until then I had never quite had the courage to start it. Something kept worrying me. From what particular "fixed point" was I to write this book? Whom would I have in mind while writing it?

Of one thing I was certain. I did not intend to write it for the professional student of art. He already could wallow in a sea of monographs and dissertations, of ten-volume *catalogues raisonnés*, of twenty-volume handbooks, of thirty-volume *éditions de luxe* containing all the paintings, drawings, and etchings ever made by all the great masters of the past, present, and future. Neither did I mean to write it for the benefit of the artists themselves. If they really knew their jobs, they would be too busy to have time for much reading. And if they were no good, then the book might perhaps tempt them to persist in their futile efforts, and that, of course, would be a complete waste of time, money, and energy.

As for the dear ladies who love art for the sake of "its moral and uplifting influence" and their estimable spouses who "don't know what is art, but who know what they like," no, they too must not be encouraged to peruse my pages, for I was quite sure that they would find nothing therein to contribute to their peace of mind or to the happiness of their mortal souls.

But suddenly everything became clear to me. I had got my "fixed point." I knew exactly who needed the sort of book I had in mind and then and there I made my decision. I shall write it for those two infants in the red mufflers and the red woolen caps. I shall write it for those two children, one of whom carried a fiddle case and one of whom carried a bunch of drawings. I shall write it for those two forlorn kids who looked so eagerly at that train of ours—that train that was going places.

HENDRIK WILLEM VAN LOON

# THE ARTS

# Prologue

*On the general nature of the artist and on the difficulties that beset us the
moment we try to decide what is Art (with a capital letter A) and what is
not, and of diverse other problems which probably
will never be solved at all.*

"ART IS UNIVERSAL." Upon that much we can probably agree without any further argument. But when I say, "Art is universal," there is an immediate danger that you will think of art (of either music or painting or sculpture or dancing) as if it were some sort of universal language, understood by everybody in every part of the world.

Which of course is not true at all. What happens to be the most sublime form of music to me, who am sitting at my desk upstairs— say Bach's Fugue in G minor—is just so much unpleasant noise to my poor wife, who within a few minutes will be copying these pages downstairs, far removed from the gramophone and the fiddle.

A portrait by Frans Hals or Rembrandt, which makes me hold my breath (for it seems incredible that anyone of mere flesh and blood could have said quite so much with the help of only a few pigments, some oil, a piece of canvas, and an old brush)—that same portrait may strike the next visitor as nothing more than an unpleasant combination of rather drab colors.

When I was young, an uncle of mine incurred the sincere disapprobation of his eminently respectable neighbors because he had bought himself a small sketch by that regrettable social outcast, Vincent van Gogh. Last winter in New York City they had to call out the police to keep order among the crowds that were storming the museum in which a few of the works of that selfsame Vincent van Gogh were being shown to the public of America.

It took us hundreds of years to learn that Chinese painting is in every way as sound and interesting as our own, if not a great deal better.

The music of Johann Sebastian Bach was a matter of constant irritation to his employers in Leipzig. The Emperor Joseph II of Austria complained to Herr Mozart that there were "too many notes"

in his music. Richard Wagner's compositions were hooted off the concert platform. Arab or Chinese music, that makes the average Arab or Chinese roll his eyes in deep rapture, happens to affect me personally as if I were listening to a bitterly contested cat fight in the neighbor's back yard.

Wherefore, when I say that art is universal, I merely mean that art is not bound to any particular country or to any particular period of time. For art is as old as the human race and it is just as much part of man as are his eyes or his ears or his hunger or his thirst. The lowest savage of the most desolate part of Australia, who in a great many ways is quite inferior to the animals which share his loneliness, who has never even learned how to build himself a house or how to wear clothes, had developed a very interesting art of his own. And while we have discovered several groups of natives who have no conception whatsoever of religion, we have never, as far as I know, come across a race (no matter how far it happened to be removed from the center of civilization) that was completely without some form of artistic expression.

That is what I meant a few moments ago when I said that art is universal. And if that be true, it does not really matter very much whether my first chapter starts in Europe or in China, among the Maoris or among the Eskimos. But in connection with this, I would like to tell you a story which I found in an old Chinese manuscript, or rather in a translation of an old Chinese manuscript, for alas, the language that is spoken by all these millions of people is a closed book to me, and I am too old now to learn it. Here is the story as it was given to me:

"When Lao-Kung felt that his end was approaching, he asked that all his pupils gather around him that he might once more see them and bless them ere he set forth upon that voyage from which no man has yet returned.

"And so they came and found the old painter in his workshop. As usual he was sitting before his easel, although he had grown much too weak to hold a brush. So they urged him to retire to his couch where he would have been more comfortable, but he shook his head, saying unto them, 'These brushes and these paints have been my steady companions and my faithful brethren throughout these many years. It is only befitting that I should be among them when the time comes for me to depart.'

"And so they knelt down before him and awaited his words, but

many of them could no longer control their grief and they wept openly. Whereupon Lao-Kung looked at them with great astonishment and asked, 'How now, my children? You have been bidden to a feast! You have been invited to share the one sublime experience which the average man is allowed to enjoy by himself! And you shed tears, whereas you should really rejoice.'

"Then he smiled at them and immediately the pupils dried their eyes, wiping them upon the cuffs of their long silken sleeves, and one of them spoke and his words were as follows:

"'Master,' he said, 'our beloved Master, pray forgive us our weakness, but we are sad at heart when we contemplate your fate. For you have no wife to weep over you and no sons to carry you to the grave and give offerings to the Gods. All your livelong days you have worked and slaved, from earliest dawn to the setting of the late sun, but the grubbiest money-changer in our meanest market has accumulated greater material rewards for his unworthy labors than have ever come your way. You have given unto mankind with both hands and mankind has quietly taken whatever you offered. But mankind has passed upon its way without bothering about your fate. And now we ask of you, has this been fair? Have the Gods shown you any mercy? And we, who must continue after you shall have left us, we would like to ask you one question. Has this great sacrifice on your part been really worth while?'

"Then the old man slowly raised his head and his face became like that of a mighty conqueror at the moment of his greatest triumph as he answered: 'It has been more than fair and the reward has vastly surpassed my highest expectations. What you say is true. I have neither kith nor kin. I have spent well nigh a hundred years on this earth. Oft I went hungry and more than once, if it had not been for the kindness of my friends, I would have been without shelter or raiment. I surrendered all hope of personal gain that I might the better devote myself to my task. I deliberately turned my back upon all that which could have been mine own, had I but cared to pit cunning against cunning and greed against greed. But in following the inner voice that bade me follow my solitary path, I have achieved the highest purpose to which any of us may hope to aspire.'

"Thereupon the oldest of the pupils, the one who had also addressed him in the beginning, again lifted up his voice, but this time his words came haltingly.

"'Master,' he said in a whisper, 'our beloved Master, as a parting

blessing, will you not tell us what that highest purpose may be to which mortal man may aspire?'

"A strange light now came into the eyes of Lao-Kung as he lifted himself from his seat. His trembling feet carried him across the room to the spot where stood the one picture that he loved best. It was a blade of grass, hastily jotted down with the strokes of his mighty brush. But that blade of grass lived and breathed. It was not merely a blade of grass, for within itself it contained the spirit of every blade of grass that had ever grown since the beginning of time.

" 'There,' the old man said, 'is my answer. I have made myself the equal of the Gods, for I too have touched the hem of Eternity.'

"Thereupon he blessed his pupils and they laid him down upon his couch and he died."

This is such a charming little story and it is so absolutely true that I could finish this chapter right here and now and leave the rest of what I have to say to your own imagination. But that final remark of the old Chinese brings up so many other ideas that we shall have to go on for a little while longer. Not, however, for too many pages, for this sort of discussion has a strange tendency to take us back to the happy days of the Middle Ages, when it meant nothing for a couple of scholars to spend a dozen years debating the exact number of angels that could balance themselves on the point of a needle.

According to Lao-Kung, the true artist is the man who is allowed to touch the hem of Eternity. But here is another way of approaching the same subject. It is my own approach. You may agree with it. You may dislike it intensely. I don't know how you will feel about it, but it seems to me that that particular notion has been uppermost in a great many people's minds ever since the days of the Greeks.

This is the answer I probably would have given had I been in Lao-Kung's place.

Man, even at his proudest moments, is a puny and helpless creature when he compares himself to the Gods. For the Gods speak unto him through creation. Man tries to answer, he tries to vindicate himself, and that answer—that vindication—is really what we call art.

In other words, and to make quite clear what I mean, you go out into the mountains and the sun is shining brightly and the sky is a deep, dark blue and the few clouds are a fleecy white and the wind is singing a queer melody of its own amidst the branches of the fir trees and the whole world is vibrating with life and you feel completely

helpless and hopeless, before this indescribable splendor of the world as created by the Gods.

But if your name happened to be Joseph Haydn, and if you had learned to express your innermost feelings by means of sound, then you would go home and you would compose that part of your oratorio that begins with the words: "The Heavens declare . . ." and after it had been finished and if you happened to be as humble of soul as that great Austrian, then you would go down on your knees to thank your Maker that you had been allowed to experience this emotion in the way it had come to you.

And after your hymn of praise had been sung before all the world, and all the world had proclaimed you a great artist, then you would perhaps retire to a quiet little corner of your room and you would say, "You see, dear Lord, of course it was perhaps not quite like that afternoon when I walked through the fields, but that was my answer to Your challenge, and so You see, dear Lord, I too am not absolutely helpless. In my own halting and imperfect way, I too am something of a creator. I can't of course quite do what You can do. That is only natural, for You can do everything. But within my own feeble powers —well, anyway, there it is, dear Lord, and if You ask me, I think it is pretty good!"

I am not so prejudiced in favor of my own profession that I fail to see how this holds true for all men—even for those who are utterly incapable of giving expression to their emotions by means of any of the arts. The people of the Middle Ages, who did not know as much as we do but who understood a great many things that we shall never even suspect—they realized this and they showed it in one of their fables. It is a tale about two penitent sinners who approached the image of the Madonna to ask her a favor, but who were conscious of the fact that they had really nothing to offer in return for all her manifold blessings.

Therefore one of them, a poor musician who had no other possession than his old fiddle, played her his loveliest tune and behold! his prayer was answered. But when it was the turn of the shoemaker, he felt that his pilgrimage had been in vain, for all he could do was to offer to make the Queen of Heaven a pair of dainty little slippers so that she might go well shod to her next dance, for it was a well-known fact that the angels in Heaven dance whenever they are very happy and that sometimes our good Lady takes part in their festivities. "But

what," so this cobbler asked himself, "is a new pair of slippers, compared to that music which I have just heard?"

Nevertheless, he made her the most beautiful slippers he could and behold! he too found favor in our Lady's eyes, for his golden slippers had been his own particular way of expressing his emotions and, after all, it was the effort that counted much more than the final result.

In connection with this little medieval story, there is something that ever again strikes me as rather curious—just one of those things I cannot quite understand. Why is it that our modern world insists upon drawing such a very sharp line of demarcation between the arts and the crafts? In the days when the arts were really an integral part of people's daily lives, that line of demarcation did not exist. Nobody was aware of a difference between the artist and the craftsman. As a matter of fact, the artist (if he were recognized as such) was merely a craftsman of exceptional ability, a stonecutter who could make figures in marble just a little better than any of the other members of the stonecutters' guild. But today the artist lives on one side of the street and the craftsman lives on the other side and the two hardly speak to each other.

I went through that stage of development myself, for when I was young, the absurd slogan of "art for art's sake" was still very popular among those who were supposed to know about such things. But that was thirty years ago and since then I am happy to say we have learned better. Today we know that the man who conceived the old Brooklyn Bridge was quite as great an artist in his own way as the unknown stonemason who drew up the plans for the cathedral at Chartres, and most of us can now get just as much real enjoyment out of the perfection of Fred Astaire's dancing as out of the quintet in the last act of the *Meistersinger*.

Let me make myself quite clear, for this is the sort of statement that can lead up to all sorts of futile discussions. Therefore let it be understood that I do not suggest that we could now do without any further *Meistersinger* quintets as long as we have Mr. Astaire dancing for us. I realize that there is a vast difference between tap dancing and singing or painting. But I have found a very simple way to decide what is good and what is bad. I ask myself this question: "What is this person trying to tell me about his inner emotions?" and "Is he succeeding in telling me his story in so convincing a manner that I understand what he is trying to tell me or not?" Having trained myself to apply this standard of perfection to everything that comes within the ken of

**THE OLDEST PICTURE OF MAN**

*The creature is engaged in his customary pastime of killing his fellowmen.*

*The mysterious art of an unknown race.*

my personal observation, I find that I have immensely enlarged my own powers of understanding and therefore of enjoyment.

Many years ago when I first began to suspect the vastness of our universe, I always felt sorry that I could not afford a telescope. A good telescope costs about five hundred dollars and I never felt that I could spend quite so much money upon a mere hobby. As a result, I never got a good look at that part of the universe which lay beyond the horizon of my own imperfect eyes. But one day I stumbled upon a small pocket microscope which I could carry with me wherever I went and which enabled me to make the intimate acquaintance of that world of small creatures and diminutive plants which exists all around us, though we never pay much attention to these humble creatures because they are hardly visible to the naked eye.

Of course I do not for a moment mean to imply that Alpha Boötes and the Milky Way are of no greater importance than the tiny little spider that tried to cross this sheet of paper a moment ago or the moss that grows on the old stone wall in front of our house. But the difference of importance between the two is one of size rather than degree. And old Maître Fabre among his insects is just as great an artist and his books are just as much of a delight to a curious and intelligent reader as the works of Jeans, who juggles with planets and light-years as if a million or a billion years were mere trifles.

Let me give you one more example so that we are sure to understand each other. I have visited cities where people never ceased to brag about the local museum, which contained a noble collection of old Italian and eighteenth-century English pictures, and about the local symphony orchestra, where Heifetz had once been the soloist. But when I came to their town, I found that they lived in houses that lacked all dignity and went to their places of business through mean and ugly streets and that nothing in their own daily existence was either pleasant to the eye or to the ear, except that museum, that was open during only part of the day, and their symphony orchestra, which played only once a week and then for only a few hours.

I have since learned better than to argue with such neighbors or try to convince them that they may be in error. But being then young and eager and quite inexperienced, I tried to convince these honest burghers that two or three really good reproductions of really good masters, hanging in their own sitting rooms and dining rooms, would be much better for the salvation of their artistic souls than a dozen original Correggios or Reynolds' tucked away in a corner of the local

art museum, and that it would be better for the future of the world at large (at least as far as music was concerned) if they exposed their children to really good gramophone music all the days of the week instead of dragging them off but once a week to a symphony concert which really meant nothing to them but an evening of solid boredom and an enforced absence from the delightful vulgarities and sentimentalities of the radio.

I never got anywhere at all with these arguments. A few dozen people agreed with me most heartily but they did not need my exhortations, for they had always shared my views. As for the others, they thought me a busybody with some newfangled educational notions (probably imported from Moscow) which I was trying to propagate in order to be different and to make myself interesting.

After a few of these experiences, I learned to hold my tongue. And yet I feel that I was absolutely right. Charity may begin in the parlor, but art begins even further back than that—art begins in the kitchen. And when you are invited to dine with a man who owns three Raphaels, two Del Sartos, half a dozen Murillos, and even a Rembrandt, yet asks you to partake of his viands with forks and knives and spoons that are of a clumsy pattern and that do not balance well —then, mark my words! that man careth nought for the true arts. He has bought these pictures to impress his neighbors or to get credit at his bank. He has not acquired them because he could not live without them. He was not a real art lover at all and his pictures meant less to him than the expensive fur coat on the back of his wife.

I had better stop right here and now, for once you start upon the subject of "What is art?" you never quite know when or where or how the discussion will end. But in order that all my cards may be on the table and plainly visible before we start playing our game, let me explain a few of my own beliefs and prejudices within the realm of the arts.

When you start forth upon quite a long trip with a stranger, it is always well to know something about his private idiosyncrasies, whether he likes to keep the portholes wide open all night, whether he is likely to smoke in bed (and perchance set fire to your cabin), at what time he usually rings for his breakfast, whether he is contented with orange juice, toast, and coffee or insists upon a hearty meal with fried eggs, tea, and lots of rolls and butter and marmalade. You can, of course, skip this part of the book, but we shall be better traveling

companions if you will glance at a few of these theories; and here they are:

In the first place, there is the question of the value of art to society. If I had mentioned this to an ancient Greek or a Frenchman of the Middle Ages, he would not have known what I was talking about. He would have been quite as much surprised as a citizen of our modern world would be if I asked him whether he thought that good health and hygiene were desirable things for the community at large. For today we take health and hygiene for granted. They are an integral part of our everyday existence. All our efforts at social amelioration put health and hygiene at the top of the list of the absolute necessities of a truly civilized form of living. Were anybody to doubt in all seriousness whether health was a good thing for the human race, people would question his sanity.

In the same way, a Frenchman or an Italian of the thirteenth or fourteenth century would have shaken his head in helpless perplexity if anybody had seriously questioned the desirability of being surrounded by beautiful things. For they would devote years of their lives to some small part of the roof of one of their beloved cathedrals, to some small detail which no one would probably ever see, but they would never give a single moment's thought to those drains and those waste pipes and those garbage-disposal plants which play such a very important role in our own lives. For they had been trained to accept unpleasant smells and discomforts as an unavoidable part of existence and their attitude toward them would therefore have been very much the same as that of our own people toward that ugliness and vulgarity and noise which surround them on all sides in so many of our modern cities.

Such reactions depend entirely upon our point of view. I happen to have a particular dislike for the billboards that disfigure so much of our landscape and I have given expression to that feeling upon a great many occasions. I vividly remember one such lecture when I happened to be speaking to some three thousand teachers. "Surely," I said to myself, "these men and women, whose task it is to turn our children into intelligent citizens, will understand the necessity for surrounding them with all possible beauty and harmony and will do away with these ghastly signs."

But nobody seemed to be quite able to follow my line of reasoning. "These billboards," so they told me afterwards, "pay taxes. These taxes pay for the upkeep of the community. Perhaps you are right and the countryside would not look quite as hideous as it does if we had

fewer advertising signs and fewer hot-dog stands and fewer filling stations. But think of all the money they bring in!"

And then and there we reached a sort of mental dead end, out of which neither side was able to extricate itself. I was thinking of the artistic effect and they were thinking, with equal sincerity, of the financial results.

I suppose (as is usual in such cases) that we were both of us right and both of us wrong. It is often said that morals are merely a matter of latitude and longitude. The arts, too, are profoundly influenced by their own geographical backgrounds, but in their case the time element also plays a very important role. A country like Italy, that was undoubtedly an artists' paradise in the fifteenth century, is today as completely devoid of all artistic sense as a manufacturing town in northern England. Whereas we ourselves, who during the last hundred years have eaten our way across the continent with as little regard for beauty as a swarm of locusts, may well be the artistic center of the world within another century or so.

Speaking of ancient times and of today, for the sake of convenience I shall in this book stick closely to the old and familiar divisions, such as medieval art and Egyptian art and Greek art and Chinese and Japanese art. Like all attempts to pigeonhole human emotions, these classifications are, of course, makeshifts. They have no scientific value whatsoever and, like the timetables of our railroad lines, they are always subject to change without notice. But we have become accustomed to them and so we might as well continue to use them, provided we realize that all so-called "artistic periods" have an incurable habit of playing hide-and-seek with each other and are apt to overlap in a most perplexing fashion.

As for such curious modern divisions as "capitalistic art" and "proletarian art"—I am sorry that I shall not use them because I do not know what they mean. I know only two sorts of art, "good art" and "bad art." It seems only fair that I should make this quite clear at the very beginning of my work.

Enters the word "genius," which has lost a great deal of its old meaning and which today, in the hands of our critics, may describe anything from a Mozart sonata played recognizably on a musical saw to the products of a not overbright young woman of sixteen who has managed to fill several hundred pages of innocent wood pulp with far from innocent sentiments.

I shall therefore stick to the definition of that word which I remember from my childhood days when we could count all our geniuses on the fingers of one hand. It read as follows:

Genius is perfection of technique, plus something else.

What that "something else" was, that we have never been quite able to find out. Some called it God and others called it "divine inspiration." Today it probably would be connected with the libido or with the glandular system. I really don't know and I am afraid that we shall never quite find out what that "something else" is. But I am very much aware of the fact that I recognize that "something else" the moment I hear it or see it.

As for the esthetic theories that are so popular nowadays, I don't think that many of the really good artists have ever seriously bothered about them. Of course, the average artist, being an average human being, likes to spend an occasional evening drinking beer with his own cronies and swapping yarns with them and talking shop. But so do motormen and elevator boys and generals and admirals and longshoremen and coal heavers and kings in exile. I suppose that, however, is something quite different from purely "esthetic discussions." It is the shoptalk of those who happen to have chosen the same way of making a living. (Except the kings in exile.) But everything I could ever hope to say upon the subject was said a great many years ago by old Papa Manet, the famous French painter, and it was said so much better than I can ever hope to say it that I might as well repeat his remark and then drop the subject.

Talking to some young men who wanted to know the innermost secrets of art, the great French impressionist growled: "It is all very simple. *Si ça y est, ça y est. Si ça n'y est pas, faut recommencer. Tout le reste, c'est de la blague.*"

Or, translated into our own vernacular: "If you get it the first time, that is fine. If you don't get it, then do the whole thing all over again until you finally get it. Anything else is just so much waste of time."

We hear a great deal nowadays about bringing art to the masses. We have brought the masses liberty, equality, and the pursuit of happiness and now we are going to bring them art. It seems very simple but I doubt whether it can be done. The people of India have a saying: "The Holy Man does not leave the shrine." The Holy Man (or "the Whole Man," for that is what the word "holy" means—something

that is "whole" or "hale") was one who had been set apart from the rest of the community. The artist in a way is such a Holy Man in the sense of "one set apart." For all art is essentially a one-man experience and therefore something innately aloof and aristocratic.

The artist himself in his daily relationship with his fellow men may be as democratic as Abraham Lincoln. But let us remember that the moment honest old Abe found himself a quiet corner and took a pad of paper on his knee to jot down a few lines of his sublime prose, he became a million miles removed from the rest of humanity. We remember him for what he did when he was apart from humanity, not for the funny stories he told as a means of keeping the crowd at a distance.

There have, of course, been periods in history when the community at large felt very deeply upon certain religious or patriotic subjects, and on such occasions the artist was often able to give such a clear expression to the spirit of his own time—what we sometimes call "the voice of the people"—that his own identity thereupon seemed to have been lost among that of the millions. But a careful study of such an era shows that that was not really so. It was very easy in an age without any newspapers or other means of publicity and information for a name to get lost in the shuffle. But just because we do not happen to know the names of the men who built the Pyramids or who drew up the plans for many of the medieval cathedrals or who composed those ancient tunes that have since become known as "folk songs"—that does not really mean that their own contemporaries did not know all about them. They merely took them for granted as we ourselves take our great engineers for granted. We walk twice a day through the Grand Central Terminal of New York City or we pass through the St. Gotthard tunnel in Switzerland or we spend all our days crossing and recrossing the old Brooklyn Bridge without ever having the vaguest notion about the men who had the vision to draw the plans for those sublime pieces of engineering.

No, I cannot, I am sorry to say, take much stock in these theories about art being in any way connected with the masses. The true artist is almost invariably a very lonely fellow and, like all lonely people (provided he has strength enough to survive his spiritual loneliness), he will insist upon maintaining his own integrity as his most valued possession. He may drink with the crowd and swap jokes with his neighbors, and he may even affect a slovenliness of attire and a carelessness of language that make people think he is one of them. But within his own domain he is, and insists upon remaining, "the Master."

Like poor Vincent van Gogh, he may love the masses when he is off duty, or, like Ludwig van Beethoven, he may refuse to lift his hat to a mere king, but the moment he smears his paints on his canvases or fishes his little notes out of his ten-cent bottle of ink, he stands apart and recognizes no law but the law that bids him be himself.

In the olden days we would have called such men aristocrats. Today we do not bother to give them a name. There are so few of them left.

The worst service one can render the arts is to apologize for their existence. This, of course, is a survival from the days when the creed of Dr. John Calvin, a sickly man with a sick man's bitter hatred for all that was beautiful and gay and that tended to make life more cheerful, was accepted as the only true philosophy of life by most of our ancestors. Art then had to be smuggled into the life of the community by means of all sorts of subterfuges. We were told that "art had an ennobling influence" and that "art had a tendency to turn men and women into better citizens." One might as well claim that a knowledge of swimming or baseball is having a similar effect upon the character of our children.

The truth of the matter is that the average artist, like the un-average genius, is at heart merely an average human being. He merely happens to have been born with a particularly sensitive set of nerves and he is therefore able to react much more delicately to the world around him than the vast majority of his neighbors. He is to the ordinary run of human beings what a highly sensitized photographic plate or film is to the ordinary film you may pick up anywhere in the nearest store —good enough for the everyday job of catching little Johnny in the act of making a snow man or riding his bicycle, but of exceedingly little value in a physical laboratory or an astronomical observatory.

Hence there have been all sorts and manner of artists, from the uncouth Richard Wagner, who gave us sublime music and who was probably one of the meanest and most despicable characters that ever lived, to Wolfgang Amadeus Mozart, who also gave us sublime music and left behind a reputation for gentleness and charm and unselfish generosity that may have been equaled but never surpassed by the saints themselves.

I think that I am right in what I have just said and I shall therefore repeat it once more in a slightly different form.

The artist is not really in any way different from the ordinary run of human beings. He merely happens to be a little more highly sen-

sitized (that is probably a better word in this connection than "sensitive") than the rest of us. He is usually quite unconscious of this fact and accepts what he does as Babe Ruth accepted the fact that he could hit a ball harder and farther than any of his fellow players. When you asked the Babe how he did it, he answered, "Huh?" and scratched his head and asked you for a piece of chewing gum. The really great artist is just as much at a loss to explain what he does and the way in which he does it as my good friend, George Herman Ruth.

Don't make the mistake of looking too eagerly for the so-called "soul" of the artist. He may have one but you won't find it very different from the souls of the rest of us. The psychology of the artist is always a very fruitful subject of discussion among people who could not draw a line or invent a tune if they tried unto the end of their days. The really good artist is likely to be a very simple fellow who is much too occupied with the work he is doing to worry about the psychological substructure of his immortal soul. His work to him is the woman he happens to love. Upon her he will therefore bestow all his devotion. She is the object of all his loyalties. He no more knows why he loves this particular woman than does the filing clerk who takes his girl out for a ride on top of a bus; and he is not really interested.

There she is.

He loves her.

And so why ask foolish questions or bother him about his soul or his psychological reactions? He really does not know or care.

No artist has the right to place himself above the law. But like the rest of us, he is entitled to judgment by a jury of his peers.

That is the rule that since time immemorial has dominated our civil life. It should also be observed within the realm of the arts.

The layman is rarely asked to favor us with his opinions upon the work of an expert surgeon or engineer. Why should we not extend the same courtesy toward the artist, who expresses himself in quite as individual a way as the man who removes our appendix or who builds our bridges and subways?

Then (for this chapter is getting much too long), what is an artist?

A painter is merely someone who says, "I think I see," and who thereupon reveals to us what he thinks he has seen in such a way that we too may see it if our eyes happen to be attuned to his own vision.

A musician is a man or woman who says, "I think I hear."

The poet is a person who says, "I think this is the way I can best express my personal dreams in some sort of universal rhythm."

The novelist says, "Let me tell you a story as I imagined that it happened or might have happened."

And so on all along the line.

Each artist in his or her own way is merely a sort of "recording instrument." Whether his "record" means something to the rest of us or nothing at all is none of his concern. The nightingale and the raven too are not interested in our opinions. They do the best they can in the hope that they will gain the approval of some other nightingale or raven. This is very sad when the nightingale finds himself surrounded by ravens or *vice versa*. But nothing can be done about it.

You may wonder after you have finished this book why I have put so much stress on certain subjects, while others that seemed equally important have been completely left out. I realize this too, but the very size of the subject forced me to be a little arbitrary in the choice of my subjects. At first I intended to include all the arts, not only literature, architecture, painting, and the theater but also the ballet, cookery, fashions, enamel, pottery—just everything. When, after several years of writing, I had actually finished that original draft, it was a book of almost a million words. No publisher would have dared to print a volume of such gigantic dimensions and who would have had the courage to read it? And so I had to take a large blue pencil and I had to cut and slash until after several more years of very hard work I finally reduced my original 1800 pages to a mere 800. I was obliged to sacrifice a great deal of material I would have liked to include. But I had to remember that I was trying to give the general reader, who had never taken any particular interest in these rather remote subjects of the arts, a love for and an understanding of the background of all that now is most enduring within the realm of painting and architecture and music and sculpture and the minor arts from 500,000 B.C. until A.D. 1937.

You can imagine what would have happened if I had presented him with an *opus* that weighed thirty pounds and that had to be taken home on a truck. He would just as soon have bought himself a tame dinosaur as a pet for the children.

That is why some of the subjects have been dealt with in great detail while others have been reduced to a few short pages. I do not think, however, that all this has in any way affected my main purpose—to show the universality that underlies all the arts, as it underlies all the manifestations of our average, everyday human existence.

# The Art of Prehistoric Man

*Wherein I shall try to light a very small candle in the heart of a very large and extremely dark cave which, in spite of all our efforts and investigations, has thus far refused to reveal most of its exceedingly interesting secrets.*

A HUNDRED YEARS AGO it would have been very easy to write this chapter. Today it will probably prove the most difficult of the whole book. For a hundred years ago the history of art was almost as simple as the chronology of the Bible. Good old Bishop Ussher had told us that the world had been created in the year 4004 B.C. (he was even willing to give us the day of the week and the month if we were very much interested—they were Friday, October 28), and of course we accepted his statement without any further argument. Why borrow trouble and get ourselves suspected of heresy, when it really did not matter very much whether Adam had been born in 4004 B.C. or 40,004 B.C. or 4,000,004 B.C.?

But a hundred years ago, in the matter of the arts, everybody still spoke with bated breath whenever the names of Goethe or Lessing were mentioned. His Excellency Dr. Johann Wolfgang von Goethe had bravely crossed the Alps in the fall of the year 1786, and when he returned in the spring of 1788 he not only gave the world a full account of his solemn peregrinations among the ruins of his beloved Italy (together with a few less solemn adventures that had nothing to do with ruins) but he also bestowed upon an eager public a very effective recipe by means of which the up-to-date young men and women of that day could reshape their daily existence along strictly classical lines.

Goethe, however, had had several predecessors. There was that rather tiresome but vastly learned Johann Joachim Winckelmann, whose *History of Ancient Art* (published in 1764) had been everywhere accepted as the standard work upon the history of Greek art. Winckelmann unfortunately was murdered by a greedy Levantine who had tried in vain to sell him a few old coins, and he had departed this life before he was able to finish his monumental *opus* about the ancient world. Nevertheless he succeeded in inspiring the greatest of all liter-

ary critics of the eighteenth century, the far-famed Dr. Gotthold
Ephraim Lessing, to write his *Laokoon*, in which that stout defender
of the ideal of tolerance for the first time endeavored to expose the
true relations between poetry and the plastic arts.

With these three mighty tomes—with Winckelmann's *History of
Ancient Art*, Lessing's *Laokoon*, and Goethe's *Italian Journey* accepted as
the Bible of the Arts, who would then have dared to stand up in
meeting and maintain before all comers that other people, long be-
fore the Greeks, had produced works of art quite as good as, or even
better than, those efforts of the Romans and the Greeks?

Since then, many things have happened. First of all, there was the
rediscovery of the civilization of Egypt during the last two years of the
eighteenth century. Already Herodotus, visiting the valley of the Nile
in the fifth century B.C., had been struck by the "incredible antiquity"
of everything he saw. But nobody, until a century ago, had even for a
moment suspected that the Greeks might possibly have learned most
of what they knew from the Egyptians or—stranger still—that those
Egyptians had in turn been the pupils of a still older race of prehis-
toric men.

Prehistoric man had, of course, been dead for such a long time that
he probably did not mind staying in his grave a little longer. But his
contributions to the arts were so interesting and so important that he
could not remain forgotten forever. All that was needed was a magi-
cian to bring him back to life. Finally, after thousands and thousands
of years, that wizard appeared and his name was the archaeologist,
the man who makes a study of things as they were in the beginning.

The archaeologist was a product of the Renaissance. Today we know
it is not quite true to say that the Italians of the Middle Ages had com-
pletely forgotten their Roman origin. They were surrounded by too
many visible Roman souvenirs not to realize that the civilization of
Rome had been a very mighty one. But everything was in ruins.
Everything was in a state of disorder. The world around them looked
as if a flood had passed over it. That is exactly what had happened. A
deluge of barbarians had swept across the continent and in the playful
mood of the mucker (who invariably destroys what he does not under-
stand) these ruffians had done as much damage as seven earthquakes
followed by seven tidal waves could have done in half a thousand
years.

In the year 1453 the Turks captured Constantinople. Whatever had
survived of the civilization of the Greeks thereupon fled toward the
West and was given a refuge in the universities of Italy and France

and Germany, just as today our own universities open their doors to the victims of Herr Hitler's violence. This was a tremendous boon to the study of archaeology, for now the people of the West were at last able to decipher those Greek texts that had been a closed book to them for almost ten centuries. Archaeology suddenly became the favorite pastime of the rich. As a result, many of the popes of the fifteenth and the sixteenth centuries and a large number of the potentates and princes of that era were really much more interested in their archaeological studies than in the work they were supposed to do as shepherds of men's souls and bodies.

Indeed, it was during this age that the word "dilettante" was coined to describe a person who "delighted" in the fine arts. All over Europe these *dilettanti* were laying the foundations for those vast and often unwieldy collections of statues and pots and pans and coins and ancient jewelry which afterwards developed into some of our best-known museums.

It would be an act of the grossest ingratitude to deny that these *dilettanti*, these worthy devotees of the spade, rendered us very wonderful services in helping us solve at least a few of the problems of the past. They were, it is true, completely one-sided in their interests and never cared to inspect the evidences of a still older form of civilization, remnants of which must occasionally have fallen into their hands. But we should remember that they belonged to a generation which was firmly convinced that the world had been created only a few thousand years before and that a belief in a so-called prehistoric race of men was a most dangerous and quite intolerable piece of heresy.

Nowadays, hardly a week goes by that we do not read of some new discovery within the field of prehistory. One day it is a strangely formed skull that must have belonged to a race that lived five hundred thousand or even a million years ago. Or some French or Austrian peasant, plowing his fields, comes upon an ancient burying place where human bones are found mixed with those of the mastodon or the saber-toothed tiger, creatures that have been extinct for tens of thousands of years. Or it is merely a handful of colored pebbles, lying by the side of a dozen finely polished stone knives.

Were such things never found by our ancestors of the sixteenth or the thirteenth century? Of course they were. But in those days nobody realized what they were. Therefore nobody paid the slightest attention to them. The skeletons were usually mistaken for the remains of some poor pilgrim or soldier who had been killed or who had died in this

lonely cave. The bones that were clearly not of human origin were used for agricultural purposes, like the skeletons of the heroic Napoleonic veterans who fell during the Austrian campaigns of 1805 and 1809 and which were afterwards sold to a number of British manufacturers to be converted into artificial fertilizer.

As for the queer and repulsive-looking statues that were sometimes uncovered, they were quite naturally mistaken for the heathenish Gods of some Germanic tribe that had lived in northern Europe before the coming of the Christian missionaries. Or they were suspected of being the work of witches and goblins and were at once thrown into the deepest lake amidst the loud pealing of the village bells, that the local trolls and ouphes should not hear of the incident and try to recover their former property.

Let me hasten to add, for the benefit of those who may feel inclined after this chapter to become professional archaeologists, that the study of the very ancient past is an exceedingly difficult one, requiring years of the most careful preparation. The layman will be peacefully smoking his pipe on a grassy slope in southern France, a slope which to him seems nothing more important than a slight elevation of the ground, caused perhaps by last year's floods. Then the archaeologist comes along and tells him that he is sitting on the walls of a prehistoric settlement, as he will thereupon prove by showing him the complete outline of the ancient fortress itself, with gates and towers and all.

Only recently, during the Great War, when the English and the Turks were fighting each other in Mesopotamia, it quite frequently occurred that the British soldiers would dig right through the heart of some ancient Chaldean city without the slightest suspicion of what they were doing or what they were destroying. Fifty years ago their ignorance was shared by almost everybody.

Therefore, if you should decide to devote your life to archaeological studies, by all means do so, for it is one of the most fascinating of all careers, but be prepared for years and years of hard and painstaking study and for as many disappointments as there are days in the year.

When did our grandfathers and our great-grandfathers become conscious of the existence of their prehistoric ancestors?

That is hard to say. But gradually during the nineteenth century, what with a more scientific attitude toward those events that are mentioned in the books of the Old Testament and with the constantly widening historical horizon that was the result of our investigations in

Egypt and in the valleys of the Tigris and the Euphrates, a few brave
pioneers began to suspect that our world, from the human angle at
least, must be a great deal older than they had always been told.
When they looked at those beautifully carved stone knives and axes
that were coming to the surface of the earth, they felt that these could
only have been made by a people that were already a long way re-
moved from their more apelike ancestors.

They were undoubtedly very unappetizing citizens, resembling in
their daily lives the evil-smelling natives of New Guinea or of the in-
terior of Australia. But within the realm of the arts they achieved
certain results which show them to have been not only excellent crafts-
men but persons endowed with a great deal of imagination.

Unless you have seen some of this prehistoric work with your own
eyes, you will hardly believe how far these cave dwellers had advanced
as draftsmen, as sculptors, and as plain, ordinary whittlers. For they
were still in the whittling stage of development, not yet full-fledged
sculptors. This is only natural when you remember that the use of
metals was still completely unknown and that all the work of shaping
and fashioning had to be done with sharp pieces of flint. But sharp
pieces of flint in the hands of a true artist may perform miracles.

The Maoris of New Zealand, until the white man settled among
them a hundred years ago, had never seen a single scrap of any sort
of metal—not even a piece as large as a dime or a nickel. Yet their
sculptured ornaments, both in wood and stone, are of surpassing
beauty and craftsmanship.

We shall have to know a lot more than we do at present before we
shall be able to discuss prehistoric art as we do that of the Middle
Ages or the Rococo. But we have already found out enough to make
a start and we have pushed our artistic calendar back by some ten
thousand years.

All art reflects not merely the economic surroundings of the artist
but also his geographical background. An Eskimo may have a pro-
found natural gift for sculpture, but during the greater part of each
year he will have to content himself with cutting his monuments out
of snow and ice. An Egyptian, on the other hand, was not restricted
to the making of mud pies. From near-by countries he could order
himself every sort of stone he might need for his palaces and his
temples, and the river allowed him to transport these to any given
place at a very small cost of labor or money.

People sometimes ask me why my former countrymen, the Dutch,
who have done so well in the fields of painting and music, have never

produced a really first-class sculptor. Well, painting and music are forms of art which one can practice indoors in a country in which it rains four days out of every five. But the only sort of building material that is truly native to the Low Countries is brick. Have you ever tried to make a statue out of bricks? It can't be done.

On the other hand, the Greeks—a race of street dwellers who regarded their houses merely as a sort of adobe stable in which you slept at night and where you raised your children and where your wife did the laundry and the cooking—the Greeks, who lived in almost perpetual sunshine and whose country was full of an excellent variety of marble, became first-rate sculptors, while their painting (in so far as it has survived, and that is not very far) seems never to have amounted to much.

This all sounds very logical; but logic, unfortunately, does not go very far when it comes to art. If it were only the presence of the marble quarries of the Pentelicus which had made the Greeks such first-rate sculptors, then by the same token the inhabitants of modern Vermont should also have produced a number of great sculptors, for their state is just one vast marble deposit. But they themselves never use it for anything except their churches (in case the congregation happens to be too poor to do the decent thing by the Lord and build one out of wood) or to construct sidewalks or pigsties and chicken coops.

In the case of Vermont, the marble is there as it was in Greece, but the economic incentive is lacking to turn it into statues. Who in that poor farming community would want to buy a piece of sculpture or who could afford to do so? Whereas in Athens there not only was the right sort of marble to be converted into images of the Gods and of the leading citizens, but there was also enough money to pay for the finished product, and there were enough people willing to spend their money that way.

Here I stop. The argument is getting too complicated. So just let us agree that every nation must make use of whatever material is nearest at hand, and then we shall understand that prehistoric man specialized in the horn provided by the antlers of the reindeer.

The reindeer still survives in Europe but you have to travel several hundred miles north of the Arctic Circle to Lapland to find the animal in a semiwild state. Twenty thousand years ago, when Europe was slowly recovering from the onslaught of the last of the great glacial periods, the reindeer lived as far south as the present Mediterranean and there it was caught and tamed and domesticated by a people who only recently had come from somewhere else.

Where that "somewhere else" was, we do not know. At least, for the moment. But give us time. Another fifty years or so and we shall probably have all the details.

As for the reindeer and the creature's popularity as a sort of prehistoric cow, that is not a subject for speculation. It played a tremendously important role in the lives of these early hunters, who were steadily moving northward and who on all their wanderings were accompanied by vast hordes of this first cousin of our native caribou. How much the reindeer must have meant to its master we begin to realize when we see with how much care he drew its picture on the walls of his caves and on pieces of stone and how he loved to adorn himself with ornaments made out of the reindeer's antlers.

Here for the first time I use the word "ornaments." Many scholars suspect that ornaments are really the earliest of all forms of art and I think that they are right. Man must have soon noticed how the males among the animal species invariably surpassed the females in pulchritude. He must have felt sorely tempted to overcome his own deficiencies along this line by means of certain artificial embellishments, such as chains of colored shells and stones or polished bits of antler bone stuck into his hair, ears, or nose.

To all good Americans, living as they happen to do in a society in which the male has most complacently accepted domination by the female of the species, such a statement may come as a surprise. But it is only in a pioneering society, where the males are much more numerous than the females, that woman has ever been able to establish herself as the dominant figure in the daily life of the community. And while the early reindeer hunters were also pioneers in the sense that they occupied an uninhabited wilderness, the mortality rate among the males was so high and so many of them perished in the endless search for food that the female counted for very little. Such luxuries as bracelets and charms and neck chains and other pieces of personal adornment were strictly reserved for the men of the tribe and for the men alone.

This so-called age of the reindeer art does not seem to have lasted very long. It came to an end as soon as the climate in southern Europe had grown too hot for the comfort of *Rangifer tarandus*. But by that time the red deer had replaced the reindeer as a source of general supply, providing the family not only with food and raiment but also with all the necessary tools for fishing and hunting. The stag hunters not only continued the artistic traditions of the reindeer hunters, but

they also acquired two new forms of expression. They became painters and sculptors.

Here we touch upon one of the strangest incidents in the whole history of the arts. It was in the year 1879 that a Spaniard, the Marquis de Sautuola, decided to take a walk through the cave of Altamira, which is situated in the Cantabrian Mountains in the northern part of Spain. He took his small daughter with him. The child, only four years old and therefore quite small, was not interested in her father's search for old fossils and decided to do a little exploring of her own. There was a part of the cave that was so low that no grownup had ever bothered to examine it. Why get your clothes all dirty when there is nothing there, anyway? But to the four-year-old, these overhanging rocks meant nothing, and so the little girl crept into the lower part of the cave and lifted her candle. But when she looked up, to her great horror she was staring right into the eyes of a bull!

Thoroughly frightened, she called for her father, and that is how the first of our famous prehistoric paintings happened to be discovered —by a small girl looking for something to do.

Alas, when the poor Marquis announced his marvelous discovery to the scientific world, he was immediately denounced as a faker and an impostor. The professors who came to examine the pictures on the premises insisted that such magnificent paintings could never have been the work of prehistoric savages and openly accused the discoverer of having hired a Madrid artist to cover the walls of this cave with products of his brush, thus enabling the Marquis to pose as a great archaeologist.

There were others who confessed that this might be so, but they expressed surprise at the strange materials this Madrid artist had used to get his extraordinary color effect. The pictures consisted of outlines scratched into the surface of the rock, but the surface itself had been covered with an unfamiliar red that proved to be an iron oxide, with a deep blue that was also an oxide, the oxide of manganese, and with a variety of yellows and oranges that were iron carbonates. These colors had been mixed with fat in order to make them stick. Here and there the artist, who had worked with a stone burin (we have since found such burins in their workshops), had used a bit of black made out of burnt bones. Hollow bones had been used as paint containers—as paint tubes—and flat slabs of stone had served as palettes. These were hardly the ingredients a modern painter would have used.

Fortunately for the reputation of the honest Marquis, similar pic-

tures were eventually discovered in the valley of the Dordogne in southwestern France. Since then pictures belonging to the same Altamira school have been found in caves all over southern France and northern Spain and a few as far down as the heel of Italy, but none in northern Europe or in England.

That settled one problem. But another problem remained that has by no means been solved.

None of these paintings has ever been found on the walls of caves that were exposed to the light of the sun, where they could have been seen by every passer-by. As they were invariably painted in the darkest part of those subterranean hide-outs, the artists must have worked by the artificial light of torches. The famous cave of La Mouthe is an excellent example of such an arrangement. It had been known for centuries that the forward part of that cave served as a home for human beings, for the floor was deeply covered with kitchen offal and bits of polished stone. Then one day, upon closer examination, a dark passageway was uncovered that led up to a series of pitch-dark chambers, all of them covered with figures of animals done in the well-known yellows and sepias and blues of the prehistoric palette.

Why, we still ask ourselves, did prehistoric man paint his pictures in such dark and inaccessible places? Why did he invariably paint animals? For by now we have counted almost a hundred different sorts of animals among the pictures that have come down to us from this remote past. Occasionally we have found something that must have been meant to represent human beings. But these early painters specialized in animal life and gradually they carried their technique to such a height of perfection that the product lost its original spontaneity and reminds us in a vague way of the stereotyped saints of the Byzantines and the Russian icon makers.

Why indeed? I am sorry but once more all we can do is offer a few plausible guesses.

There are those who insist that all art was born out of religion. We now know from our studies of primitive life in Africa and especially in the southern Pacific that practically all races at one time of their career have been addicted to a belief in necromancy, that strange form of magic which occasionally still bobs up in some distant village. In one of its many varieties, as practiced in ancient Babylon, necromancy meant the ability to predict the future from communicating with the dead.

But there were other ways of exercising this mysterious magical power. If you had reason to fear an enemy, you made yourself a clay

image of this person and then you stuck it full of pins, thereby (as you fondly hoped) causing the victim to die both speedily and painfully. Hunters were very apt to indulge in this practice before going forth in search of their quarry. Prehistoric man, a nomad with only the slightest knowledge of agriculture, depended for his daily sustenance upon the chase. If he failed to catch his stag or his wild boar or his bear, he just did not eat and that was all there was to it. And when he himself went hungry, his wife and children did likewise. His whole philosophy of life, his whole religion therefore, revolved around those wild animals of which he has left us the painted images, and which either ate him or were eaten by him, creatures, therefore, that played a very important role in his life.

In Egypt this attitude toward the animal world eventually led to their worship, even to their deification. In India it has done this, too, and in a most uncomfortable way, for it gives every cow the right to walk into your house and make itself at home, and you can't do anything about it without causing a riot.

The question now suggests itself: Were those prehistoric paintings of animals, done with such infinite care and giving proof of such very careful observation—were they perhaps part of man's earliest religious exercises? Were those dark caverns in which all the walls were covered with pictures of bison and wolves places of worship, some sort of ancient temple where the elders of the tribe came together to produce magic formulas and to bewitch those images in order that afterwards the hunter might be all the more successful in his search for food? I am sorry, but I must repeat once more that we do not know.

Meanwhile, from a purely artistic point of view, we have every reason to be grateful to the priests who had devised this strange form of wizardry, for out of this emotion (whatever that emotion may have been) grew our earliest school of painting; the men who handled those burins were artists of the first rank.

The few bits of statuary that have come down to us from prehistoric times are very much like the images still being made by the witch doctors of many modern tribes in Africa and the Pacific islands. They are pretty terrible, at least to my way of thinking. As a rule they are both obscene and repulsive and are completely lacking in all those qualities which make us rate the work of the caveman painters and draftsmen with the best that has ever been done.

But one fine day that early school of painting seems to have completely disappeared from the face of the earth. Thousands of years had

to go by before Europe would once more see an art that showed such an uncanny gift for observation. During those thousands of years, however, a great many things happened of the utmost importance in the development of the arts. For it was during this period that the human race learned the use of metals and the use of fire for the purpose of changing lumps of clay into lasting pieces of pottery.

The lovers of order who must have their precise date for every historical event will have to go home disappointed, for we are still talking about an epoch when time, in our sense of the word, did not exist. Also, as you will notice on every page of this book, historical periods, whether they deal with the story of man or give an account of his artistic achievements, have a most annoying habit of overlapping each other without the slightest regard for the convenience of the poor scribe who is afterwards supposed to reduce them to so many definite dates.

Take this matter of the Wooden Age and the Stone Age and the Bronze Age. They are supposed to have come to an end thousands of years ago. They have done nothing of the sort. We continue to build in wood, as our earliest ancestors did. We still use stone for all sorts of grinding and polishing purposes. Bronze enters into our modern lives in dozens of forms. So do iron and steel, which also had special "ages" called after them.

What we really mean, therefore, when we speak of the Wooden Age or the Bronze Age is this: that during its period wood or bronze was the most important material at the disposal of man. And quite naturally he used wood or bronze until he got something better, just as we ourselves do today when we do not give up gas until the house has been properly wired for electricity. We know when Edison invented the electric light, but when did the knowledge of the use of bronze first reach the Western World? Bronze is an alloy. An alloy is a baser metal mixed with a nobler one, for even in the mineral kingdom there is a certain amount of snobbishness. The copper family probably felt it as a sort of *mésalliance* when forced to associate itself with a member of the vulgar tin tribe.

The earliest pieces of bronze that we have found so far were discovered in the central court of the ancient palace of Cnossus in Crete, and that was built some fifteen centuries before the birth of Christ. Bronze had probably been brought to Crete by the Phoenicians. It had already found its way to Egypt and a thousand years later (in

the age of the Trojan wars) it reached the mainland, going first of all to Greece and next to Italy.

From northern Italy peddlers carried it across the mountain passes of the Alps and sold it to the lake dwellers of Switzerland, who were still living in a complete Stone Age atmosphere. Meanwhile it had probably also come to England, for the Phoenicians needed tin and they knew that the best tin was found in Cornwall. It is typical of the distrust in which the slave-hunting Phoenicians were held by the rest of humanity that the natives of England did not allow them to set foot on their shores. They carried their tin to the Scilly Islands, a day's sail from the coast, where the Phoenicians could then come and do their bartering, but at a safe distance.

Hardly had bronze spread all over the continent than iron made its appearance. Being much harder than bronze and so easily convertible into steel that even the clumsy heroes of Homer knew how to perform this miracle, it soon replaced bronze for almost all practical purposes. Bronze, however, being a more pliable metal and more agreeable to the eye and touch, maintained itself as a favorite metal for the artists. Ornaments were occasionally made out of iron, especially in northern Europe. But iron became the masculine metal, the metal out of which swords and lance points were made. Bronze, as the feminine metal, survived in the jewelry shops.

The ironworker is a great favorite with all historians, for it is very easy to keep track of him. He leaves definite traces behind him wherever he goes. Therefore we know a great deal about the spread of the iron civilization across Europe. But it is very disappointing to notice how inferior the ornaments of the Iron Age were as compared with those of the Stone Age. Iron is not an easy material to handle. Neither is stone. Yet the artists of the Stone Age showed a much greater deftness and much more imagination in the way they solved their problems than the men of the Iron Age who lived thousands of years later.

Here the anthropologist comes once more to the rescue of the archaeologist. He has observed that the skulls that have been found in the earlier graves seem to have belonged to a much more intelligent race of people than those that date back to a much more recent age.

Evolution does not necessarily mean that the superior types will always survive. On the contrary, the superior types from the point of view of civilization are quite often completely exterminated by their inferior neighbors who happen to be less civilized but are much better prepared for purposes of war. In this case the facts seem to hint at some such development. After the late Stone Age there is a very defi-

nite and very sudden slump in the artistic output of the human race
as it was then to be found in northern and western Europe. For a long
time thereafter Europe was so completely overshadowed by Africa
and Asia that it lost all importance as a center of art. Eventually it
regained that leading position which it had lost during the Iron Age.
But only after it had gone back to school—after it had gone to the
school that stood in the valley of the Nile and that was known as the
land of Egypt.

# The Art of Egypt

*A country in which the living played the game of "let's pretend" with the dead.*

WHEN GENERAL NAPOLEON BONAPARTE went to Egypt in the year 1798 he had only one purpose in mind. By an unexpected attack on India (entering the premises by the back door) he hoped to give the British such a scare that they would hastily sue for peace.

His far-famed military exploits in the valley of the Nile got him nowhere at all. They merely meant a waste of men and money and a great deal of unnecessary suffering to a great many patient little donkeys and camels. But without quite realizing what he was doing, it was this young Corsican adventurer who once more gave Europe a glimpse, after almost twenty centuries of neglect and oblivion, of the treasures that lay hidden in the ancient land of Goshen. For one of his companions found the famous stone of Rosetta, which was afterwards deciphered by Champollion and which gave us a key to the language of the Egyptians, all knowledge of which had been lost for more than fifteen hundred years.

It was not, however, until the middle of the last century that the exploration of the Egyptian antiquities was at last undertaken along scientific lines. Soon the archaeologists came to the conclusion that the task of studying and classifying the accumulated remnants of almost forty centuries of an uninterrupted form of civilization was too much for a single nation. They thereupon agreed to divide the territory, and since then almost every country has done its part in trying to discover what manner of men and women these old valley dwellers had been, those humble little peasants who never ceased to produce beautiful things (and also a considerable amount of rubbish), while their own lives must have been as dull and monotonous as the lives of my little boy and girl with their red mufflers whom we met in the beginning of this book.

The entire pattern of our modern existence is based upon an unconscious ideal of restless change. Something exciting must happen every moment. We continually rush from one thing to the next, apparently for the mere joy of being on the go. It is curious then to

realize that two-thirds of our so-called "historical periods" of man-kind (the six thousand years that stretch from 4000 B.C. to the present time) was an era of mere vegetation and of complete boredom when we look at it from our modern point of view.

The little fellahin so busy plowing their fields while your boat moves slowly toward Memphis or Thebes—they were busy plowing those selfsame fields, and plowing them very much as they do today, when this fertile valley was first occupied by that mysterious Hamitic race which, like most other highly gifted races of our planet, was a mixture of all sorts of tribes and individuals who had left their ancient home-steads to begin a new career among the more favorable surroundings of the valley of the Nile. They had been plowing those identical fields for thousands of years before the so-called Old Kingdom had been founded by the rulers of Memphis, who dwelt in the lower part of the valley. They continued to till their fields while Khufu, Khafre, and Menkure built their Pyramids, a thousand years before Abraham de-cided to take himself and his household goods from the land of Ur to the shores of the Mediterranean.

They patiently went on tilling these fields during the six centuries of the so-called Middle Kingdom, when the art of their valley reached its highest point of perfection. They went on tilling their fields when, for the sake of greater safety, the capital of the Old Kingdom was moved from Memphis to that famous city of Thebes which old Homer called "the town of the hundred gates."

They went on tilling their fields while Amenemhet III built those large reservoirs that were to regulate the water supply of the Nile, so that the ever-increasing population of his domain might never lack for food or drink.

They went on tilling their fields while the Hyksos, who had just con-quered western Asia, overran their country in the year 2000 B.C., and they went on tilling their fields when the conquerors asked another wandering Semitic tribe, called the Hebrews, to assist them in the administration of their conquered territories in the valley of the Nile.

They went on tilling their fields when after several hundred years the Hyksos were finally expelled and King Amasis (the George Wash-ington of the seventeenth century B.C.) founded the New Empire, which under such brilliant rulers as Thothmes, Amenhotep III, and Rameses the Great extended its frontiers all over Ethiopia, Arabia, Palestine, and Babylonia.

They were still tilling their fields when fourteen hundred years be-

fore the beginning of our present era an attempt was made to connect the Red Sea and the Mediterranean by means of a canal.

They went on tilling their fields when the Hebrews were at last forced to follow in the tracks of their Hyksos masters and established themselves among the hills of Palestine. They hardly noticed that the glory of the empire was so rapidly declining that in the year 1091 B.C. an upstart princeling in the south was able to declare himself independent and to make the city of Tanis, in the heart of the delta of the Nile, the capital of a new kingdom of his own.

They went on tilling their fields while Ethiopia was lost and while Jerusalem was captured and plundered. They went on tilling their fields when the Ethiopians paid an unexpected return visit and ruled Egypt for more than half a century. And they did not in any way change their mode of living when the Ethiopians in turn were driven out by the Assyrians, who turned Egypt into a province of their own empire.

Neither did they bother to inquire who was successful in the long struggle for independence, which in the year 653 B.C. brought another nation to the throne of still another Egyptian kingdom, now ruled from the city of Saïs, also situated in the delta.

They were still tilling their fields when, after eight hundred years of neglect, King Necho revived the plans of the great Rameses and once more started work on thàt old canal between the Red Sea and the Mediterranean, that was not to be finished until A.D. 1869.

They went on tilling their fields when the Persians conquered the valley of the Nile and they went on tilling their fields while vast numbers of Greeks and Phoenicians descended upon this fertile valley to exploit it and plunder it in the name of foreign trade. They watched the waters of the river flood their fields while Alexander the Great gave a banquet in the old palace of Karnak, that had been in a very sad state of neglect and decay for almost a thousand years.

They went on tilling their fields while the descendant of one of Alexander's Macedonian generals got herself so deeply involved in love affairs and politics with two rival Roman generals that, while she gained great literary and sentimental renown, she also lost her kingdom, which thereupon became a Roman province.

But thereafter they were obliged to till their fields a little more industriously than ever before, for Egypt had now become Rome's most important granary and the Egyptian peasant had to feed the masses of the Roman unemployed as well as himself.

They went on tilling their fields (for how should they ever hear of

anything that happened beyond the confines of their own little villages?) while rival gangs of Christian converts willfully destroyed the glorious civilization that Alexander had established in the city he had founded at the mouth of the Nile and which bore his name. They never stopped in their ceaseless labors when a Christian zealot destroyed the last of their temples and closed the last of the schools where the art of their sacred picture writing had been taught for almost four thousand years.

When the Caliph Omar (the same one who had built the famous mosque in Jerusalem named after him) conquered their country, they quietly turned to the new faith and they continued to till their fields, without worrying much about their new chance for salvation.

A strange life and an even stranger civilization! Four thousand years of little brown men and women, tilling their fields, raising their crops, waiting for the waters of the Nile to inundate their tiny farms, raising their little brown children, paying taxes to whatever master happened to rule their land, finally returning to the dust of the ever-patient desert and bestowing upon the world the spectacle of a land where nothing apparently ever changed, where all the days were alike, where life was lived in a sort of anonymous continuity, resembling in its outer aspects the placid waters of the great river that ran through the heart of their happy valley, so completely oblivious of its turbulent youth among the cataracts of the upper Sudan.

And yet in some mysterious way, these countless generations of little brown men and little brown women and little brown children, tilling and toiling from early morn till late at night—in some subtle and mysterious fashion these little brown men, who had no individuality of their own, gave to our world an art of such gigantic proportions, of such subtle craftsmanship, that it has remained unique, not only in its perfection but also in its universal appeal.

Such things must have a reason. They are not just a matter of luck or of chance. There must be an answer to them, though in a way we are just as much puzzled as Herodotus when he visited the valley of the Nile in the fifth century before our era and stood in front of the Pyramids, then already hoary with age, and asked himself, "Why?"

The Pyramids, of course, have very little to do with art. They do not even come under the department of architecture. They were problems in engineering, pure and simple. They were not born out of a desire for beauty. They were as highly utilitarian in their final purpose as the safe of a modern bank, which they greatly resembled, except that they were not erected for the purpose of giving shelter

to people's treasures, but to the infinitely more valuable bodies of their departed sovereigns.

The exact reason for their immense dimensions has never yet been discovered. Maybe the desire to keep up with the Joneses, which has been responsible for so much that is bizarre within the realm of the arts, was at the bottom of this terrific display of energy and wealth.

There are historians who claim that these Pyramids were the result of long periods of poverty and unemployment and that they were merely constructed to keep the people busy and to allow their king to feed them. But whether they come under the heading of "conspicuous waste"—as Thorstein Veblen undoubtedly would have claimed—or were connected with a W.P.A. project of five thousand years ago, the fact remains that they have no real connection with any of the fine arts, except in so far as very careful and conscientious building will always be a fine, as well as a very rare art.

But the Pyramids, although the most widely publicized of the Egyptian antiquities, are relatively unimportant. All sorts of people in almost every period of history, when sufficiently organized by their rulers and reduced to antlike docility and unreasoning obedience, have left us the same sort of useless monuments in almost all parts of the world. But none of the others, neither the Celts who erected Stonehenge nor the much vaunted Greeks, have produced so many masterpieces within the realm of sculpture and the graphic arts. And most certainly no other people has succeeded in maintaining such a high average of excellence for quite so many thousands of years. The others flourished for a couple of centuries or sometimes for only half that length of time and then, just as suddenly as they had broken into the delectable Gardens of the Muses, disappeared again and were never able to repeat the miracle, no matter how desperately they tried. Whereas the Egyptians did first-rate work for almost four thousand years. And that is quite a long time, when you remember that the white man has not yet been fully five centuries on the American continent and that our ancestors did not occupy western Europe until fifteen centuries before that.

The main reason for the extraordinary success of the Egyptians may well be found in their respect for tradition. They came naturally by this respect, just as we come naturally by our contempt for tradition. The life of ninety-nine per cent of the Egyptians was completely interwoven with the seasons, and the seasons are the most traditional thing in the whole wide world. In order to keep track of these seasons, the Egyptians had made a profound study of the heavens, and the

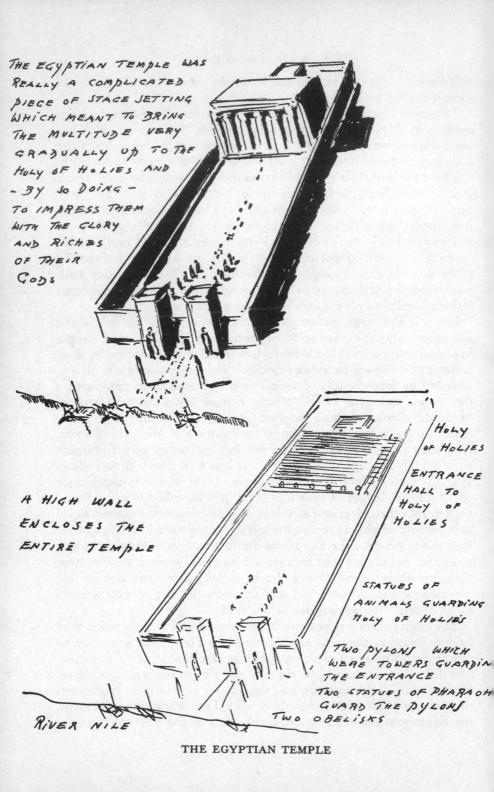

THE EGYPTIAN TEMPLE WAS REALLY A COMPLICATED PIECE OF STAGE SETTING WHICH MEANT TO BRING THE MULTITUDE VERY GRADUALLY UP TO THE HOLY OF HOLIES AND - BY SO DOING - TO IMPRESS THEM WITH THE GLORY AND RICHES OF THEIR GODS

A HIGH WALL ENCLOSES THE ENTIRE TEMPLE

HOLY OF HOLIES

ENTRANCE HALL TO HOLY OF HOLIES

STATUES OF ANIMALS GUARDING HOLY OF HOLIES

TWO PYLONS WHICH WERE TOWERS GUARDIN THE ENTRANCE

TWO STATUES OF PHARAOH GUARD THE PYLONS

TWO OBELISKS

RIVER NILE

**THE EGYPTIAN TEMPLE**

stars in their courses are a close rival of the seasons when it comes to regularity and tradition. And so the Egyptian accepted "tradition" in his art as he accepted tradition in his daily existence—as the beginning and end of self-preservation. Once we realize that fact, it is easy for us to understand why the Egyptian artists were infinitely more interested in the "type" than in the individual and why they tried much harder to achieve perfection in rendering the type (be it a type representing royalty or royalty's sacred cat) than to give expression to the individual idiosyncrasies of their models.

That brings up the question of likeness. "It's a lovely picture but it really doesn't quite look like Uncle Jeremiah." When Aunt Emmy makes that remark about Uncle Jeremiah, with whom she spent fifty happy years ("If there's anyone in this world who ought to know what he really looked like, it's me!"), the artist is out of luck. For ten to one, Aunt Emmy did not have the slightest idea what her departed spouse really "looked like" while the artist, if he was a good one, could tell more about his model's looks in ten minutes than Aunt Emmy had ever been able to learn in half a century. But unfortunately that is something it is very difficult to make the average layman understand. Meanwhile the picture, however excellent as a work of art, is curtly refused by the loving relatives, and the artist has wasted another six weeks on nothing in particular.

The Egyptian sculptors and painters were more fortunate. When they were ordered to make a statue of a king, they paid, of course, considerable attention to those traits especially characteristic of his face—the shape of his eyebrows or the formation of chin or nose. But to them and their customers this was apparently a detail—important, of course, but not really terribly important. The main thing was to represent the sovereign in such a way that everybody would exclaim at once: "That must be a king!" and recognize certain qualities in him which he expected to find in his ruler—a person aloof from the worries of everyday existence, a creature of this world yet sufficiently identified with his godlike ancestors not to be like the rest of mankind. Hence the complete absence in all these old Egyptian faces, no matter of what period, of any mortal emotions such as grief, anger, joy, surprise, approval, or discontent. The eyes always look straight ahead. It would not be quite fair to say that the eyes stare. They are looking very intently at something, but that something lies far beyond the sphere of observation of mere ordinary mortals.

If you want to know what I mean, compare the statue of a Pharaoh

of the age of the great Pyramid builders to the works of such modern-minded sculptors as Michelangelo or Rodin. Even the latter's heroes and Gods give evidence of being animated by the same passions and emotions that inspire the poor beggar asking for alms just outside the door of their palace or church.

To our modern taste it is that essentially "human appeal" which makes the sculptured works of the last four hundred years so interesting. But the Egyptians would have greatly disapproved of such an approach. As a matter of fact, I doubt whether they could even have understood what it meant. All nature was full of inequality. They did not expect to be higher than nature. A God was a God. A king was a king. And a subject was a subject. It was a simple arrangement and, best of all, it fully suited their needs.

In practically every other part of the world, art has always been intimately connected with the here and now. Egypt was no exception to this rule but there the "here and now" lasted for almost four thousand years. That was bound to have great influence upon the entire outlook of all the people. For time, in our modern sense of the word, did not exist for the people in the valley of the Nile. No more than it exists for our cats and dogs and all other animals.

These good people lived exactly the same lives, tilled exactly the same fields, ate exactly the same food, married exactly the same sort of wives, had exactly the same sort of children, thought exactly the same thoughts, and worshiped almost exactly the same Gods, whether they happened to have been born in 5000 B.C. or in 500 B.C. But not only was there an absence of "time." In a sense there was also a certain absence of "landscape."

Man, not only in his daily economic life but also in his artistic expression, is bound to be the product of his surroundings. In Egypt the very monotony of that landscape, that vast stretch of fertile fields, bounded by mountain ridges or desert, must have been a very important factor in deciding the religious ideas of the natives. They seem to have been influenced toward an ultimate ideal of perpetuity as they saw it expressed in the eternally recurring seasons, the eternally revolving sun and moon and planets and stars, the river that flowed eternally past their eyes, bound for the eternal horizon.

If every civilization has a rhythm of its own (and I am sure that that is true), then we can say that the rhythm of Egypt was that of eternity and of a self-perpetuating universe. But just as that self-perpetuating universe remains true to its general arrangement but is subject to certain minor changes which will soon become evident to the

very careful student, so did the art of Egypt, while undoubtedly never wandering very far away from its main outlines, vary greatly in many of its details from one thousand years to the next. It is these details we have to study if we want to understand that particular form of art.

Right here I should mention another difficulty which is very apt to be overlooked in all such discussions. The kings of Egypt were the exclusive patrons of the arts within their own domains. Quite naturally they never expected that the day would come when their temples and palaces would become out-of-door museum pieces, while they themselves were being shown to the passengers of a Mediterranean cruise ship as "Mummy No. 489-A, in the second glass case from the right when you enter the seventh room in the left wing of the National Museum. The X-ray photographs of Her Majesty are by David Rosen."

Like the Romans afterwards and the people of the Middle Ages— indeed like almost all nations that were not conscious of a difference between art and daily life—they built and pulled down and arranged and rearranged their palaces and their temples as they pleased and with no thought to posterity. If King Rameses XII happened to discover a temple built several hundred years before by another Rameses but now considerably the worse for wear and badly in need of repair, he would not merely give orders that it be restored, but being human and therefore not entirely without vanity, he would probably decide that the statues of his famous ancestors which guarded the entrance portals should be replaced by a few nice new statues of himself and have the others put wherever convenient.

The habit of slapping a façade of the year 1500 B.C. on a temple of the year 2500 B.C. or of adding a new row of pillars, ornamented in the style of 1000 B.C., to another row of pillars two thousand years older, makes the study of Egyptian art very difficult. But I warn you that we shall meet with similar acts of what we now call vandalism in almost all other countries until well within our own times.

Our own medieval ancestors, who were practical men of business, would unconcernedly convert an entire Roman Colosseum into a miniature village without the slightest respect for the wishes of the original architects. They would build dozens of little homes between the buttresses of their Gothic churches. They would erect a couple of Protestant "houses of worship" right in the heart of an old cathedral. They would fasten Gothic faces on the Romanesque bodies of twelfth-century saints. They would paint eighteenth-century fig leaves on fifteenth-century Adams and Eves. They would fill their Baroque

parlors with Rococo sofas. They would be guilty of all sorts of unpardonable sins against our modern notions of "good taste" and "period furniture," and, instead of being ashamed of such acts of sacrilege, they would have thought that we were ourselves very silly whenever we sacrificed our comfort or civic necessity to considerations of a purely artistic nature. Life and the fullness thereof, so they claimed, existed to be lived and enjoyed, not for the purpose of being reduced to a few esthetic theories preached by a couple of learned professors. When such a process of continual renovation has extended over several thousand years, the results are apt to be a little perplexing, even to those experts who have made a special study of this period.

Take the temple of Luxor. The original part goes back to the days of Amenhotep III (or Amenophis or Memnon, for almost every Egyptologist, ever since the days of the Greeks, has had a way of his own of spelling these names). Amenhotep III lived during the first few years of the fifteenth century B.C. Over a hundred years later, Rameses II began to "restore" this temple. And when Alexander the Great visited Egypt in the fourth century B.C., the Egyptians were still busy tinkering with Amenhotep's original edifice. They therefore were not in the least upset when the young Macedonian king gave orders to rebuild the main halls of the temple entirely, according to the plans of his own architects.

I grieve to say that almost every temple and palace in Egypt has suffered quite seriously from a similar fate. Worst of all was the fate of the Pyramids. One could not very well change their shape. But these vast piles of stone, higher than St. Paul's Cathedral in London, had been protected against the heat of the desert by a layer of fine, hard stone from the quarries in Tura. Three thousand years later the Arabs needed building materials for their own mosques in Cairo. They quietly stripped that protective layer from the Pyramids, which are now doomed to crumble into dust. It may be a matter of one thousand years or of two thousand years, but they are doomed to disappear.

So much for the vandalism or rather indifference (for it was sheer laziness and indifference and not the result of any evil intent) of the people of bygone times, and why it is so difficult to be entirely "systematic" in our discussions of the art of the past. When in addition you will remember that the old sculptors and painters practically never signed their work (we have scarcely a single piece of Greek sculpture with the authentic signature of its maker) you will begin to feel a rather profound respect for the men who within a single

century have brought order into the chaos of the world's oldest treasure chest.

The art of the Egyptians, like that of the Japanese and all other Oriental peoples, did not know the meaning of perspective. As perspective plays such a very important role in our own relation toward the arts, we might as well begin with a definition of the word.

Here it is: Perspective is the art of drawing solid objects upon a plane surface in such a way as to produce the same impression of relative positions and magnitude or of distance as the actual objects do when viewed from a particular point. Here is another one, a little less complicated: Perspective is the method by which we portray three dimensions on a two-dimensional surface.

Today every child is familiar with at least a few of the basic rules of that perspective which allows him to look "into" a picture as he looks "into" a landscape. He knows all about the mysterious vanishing point and the apparent convergence of parallel lines and planes. Even a boy or girl of seven can give each object its correct position in the general scheme of things so that it will look as if it were surrounded by space and had not been painted on a flat surface.

But it was not until the fifteenth century that artists began to bother seriously about their perspective, and the Oriental artist has never worried about it until this very day. This does not make his pictures any the less agreeable to those of us who have learned to look at paintings the way he does. But to most people, who have lived all their livelong days in a world in which perspective was taken for granted, the Oriental method is a serious cause of irritation. They feel about a Japanese print the way most of us do when for the first time we are exposed to some modern piece of music that no longer bothers about that definition of harmony which we were taught when we were young —"a pleasing arrangement of musical sounds." It may be music to some of our neighbors, but to us it is just so much unpleasant noise.

Perspective, therefore, like a taste for olives or broccoli or modern music, is something you have to acquire. Nobody has ever been born with a knowledge of perspective, any more than he was born with a natural understanding of the mysteries of a table of logarithms. Therefore, all children, whenever left to their own devices, will draw "flat" pictures without bothering about getting a three-dimensional effect. And all art in its childhood days has been perspectiveless—or if it showed a sense of perspective, it did so by accident.

Now when art, as in Egypt, becomes a matter of "tradition" and

when circumstances are such that a particular class of priests or rulers are able to revaluate these traditions (until then a matter of preference on the part of the artist) into certain hard and fast rules, then the results are apt to cause an almost complete rigidity of expression and gesture. Would the Egyptians have been able to do otherwise if no priestly class or worldly master had ordered them to stick to their formula? I think so, for they were very keen observers. Their earliest wooden statues, which had an excellent chance of survival in that hot and dry climate (a country of inundations, but without any rain) show a marvelous gift of portraiture. The royal tombs, filled with these retinues of wooden servants, bear witness to the genius of these unknown sculptors for this very difficult sort of work.

But in this land of tradition, everything tended to make life static. Methods of agriculture, social behavior, village customs—they all got "set," as our New England neighbors would say, and thereafter nothing short of a national catastrophe could budge them.

In one particular field, sculpture, nature contributed greatly to that rigidity of which so many people complain when they begin to study Egyptian art. The sculptor of the valley of the Nile was obliged to do his work in granite or basalt. He had no marble which can pulsate with life if treated in the right way. He had to use either granite or basalt and both those stones are "as hard as granite" (to use a well-known comparison). They do not merely invite rigid lines, they absolutely insist upon them.

But even if the sculptors had been able to work in softer materials, I doubt whether they could have escaped the rigidity imposed upon them by the social and religious system under which they lived. In those countries where the majority of the people are herdsmen or small-scale farmers, each one of whom raises just enough vegetables for his own family, there is very little need for constant co-operation. Each individual can shift for himself. If he is lazy or careless, his own children and his own wife and relatives may go hungry but his shiftlessness will hardly influence his neighbors. Unless in a moment of indifference he sets fire to his own premises and thereby threatens the possessions of the other tribesmen, those others will probably leave him severely alone. For their own happiness and continued prosperity do not depend upon those of anybody else but entirely upon themselves, as they did in our own country until a hundred years ago.

But in the valley of the Nile nothing could be accomplished without the constant co-operation of all of the people all of the time. One does not build an irrigation dam by oneself. One does not feed hundreds

of people per square mile (the density of population in the actual valley which has not changed a great deal since olden times) by irrigating a few acres here and there and by inundating and irrigating them at irregular intervals, whenever the spirit moves you. In order to keep all those teeming millions alive in their narrow valley, which is rarely more than ten miles wide, the people had to obey a single will. Originally, it was a matter of self-preservation. But because it worked—because it proved successful—it was accepted and continued to be accepted for all the thousands of years that Egypt existed as an independent unit.

The Pharaoh—the Big Chief who lived in the Big House after which he was named—was the head of the state. I don't think that it ever dawned upon these good people that there might be other ways of accomplishing the same results. Why should they have bothered their heads with such vague speculations? Their own system worked like a dream. In a world of hunger and poverty and want (for that is what the ancient world was) the Egyptians realized that they in their vast granary were infinitely better off than any of their neighbors. Once in a long while when taxes were too high, especially when the country was under the domination of some foreign invader, they could be exasperated to the point of open rebellion. The rest of the time they were docile little brown men, knowing no other sort of life and therefore perfectly willing to obey their master, perfectly willing to pile up those millions of stones necessary for the vast palaces and temples that surrounded the capital cities. There was only one thing they did not want to do and that was to die.

That was nothing out of the usual. Nobody since the beginning of time has really ever wanted to die. And many nations, like the Greeks, have made very wry faces at death and have called the grim sickle carrier all sorts of uncomplimentary names. But the Egyptians were the only people on record who ever tried to fool death by pretending throughout that there was no such thing.

Several thousand years later the art of the Christian Church devoted itself almost exclusively to depicting the pleasures and joys of the world hereafter—a world in which the pious would dwell forever in perfect joy and a million miles removed from the manifold iniquities of this doleful vale of tears. And by trying to reconstruct the philosophy of life and death of the old Egyptians from our own Christian angle, the historians of a previous generation came to the conclusion that the Egyptians, like the Christians, had despised this world and had therefore turned the whole of their country into one

vast charnel house, with its endless pyramids and tombs and all its elaborate caskets and sarcophagi and its crypts and necropoleis and all the other concrete manifestations of their curious worship of death. Finally the Egyptians stood revealed as a race of gloomy people who had lived such dreadfully unhappy lives on this earth that, quite like the good Christians after them, they were forever creeping into the abysmal darkness of their temples and mountain sepulchers, there to study the chapters of their famous *Book of the Dead*, a sort of guidebook to the nether world.

But this was the exact opposite of what was actually in their minds. The Egyptians (I think that I have made that sufficiently clear) led very monotonous lives. One day was very much like the next. One year was very much like the next. One thousand years were like the next thousand. But monotony does not necessarily exclude happiness nor does it imply a discontent with the sort of existence one is forced to live. On the contrary, the people who lead what seem to us modern Americans very dull and uninspired lives are apt to be infinitely happier and infinitely more contented than we who are convinced that we will finally discover some earthly paradise if only we keep looking for it with sufficient energy and fury.

An Egyptian peasant may have been merely a rather grubby earth animal, but he was a cheerful creature, for he had never been exposed to the doctrine of "sin," a Jewish invention of a much later date. Like the Eskimos, he might not have a thing he could call his own, but he laughed a great deal more than the inhabitants of our cities whose existence is all cluttered up by gadgets and by those terrible inanimate objects that make modern life such a burden.

Being also a very simple fellow, he thought that since one could not quite deny the existence of death, one might at least pretend that one had never heard of it. That is probably the way that vast cult of the dead originated. For it was really a "cult of the living"—a pathetic attempt to fool oneself about the fate that awaits all men—a childish desire to hear grandmother say, "All right, my little darling, there is no bogeyman, so go to bed and happy dreams."

The moment you begin to examine the things we have found in the old Egyptian graves with this thought in mind (that it was all part of a game of "let's pretend"), you will understand what I mean. The Christian tomb of the Middle Ages was really a place of horror. It was covered with images of crossbones and skulls and of poor sinners burning in hell. The accent of everything that had to do with the Christian faith was one of agony, of despair, with never a note of gaiety. Com-

pare with that the lovely pieces of furniture that went into an Egyptian tomb—the jewelry, the perfume, the costly garments, the miniature army of chambermaids and pastry cooks and musicians and secretaries and guards and boatmen that accompanied one into the grave. Remember that they were there for a purpose, to allow people to play the pleasant game of pretending that nothing at all had really happened and that their king or father or husband or uncle or wife—although they had departed this life—were continuing to enjoy existence in the hereafter as much as they had done when they were still rejoicing in the good things of this planet.

The Egyptians, like all agricultural people, had endowed all the forces of nature with definite personalities of their own. They thought of them as a sort of divine hierarchy able to influence the lives of ordinary mortal beings as directly and as definitely as the Pharaoh and his soldiers and councilors and priests could do on this earth. Strange things, of course, would happen to these Gods when they grew as old as Osiris and Isis and Horus and many of the other deities of the valley of the Nile. These Gods, once they had lost some of their inaccessibility, were found to be very much like ordinary officials, tax-gatherers, and irrigation inspectors. That is to say, they could be "approached" if one only knew the ropes.

In the case of the king's minions, this was comparatively easy. One slipped them a couple of silver pieces and they looked the other way. In the case of the Gods, the process was rather more complicated, for their favor could only be gained by the right sort of incantations and prayers. If one knew the correct ones, there was even a chance of getting occasionally out of one's tomb for a short holiday to enjoy the companionship of one's former friends. Therefore it behooved the survivors to surround their departed relatives with all the pomp and circumstance of their former existence. Hence there arose whole tribes of artists who worked for no other market than that of the dead. But in their heart of hearts, they knew that they were really working for the living. Hence the note of grace and charm and gaiety in everything they made. They too were playing the game of "let's pretend," and playing it with a will.

So much for the minor arts, which in Egypt are really much more interesting and fascinating than the more massive manifestations of the national creative genius as revealed to us by those miles and miles of desolate palaces and somber temples, by those unhuman proportions of both the Pyramids and the Sphinx, and by the superhuman aloofness of those thousands upon thousands of statues of Gods and

kings which stood guard over every door and courtyard of that land of Egypt and seem to have been created for the sole purpose of reminding the populace that within the realm of spirits there was neither beginning nor end, amen!

But inside their palaces and temples the innate happiness of the people and their childlike joy in gay and colorful little pictures made itself manifest in all the hundreds of thousands of miniature illustrations that cover the walls and pillars and roofs and lintels. No matter how inaccessible or how completely hidden from human view, every available inch of surface was covered from top to bottom with bits of pictorial information showing little scenes from the daily lives of the masses. Everything was there, from the correct way to prepare a fish to the correct (if rather unpleasant) methods by which a king should send terror into the hearts of his enemies.

Sometimes this pictorial information was given by means of paintings, but wherever possible the figures and the accompanying text were scratched right into the actual stone of the walls and pillars. We call this method of working in stone "bas-relief." The name is of Italian origin. In the Middle Ages people drew a sharp difference between *basso-rilievo*, in which the pictures projected less than one half of their thickness from the background, *alto-rilievo*, in which they projected more than half of their thickness, and *mezzo-rilievo*, in which they projected half their true proportion from the background.

We shall afterwards find some exquisitely carved bas-reliefs on the Parthenon in Athens and on the Borobudur in Java and on a great many Indian temples. Quite often, however, the Egyptians did not try to make their figures actually stand out from their background. They contented themselves with etching the outlines of their figures into the stone without very much effort at modeling. This is what we call "sunk relief." Today we are so unaccustomed to this form of art that we no longer make these fine distinctions, but call every sort of sculpture that does not stand entirely free from its background bas-relief, and I shall use the word in that sense. Incidentally, it is very difficult to make a good bas-relief. Nobody but an experienced sculptor should try his hand at this sort of work. But a first-rate craftsman can give such bas-relief pictures a very pleasant effect, and the simpler they are, the better we usually like them.

I do not belong (as you must have discovered by this time) to those who think everything done four thousand years ago must therefore necessarily be better than what we do today. But there are certain

things that the ancient artists did infinitely better than we ourselves can do them, and for good reasons, too.

In the first place, art today has ceased to be an integral and necessary part of the lives of the people at large. The artist therefore has become someone who stands apart from life, a sort of public entertainer, someone whom we pay to amuse us.

In the second place, since someone invented the terrible slogan "Time is money," the elements of hurry and haste have been introduced into the workshops of both the craftsmen and the artists. Now, one might just as well try to speed up the works of nature, such as the growing of a tree or the bearing of a child, as those of a painter or sculptor. Bas-relief is something that takes a great deal of time and patience. We have lost both these excellent virtues and we pay for that loss in our works of art.

Thirdly, our modern way of living does not really lend itself very well to either sculpture or bas-relief. The home we built yesterday comes down again tomorrow. The sculptor knows this and he does not like the idea that all his work will thereupon be loaded onto a truck to be sent to some vacant yard, there to await a possible customer who most likely will never make his appearance, as the demand for statuary in the modern world is exceedingly small. And bas-relief, which is a part of the walls themselves, will fare even worse than mere statues. It will be carried away by the house wrecker, and he won't even notice that it is something different from the rest of the rubbish which will be used to fill in a near-by road.

The Egyptian artists suffered from none of these disadvantages in practicing their craft. They worked for all eternity, for the whole of their national life was based upon the assumption that nothing would ever change. And you are much more likely to put your heart into your labors when you know that three thousand years from now an admiring multitude will still stand in front of your picture of a couple of birds and a donkey, and say, "How in heaven's name did this fellow ever do this!" than if you know all the time that no matter how surpassingly good your stuff may be, it is hardly likely to survive you by more than a couple of years.

And finally, the very method of construction as practiced in the valley of the Nile gave the Egyptian artists a wonderful chance to practice their craft, for nobody has ever filled the world with quite so many square miles of flat and round surface as the architects of the Pharaohs.

Please remember that these ancient temples were not churches in

our sense of the word. To the modern Protestant mind the word
"church" suggests a hall big enough to seat several hundred people
who have come together for purposes of worship. This congregation,
except for the half-hour or so during which it listens to a short moral
or spiritual lecture upon some text taken from either the Old or the New
Testament, takes an active and immediate part in the actual church
service. It prays together with the minister. It participates in the
hymns that are being sung. The congregation itself is so essentially
the Church that if the building in which it happens to meet should
burn down, it could just as well meet in a theater or barn or even out
in the open, and the actual act of worship would suffer no interrup-
tion whatsoever.

The Egyptian temple, the prototype of the Greek and Roman temple
and the cathedral of the Middle Ages, served no such purpose. The
congregation took no part whatsoever in the service. That service,
consisting of certain symbolic acts on the part of the priests, was the
main thing. As for the congregation, it did not count. It made no
difference whether ten thousand people were present or no one at all.
The service would have been held just the same.

Hence an Egyptian temple really consisted of two entirely different
units. There was the dark little room which served as a sort of town
residence to the God who happened to be worshiped on that par-
ticular spot. I say "town residence" because the Gods, of course, were
supposed to dwell in a realm of their own, situated far beyond the
distant mountain ranges. But this idea was too vague, too remote, for
the needs of the ordinary citizen. He needed something a little more
concrete, something a little more tangible or at least visible. Even if
he himself was never allowed to behold the Deity, he felt happy in the
knowledge that the Deity sometimes visited a spot where a few highly
privileged personages could behold his countenance.

Perhaps I can make this attitude clear to you by giving you a modern
parallel. Take that mysterious yellowish metal which has become the
great object of veneration of the people of today, the gold supply of
the nation upon which (as most citizens seem to believe) the safety of
their country depends. Except for a few guards, nobody has ever seen
it. Like an old Egyptian God it lies hidden in a dark cave, and even
the President of the United States or the Secretary of the Treasury is
not allowed to enter this holy of holies which contains the basis for
our national credit.

Nobody so far has hit upon the idea of connecting this modern
golden calf with some new form of ceremonial worship. But such a

thing is not out of the sphere of what one might call "spiritual possibilities," for stranger things than that have happened before and may easily happen again.

If, however, such a veneration of our gold supply should be elevated to the dignity of a regular national form of worship, then we would have a parallel to the religion of ancient Egypt. We merely need to substitute an invisible Deity for an invisible barrel of gold stones. And we must thereupon convert Wall Street and Broad Street and William Street into a series of great courts in which the populace will stand and wait, while way down in the dark and invisible interior of the Sub-Treasury some assistant Secretary of the Treasury intones, "One billion and ninety-seven cents—two billion and forty-eight dollars." Whereupon the congregation, reassured as to the actual presence of the object of its devotion, returns happily to its daily tasks and duties, for all is still well with the world.

I am going into considerable detail right here because you will never understand these ancient temples unless you keep this general idea well fixed in your mind. The ancient temple was the worldly residence of some particular God, usually a small and very humble little building which stood at the end of an array of outer and inner courts of the most imposing proportions. You may well ask why all this should not have been the other way around? Why were not the outer and inner courts kept plain and simple, while the actual place of residence of the Deity was converted into a miniature palace? But no priesthood could ever have hoped to maintain itself (and for such a long time) without a profound sense of the dramatic, without knowing to a T how to work upon the emotional reactions of the multitude.

A professional priesthood is like a group of professional politicians. First of all, it is under an obligation to keep itself in office. In Egypt the method of creating an atmosphere of mystery was best suited to the national temperament. But in other countries like Greece, where there were no professional priests, an entirely different arrangement was necessary. There the shrine was the thing and the outer hall counted for nothing. Indeed, in the beginning there had been no outer hall. The landscape itself had served as such. But in Egypt, the country of mass action, these entrance halls played a most important role and were therefore an object of constant affection on the part of the artists.

Originally, before the introduction of metal into the valley of the Nile (it apparently arrived together with the Pharaohs, which makes us suspect that the Pharaohs, too, may have been a foreign importa-

tion), these entrance courts as well as the temples themselves had been made of wood. After the introduction of metal, temples were often dug into the rocks of the near-by mountains. But with the growth of the big cities in the plains, Memphis and Thebes, it became customary to erect temples that were copies of the old wooden ones, only that this time everything was made out of stone. And it was these stone walls and stone pillars that thereupon offered the painters and sculptors such a wonderful and spacious background for the display of their powers.

Take the big hall in the temple of Karnak. It was 338 feet long, 170 feet wide, and 79 feet high, and it contained 134 columns. It was lighted by means of windows that were situated just under the roof but except for these windows, all this wall space was available for the art of the painter and the specialist in bas-relief.

The painter, as I told you, had no idea of perspective and he had to rely entirely on distemper. Distemper is the oldest form of painting. The caveman used distemper. All of you must have seen a plasterer whitewash the rooms of a house. Well, whitewash is merely a very simple sort of distemper. In its more complicated forms, distemper consists of the different colors mixed with some sticky or gluey material that will dissolve in water and then can thereupon be applied to a background of plaster or chalk. The background itself must be dry when the distemper is applied. In modern painting, we use the *alfresco* way of painting. In this "fresh method" of painting (I am giving you the literal translation of the Italian name) we apply the colors before the plaster is quite dry. This allows the paint to sink in and thereupon gives us quite a different effect from the older method of painting directly on a dry surface.

As for the colors of the Egyptians, these consisted at first of only two kinds of ink, black and red. For the Egyptians were the inventors of that marvelous writing and drawing fluid which we call ink. Whether they invented ink because they had learned the art of hieroglyphics or picture writing, or whether they became picture writers because they had first invented ink, is something I cannot tell you.

In addition to the black and red, the Egyptians afterwards used yellow, green, blue, and a sort of red that tended more toward ocher or dark orange than toward vermilion or carmine.

Egyptian painting reached its highest development between the twelfth and the nineteenth dynasties, roughly speaking from 2000 B.C. to 1300 B.C., the era of the Rameses. That gave to Egyptian ar-

tist seven hundred years in which to develop their technique. The Van Eyck brothers invented modern oil painting about the year 1400. That means that we are still in the initial stage of development as compared to the artists who worked for the Pharaohs.

To us there is something incongruous in this art of Egypt, this completely anonymous art that seemed to have neither beginning nor end, that had begun the Lord only knew when, that continued under every form of rule and misrule, that survived foreign invasion and natural cataclysm as the sea survives storm and tide, that built and sculptured and painted and drew and carved and practiced some sort of music and devised ever more complicated ornaments and that passed from wood to bronze and from bronze to iron and from clay to glass and from cotton to linen as if life had no other purpose than to be lived—quietly, patiently, peacefully, without expectation of great reward or fear of grave disaster.

A strange world when we contemplate it in the light of our modern philosophy of life, with its exaggerated accent upon the rights and privileges of the individual in which the word "I" dominates the entire social, moral, and artistic fabric of society. A very strange world indeed, but one which, next to that of China and India, has been able to maintain itself for a much longer period of time than any other experiment in statecraft of the last five thousand years.

Our modern art is the expression of some individual personality. The temples and statues of Egypt were the expression of the personality of the community at large. When Moses looked upon them, they were already very old. When Caesar looked upon them, they were still older. When Napoleon used them as a background for his high-sounding oratorical efforts, they were hopelessly old.

And yet when you go forth to study them for yourself (as I hope you will be able to do some day), you will notice that many of these little wooden figures and silent stone watchmen and many of these paintings look as fresh and young as if they had been made only the day before yesterday.

I can't explain it. Nobody can. Perhaps it is better that way. Within the realm of the arts, at least, it is always dangerous to depend too much upon our faculty of reasoning, for reason alone will never get us anywhere. It is wiser just to accept and to be grateful.

I can think of no better text to carve over the doors of all our museums:

ACCEPT AND BE HUMBLY GRATEFUL.

# Babylon and Chaldea and the Land of the Mysterious Sumerians

### The unexpected art of the valley of Mesopotamia

W HEN THE UNITED STATES OF AMERICA made their appearance as
an independent nation the art of Egypt had been hidden to the
Western World for almost fifteen hundred years. But at least it had
been suspected. There always had been a few vague rumors about
Pyramids and ancient temples that were said to be a mile high and to
cover miles and miles of territory. The Turks did not exactly welcome
visitors to this part of the world, but once in a while some particularly
courageous globe trotter would succeed in slipping past the Moslem
guards and he would return with weird stories about his adventures
among the mummified kings and cats and crocodiles that were to be
found in every part of the desert.

Meanwhile Europe continued to live in almost complete ignorance
of those treasures that lay hidden in the valleys of the Tigris and the
Euphrates. The Old Testament mentioned a tower of Babel and a few
Crusaders who had ventured beyond the River Jordan had sworn a
solemn oath that they had seen the ruins of this edifice with their own
eyes. But nobody had taken these tales very seriously. They were on a
par with the yarns of Sir John Mandeville, who some time between
1357 and 1371 had published a book describing the remnants of the
ark of Noah, which he had found on the top of Mount Ararat.

Finally, however, in the forties of the last century the archaeologists
of Europe began to pay serious attention to the sandy wastes of the
great Mesopotamian plains. They were then a wilderness, but once
upon a time they had been so fertile that the traditional paradise of
the Old Testament was said to have been located right there, on the
long stretch of land that lay between the Euphrates and the Tigris.

There was, of course, a great difference between Egypt and Meso-
potamia. Egypt had been inhabited by one single race for almost four
thousand years. Mesopotamia, on the other hand, had changed hands
so often that it was well-nigh impossible to classify the treasures that
were being dug out of its soil in such vast profusion. There were the

Sumerian mosaics and the Babylonian statues and the ruins of Chaldean temples and the Babylonian tablets and the statues of the Hittite warriors (who bore a strange resemblance to some of the old Hindu figures from near-by India), and there were the very important excavations in the land of Ur, the original home of Abraham, who was recognized as their common ancestor by both the Jews and Moslems.

For a long time the archaeologists were not quite clear which of the two arts was the older, that of Mesopotamia or that of Egypt, and whether the Babylonians had influenced the Egyptians or *vice versa*. In the matter of dates, the two countries were pretty evenly balanced, for in both parts of the world we have within the last fifty years found antiquities that go back to the fortieth century before the beginning of our own era. But as for the influence of Egypt upon Mesopotamia or that of Mesopotamia upon Egypt, we shall have to know a lot more than we do today before coming to any definite conclusions. For if these two countries had actually known about each other or had communicated with each other, then how does it happen that the Egyptians never learned the art of vaulting and stuck to their flat roofs and passageways, while the Babylonians were past masters at that difficult sort of construction and even knew how to construct their vaults without the help of any wooden supports?

This may have been merely due to the building materials they had to use. The Egyptians could get every sort of stone they needed from the near-by mountains, whereas the people of Mesopotamia depended almost entirely upon brick. Hence their palaces and temples are by no means as well preserved as those of Egypt. But in the matter of pure craftsmanship, the Assyrians and Chaldeans were in every way the equals of their western neighbors. On the whole, I think it is even safe to say that they were slightly superior to the Egyptians, for their realistic way of expression, especially in depicting animal life, was of a much higher order than that of the Egyptians.

But at this point we can for the first time observe how definitely the art of a country is the visible and audible expression of its national soul. For whereas the Egyptian was by nature docile and peace-loving and so thoroughly detested the idea of taking life that he would never come in close personal contact with the men who prepared his mummies for him (and who therefore were obliged to make a small incision in the corpse so as to remove the entrails), the Babylonians and the Assyrians loved cruelty for cruelty's sake. Many of their marvelously executed bas-reliefs represent torture scenes of such absolute bestiality that they make you feel slightly uncomfortable, even at this

late date when all the participants in these orgies of blood have been
dead for more than six thousand years.

Their harshness and their lack of refinement express themselves
also in the way they handled the human figure. The Egyptian is apt
to depict his men and women with a certain worldly elegance. Some
of his women's pictures remind you of fashion plates, for the charm of
the women has been most carefully and skillfully exaggerated so as to
make them look more attractive than they probably were. The

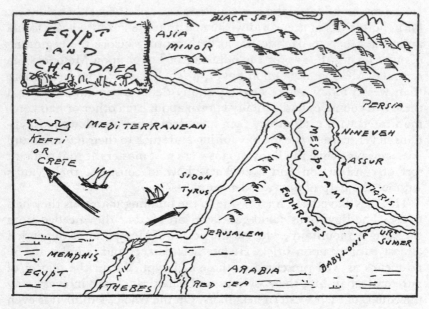

EGYPT AND CHALDEA

Chaldeans, on the other hand (I am using the more familiar Biblical
term of Chaldeans whenever I speak of the people of this entire re-
gion), loved to make their men look short and squat and very power-
ful, with wide shoulders and enormous biceps, veritable regiments of
Nazi storm troopers. As for their women, we have few pictures of
them. They do not seem to have entered very seriously into the lives
of these ancient Chaldeans. The rare surviving female statues—an
occasional queen or slave girl—usually reveal this same complete
lack of all gracefulness.

Here we touch upon one of the oldest and most perplexing problems
confronting the student of art. Is there a real connection between

man's soul, his higher sensibilities, and his artistic ability? Does perfection in any one of the arts mean that a person is also outstanding in kindness, generosity, or common, everyday decency? I am sorry to say that it is very difficult to discover any such connection. We shall have many opportunities to return to this painful subject. But a morning spent in the Babylonian and Assyrian rooms of the big museums of London, Paris, and Berlin (the best collection is in Paris) will make you gasp at such marvelous craftsmanship combined with such complete absence of any ordinary human feelings.

This impression may be partly due to the fact that practically all the art of Mesopotamia was official art. The minor arts, the arts of the common man that make the old valley of the Nile such a delightful place of study, do not seem to have been greatly encouraged. And the official art of the Assyrians and Sumerians and Babylonians lacked the timelessness and the sense of duration that was so characteristic of everything done in Egypt. It was an art created for the purpose of emphasizing the brutal strength and the ruthless determination of a small number of local dynasties. Since those dynasties depended for their success upon the good will of the priests, they contributed generously to the erection of very costly temples which in turn were filled with bas-reliefs and statues extolling their own mighty deeds.

Here I must give you a short chronology of this part of the world, for otherwise you will be entirely lost when you go to the museums to look at the work of the different races that succeeded each other in the valleys of the Tigris and the Euphrates during so many thousand years.

In the fortieth century before the beginning of our era all this territory seems to have been occupied by a people known as the Sumerians. We know that they were there in 3500 B.C. and we also know that as an independent nation they disappeared from the scene shortly before the year 2000 B.C. They probably were of northern origin and may well have come from that same high plateau in central Asia which was the original home of our own ancestors.

I am proceeding very carefully and I am constantly using the convenient alibi that hides in the word "probably," for further investigations during the next few years (and all our museums are digging most diligently in the soil of this desert) may completely upset our present theories. We know, however, from their sculptures that the Sumerians looked entirely different from the Semitic tribes which at a later date took possession of all this territory and who hailed originally from the sandy wastes of Arabia.

The Semitic tribes from the south were hairy fellows with long black beards. Indeed, beards seem to have been considered so necessary to a truly manly appearance that they were part of the ceremonial costume of the "well-dressed man." If he had no beard of his own, he put on a false one and wore it upon festive occasions, just as the English nobility, going to their king's coronation, wear little crowns and just as our own Indians used to wear feathers whenever they went forth to war.

The Sumerians, on the other hand, were as beardless as the Romans or we ourselves. In the beginning, they too went around with whiskers (as our own grandfathers did during the period of the Civil War), but the moment they became a little more civilized, their barbers were set to work and thereafter the Sumerian soldiers and chieftains are represented as smooth-shaven and with long, beaked noses entirely different from the curved Semitic noses of the Assyrian and Babylonian statues.

The country during this period (from 4000 until 2000 B.C.) was apparently divided into a number of small and semi-independent units, ruled over by a number of kings who lived in well-walled cities. Ur of the Chaldees, famous as the town from which Abraham started upon his peregrinations, was one of those Sumerian strongholds. The palaces of these petty monarchs are gone, but we have discovered a great many of their graves. These were filled with all sorts of articles made out of gold and silver and bronze and ivory and mother-of-pearl. The craftsmanship of these articles was of a very high order. But of course they had been manufactured for the exclusive use of their departed majesties and in such cases no expense was spared.

After the year 2000 B.C. the Sumerians themselves stepped out of the picture, but, oddly enough, their language survived. You will notice that most of the Mesopotamian bas-reliefs are covered with a curious sort of script. This script had been invented by the Sumerians at about the same time the Egyptians invented their hieroglyphics. But whereas the Egyptians painted their script with a brush, the Sumerians engraved theirs into bricks of clay with the help of a nail or wooden stick. Hence the name "cuneiform." *Cuneus* was the Latin name for a wedge and the writing of the Sumerians looks indeed like little marks made by a wedge. Take some soft clay and set to work on it with a nail or a stick, and you will get exactly the same results.

These wedge-shaped or cuneo-shaped marks must have provided the people with a very handy method of keeping their records and of communicating with each other, for the newcomers, who undoubtedly

conquered and absorbed the Sumerians, continued to use the Sumerian script for another two thousand years, and their written language, too, seems to have maintained itself. But whether it was still spoken—that we do not know.

The process of absorption and intermarriage between the original settlers and their conquerors must have taken quite a long time and it must have been very gradual. Ur disappeared and Accad took its place but the art of Accad was almost as Sumerian as that of Ur had been. Apparently the conquerors realized their own cultural inferiority and were willing to let the Sumerians look after their spiritual interests while they themselves collected the taxes and attended to the political needs of the hour.

By this time news must have been spread far and wide of the superior advantages of the land of Mesopotamia over all the surrounding country, for after the twentieth century B.C. the two valleys were forever being overrun by still other races and tribes in search of happier living conditions. In or near the year 2000 B.C. the little village of Babylon suddenly developed into a formidable city under its famous King Hammurabi, the ruler who wrote that noble code of laws (still preserved) from which Moses borrowed so heavily when, almost a thousand years later, he gave his people their own Ten Commandments just after they had left Egypt to find a new home in the north.

Shortly after the death of Hammurabi, Mesopotamia was overrun by those mysterious Hyksos who afterwards played such a great role in Egyptian history and whose success was due mainly to the fact that they were horsemen and that the rest of the world still did its fighting on foot. The Hyksos passed quickly through Mesopotamia and conquered Egypt, where they put an end to the Middle Kingdom. After several centuries, during which they meekly accepted this foreign yoke, the Egyptians finally drove the Hyksos out of their country, and these horsemen trotted back to Mesopotamia. But this time they found themselves opposed by the Hittites.

The Hittites must have defeated the Hyksos some time in the fourteenth century B.C. but a hundred years later these sons of Heth (you will find them in the Old Testament) were in turn conquered by the Phrygians (or Free Men, as the Greeks called them) who came from Asia Minor and who several thousand years later were to provide the French Revolution with that conical Phrygian cap all good patriots were supposed to wear while dancing around the tree of liberty.

But the Phrygians were no more able to maintain themselves than

any of their predecessors. Now it was the turn of the Assyrians to rule all of western Asia. At last we are on a little more familiar territory, for these Assyrians were the contemporaries of the great Hebrew proph-

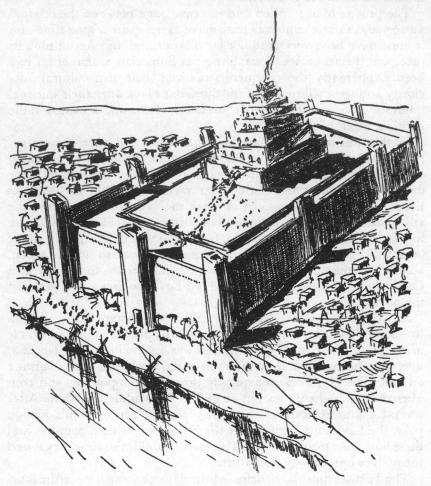

THE BABYLONIAN TEMPLE

ets. Nineveh was their capital city and they built themselves huge palaces which we have located and the walls of which are covered with pictures showing the terrible things the Assyrians did to those who dared oppose them.

Then, for no known reason, Babylon suddenly arose once more

from its ashes. The empire of the Assyrians was overthrown. Western
Asia was subjugated. The Jews were forced to leave Palestine and to
settle down in Babylon, or, as others have it, they left Palestine of their

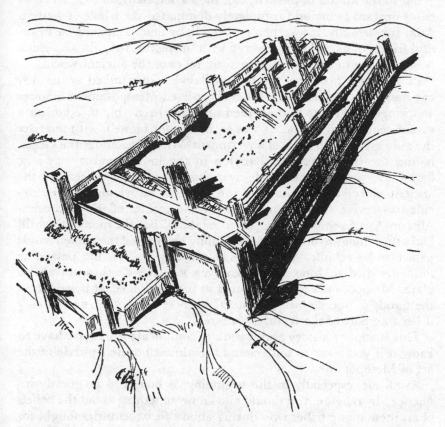

THE TEMPLE OF SOLOMON BUILT BY BABYLONIAN ARCHITECTS
ACCORDING TO THE USUAL BABYLONIAN PATTERN

own account as the rich city of Babylon, the New York of that time,
offered them much better opportunities to do business than the
shabby little town of Jerusalem that was forever in the throes of
some religious upheaval.

These later Babylonians, infinitely more civilized than their As-
syrian predecessors or their own ancestors, turned their capital into
a mighty center of learning and science. They laid the foundations
for that science of mathematics and astronomy which so fascinated

the Greeks that they referred to Babylon as the Mother of all Wisdom and borrowed most generously from their Babylonian teachers when they themselves began to take an interest in such things.

But in the matter of the arts, too, the second Babylon took an enormous upward swing and completely dominated the whole of western Asia. Incidentally, it was then that the Babylonians made those beautiful friezes of glazed tiles, covered with the pictures of animals, which belong to the most interesting artistic relics of the ancient world.

In the end, however, the second Babylon succumbed as the first one had done and all of the other short-lived Mesopotamian empires and kingdoms. None of them seems to have been able to establish a strong centralized nation. It was each man for himself, with anarchy the only established form of government. When Alexander the Great, bound for India, reached Babylon in the fourth century B.C., he found the town in ruins. He was, however, so impressed by the ancient glory still surrounding the name of Babylonia that he decided to revive the city and make it the capital of the European-African-Asiatic empire he hoped to establish. For the moment he still had other things to do but as a beginning he ordered the ancient royal palace to be rebuilt. And in the banqueting hall of that palace he suddenly died in June of the year 323 B.C. His death upset all his plans. Mesopotamia never regained its independence. It passed from the hands of one ambitious general to those of another until finally it became part of the Roman Empire.

This is a lot of history and it is quite complicated. But you have to know it if you want to understand the almost hopeless puzzle of the art of Mesopotamia.

As all art, especially in the beginning, is bound to be greatly influenced by religion, you should also know something about the beliefs of all these many tribes who during almost forty centuries fought for the possession of this fertile region which to them had the same appeal our own country has had to the disinherited masses of Europe during the last four hundred years. They had all of them been nomads, wandering tribes moving from place to place with their families and their herds, trying to find a place where they could settle down for good. Their religion was therefore the usual one of a people who are changing from a wandering sort of existence to a stationary one, who are no longer herdsmen and who are trying to become farmers and to live in towns and to practice some sort of trade and engage in business. They still remained faithful to the old Gods of the deserts and the mountains in which they had spent all their previous years.

Those Gods, however, enjoyed wide hospitality throughout western Asia, as you will remember from your Old Testament, for those "false Gods" against whom the Hebrew prophets fulminated with such justifiable violence were really the foreign Gods of Mesopotamia. A few of these were able to maintain themselves indefinitely and we still have them with us. I refer to those strange creatures that were half-human and half-bull or half-human and half-bird and that somehow or other found their way into the religion of the Jews, who then handed them down to us as cherubs or angels.

This was only natural. The Jews, in the beginning essentially a pastoral people without any traditions of an art of their own, could not help falling under the influence of these Babylonians in whose city they had spent so many years of their lives and whose art was far superior to anything they themselves were ever able to develop. Even after they had founded a kingdom of their own, the Babylonian influence prevailed and as a result the famous temple of King Solomon was really a copy of an old Chaldean model.

But Solomon was by no means the only one who went to the valley of the Euphrates to learn his architecture. The Greeks, for reasons we do not quite understand, never seem to have taken very enthusiastically to the idea of vaulting the roofs of their public buildings. They remained faithful to their flat roofs. But this interesting structural novelty spread all over Asia Minor. From there (if we are to believe Herodotus, who was usually well informed upon such subjects) a Lydian tribe, afterwards known as the Etruscans, carried the vault to central Italy when they found a refuge in that distant land. Then in the fourth century B.C. the Romans conquered Etruria and there got acquainted with the vault. They in turn spread their newly acquired technique all over Europe and that is how we in America got our own vaults (without which we never could have done what we have accomplished in our own architecture)—from old Mesopotamia by way of Lydia, Etruria, Rome, and western Europe.

Incidentally, since we happen to be in this eastern portion of the world, I might as well add a few words about the ancient Persians. I am calling them the ancient Persians to keep them separate from those other Persians who during the early Middle Ages became the clearinghouse for all the arts of both the East and the West. The Persian Empire, that had been such a menace to Greece, lasted only a couple of hundred years. It reached a high degree of civilization. Cyrus and Cambyses and Darius and Xerxes were mighty builders before the Lord. But they had very little original ability. Their pal-

aces in Susa and Persepolis were built for them by Greek architects,
while the interior decorating was done by Babylonians. When their
empire vanished, their palaces and temples quietly returned to the
sands of the desert and the whole of their civilization disappeared.
Here and there is a pillar or a piece of an old vaulted hall, and that
is all we can find today of their short-lived glory.

And that would have been the end of the art of western Asia if it
had not been for the ever-present Phoenicians. The Phoenicians,
closely related by blood and language to the other Semitic tribes of
Chaldea, were good craftsmen but, like most people primarily inter-
ested in business, they were sadly devoid of any artistic imagination.
Yet in a way they played a very important role in the history of art,
for they were the great distributing agency of the ancient world.
Wherever they went they established small trading posts. Not only
Marseilles but also quite a number of other modern cities of the
Mediterranean probably began their existence as Phoenician colonies.
These usually consisted of the mud-covered huts of the natives
grouped around a Phoenician fortress and a few Phoenician store-
houses and in that way the natives, who quite often were only a few
centuries removed from the Stone Age, got exposed to the infinitely
higher civilization of central Asia.

Such little villages were, of course, no Babylons or Ninevehs, no
more than the Chicago of the year 1840 was another Boston. But a
few notions about a civilized way of living must have stuck, and even-
tually these must have found their way into the hinterland, as today
they find their way into the islands of the Pacific by means of our
movies.

This went on for hundreds of years until, during the fourth century
B.C., Phoenicia was conquered by Alexander the Great and its two
main cities, Sidon and Tyre, were destroyed. The Greeks thereupon
established themselves in several of these old Phoenician strongholds.
They built new houses and new temples but in their own style. The
natives in this way got exposed to the art of the Greeks and in due
course of time this too must have penetrated into the adjoining terri-
tory.

To what degree was the style of the natives thereupon influenced
by Babylon and how much by Athens? Suppose I ask you this: How
much is the New York of today influenced by the architecture of
Nieuw Amsterdam or by the art of the English of the eighteenth cen-
tury? How much is the Washington of today influenced by the Ver-
sailles of Louis XIV which Major l'Enfant hoped to copy in the New
World or by Thomas Jefferson who had visions of reviving the glories

of Greece in the new democracy he had just helped to found among the people of America? What have the bright young men and women who studied their sculpture in the American School in Rome done to many of our modern cities?

These are interesting problems but it is not possible to settle them in an offhand way. They warn us, however, to proceed very carefully before we venture to give any definite opinions upon the way in which the art of one country has reacted upon that of another.

Three of the most popular words in the English language—tobacco, potato, and tomato—are not English at all but are of Caribbean origin. Yet no one who uses them ever thinks of this or realizes that they were given to us by a people who have long since been almost completely exterminated. It is the same with many of our forms of art. We picked them up here and we picked them up there. We used them for a while and discarded them or kept them for our own, and that, of course, is as it should be. But regardless of what happened to them, they were and are part of that moral lesson which the modern world needs more than anything else—a realization of the all-important fact that none of us can hope to live alone in this world and that the idea of a purely national or rational culture is as absurd as the notion that there could be an art completely independent from the art of all its neighbors.

So much for the land of the Babylonians, the Assyrians, the Sumerians, the Hittites, and all those many other races who for so many thousands of years fought each other for the possession of the ancient land of Mesopotamia. They had played their role in our little history. They had built and they had made their statues and they had glorified their mighty deeds in innumerable pictures. They had made jewelry for the adornment of their men and women. They had added a new technique of construction and had given the world its first vault. Now they had exhausted their energies. It was time for them to disappear. When history rings the gong, there is only one thing to do.

The show, however, goes on. And so the curtain rises upon a landscape infinitely lovelier than that of northern Africa or western Asia.

Somewhere in the distance, carefully hidden from the view of mortal man by a cluster of cypress trees, Pan is softly blowing his pipes. In the foreground the Muses are singing an ode to the great God Apollo. The shadows of the hills of Attica begin to stand out sharply from the surrounding plains. A stonemason is giving shape to a gigantic block of marble. The snow-covered dome of high Mount Olympus reflects the earliest rays of the eastern sun.

Greece!

# Heinrich Schliemann

*A short chapter which for the greater part is devoted to
an explanation of the word "serendipity."*

I HOPE YOU WON'T MIND a slight detour before we get to ancient
Hellas, but it is a necessary detour if we want to be fully prepared
for what awaits us in the country of Pericles and Phidias. I want to
say something about my old friend "serendipity." You will find that
strange-looking word in the dictionary. It occurred originally in a
story mentioned by Horace Walpole, the English wit and con-
noisseur, who died in 1797. The title of the novel was *The Three
Princes of Serendip*, which was the old name for Ceylon. These three
young men were forever making discoveries by "accidents and sa-
gacity" of things for which they were really not looking at all. Since
then, serendipity came to mean "the faculty of making happy and
unexpected discoveries by accident."

The career of Heinrich Schliemann is one of the best examples of
serendipity that has ever come to my notice. As a child he listened
spellbound to the stories about the Trojan War, which his father, a
poor north German minister, read to him. He made up his mind that
some day he would go forth to discover the site of ancient Troy. He
realized, however, that such an expedition would cost a lot of money,
and so first of all he determined to get rich.

He left the paternal roof as soon as he was old enough to do so, and
apprenticed himself to a grocer in a near-by village. But weighing
cheese and prunes was not a very lucrative business. He therefore de-
cided to try his luck in South America, and shipped as a cabinboy.
His ship was wrecked before it had reached the shores of that fabulous
land of the Incas, and Schliemann found himself in Amsterdam work-
ing as an assistant bookkeeper for a firm of Dutch merchants.

His evenings he spent learning languages. Before he got through he
knew eight of them and knew them well. On account of his familiarity
with Russian his employers sent him to St. Petersburg. There he set
himself up as an importer of indigo. When the Crimean War broke
out in 1854 he took on several military contracts and made an out-

rageous profit. Not yet satisfied with the results, he went to California during the gold rush and became an American citizen.

Finally in 1868 he decided that he had money enough to start upon his real life task. After a trip around the world he landed in Constantinople, bribed all the Turkish officials whose help he might possibly need, and went forth to a certain hill called Hissarlik, which was situated not far from the Hellespont but on the Asiatic side of these famous straits and where, so he was convinced, he would find his beloved Troy.

Soon it became clear that this crazy German had guessed right. That low hill, to which nobody had paid any attention for almost two thousand years except a few goatherds and their nimble charges, had once upon a time been one of the most important trading centers of the ancient world.

Unfortunately Schliemann was not a trained archaeologist. In his eagerness to get results and to locate the palace of Priam, he dug his way straight through the remnants of the Troy of the Homeric days and uncovered several villages which were so much older than the historic Troy that they had already been in ruins when Achilles and Agamemnon visited this spot to avenge the theft of the lovely Helen, twelve hundred years before the beginning of the Christian era.

Schliemann, like all men with a fatal hobby, refused to consider the possibility of error. He proudly proclaimed to all the world that the problem had been solved and that Troy at last had been given back to the world. This might have led to a bitter dispute between the amateur and the professionals, but at that moment the Turkish officials made an end to all further dispute by telling Schliemann to leave the country. They were dissatisfied with their bribes. The foreigner had promised them gold. Where was the gold?

It was there but it lay much higher up in those strata through which Schliemann had so unceremoniously dug his way in his hurry to get at the real thing. For the moment, at least, there was no further chance to ransack the mound of Hissarlik, and so Schliemann paid his native workingmen, shook the dust of Asia Minor from his feet, and made for the mainland of Greece.

In the central part of Argolis, in the northeast corner of the Peloponnesus, there stood the ruins of an ancient city called Mycenae. It was widely known for the gigantic size of the blocks that had been used for the walls of its citadel and the enormous piece of carved stone over the entrance gate, which showed the figures of two lions, reminiscent of the sort of wild animals the Babylonian sculptors used to

carve. No one had ever explored these ruins very seriously until Schliemann made his appearance. He began to dig near the Lion Gate and at once he discovered something very rare, a series of shafts in which the people were buried standing up instead of lying down. These graves had been arranged in a circle and they had never been touched. Not only were the bodies themselves intact but none of the gold and silver that had been buried with the corpses had been stolen. This could only have happened if the city of Mycenae had been attacked so suddenly and unexpectedly that none of the inhabitants had been able to buy their lives by telling their captors where they could find a treasure.

Some ten years later (in 1885), after a second visit to Troy and an attempt to discover the palace of Odysseus in Ithaca, Schliemann tackled the problem of Tiryns. This was another city in the Peloponnesus and a spot of such great antiquity that it was supposed to have been the site whence Hercules had embarked on his career as the major miracle worker of Greek mythology. Here, in Tiryns Schliemann uncovered a complete palace that also showed traces of going back to the pre-Homeric period of Greece.

He then turned his attention to Crete, which was known to have been settled at a much earlier date than the Greek mainland. But here, once again, the desire for graft on the part of the local Turkish officials prevented him from doing the work he had in mind. And so this curious creature, this strange mixture of war profiteer and daydreamer, gold miner, and explorer, died and undoubtedly started digging for a pre-paradisean civilization before he had been in heaven for more than half an hour.

Schliemann had made some very serious mistakes. But when he departed this life in the year 1890, the calendar of Greek history had been pushed back by fully seven hundred years. Best of all, this self-taught German had made the learned world realize that there was a great deal more to the civilization of that particular part of the world than most of the professors had even begun to suspect.

Until then it had been customary to begin the history of art in Europe with that of the Greeks. Now it was shown that the Greeks, far from being the first to appear upon the scene, had been among the last to arrive and that the Aegean Sea had been a center of trade and art and of a very high degree of culture thousands of years before the Athenians laid the cornerstone of their Acropolis.

I often listen to the complaint of the younger generation that this is a dull world because everything has already been done. If anybody

wants a job that will keep him busy for the rest of his days, he might devote his attention to the history of the Aegean Sea. For the problems connected with the civilization of these waters, which for so many centuries served as the connecting link between East and West, are still far from solved. And they are not of local interest, either, but touch every part of the Western World. For example, just what sort

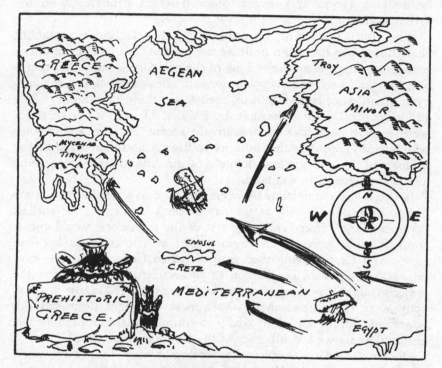

**PREHISTORIC GREECE**

of people were the first to occupy all this territory, once it had become habitable, and whence had they come? It is only through their art that we shall ever come near a satisfactory answer.

The artists of what we now call the Minoan Age, the artists of Crete in the twentieth century before our era, had a great gift for depicting animal life with all that vivacity and all that power of scrupulous observation which were so typical of the paintings we have found in the caves of prehistoric Europe. But thousands of years (it may be as many as seven or eight thousand) separated the paintings of the caves of Altamira from those in the palaces in Cnossus. What

had happened to these cave dwellers during those seventy or eighty centuries? When a change in the climate of central Europe forced them to leave their old home, had they taken to sea and had they finally found a new home among the islands of the Aegean, the last bits of European land before they must touch the shores of a hostile Asia? Or again, how about these mysterious cyclopean walls of Mycenae and Tiryns and several other deserted strongholds on the Greek mainland?

When I first learned my Greek history, forty years ago, I was taught that those walls had been built by the earliest invaders of the Greek peninsula, long before the coming of the real Greeks, and that therefore they had been called cyclopean walls after the Cyclopes, the one-eyed giants who, Homer tells us, used to eat their human prey while still alive. Today we know that these walls, far from being very old, were merely part of a comparatively recent form of architecture which shows considerable similarity to the methods employed by the builders of the menhirs and dolmens of the Atlantic coast in Europe and of Stonehenge in England.

Is there any connection between the two? We would very much like to know. Is Cyprus, as the name seems to suggest, the earliest "copper island" from which the rest of the prehistoric world got its copper? What were the ceremonial and artistic relations between Egypt and Crete during the centuries when Cnossus was the most important center of civilization of the ancient world (during the period, roughly speaking, from 2500 till 1500 B.C.)? Finally, who exactly were those newcomers who almost overnight destroyed this flourishing empire and destroyed it so completely that for almost five hundred years we lost all trace of the original population?

Once more we must confess that we do not know, though we would dearly love to, for the Cretans of thirty centuries ago had so many things in common with us of today that we have a much greater feeling of kinship for their statues and their paintings and their jewelry than for those of the Egyptians or the people of Mesopotamia.

These early Aegean sea rovers must have had a great sense of order and comfort. Their palaces were well lighted and decently aired, in complete contrast to the royal residences of Thebes and Babylon and Nineveh, which were as dusty as those of Queen Elizabeth or Louis XIV of France. Their public buildings had drains and running water and an installation for heating the premises. We have found arrangements by which they could hoist people from one floor to the next—a sort of primitive elevator for the benefit of the aged. Furthermore,

there were bathrooms inside the houses and sliding doors between the different apartments and there were also separate quarters where the royal secretaries could do their work without being disturbed by the other menials.

The wheel, at the time of the Minoan civilization, had been in common use in Egypt and Chaldea for at least a thousand years. Carriages (which incidentally were not introduced into Scotland until the middle of the eighteenth century) were not only used for purposes of driving but also apparently for racing. Like ourselves, these people were devotees of all sorts of sport and they went in quite seriously for dancing and boxing and wrestling and (as one would have expected in the land of the Minotaur) also for bullfighting.

The form of government under which they lived was not the democratic one which afterwards was practiced by the Greeks and which was so sadly responsible for their ultimate collapse and loss of liberty. The early Aegean nations were ruled by kings. As we have found practically no statues of soldiers but on the other hand a large number of laws engraved on stone tablets, these potentates seem to have tried to maintain themselves by means of an efficient civil service rather than by violence. This may account for a certain air of something that reminds us quite distinctly of the art which forty years ago was known as *fin de siècle*, the art of the end of the nineteenth century. The last forty years of that century, too, were an era when a great many people felt convinced that the age of sweet reason had at last made its appearance and that armies and navies could not be discarded as unpleasant survivals from the days of the Middle Ages. The Great War gave them their answer. The present dictatorships continue that answer. And the rather effeminate civilization of the "end of the century" has been smashed to pieces.

Judging by their art, it is more than likely that the people of Crete had landed in exactly the same sort of blind alley where all effort was lamed by the thought that sheer intellectuality would eventually cure the world of all its ills. This may seem far-fetched to you, but wait until you see some of these late Cretan products. You will then understand what I mean.

It was not until the year 1900 that Sir Arthur Evans began to excavate the ruins of Cnossus. Since then we have learned so much about Cretan antiquities that we are now able to follow the development of this Aegean civilization quite accurately.

First of all, there was a slow growth of almost a thousand years.

This was the Early Minoan Age from 3000 to 2000 B.C., during which this civilization gradually spread from island to island.

Next came the Middle Minoan Age (from 2000 B.C. or thereabouts to 1500 B.C.) during which Crete was the center of this civilization and Cnossus the London of this island empire.

Then came the Late Minoan Age (1500 to 1000 B.C.) during which the island culture established itself firmly on the mainland and, marked by some characteristics that make us differentiate it as Mycenaean civilization, spread its art all over the Greek peninsula.

And then, as has so often happened under similar circumstances, it appeared that the colonists in these little settlements in the wilderness of a distant land were of tougher fiber than the rather blasé young men and women at home. Until finally a place like Mycenae, a mere hick town that had begun its career as a small Cretan trading post, was able to conquer its former rulers and in turn change the island of Crete into a colony of its own.

Thereupon art, which invariably follows the full dinner pail, hastily moved from the island to the mainland and enjoyed a new lease of life, bursting forth into a great many new forms, such as pottery and metalwork and ornaments of silver and gold, which from then on were spread all over the Mediterranean Sea, from Spain to Phoenicia and from Egypt to Italy.

And then?

Then we suddenly lose track both of the Cretans and the Mycenaeans and for almost five hundred years the people of the Aegean Sea go through a period of obscurity not unlike that of those Dark Ages which followed in the wake of the downfall of the Roman Empire.

But how could such vast and distant citadels as those of Tiryns and Mycenae be overrun and destroyed by an enemy unless that enemy was possessed of much better weapons than the defenders? The answer is that the newcomers, although complete and unmitigated barbarians from an artistic point of view, were probably much better soldiers than their opponents. The business of war was as important to them as the business of living beautiful and artistic lives had been to their former oppressors. Furthermore, as we have reason to believe, these new arrivals had originally come from the north, from the valley of the Danube, and there they had learned how to make excellent swords and lance points from those ironmasters who had been working their primitive little furnaces in that part of the world ever since prehistoric days.

Homer does not bear this out, but Homer was a poet, not an exact

historian. According to him, the original inhabitants of Greece had been called the Achaeans and they had lived somewhere in the north of Europe, perhaps in the land of the Scythians, the ancestors of the present Cossacks. But whoever they were and whether they were called Achaeans or not, these intruders completely overthrew the civilization of the Aegean Sea, as it then survived among the fortified towns of the mainland. They must have done this with great brutality and quite unexpectedly. For otherwise they would never have over-looked the gold that lay hidden in those curious shaft graves which, almost three thousand years later, were found still quite intact by our friend, Herr Schliemann.

After this surprise attack, what ever became of the Aegean civiliza-tion that had first of all moved from the islands to the mainland? It was forced to go back whence it had come. The few people who sur-vived this wholesale slaughter escaped to the islands of the Aegean, as fifteen hundred years later the Italians from the mainland were to flee to the islands of the Adriatic and there found the mighty city of Venice that they might be safe from the Goths and the Vandals and the Huns and all the other marauding tribes from the east. And grad-ually these refugees picked up the odds and ends of their former mode of living. The fishermen once more caught their fish, the bakers once more baked their bread, the potters returned to their wheels, the jewelers began to engrave their cameos, the goldsmiths dreamed of the time when they should once more hammer away at their little bits of precious metal.

Meanwhile, on the mainland, the new masters were trying to feel happy among the unaccustomed splendors of these ancient palaces (no temples could here be desecrated, as the Mycenaeans and their neighbors seem to have got along quite happily without any definite places of worship), and now and then they must have noticed that they were lacking something which the former occupants had had in rich abundance. Gradually, too, both the victor and the defeated must have felt the need of re-establishing some sort of commercial re-lations. For commerce, being part of the natural order of things, can never be easily suppressed, no matter how hard all sorts of govern-ments may try to do so. The barbarian, plagued by his wife who wanted to know why she and her children could not enjoy all the ad-vantages these Mycenaean women had enjoyed, must have sent to the nearest island for a few artisans and architects and bronze work-ers, for a few people who could teach him those crafts of which he was

completely ignorant but which filled his simple soul with awe and that of his wife with envy.

At first these craftsmen may have hesitated to go. But they had to live and so they ventured back to the mainland. Once it was proved that they ran no unusual risks, others followed their example.

Such events do not happen from one day to the next. They take a lot of time. In this case, they took almost five hundred years. But then at last we find ourselves face to face with an art which was no longer either Aegean or Minoan or Mycenaean, but which was definitely Greek.

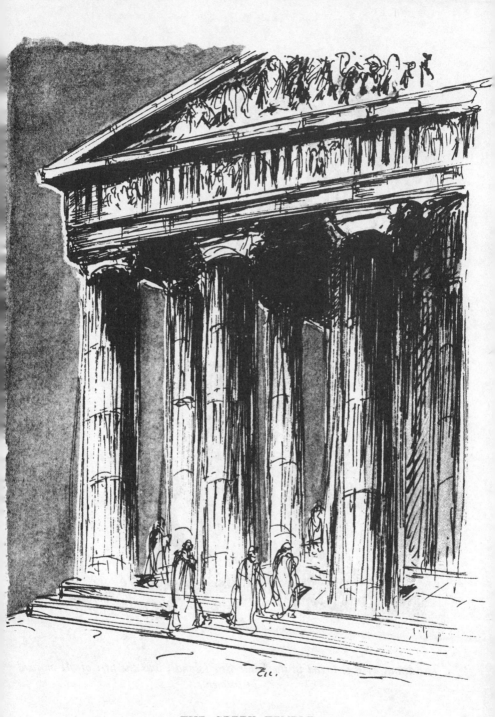

THE GREEK TEMPLE

*The drum, as still found in the South Sea Islands, was the first of all musical instruments.*

# The Art of the Greeks

*The story of a mere handful of people who taught us
most of the things we know.*

IT WAS SOCRATES WHO SPOKE—the wisest of all the Greeks, if there be
wisdom in facing the problems of life quietly, courageously, and
intelligently and in thinking them out to their ultimate values.

"Beloved Pan," so he said when asked by his friends along the
banks of the Ilissus to offer a prayer to the local Deities, "beloved Pan
and all ye other Gods who haunt this place, give me beauty in the in-
ward soul and may the outward and the inward ever be as one. May
I reckon the wise to be wealthy and may I have such a quantity of
gold as a temperate man, and he only, can bear and carry.

"Is there anything more? No. This prayer, I think, is enough for
me. I shall say no more."

I place these few words at the head of this chapter. They are the
*Leitmotiv*, the leading theme, the very keynote of all that is to follow.
It will, of course, be impossible to reduce the whole of Greek art to
one single short chapter and it would be entirely impossible if I tried
to give you a detailed account of everything their craftsmen created
during the few short centuries of their country's independence. For
bear in mind that the Greeks held the center of the historical stage
for only a very few years.

The art of the Egyptians had begun in the fortieth century before
our era and it continued with the inevitable ups and downs until the
Christians closed the last of the old schools of hieroglyphics during
the first half of the fifth century after the birth of Christ.

The art of the valleys of the Tigris and the Euphrates, the so-called
Chaldean art, and that of the Babylonians and Assyrians and the
Hittites and all the other conquerors of Mesopotamia—that art, too,
can be traced from the fortieth century B.C. until Alexander the Great
died in the royal palace of Babylon in the year 323 B.C.

The art of Crete and the Aegean Sea and the Aegean settlements
on the Greek mainland lasted about fifteen hundred years. But the
oldest of the Greek temples was built in the middle of the seventh
century B.C. and by the middle of the fourth century, after the de-

struction of Athens by its Spartan rivals, there was an end to this short period of glory. Everything the Greeks accomplished, therefore, was done within less than three hundred years. When you reflect that during these few years the Greeks were able to lay the foundations for the entire fabric of our own modern Western civilization, not only within the realm of politics and science but also within that of the arts (and that in the widest possible sense of the word), then you begin to realize that these ancient Hellenes (they themselves never used the word "Greeks," which was a Roman invention) must have been a people of extraordinary ability.

The word genius is being so sadly abused nowadays that one hesitates to write it down in cold black print. But if we take genius to mean "an outstanding natural ability," then the Greeks undoubtedly qualify as the most brilliantly endowed race of all times. But let us not tumble into the very common error of depicting ancient Hellas as some sort of terrestrial paradise. Nor was the average Greek a paragon of all the virtues—a noble hero, moving with Homeric dignity across the stage of history, spending his days in battling for freedom and democracy and burning his little midnight oil lamp, discussing some of the finer points of Plato's most recent philosophical disquisitions with half a dozen assorted friends. There undoubtedly were a few men of such caliber during the age of Pericles, but they were the exceptions, as they always have been and always will be.

Meanwhile, the majority of the people, taking them in the rough, were just about the same as the majority of the people have always been. Looking at them from the sober angle of our common, everyday decencies, and judging them by the prevailing standards of honesty as practiced (more or less) in the year of grace 1937, I feel inclined to say that they were sad and dismal failures. For in their commercial dealings they were fully as crooked as the Phoenicians, undoubtedly the most cunning and rapacious of all the many crooked races that have infested the eastern half of the Mediterranean, which is saying a great deal. When it came to double-crossing their friends, these noble Greeks were such past masters in the rather unpleasant art of hocus-pocusing a neighbor that they sometimes succeeded in doing what few other races have ever been able to do and not infrequently managed to double-cross themselves.

Their natural ability for intrigue and their love of backstairs gossip and politics were such that they apparently were never quite happy unless they were engaged in an underhanded attempt to upset the established form of government, even if it happened to be a gov-

ernment of their own making and one which only a few weeks before they had helped to erect by a series of the most intricate conspiracies.

They were tremendously proud of their old lineage. They considered themselves to be the descendants of Hellen, the son of Deucalion, the Greek Noah, who most appropriately had navigated his ark to the top of Mount Parnassus, the home of Apollo, and who had thereupon landed his passengers right in the heart of the Garden of the Muses. But this pride of race did not prevent them from making common cause with any convenient barbarian chieftain, if he could be of any help to them in furthering their own interests.

They were, however, possessed of one eminently likable quality. They were tremendously alive. They were capable of the highest expressions of devotion and enthusiasm. They were possessed of an almost divine arrogance. They boldly approached Nature, bade her reveal her secrets, and quietly assumed that they themselves were the beginning and the end of the whole of creation. They never did anything by halves. If they were heroes, they were the sort of heroes of whom the poets will sing until our shivering earth sinks frozenly into its final sleep. If, on the other hand, they made up their minds to be bad, to play the scoundrel, they fully intended to make a name for themselves as the most notorious and perfidious of all the many villains that have appeared upon the stage of history.

At the same time their versatility was such and they were so quick-witted and so entirely without scruples or convictions, that once they had set out upon a definite course they could change from one role into the other without any noticeable qualms of conscience or any audible change of moral gear. The Italians of the Renaissance are the only other people who have ever been able to do this with an equal degree of elegance. Hence it is very difficult for us to be fair in judging these ancient Greeks or to appreciate them at their true value. For while their virtues delight us, their vices repel us. Having been brought up in a world in which black is black and white is white and never the twain shall meet, most of us prefer a clearer sort of color scheme and do not quite know what to make of the muddled Greek palette.

The best thing we can do under the circumstances is to accept them as they were. By this time they are all of them dead and gone. Their works, however, live after them. Only that which they actually did and thought when they were investigating the universe around them is of real importance to us. The way in which they spent their days in the market place or wasted their time playing dice in some ill-lit

tavern may have a sentimental value, but it does not affect our own lives.

Whenever the Greeks put their brains to any given task, they fought it out until the bitter end and thus they bestowed upon the world something entirely new—a profound faith in the dignity of man. Before the Greeks made their appearance upon the stage of history, all races had groveled and cringed and prostrated themselves before their Gods. For the Gods of the East had been malevolent tyrants, jealously watching lest they suffer insult to their own dignity, smiting and chastising all those who even for a moment dared to question their authority and their right to rule their worshipers with unreasoning and cruel severity. They had been the local chieftains, multiplied a thousandfold, and their subjects had accepted them as tyrants who had to be obeyed at all cost and whose evil tantrums must be placated by a constant series of self-abasements and mortifications of the flesh, lest greater evils befall the people who had incurred their displeasure.

The geographical background of these other races had undoubtedly a great deal to do with such a feeling of abject helplessness. The desert has always made for slavery. The Egyptian or Babylonian peasant could not possibly escape from the tyranny of his master. When he ran away he was obliged to go on foot. The plains offered few hiding places and the horsemen of the king could easily overtake him. The poor devil was in the same predicament as the Russian serf of a hundred years ago. No matter where he went, he was sure to be found and then he would be brought back to his hovel with an iron ball around his leg to spend the rest of his life digging in a stone quarry.

Sea air, on the other hand, has always made for liberty. Once out of the sight of land, no matter in what sort of boat, the runaway slave had an even chance, for the biggest galley was no faster than an old fishing smack, sailed by a competent hand. The subject knew this, but, what was infinitely more important, his master realized it too and therefore tempered his severity with a little common sense, lest one day he find himself alone in his royal palace with everybody gone but the watchdog chained to the garden gate. And since everywhere and at all times, man has fashioned his Gods after his own image, the Divine Beings gathered together on top of Mount Olympus were very different from those who brooded over the hills and plains of Egypt, Palestine, or Chaldea.

It is, of course, impossible for us to recapture the attitude of the Greeks toward their Gods. We have so completely accustomed ourselves to the idea that the Lord of Heaven is an absolute autocrat,

responsible to no one but himself, that we cannot think of him in any other role. The Greeks and Romans were much more democratic in their ideas about their Gods. Zeus-Jupiter was by no means certain of his position. It is true he could not actually be deposed, but he could (and indeed, he often was) completely overruled by his wife or by a combination of the lesser Deities. His power over his relatives was no greater than that of any ordinary citizen over his own dependents, except that of the Roman father who exercised a much more far-reaching control over his sons and daughters than Jupiter exercised over his own children.

As for the cousins, uncles, aunts, and nephews who were all of them members of the clan of Mount Olympus, each one of these was supposed to have a job of his or her own. A few looked after commerce and trade. Others were responsible for the even flow of brooks and rivers. Still others superintended earthquakes and floods or manufactured thunderbolts and flashes of lightning or were responsible for the safe arrival of little children and little goats and puppy dogs.

We still use the expression "the spirit of the road" or "the mood of the mountain," but to us it is something very hazy—a poetical allusion to our feelings when we walk down a charming country lane or climb a mountain at sunrise. The Greeks and the Romans, on the other hand, were convinced that there was an actual God who inhabited that mountain or who watched over the travelers on that particular road. Sometimes he would even catch up with a wanderer and accompany him for a few miles, swapping stories about the price of eggs in the near-by city market and the chances for a good crop. Those who had been fortunate enough to meet the God socially, so to speak, could then provide the sculptor or painter with a detailed description of his features and his gait and the color of his eyes, until every one of the Olympians had been caught in marble, in clay, or in paint, and had become as much of an actuality to the people at large as the former Prince of Wales used to be to the stenographers of a few years ago.

They had never seen him and they never expected to see him, but that did not matter. They had seen his picture and they had heard people tell about him and that was all they really cared to know. To them he existed and they knew that he led a wonderful life, a million miles removed from that of the average dirt farmer on his little plot of land in the stony backwoods of Attica or Argolis. But he was, of course, obliged to work very hard to keep things going smoothly and so there was very little envy mixed with all this admiration. The

prince, like the God, belonged to another sphere, but that was as it should be in a world based upon the principle of inequality. And therefore, when you bought his picture, you did not mind if it were just the least little bit flattering and if the features were just a trifle idealized. Otherwise that God (or that prince) would look exactly like everybody else, like Uncle Ephraim, and that would spoil the whole thing.

So much for the Gods. Now a word about their statues.

The Greeks as a race believed in athletics. They also dearly loved a fight. Warfare has become so barbarous that we are apt to forget that a good healthy fight is really a most delightful experience and an excellent way to let off steam. And warfare, as practiced by the Greeks, was really a superior form of athletics. Two magnificent creatures, as hard as nails, battered each other with swords and battle-axes while both camps looked on and cheered the winner. In order to be fit for such encounters, one had to keep in constant training. But we have to examine the subject a little further to get at the relation that existed between the ancient Greeks and their devotion to sport.

The Greeks were the first people to see and to appreciate the beauty of the human body. Being completely devoid of any sense of inferiority, and courageously proclaiming the doctrine that man was the beginning and end and sole purpose of creation, they never regarded their bodies as something of which they should feel ashamed and something they should neglect in order to gain approval in the eyes of their Gods. For their Gods, too, were very particular about their personal appearance. Their Gods, too, went in for running races and for swimming races and for riding unruly horses.

The climate again played a great role in giving the Greek his love for outdoor sport. It was neither too hot nor too cold to spend the greater part of the year in the open.

Then there was their tremendous intellectual curiosity. They had long since discovered that a clear brain is capable of much more sustained and much better thinking than one that dwells in a body clogged up with the accumulated rubbish of years of a sedentary existence.

Finally, we must not overlook one most important item—the economic independence of the freeborn Greeks and the vast amount of leisure they enjoyed by living on the fruits of a carefully manipulated system of slavery. We, the enlightened people of the twentieth century, who send our navies to the ends of the earth to suppress slavery, find it difficult to associate all these superior virtues of the old Greeks

with their idea of slavery, for they accepted it as unconcernedly as we accept the fact that our modern iron slaves (our engines) work for us and receive nothing in return but enough water and fuel to keep them going. It would never enter our heads to go to the village pump when we can have all the water we need from the city's reservoir for the mere trouble of turning on the faucet. Life would become unbearable if we were obliged to do all the things that our iron slaves do for us at such small cost.

The Greeks felt just the same way about their human slaves as we do about our iron servants. Undoubtedly the more enlightened among the Greeks were conscious of certain obligations toward their human slaves, just as an intelligent modern manufacturer is conscious of his duties toward his engines. The creatures have to be treated kindly and must be tended carefully, if for no other purpose than to get a maximum of labor out of them. If you appreciate your car and want it to be of the greatest possible service, you will feed it regularly and you will not let it be exposed to snow and rain and you will provide it with all the necessary repairs, so that it will not break down by the roadside.

To which the modern critic will inevitably answer that this comparison is not quite fair. For your car has no soul, whereas your slave might have a soul infinitely more worthy of salvation than your own. Granted. We have learned better and we shall never be able to go back to the old days of an economic system based on chattel slavery.

But the Greek didn't see it that way. Or if he suspected that there was something wrong with the arrangement, he would have asked you, "Yes, but if I should give up this arrangement, how would the world go on?" It is the same answer we are very apt to give when someone draws our attention to the dangerous and uncomfortable calling of the coal miners, of the structural steelworkers or the deep-sea fishermen. We do need coal, don't we? We must have houses. We must have fish. And then we try to satisfy our consciences by a clever bit of rationalizing about how these people really love their jobs and how they are really much happier in a coal mine or in a dory on the Grand Banks than they would ever be in an office or in a factory. Knowing nothing at all about the way they actually feel (we only meet them once in a while in a magazine article or a novel), we quiet our innermost doubts that way as well as any.

This is going to become an economic tract if I am not very careful. I can't quite help it. Economics is in the air and it is impossible to get away from it. But in studying the art of the Greeks, we should

THE ROUND HUT OF THE EARLIEST GREEKS WAS MADE OF
TWIGS          COVERED WITH MUD.

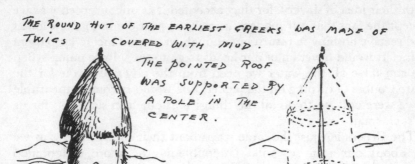

THE POINTED ROOF
WAS SUPPORTED BY
A POLE IN THE
CENTER.

THE HUT BECAME OBLONG - THEN SQUARE. IT GOT
ITS LIGHT THROUGH THE DOOR

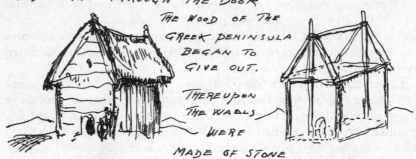

THE WOOD OF THE
GREEK PENINSULA
BEGAN TO
GIVE OUT.

THEREUPON
THE WALLS
WERE
MADE OF STONE
OR BRICK.
THE ROOF HAD
A GABLE

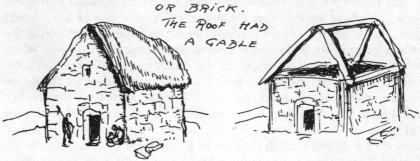

BUT THE ONLY LIGHT INSIDE CAME IN THROUGH
THE DOOR.

### THE DEVELOPMENT OF THE GREEK TEMPLE

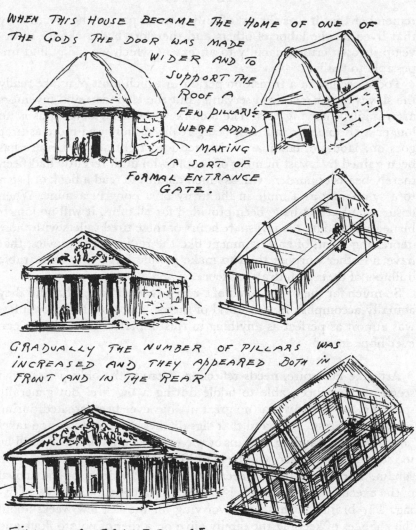

WHEN THIS HOUSE BECAME THE HOME OF ONE OF THE GODS THE DOOR WAS MADE WIDER AND TO SUPPORT THE ROOF A FEW PILLARS WERE ADDED MAKING A SORT OF FORMAL ENTRANCE GATE.

GRADUALLY THE NUMBER OF PILLARS WAS INCREASED AND THEY APPEARED BOTH IN FRONT AND IN THE REAR

FINALLY A GALLERY OF PILLARS WAS BUILT ALL AROUND THE ORIGINAL HOUSE AND THE GABLE WAS FILLED WITH STATUES. BUT NO WINDOWS HAD AS YET BEEN ADDED. THE ONLY LIGHT CAME IN THROUGH THE DOOR.

**THE DEVELOPMENT OF THE GREEK TEMPLE**

remember that it was the art of only a small part of the community that lived on the labor of others and therefore had a chance to develop its own critical faculty to an extent which we today find impossible to realize.

Today we are in a transition period in which most of us are really the slaves of our own iron servants. But the engineers and inventors are rapidly changing this. The factory without factory hands is no longer a Utopian dream. It is being realized more and more as time goes on. Hours of labor are being reduced right along. Leisure has been gained by a vast number of people who until recently had been merely beasts of burden with as much chance to read a book or listen to a symphony as a mule in the army or a pony in a mine. When leisure shall at last have been provided for all of us, it will no longer be necessary to fill the few spare hours of these tired toilers with those depressing forms of entertainment like the radio or the movies, that have no other purpose than to make people forget the unbearable dullness of their own drab existence.

So much for the background of Greek art. And now, what did they actually accomplish in this world of theirs, which for the chosen few was almost as perfect as anything in this imperfect vale of tears can ever hope to be?

Art, like literature, needs reflection. Nero is the only person who seems to have been able to fiddle during a big fire. But generally speaking, we can say that no great art has ever been created during periods of unrest. The hand that digs ditches and fells trees and takes pot shots at marauding Indians or waves a flag on a barricade will be too sore and the fingers will be too stiff and tired to play a Beethoven sonata. The ears that have been listening all day long for the arrival of the executioner are not likely to turn out an ode to the glory of living. The brain that has been worrying for the last few weeks about the chances of keeping the family alive on a diet of potato flour and horse meat is not the sort of brain that will plan a new form of church architecture.

Art needs reflection and you cannot do much reflecting while sailing a boat through a squall. But when the squall has subsided and the waters have returned to their usual tranquillity, the experience may suddenly have opened your eyes to certain new forms of beauty you had never suspected before. Then is the moment when you may become a great poet or a painter or a great composer, and that is the

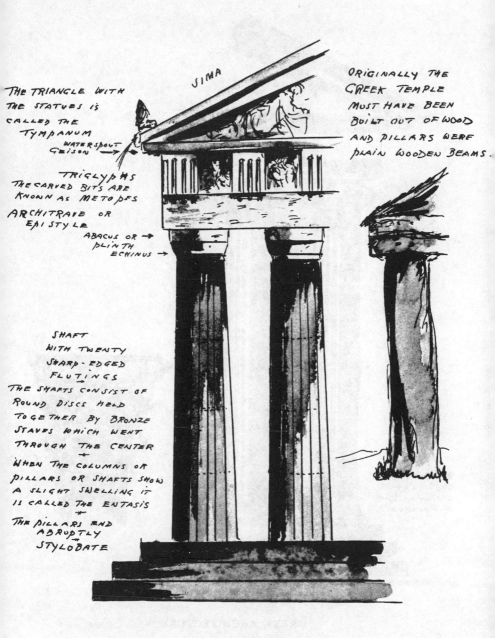

THE TRIANGLE WITH
THE STATUES IS
CALLED THE
TYMPANUM

JIMA

ORIGINALLY THE
GREEK TEMPLE
MUST HAVE BEEN
BUILT OUT OF WOOD
AND PILLARS WERE
PLAIN WOODEN BEAMS.

WATERSPOUT
GEISON →

TRIGLYPHS
THE CARVED BITS ARE
KNOWN AS METOPES

ARCHITRAVE OR
EPISTYLE

ABACUS OR →
PLINTH
ECHINUS →

SHAFT
WITH TWENTY
SHARP-EDGED
FLUTINGS

THE SHAFTS CONSIST OF
ROUND DISCS HELD
TOGETHER BY BRONZE
STAVES WHICH WENT
THROUGH THE CENTER
→

WHEN THE COLUMNS OR
PILLARS OR SHAFTS SHOW
A SLIGHT SWELLING IT
IS CALLED THE ENTASIS
→

THE PILLARS END
ABRUPTLY
→ STYLOBATE

**GREEK ARCHITECTURE**

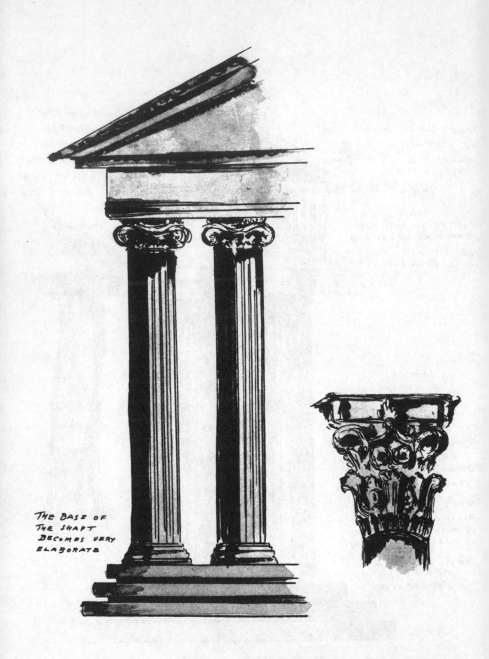

THE BASE OF
THE SHAFT
BECOMES VERY
ELABORATE

**GREEK ARCHITECTURE**

time, immediately after such a tremendous crisis, when nations have invariably produced their noblest works of art.

In the case of Greece, we know really nothing about the early period that followed upon the actual settlement of the land, for whatever they built or carved was made of wood. The climate was not like that of Egypt and all the wood of that period has long since rotted away. The method, however, by which the Greeks afterwards built their temples shows that originally they must have been constructed out of wood. Their statues betray a similar wooden origin. Rather than tell you about them (for words can never hope to tell anyone what something looks like or sounds like) I shall ask you to study the photographs of such early statues that are surely to be found in your town library. You will probably say that they remind you of something and you will be right. They will remind you of our Alaskan totem poles. It is their rigidity which gives them this effect, but such a rigidity was inevitable because the sculptor was obliged to carve his image out of the trunk of a tree.

Here the philologist comes to our assistance. The earliest Greek word for a "carved image" was derived from the verb which meant "to scrape." Whenever you want to know about the origin of something, study its name. Quite often it will surprise you and it will tell you almost the whole of the story in just one single word.

None of these wooden statues have ever been found, but the earliest marble statues, dating back to the seventh century B.C. and discovered on the islands of Delos and Samos, still bear a very close resemblance to wooden pillars. The figures wear draperies, but these draperies do not have the easy flowing grace that we will find on the Greek statues of a later date. They hang straight down. They had to, so long as the sculptors were expected to remain faithful to the traditions of the wood carver.

As for the earliest temples, they too must have been made out of wood, as even a very superficial study of the stone temples will show you. The Greeks do not seem to have had regular temples until several centuries after the Trojan War. Until then they had worshiped their Gods out in the open. A simple altar made of the boulders that lay spread all over the landscape was all they needed.

Their religion never developed a class of professional priests in the generally accepted sense of the word. In such places as Delphi, where the oracle needed a go-between whenever man wanted to consult the unseen forces (and someone to collect the fee for this "free advice"), there were a few clerical attendants who in our own scheme of things

would probably have been called priests. On the whole, this was a very intelligent arrangement. The Greeks had trouble enough, God knows, and they fought a great many useless wars. But hardly ever during all their history did they have to cope with that most disastrous of all conflicts—a religious war.

But when their stonecutters had at last developed their technique to the point where they could provide the people with the "living images" of their Gods (a nice and vivid expression, this "living image"!), they began to feel the need of some definite shelter for this marble counterpart of their distinguished guest and it is then that they built him a small permanent residence—a shrine, as we would say, which afterwards became a temple.

As for the change from wood to stone, it was a perfectly natural one. Architecture will always be influenced by the materials at hand. People who live in a forest are not going to build themselves marble churches, and people who live on the brink of a marble quarry are not going to import lumber just for the fun of paying the extra expense of hauling it across their mountain.

It has, of course, happened that some enterprising tyrant, trying to impress the world at large with his power and his wealth, has reversed this process and has built his palaces and his temples and tombs out of materials that had to be imported from the other end of the world. But that was invariably done for show—"to make the multitude gape," as the French so aptly put it—and invariably the results have been most disappointing.

Dirt, according to the definition in the dictionary, is matter out of place. Within the field of the arts, the slightest indication that something is out of place will affect us most unpleasantly and there is no use looking for a compromise, for art does not compromise. A thing either fits or it does not fit. All good architects have always known this and during the last twenty years they seem to have been able to persuade at least a few of their clients that the days of Amenophis or Louis XIV are gone. And in our own country, at least, we are once more beginning to build as the Greeks used to build—with a sense of the "fitness" of things in regard to both background and material.

Their architects seem to have been conscious of the one principle that must underlie all art: Have something to say, say it in as few words as possible, and then stop talking. When they were given a job, they seem to have asked themselves first of all: "For what purpose is this building going to be erected?" Having satisfied themselves upon this point, they drew up their plans accordingly, then let their build-

ing say what it was supposed to say, and called it a day. Hence their temples did not resemble railroad stations and their railroad stations did not resemble banks and their banks did not resemble temples and their universities did not resemble country clubs. I am, of course, guilty of mixing my dates, as the Greeks rarely patronized a railroad station. But those of my readers who are familiar with our modern American cities and have eyes to see will know what I mean.

Now let us have a few actual facts concerning the temples of ancient Greece. They were as simple as a garage, and a one-car garage at that, for every temple was the home of one single Deity. The Greeks, with their sense of moderation, did not mix their Gods. If a temple was dedicated to Zeus, it was his exclusive property and he was not obliged to share it with his wife Hera or his daughter Athena. They were, of course, very distinguished Deities in their own right. As such they had temples of their own and there they could enjoy the same privacy as that accorded to their husband and father in his holy of holies.

In the beginning such a temple consisted merely of a floor, four walls, a roof, and a door. The door also served as a window. At the other end of this stone box, exactly opposite the door and where it would therefore catch the most light, stood the statue of the master of the house, made of bronze or marble or a combination of both with certain additions carved out of ebony, ivory, and gold. For contrary to our modern belief, the Greeks were a people with a great love for the gaudy.

Gradually the word "gaudy" has come to mean something unnecessarily showy, something a bit vulgar in its ostentatious display of colors. But in the days of the Romans, "gaudiness" implied *gaudium*, an inward joy as well as a sensuous delight. When I say that the Greeks in their statuary loved the gaudy, I simply state that brilliant and cheerful color combinations filled their hearts with a genuine joy, with the sort of delight that small children feel when they see their first Christmas tree.

When Greek art was rediscovered after a thousand years of systematic neglect, the statues and the stones of the temples remained as they had always been but all the paint was gone. Remember that these old works of art were brought back to life by people who had lost all touch with that strange world they were digging out of their own back yards and who sincerely believed that anything the Greeks or Romans had produced was infinitely superior to anything they themselves could ever hope to achieve. They would no more have

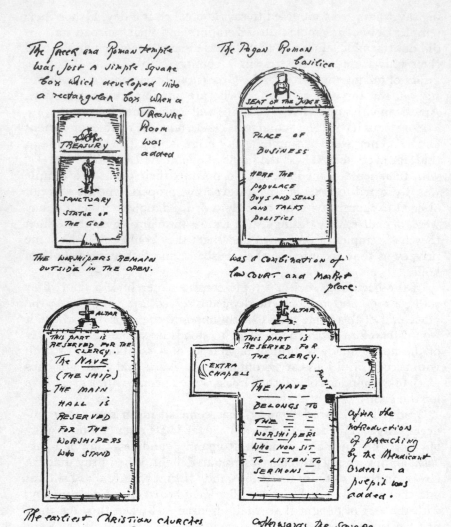

The Greek and Roman temple was just a simple square box which developed into a rectangular box when a Treasure Room was added

TREASURY

SANCTUARY

STATUE OF THE GOD

THE WORSHIPERS REMAIN OUTSIDE IN THE OPEN.

The Pagan Roman Basilica

SEAT OF THE JUDGE

PLACE OF BUSINESS

HERE THE POPULACE BUYS AND SELLS AND TALKS POLITICS

was a combination of law court and market place

ALTAR

THIS PART IS RESERVED FOR THE CLERGY.

The NAVE (THE SHIP) THE MAIN HALL IS RESERVED FOR THE WORSHIPERS WHO STAND

The earliest Christian churches were merely a Roman basilica in which the altar of God had replaced the Seat of the Judge

ALTAR

THIS PART IS RESERVED FOR THE CLERGY.

EXTRA CHAPELS

THE NAVE BELONGS TO THE WORSHIPERS WHO NOW SIT TO LISTEN TO SERMONS

PULPIT

After the introduction of preaching by the Mendicant Orders — a pulpit was added.

Afterwards the square or rectangular box was given the form of a cross.

FROM PAGAN TEMPLE TO CHRISTIAN CHURCH

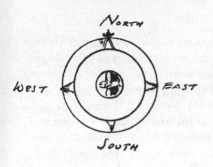

IN THE GREEK Temples the
ENTRANCE WAS ON the
East and the people
faced WESTWARD

IN the CHRISTIAN
Churches the
ENTRANCE WAS ON
THE WEST and the
WORSHIPPERS faced
eastward

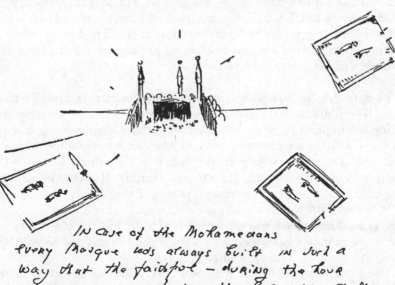

IN Case of the Mohamedans
EVERY Mosque was always built in such a
way that the faithful — during the hour
of prayer were facing the Holy city of Mecca

HOW TEMPLES WERE LOCATED ACCORDING TO THE COMPASS

dared to criticize an old Greek statue than we ourselves, until very recently, would have dared to question the attainments of a singer or fiddler who came to us with an established European reputation.

But worse was to follow when the enthusiast of the Renaissance, who was at least inspired by an honest love for beautiful things, was succeeded by the pedagogue who hoped to build a complete system of esthetic appreciation around these "perfect" examples of a perfect art. They were by no means perfect and they have frequently been surpassed in technique by Egyptian and Buddhist sculptors. Nor had the Greeks themselves ever laid claim to any such pretensions. They were honest and faithful craftsmen, so completely unconscious of their own excellence that they never even bothered to sign any of their works. But the pedants and the professors of the eighteenth and nineteenth centuries, with a deep contempt for the amateurishness of the Renaissance folk, put Greek sculpture upon a really scientific basis. They knew what was good even more than the Greeks themselves. Nothing mattered to them but the line, the contour, the wonderful way in which these old masters had rendered the interplay of the muscles. Therefore a plaster cast was quite as good as an original, for it showed all these details that were of such paramount importance.

I have often wondered what Phidias would have said if he had suddenly walked into a museum of plaster casts. He probably would have been as much at a loss to recognize his own handiwork as Shah Jahan contemplating a mother-of-pearl version of the Taj Mahal made in Birmingham or Ludwig van Beethoven aiming his ear trumpet at a ukulele version of his *Leonora* overture.

I began this chapter with sculpture, which is only natural. To most of us Greek art means statues. The temples themselves we never see unless we happen to go to Greece. The pottery is interesting, but apt to grow a little monotonous with its everlasting repetition of black and red. The coins, neatly tucked away in their little boxes in the showcases of our museums, are not very exciting. But Greek sculpture has entered deeply into the consciousness of the West.

It began with wooden sculpture and with the technique of the totem pole. Then wood was discarded for stone, but the old rigidity of the wooden image remained, and with it the stereotyped smile of the face, the so-called archaic smile.

The archaic smile which we find on very old statues all over the world was not really meant as a smile. Quite often it was intended as

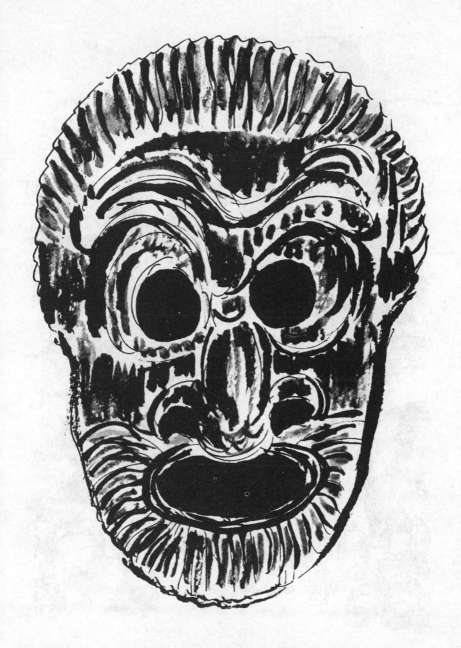

*The Greek actor played his role in a mask so that the audience never need doubt what mood he was portraying.*

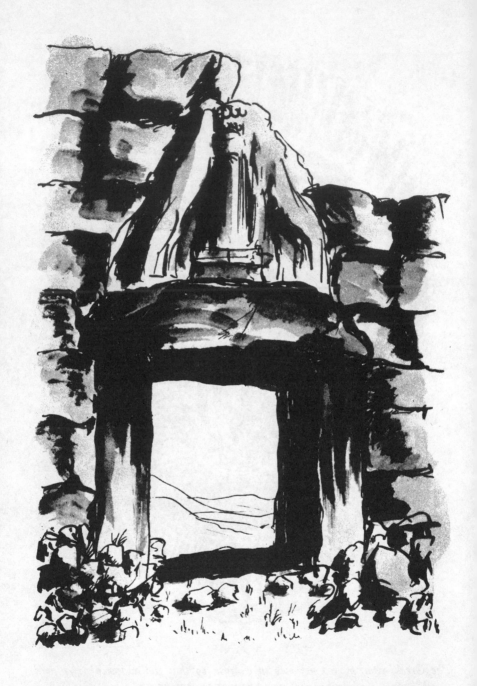

*The Lions' Gate of Mycenae was impressive through its sheer strength.*

an expression of profound grief. But the poor sculptor did not quite know how to handle his problem and as a result all his statues have a slight grin. If you have ever tried to draw portraits you will know what I mean. The nose is easy. The eyes are difficult, but not too difficult. The mouth is by far the hardest part of all. Indeed, it takes an artist of the very first rank to draw or paint a good mouth. If he is not of the first rank, he will invariably achieve that slightly futile grin which all of us know from the *Mona Lisa*.

"Look at her lovely smile!" so the visitors to the Louvre tell each other. "The smile of the eternal woman. So full of meaning! So wistful, yet so wise!"

Wistful—alas and alack! The wistfulness is there, but quite unintentionally. Old Leonardo was a great architect and an excellent draftsman, but, like many first-rate black and white artists, not a great painter. That wistful smile of his "eternal woman" was a piece of pictorial clumsiness. Leonardo did the best he could, but like the sculptors of the early Egyptian epoch and the Greek Middle Ages (and our own children), his technique did not quite come up to his ambitions.

However, practice makes perfect. This is a platitude, but platitudes, I am beginning to discover, are the storehouses for the wisdom of the ages and so I am no longer ashamed of them. Practice makes perfect, and so, after centuries of hacking away at his marble, the Greek stonecutter finally mastered the elements of his technique and got that necessary "looseness" in his wrist and in the tips of his fingers, without which all painting and drawing and sculpturing and all fiddling and piano playing (and baseball playing, too, I suppose)— without which all forms of art must ever remain archaic and wooden and amateurish and everything we don't want them to be.

I am strongly in favor of the amateur. But the good amateur carefully avoids being guilty of "amateurishness." What do I mean by that word? Well, a certain pretentiousness which thinks that a modest modicum of natural talent will overcome a painful lack of technical perfection.

We hear a great deal nowadays about the right of every man, woman, and child to express themselves in their own way. I don't for a moment deny them their good right to do so as long as they keep the results to themselves. For genius without technique is apt to be very painful, both to the eye and to the ear.

Twenty years ago it would not have been necessary to stress this point. Today it is. The great revaluation of all old values, now in

progress in every department of life, has also made itself manifest among our budding musicians, painters, and poets, and people often ask us, "Why all this everlasting harping on technique, this insistence upon the 'classical way' of doing things? Isn't genius alone enough?"

No, genius alone is *not* enough!

A short while ago I gave you my definition of genius as perfection of technique plus something else—plus something else that is as inde-

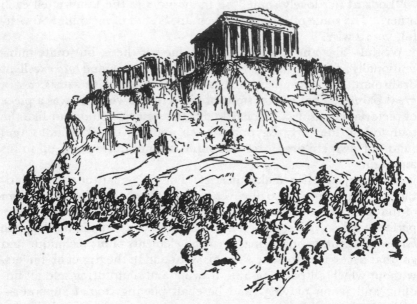

*For more than twenty centuries the ruins of the Acropolis stood erect . . .*

finable as the grace of God, but which all of us recognize the moment we hear it or see it or taste it. What that something else is may well be a matter upon which opinions will differ as circumstances change. But technique as such will always remain the same and mechanical skill will always be the result of having, by dint of constant practice, acquired such an absolute control over both nerves and muscles that this control has become part of the unconscious self, like the muscular skill that goes into the driving of a car.

Everybody can, after a fashion, learn how to drive a car, and how to get the thing started and how to stop it. Everybody can learn the rules of the road, can learn how to pass another car and to keep away

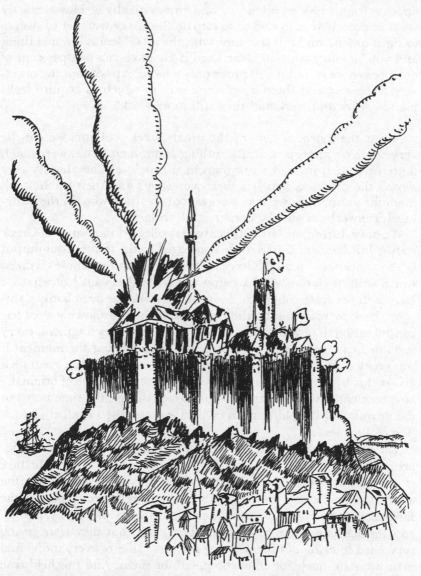

*Then in the year 1687, during a fight between the Turks and the Venetians, when the Turks used the Parthenon as a powder magazine, it was blown to bits*

from fire hydrants. But in the case of the really good driver, that knowledge has identified itself so completely with his brain and his muscles that he acts and reacts instinctively. Another car suddenly appears from a hidden side street and automatically he knows exactly what to do, whether to stop or to step on the gas or whether to swerve to right or left. And it is the same with the arts. Genius is a fine thing and you should thank the dear Lord if He gave you one per cent of one per cent of it. But it will prove only a handicap without the necessary technique and there is only one way in which to acquire technique—work and work and then still more work!

About the personal lives of the great Greek sculptors we can be very brief. We know practically nothing about them. They were much more interested in their work than in themselves. They hardly ever signed the products that left their workshops and their public took them for granted, as we take for granted the men who do the structural ironwork on our skyscrapers and bridges.

We have during the last four centuries collected thousands of Greek statues but they are a mere trifle compared to the tremendous output of the centuries when the Greeks were providing the whole civilized world with its statues. And I regret to say that very little of what we have is in first-rate condition. Most of the work has been badly damaged, both by man and by the elements, with man showing even less consideration than wind and rain and sleet. But every fragment, every torso or head, reveals the technique that prevailed at the moment it was created. It is interesting to notice (and you can learn a great deal about this by a very patient comparison of photographs of originals) how tremendously the technique improved during the time between the downfall of the old Aegean civilization and the so-called Golden Age of Pericles.

The wooden stare of the eyes disappeared first of all. Next the figures lost their stiffness. The eyes, the nose, the mouth, the very texture of the muscles of the arms and legs and the body itself showed that the artists were no longer content with trying to represent types (as the Egyptians and Babylonians had done before them and the Byzantines and the Russians were to do after them) but that they were trying very hard to bring out the peculiar idiosyncrasies of every individual man, woman, horse, or cow who posed for them. And this held true not only of the sculptures of that day but also of the paintings and the pottery. Very likely the same thing happened to their music, but

we know so little that is definite about the old Greek music that we dare not even guess.

In regard to their theater, however, we are on familiar ground, for we know the Greek theater of 500 B.C. as well as we know that of America of A.D. 1937. The tremendous improvement in their theatrical technique shows us how rapidly they were advancing along every line when disaster overtook their country and the Greeks lost their independence and therefore their purely national characteristics.

It is the year 500 B.C. Greece, a little rocky peninsula, a small country with no natural resources, no great national wealth, lies at the other end of the civilized world, far removed from the great centers of civilization—the thousand-year-old cities of Egypt and Chaldea and Crete. There has been some trouble between the Greeks who live along the coast of Asia Minor and the Persians who have recently conquered this part of the world. Athens encourages these outbreaks of discontent. It is considered good business to do so and Athens sends money to the rebels and hints at further support. The revolution, however, is quite easily suppressed, but in order to avoid such unpleasant occurrences in the future (for Asia Minor is far away from Susa where the King of Kings resides) the Persians decide to get hold of the old trade routes between East and West that used to run by way of Troy, to establish themselves on the European mainland, and to wipe out the city of Athens. A perfectly feasible plan that could not possibly go wrong. Athens was merely a little village at the other end of the world.

The Persian armies begin to move westward and cross over into Europe, and at Marathon the Athenians and their Plataean allies push the whole lot of them into the sea.

It takes three years to reorganize themselves. This time they avoid open battle and, following an old Asiatic tradition, they buy their way into the heart of Greece rather than fight for it. A traitor (and next to Ireland, poor old Greece suffered more than any other country from this particular affliction)—a traitor by the name of Ephialtes shows the invaders how they can slip by the Spartans who are guarding the mountain passes. Leonidas and his handful of men sacrifice themselves, but Athens is taken and both the city and the Acropolis are burned to the ground. A few days later a Greek fleet destroys the Persian ships. The war ends as a draw.

This news greatly disturbs the King of Kings in far-off Persia. His

THE OLDEST STATUES — EVEN IN EGYPT AND GREECE
WERE UNDOUBTEDLY CUT OUT OF THE TRUNK OF A TREE
ALL OF THOSE HAVE DISAPPEARED BUT UNTIL VERY
RECENTLY THAT ART SURVIVED IN ALASKA AND IN
BRITISH COLUMBIA

THE FIRST STATUES MADE OUT OF STONE STILL RETAINED ALL
THE AWKWARD STIFFNESS OF THE ORIGINAL WOODEN STATUES.
IT TOOK CENTURIES BEFORE THE SCULPTORS WERE ABLE
TO MAKE THEIR STATUES DO THINGS AND COME TO LIFE.

### HOW STATUES DEVELOPED OUT OF TREE TRUNKS

little colonial war has now become a struggle between East and West. Fresh hordes of mercenaries are hired and for the third time, Asia stands on European soil. At Plataea and Mycale the East is decidedly defeated, both on water and land. The danger of further invasion has been definitely averted.

The people are in a humble mood. A hymn of jubilant praise arises —a hymn of praise unto the distant Gods who have wrought this mighty miracle and who have saved their children from the harsh yoke of a foreign bondage.

At the foot of this lofty hill as of yore there lies a handful of small adobe houses, but the citizens who live in them bear such names as those of Pericles, Sophocles, Euripides, Aeschylus, Anaxagoras, Callicrates, Zeno, Herodotus, Polygnotus, and the irrepressible Socrates who left his stone quarries to wield the chisel of his uncompromising intellect upon that unyielding substance now known as the human soul.

And then, suddenly and for no very good reason, there broke out a war that lasted an entire generation and was one of the most tragic conflicts ever fought. On the one hand, the people of Athens and Attica, intensely curious, independent of mind, insolent in their defiance of revealed authority, skeptical and inquisitive, ready at any moment to storm the pinnacled heights of Mount Olympus, a Cyrano among the nations, ready for any adventure if it promised glory and gaiety—and on the other hand, the landlocked Lacedaemonians, the heavy-footed, slow-witted Spartans, who firmly stood for the three ancestral virtues—purity of race, physical endurance, and blind obedience to the interest of the community.

The ant, when sufficiently persistent, can destroy the brilliant little colibri, and twenty-five years after the death of Pericles the walls of Athens came down, her navy was surrendered to the enemy, her democratic form of government ceased to function, and the city was ready to become part of that fantastic empire which had been recently founded by a tribal chieftain from beyond the northern frontier and which was shortly afterwards carried to the very ends of the earth by his son, young Alexander of Macedonia.

Thereafter Greece no longer played a role as an independent political unit. The Greeks, set free from the irksome cares of state, could now devote all their energies to the more congenial task of providing the world at large with its art, its literature, its theater, its music, its cookery, and its handbooks of etiquette.

But the moment they no longer were responsible for their own fate,

something happened to them. They lost their truly national characteristics. Their art ceased to grow out of the soil. Their artists no longer expressed the feeling of the community in which they lived. There was no longer anything spontaneous or cheerful about the work that was being turned out in the workshops of the Athenian potters, and the sculptors might as well have worked in Naples or Marseilles as in the old land of Attica.

There is such a thing as an art that is inevitable. We have already come across it in Greece. We shall meet it again in the Italy of the Renaissance, in the Holland of the seventeenth century, and in the France of a hundred years later. There also is an art that has been created for an ulterior purpose and invariably it is of very inferior quality. Not that the craftsmanship need be worse than before. Technical perfection will continue for a long time after the death of inspiration. And that is exactly what happened after the Greek city-states had lost their political independence and had become part of a world empire. One can almost hear the master stonecutter say to himself: "I have got to make this Niobe a little more voluptuous. I must give her a little more of a bust, for otherwise that fat Roman war profiteer who has promised me five thousand drachmas for the job won't like it and he will either give me half or refuse to pay at all."

One suddenly realizes that the potters, who for hundreds of years have been honest workmen with a sincere respect for the traditions of their trade, now write to the wholesaler in the recently founded city of Alexandria: "We have changed the old pattern slightly so that it will be more in keeping with the taste of the local Egyptian market. We await an initial order for ten gross."

When that moment has come in the history of any country, it were better (at least from an artistic point of view) that a tidal wave take it to the bottom of the ocean, for there are few things as tragic in this world as the suicide of genius.

Here and there in some of the Greek colonies, such as Pergamum or Antioch, there may be a sudden apparent revival of the old spirit and the flame may seem to burn as brightly as before. For technically, such groups as the dying Laocoön and his sons, which every visitor to the Vatican Museum will forever remember, or such statues as *The Dying Gaul* and the *Apollo* (known more familiarly as the *Apollo Belvedere*), are as good as anything that was ever made before. And yet there is a difference. They are, one might almost say, just a little too good, just a little too perfect. Something is lacking. The element of spontaneity is gone. These statues no longer depend for their effect

upon themselves. They have to tell a story, like that other Gaul killing himself and his wife, which you will also find in Rome. And when art, instead of being a story in itself, begins to tell a story about something that happened to somebody else and begins to tell it deliberately, that is always the beginning of the end.

# The Age of Pericles

*and the transformation of a small rock, such as you might find in the Jersey flats, into one of the world's most famous shrines*

FOR THIRTY-SIX YEARS Pericles was the dominant force in the life of Athens. He had no title and held no office. His fellow citizens accepted him because he was best fitted to be their leader. They might have preferred someone else, but there was no one else and in one respect, at least, they were right, for it was undoubtedly due to his influence that his native city achieved those artistic triumphs that stand absolutely unique in the history of the human race.

Pericles himself excelled in none of the arts except public speaking. But he was the driving force that gave others their chance and it was his powerful position in the community which allowed him to do this and to do it successfully against every sort of opposition. For quite naturally there were a great many people in Athens who thought that this New Deal in the arts was nothing short of a public scandal, an inexcusable waste of money that should have been used for more practical purposes. As a matter of fact, no sooner was Pericles dead than the Athenian mob tried to impeach Phidias, his chief assistant, who was obliged to save himself by a hasty flight to one of the neighboring islands where he spent the rest of his days in exile.

That, by the way—the story of his flight and exile—forms almost the only concrete facts we possess about the career of this famous architect and sculptor. We are still uncertain about the day of his birth and we are equally uncertain about the day of his death. Not a single authentic work from his own hand has come down to us. No contemporary had deigned him worthy of a detailed biography and Plutarch, who wrote two hundred years after his death, had to depend upon studio gossip for those little interesting items upon which he relied for his literary effects. But even without Plutarch we would have remembered the name of Phidias, for he was the man responsible for the Acropolis.

The Acropolis to us stands forth as the ideal combination of natural background, structural perfection, and social usefulness. The hill itself was neither high enough to dominate the landscape nor low

enough to be overlooked. The buildings on top of it had been erected to perform a certain definite service and they performed this service with the greatest possible economy of material. Together, this hill and these temples served the purpose of providing the people of Athens with a perfectly natural civic center, a fortress in case of war, a shrine during periods of peace, and to the rest of the world the visible expression of the pride and the strength and the genius of this noble city at the foot of Mount Lycabettus.

The most important temple on the Acropolis was that devoted to the Goddess who, having been born out of the head of Zeus, was supposed to have been endowed with more than her due share of intelligence and prudence and whom most Greek cities accepted as their patron saint and counselor and guide. She was Athena, the virginal Athena, for she, like her half sister Diana, was a most superior and exclusive person who rarely deigned to associate with her more boisterous relatives on Mount Olympus. On occasion, however, she could be a mighty warrior and as such she has survived in many images, crowned with a helmet and carrying both sword and spear.

The people of Athens, ever conscious of the fact that they had called their city after this particular Deity, therefore erected the most important of their temples to Athena Parthenos—the Virgin Goddess. It was their Saint Peter's church, and during full twenty years the quarries of Mount Pentelicus were stripped of their most valuable marble that the protectress of the Athenian people might have a residence worthy of her exalted position in the divine hierarchy.

It was not so very long ago, only a few dozen years (in 480 B.C. to be exact), that the old Acropolis had gone up in flames, destroyed by the mercenaries of the Persian invaders. From the near-by islands of Salamis and Aegina, the panic-stricken refugees watched the white column of smoke as it slowly ascended against the blue sky of Attica. But behold, a miracle had taken place! The Persian no longer existed except as a bogey with which to scare children. Athens stood forth as the savior of the common country, the richest colonial power of that day, the tacitly accepted leader of that confederation of independent city-states that some day very soon hoped to make Greece a powerful and united nation.

It was during these short years of the great Athenian boom that the Parthenon was erected as well as the temple of Athena Nike, the victorious Athena, the Erechtheum which had contained the shrine of Athena Polias, the guardian of the city, and which gave us our well-

known caryatides (female figures used as columns to support a roof), and the Propylaea, the gateway that led to the top of the Acropolis.

As for the Parthenon, the most important of all these buildings, towering well over its neighbors, it was still a very small structure compared to those dimensions with which we have become familiar in more recent times, for the platform on which the forty-six outer columns rested was only 228 feet by 100 feet, while the cella (the real sanctum) was 194 feet long and 71 feet wide. Here stood the statue of the Athena Parthenos, the Virgin Athena. It reached almost up to the roof and was 42½ feet high. The walls were painted a dark red, but the ceiling was brilliantly colored.

As for the statue itself, supposed to have been the work of Phidias, we know it only from several small replicas made at a much later date, the original having disappeared long ago. Small wonder when we remember that it was a composite statue made out of bronze and gold and ivory and that Athens was for years at the mercies of all sorts of foreign mercenaries.

These composite statues are no longer made and it may therefore interest you to know the process of fabricating one. The inner kernel of the structure consisted of wood and around this wood the figure of the Goddess was modeled in some plastic material, but we don't know exactly what. This plastic material in turn was covered with plates of ivory which represented the flesh. The garments and the accessories were made out of solid gold. Altogether, the gold alone represented forty-four talents, or, in its modern equivalent, a sum of three-quarters of a million dollars. Think of what must have become of that when a group of marauding soldiers were turned loose on this shrine and told to help themselves!

When they got through, nothing much remained except the columns of the temple and the walls and the roof; some fifty life-size statues that adorned the pediment, the triangular space at the end of the building and cut off on two sides by the sloping roof; and the famous frieze of legendary figures, 524 feet long and 3 feet, 3½ inches high, that ran all around the temple just below the cornice, which is the broad band of stone just below the roof. Today none of these except a few heads on the pediments and a few parts of the frieze remain in their original positions.

The frieze represented the solemn procession that took place at the end of the festival known as the Panathenaea. It took place once every four years and was celebrated by all sorts of sports such as running, jumping, discus throwing, and chariot racing. On the last day the

**GREECE**

*A monument in gracious memory of a lovely woman*

THE EGYPTIAN TEMPLE

whole of the populace marched up to the Parthenon to present the Virgin Goddess with a saffron-colored robe, woven and embroidered by Athenian virgins. At the same time the winners in the different events received their wreaths of laurels. The Panathenaea was the most solemn of all Greek feasts. It was, therefore, on the last day of the Panathenaea of the year 438 B.C. that the Parthenon, which it had taken ten years to build, was officially dedicated. This festival survived Greek independence for many centuries, for it did not come to an end until the third century of our own era and so we can say that the Parthenon functioned as a temple for almost seven entire centuries.

Today part of that lovely frieze is in London and part of it is in the museum at Athens. As for the statues of the pediment, all of them are gone except a few heads. In the year 1801 Lord Elgin, the British ambassador to the Sultan of Turkey, got permission to remove them and some years later he took them to London "for safekeeping." They are still there in the British Museum. Elgin has often been blamed for this act of vandalism, but I have no doubt he was entirely sincere in his attempt to save what still could be saved. For the story of the Acropolis is a very sad one.

The builders of the Acropolis, knowing their job, had worked with a minimum of cement and mortar under circumstances where we would have used whole shiploads of the stuff. All these enormous blocks of marble and all these many columns had been put together without the help of any binding material. The columns consisted of round slabs of marble ("drums" would be a more technical word). They had holes bored in the center and through those a bronze or sometimes a wooden pivot was thereupon passed to give them greater stability. Yet if these temples had not been deliberately destroyed by gunfire, they would still stand as erect as they did on the day they were finished.

Their actual destruction did not take place until the end of the seventeenth century. In the meantime, however, they had suffered severely from the violence of religious fanaticism. About the fifth century of our era the Parthenon, the shrine of the Virgin Athena, had been converted into a Christian church, dedicated to the Virgin Mary. The entrance was then transferred from the east to the west and the interior was completely changed. A gallery was added for the women and a pulpit was built and the walls were covered with pictures of Christian saints. In the year 1456 it ceased to be a Christian church and became a Turkish mosque. The interior was emptied of

everything the Christians had needed for their worship and a minaret was built at one end to remind the faithful of the hours of prayer.

In 1675 the Acropolis was visited by two Englishmen who still found most of the statuary as it had been in the days of Pericles, but twelve years later, a Venetian army under Count Königsmark laid siege to Athens and then the Turks decided to use the Parthenon with its heavy walls as a powder house. On Friday, September 26th of that year, a German lieutenant fired the fatal shot that blew up the Parthenon. Three hundred soldiers were killed by the explosion and three days later the Turks surrendered.

The Venetian commander in chief tried to remove the statue of Poseidon and the horses of Athena's chariot from the western pediment, but his workmen bungled the job and the statues fell down and were smashed to pieces. A year later the Venetians left Athens once more to the mercies of the Turks, who built another mosque among the ruins of the Parthenon.

Early in the nineteenth century came Lord Elgin, who took away the remaining statues, and then came the Greek War of Independence, which lasted from 1821 till 1829, during which period the Acropolis was once more the scene of several bitter fights. A few lovely ruins are all that remain of the building of Phidias and Pericles.

One hates to play the moralist. If the Acropolis had been destroyed by the Persians or the Romans or the Goths—well, they just did not know any better. But it makes one see red when one remembers that the original buildings were still all there when Harvard celebrated its first semicentennial.

Pericles died of the plague in the year 429 B.C., two years after the outbreak of the Peloponnesian War. In 404 Athens surrendered to the Spartans. But the old spirit survived for some time longer in the art of the city. This art, however, underwent a profound change, for a spirit of contemplation had succeeded the spirit of action and this was reflected in the work of the Athenian sculptors. These sculptors, incidentally, were no longer doomed to a life of complete anonymity. Working for a world market they depended now for their livelihood upon a well-established reputation. It was not enough that their own neighbors knew them well enough to call them Bill or Joe. The people of Rome and Alexandria, who could pay well for their wares, must have something a little more tangible than these nicknames. So we begin to hear about Praxiteles and Lysippus and Scopas and others of smaller caliber. Furthermore, they now began

to sign their work so that we possess a few statues that were undoubt-edly the work of their hands.

Very little of the sculpture remained in Greece. It has come down to us by way of Italy, for the Romans, who were at last beginning to show signs of civilization, were very fond of filling their houses with all sorts of expensive bric-a-brac. They ordered their statues whole-sale from the Greek studios. When a particular piece of work became popular, like the *Hermes* of Praxiteles or the so-called *Apoxyomenos* of Lysippus (the wrestler who is scraping the oil and dirt off his arms), there was a call for a great many copies and some of these found their way to queer places. It is hardly likely that the handful of inhabitants of such islands as Melos or Samothrace could have afforded such masterpieces as the *Venus* and the *Victory* which are now in the Louvre in Paris and which respectively bear their names.

How did they get there? There is no way of telling. Maybe they were part of a cargo that never got farther than their harbors. Or they had been plundered from the mainland and hidden on one of the islands. But books and works of art have such strange adventures that we need not be surprised at anything.

Only once in a long while, as in the case of the Mausoleum at Halicarnassus (built in 353 B.C. by Queen Artemisia to the memory of her departed husband Mausolus), have the statues actually re-mained where they belonged. For the rest, they were either sold or stolen or smashed to pieces when the triumphant Christians decided to purge this world of all heathenish images.

There was one sort of sculpture that escaped such a fate. I refer to the monuments placed over the graves of the dead. The Greeks did not like death. They violently resented it as an interruption of a happy life, but since nobody could very well hope to escape from this un-pleasant inevitability, it had to be accepted as gracefully as possible. The monuments they erected to the memory of those who had started forth upon their final voyage reflected this mood. They were very simple but full of dignity.

I have seen so many hideous cemeteries in so many parts of the world that I almost feel it a sort of public duty to draw your attention to this Greek approach to the final miracle. We are fortunately out-growing the dreadful heritage of the Middle Ages, when thoughts of the charnel house filled the minds of men, instead of the pleasant pros-pect of that eternal peace and repose which is to be our share when we shall return to the bosom of the Great Mother that gave us birth. Especially during the last twenty years we have made great progress

in reaching a more sane attitude toward this inevitable problem. But there is still a lot to be learned and nowhere can we hope for more enlightened inspiration than among the tombs that hold the dust of those who had been loved by the men and women who trod the earth in the days of Pericles.

The genius of the ancient Greeks had known how to convert even death itself into a work of art.

When shall we have the courage to do likewise?

CHAPTER EIGHT

# Pots and Pans and Earrings and Spoons

*A chapter about the so-called minor arts of the people of Hellas*

I NEED NOT TELL YOU that I am not using the word "minor" in the sense of "inferior." Within the domain of the arts there reigns an absolute equality as far as true merit is concerned. A marvelously well-baked omelet is superior to a badly painted mural and a tiny terra-cotta figure from Tanagra (that Tanagra in rustic Boeotia which was the Squeedunk of the Athenians and produced its loveliest little statues) can give one much greater joy than the face of a Founding Father, hacked out of a mountain side.

But life is short and the Chinese are the only people who will publish books consisting of a hundred volumes or more. I must say everything I have to say within seven hundred pages. And so for the sake of convenience I shall stick to the old terms. Since I have got to begin somewhere, I shall start with the potteries, for when you go to our museums, you get the impression that a million Greeks did nothing else for at least a million years except make pots and pans; or *amphorae* and *kylikes*, if you wish to show your classical education and be a little more refined.

The Greeks (the real ones and not the storybook variety) were brilliant and highly cultured people, and like so many other brilliant and highly cultured people they were very direct and outspoken in their attitude toward life and nature. Hence we are obliged to confess (of course with deep and sincere regret) that a certain note of vulgarity is quite frequently to be observed in a great deal of the work that they have left behind to further our own artistic education. That the pottery boys of Athens (a bawdy and lawless set of fellows) should have rather prided themselves upon being the worst offenders along that line is one of those things that will ever remain a subject of sincere mortification to all those who mean well by art with a capital letter *A*. The real artists, however, will loudly cheer, for they too are apt to be a bawdy and lawless set of fellows. Why this should be so I could not possibly tell you. But as far as I can discover, there has not been a painter or musician or sculptor of note who did not at

105

some time of his career suddenly give a wild whoop of joy and there-
upon compose or paint himself a lusty piece of ribald nonsense.

I hope that this will serve as a warning for those who are looking for
illustrative material for their Sunday-school lessons not to make too
close a study of these beautiful old Athenian vases. They would have
ample opportunity, for all our museums are chock-full of *oinochoës*
(wine jugs), *hydriae* (water jugs), *craters* (nothing to do with volcanoes;
it merely means large bowls in which you mixed your wine and
water), *lekythoi* (oil flasks), *amphorae* (double-handled affairs for honey
and grain and olive oil), and all the many others whose names I have
forgotten just now. This is very natural as the Greek world was a
world of wine, honey (which took the place of sugar), and olive oil;
and while glass was known, it was very expensive and wooden barrels
were too hard to make, and so all these ingredients had to be saved
and transported in jugs and carboys and gallipots.

Like everything else, the potter's craft had come to the Greeks
from their Cretan and Aegean teachers. It was the Cretans, it seems,
who had learned the use of the potter's wheel, which was, of course,
a tremendous improvement over the old stationary method of giving
shape to a lump of clay. Also they had invented quite a wonderful
glaze, that liquid coating which is poured over a piece of earthenware
and which, after it has been baked, gives it a lovely lustrous surface.
The secret of making that glaze has been lost, like so many other
secrets which allowed the ancient artists to achieve results that we
ourselves are unable to get. But once they had learned the pottery
business, the Greeks were so successful at it that they were soon
making the pots and pans of the whole of the Mediterranean.

In the beginning this industry had centered in Mycenae, where the
potters specialized in ornaments that had been borrowed from the
world of the plants and the fishes. But after the collapse of the civiliza-
tion of Mycenae, Attica had gradually become the pottery center
for the entire eastern half of the Mediterranean and finally, during the
middle of the sixth century B.C., the Athenians succeeded in con-
verting this business into a purely Athenian monopoly.

It is interesting to note once more, in studying this Greek pottery,
how everything in this world has to be learned slowly and by an end-
less process of trial and error. The earliest products of the Athenian
kilns were very inferior to the work that had been done by the Cretans
and their colonists on the Greek mainland. Figures were entirely be-
yond the reach of these puttering potters. All they could do was to
embellish their wares with geometrical figures which rather remind

one of the geometrical designs impatient people draw on telephone pads.

However, as time went by they became more and more bold in their graphic experiments. Now and then human figures made their appearance. Then the figures were combined into groups. Suddenly these groups began to do things. They no longer stood still, but wandered all over the surface of the bowl or jar. Finally we find them playing games, going to weddings and funerals, running races with each other, or engaging in battle. These subjects exhausted, the scenes were transferred to Mount Olympus and the Gods were portrayed in both their more and less intimate moments. For the greater convenience of the spectator the potter usually added a few words of text and the names of his heroes, so that there should be no mistake about who they were or what they were doing.

Unfortunately (at least to my own taste) the old Greek pottery is rather monotonous. The color of the original clay was a dark red and as a rule the figures were painted in black. The details, such as the folds of the garments worn by both men and women, were then scratched into this black, once more exposing the red clay underneath. Sometimes, especially in Corinth, a little white or purple was used, but in the main, the red and black predominated. Although the Greeks were exceedingly ingenious in discovering new forms and shapes for their vases and drinking cups, the eternally repeated black and red create a very decided atmosphere of monotony when we see too many of such objects at the same time.

However, that is a matter of taste. Judging by their vast output, the Greeks themselves seem to have been very fond of their vases, for there was an increasing demand for elaborate shapes and intricate ornaments. This may have been due to the fact that the Greeks (like the modern Japanese) lived in houses that had very little furniture and none of the endless gadgets with which we clutter up our own homes until they look like auction rooms. The only chance to show one's opulence was by a display of amphorae and craters. There was nothing else upon which one could spend more than a few drachmas. Even those expensive wardrobes of the days of the kings, the purple togas and embroidered cloaks of the nobles who then ruled Athens, had been replaced by plain garments of white wool. The food that was served twice a day was as simple as that of an Arab and the menu was exceedingly limited. Meat and bread, hardly any vegetables, very little fish, and no sweets, except those that could be prepared with honey.

On the other hand, in a community in which even the best crafts-men received only twenty cents a day and in which one could hire all the sailors one wanted for a dime a day, it was easy for a rich man (ten thousand dollars made you quite well-to-do in Athens) to hire a vast retinue of servants. Hence the few absolutely necessary pieces of furniture could be heavy and cumbersome. The sofas (both the Greeks and Romans ate their dinners lying down), the oil lamps, the beds and benches for the women and children might weigh ten times as much as our own. It did not matter because there were always enough serv-ants to move them. Another item of interest largely determining the sort of furniture people would buy: Nobody ever moved. You lived all your life long in the house in which you were born, and after your death your children continued to live in the same place. Today most of us are forever on the move. We buy furniture that is as light as pos-sible. We are careful not to acquire too many paintings, for we are never quite sure whether they will go with the next house. That may also be one of the reasons why modern people spend so much money upon jewelry and personal ornaments. They can carry such things with them wherever they go.

The Greeks, of course, were also great collectors of jewelry, but for a different reason. Their golden rings and their precious stones were their investments. Today we try to prepare for the future by buying lots of stocks and bonds. The Greeks had no stocks and bonds. The only way in which they could protect themselves against a rainy day was by accumulating large quantities of golden cups and by providing their womenfolk liberally with pearls and emeralds and expensive bracelets. This will strike us as a somewhat complicated method. Why go to all this expense? Why not just hoard money? For surely the Greeks must have had money?

Yes, they did. Golden and silver coins had been dribbling in ever since the seventh century and they had come to them from Asia Minor. But money was still essentially a medium of exchange. In a world in which barter (two chickens for one goose and one ox for ten hogs) was still accepted as the normal way of doing business, there was not much demand for these small chunks of precious metal which in many cases bore a picture of the animals of which they were sup-posed to be the economic equivalent.

Perhaps because money was still so scarce and something mys-terious which nobody quite understood, such a great deal of care was bestowed upon the engraving of the dies from which that money was struck. These old Greek gold pieces deserve your very close attention.

They will make you feel that we still have a lot to learn if we shall ever hope to do as well, especially in regard to our commemorative medals, most of which are downright ugly.

Of course, in one respect our modern money suffers from a very serious handicap. Our coins must be flat so that they can be stacked. The Greeks did not care how much their gold pieces and their silver pieces bulged. The die cutter could therefore do his modeling as if he had been working on an ordinary cameo, one of those engravings on a precious stone in which the figure itself is carved into the upper layer while the lower layer serves as the background. The flatness that is so characteristic of our own coins and interferes so greatly with their beauty was thereby avoided and the artist was given an amount of liberty which would be seriously frowned upon by the master of a modern mint.

Here arises the question: What shall we do with literature and music and acting—do they belong in a book of this sort? I decidedly think that they do, for they come under that definition of art which I gave you in the beginning of this book—they are part of man's effort to vindicate himself in the sight of his Gods and I wish to high heaven that I had more space to devote to them, especially to literature.

In the case of the Greeks, they were a very serious matter. Their books and their plays were not written to give the people a chance to run away from themselves and to "kill time"—perhaps the most objectionable expression in the whole English language. In the first place, the Greeks were intelligent enough to realize that when you kill time, you kill the most precious of all your possessions. In the second place, they do not seem to have been familiar with a spiritual phenomenon that plays such a very important role in our own lives. I refer to what we call "boredom."

The Greeks and Romans were familiar with dull people. They regarded them with particular disfavor and were absolutely relentless in their persecutions of the "bore" who was a familiar figure on their stage. They also knew the meaning of the word "ennui" which during the eighteenth century moved from the French into the English dictionary and which indicated a vague mental weariness brought about by having had too many of the good things of this life without having been obliged to work for them. But boredom as we now know it, that terrible affliction of the upper middle classes, did not make its appearance until during the last two centuries of the Roman Empire when people were either immensely rich or hopelessly poor and when every-

body knew that they would continue to be so, regardless of their efforts to bring about a change.

The Greeks were never able to found an empire. They remained small city folks and thereby escaped many of those evils which seem to be unavoidable when a family or a nation grows too large for its own good. And all the time so many things were going on in these small cities, there were so many new ideas flying around, that there was no reason why any halfway intelligent man should grow stale. And since staleness is both father and mother of boredom, the Greeks never felt the need of a Hollywood to help them get through the hours of the day. They could go to the theater not for the purpose of being mildly amused but for the deliberate purpose of being wildly excited, in the right and healthy meaning of the word.

As in the case of many other forms of art, we really do not know a great deal about the beginnings of the theater. Our theatrical literature is full of all sorts of hypotheses, some of them quite plausible, others less so. Being most lamentably ignorant about the stage in general, I shall not indulge in any theories of my own but I shall do what I always do under such circumstances, I shall make for the nearest dictionary and try to dig some information out of that most useful book.

I then discover that the Greek word "drama" is derived from the verb *dran* and that *dran* means "to do" or "to act." Which is a reasonable explanation, for there has to be action if the drama wants to be true to life. In real life, people do things. They do not merely sit around and talk, except in Russia, and even there they seem to have learned better. They go out in the street and market place and hate or love or kill as their emotions make them do and they only talk afterwards to find a few plausible motives for their deeds and misdeeds.

Now as far as I can discover there are two conflicting theories about the origin of the drama. There are those who say that the acting grew out of the singing and dancing that was part of those religious ceremonies that played such an important part in the lives of all savages. Then there is another school which believes that the true drama was merely an elaboration (in a very simple way and therefore easily understandable to the whole community) of the famous deeds of some departed hero who would thereby gain further fame and prestige, both in this world and in the next. If this had been true, then the original actors would have been merely participating in some sort of mystic symbolism and the drama would have been connected with a religious emotion.

Whatever its origin (and I leave the choice to you) this much we

know for certain—that once the theater had made its appearance among the Greeks, play acting became the most popular of all the arts, for here was something in which the whole community could take an active part. Acting was not at all like painting or sculpture, where the artist himself does all the work and where the people play an entirely secondary and passive role. On the contrary, once the show had started, the Greek spectator was expected to take sides and to become (emotionally, at least) an active participant in the events that took place right before his eyes.

That sort of theatergoing, I am happy to say, still exists. It has become very rare in our own day and age but there are still a few people left who when they go to the theater are able to forget all their own troubles because they have completely lost themselves in the troubles of the characters behind the footlights and—for the moment, at least—are living the lives of the persons in the play.

As for "comedy" and "tragedy," their names tell us what they really were. A "comedy" or "revel" was originally an exceedingly bawdy and vulgar farce, invariably ending in an orgy which the police of today would never tolerate. That was only to be expected, as all primitive people are very outspoken upon the matter of sex. But already during the fifth century B.C. the Greeks had reached a state of development at which such vulgar and shameless goings-on were beginning to shock even the more robust members of the community. Thereupon the comedy lost most of its former barnyard appeal and after the reforms of Aristophanes it became a witty discussion of the events of the day to which the average Athenian could take his grandmother without any fear for the consequences.

As for the word "tragedy," that cannot be explained quite so easily. Originally, tragedy (meaning the ode to the *tragos* or goat) was the lamentation that was sung over the slain body of the goat who was supposed to be the incarnation of Dionysos. As for Dionysos, whom we now regard as the most typical of all the Greek Gods, he was really much older than Hellas itself. Indeed, he was one of the founding fathers of all religions, for we can follow him way back to the earliest dawn of the human race. He was possessed of such a healthy constitution that for all we know he may, like Pan, still be living with us, carefully hiding his ruddy countenance from the suspicious gaze of our Watch and Ward Societies. For Dionysos had always been a stanch advocate of the doctrine that the good things of this earth had been created to be actually enjoyed. Such an ideal did not quite fit in with the "Repent, ye wicked sinners!" of a later band of prophets.

The Greeks, who were born naturalists and accepted the world as they found it, who regarded man as a mammal endowed with unlimited intellectual possibilities, but a mammal nevertheless—both they and all the people of the eastern Mediterranean, having no consciousness of sin, regarded Dionysos not merely as one of the lesser Olympians but in certain respects they accepted him as the absolute equal of Zeus, which may very well explain his strange name, "the son of God."

This may seem rather curious to us because we merely connect him with the worship of the vine. But that came much later. Originally his worshipers, in order to associate themselves the more completely with the object of their veneration, seem to have celebrated their annual Dionysian feast by the cannibalistic practice of eating human flesh. Savages, however, do not eat their enemies because they are hungry or like the taste of human flesh. That has nothing to do with this unpleasant practice. They merely hope to gain some of the courage and strength of their enemies and their Gods (both objects of fear to the primitive mind) by "assimilating" part of their flesh and blood.

As the Greeks grew more and more civilized, they began to feel a distinct horror at this idea of slaughtering their fellow men. They reasoned that the same effect could be produced by drinking the wine which was part of the blessings the great God of fertility had bestowed upon mankind. A goat was substituted for the person of the Deity himself. After the God-Goat had then been duly slain and eaten, it was quite natural that the virtues of the God-Goat should be extolled by one of his devout followers, usually by the one best fitted for such a task. The others, less adept at rhetorical lamentations, stood around in a circle and acted as a chorus which accentuated some of the more salient points of the "goat song" or hymn of praise which their leader had intoned.

After a while, all this grew very monotonous. It was a little too simple to satisfy the more sophisticated tastes of a people who were beginning to feel "modern." They wanted something a little more elaborate. Thereupon an "answerer"—a "hypocrite" (yes, the Greek word for actor was hypocrite)—was added to engage in a dialogue with the extoller of the God-Goat's virtues. There were then two "actors" who spoke their pieces and a chorus which at irregular intervals indulged in a slowly chanted eulogy or lamentation, a little like the sort of thing you hear when you attend Bach's *Passion According to Saint Matthew* or Haydn's *Creation* or any other modern oratorio.

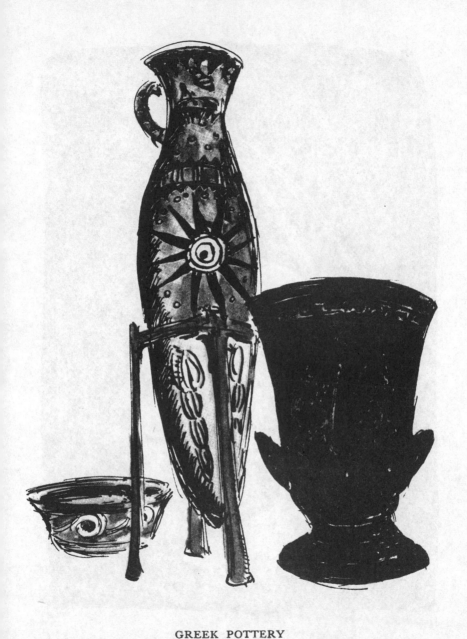

**GREEK POTTERY**

*From the symmetrical black figures on a yellow background to the red human figures on a glazed black background*

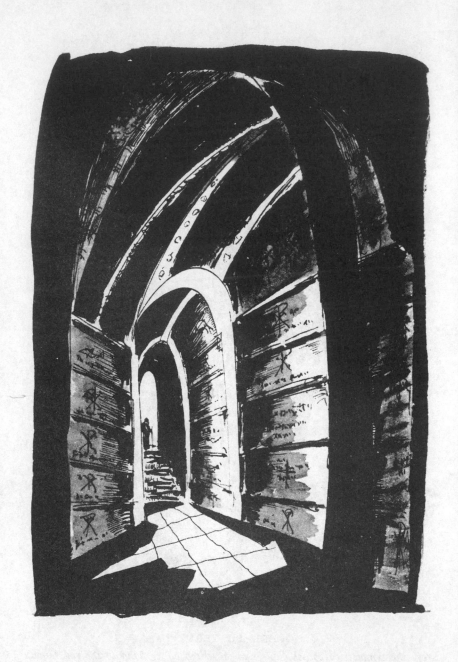

**THE CATACOMBS**

*Art goes underground.*

This novel arrangement satisfied the crowds for several centuries. Then a man of genius came along, a fellow with a new and bright idea, and he completely revolutionized the old theater. His name was Aeschylus and he introduced a second "answerer" so that thereafter (it was the fifth century B.C.) we have not merely two but three regular actors, three people who now begin to re-enact some scene from the lives of the Gods or the familiar local heroes, for by that time most people had completely ceased to associate going to the theater with the worship of Dionysos.

That sort of thing happens every day. We associate the ringing of church bells with divine service. Is there one person in a million who knows or cares that originally those bells were rung to frighten away the evil spirits while people were on their way to the house of worship? We put our widows in black as a sign of respect for the departed, whereas she is merely wearing black so as to be invisible to the evil spirits that were suspected to infest a house of death.

And so, behold! Without really knowing how it had come about, the Greeks one day found themselves possessed of a full-fledged theater, for once you have three actors, the next thing you know you have four of them, and the Greeks who "intelligized" (I think you will know what I mean) everything they touched (just as other nations have "vulgarized" or "dullified" everything they touched) now began to regard playwriting and acting as forms of expression quite as important and interesting as the building of new temples or the carving of statues or devising a new color combination for one of their rare glass vases.

In a world devoid of all public buildings except a few temples and law courts (and very often these were the same), in a world in which men like Solon or Pericles never really had an "office," carrying most of their official business in the *sinus* of their toga (the pocket formed by wrapping the toga around the left arm)—in such a world where the climate encouraged people to live out in the open all the time, nobody would have dreamed of erecting a special edifice for the purpose of attending a mere show. All they needed was a convenient hillside, not too steep, of course, on which the crowd could sit and look, grouping themselves in a semicircle around the foot of the hill where the actors and the chorus were about to engage in their songs and in their speeches. This flat circle on which the actors performed, and which today we would call the stage, was known to the Greeks as the orchestra. As the Greek word *orchester* meant a dancer, not a member

of a band of musicians as it does today, it follows that originally the goat songs must have been accompanied by goat dances and that dancing is therefore quite as old as if not older than regular acting.

After a while when the theater grew a little more complicated, a tent was erected right behind the circle in which the actual performance took place. This tent, called the *skēnē*, was used as a dressing room by the actors and by the chorus whenever they changed their masks. For the distances were so great in these open-air theaters that mere facial expression would have meant nothing to the audience. The actors and the chorus therefore wore masks, indicating their moods and indicating them in such unmistakable fashion that every spectator, even the dullest, could understand whatever emotions the actors were trying to display.

Eventually the orchestra (the circle in the center) became the pit of our modern theaters while the *skēnē* or scene became the modern stage. Otherwise everything is pretty much today as it was twenty-five centuries ago, except that by and large the Greeks insisted on much better plays than we do and therefore got them.

But let us remember that to the Greeks this business of going to the theater meant something entirely different from what it means to us. The Greeks went to a dramatic performance in very much the same way the people in our own villages go to the circus—to make a day of it. The entertainment began the moment the sun had risen and it often lasted till evening. As soon as one play had been finished, the next one began. Then time out for a bite to eat and back to the hillside for a third or fourth play.

Theatergoing having become such a very important part of the average man's happiness, the art of the playwright developed at a rapid pace. Sophocles, who lived while the Acropolis was being built (if we are to believe Aristotle), was the first playwright to introduce scenery in our modern sense of the word. He ordered houses and trees and mountains to be built that were thereupon placed around the orchestra.

Euripides, one generation later, took the chorus out of the play proper and pushed it into the background, making the actors the chief center of interest, a position which they have been delighted to hold ever since except in a few of our operas. By this time, even the last vestiges which had until then connected the theater with its religious origin had been completely forgotten. Thereafter the theater was openly used as a place for political propaganda, where all the battles between the New Deal and the Supreme Court of the year 436 B.C. (New Deals are among the oldest of human institutions) were

thoroughly thrashed out among the cheerful catcalls of the New Dealers and the answering yells of the Supreme Courters.

It was much easier to do this in as small and compact a community as Athens or Corinth than it would be to do the same thing in the New York or Chicago of today. In such a village of only a few thousand free people (the slaves were never allowed to attend a performance), where everybody knew everybody else, the slightest reference to the personal characteristics of a figure about town (the broken nose of a popular philosopher or the nagging wife of a leading politician) was enough to give the whole of the audience a cue as to what was meant.

Finally, the Greeks enjoyed one other advantage which made it much easier for them to use the theater as a public forum for the discussion of current ideas than it would be for us to do the same thing. Every Greek who boasted some sort of education, even the common little dirt farmers from the country districts, not only enjoyed the same religious background but shared a common knowledge of one magnificent piece of literature. All of them knew their Homer.

That Homer never really existed, as has now been conclusively proved by some of our professors of literature, is of very small importance. Literary criticism like every other variety of art criticism is of comparatively recent date. As long as the arts were really part of everybody's life, there was no need for that sort of comment.

The works of Homer were in a sense the Bible of the Greeks, except that the Homeric songs did not particularly concern themselves about a man's morals and were much more concerned with his manners and his general behavior according to the code of the perfect Greek gentleman of the year 1000 B.C. That is why they so successfully kept their hold upon the imagination of the people of Hellas. When once every four years the Athenians celebrated their Panathenaean festivals and when the *Iliad* and the *Odyssey* were then re-enacted by groups of rhapsodists or professional reciters, the spectators felt that they were coming face to face with absolute reality, just as a pious pilgrim feels that he has at last come face to face with his sort of reality when he visits the *Passion Play* of Oberammergau. For then the Greeks were able to watch their heroes and their Gods actually engaged in all those valorous deeds which had made the people of Hellas what they were—the noblest people on the face of the earth. And every boy and every girl promptly learned part of these marvelous poems by heart and could quote them *ad lib.* as our own ancestors of a century ago could still quote their Old and New Testaments or as the Germans could quote their *Faust* until the works of Adolf Hitler were substituted for those of Johann Wolfgang von Goethe.

It was a curious situation when you come to think of it. The Greeks had no literature in our sense of the word. There were no novels in ancient Hellas, no magazines with continued stories, no romances— only a handful of manuscripts owned by a few rich people and written in the letters the Greeks had only recently learned from the Phoenicians. And yet the Greeks, the average country people and townsfolk who for their sagas depended entirely upon their ear and upon their memories, had a much greater feeling of literary homogeneity, a much deeper sense of a "common familiarity" with the best literary products of their race than have we who wallow in a veritable sea of printed wood pulp.

I was thinking of all this the other day in connection with the Greek word "music." Now to us, music means either the syncopated noise that comes to us out of the radio or, in a more serious way, it means an evening sitting on uncomfortable chairs while listening to the compositions of one of our great classical masters. The Greeks used the same word we do—*mousikē*. But it did not in the least mean what "music" means to us today. The Greek word *mousikē* was used in connection with all the arts of the Nine Muses, those charming Goddesses who used to sing for the delectation of the other Gods while Apollo accompanied them on his lyre. Gradually *mousikē* began to include everything connected with the cultivation of the mind, just as *gymnastikē* included everything that had to do with the development of the body.

To get a "musical education," therefore, did not mean that you learned to play the piano or the violin or even the saxophone. It meant that you were receiving a profound training in all of the liberal arts, in writing and mathematics and drawing and reciting and physics and geometry, and that you could also hold your own singing in a crowd and were able to play at least one instrument fairly well.

That Greek ideal, based upon the recognition of the "ideal of universality" that should underlie all true education, survived for a great many more years than we usually realize. Even in the days of Queen Elizabeth, a young gentleman was supposed to be able to do most of these things. It was taken for granted that he could write decent English, read simple Latin texts, and sing or act or play the lute when he was invited to spend a week end in the country. It was also expected of a well-bred gentleman that he know the difference between a madrigal and a rondeau and that, if the occasion demanded, he could also write a pleasing sonnet or sing first tenor in a cheerful gathering around the yule log.

People often wonder how it was possible for the composers of the sixteenth and seventeenth centuries to write quite as many pieces as they turned out. Think of the millions of notes they were obliged to put down on paper! But that is exactly what they did not do. They never bothered about the details. They merely indicated the general outline of the melody they had in mind. For both the musicians and the laymen of that time knew their business so thoroughly that such a mere outline—a few stenographic notes—was all they needed to guide them through their cantatas and their concertos.

The Gypsies still play that way and some of our Negro jazz artists have been very clever at that sort of thing (the "swing music" that is now so popular is supposed to give every man complete freedom of action) and you will find it among the *Schrammelspieler* of the Tirolese Alps, but in our modern world in which spontaneity has almost completely disappeared and in which everything connected with the arts has been neatly classified and ,tabulated and has been reduced to a "science" or a "school," that feeling of the absolute and complete universality of everything pertaining to the arts has been most successfully eradicated.

Perhaps this is one of the most important lessons we can learn from the Greeks. We cannot build the way they used to build without making ourselves ridiculous. We cannot write the way they used to write without getting hopelessly stilted. When we try to imitate their sculpture, we get something entirely different from what they used to make, something that reminds us of the worst copyists among the Romans of the imperial days. I am not mentioning music in this connection, because a complete lack of any definite system of notation among the Greeks makes it impossible for us to so much as guess at the meaning of those few tunes that have come down to us from the days of ancient Hellas. No, we can never hope to be Greeks and we should never try to be. The wise Biblical injunction to let the dead bury the dead holds even more true within the realm of the arts than in any other department of human activity.

But there is one thing we can do and there the Greeks can be our masters and our teachers, as they have been our masters and our teachers in so many other things. They can show us the way back to a consciousness of that universality that underlies all human achievements. They can make us once more realize that nothing in this world exists quite in and by and for itself, but that everything pertaining to the human spirit is correlated and interrelated with everything else. And by so doing they can once more give us a feeling for something that is in truth the beginning and end of all wisdom.

# The Etruscans and the Romans

*Another chapter full of uncertainty due to our profound ignorance about
many things we hope to discover during the next few years*

CIVILIZATION CONTINUED its westward peregrinations and art as
always, in the wake of the full dinner pail, followed suit. But
when the first Greek sculptors and the Greek painters finally set foot
in Italy, ready to carry the blessings of their craft to the barbarians
of Rome, they discovered that they came several centuries too late. The
Etruscans had already performed this highly useful service and Rome
had learned the rudiments of its art from the very people whom it
had incorporated into its own state.

Here at last is an easy way of beginning a new chapter. "Who were
the Etruscans?" The answer is simple. "We do not know." To con-
tinue our catechism:

*Q.* Can we ever know?

*A.* We thought we never could.

*Q.* Why do we now think differently?

*A.* Because the archaeologist has found the solution to the riddle.

There have been several other races who played an important role
in history but about whose antecedents we are still completely in the
dark and will probably always remain so because they had not learned
the art of writing and therefore left us nothing but a few scraps of cir-
cumstantial evidence. The Etruscans, on the other hand, have left us
several thousand inscriptions and we can read them (that is, today
we can read the letters) but as their language has completely disap-
peared, these letters and words were almost as hard to decipher as the
inscriptions we have found on the rocks of several islands in the Pacific
Ocean. For over a hundred years, philologists with a crossword-puzzle
complex have been playing hide-and-seek with these Etruscan texts
and they are little further today than when they started. We there-
upon looked for some definite information in the works of the ancient
Roman historians. For Etruria, which rightly speaking covered all
the territory between the Tiber (Rome), the Arno (Florence), and the
Apennine Mountains, was once upon a time a powerful state which

dominated the western Mediterranean with its navies and engaged in several successful wars against the Carthaginians.

But the Roman historians were also patriots and thought it their duty to belittle these dangerous neighbors who more than once had threatened the safety of their home city. They merely repeated old Herodotus, who, being the father of all history, was supposed to have known everything. When Herodotus wrote that the Etruscans were a people of Asiatic origin who had moved from Lydia in Asia Minor to Italy as the result of a prolonged period of economic depression, they accepted this statement as the gospel truth and asked no further questions.

Finally, however, during the reign of the Emperor Augustus, a Greek historian, Dionysius of Halicarnassus (where Queen Artemisia built her famous Mausoleum) wrote a work in twenty-two books on the antiquities of Rome. Therein he made the startling statement that Herodotus had been wrong, that the Etruscans had not been of Asiatic origin, that their ancestors had not come from Lydia, but had always lived in northern Italy. Thereupon all historians faithfully copied Dionysius and proclaimed the Etruscans to be of European origin, although their language was as different from that of the other Italian tribes as Basque is different from both French and Spanish.

And there the matter rested until the archaeologist began to dig in the soil of Etruria and found what seems to be the true solution. All the earliest works of art of this highly civilized people clearly showed an Asiatic origin. They were excellent sculptors and expert workers in gold and bronze, but all the pictures of their Gods might just as well have been made in Babylonia or some other part of the Mesopotamian plain. They also were very fond of those realistic hunting scenes which had been so popular in Assyria, and their habit of predicting the future from the livers of sheep was also of Chaldean origin, not to be found anywhere among the people of the Aegean Sea or the Greek peninsula.

As the art of the rest of Italy showed very clearly that the people who lived in those parts of the Apennine peninsula had never come in touch with either Crete or Mycenae, it followed that the Etruscans for several centuries after their departure from Asia must have kept up some sort of direct communication with the old mother country, for otherwise they would not have known what their former neighbors were doing, way at the other end of the Mediterranean.

There is still another piece of evidence which seems to bear out the truth of this archaeological guess. The Babylonians and Assyrians, in-

deed all the peoples of western Asia, had been familiar with the architectural trick of building vaulted roofs. The Greeks had known only flat roofs and had never even tried small vaulted passageways. The fact that they used only large blocks of native stone and no bricks may have had something to do with this, just as the fact that the Assyrians and Babylonians had no building stones and only bricks may have forced them to discover the art of vault making. The presence of a great deal of vaulting in Etruria, whereas this form of construction was completely unknown among the other Italians who had got their art directly from the Greeks, seems to be final proof for the contention that the Etruscans were an Asiatic race which shortly after the end of the Trojan War (roughly speaking, about 1000 B.C.) had left its native shores and established itself permanently on the Italian peninsula just north of the Tiber.

Judging them by the buildings they erected, these old Etruscan rulers must have been men of excellent taste. But they had no gift for politics, and were forever fighting among themselves. Centuries of border warfare with their Roman neighbors should have taught them the wisdom of a little co-operation, but they remained blind to every warning. Even the ten-year siege of their greatest stronghold, the city of Veii, only ten miles north of Rome, apparently did not open their eyes to the fate that awaited them. They continued to quarrel among themselves. So the inevitable happened and in the third century B.C. their lands were incorporated into the Roman state. This conquest of Etruria meant a lot to Rome, for the Etruscan cities had been the center of the "heavy industries" of that part of the old world. Etruria had been rich in copper mines and the near-by island of Elba was full of iron ore. The Etruscans had very shrewdly exploited these natural treasures. Today it is curious to note how the art of the country reflected the spirit we so often find among our own industrialists who live far removed from the centers of culture and therefore get out of touch with the realities of life.

There is something sinister in all Etruscan art. It lacks the charm of the work of the Greeks. There is also something slightly primordial in their sculptures. The archaic smile survived, long after it had disappeared among the Greeks. On the other hand there was great strength in all Etruscan portraits, and they carefully reflected the austerity and ruggedness that must have been a dominant characteristic of these ancient steel barons. In Rome the marriage vows, especially during the Empire, were not taken very seriously. But among the Etruscans, husband and wife were husband and wife, not to be sepa-

rated in the next world any more than in this. And their strange-looking sarcophagi (the word really means a flesh-eating stone, because the Greeks used to think that certain sorts of stone would consume the corpse very quickly and these were therefore highly desirable as coffins)—those elaborate terra-cotta sofas which we have found in their vaulted tombs—these show the existence of a highly developed sense of domesticity and family life.

And so does the fashion (also known to the people of Mycenae) of making portrait masks of the dead. These masks were no mere formality that belonged to the routine of giving the departed a decent funeral. They showed great individuality of expression and we feel that the artists who made them had striven very hard after an exact likeness.

The Romans eventually copied this Etruscan custom and every Roman patrician thereupon had a collection of wax masks that had been taken from the faces of his departed relatives. These masks used to hang on the walls of the *atrium* (the central hall of a Roman house) and they served the same purpose as the family portraits with which we adorn our dining rooms. We have found a great many of them. Gradually they developed into regular portrait busts and it is those portrait busts that have made us familiar with the countenance of almost every Roman of any importance. The only difference between these Roman portrait busts and the Etruscan masks was that of the materials used. The Romans carved theirs out of marble; the Etruscans contented themselves with the much cheaper terra cotta.

Terra cotta is almost as old as the human race itself, for it is really what the word implies—it is "baked earth," it is clay that has not been glazed, and even the most primitive races knew how to handle this stuff. As a result, terra cotta has been used all over the world from China to Peru and from Spain to Mexico. But the Etruscans were among the greatest terra-cotta workers of all time. Today the art has almost disappeared. A really first-class piece of terra cotta demands a great deal of very careful personal supervision and as a rule it has to be retouched by hand before it can leave the workshop. All that takes time. Time is money, so why bother?

And now at last we come to the Romans. But, Heaven help us, they were dull fellows! I have had the virtues of the Romans dinned into my ears ever since I can remember. They bored me as a child. They still bore me. And that goes for the glorious city of Rome, too!

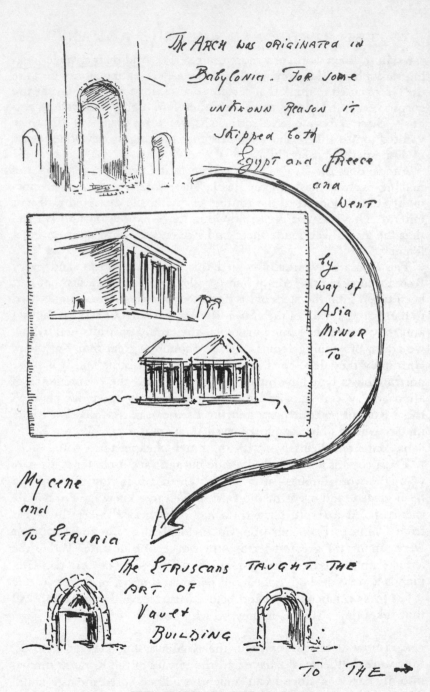

The ARCH was ORIGINATED IN
BabyLonia. For Some
UNKNONN REason IT
Skipped both
Egypt and Greece
and
WenT

by
way of
Asia
MiNoR
To

My cene
and
To ETRURIA

The Etruscans TAUGHT THE
ART OF
Vault
BUILDING

To THE →

THE STORY OF THE VAULT

ROMANS WHO DEVELOPED IT FURTHER
and TAUGHT IT TO THE REST
OF EUROPE

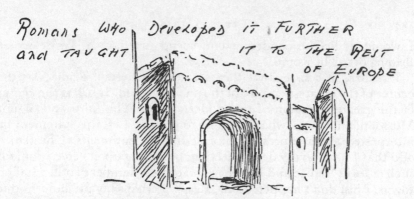

THE ROMANESQUE ARCHITECTS USED
THE ROUND ARCH

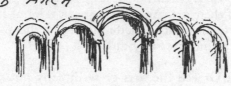

SO DID THE BYZANTINES

BUT THE GOTHIC BUILDERS DISCARDED THE
ROUND ARCH AND INVENTED THE
POINTED ARCH.

THE STORY OF THE VAULT

I would as lief be condemned to spend my days in Bordeaux or Bridgeport as in Rome.

I realize, of course, that this is a terrible heresy. Rome was the center of the greatest empire of the ancient world. It still is the center of the greatest religion of the modern world. The Lord and Signor Mussolini only know what it will be tomorrow. Lest this statement be interpreted as an expression of anti-Italian sentiments, I hasten to add that I have a very deep affection, bordering upon veneration, for such cities as Venice and Florence and quite a number of other Italian towns. I just don't happen to like Rome. Perhaps my prejudice is due to the fact that so many of the old Roman statesmen look exactly like the "strong men" who are responsible for the success of the present German Government. Or it may be their art. They have left us a great deal of their art. And I have seen a lot of it. On the whole, I think it was their art that made me dislike them. It was all so magnificent and so inexpressibly dull.

In ancient Greece the arts grew directly out of the soil and remained true to the landscape that gave them birth. In Rome conditions were entirely different. The city of Athens had been a perfectly natural development. It had easy access to the sea. The Acropolis provided a safe retreat in case of danger. And so trade and industry insisted upon making this particular spot a center of business. The city of Rome, on the other hand, was an accident. It was man-made and not God-made like Athens. It was far removed from the sea and never, even to the end of its imperial days, did it enjoy the benefits of easy access to the ocean. The river Tiber was a sluggish and muddy stream, more like the Bronx River than the Hudson. There was no natural hinterland. There was therefore no reason why it should ever have become a center of either trade or industry.

It was situated in the heart of a marshy country and therefore subject to all sorts of epidemics, malaria preferred. Even the famous Forum was a mud puddle until the emperors finally drained it and made it habitable. The town had no natural springs. Every drop of drinking water had to be brought from the mountains by a system of gigantic aqueducts, varying in length from ten to forty miles.

As long as Rome was the center of a farming community, it could feed itself, but the moment it grew into a metropolis, every pound of grain to feed the rapidly increasing population had to be brought from overseas. The authorities, until the very end of the Empire, were never quite certain that they could get enough flour to keep the hun-

gry mob in check. Let an enemy appear with a navy stronger than that of the Romans (and this occurred more than once) and the city was immediately in danger of starvation.

And yet—Rome came to rule the world.

People have spent fifteen centuries speculating upon the reasons for this mysterious rise to power. I would like to make a suggestion. So far we have always tried to explain the art of a people from their personal characteristics. Why don't we for once turn the process inside out and explain the nature of a people from the art they have left behind? When we then sum up everything they created—all those endless public markets and courthouses (which survive in our modern public buildings and railroad stations and churches)—all those roads and bridges and theaters and triumphal arches that are to be found from the Irish Channel to the deserts of Arabia, we get a sense of dogged determination mixed with an almost complete lack of imagination. Everything they touched remained of this earth earthy. Everything smacked of the heavy-browed husbandman who lived and slept and bred and died among his sheep and his cattle, who rose with the sun and went to bed with the chickens, whose needs were few, whose avarice was born out of necessity and who (also driven by necessity) had but one single purpose in life, to hold on to his hard-gained strip of soil and to leave to his children and his children's children that which had been his father's and grandfather's property from the very beginning of time.

This peasant philosophy of the good life dominated Roman history from the beginning until the end. The Roman politician might try to hide his humble ancestry behind a phalanx of imaginary ancestors. He might even become viceroy of vast foreign domains and for a time he might actually enjoy the luxurious splendor of an Asiatic or African country. But inevitably in the end he returned to his native hills and if he were a man of reflective mood, he would finish his days in a simple villa on the bay of Naples, deriving consolation and inspiration from the writings of those authors who praised the rustic life as the apotheosis of human happiness, the one desirable goal after which every sensible citizen should strive with might and main.

Whenever circumstances forced him to leave his well-regulated existence at home (the houses of Pompeii show us how practical and convenient they were), he took his own civilization with him, like an Englishman carrying his portable bathtub and his terrible food into the very heart of the African veldt or the Malayan jungle. That explains those incredible theaters and public bathing establishments

which you will find in little provincial French towns, way off the
beaten track, or lying buried underneath the sands of the Sahara or
the Arabian desert. And it explains their roads and bridges and when
it comes to those, I am a tremendous admirer of what they accomplished.

I don't know why roads—ordinary, everyday roads—have never
been classified among the finer works of art. I have seen mountain
roads in Switzerland and Austria that affected me with a sense of
beauty and balance just as great as that which one occasionally finds
in a well-proportioned building. Bridges, however, being made out
of stone, somehow fall under the head of architecture and they may
therefore be mentioned in a book of this sort. The Romans were expert bridgebuilders and their bridges were invariably built with an
eye for eternity, for several of them have survived until our own day.
During the Great War it was an old Roman bridge which saved the
Serbian army from complete annihilation and allowed it to escape
to the coast.

The success of the Romans with this difficult sort of construction
was, of course, due to their sound knowledge of how to handle both
arches and vaults. Arches and vaults are really nothing but a curved
sort of wall and the ancients used them principally for their roofs.
Being necessarily larger and therefore heavier than a flat roof, a
curved roof will exert an amount of pressure on the walls that support
it that would make them bend backwards unless they were properly
reinforced in such a way as to counterbalance the pressure that comes
from above. The Babylonians and the Cretans and the Etruscans had
tried to remove this danger by making the walls themselves much
heavier than the vault they had to support. But this method did
not satisfy the Romans. They needed large buildings for their law
courts and other public buildings and such edifices were impossible
without several doors and windows. This made it inadvisable to add
very much to the thickness of the walls. There was only one way out
of the difficulty and the Romans hit upon it. They erected buttresses.

This is a word that dates back to the days of the medieval Gothic
churches. All it means is a "pusher" and that tells you the whole
story. When you had weakened the strength of a wall by removing
twenty thousand pounds of support, sacrificed to your doors and windows, you divided those twenty thousand pounds among the remaining parts of the wall in the form of buttresses and got the same effect
and the same strength necessary to resist the side thrust of a vaulted
roof. I am explaining this quite unprofessionally and merely for the

benefit of the layman. I don't advise a modern builder to use this volume as a practical handbook of architecture. But the layman will get the general idea and that is important, for until we began to construct houses the way we nowadays build them (our skyscrapers are really ocean liners that have been put upright) the buttress was indeed a most important part of the building, as we shall see again when we reach the age of the great Gothic cathedrals.

A moment ago I talked about the public buildings of Rome. The most important of these were to be found on the Forum. When we hear the Forum mentioned, we instinctively think of a collection of dignified and noble buildings, with Roman senators dressed up in spotless white, moving about in stately fashion to discuss weighty affairs of state. The actual aspect of the Forum during the Kingdom and the first centuries of the Republic was entirely different. It was merely a small town market place full of pigs and cows and chickens and vegetables and cheese and countryfolk, noisily bartering for this and that, and mothers with too many children and fathers who had spent too many hours in the taverns, talking politics—a laughing, shouting, squabbling mass of perspiring humanity, emitting a lusty smell of garlic, onions, wine, mud, and cow dung, ready to put its last pennies on a cockfight, and deriving a hearty joy out of seeing a pickpocket being caught by the police and receiving twenty-five lashes on his posterior parts for an unsuccessful attempt at purse-snatching.

As you will notice when you go to Italy, even today every city has a certain spot, a street or a market place or a *corso* or drive where the whole town gathers together at certain definite hours of the day to sit in the coffeehouses and to talk gossip or transact business. In Rome this meeting place was the Forum—the fair—which was the real heart of all civic life. And because everybody was to be found there anyway, the judges used to keep court in the Forum. The priests who tended the shrines of the different Gods that were worshiped in this cosmopolitan city used to gather together on this spot to predict the future from the bowels of a slaughtered lamb. The candidates for office, who were supposed to go about in spotless white (the *toga candida*, which indicated the purity of their motives), used to come here every morning because then they were certain of an eager audience. The successful generals, who had just returned to the home city after having plundered half of the inhabited world, used to hasten to the market place to impress the populace with their generosity. This went on until the Forum became so crowded that there was no longer any room for the peasantry and their pigs and cabbages and onions. They

were thereupon driven into the side streets and back alleys, while the available space in the center was filled with temples and law courts and basilicas, which were a sort of mixture of law court, business office, and political meeting hall.

The basilica, as we know it, was a typical Roman invention. It had been born out of the necessity of giving shelter to large numbers of people at one and the same moment. It consisted of a large hall (usually of an oblong shape) surrounded by galleries separated from the main part of the building by rows of columns. The court of justice was established in the apse, the semicircular end of the oblong part, and there the plaintiff and the defendant and their witnesses and lawyers appeared before the attending judges.

In the modified basilica of later centuries, which was no longer a pagan building but served as a Christian church, the judge's seat became the altar. That part of the basilica where business used to be transacted was given over to the congregation, while separate chapels were erected in those colonnades that had formerly been occupied by vegetable stands. For further details I refer you to the Works of Vitruvius, the eminent Roman architect and engineer, who was superintendent of the military engines (the catapults and tanks) of the Emperor Augustus and whose handbook of practical architecture (lost for almost fifteen entire centuries and then rediscovered in an ancient Swiss monastery) became the artistic Bible of Michelangelo and Bramante and most of the great architects of the sixteenth century.

Almost all of the earlier Roman basilicas have disappeared. The oldest one with which we are familiar (dating back two hundred years before the birth of Christ) was dug out of the ashes of Pompeii. But another type of Roman building that was equally interesting has survived in quite large numbers and it survived by means of its monumental proportions. I refer to the arenas and colosseums and theaters, to all those mountains of stone which the Romans erected to entertain the multitude and, by entertaining them, to prevent them from taking their troubles and their politics too seriously.

Their discovery of the use of concrete was a great help in erecting such large and unwieldy edifices. Concrete is a combination of sand and gravel mixed with water and some cementing material. In the case of the Romans, the cementing material usually consisted of some variety of limestone. Our modern civilization would be impossible without concrete, for we use it for hundreds of purposes, for the foundations of our piers and docks, for pavements and water tanks and all sorts of constructions that must bear heavy burdens and that are

constantly exposed to the violence of the elements. Once this concrete has "set" it becomes as hard and unyielding as granite. How the people of the Middle Ages managed to destroy part of these concrete structures, the good Lord only knows. But they needed stones for their own palaces and fortresses. They had no means of conveying heavy boulders from the quarries to the cities and so they used the old Roman amphitheaters as their quarries, finding them absolutely inexhaustible.

Even today the Roman Colosseum, which has been systematically plundered for over a thousand years, makes a very imposing impression. Several generations had worked at it until it was finally completed by the Emperor Titus, the same one who destroyed Jerusalem in the year A.D. 70. It could seat 87,000 spectators and in front of it arose a colossal statue of the Emperor Nero. Hence the name. It was inaugurated with a series of gladiatorial fights, during which more than five thousand wild animals were killed to give the mob a happy Roman holiday.

These figures tell an interesting story. The Roman was impressed by size, by gigantic proportions, and by waste. The Greek was impressed by harmonious proportions and by a restrained use of energy.

These differences also become apparent when you look at the monuments which these two races erected in memory of their famous men. The Romans specialized in triumphal arches and commemorative columns, covered from top to bottom with elaborate pieces of statuary. When the Greeks wished to honor a charioteer who had won first prize in a race, they showed the figure of a single man holding the reins of a horse. But that solitary figure told the story. On the column of Trajan there are 660 feet of pictorial information with twenty-five hundred different figures, telling us everything that had happened during the Emperor's campaign in Dacia, from getting his catapults into action to the moment when the executioners decapitated hundreds of captive barbarian chieftains. The arch of Titus, too, which celebrated his victories over the Jews, was just as ornate. The Greeks would have done such a thing infinitely better and at a much smaller outlay of energy and money. But the Greeks were gone. The Romans had to shift for themselves.

The Greeks in their daily lives wore a costume consisting of two parts: a short tunic or *chiton* worn next to the skin and reaching to the knees, and a *peplos*, a long outer robe (we would perhaps have called it a shawl) worn over the *chiton*. With clothes like these, everything depended upon the figures underneath and upon the way in which

they were worn and the ability of the wearer to appear at ease under all circumstances. The Greek statues, not only those of athletes but also those of statesmen and philosophers, have an air of elegance and style which achieves a maximum of results with a minimum of effort.

Compare these statues with their much more elaborate Roman counterparts and you will at once notice the difference. The Roman looks as if he has spent hours in front of his mirror, while his slave of the garderobe arranged and rearranged the folds of his toga until they looked absolutely correct.

As the years went by and Rome passed more and more under the influence of her Oriental possessions, the ceremonial robes from Asia made their appearance in the imperial capital, as they did to an even greater extent in Constantinople. The upper classes then began to wear togas of wool that were richly embroidered and into which so many colorful ornaments had been woven that they weighed a ton and allowed no freedom of action whatsoever.

The Roman toga has long since disappeared, but those later Roman garments have survived until our time. You can see them being worn by the priests officiating in our Catholic churches and reading mass in the former law courts of a Roman basilica.

During the middle of the fourth century, the Roman Empire was divided into two parts and Constantinople became the capital of the eastern half. Fifty years later, the capital of the western half was removed from Rome to Ravenna on the Adriatic Sea. Three generations more and the last of the Roman emperors was replaced by a barbarian chieftain. That, according to all those who witnessed this sad event, was the end of the power of Rome. Yet in a way, it was really a beginning.

For Rome was once more to rule the world. But this time her conquests were not to be made by means of the sword.

# The Jews

*The people of one building and one book*

THEIR NEIGHBORS never mentioned them. Their contemporaries do not seem to have been aware of their existence. Famous historians wrote famous books and learned geographers composed learned geographies, giving information upon every possible detail that might interest their readers. But all of them completely overlooked this tiny speck of land that lay on the crossroads between Egypt and Syria and Chaldea and the seaports of Phoenicia.

How could it have been otherwise? Strangers were not welcome in this desert town. At best they were tolerated but never for a moment were they allowed to forget that they were living in a community where all the inhabitants from earliest childhood on had been taught the difference between the holy and the profane, between the "unclean" outsiders and their own "clean" fellow tribesmen.

Yet the very people who so uncompromisingly divided all the world into sheep and goats, and who were so dreadfully afraid lest they should inadvertently break bread with an uncircumcised unbeliever, were themselves strangers in the country which they claimed as their homeland. They had come from the east, from the land of Ur, and after centuries of wandering, which had taken them all the way from the Persian Gulf to the valley of the Nile, they had at last conquered several cities of the Jebusites in the hinterland of Phoenicia and nominally part of the Egyptian kingdom. There they had established several principalities of their own which finally in the days of the Trojan War had been united into one single state, the famous Kingdom of Israel.

Exposed to danger from all sides, one common ideal had held these people together: the conviction that their own God was the only true God and that he who feared this mighty God in a meek but righteous spirit would eventually inherit this earth. The Assyrians, the Babylonians, the Egyptians, the Macedonians, the Romans—all of whom at one time or another overran and conquered this mysterious kingdom—may well have smiled at such a pretension when they stabled their horses in the Holy of Holies of their Temple. But logic, appar-

ently, was on the side of the defeated. After having passed through more than twenty sieges and having been destroyed and rebuilt eighteen different times, Jerusalem still stands and remains the spiritual capital of three of the most important religions in the modern world —the Jewish, the Christian, and the Mohammedan.

Such a turbulent existence did not encourage the development of the arts. As a matter of fact, the Jews contributed very little until they turned musicians and that was only a few hundred years ago. But they gave the world two things which made a profound impression upon Western civilization. They gave the world a temple and a book.

That building was the Temple of Jerusalem and that book was the Bible.

The Temple is gone. All our knowledge about it we have derived from the sixth and seventh chapters of the first Book of Kings. It shows that Solomon must have been very rich, for he could afford to hire architects from Assyria and Phoenicia and Egypt and to order his materials from all over the Eastern World. If his architects were men of taste, they must have shuddered at what they were doing, for the Biblical description reveals this shrine as something which twenty years ago might have been built in Hollywood during that happy era when a theater that had cost two million dollars must therefore be much more beautiful than one that had cost only one million dollars.

As for their second contribution to the arts, it was a book, but it happened to be the Book of Books. It was the Bible. And during the next two thousand years, the entire art of the Western World was to be influenced by the literature of a people who themselves had been completely without any art.

# Early Christian Art

*The old Gods die and mankind turns its back upon a sinful world.*

THE POPULATION OF ROME in the days of the Emperor Titus con-
sisted of twenty million slaves and less than eight million free
men, or three slaves for every citizen who was able to call his soul his
own.

By and large, the lives of these slaves were utterly miserable. Grad-
ually (as centuries afterwards in Russia) they reached such a point
of utter despondency that they began to die out, willingly and delib-
erately. But one day strange rumors began to be heard in the kitchens
and in the basements and in the mines and in the factories and in the
mud hovels of the large estates. A new Messiah had made his appear-
ance in a distant land. He taught that there was no difference be-
tween master and slave, that all of them were but children of the same
Heavenly Father and therefore had an equal chance at salvation.
The submerged millions listened to this message of a new hope with
the desperate eagerness of a drowning man reaching out for a straw.

It often seems a miracle that Christianity, which after all was only
one among dozens and dozens of other Asiatic and African "mys-
teries" then widely popular in Rome, should have been able to
captivate the imagination of the masses and to succeed in establishing
itself as the official religion of the whole of the Empire. Afterwards,
of course, when it had become the greatest political power in the
state, the Christian faith was used as a vehicle for personal advance-
ment by a great many ambitious people who would just as soon have
become followers of Astarte or Mithras, if those deities had been pro-
claimed the legal successors of the old Olympian Gods. But during
the first hundred years after the death of Christ, the zeal for the new
doctrine must have been entirely genuine, for it was highly danger-
ous to proclaim oneself a disciple of the Crucified One and there was
no chance for any reward except in the hereafter.

This is not the place to explain the gradual growth of the new sect.
But it is interesting to note its influence upon the development of the
arts. It would be easy (as well as true) to say that the Christian faith
had a most unfortunate effect upon the arts, for it was a creed which

deliberately turned its back upon everything the older forms of civilization had held in such high esteem. It mumbled a decisive "No" to everything that had caused the Greeks and the Romans to shout their cheerful "Yes."

But the arts were already in a serious state of decline when Christianity appeared upon the scene. Even without the triumph of Christianity, they would have fared badly. Nevertheless, the fact remains that the early Christians were the sworn enemies of everything that reminded them of the days of their servitude and misery and derived just as much satisfaction from destroying whatever seemed typical of the "old order of things" as the followers of Lenin experienced many centuries afterwards from eradicating the last vestiges of a czarist Russia.

The Greeks and Romans had worshiped the human body. They had delighted in its strength and in the beauty of its thoroughly co-ordinated muscles. The human body therefore became anathema to the new masters. The Greeks and Romans, feeling rather skeptical about the possibilities of a future existence, had put the accent on living and had considered dying as an unavoidable but highly unpleasant necessity. The Christians therefore went to the other extreme, despised their terrestrial existence, and were forever busy preparing themselves for their final trip to the cemetery.

The Romans and Greeks had learned to eat well and to drink well and to enjoy all the good things of this earth. The Christian therefore lived on a diet of locusts and water and decried all the gracious gifts of a bountiful heaven as temptations of Satan.

Under such circumstances it was not easy to be an artist and to remain faithful to the old Athenian school. One either had to compromise and do the bidding of the new employers or starve. There have, of course, been artists who have preferred to starve but their number has never been very large. The others simply made the best of things and, for the moment at least, accepted whatever compromises seemed necessary. But it is very interesting to notice that whenever there is such a conflict between the artist and his public, the artist will invariably win out and (after a very short interval) will once more be able to force his own ideas upon the public instead of the other way around.

The earliest Christian art is to be found in the catacombs. These were not (as I myself was told as a child) dark subterranean sanctuaries in which the poor, persecuted Christians could take refuge in times of danger. They were merely underground cemeteries which had been in common use long before the birth of Christ and which

the Romans had copied from the Etruscans. The name itself refers to a particular burying ground near a quarry (a *kata kumba* or "near the hollows," as the Greeks used to say) in which the body of the Apostle Peter was said to have lain for a while until it could be removed to the church which bore his name. They were long narrow corridors, not more than three or four feet wide, dug into the soft tufa stone that is found all around the metropolis and which the Romans used to build their houses and tenements, for six-story tenements were quite common in imperial Rome. The dead were placed in the graves dug along the sides of the walls and the graves were closed by huge slabs of marble. On these slabs the sculptor or painter was given the chance to commemorate the virtues and achievements of the departed.

The more opulent families were apt to buy small mortuary chambers of their own and these as a rule were dug along both sides of the galleries.

At regular intervals there were openings which connected the catacombs with the outside world and acted as ventilators and light shafts. The only other form of illumination was provided by small oil lamps which during the daytime were not necessary. The artists responsible for the interior decorations of these sepulchers (I suppose that that is what we would call them today), far from trying to create a funereal atmosphere, had done their best to make these burial places as cheerful as was compatible with the purpose for which they were used. But now it is interesting to note how much tradition really means, not only in our daily lives but also in the arts. For both the pictures and the sculptures of the Christians remained as pagan as they had been in the days when the old Gods were still in power.

We would, of course, expect to find pictures laying stress upon the Crucifixion, for the scene on Golgotha was the clearest evidence of the complete change in point of view that had come over the world since the death of Christ. The old Gods had demanded sacrifices on the part of others. But in this new "mystery" that had swept across the Empire it was the God himself who had offered His own Son as a supreme sacrifice. But, search as we may, we find no reference to the Crucifixion in any of the surviving Christian pictures until almost four hundred years after the event.

Then what do we find in these ancient cemeteries where the faithful gathered together on all possible occasions to celebrate the Eucharist —to partake of the sacrament of the Lord's Last Supper? We find very charming but rather naïve and simple fairy stories about Jonah

and the whale and Moses and the burning bush and Daniel in the lions' den and the young men in the fiery furnace. It has been argued that these were merely a sort of camouflage in case the Roman police became a little too inquisitive about what was happening there among the followers of this strange new Messiah who preached the uncomfortable doctrine of the equality of all men. The explanation is much simpler than that. These new recruits of the brotherhood of man were still dominated by the artistic conceptions of the old world they despised. They probably would have liked something different, but tradition was too much for them. We notice that very markedly in the pictures of the new Messiah. He continued to be represented as a Roman God, as a very handsome young man bearing a close resemblance to Apollo or Orpheus. Only very slowly did they get away from this and evolve an ideal portrait which, with certain slight modifications, has survived until our own days. Even then, they retained the halo which had been the attribute of the Sun God Apollo.

Of course, we cannot really speak of a definite art of the catacombs as if it were the result of only one or two generations of painters and sculptors. The catacombs were used as Christian cemeteries for more than four hundred years, and the style of this subterranean art changed in exactly the same way as the style of the world above ground changed. Unfortunately, most of the earliest paintings of the catacombs have been lost. They were ruthlessly destroyed by the gravediggers whenever they needed more room for new arrivals. But enough remains to show us that for a very long time the new and the old were so completely interwoven and intermixed that one hardly knows where the pagan world came to an end and the Christian world began.

Then came the fifth century. Rome fell upon evil days. In the year 410 the town was taken by the West Goths under their famous King Alaric, who, however, seems to have shown considerable respect for "the things that belonged to Saint Peter."

A century later the Long Beards (the Lombards) captured all of Italy but ere then the capital of the western half of the Empire had been moved to Ravenna. This had been a great boon to the Christians, for now the Bishop of Rome was no longer obliged to compete with the worldly head of the nation and it was therefore easy for him to enlarge his power until the whole of the Christian world recognized him as their Pope—as their spiritual head.

Thereafter it was no longer necessary for the faithful to bury their dead out of the sight of the authorities, for they themselves now exer-

cised the highest power in the state. And so the catacombs began to fall into decay. After a while even the pious pilgrims who had visited them to pray at the graves of the earliest martyrs were beginning to forget where these holy shrines might be located.

For almost eight centuries the dead slumbered in peace. Quite by accident their hiding place was rediscovered in the year 1578. Today these *coemeteria* or resting places (as they were called by the people who dug them, hence our word "cemetery") are one of the sights of Rome and of all the other cities where they are found. But they are not really half as interesting as the earliest Christian churches which have survived and which show us that this new Christian church was nothing but an old Roman basilica or courthouse, slightly modified to serve its new purpose as a gathering place for the members of a Christian congregation.

The Christians must have been placed before a difficult choice. They could, of course, have converted the ancient pagan temples into houses of worship, but their hatred of the old religion was much too intense to allow them to do so. The Pantheon, the only large sacred edifice of ancient Rome that has remained intact since the days of Hadrian, was one of the few exceptions. Although originally devoted to the worship of "all the Gods," as the name implies, it was dedicated as a Christian church in the year 609. It is interesting to reflect that the tremendous dome, 142 feet in diameter, which rests on walls 22 feet thick, has been in its present position for eighteen entire centuries. Surely the Roman architects knew how to handle their concrete and how to build their walls in such a way that they could withstand any amount of pressure.

But whenever possible the Christians refused to have anything to do with these old pagan shrines and built themselves brand-new churches. Unfortunately they did not have imagination enough to devise a new architectural arrangement and so they remained faithful to the model of the Roman basilica. There were, of course, certain changes in the interior arrangement. The bishop now occupied the seat of honor in the center of the round apse where formerly the judge had sat upon his bench while doing justice. The congregation was housed in the central part of the big hall that had formerly been used for commercial purposes. The transept was as yet unknown. The transepts are those transverse sections which we find in practically all modern churches and without which a church hardly seems a church at all. They did not, however, become a regular part of these holy edifices until after the Byzantine architects had invented them in the

eighth century and had introduced them into France by way of St. Mark's in Venice.

These early Christian churches were therefore merely large stone boxes, but they could be made tremendously impressive by means of mosaics (paintings done by means of small bits of colored glass which are cemented together) which during the fourth and fifth centuries of our era reached a height of perfection they have never again attained. The best of these mosaics are not to be found in the Roman basilicas but in those of Ravenna, the town which in the year 404 had become the official residence of the Emperors of the western half of the old Roman Empire.

If ever you feel the need of meditating upon the vanity of all earthly ambitions, I cordially recommend a visit to Ravenna. It is a dreadful hole and the Countess Guiccioli must have been very fascinating indeed to have kept Lord Byron here for almost a year and a half. The moment you have finished with the last of your churches, you find yourself stranded in a drab, poverty-stricken provincial nest where nothing apparently has happened since Dante died here in the year 1321.

Meanwhile, inside these churches, you have been face to face with a display of such wealth and such refined luxury as you will never again see in any other part of the world. The solid dome of King Theodoric's grave, well outside the gates and covered by a single slab of stone thirty-six feet in diameter, will already have given you a decent respect for the engineers of the year 526 who had been able to hoist this monster into place. The Roman Empire may have been dead but the Roman traditions of efficiency were apparently still alive.

But nothing has quite prepared you for the wonders inside that church of San Vitale which impressed Charlemagne so deeply that he built himself an exact replica of it in Aix-la-Chapelle. Nor for the mosaics (about a hundred years older than the church itself) that cover the walls of the burial chapel of Galla Placidia, the sister of the Emperor Honorius, who had administered the Western Empire during the minority of her son, Valentinian III.

As for the pictures in San Vitale, they take us back to the court of the Emperor Justinian and his wife Theodora, former chorus girl in the famous circus of Byzantium, but a woman who had so greatly appealed to her imperial lover that in order to marry her he had ordered the repeal of the law which until then had made it impossible for a nobleman to espouse a girl who had been on the stage. You will see her there in all her forbidding pomp, for like many chorus ladies

of her kind, she got to be terribly proper and very pious, once she had bidden farewell to the old life. Yet somehow or other her portrait will make you understand the power this pale-faced courtesan with the lustrous black eyes must have held, not only over her husband but also over the millions of subjects that came to worship her as a saint.

This chapter has been rather meager but there really was not very much to say. The early Christian art of the Western World was merely the old, decadent art of the pagan world, slightly modified to suit the needs of the times. Meanwhile, some very interesting experiments were being made in this new form of art. But they took place in another part of the world. Once more Egypt and Greece reappear upon the scene to take the lead.

# The Copts

*A forgotten people, but who made very interesting contributions
to the art of the early Christian period*

IN THE YEAR 332 B.C. Alexander the Great reached the mouth of the
Nile and there he built himself a wonderful city which as Alex-
andria became the great center of Greek civilization in the East. For
almost a thousand years, until the Arabs finally captured it in the
year 640, Alexandria maintained its position as one of the outposts
of Greek culture. And when (in consequence of the expedition of
Alexander) the civilizations of the East and West combined to give us
the so-called Hellenistic era (which retained some of the best as well
as some of the worst features of both the East and the West), Alex-
andria became the artistic metropolis of the Mediterranean. While
Rome was the London of the old world, Alexandria played the role
of Paris.

It had the best schools, the best universities, the best restaurants,
the best museums and libraries, the best dressmakers, the noisiest
night clubs. Every young man of fashion was supposed to get at least
part of his education in this city on the Nile, and in that way Alex-
andria played an exceedingly interesting role in the development of
the arts.

Much of this glory came to an end after the Christians had gained
the upper hand. They despised the old learning, had no use for the
ancient books, and finally gave expression to their sentiments of dis-
approval by lynching Hypatia, the last of the great Alexandrian phi-
losophers, and a woman at that. Nevertheless, it was still a consider-
able town when the Arabs took it in A.D. 640. The Moslem general
reported to his master, the Caliph Omar, that he had taken a city
that contained four thousand palaces, four thousand public baths,
twelve thousand gardeners, forty thousand Jewish merchants capable
of paying tribute, and four hundred theaters and dance halls. There-
after it steadily lost its importance as a commercial and artistic center.
After Vasco da Gama discovered the ocean route to the Indies in 1498
it almost dwindled down to the rank of a village, a position from

which it did not recover until the construction of the Suez Canal in 1869.

Of course it was really never an Egyptian city. Its three hundred thousand inhabitants hailed from every part of the Mediterranean and the language spoken in its streets was Greek and not the ancient tongue of the Egyptians.

Meanwhile, there were as many of those Egyptians left as ever before. There were no longer any Pharaohs left to direct their building activities, for they were now being ruled by foreigners. But the old native genius for creative work had by no means disappeared. It now manifested itself within that nucleus of the population which had most fully retained its old national characteristics. These people became known as the Copts. The word is merely a European version of the Arabic *Kibt*, and *Kibt* was the way the Arabs pronounced the Greek name for *Aigupt* or Egypt. Today we usually associate the Copts with the Coptic religion which is an early version of the Christian faith and which got once more into the limelight (after a great many centuries of complete obscurity) when Italy last year destroyed Ethiopia and it was discovered that the Abyssinians belonged to a branch of the old Coptic church.

By the way, the modern Coptic-Ethiopian art as practiced in Abyssinia was an exceedingly interesting survival, but it bore very little resemblance to the Coptic art of the early Middle Ages, which was as good as anything then being made.

But its chief importance to us lies in the influence it brought to bear not only upon the Arabic art of the caliphates (which was unavoidable after Egypt had become part of a vast Arabian empire) but also upon the art of medieval Europe. This was not the result of the commercial relations between the Copts and the Franks, for there were not any. But all during the first half of the Middle Ages pilgrims from western Europe used to travel to the Holy Land and Alexandria was their port of debarkation for Palestine. If they survived the trip through the desert, they were apt to take a few souvenirs with them when they went home. In that way a great many pieces of Coptic work—carved ivory boxes and cups and, especially, textiles—gradually found their way westward and were distributed among the monasteries of France. Saint Patrick may also have taken a few to Ireland, for according to the tradition he spent several years of his life in the Coptic monastery of Lérins, on an island just off the modern city of Cannes.

The textiles probably were the most important contribution the

Copts made to European civilization. For western Europe was still in
a frontier stage of development and textiles with intricate pictures on
them (the Copts had continued the colorful tradition of their Egyp-
tian ancestors) were quite as new as a phonograph in Greenland.
And so these ornaments traveled all the way from the Mediterranean
to the Arctic Sea and many of them were adopted by the stonemasons
who looked for something to relieve the monotony of their flat stone
walls, and in a simple, medieval chapel in Norway you may suddenly
come upon a bit of carving that reminds you of a pattern you are sure
to have seen somewhere else. Then you begin to wonder where it was
and suddenly it dawns upon you that you saw it in the museum of
Cairo or in some small local museum of southern France.

But that is nothing unusual. The history of art is full of such strange
developments. I have not got space to mention more than a few. All
I can hope to do is to give you such an interest in the subject that you
will want to become your own "style detective" and follow the tracks
of some curious new idea throughout the ages and across the face of
the globe.

# The Art of the Byzantines

*When art became a final refuge in a world of fear*

BYZANTIUM is one of the oldest cities of Europe. When in the year 657 B.C. a Greek adventurer by the name of Byzas decided to build himself a fortress on one of the seven hills that overlook the waters of the Bosporus, he found that the place had already been occupied for some ten centuries. This was only natural since the main trade route from southern Europe to Asia ran right through the heart of this region. Afterwards, both Sparta and Athens fought for the possession of this stronghold. Next the Macedonians added it to their territories and finally, of course, it became incorporated into the Roman Empire. The city, however, remained comparatively obscure. It was a little too far removed from the center of things to be of any political significance and as the Romans never tried to gain a foothold in southern Russia and preferred to go east by way of Alexandria, Byzantium was just a little town on the edge of the world.

All this was suddenly changed in the fourth century when it had become very clear that Rome was no longer safe as a residence for the emperors. It was then that the illegitimate son of a Roman emperor and a Serbian woman, born in what is now Nish (the Serbian capital in the Great War after the loss of Belgrade) and therefore hardly what one might call a hundred-per-cent Roman, decided that this was the spot on which to erect a new capital that should not be forever at the mercy of the barbarians. He had previously considered two other cities—Troy, just across the Bosporus on the Asiatic side of the straits, and Sardica, the present Bulgarian capital of Sofia, founded two hundred years before as a post of observation to watch the natives who then lived in the plains of Hungary. However, after studying the plans very carefully, he had chosen Byzantium, which he thereupon named after himself—Constantineville or Constantinople, as it was called in Greek. The town was given a new set of walls and harbors and it was made so strong that for almost a thousand years no foreign enemy succeeded in taking it except by treason.

The career of the Byzantine Empire (for as such the eastern half of the Roman Empire was known all through the Middle Ages) is very

interesting, but for some strange reason it is rarely mentioned in our schoolbooks. Few of us realize that it lasted for almost twelve centuries and that when it finally perished before a fresh onslaught of Mohammedans it had existed for much longer than any of the present European states and seven times as long as our own country.

During all this time it had never known a moment of respite. The armies of Islam had been just outside its gates for six full centuries before they were finally able to break its resistance. The Crusaders on their way to the Holy Land had also paid their respects and had pillaged the city mercilessly. But while the whole of the rest of Europe was in a state of chaos, there still was one imperial court that actually functioned—there still was one Roman city ruled over by an imperial senate, one Roman community in which the power was in the hands of a patrician class, one center of civilization where the artists could continue to work undisturbedly for an international market and where the hairy chieftains from the barbaric West, whenever they came to pay their respects to the emperor, could go shopping for some lovely pieces of jewelry or marvelously carved bits of ivory to take home and present to their wives or their favorite saints as token that they actually had paid a visit to the Big City on the Golden Horn.

You may find it rather difficult to appreciate the art of the Byzantines. For it grew out of an attitude toward life that was the exact opposite of our own. We may not all of us agree that life, as it is lived today, is a pleasurable experience, but we surely all of us are convinced that, if possible, it should be so. The barbarians who had just overrun western Europe felt the same way. They may not have been very refined in the way they expressed their joy of living, but they were young and vigorous and curious and restlessly interested in all new experiences. But the people of eastern Europe and western Asia felt quite differently. They were old and tired and ready to withdraw from all further participation in the adventure of existence.

Hence the East produced a Saint Simeon Stylites, who sat perched for forty long years on the top of a pillar in the Egyptian desert, living in dirt and misery but keeping his filthy rags uncontaminated from the evils of this world. The West gave us a Saint Francis, who composed cheerful odes to the sun and who, when he could find no other audience, chatted amicably and wittily with the animals of the field.

The West sent its missionaries into the wilderness to tame both forest and plain and to teach the painted savages of the British Isles and the German jungle how to live civilized lives, whereas the monks of the East crept into dark holes or hoisted themselves to the pinnacles

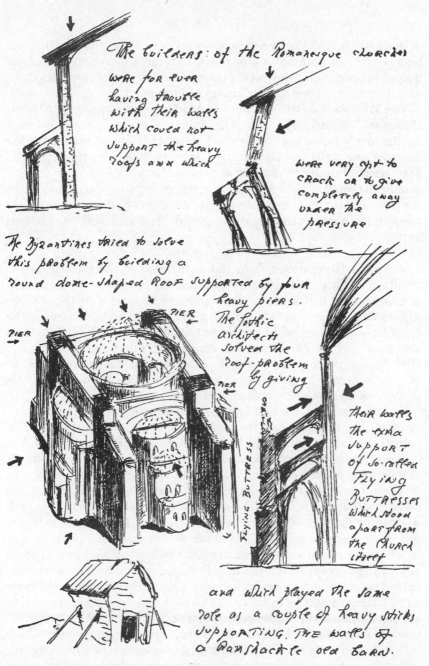

The builders of the Romanesque churches were for ever having trouble with their walls which could not support the heavy roofs and which were very apt to crack or to give completely away under the pressure

The Byzantines tried to solve this problem by building a round dome-shaped roof supported by four heavy piers. The Gothic architects solved the roof-problem by giving

PIER

PIER

PIER

FLYING BUTTRESS

their walls the extra support of so-called Flying Buttresses which stood apart from the church itself

and which played the same role as a couple of heavy sticks supporting the walls of a ramshackle old barn.

*The everlasting difficulties connected with the building of walls that could withstand the pressure of a heavy roof*

of inaccessible rocks where they never set eyes upon any other human beings and did nothing of any particular value to anybody, but acquired among their many other odors an effluvium of sanctity which gave them great prestige in the eyes of their neighbors.

The West gave us those delightful Madonnas of exquisite grace and charm with their happy little Bambinos, reaching out with both fists for the lovely flowers of the fields. These same holy personages in the East became stern and forbidding females who looked as if they had been born a hundred years old and whose haughty nostrils had never caught the smell of the good earth, when spring is in the air and when the mother cat takes her kittens for a first short stroll across the stable yard, filled with a thousand delightful mysteries and unexpected perils.

We stand far removed from the civilization of the eastern half of the Roman Empire. It is easier to think ourselves into the mentality of a Greek of the fifth century B.C. than into that of a citizen of Constantinople of the year A.D. 900. But if I were asked to mention the emotion which seemed to predominate all Byzantine life, because it also animated all Byzantine art, I would mention the word "fear." God knows, there was reason enough for such an attitude toward life, for existence in the Constantinople of that day was exceedingly precarious and beset by a thousand perils.

Today, of course, we hardly know the meaning of the word "fear" in its medieval sense. Anesthetics have removed the fear of physical pain. Logic and intelligence have extinguished the fires of hell. We live in a world of such superabundance that the hideous nightmare of starvation no longer plagues us—or, at least, should not. If all of us do not get enough to eat, we realize that it is the result of bad management and not the result of the actual absence of whatever we need. And as for the fear of foreign invasion—yes, such a thing is still possible, but even during the Great War, which was not exactly fought in what one might call a "gentlemanly spirit," no country suffered any of the horrors which up to a few hundred years ago were connected with the idea of an invasion by a hostile army. Here and there a few citizens might be inadvertently killed, but there was no question of exterminating the whole population or of selling hundreds of thousands of women and children into slavery, and even those cities which suffered most were carefully rebuilt as soon as peace had been signed.

But for almost a thousand years, the inhabitants of Constantinople were never quite sure of the fate that the day of tomorrow would

bring them. Their country was a small cork of civilization, floating disconsolately on an ocean of savagery. Corks have a great floating capacity but in the end they get waterlogged, deteriorate, and sink.

Yet the instinct to survive forced this state to exert itself to the utmost to continue its independent existence. Hence, like all weak nations, the Byzantines were forced to assume an attitude of cringing obsequiousness toward an opponent who was stronger than they themselves, while they indulged in bestial cruelties when dealing with someone who was weaker.

At home the government maintained itself by an Oriental aloofness from its subjects. The emperor, as head of both the state and the church, enjoyed greater power than any of his Roman predecessors, but he was in a much more difficult position. For his capital was a melting pot filled with all sorts of racial odds and ends which refused to melt. Never at any time did they have any consciousness of belonging to the same nation. And there was the new creed to add further difficulties to the worries of the authorities.

There were the strictly orthodox who meant to stick to the very letter of the Ten Commandments and who were therefore fanatically opposed to having pictures in their churches. But on the other hand there were a great many more men and women who had outwardly accepted Christianity but who had never been able to rid themselves of their belief in the old Gods whom they had brought with them into the new house of worship only thinly disguised as Christian saints.

All during the eighth and ninth centuries the image-worshiping congregation and their opponents, the iconoclasts, the image breakers, fought each other in a most murderous fashion. Some of the emperors happened to be image lovers and they filled the churches from top to bottom with their saints. Their successors on the other hand, if they happened to belong to the sect of the iconoclasts, threw all their pictures back into the street. Heaven only knows how many thousands of people were killed in consequence of this quarrel. Finally the Bishop of Rome took a hand in this disastrous warfare, but that only made things worse, for by that time Rome and Constantinople were miles and miles apart.

In Rome the earliest churches had always been meetinghouses where the faithful came together to partake of the Eucharist and to listen to the reading of the sacred books. Hence that impression of an assembly hall that most of the older basilicas make upon you when you enter them for the first time. You know, of course, that they belong to the Catholic rite, but with a little whitewash they would do

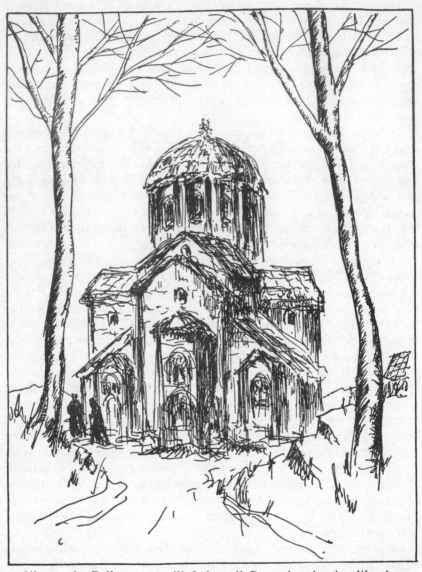

*All over the Balkans you will find small Byzantine churches like these.*

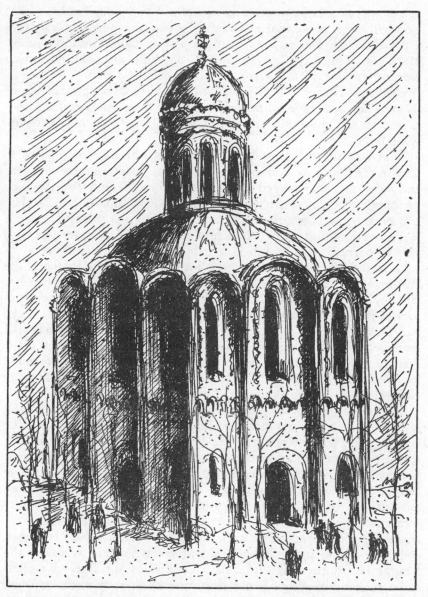

*In Russia during the twelfth century they developed into something that looked like this.*

just as well as a kirk for some very strict sect of Scotch Presbyterians. You will never make that mistake when you unexpectedly walk into a Byzantine church such as Santa Sophia in Constantinople or St. Mark's in Venice (a Catholic church but built after the Byzantine pattern) or one of the many small chapels that have survived in Greece and Thrace. There is nothing comfortable or familiar about them. They are places of mystery and they have but one purpose—to impress the multitude with the mystery of mysteries, the Word become flesh.

That was the role these dimly lighted structures were supposed to play in the life of the community—to fill the hearts of men with fear and awe—and they played it most successfully. Even outwardly they no longer bore any resemblance to the old Roman basilicas, for they had been constructed according to an entirely new principle, which was a continuation of the vaults and arches of the Romans but with very important changes introduced by the Byzantine architects.

Look at Santa Sophia. The dome was almost as large as that of the Pantheon but the Romans had had a comparatively simple problem, for they had placed a round dome on a round wall. But the curious part of this Byzantine way of building was this: Here a round dome had been placed on a square substructure. This the architects had managed to do by a most ingenious combination of arches and piers. Four piers supported four arches and on top of these arches the dome itself rested, as you will be able to learn from the pictures much more easily than from a dozen pages of mere words.

All this may seem very simple when you read about it in this casual fashion, but it had not been accomplished in a day or a week or without a great many previous trials and failures. The popular notion that the ancient builders were possessed of some sort of secret information which allowed them to do all sorts of things which we ourselves cannot do is sheer nonsense. Many of the great medieval cathedrals met with all sorts of misfortunes, which were invariably due to faulty construction. Santa Sophia, too, although the plans had been entrusted to a mathematician rather than to an architect or engineer, collapsed during an earthquake soon after the death of its maker, the famous Anthemius of Tralles, a native of Asia Minor. Everything had to be done all over again and this time the dome was raised some twenty-five feet. But after that, the building held its own for thirteen hundred years and survived the violence of both the elements and of man without showing any signs of weakness or old age, except an occasional slight crack in the walls, which could easily be repaired.

But like most architectural products that are worth while, the church had cost an awful lot of money. We have no very accurate figures at our disposal, but it must have cost the people of the Byzantine Empire somewhere about seventy million in modern dollars to be able to worship in this noble edifice, which had so completely drained the state of its ready cash that there was no money left with which to buy oil for the lamps that were supposed to light the altars. Four thousand years before, another empire had been ruined to build a suitable grave for a defunct king. This time the peasant lost his only shirt and the merchant half of his fortune to erect an edifice worthy of another king. But it was the King of Heaven, and peasant and merchant were willing that it should be that way.

And in the end, the building paid for itself. For the practical-minded people of the Middle Ages knew how to combine business and salvation much better than we, although there are still a few exceptions to this rule. If you had the most talked-of church in your town with the largest number of holy relics, you would attract the largest number of pilgrims. In that way your city would become the recipient of all the gold and silver from hundreds of miles around. In an age that suffered from a constant shortage of precious metals, this meant a tremendous financial advantage. And furthermore there was the chance of impressing your neighbor with your own power and your own riches and that would discourage him from attacking you.

It was said during the Middle Ages that when the rulers of Russia were in doubt as to what religion they should adopt for their own people, they sent delegations of wise men to different parts of the world to look into the respective merits of all the conflicting creeds. Santa Sophia so completely overpowered them with its magnificence that they decided in favor of the Greek church. When you consider the size of the hinterland that was in this way opened up to Byzantine commerce and trade and to all of the Byzantine arts, the original investment of seventy million dollars was really not so very exorbitant. And furthermore, the people of Constantinople had got exactly what they wanted, a church completely suited to their own spiritual needs, a vast hall resplendent with gold and bronze and porphyry, where they could lose themselves in awe-struck contemplation of that Heaven which was to reward them for the indignities and sufferings of life upon this planet.

Byzantine sculpture never reached the heights attained by the sculpture of western Europe. The second commandment about the

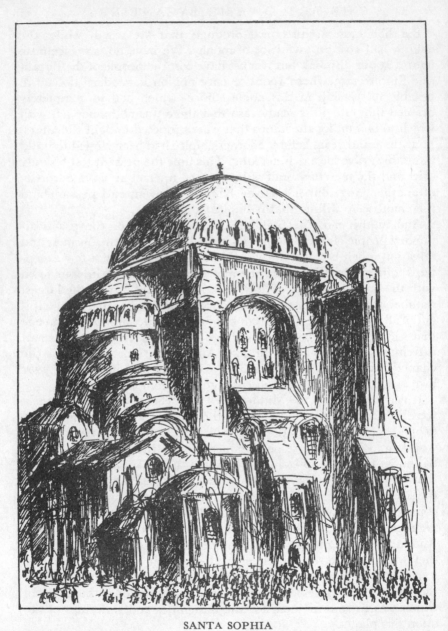

SANTA SOPHIA

*"The dome floats as though it were hung from the Heavens with chains of Gold."*

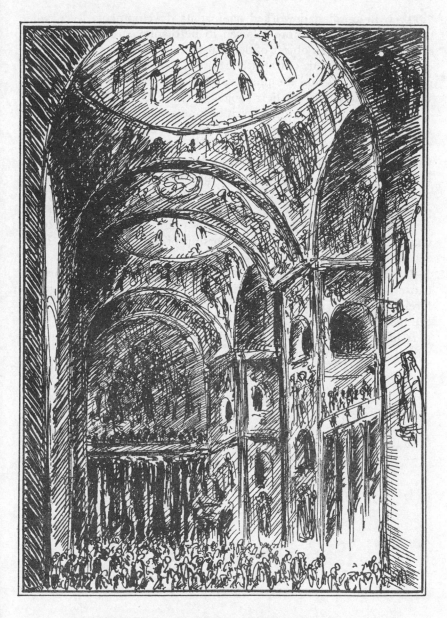

INTERIOR OF A BYZANTINE CHURCH

"graven images" had worked against its development. Even when paintings were once more allowed to be displayed in the churches, statues remained an object of deep suspicion. The ivory carver, however, could follow his craft without interference from the clerical supervisors and so could the painter, but both of them were greatly restricted in the choice of their subjects.

In this world in which the spirit of man seemed numbed with fear, both of the seen and the unseen, the artist felt compelled to follow the rules and regulations as laid down by those who knew their way about within the realm of the supernatural. Experience, too, had taught the brethren of the artistic fraternity to proceed with great care, for the authorities who resided unseen behind the high walls of the imperial palace were exceedingly well informed and knew how to punish with quick severity. The result was a style of painting better suited to the charnel house than to a place of worship of happy Christians. But it could hardly have been otherwise.

Byzantine art had degenerated into the art of the charnel house because Byzantine life had done likewise. That is why it is so utterly foreign to our own spirit and why we know less of (and care less for) the history of this curious empire than for that of almost any other part of the world. It was interesting enough, but it had a quality which repels. It was touched with the doom of death.

# Russia

*Art up a blind alley*

LONELINESS WILL DO STRANGE THINGS to individual men and women, but it will have an even more disastrous effect upon nations that find themselves cut off from the main currents of the world. The art of Russia and the art of many of the inhabitants of isolated island groups in the more remote parts of the Pacific Ocean are there to prove this point, as well as the lives of painters and sculptors who either by temperament or as a result of some malady were forced to a secluded existence.

If you will look at a map of Russia (and it is wise to keep your atlas near at hand while studying the arts), you will notice a vast plain that stretches all the way from the Ural Mountains to the Baltic and the Carpathian Mountains. That plain through which a number of rivers flow from either south to north or north to south, but never from east to west, had slowly been occupied by tribes of wandering Slavs. These Slavs belonged to the same racial stock as that which had settled in the rest of Europe but already during the days of the ancient Greeks they had lost all further touch with the rest of the world.

Then as now they had remarkably little gift for self-government. As nature abhors a vacuum (especially a political one), this enormous space, devoid of capable chieftains, had fallen an easy prey to the ambitions of the hardy citizens of the barren peninsula of Scandinavia. According to all patriotic Russian historians, it was the Slavs themselves who bade these Viking princes come and rule them.

Rurik, the first of these foreign "administrators," reached Novgorod the Great (not to be confused with Nizhni-Novgorod) in the year 862. Half a century later, the Norsemen must have reached the Black Sea, for in the year 911 they concluded their first treaty with the rulers of Tsargrad, which was the Russian name for Constantinople. On their way south they occupied the very ancient city of Kiev on the Dnieper River and this became the great trading center for the entire Russian plain, where Russian furs and grain and wax and slaves were exchanged for wine and dried fruit and silk and other products of the Mediterranean.

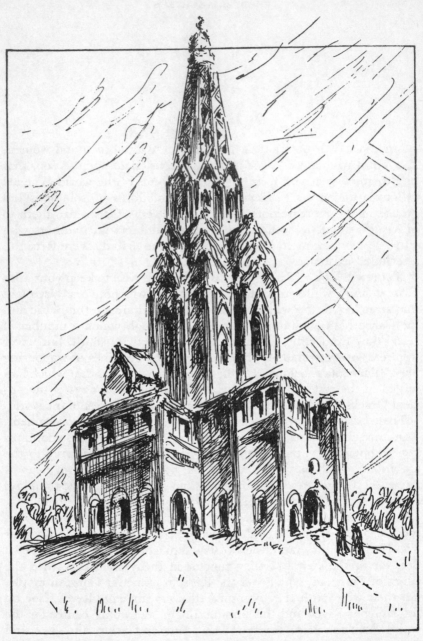

*Early during the sixteenth century the Byzantine churches began to assume queer shapes . . .*

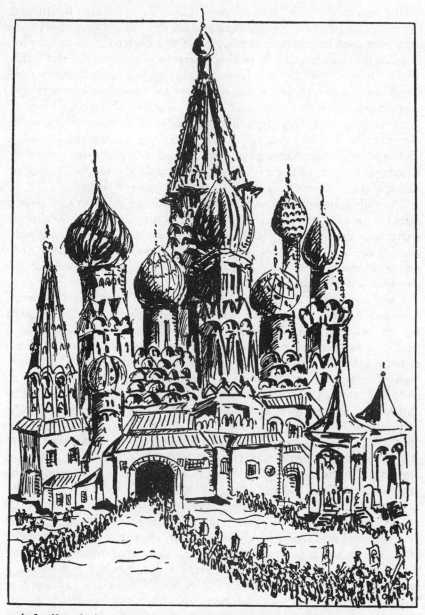

*and finally, during the latter half of the sixteenth century, these Russian churches began to look like the dream of a demented mind.*

Needless to say, this prosperous and densely populated heathenish town was an object of great solicitude on the part of those holy men who were now in power in the capital of the Eastern Roman Empire. Zealous missionaries slowly worked their way up along the flat banks of the Dnieper and Desna rivers. As the natives had no established creed of their own (being addicted to a vague sort of nature worship), they encountered few of the difficulties of their colleagues who were meanwhile penetrating into the wilderness of northern Europe. In the year 988, Prince Vladimir of Kiev was accepted into the Christian faith and was duly baptized. From that day on until our own day, Russia belonged, culturally speaking, completely to the Byzantine Empire and was never exposed to the influence of Rome.

The oldest surviving Russian church, built in Kiev in 991, was a direct copy of a rectangular Byzantine original and that Byzantine pattern, in the southern part of Russia at least, was faithfully followed during all subsequent centuries. But in the north it underwent considerable change, for in the north people had to use wood for the construction of their meetinghouses.

I use the word "meetinghouse" on purpose. It suggests a sort of community background that smacks of New England. The Russian village, organized on the basis of common possession of all the land, needed a meetinghouse to discuss village affairs, and the earliest Russian churches were just that. It was really a very practical arrangement. For in addition, the churches were held in great awe by all the people on account of the saints whose pictures were on every wall. The churches were also used as treasure chests for the convenience of the local rulers. And finally, in this flat and defenseless country which was completely at the mercy of the riffraff from both east and west, both the churches and the monasteries that had arisen in the neighborhood were built in such a way that they could also serve as fortresses whenever wild bands of Tartars swept across the plains.

Being therefore most intimately tied up with the daily lives of the people, the architecture of these churches was greatly modified by the geographical and social needs of the times. Large churches were out of the question because they had to be constructed entirely of wood. The slightly arched roofs of the Byzantine churches had to be given a steep slope to keep off the snow of winter. Under the influence of Asia, where the Buddhists had developed the bell-shaped cupola, the Russians evolved that strange looking bulb-shaped church spire which seems such an inseparable part of the Russian landscape.

You may remember from picture postal cards you have received

from central Europe that this same bulb-shaped church spire is also to be found in Austria and in Bavaria and in many other parts of central Europe. I have never found a satisfactory explanation for that curious coincidence. I rather suspect that the Austrian and Bavarian bulb architecture, which made its appearance during the counterreformation in the sixteenth century, was brought to these mountain valleys by the Jesuits, who must have been influenced by some of the architecture which the Moors had left behind when they left the Iberian peninsula after having had it in their possession for more than six hundred years.

As for the other arts imported from Constantinople (for the Russians got everything from their southern neighbors, including the Greek alphabet), the most important of these was painting. During the first three centuries after the introduction of Christianity, the rigid Byzantine rules of rendering the pictures of the saints were very carefully observed. Then came the conquest of Russia by the Tartars. Their rule lasted during the greater part of the thirteenth and fourteenth centuries and after they had at last been expelled, the poor Russians had to begin all over again, for the Tartars had been as destructive as a tidal wave.

Under the stress of the great patriotic outbreak which finally set the country free, both the painting and the architecture became much more national than they had been before. And when shortly afterwards, in the year 1453, Constantinople was taken by the Turks, the Russians were left completely to their own devices.

For in the east the country was cut off from the rest of the world by the Teutonic Knights and the Swedes; in the south it was cut off from the Mediterranean by the Mohammedans, and in the center Poland prevented the Muscovites from dealing directly with the nations of western Europe. How great their isolation was we learn from a little episode that took place in 1492, the same year in which Columbus discovered America.

Another expedition, sent out by an Austrian bishop to locate Moscow, returned without having been able to accomplish its purpose. And when Peter the Great at last broke a hole through that wall that for so long had kept Russia apart from all her neighbors, the brave adventurers who hastened eastward to exploit this rich but unknown territory found an art that had become completely petrified and that had lost all touch with the rest of the world.

Russia since then has contributed a great deal to modern art but this art was really that of western Europe, slightly modified to suit the

Russian taste. What was typically Slavic were the churches and the paintings which we rarely saw until the days of the revolution and the wholesale plundering of the big Russian country estates, whereupon thousands of stolen icons were smuggled across the Polish or Roumanian frontiers to be sold at a handsome profit to Western collectors and to those in America.

To most people these old Russian icons—these images of the traditional saints and these episodes from their lives—came as a complete revelation. For they had a singularly appealing quality in spite of their many technical defects. They were badly drawn, as we ourselves understand the art of drawing. They sinned against all the canons of good taste in the matter of color combinations, as these are taught to us in our art schools. They told hackneyed or trivial stories in a hackneyed and stilted way. And yet they had something that made you remember them and like them in spite of themselves.

I suppose that "something" was their complete honesty of purpose. The best examples were painted from five to six hundred years ago. Now to any Slavic peasant of the twelfth or fourteenth century, Christianity was not a philosophy of life or even a moral code. It was the living account of everything that had been said or done by his Saviour, by his apostles, and by his saints, and it provided the true believers with the only safe key to the door that could lead to the blessings of a very actual heaven. That heaven was, of course, the exact opposite of the sort of existence the poor peasant had been obliged to live on this earth. The streets were of gold. The sky was always blue. Everybody always got enough to eat. The officiating angels were kind and obliging. Therefore into these religious pictures —the only things of beauty the average muzhik would ever see—went all the dreams of happiness of a highly sensitive but terribly oppressed race. And so today, across this long span of time and in a country with a historical background that is completely different from that of Russia, we are nevertheless able to come under the spell of an art, which according to all the laws of logic should be completely foreign to our own nature.

# Islam

### The art of a desert people

MOHAMMED was the Hitler of the Arabs. He found his people divided into hundreds of tribes that were forever fighting each other. He united them by giving them a common purpose. That in the choice of his means he was quite as relentless and unscrupulous as his famous German imitator does not detract from the undeniable fact that without him the Arabs would probably have suffered the fate of the Abyssinians of today and that under his leadership they were able to conquer a very considerable part of the world.

When Mohammed went to his final reward in the year 632, his work was done. The whole of Arabia acclaimed him as God's one and only true prophet. Under his successor, Abu Bekr, who had gathered together all the sayings of his late father-in-law (Mohammed, who could neither read nor write, had depended upon the spoken word for the spread of his ideas) and who had called this collection the *Koran* (the book of recitations), both the Byzantines and the Persians had been successfully attacked. Three years later, the Arabs had reached Damascus. Ten years later they had overrun the whole of northern Africa. Sixty years later Tarif had conquered the rock that since then has been called after his commander in chief Tariq "Jeb el Tariq," (or Gibraltar) and invaded Spain.

Mohammedanism, judging by the number of its converts, was the most instantaneous success ever achieved by a similar enterprise, and this success was undoubtedly due to the absolute lack of even the most rudimentary forms of tolerance on the part of the Arabs who first carried the Moslem faith abroad.

It is curious to reflect that this religion was really an offshoot of the creed of Israel, but that Israel, while equally devoted to the principle of intolerance, had hardly made any converts during all the thousands of years of its existence. But whereas the Jews had practiced what one might call "the tolerance of exclusiveness," these simple desert folk, who followed the green battle flag of the Prophet, included all of humanity in their tender solicitations for other people's souls. The Jews had proudly argued, "We alone are right. All the rest of you are

therefore wrong. But if you want to persist in your erroneous delusions, that is entirely up to you. You know where to find the Truth if you want it. You can come to us and ask permission to share it, a request which we may grant or not grant, as we shall feel inclined. Meanwhile we shall dwell in the high tower of spiritual perfection and shall ask you to leave us alone as we intend to leave you alone." And while the Psalmist occasionally indulged in an appeal to "all ye nations" and "all ye people," what was really in his mind was the highly exclusive tribe of Israel. The rest was really no concern of theirs.

But proselytizing was the only thing that interested these queer disciples of theirs from Arabia Deserta. When the muezzin called the faithful to prayer with his, "Hark ye, all men! God is great. There is no God but God and Mohammed is the only prophet of God," they meant what they said for all the people everywhere, and you either joined the faithful at prayer or you quickly went where prayer would no longer do you any good.

This absolute one-sidedness of the Moslems, this absolute conviction that there is no salvation outside their own creed, has to be stressed if we want to understand Mohammedan art. Mohammedanism was probably the simplest form of faith ever offered to man. There was no complicated form of worship. There was no priestly class that set itself deliberately between man and his God. There were certain officials who recited and explained the sacred writings, but the poorest dervish in the meanest tent in the most Godforsaken part of the desert still had immediate access to his God, for Allah was the beginning and the end of all things and there was no use even considering any other Gods.

Now these desert Arabs were poor in a sense of the word we ourselves would hardly understand. The few things they absolutely needed outside of their tents and horses and sleeping rugs they possessed in common. As they knew no other sort of life, they were perfectly satisfied with this arrangement. They had to have tents, of course, to protect themselves against the heat of the day and against the cold of the night, which in certain parts of Arabia could be very considerable. They had no use for furniture. Chairs and tables and cupboards would only have proved a nuisance to a people who were forever on the move. But since they could not very well sit or sleep on the sand of the desert, they had learned the art of weaving rugs. The tent and the loom were therefore the basis of their artistic life. Whereas all along the Mediterranean art had been born in cities built out of stone and had served the purposes of the property-owning

classes, the art of the Mohammedan was a product of the desert and was based upon the communistic philosophy of life.

If you want an analogy you will find it in our own country among the Indians of the Middle West, who also were nomads, who also possessed everything in common, and who (even less fortunate than the Moslems) had to depend upon the backs of their women to carry their few absolutely essential household articles when they broke camp and traveled from one hunting ground to the next.

Now when these desert wanderers ceased to worship the sticks and stones which thus far had been their Gods (and of which the black stone in Mecca's Kaaba or Holy of Holies is a concrete survivor) and began to worship the invisible God whom they could only come to know through the study of one single book, they felt the need of a few places where they could come together for their daily and weekly prayers and where they could listen to the recitation of chapters from the Koran. Out of this need the mosque was born.

It bore no resemblance to either the Greek or the Egyptian temple or the Christian church. It was not considered holy ground because no God lived inside. It was something very closely akin to the meeting-house of our own Quakers, but a Quaker meetinghouse reduced to the simplest of all possible forms. The worshipers, being accustomed to live in tents, squatted on the floor and did not sit on either benches or chairs. All that was necessary for the comfort of the congregation were four walls and a roof, a niche in the wall to indicate the geographical position of Mecca, so that the faithful might know in what direction to prostrate themselves while engaged in their daily prayers, and finally a pulpit from which a wise man might explain the words of the Prophet during the Friday recitations, which were the only ceremony that bore some sort of resemblance to divine service as we know it in our own churches.

There was one other characteristic detail typical of all Moslem mosques and not to be found in synagogue, temple, or cathedral. That was the fountain of running water at which the faithful were supposed to wash themselves thoroughly ere they entered the house of prayer. Only those who have lived in the desert will ever be able to appreciate what water—fresh, cool, running water—means to an Arab or a Berber. It means life in the most realistic sense of the word. Mention thirst to a person who has grown up in our part of the world and he will casually answer, "Oh, yes, I have been thirsty at times." Which may mean that he had to go for a couple of hours without drinking a glass of water or a glass of beer. But thirst to the desert

nomad means something a great deal more than just being uncomfortable. It means death. Therefore, when Mohammed insisted that all the faithful wash at least part of their bodies ere they lose themselves in their devotions, he showed his profound knowledge of human psychology. For a good wash in fresh clean water after a stifling hot day in the open fills the body with a sense of such complete satisfaction that this in turn affects the mind with a delightful sensation of serenity, which thereupon allows the supplicant to say his prayers in complete accord with all creation.

There are few things in this world as delightful to contemplate as these fountains in the mosques and palaces of the Moslems. I wonder what the Crusaders thought of them? It is not quite true, as it is often said, that the people of the Middle Ages were averse to bathing. Every medieval city had its own public bathhouses and these were not closed until after the outbreak of the epidemic of a malignant disease that swept over Europe shortly after the discovery of America. But one had always been obliged to bathe *sub rosa*, so to speak, for the Christian Church, which despised the human body, frowned upon this dangerous habit of exposing one's skin to water and soap and possibly to the gaze of the curious.

But now that we in America have at least almost returned to the ideal of the Greeks, who believed that good health should be part of every man's religion, we might well make a careful study of such buildings as the famous Alhambra, the palace of the Moorish rulers of Granada, where fountains and pools play such an important part in the general architectural arrangement of this vast and pleasing structure, which now, alas, due to the Spanish civil war, seems to be a thing of the past.

Especially in our big cities, which in the summer become veritable caldrons, we could accomplish a great deal with a lot of public fountains and we would make the lives of the poorer classes much more comfortable by having swimming pools in every overcrowded district. It would cost very little money, too, compared to our annual expenditure upon our public hospitals. Will Mr. Moses please take notice of this? He has already done so much to make our metropolis a happier city to live in. Why not go a little further and add a touch of Moorishness by having fountains all over the place?

By nature the Mohammedans were not an artistic people. There was no law against "making unto themselves graven images or any likeness of anything that is in Heaven above or that is in the earth

beneath or that is in the water under the earth," but there was a very decided prejudice against that sort of thing which made it impossible for the portrait painter to ply his craft. He could only try his hand at a few ornaments with which to break the monotony of the temple walls. In those southern countries, the heat of day is apt to do all sorts of strange things to objects made of wood. That the Arab wood carvers were nevertheless able to carve doors and pulpits that have withstood the sudden changes in temperature of their country for four or five centuries shows us in a most convincing manner that these gentlemen knew their business.

The tilemakers too were allowed free rein to their imagination, for as the faithful were only permitted to enter the mosques after having divested themselves of their shoes or sandals, it was pleasant for them to be able to walk on well-glazed tiles, and every mosque was full of them.

But the really interesting part to the student of the arts is the change that overtook Moslem architecture in the different countries that were gradually brought under the sway of these fast-conquering Arab hordes. Being a desert people and therefore a tent-dwelling people, the Arabs at first had known nothing about building in stone. In the beginning, therefore, their most important edifices had to be erected by foreign architects. For example, one of their very oldest mosques, the so-called Dome of the Rock, built in the year 691 in Jerusalem over the rock from which, according to legend, the angel Gabriel had carried the Prophet in a dream through the heavens—that Moslem mosque is still completely Byzantine, and it was, indeed, erected by Byzantine architects.

Incidentally the Crusaders, who were a little vague in their notions about archaeology, mistook the Dome of the Rock for the original temple of Solomon and copied this Byzantine model all over Europe, as you may see for yourself by going to Mayence and London and Laon and quite a number of other cities of western Europe. The Aksâ mosque in the same city (to which Allah is said to have carried Mohammed all the way from Mecca in a single night) is even older than the Dome of the Rock, for it is built in purely Roman style and may originally have been intended as a Christian church in honor of the Virgin Mary. And so it went until finally in Spain the Moslems developed a style of their own, which came to be known as the Moorish style.

Meanwhile, in the caliphate of Baghdad, where there was only brick, the architects went back to the old Babylonian method of

building vaults. Eventually they too invented a separate type of mosque, based upon the principles of the ancient Chaldean temples. Finally, in the thirteenth century, after the Mamelukes had established themselves in Egypt, another independent Mohammedan style of building was developed, as you may still see for yourself by visiting the tomb of the caliphs and the mosque of Sultan Hasan, both of them in Cairo and constructed about the year 1357 by a Syrian architect. He solved the problem of getting the necessary building material by the simple procedure of stealing the solid stone slabs which for the last three thousand years had acted as a protecting shield for many of the ancient Egyptian monuments.

We are accustomed to read in our history books that the Crusaders during the two hundred years they spent in the Holy Land learned a great many things from their heathen enemies and that the civilization of western Europe was greatly benefited by having been exposed for such a long time to the infinitely higher cultural ideals of the men from the East. This is true, but with certain reservations. The Mohammedans as such were not really in any way superior to the barbarians from the West. The Moors of medieval Spain were ahead of the Christians of that era but the typical Arab was much too conservative, much too much of a "fundamentalist" (Mohammedanism is full of what we would call "Puritan sects") to be interested in progress. And Arabia and northern Africa remained very much as they had always been and as they are today.

There was, however, in the Near East and right in the heart of the Moslem world one small enclave that made an exception to this rule. It had accepted the Moslem faith and was one of the most efficient and dangerous enemies of the Christian invaders. But it had none of the indifference of the typical desert Arab toward the arts and toward the many gracious attributes of life. It was called Persia. It had very little in common with the Persia that had fought the Greeks in the days of Themistocles and that had lost its independence at the hands of Alexander the Great. At the same time there must have been something in the soil of the land and in the air of its mountains to allow it to make such a magnificent comeback. It was this Persia of the Middle Ages which put its imprint upon all contemporary Europe, and therefore I shall give it what it fully deserves—a chapter of its own.

# Medieval Persia

*The great melting pot of all the arts*

THERE ARE, when we come to think of it, only a mere handful of books that have really influenced the human race at large. And one of those is hardly twenty pages long. I refer to the poems of Omar, the tentmaker's son of Nishapur. In some five hundred epigrams this learned Persian mathematician expounded a general attitude toward life and death that has always strongly appealed to those who for one reason or another derive no satisfaction from the purely negative philosophies of the days of their youth. For although Omar was entirely negative in describing the joys of the hereafter, he was completely positive in enumerating the less doubtful joys of the here and now.

Almost everyone is familiar with at least a few of these pleasant *ruba'is* which Edward FitzGerald in the year 1859 recast into those delightful quatrains that have since then found their way all over the world. But I have an idea that when you read them, you felt very much the way I did. "Surely," I said to myself, "such a world of nightingales singing among the roses, of pale blue moonshine flooding turreted towers, of red wine and of lovely women sitting by the side of a running brook—such a world can never have really existed. It is much too good to have been true on a planet as imperfect as ours."

Those, however, who knew that part of the world from personal observation have since then told me otherwise. Such a world did exist. Even today, apparently, it may be found in remote corners of the high Persian plateau. The turreted towers have gone to ruin. The rose beds have been overgrown with weeds. The nightingale sings in melancholy loneliness. But the running brooks still glide silently through the decaying gardens. The light of the moon is as pale as it was eight hundred years ago when Omar lived. And it is possible, even after all these centuries of strife and neglect, to find concrete proof of a civilization which during the heyday of its glory must have been as lovely as anything this world has ever seen.

Unfortunately it did not last very long. Such things never do. Soon those who hate nightingales and moonlight and tumbling brooks get

filled with such intense hatred for those who like them that they arise in all their fury and destroy everything the others have wrought. And when they get through with their job, the lion and the lizard once more "keep the courts where Jamshyd gloried and drank deep."

But in life as in art, it is really the minutes that count. We so glibly talk about the happy fate of the artist, allowed to work for the ages. The ages indeed! Another five thousand years and the Pyramids shall have returned to dust. Two more centuries (not counting the possibilities of warfare) will do for the Parthenon. Most of Rembrandt's pictures will have turned a deep, dark brown in another couple of centuries, as the pictures of Whistler and many of his contemporaries have already done. A hundred years from now the music of Beethoven will perhaps appear on a few concert programs as a sort of musical curiosity, but the public will feel the same way toward his symphonies as it does now toward the works of Pergolesi or Kuhnau.

Art is as fleeting as life itself and it is good that it should be that way. Imagine a world turned into a vast storehouse for defunct works of our artists! No, let them serve their purpose and spread beauty and happiness among their own contemporaries. Then let them return to dust.

The Persian civilization of the Middle Ages lasted only a few hundred years, but during that short period, Persia became the clearing-house for the art of the whole of the Eastern World and the teacher of all of western Europe. Is not that enough glory for any nation? Better fifty years with Omar Khayyám than five thousand years contemplating the mummy of a Pharaoh. Who cares about dates when rejoicing in the beauties of an ancient Persian manuscript?

What makes the Persia of the Middle Ages so interesting to us in America is the fact that the Persian people, too, had achieved greatness as the result of their being a mixed race. It was a veritable melting pot for dozens of races. The city of Baghdad, the capital of practically all the territory between the Mediterranean and the Indus River, was as international a center as the New York of today, attracting artists not only from India but also from China, who taught the Persians many tricks of the porcelain makers' trade.

Situated on the Tigris, it also commanded the navigation on the Euphrates. As a result, until Europe discovered the route to the Indies by way of the Cape of Good Hope, Baghdad was the most important trading post on the roads that ran from China and India to Europe and on those that led from northern Asia to Egypt and Arabia. Early in the seventh century it suffered the fate of all of western Asia.

BUILDING THE MEDIEVAL CATHEDRAL

**PERSIA**

*From the looms of Persia color once more began to flow upon this world.*

It was overrun by the Arabs and the people of Baghdad were forced to become Mohammedans.

But the Persians belonged to a different race from the Arabs. The Arabs were Semites. The Persians were Aryans, just as we are, and their Mohammedanism was therefore something quite different from that practiced by the desert-dwelling Arabs. Conscious of their proud past and of having created not one but at least three different civiliza-

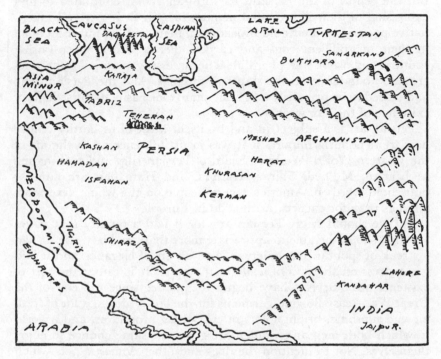

THE RUG REGION OF PERSIA

tions during the previous twenty centuries, the Persians modified their new religion to suit their own convenience and being in every way superior to their conquerors (except as soldiers) they did what a great many other nations have done under similar circumstances—they turned their conquerors into their cultural slaves.

If you will allow an old platitude, they did not care who gave their country its laws as long as they were allowed to give it its paintings and its art. And they succeeded in making the caliphate of Baghdad, the home of Harun al-Rashid and the scene of the *Thousand and One*

*Nights*, a center of civilization, Mohammedan in name but cosmopolitan in its tastes, although on the whole the Persian remained the predominant one.

In due course of time the city of Baghdad fell a prey to those endless political quarrels that were so common among the rulers of all Moslem countries and that finally (for safety's sake) led to the odd custom which bade a sultan kill all his relatives when he mounted the throne. But the genius of the Persians for form and color continued to find expression in their illuminated manuscripts, in their gay and imaginative pottery, in their gold brocades, in their textiles, but most of all in their magnificent rugs and carpets. Persia was a sheep-raising country and wool was plentiful. The necessary plants for the dyes grew in abundance on the slopes of the hills. And the Persian, who had ceased to be primarily a fighting man, took easily to the sedentary existence of the rug weaver.

Persian art is a subject in and by itself. Most of us hardly realize how tremendously important it was in its influence upon the art of the Western World. We have heard of Persian rugs and such names as Isfahan, Meshed, Shiraz, Kashan, and Hamadan are familiar household words in America where people on the whole care more for rugs than for carpets, as they do in Europe.

But we should study Persian art, for it had a quality that we as a nation should be able to appreciate more than anybody else. It had a streak of spontaneous gaiety. It had an air of elegance and it laid great stress on the joys of a life in the open. It is rather the sort of existence we ourselves have begun to practice since the end of the Great War—easy flowing garments for the out-of-doors, a lot of fresh air and sunshine, bright colors in everything around us, and a world in which both men and women are given the same chance to enjoy themselves. Not to mention the dogs and other domestic pets which play as important a role in the illuminated manuscripts of those medieval Persians as in the daily lives of the Americans of the year of grace 1937.

This Persian civilization not only survived the Middle Ages but its art, too (although there were many ups and downs), was somehow able to maintain itself. Persian work of the seventeenth and eighteenth centuries is in many ways as interesting as that of the days when Baghdad was in the heyday of its glory.

Politically the country became a third-rate power and gone were the days when a national dynasty (like that of the Sassanids, who ruled from the third until the seventh century) had been able to

construct such palaces as you may still observe among the ruins of Ctesiphon.

In the middle of the fifteenth century the Turks, by capturing Constantinople, cut Persia off from the rest of Europe, and this Oriental influence ceased to affect the art of the West. Which was a great pity, for the art of the Persians had been essentially an aristocratic form of art—a worldly one. And now, left completely to themselves, the Europeans were obliged to develop the only sort of art they were allowed to practice—religious art. A one-sided diet has never been good for any community. Least of all a one-sided artistic diet.

# The Romanesque Period

### Art among the ruins

IT IS VERY DIFFICULT to get rid of the artificial classifications that the historians of art have invented in their efforts to reduce this branch of learning to a mere science. Take the name at the head of this chapter, the Romanesque period. Until a century ago, nobody would have known what it meant. Even today people are quarreling as to who was the first writer to use this term. As art criticism does not go much further back than the era of the French Revolution, the name Romanesque must have come into general use sometime during the first half of the nineteenth century. The term refers to that art, predominantly religious, which developed out of the art of the Romans. In a more general way it refers to the entire cultural system that prevailed over Europe between the fall of Rome in the year 476 and the beginning of the thirteenth century when the Gothic style began to supplant the older Romanesque.

Since man, however, is not a rational animal and hates logic as a cat hates water, and obstinately refuses to fit into any nice little scheme of dates, the Romanesque period did not come to an end in all parts of the world at exactly the same moment. The Italians, for example, who despised Gothic as an invention of those barbarians who continued to live in the outer darkness of what to them was still Gallia Transalpina (the Gaul that lay on the other side of the Alps), never took very kindly to it and continued to build in a modified Romanesque style until the beginning of the fifteenth century. But even today, especially in our own country, one will find an occasional Romanesque church which was built only a few years ago and which usually is as much out of place as a skyscraper would be on top of the Acropolis. For that church in the Romanesque style which so completely filled the needs of the people of the eleventh and twelfth centuries no longer speaks a language we people of this modern age can understand. Perhaps in some small provincial town in the interior of France, where the Romanesque reached its highest perfection, in Angoulême or Caen or Morienval, and where French life seems to have changed but very little from what it was a thousand years ago

--in some such sleepy little borough where nothing has ever happened since Charlemagne's cat had kittens—you may not only learn to appreciate and enjoy the rather forbidding beauty of these heavy piles of weather-beaten stone but in the end you may come to know them so well that they will reveal a few of their secrets—secrets that will fill your heart with dread when you contemplate the chances that our own civilization within a few years may suffer a similar fate.

What sort of world was this that gave birth to the Romanesque form of art? It was a world in ruins. The roads were gone and the policemen were gone. That meant that the law, too, was gone. Now Roman law may have been harsh but it had been made to maintain order among a strangely assorted mass of people who, the moment the fear of the imperial executioner was removed, fell upon each other with the ferocity of Mohammedans slaughtering their Hindu neighbors whenever the English constable happens to be looking the other way.

A strict but unified military rule had been replaced by an almost universal gangsterdom which destroyed not merely for profit but also for the sheer joy of playing the vandal. Here and there a more unscrupulous racketeer had succeeded in getting himself recognized as the Big Boss, in which case he bedecked his unworthy shoulders with a cloak of spurious dignity and proudly proclaimed himself King of the Lombards or Duke of Aquitaine, to play his little role and make an unexpected exit by way of the poison cup or the assassin's dagger.

Cooped up in his lonely palace, defended by high walls and broad marshes, a titular descendant of the Caesars still pretended to be the Emperor and promulgated edicts which no one bothered to read because, among the recent arrivals upon the scene, only one man out of every ten thousand or so could as much as spell his name.

Art in order to come to full fruition needs tranquillity, just like the trees in your garden. The artist therefore ceased to function as a necessary part of society. The craftsman, feeling himself employed upon unworthy tasks and working for indifferent masters, grew negligent, which is the end of all decent craft. The schoolmaster became an object of ridicule in a society which until well into the fourteenth century took a positive pride in being illiterate. The physician, trained in the traditions of Galen and ever conscious of his Hippocratic oath, found himself replaced by the tribal medicine man, who cured you by studying the entrails of a dead rooster. The scientist became a superfluous luxury and starved to death amidst his formulas. The international merchant, deprived of his old and familiar roads

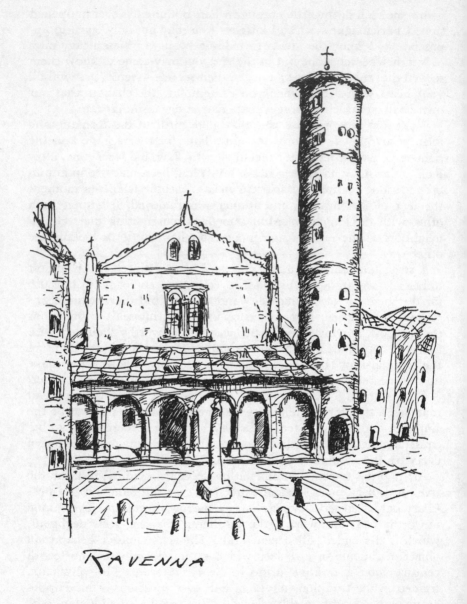

RAVENNA

and sea lanes, became a frightened peddler who now carried his humble pack from village to village and was willing to pay heavy tribute to any highwayman who in return could guarantee him at least a modicum of safety. And this condition did not last for merely one or two generations, as it is apt to do in cases of a revolution, but it went on for century after century and did not really come to an end until, in sheer despair, Europe finally bent its neck under the iron yoke of feudalism.

The word feudalism does not enjoy a good repute among us, for we associate it exclusively with the harsh brutality that was one (but only one) of the characteristics of life during the later Middle Ages. It is true that those stone knights whom we know so well from their sepulchral monuments in our Romanesque and Gothic churches—it is only too true that their lives were rather different from that attitude of humble piety which is so eloquently reflected by their hands folded in perpetual prayer. But they had to be brutal and they had to be harsh if they wanted to assert themselves. They were the G-men of medieval society, and furthermore they were the executives of their own decrees and the guardians of the liberties of their subjects. Their castles were built on top of dungeons that make us shudder when we look at them. Let us, however, gratefully remember that the occupants of those dungeons, at least in the vast majority of cases, were ordinary criminals fully deserving of the fate that awaited them when for a few final moments they were once more exposed to the light of day to be surrendered to the executioner's ax.

To us, this feudal age may seem something unworthy of the human race. But the men and women of the sixth or seventh century, could they but have foreseen what was to come, would have welcomed such an institution as an ideal arrangement, for it would have promised to give them the one thing they lacked most of all and without which all civilized existence comes to an end—a sense of security.

Under those circumstances, the brighter lads and those in whom all enthusiasm had not been killed by the sense of despair that had gradually taken hold of the minds of all men turned instinctively toward the only organization that seemed to offer them some scope for their talents and their ambitions—the Church.

In ancient Rome the emperor had been recognized not only as the worldly ruler of all his subjects but also as their spiritual head. As Pontifex Maximus, as the chief of the priests who brought the annual propitiatory offerings, the imperator or commander in chief of the armies was also the commander in chief of the hosts of the faithful. It

is true that the commander in chief of the armies had long since ab-
dicated his office. The loyalty of the masses had been transferred from
Mount Olympus to Golgotha. But there was a new commander in
chief of those who, formerly rendering homage to almighty Jupiter,
now bent their knees before the altar of the strange new God who had
died the death of a slave that by this act of self-sacrifice He might
show His love for the misguided children of His heavenly Father.

Loyalty is not only one of the oldest of all our emotions but it seems
an indispensable part of the human make-up. And when it was no
longer possible to enroll in the armies of a captain who carried a
sword, millions of people eagerly turned toward the leader who
carried a cross as symbol of his dignity. The sublime beauty of the
ideas that had first been expounded in the Sermon on the Mount
appealed to only a restricted number of people. For in an age when
all the old philosophies lay buried beneath the ruins of their own im-
perfections, men did not care to lose themselves in abstract thought.
But in the new faith they found a practical system of everyday life
that held firm in the midst of the chaos that had so suddenly de-
scended upon a world accustomed for centuries to a happy and well-
ordered existence. Here was at last something visible and tangible to
which one could attach oneself, to which one could surrender all of
one's pent-up loyalties—an ideal that gave purpose and direction to
every thought and action.

There is a little of the missionary in almost all of us. Somehow or
other we have a secret hope that in some humble way we may leave
this world a little better than we found it. When the chances of ac-
quiring material wealth are unusually great (as they were in our own
country until very recently) this feeling can be temporarily overcome
by the ease with which we gather riches. But during the early Middle
Ages, when even the king in his castle lived like a peasant, the chances
of ever rising to a competency by one's own efforts seemed far re-
moved. There was only one thing left. That was power, which is as
dear to the heart of the average man as gold. This the Church offered
in rich abundance to all those among its followers whom it deemed
worthy of such a responsibility.

There, in a few words, you have the background of all Romanesque
art, a world reconquered by Rome, not however by the Rome of the
Imperial Eagle, but by the Rome of the Nazarene's Cross.

We are all of us familiar with the mission stations which the Spanish
padres erected in California during the eighteenth century. We under-
stand something of the perils and difficulties that awaited these spir-

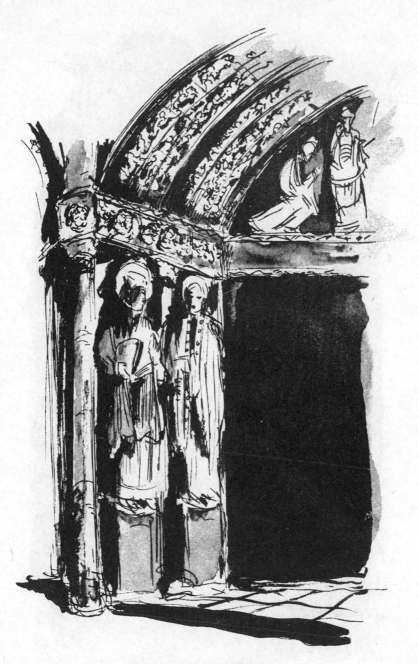

**ROMANESQUE SCULPTURE**

*Everything is rather heavy and solid.*

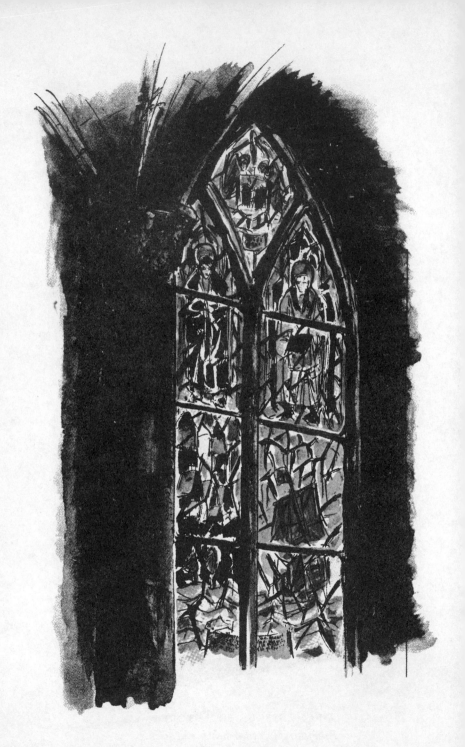

A STAINED GLASS WINDOW WHEN SEEN AS A WHOLE

itual pioneers when they penetrated into the hostile and barren wilderness of the Far West to preach the Gospel and show the shiftless natives the benefits of a well-regulated economic life. Substitute the seventh century for the eighteenth, turn the Franciscans into Benedictines, change the scene from southern California to northern Europe, and you have the exact equivalent of what not so long ago happened in our own country.

The actual work of spreading the good tidings and reconquering the world for civilization, then as later, was done by the monks. The lonely hermit of the first few centuries of the Christian era took no part in it. His purpose was a selfish one. He was only interested in his own salvation. Even the Church recognized the dangers of such a selfish attitude toward life and when the movement of gaining heaven by escaping from this earth threatened to gain too many adherents, the Church decided to take steps that this force for evil might be turned toward a useful purpose.

Under the firm guidance of Saint Benedict, a member of an old and powerful Umbrian family in which the traditions of the old Roman ability for large-scale executive work had fortunately survived, the individualistic and often anarchistic energies of those who desired to spend the rest of their days in lonely meditations were given a definite direction and were set to work upon the gigantic task of reconquering Europe for the Rome of the Popes.

Across the broken bridges and along the tracks that had once upon a time been imperial highways, the shock troops of Christ went forth into the wilderness of an unexplored continent. Wherever they settled down, they needed high stone walls to protect themselves against possible attacks on the part of the natives. They needed administration buildings, for they were the keepers of records in a world that had almost forgotten the meaning of "deeded property." They needed hospitals, well knowing that by such care they would gain the good will of their suspicious neighbors. They needed shelter for the orphans they adopted, for they had already learned that by getting hold of the children they would afterwards be able to direct the lives of the full-grown men. And they needed churches in which to bring together the faithful and in which to demonstrate the miracle of the Mass and to explain to these incredulous ears that no good could ever come of repaying evil by evil.

And since the native population still dwelt in rustic simplicity in houses built of mud and straw, these monks did the only practical thing they could do—they introduced their own Roman architecture

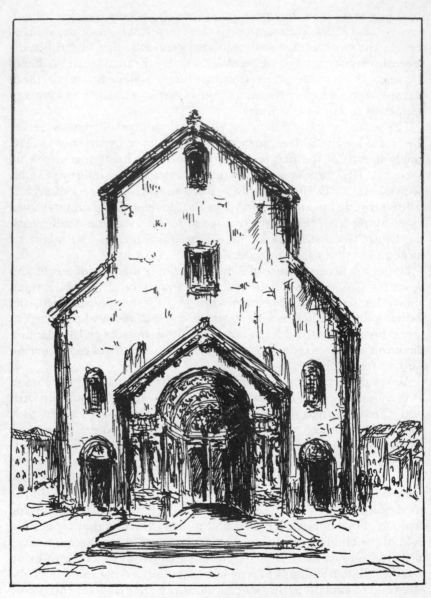

A ROMANESQUE CHURCH

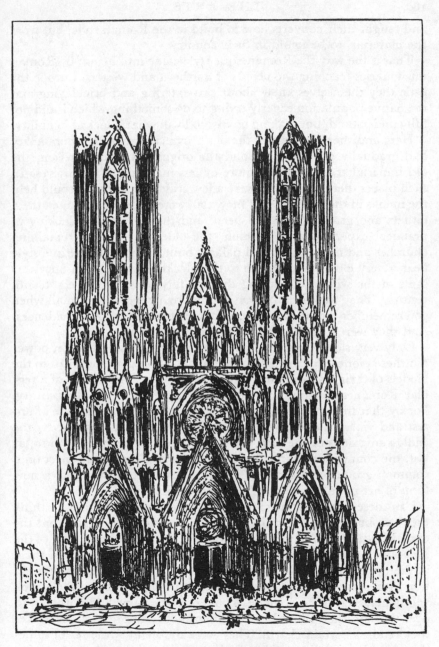

**A GOTHIC CHURCH**

and taught their converts how to build in the Roman style, but from the materials to be found in their country.

That is the way the Romanesque style came into being: by Roman missionaries teaching the people of northern and western Europe the little they themselves knew about carpentering and bricklaying and the native population eagerly trying to do something which it did not fully understand, but making up in good will what it lacked in ability.

Here and there in some of the old provincial capitals, where a city had gradually grown up around the original Roman garrison, the old imperial traditions had more or less maintained themselves. In such places there sometimes were a few craftsmen left who could help the monks in their labors. But they, too, were no longer the men their fathers and grandfathers had been, and they were sadly lacking in practical experience. As a result, the oldest of the few remaining churches and monasteries and palaces built in the Romanesque style bear a very close resemblance to the blockhouses our own ancestors built in the wilderness during the last fifty years of the eighteenth century. They were small, some of them really incredibly small when you remember that they had been erected to serve as royal residences. And they were devoid of all superfluous ornaments.

Only very slowly and after they had gained considerably in power did these pioneers of the old Roman civilization dare to return to the models of their Italian home, so that we really cannot speak of a regular Romanesque style until the beginning of the twelfth century. For by that time, too, Italy had at last emerged from the state of unrest and violence and poverty that had been brought about by the endless invasions of the fifth, sixth and seventh centuries. And so, at last, the countries both north and south of the Alps could meet on a common ground and could begin the work of reconstructing a new form of art upon the ruins of a bygone civilization.

Can these Romanesque churches still mean anything to us? I think they can but in the beginning of this chapter I warned you that the early Middle Ages are further removed from us than the Egypt of the Pharaohs or the Athens of Pericles. However, if you approach them in the right spirit, you will be able to derive a great deal of satisfaction from studying these Romanesque buildings. Many of them look very lonely and quite desolate. You feel as if no one had bothered to peer through their small barred windows for hundreds of years. Yet they retain a certain charm. They were the silent witnesses of something that is no longer with us, for in every detail they show the naïve happiness and surprise of a very simple people who have just been

told a story that has appealed to them in the same way as the story of Santa Claus appeals to our children.

The ornaments of these buildings are as a rule exceedingly simple. The Christian missionaries soon discovered that the people of northern and western Europe had great abilities as decorative artists. The bracelets and other articles of personal adornment which have come down to us from the iron and bronze ages in Scandinavia show this very clearly. The old Germanic tribes had as fine a sensitiveness to the forms of animals and trees as the unknown painters of our prehistoric caves and, like most very simple peoples, they also had a great gift of imitation. Furthermore, they were very curious about what was being done in the rest of the world and eager to learn.

When in the ninth century their mightiest monarch, Charles the Great, established more or less cordial relations with Harun al-Rashid, the Caliph of Baghdad, and these two potentates exchanged gifts, the people of the West got their first glimpse of the art of the old land of Persia, mostly in the form of carpets and tapestries, for these (except for an occasional set of chessmen and some other pieces of carved ivory) were easiest of all to transport. It thereupon became the fashion among all the richer abbots to acquire a few of such rugs for their own churches that they might expose them on festive occasions and show the local craftsmen how such things should be done. The local craftsmen were quick to learn and by the middle of the ninth century we begin to notice Oriental motives being worked into the carvings over the doors and windows of the Romanesque chapels.

Those who did not have any talent for the chisel and the hammer, and the less robust members of the community, who nevertheless felt the urge to create something to the greater glory of God, could give expression to their piety by working these same elaborate ornaments into the pages of an illuminated manuscript or by reproducing them on the cover of a holy book. In a society much too poor to support any professional goldsmiths or silversmiths, the miniaturist, living in the safe seclusion of his monastery, had a chance to perform all those manifold tasks which in a later society were taken over by the painter and the jeweler.

You may remember that I told you how the Greeks, when still young and full of the joy of living, had liked bright colors and had always painted their statues in the gayest of all possible reds and blues and greens. In that respect, the indoor arts of the Romanesque period also clearly showed their youth. Nothing could be too loud or too boisterous for the taste of that day. Two rubies or opals or sapphires,

set into the cover of a book, were better than one. A dozen were in-
finitely better than two, and two dozen better yet. All the art, there-
fore, of that period, except the sculpture and architecture, is loud and
ostentatious and, to be perfectly frank, almost unpleasantly vulgar.

But what can you expect when you remember that the owner of
these treasures, although he might have paid a hundred golden bez-
ants for such a volume, could neither read nor write and lived as
primitively as a farmer in the backwoods of Vermont using a wooden
cart for travel?

And now, because after all such things belong in a history that is
supposed to be a history of art, where will you have to go to find your
finest examples of Romanesque architecture? The most important
remnants of the minor arts you will find in the museums of France and
in those of Ireland, for the Irish were the first people of northern
Europe to accept Christianity as they probably will also be the last
to relinquish it. But for the churches, you will have to go in the first
place to Italy and next to France and Germany.

In Ravenna you will find the Romanesque, but blended with the
Byzantine. In Aix-la-Chapelle or Aachen, you will find a direct
copy of the Ravenna church of San Vitale, which Charlemagne, in
his enthusiasm for probably "the finest thing he had ever seen,"
ordered to be built by his Alsatian architect, thereby proving once
more that the arts recognize no political boundaries. Another direct
imitation of the Ravenna school you will find at Grenoble in south-
eastern France. For in that city, and almost two centuries before
Charlemagne, an unknown architect had constructed a small chapel
(now the crypt of St. Lawrence) which was also a perfect replica of
the church in Ravenna.

But all this, as a precisionist in such matters might well claim, is of
course really pre-Romanesque. Or at best it belongs to some inter-
mediary state of development. For regular and fully recognizable
Romanesque we must go to northern and central Italy.

There the Roman basilica gradually developed into the Latin cross
type of church. The Latin cross type was a typically Romanesque
innovation and one of the few that has survived until our own day,
for most of our Catholic churches are still being built in the form of
a Latin cross and rarely does any architect venture to go back to the
rectangular box of the old basilica. There too, in northern and central
Italy, you will find the beginning of those side aisles constructed to
give extra support to the main walls that had to carry the roof. There

too you will observe the first of those rows of chapels which opened up from the apse (the semicircular space behind the altar) and which afterwards played such an important role in the Gothic style. Finally it is there that, by craning your neck, you can study the even more complicated system of vaulting with which the contemporary architects were struggling in their attempt to solve the problem of wider and more dependable roofs. How difficult this was and how unsatisfactory these roofs remained for a great many centuries is shown by the number of authentically recorded cases where such roofs fell in, killed a large number of worshipers, and forced the builders to begin all over again.

If you want names you will find some of the most interesting Romanesque churches in Pisa (eleventh century) and in Florence (San Miniato, also begun early during the eleventh century and remaining faithful to the older basilica model, as it is rectangular and not built in the form of a cross). In Lucca there is another cathedral in the Romanesque style but built a century later than that in near-by Florence.

In Milan, in the old land of the Lombards, there is the most famous of all the Italian Romanesque churches, that of San Ambrogio. Saint Ambrose, as we call him, was the bishop who had dared to close the doors of the House of God upon the Emperor Theodosius to express his disapproval of the brutal way in which that emperor (supposed to be a Christian) had exterminated the entire population of Thessalonica after a minor local riot. Yes, there were real churchmen in those days, and in memory of this courageous act the people of the twelfth century erected a Romanesque church on the very spot where seven hundred years before the good saint had baptized Saint Augustine.

At Verona, in the plain of the Po, is the church of Sant'Elmo and at Pavia that of San Michele where Frederick Barbarossa was crowned as King of the Lombards. In Sicily and all through southern Italy one also finds Romanesque churches which are a mixture of the Byzantine, the Roman, and the Lombard. These influences are completely absent in the Romanesque buildings of the Provence, for in the Provence, where the Roman influence had lasted longer than in any other part of Europe, the churches had all of them been built after the Roman pattern. The most interesting of these you will find at Arles in the church of St. Trophime, and farther west at Toulouse and farther north at Angoulême and at Vezelay and all over Normandy, where a decided Lombard influence is noticeable, due to

the fact that a native of Pavia was in charge of all of Normandy's monasteries during the eleventh century, and he, of course, worked with his own architects and according to his own plans.

From Normandy the Romanesque style crossed to England with William the Conqueror in the year 1066 and there it made itself felt (in a modified form, of course) in the cathedral of Durham and in all the subsequent structures built according to the so-called Norman style. In Spain the Romanesque soon fell under the influence of the

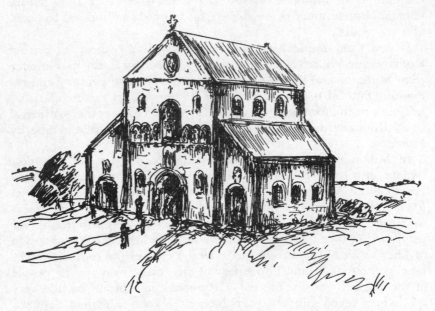

*In order to be truly appreciated, a Romanesque church should be seen standing alone and it should be seen from a distance . . .*

Moorish style and became something quite different from what it was in the rest of Europe. The church of Santiago de Compostela, which was one of the most popular shrines for the people of the Middle Ages and attracted pilgrims from all over Europe, was also one of the first churches to show what could be achieved by means of elaborate decorations consisting entirely of pieces of sculpture.

But some of the most interesting Romanesque churches are much nearer by. They are to be found in the valley of the Rhine, in Speyer and Mayence and especially in Cologne. One of these, St. Maria-im-Kapitol, was dedicated by Pope Leo IX a hundred years after the

Normans had burned down the original cathedral of Cologne. It stood on the ruins of an earlier church which in turn had been erected on the ruins of a very old Roman temple. Near by stands the church of St. Cunibert, completed only two centuries after St. Maria-im-Kapitol had been begun and built in a mixture of Byzantine and

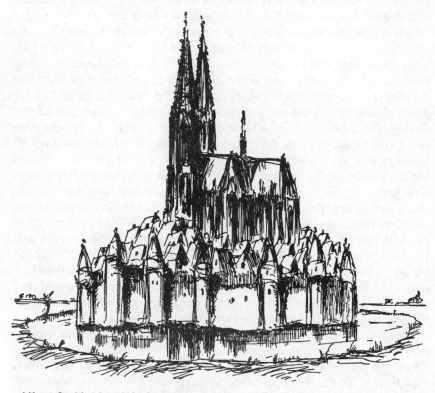

*while a Gothic church looks its best when seen from near by and surrounded by many other buildings so that you have to look upward in order to get a good view.*

Moorish. How that happened I don't know, but I have already warned you that definite periods of art are only to be found in the textbooks. In actual life, the architects and the artists never bother about them.

Remains the question which I am stressing in this volume: Can the Romanesque era give us anything which we ourselves can use? I doubt it. With all the great personal liking I have for the work of these early medieval masters, especially for the architects and sculptors, I fear that they speak a language we no longer understand. Of course, if

Europe should insist upon committing suicide, as it seems intent upon doing, we might have to pass through a second Middle Ages before we return to a civilized form of life. But we have made too much progress along every line to be able to get back to an age when man dwelt in perpetual unsafety, when he lived in an eternal fear of visible and invisible enemies. In all Romanesque art there is a certain element of nervousness which often lapses into the grotesque and which quite frequently gives concrete evidence of the cruelty and inhumanity so characteristic of that age of wholesale violence.

I realize that like all generalities this is only a half-truth and that there are many exceptions which seem to prove the contrary. The Wartburg, one of the few palaces remaining from the early Middle Ages, shows us what such a Romanesque castle in the heart of the European forests must have looked like. The lives of the people who spent their days in these halls cannot have been entirely uncivilized. Walther von der Vogelweide and his fellow minnesingers were men of sensitive feelings, far beyond those of their contemporaries. They were lyric poets of great delicacy and excellent musicians, as music went in those early days. But they were the exceptions, like Dante who wrote his tremendous *opus* among the narrow and evil-smelling little streets of the half-ruined city of Ravenna, forever surrounded by fishermen and peasants who were but little removed from the beasts of the fields. Or like Petrarch, singing of the glories of Rome in a town that had dwindled from a million inhabitants to a mere twenty thousand and where gangs of cutthroats would on occasion even attack the Holy Father himself and plunder him of all his possessions.

Meanwhile the vast majority of the people lived in abject misery, in poverty and squalor and sickness, all of them doomed to an early death, for only a few ever reached the advanced age of fifty and three-quarters of all the children died in early infancy. If you want any further proofs of the mentality of that age, think of the panic that spread all over the world at the approach of the year 1000 when (as most people firmly believed) Christ would come for the second time and the world would come to an end. Think of such mass insanities as the first Crusades or the final tragedy of that dreadful Children's Crusade, the failure of which (only a mere handful of those poor children ever returned to their homes along the Rhine) led directly to one of the worst epidemics of anti-Semitic riots and pogroms the world has ever witnessed.

It is true civilization never entirely disappeared from the face of the European continent, but the flame of enlightenment burned ex-

ceedingly low. Wherever we can catch a glimpse of it, we are pleased by the scene our eyes are allowed to behold. It is a scene of peaceful industry, like the nuns of Normandy embroidering the tapestry of Bayeux or of some learned cleric patiently teaching the mighty Emperor Charlemagne how to spell his name. But unfortunately such incidents were very rare in a world in which the hand of every man was lifted against that of his neighbor and in which abject piety was so closely intermixed with the most savage outbreaks of personal wrath that most of the time we do not quite know whether we are dealing with a saint or a maniac.

Yet with all its many faults and shortcomings, Romanesque art was the perfect expression of something that has since then completely disappeared from this planet—the ideal of a universal Christian church.

It was a magnificent experiment but it could only hope to be successful as long as all the people who took part in it belonged more or less to the same social and economic background—as long as the vast majority of the populace lived on the land and were possessed of much the same sort of peasant mentality. In Egypt where such conditions had prevailed for almost five thousand years and where the people had been peasants for fifty long centuries, neither society nor the arts had changed very noticeably from the beginning of their history until the end. But on the western continent, where the tempo of life was much more rapid than in the east, conditions did not remain static for more than a few centuries at a time. The moment the simple and uncomplicated rhythm of birth and death and sowing and harvesting was interrupted by the return of trade and commerce and a form of economy based once more upon money instead of barter, the Romanesque period was doomed to come to an end. The curtain was ready to rise upon the next act—the Gothic.

# The Provence

*The last stronghold of the ancient world becomes the rallying point for several of the new arts. The troubadour and the minnesinger begin to fill the world with their music and songs and once again we seem to detect the subtle influence of distant Baghdad.*

TO THE ROMANS it had always been "the Province."
Rome had had many provinces—by far too many—but only one Province. You will find it on your map by letting your finger run down the course of the Rhone. Where this rather useless stream loses itself in the Mediterranean, you will notice the city of Marseilles. Two thousand years ago it was known as Massalia. According to those who know about such things, that was the Phoenician word for "the Settlement." The Phoenicians had a trading post here which must have been very profitable, for the city of Phocaea in Asia Minor captured it as soon as it had a chance and made it a Greek town. When the Persians conquered Asia Minor, this colony was left to its own devices and thereupon began to found little colonies of its own all along the coast of what is now southern France, northern Italy, and eastern Spain.

Being an industrious as well as a restless people, the Phoenicians extended their trade all over northern Europe. Their coins show that they not only crossed the Alps and did business with the Tirolese, but that they also visited Africa and reached the mouth of the Senegal River.

During the Punic wars, the Massalians took the side of Rome, but when Caesar and Pompey fell out, they put their money on the wrong horse and as a result lost their freedom and were incorporated into that part of southern Gaul which the Romans called the Provincia Romana, of which Aquae Sextiae (where almost a hundred years before Marius had slaughtered the Cimbri and the Teutones) became the capital. The city still survives as Aix, an important town in the department of Bouches-du-Rhône.

Some five centuries later, when northern Gaul was conquered by the barbarians, the capital of this ancient province was established at Trèves or Trier, where there are some magnificent Roman buildings,

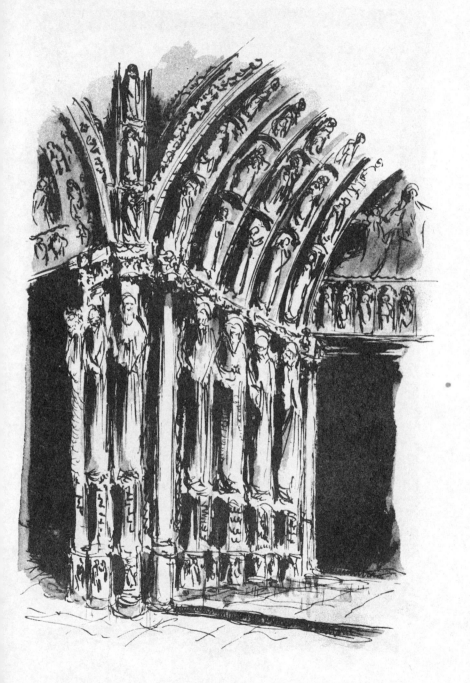

**GOTHIC SCULPTURE**

*The statues seem to have been streamlined. They have acquired grace and*

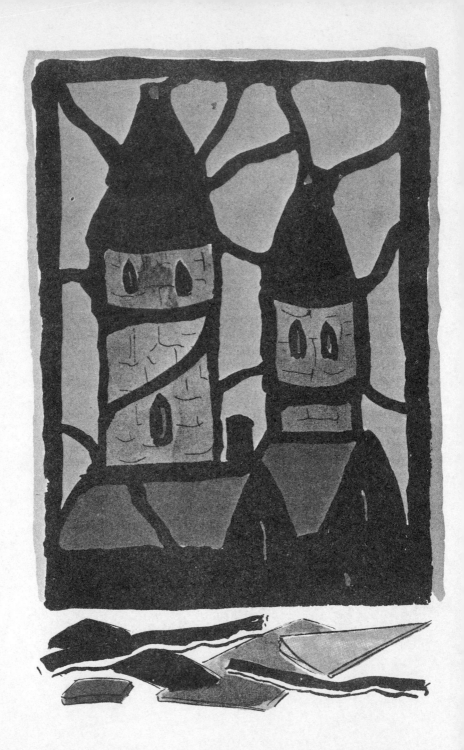

A STAINED GLASS WINDOW WHEN SEEN IN DETAIL

especially the so-called Porta Nigra, one of the few remaining Roman city gates.

It will always remain a puzzle why it was Rome rather than Marseilles which developed into the most important city of the Mediterranean. The town was infinitely better situated to engage in foreign commerce than Rome on its muddy and sluggish Tiber. It had a magnificent hinterland, while Rome had none. It had a better climate. It had every possible advantage but it always remained a second-rate town, while Rome conquered the whole world. I leave this problem on your doorstep and continue where I left off. For although the Provence never quite became the center of a world empire, it played almost as important a role by developing into an international experimental station for the arts and sciences of all the rest of the Mediterranean. It gained great fame for the excellence of its universities and its medical schools and for the pleasant and gracious way of living that survived in this little corner long after it had disappeared from every other part of the Roman dominions.

The fortunate geographical position of the country may have had a lot to do with this. The Provence was situated on the main trade route from western Europe to Asia and Africa. It was in regular communication with Constantinople. Its rulers were so highly regarded by the Byzantine rulers that they allowed them to marry their daughters. As a result, when the Crusades began, the Provence reaped so rich a harvest (for these poor pilgrims paid through the nose for everything they got, from transportation down to a drink of water) that their country almost overnight became one of the richest parts of western Europe.

Today when you visit the ruins of Les Baux it is difficult to imagine that once upon a time this was the residence of a family that ruled as kings over Jerusalem. And when you discover a little, sadly neglected garden at the base of that vast pile of stone, it takes all of your imagination to believe that once upon a time this was a Court of Love where the noble troubadours used to gather together to decide who could most eloquently sing the perfections of the lady of his choice.

And yet, that is the spot. Right there in that tiny garden one of the despised native dialects of the barbarians was given its first chance to compete with the official Latin in which up to then all literature and all poetry had been written. And right there, underneath the ancestors of these olive trees, the Provençals stoutly proclaimed their right to beauty, laughter, and happiness while all the rest of the world firmly turned its back upon the pleasures of a sinful world.

Remember Romanesque as something HORIZONTAL

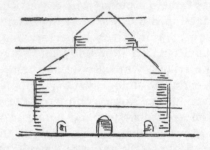

Remember Gothic as something Vertical

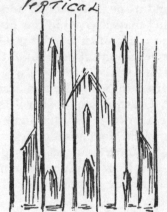

and Byzantine as something CIRCULAR.

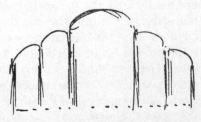

**A SIMPLE LESSON IN ARCHITECTURAL STYLES**

The Provencals never created an architecture of their own and they had once more disappeared from the historical stage when medieval painting came into its own. But they had erected themselves one imperishable monument in the most enduring of all materials, for they built in words.

Art is not something that hangs suspended in mid-air with no direct relationship with the practical affairs of the day. The economic stage must be carefully set before the artist makes his appearance, and that happened in the Provence long before it took place in any other part of Europe.

The Provençals were a simple and hardy race. Their fertile soil provided them with two very profitable articles of export, wine and olive oil, and these could be exchanged for foreign goods which in turn could be sold quite advantageously to the people of the hinterland. And so the merchants prospered and the peasants here were a great deal better off than elsewhere. The feudal chieftains were under no necessity to turn highwaymen in order to make both ends meet. They even enjoyed a certain amount of leisure and therefore became conscious of the boredom and monotony that were an inevitable concomitant of all feudal life, not merely in the one-room hovels of the serfs but also in the uncomfortable stone halls of the nobleman's castle. After their long hibernation they were eager for a little fun. So were their wives and so were their daughters, who became the first "emancipated women" of the Middle Ages.

During the early Middle Ages there had been very few games. Tilting and dueling were out-of-door sports. But gorging oneself with food and getting very drunk were about the only pastimes that could safely be played indoors. Music—which the Greeks and Romans had considered so highly that every civilized man had been supposed to be able to carry a tune—that same music had long since been converted into a monopoly of the Church, and one could hardly have expected the young men of the castle to spend a gay evening at home singing merry Gregorian chants. Besides, the Church would have regarded this as blasphemy and would have severely punished all those who had taken part in the performance. The game of chess was known but there were as yet no cards and the throwing of dice was not considered a suitable pastime for gentlemen unless they withdrew to the taverns to try their luck.

Therefore, when the troubadours made their appearance, their art swept across the Provence as the art of Johann Strauss swept across the world in the forties of the last century.

So far I have followed the usual pattern of the story as you will find it in every textbook. But I would now like to suggest that there may have been still a further influence which contributed heavily to make the Provence the country where the arts experienced their first revival.

The troubadours—the gallant, knightly singers of the Middle Ages —did not make their appearance from one day to the next. They were part of a much more extensive organization. They were an offshoot of the order of chivalry which just then was beginning to spread all over Europe. The professional soldiers had always had their own rules, their own prerogatives, and their own obligations. But chivalry had very little to do with the men who were merely fighters and nothing else. Chivalry stressed the duties of the knight, rather than his privileges. Because of his exalted position, chivalry demanded of him that he be conspicuous through his gallant, courteous, and generous behavior. These were words that had not been heard in the Western World for quite a long time and they bore a very decided resemblance to certain ideals that had been held in high honor among the knights who used to frequent the court of Baghdad in the days of the great Harun al-Rashid.

The Persian-Moslem culture of Baghdad had gradually found its way to Spain. One Moorish kingdom, of which Granada was the capital, had become a sort of European Baghdad. If things were ever done in a logical way in our world, this new and more agreeable way of living would thereupon first of all have been adopted by the Spaniards who lived in that part of the Iberian peninsula that still remained in Christian hands. But the Spanish knights of the Middle Ages were frontiersmen who had neither the time nor inclination to bother about such things. The Provençal knights, on the other hand, were free to do as they pleased. Only a short sea trip separated them from the harbors of Moslem Spain. To me it seems that they must have been thoroughly familiar with life as it was then being lived in the Alhambra. And I am firmly convinced that it was this Persian influence which gave the final impulse to their sudden and otherwise inexplicable outburst of interest in the higher things of life. It did not last very long, this glory of the Persians, only two short but blessed centuries, during which the minds of the people (both knights and peasants) were turned toward something of more vital interest than a quarrel between two feudal chieftains or the current price of Persian flax on the market of Marseilles.

The medieval chronicles do not tell us in what year the first of the

troubadours lifted his voice. But early during the twelfth century these men—"mighty sweet in their songs," as the contemporary scribes inform us—began to entertain their noble audiences with their pastorals and their laments and their political quips, most of which are now quite as meaningless as the bits of spicy local gossip which Dante wove so casually into his *Divine Comedy* but which were tremendously popular among the people of that time.

Now, such songs of theirs as we have been able to reconstruct sufficiently well to give us at least some sort of idea of what they must have sounded like do not exactly inspire us with a feeling of hilarity.

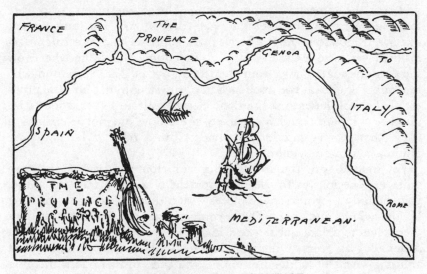

THE OLD ROMAN PROVINCE

This could hardly be otherwise. We have been spoiled. We have heard too much since then and too much that is better. But that should not make us think the less of these first attempts to give the world something a little more cheerful than a Latin psalm or a Gregorian chant.

William IX of Poitiers and Duke of Aquitaine is the earliest of the troubadours about whom we have a few definite facts. The names of the other troubadours, too, read like a page in the *Almanach de Gotha*. Of Richard Coeur de Lion's career as a troubadour, even schoolboys know the inspiring details. Several of his colleagues we meet in Dante's *Inferno* and regardless of their misdeeds that got them there, they are given high praise for the perfection of their performances and the sweetness of their poetic thoughts.

In our modern world the words "troubadour" and "jongleur" are often very carelessly used, as if the two had been the same. The people of the twelfth and thirteenth centuries would never have made such a mistake. The troubadour was the gentleman who spoke or sang his lines. As a rule the jongleur was the man of common birth who accompanied him on the lute or some other instrument. Today the accompanist is the social equal of the singer or fiddler, but in the Middle Ages he was not. His status was more or less that of the piano tuner, who now accompanies the virtuoso on his special train and who tunes his instrument for him before he plays, but who is not supposed to dine with him in his private car.

It was the same in Germany among the minnesingers, who were the Teutonic equivalent of the French troubadours. The minnesinger, like the troubadour, might be his own composer and as a rule he set his own verses to a tune of his own invention. But those who know their minnesingers only from the second act of *Tannhäuser* and who remember Wolfram von Eschenbach busily strumming his little property harp, will have to revise their ideas. Wolfram left that job to his hired accompanist and most likely the fellow did not even play a harp (then a very inferior instrument) but a rebec, which was the grandfather of our violin.

Yet in one way the troubadours contributed greatly (although quite unconsciously) to the development of a more modern music. Occasionally they also spoke pieces with a refrain that could be sung by the whole audience. These compositions not infrequently lent themselves to a dance or *balade*, which is the same word as our modern ballet. But as every audience will eventually tire of even the most amusing forms of lighter music and will then insist upon something a little more substantial, the troubadours also tried their hand—and quite successfully—at those *chansons de geste* which had come to them from northern France and in which the adventures of some famous hero were presented with a great deal of glamour but also with such a complete indifference to the actual facts that they remind us very much of a modern historical movie.

As for their humbler companions, the fiddlers and dancers and jugglers and animal trainers and mummers who soon began to follow in their footsteps, these too played their part in the development of our modern theater. At first they were attached to the castles of some rich baron (either in France or England) where as menials or ministerials (our word "minstrels") they were supposed to entertain his lordship's family. But in due course of time they set out for themselves

and began to do the country fairs, amusing the farmers and their wives as formerly they had done their best to give pleasure to their less humble employers. They were (as they still are) bright and alert fellows, ever ready to try their luck when some new field of entertainment seemed to offer a better opportunity to make a few pennies. They became actors when the theater once more made its reappearance. They became musicians when the different cities organized their civic bands. Or they remained strolling minstrels and eventually drifted into vaudeville. There many of them still are in England. They came to that country in some such capacity with William the Conqueror. They bid fair to survive the movies. Surely theirs is an old and honorable profession.

As the Provence had become the most civilized part of the Christian world, ahead of any other part of Europe, it follows that its people were among the first to insist upon their good right to think occasionally for themselves. That led to their downfall. By the end of the twelfth century it was generally known that all was not well with the people of southern France. Under the lax rule of their artistic rulers they had dropped into several most abominable heresies. What these heresies were would hardly interest us today, for dead heresies are as completely unimportant as dead love letters. But they were of vital interest to the religious world of the era of the Crusades.

In the year 1207 Pope Innocent III preached a crusade against the people of Albi. Innocent III was a great specialist in crusades. He not only organized them against the Mohammedans in the east but also against the Letts in the north, and finally against the English. In this case King John was only able to save himself by consenting to accept both England and Ireland as a fief from the Holy See.

Against this stanch defender of the claims of the Church, who in a letter to the Patriarch of Constantinople dared maintain that the Lord had left to Peter not only the guidance of the Church but also of the whole world, the poor people of Albi were completely helpless. In one of the most ghastly butcheries of the Middle Ages these French heretics—these "pure souls" or "true Christians," as they liked to call themselves—were almost completely exterminated. For a while the Inquisition was busy burning as many as two thousand a day. The Provençal nobles, who on the whole had sympathized with the views of their subjects, paid bitterly for their rashness in supporting the enemies of the Church. Their lands were laid waste by the mercenaries of Simon de Montfort and they never recovered from this blow.

The troubadours seem to have avoided very carefully getting them-

selves entangled in the religious disputes of their day but they lost their patrons, for the castles had been burned down and the noble families had been sold into slavery to the officers who commanded De Montfort's crusaders.

The last of the troubadours died in the year 1294 at the court of Alfonso the Learned, King of Castile, who not only composed excellent astronomical tables but who elevated the Castilian dialect to that literary vehicle which it has remained until our own time. When this last representative of a great artistic tradition felt his end approaching, he said, "Songs should express joy. But too much sorrow oppresses my soul to let me sing. Alas, I came into this world too late." He was neither the first nor the last of the poets and musicians and painters who have felt that way.

# Gothic

*A beautiful fairy story in an ugly world*

GOTHIC ARCHITECTURE was the logical result of the search for more light and greater space. But the art of that entire period to which we refer as the age of the Gothic was really an effort to create a lovely fairy story in the midst of surroundings that were too brutal to be supported without some spiritual means of escape.

Our ancestors did not see it in exactly that light. Giorgio Vasari, the famous Italian architect and a painter of considerable merit, expressed himself about as follows:

"These Goths" (all the people who dwelt across the Alps were Goths to him, or "Huns," as we would have said a few years ago)— "these barbarians, untutored in the true classics, have evolved a style of their own which is a mere hodgepodge of spires and pinnacles and grotesque decoration and unnecessary details which are completely lacking in the simple beauty of the classical world."

So much for what one of the best-known pupils of Michelangelo had to say upon the subject. But how about ourselves? I am afraid that we have gone much too far the other way. For there still seems to be a large number of people (including many architects who really ought to know better) who associate Gothic with either religion or scholarship and who therefore insist that a church is not really a church and a college is not really a college unless they be built the way Oxford and Cambridge were built in the fourteenth and fifteenth centuries.

This, of course, is just as absurd as the idea that all modern dancers must hold their feet at an angle of ninety degrees from each other because that was the way the feet had been held by those Oriental dancers who had inspired the Italian ballet, which Catherine de' Medici introduced into France to distract her son from his somber meditations upon the Massacre of St. Bartholomew.

"Everything in its own time and in its own place" may be a platitude but not when it comes to the arts. To cover a modern library, built out of steel and intended to provide as much light and space as possible to both the books and the readers, with a stucco layer of imitation Gothic until it looks like a wedding cake for one of the best

families in one of the Italian suburbs is, of course, one of the absurdities of the age. For there is no need for us in the year 1937 to erect houses and libraries with small and pointed windows and enormous buttresses which buttress nothing at all and which, like the extra smokestack on some of our modern ocean liners, are only used as broom closets or dog kennels, while the architect of the thirteenth and fourteenth centuries had to build that way or not at all. Architecture, in order to be sound and pleasing, should be the result of some absolute necessity. The Gothic architect was given a practical task. He was asked to solve his problem as best he could with the means at his disposal, and he did solve it brilliantly. Above all things, he solved it in the most practical way possible. He therefore was a first-rate craftsman. But the architect of A.D. 1937 working in the style of A.D. 1237 is merely an imitator and a bad one at that. For the Gothic style, which first made itself manifest during the second half of the twelfth century, was a product of its time and that time was one of the most interesting eras in all Western history.

While in faraway Asia an unknown people were laying the foundations for that mysterious temple of Angkor Wat (which far surpassed anything the Europeans had ever tried to do until then), the western continent was at last returning to a semblance of that law and order that had been the keynote of the civilization of the Roman Empire. The Crusades, the last manifestation of that great restlessness that had been so characteristic of the period of the great migrations, were coming to an end. Both Christians and Mohammedans had accepted a stalemate, with the advantage slightly on the side of the infidels. The destructive energy of the Norsemen, from whose fury the people of the seaboard had prayed to be delivered during so many centuries, had run its normal course. Those sea rovers had either been killed or had settled down as the highly respectable rulers of a number of European states, as kings of England or dukes of Sicily or of Normandy or as lords of some short-lived principality in Greece or on the outskirts of the Holy Land.

The Moslems were no longer a menace to the safety of the mainland except along the far eastern frontier, where the Byzantines were engaged in their final struggle with the Turks. But what was happening in Constantinople in the thirteenth century was of absolutely no interest to anybody in the western half of Europe.

Austria (the Eastern "Mark," as the name itself implies) had been founded for the special purpose of keeping both the Slav and the Mohammedan out of central Europe. As long as Vienna was not threat-

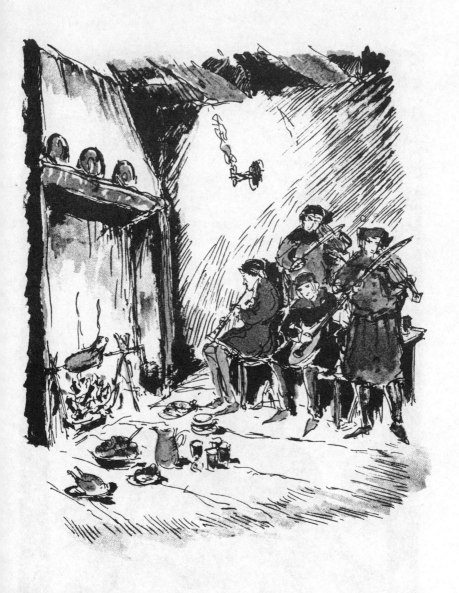

*The beginning of our modern orchestra. Jongleurs improvising a little concert
while waiting for their dinner to get ready in the kitchen.*

THE MINNESINGER

ened, nobody cared what happened beyond the plains of Hungary or the mountains of the Balkans.

The fleets of the Hanseatic League were beginning to make the Baltic and the North Sea once more safe for international trade and their commercial integrity was so great that the people of England adopted the "pound easterling" as the standard coin for all their dealings with the rest of the world.

The mountain passes of the Alps were still carefully avoided by all good Christians. But some time previous to the year 1000 St. Bernard of Menthon had erected a house of refuge on top of the pass later called after him and so northern and southern Europe were no longer separated from each other by an unsurmountable barrier of snow-clad mountains.

All over Europe there was the stirring of a new life. It is true all that was only a beginning and that much more would be accomplished during the sixteenth and seventeenth centuries. But the average peasant at last ceased to be merely an earth animal. He once more became a human being and the experiences of the recent past were beginning to show him that he could only hope to maintain his newly regained dignity by means of co-operation. The twelfth century, therefore, was the great era for the city builder and for the organizer of those associations of fellow craftsmen which as guilds were to play such a very important role in the political developments of the next five centuries.

During the twelfth century we therefore witness the first reappearance of a sort of architecture intimately associated with the civilization of the city, just as the Romanesque had been the product of an agricultural society in which the city had played practically no part.

There used to be a charming myth that the Gothic cathedrals with their high pinnacles and their tall columns had been constructed in direct imitation of those forests in which the Teutonic invaders of Europe had spent so many years of their lives. The invaders of Mesopotamia three thousand years before, having only recently left the mountains of central Asia, were said to have built themselves their Babylonian towers because they had felt that one could only worship one's Gods from the top of a hill. By the same process of reasoning, the historians of art of a few generations ago had the people of the early Middle Ages construct churches with high, vaulted windows to surround themselves with the atmosphere of their ancestral forests. I am afraid that the reason for this form of architecture was a much more practical one. Less poetic, but much more practical.

Today in our modern cities, economic necessity (the cost of real estate) forces us to erect skyscrapers. In the Middle Ages it was the effort to combine a maximum of safety with a minimum of expense that made the feudal families of Italy live in houses that were towers and that obliged these honest burghers to construct their churches on the well-known skyscraper plan.

City walls cost a lot of money. So did city moats. The surface of the city therefore had to be as small as possible. And this again reacted upon the space available for the cathedral.

Now I hope that there is at least one idea I have made quite clear in what I have told you so far. Every work of art is the direct result of some human ideal. And human ideals have undergone certain very subtle but very profound changes during the last two centuries of the Romanesque period. I find it very difficult to explain these changes in just a few simple words, for the inner soul of medieval man is quite as much of a closed book to me as that of the cave dweller. But let me try to express it this way:

The actual world in which the people of the Gothic world lived was really not so very different from the world of the ninth and tenth centuries. Undoubtedly there was a greater degree of safety. There was a little more prosperity. But might still defied right, as it is still doing today and as it will do for a great many more centuries to come. The ignorance of the masses was still as complete as it had been since the Roman and Greek philosophers were forced to close the doors of their schools and academies. Epidemics continued to depopulate entire countrysides and the belief in spooks and devils and evil spirits still dominated the minds of even the most enlightened scholars. And yet there was a difference. The troubadours and minnesingers had shown that there was a difference. A somewhat lighter touch in all matters spiritual and a greater gaiety in the general attitude toward life were undoubtedly making themselves evident in a hundred different ways.

Often when words are inadequate, music will help us out. Wagner in his transformation scene between Acts I and II of *Parsifal* comes about as close to making me feel that dreadful weight of a mysterious doom that lay so heavily upon the soul of the man of the Romanesque period as anything else of which I can think just now. The little tune played by the shepherd boy in the second act of *Tannhäuser* would then represent the Gothic feeling. Of course, neither of these two compositions is in the Gregorian mode, which would make them even more authentic, but play them both on your phonograph and I think that you will have a better idea of what I mean than if I merely

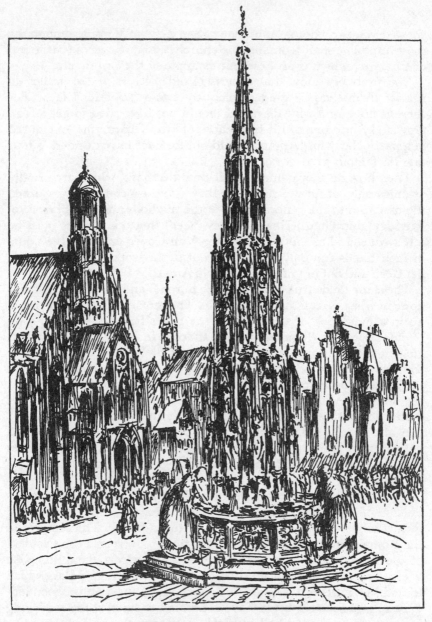

A MEDIEVAL MARKET PLACE

showed you two photographs, one of San Zeno at Verona, among the most imposing of all Romanesque churches, and one of the cathedral of Chartres, which is an excellent example of the Gothic era.

You probably know that experts in old pictures or old fiddles do not let themselves be guided solely by a few "scientific" facts. For there is no reason why Ruysdael should not have tried to get a Van Goyen sky into one of his landscapes or why Guarnerius, enamored of a particularly fine Amati, should not for once have decided to imitate his famous predecessor.

Then how do they come to their final decisions, which are usually astonishingly accurate? Because they have so completely worked themselves into the general spirit of the methods and mannerisms of Ruysdael and Guarnerius that they "feel" that this picture must be a Ruysdael and cannot possibly be a Van Goyen and that the fiddle in their hands can only have come out of the workshop of Giuseppe del Gesù and not out of that of Nicolò Amati.

The same holds true of all Gothic churches and all other buildings done in what we call the Gothic style. The moment the subject comes up in a handbook of architecture, the pages begin to be filled with references to the "pointed arch." Indeed, in many European languages, Gothic is actually referred to as the "pointed arch style." This was partly true, for the Gothic builders, under the influence of the Moslem builders, got definitely away from the barrel vaults and the domelike vaults of the Romanesque stonemasons. They did not bother to imitate the domes of the Byzantine architects and finally they also succeeded in working out the plans for a pointed vault which not only gave a much lighter, a much more airy effect to their churches but which allowed them to give a much greater height to their cathedrals.

But in trying to overcome the difficulties that faced them by introduction of the pointed vault, they were merely continuing what the Romanesque architects had started centuries before. The builders of the Romanesque period had already tried to overcome the problem of the heavy walls that were necessary to support their domelike vaults by letting the four vital points of contact rest on pillars which looked like parts of the walls but which really lived an independent existence and which would have continued to support the roofs long after some earthquake had suddenly destroyed the walls proper.

The Gothic architects now went several steps further. They began to think solely in terms of pillars and then afterwards erected their walls just as we today first of all erect the skeleton of a steel skyscraper

and then cover this skeleton with the necessary walls, which, however, bear so little resemblance to the original idea of a wall (that had served only one purpose—to support the roof) that we may start our wall making at the top floor and then work our way downward.

Having successfully accomplished this purpose, the Gothic architects thereupon reduced the walls to something which we might call "window containers," for quite often (for example, in the incredibly lovely Sainte Chapelle in Paris, built in 1246 for St. Louis of France) it looks as if the walls, or what little remains of them, were merely convenient window frames and nothing else.

The pillars of a Gothic church were therefore the most important part of the entire structure. In order to strengthen them still further the architects of the twelfth century once more borrowed an idea from their Romanesque colleagues. In the Romanesque church, regular side aisles had been added to support the walls of the main structure. The Gothic architects in their search for a vertical streamline effect invented the so-called "flying buttress" or "pusher." The flying buttress by pushing inward then relieved the supporting pillars from the outward thrust that was exercised by the heavy stone roof. Have you ever leaned against the wall of a small wooden shed and heard someone say, "Oh, look out! The roof is coming down!" If you have, then you will know how it feels to be a flying buttress.

Sometimes in their desire to go higher and higher, the Gothic architects arranged for a double set of flying buttresses, as you may see in Reims where those double flying buttresses saved the building when it was exposed to a German bombardment during the Great War. Let me observe, however, that the idea, still held by a great many people, that these unknown medieval architects were master builders who possessed some sort of secret formula which allowed them to build for all time—let me observe in all humility that these Gothic masons took very dangerous risks and that in a great many cases the results of their work were far from satisfactory.

The average Gothic cathedral resembles a monstrous animal whose skeleton is all on the outside. When something—the least little tiny thing—happened to that skeleton, the creature collapsed. Even today the few Gothic churches that have survived the ravages of nature and gunpowder demand infinitely more attention than the less inspiring but much more solid structures of the Romanesque period. They are forever in need of being repaired. The chronicles of the fifteenth and sixteenth centuries are full of accounts of the terrible disaster that befell such and such a country when on All Saints' Day of the year 1486

or on Epiphany of the year 1571 during a thunderstorm the whole of the choir or part of the roof came tumbling down upon the congregation and killed hundreds of people.

But, as I have said before, art should never try to be immortal, for nothing can hope to be immortal in a universe which itself seems bound to a definite time limit. While very few Gothic churches were ever actually finished (for either the necessary money or the necessary enthusiasm or both of them at the same time gave out long before more than half of the building had been finished) and while even those, like the Cologne Cathedral, that are now admired as "perfect specimens of Gothic" were in reality finished during the last century (when the necessary cash was usually found by means of a cathedral lottery), these buildings, at the pinnacle of their glory and usefulness, must have been a sight to make people feel that they had had a glimpse of Heaven itself.

I am thinking more especially of those Gothic churches in which the side aisles were made of equal height with the nave (the *navis* or "ship," the central part of the building) and in which, due to a clever trick of the original architect, one can find a few spots from which it looks as if all the pillars had suddenly disappeared. In such houses of worship, bathed in the mysterious light that filters through thousands of little bits of colored glass, one suddenly comes face to face with a fairy story of such charm and beauty that it may well have compensated the people of that age for all their manifold sufferings in this most lamentable vale of tears.

And here I have touched upon another detail that goes toward the making of a truly Gothic interior. I mean the windows. With the disappearance of so much of the regular wall space, the painter no longer had yards upon yards of a flat surface upon which to practice his trade. At first this was greatly resented by the members of his craft, but in the end it proved to be a godsend to the art of painting. For deprived of his familiar stone walls and forced to discover some other substance upon which he could express his ideas, the painter now began to play around with wood and parchment and canvas, until finally after several centuries of highly unsatisfactory experimentation, the inventive mind of the brothers Van Eyck of Ghent solved the problem by mixing their pigments with oil, a method which has maintained itself to this very day.

And, furthermore, the painter's loss proved the glass burner's gain. I am using this ancient expression for a variety of reasons. It has a nice sound, it tells half of the story of the process of making stained glass,

and it seems to carry us right back to the Middle Ages when all the artists who worked in steel and brass and copper and iron (and they were then very important personages) depended so greatly for their success upon their furnaces.

Technically speaking, stained glass is plain window glass that has been colored either by mixing some metallic oxide into the glass or more usually by burning some pigment into the surface of the glass itself. These little pieces of colored glass are thereupon put together by means of bands of lead until they form a definite pattern or picture. They therefore bear a closer resemblance to mosaics than to painted pictures, but they are really quite different from both of them in their ultimate purpose. The glass burner must avoid arranging his colors in such a way that the interior of the church is filled with unconnected blotches of green and yellow and red and purple. He must blend his colors so skillfully that the effect is one of an agreeable diffusion, something like the atmosphere which you will remember from having dived into the ocean on a sunny day.

In one particular way the glass burner had to solve a much more difficult problem than the painter. The windows on which he had to work were very narrow and it was therefore impossible to bother about such details as perspective. This did not greatly matter during those many centuries when our ancestors were still as ignorant of the laws of perspective as the Chinese and Japanese. But later on when the public had learned to look at pictures from the angle of perspective, this gave to all stained glass windows a certain air of "primitiveness" which was quaint rather than entirely pleasant.

Like so many of the other "inventions" of the Middle Ages, stained glass windows were really of Oriental origin, but when they were first introduced into northern Europe, that we do not know. Venice, still a center of the glass industry, seems also to have made the first stained glass windows and that must have happened sometime during the tenth century. The oldest surviving pieces of stained glass are to be found in the cathedral of Augsburg but they do not go further back than the middle of the eleventh century. A short time later there were stained glass windows in the church of Le Mans, a French town not far away from Chartres. And still a few years later they had reached England, where some of the oldest glass is to be found in the cathedral of Canterbury.

This innovation must have been very popular, for it spread all over Europe, and with great rapidity when we remember the difficulties and the risks involved in transporting such treasures, then worth their

weight in silver. But of course the stained glass window filled a highly practical purpose and it was something for which the world had been waiting for centuries.

Glass was still so rare and so expensive that the average castle and private house could not boast of a single glass window. The windows were merely holes in the walls, covered over at night by means of wooden blinds or the skins of animals. As everybody got up with the sun and went to bed with the chickens, this did not interfere very seriously with the daily lives of most of the people. In an age that knew neither chimneys nor forks, such a trifling inconvenience as a drafty sitting room can hardly have been noticed. Should you be curious to know how it must have felt to a person accustomed to a little more comfort, just spend a few hours in an unheated Italian cathedral on a cold day in January.

The development of the Gothic style gave, of course, an enormous impetus to the glass industry, for there was a sudden demand for more and more glass. Some of the colors, especially the very popular ruby-red, were almost exorbitantly expensive and hard to get. When finally the Gothic architects not only filled their side walls with enormous windows but boldly removed the entire center part of the front wall to make room for a large round rosette of glass, the workshops of the glass burners had to work day and night to supply the demand and these craftsmen experienced a boom which they have never again enjoyed.

But so did the stonemasons and the wood carvers and all the other artists who were working on these cathedrals. For there never has been such a passion for building as in those days. It was no longer enough for a young craftsman to know only that which he could be taught at home. He must spend many years as a wandering apprentice. Let him hear of a new architect in Cracow or in faraway Trondhjem and at once he must pack his bags and take his tools and his notebooks, to wander leisurely from Poland to Norway and to observe on the way what was being done in Prague and Leipzig and Wittenberg and Lübeck and Stockholm. If he was lucky and survived shipwreck and pestilence and came safely back to his own family, he thereupon incorporated everything he had learned into the style that happened to be most pleasing to his fellow townsmen. As a rule he was quite content to lose himself in his task for the rest of his days, receiving the wages of a mere stonemason and not being particularly aware of the great service he was rendering the cause of art. Being human, he wanted his share of glory and immortality, but he achieved his ambi-

tions in a different way from what he would have done today. It went into his labors for that cathedral which was the visible expression of the spiritual aspirations of the entire community. Afterwards when their city grew more prosperous and the guilds or some merchants' associations grew rich enough to contemplate the erection of some buildings of their own, a town hall or a weighing house or a corn exchange or an assembly hall for the clothiers or the drapers or the brewers, they sent the brightest of their young men to make preliminary studies all over Europe. Judging by the results, this system that insisted on a very long and very thorough apprenticeship was extremely effective.

What religion alone had not been able to do, the arts accomplished. They made the people of Europe internationally-minded. Of course, nations in our sense of the word did not yet exist. One was still the citizen of the village or town or country in which one happened to have been born. The emperor or king lived far away and one might spend one's entire lifetime in a given spot without ever coming in touch with them. But even so, there were certain differences in the languages and in the dialects the people spoke and in the manners and customs and in the things they ate or drank, for was not a wine drinker the very antithesis of a beer drinker? But the common feeling of being engaged in a mighty task gradually overcame those nationalistic prejudices that are making life in our own days such a disheartening affair. There arose an internationalism of the spirit that Europe was to see only once more during the latter half of the eighteenth century. But that time it was based upon a common interest in certain philosophical ideas, whereas during the Gothic period of the Middle Ages it had its roots in a common interest in the arts.

And then something happened. Something very sudden and very unpleasant and something nobody had been able to foresee. Millions of people were taken sick with a mysterious illness. The leeches, who had really no idea what it was, called it the Black Death. As far as our modern physicians have been able to reconstruct it from the vague descriptions the contemporary authors, such as Boccaccio, have left us of this "great mortality," it was a form of the old bubonic plague. The Crusades, among many positive blessings that they had brought with them from the East, had also presented Europe with leprosy, scurvy, and the influenza. The Black Death, too, seems to have come to Europe from Egypt or Palestine or Asia Minor. Venice felt it first of all and tried to stop its progress by subjecting all foreign vessels to an enforced period of isolation of forty days, a so-called *quarantaine*. But the plague bacillus laughed at such little obstacles.

Soon afterwards it made its appearance in Marseilles and from there it swept all over Europe, killing more than sixty million people or one-fourth of the total population of the Europe of that day. It was the worst epidemic Europe had ever experienced, for it did not really come to an end until the end of the seventeenth century when the last of the pesthouses, which were to be found in every city and which appear on so many contemporary pictures, were finally discontinued.

While the disease lasted there was no means of escape. Panic-stricken parents hired boats, loaded their children on board, and sailed away from dry land. The next day all of them were dead. The churches were open day and night, but there were no priests to officiate. They, too, lay dead. Fear affected people's minds. Some withdrew into the wilderness to spend their last few days in prayer. Others, like Boccaccio and his friends in the *Decameron*, withdrew to a pleasant country house and decided to eat, drink, and be merry until their last hour had struck.

The painters of that period, in their gruesome dances of death, give eloquent evidence of the general disorganization. When the sickness finally began to lose some of its virulence, whole regions remained for years without any inhabitants, and an entire continent, Greenland, was definitely forgotten so that several centuries later it had to be discovered all over again.

The arts suffered, perhaps, most of all. The feeling of universality that for a short while at least had predominated in the minds of men was destroyed. The greater part of the older artists and apprentices had been thrown into some mass grave outside the city walls. Century-old traditions had been broken and in an age without books, the oral tradition was the most important of all teachers. Slowly the few surviving architects and masons and painters and stonecutters went back to their interrupted tasks. But there was an end to their merry and instructive *Wanderjahre*. One played it safe now. They no longer dared to travel. They stayed at home and from that moment on the Gothic style ceased to be a universal European expression of the will-to-create and became either definitely French or Swedish or Austrian or German.

In one other and very important manner did the Black Death make itself evident in the artistic development of that day. That was in the matter of the people's dress. Until the twelfth century the old Roman tunic had continued to be worn all over Europe, except that trousers, which the Romans despised as a barbarian invention, were added for greater protection against the cold. Buttons or "pushers"—the same root as the word "buttress"—were ornaments but were

never used for practical purposes. One climbed into one's garments as all of us were in the habit of climbing into our shirts until some thirty years ago, and these garments were almost the same for both men and women, for men continued to wear long cloaks that resembled skirts.

During the craze for the vertical streamlines of the Gothic period, a craze that affected every department of life and not only made itself evident in the pointed arches of a cathedral but also in such simple household utensils as forks and saltcellars, the looseness and flabbiness of these older garments gradually became to be regarded as something as outdated as a model-T Ford in 1937. And since fashion dominates the lives of both men and women much more rigorously than law, their costumes underwent a complete change. They grew tighter and tighter until at last it was no longer possible to put on one's coat or dress by slipping it over one's head. It was then that buttons finally came into their own. That was also the period when the coats of the men became shorter and shorter so that from that moment on there was a definite difference between the sexes, as you will notice in all pictures of the latter half of the fifteenth century.

The return of prosperity during the beginning of the Gothic period which I mentioned at the beginning of this chapter permitted the townsfolk to indulge at last in much richer materials than they had worn for centuries. Judging by the contemporary miniatures, yellow and brown were not at all popular. Gray, which did not so easily show dirt, was the color for the poorer classes who even today in many parts of Europe are derisively known as "the gray ones." Persian and even Chinese patterns were beginning to make their appearance, and people paid fabulous prices for the famous gold brocades of Baghdad.

Came the Black Death. So many people suddenly died that enormous wealth suddenly accumulated in the hands of a few people who until then had hardly been able to call their shirt their own. These unexpected riches which all too often inspired the new owners to make themselves as conspicuous as possible led to an outbreak of a number of fashionable follies which gave the entire latter half of the Middle Ages that strange air of a perpetual masquerade which is so fascinating a part of all the paintings of that time. After everything possible had been tried to give the gowns and the headgear of the women and the dresses of the men as exaggerated a shape as possible, there followed a number of years when both hose and coats were green on one side of the body and red on the other or were given some other strange combination of colors, such as is still worn by the Swiss Guards of the Pope.

After sleeves that reared toward heaven like church spires, shoes, the last part of the costume that had so far escaped, were taken in hand. These shoes, made out of a soft material, grew longer and longer until finally it became necessary to fasten the tips to the wearer's knees in order that he might be able to walk at all. Those who wanted to be really well dressed went even a little further and had their shoes embroidered with pictures of saints or they copied the stone traceries that were to be found on the façades of the churches. Priest and bishop loudly fulminated against these follies, as today they fulminate against shorts and backless bathing suits. But alas, against the fashions even the Pope himself proved to be powerless, and it was only when reason reappeared during the days of the Renaissance that there was an end to these excesses.

As a final outburst of this craze for conspicuous waste, I might mention the silver bells which were sewn all over a man's coat and hat, so that he tinkled pleasantly when he went from place to place. These little bells still survive, for ever since they have remained an integral part of the costume of the court fool.

That noble office has unfortunately been discontinued, for the court fool disappeared together with the age of the Gothic. But what has not disappeared, indeed what you can still see if you go to France, to Belgium, or to Holland, is that strange architectural exaggeration which we know as the Flamboyant Gothic style. Once a certain craze becomes popular, there is nothing you can do about it. It is easier to stop an epidemic than a new fashion. A few years ago our automobile manufacturers, in order to get the natives interested in a new idea and to make the owner of last year's car look a little ridiculous, invented that most uncomfortable of all modern instruments of torture, the streamlined car which you are forced to enter crouching snakelike on your belly. The streamline may have offered certain practical advantages to the man who flies an airplane because it allows him to go perhaps two hundred miles an hour instead of merely one hundred and ninety. But the average car moving perhaps at a pace of thirty miles an hour hardly needed that exaggerated outline. But the new streamlined car was a success. We still have it with us. Since then we have had streamlined iceboxes, streamlined forks and spoons, streamlined typewriters and dictaphones, streamlined radios. Newborn babies are about the only things that have not yet followed suit but they get their daily airing in streamlined perambulators. This is the age of the streamline and therefore streamlined we shall be until some clever fellow invents something new that is triangular or octagonal.

In the same way, once the people of the Middle Ages started out to go in for exaggerations, they had to pull everything out of shape until it had become a caricature of its former self. Already during the beginning of the fourteenth century (and even a few years before) we notice a tendency to magnify and stress certain details of Gothic ornament until these details threaten to become more important than the basic outlines of the building of which they happened to be a subordinate part. You can observe this change in the cathedrals of Amiens and Rouen, in parts of the cathedral of Chartres, and in the well-known church of Mont-Saint-Michel, which have assumed the "flamelike qualities" that gave the new style its name—the Flamboyant or flamelike Gothic.

Civic buildings and castles were less often erected in the Flamboyant style because the invention of gunpowder and the introduction of heavy artillery had introduced a new peril which the contemporary architects did not dare to overlook. But the Flamboyant style entered into every detail of the builder's art because it was entirely in keeping with that strange and unreal attitude toward life that had followed in the wake of the Black Death. It therefore satisfied the esthetic needs of a people who for almost eight centuries had been completely satisfied with the simple and straightforward lines of the Romanesque and the early Gothic.

The Church authorities might, I suppose, have done something to discourage the new style had they seriously disapproved of it. But the Church as a social and spiritual organization has always been part of life and most wisely has refrained from keeping itself aloof from the everyday existence of the average man. And so no edicts were issued that interfered with those crazy quilts of stone and mortar. For almost two entire centuries Flamboyant towers continued to rear their grotesque pinnacles toward the high heavens. Then the craze spent itself. The pretty fairy story gave way to a grim tale of reality. The Gothic style no longer fulfilled a practical purpose. And since all art, in order to flourish, must be a material or spiritual expression of a concrete need, Gothic no longer had any reason for being.

When that happens to an individual, the individual dies. When that happens to a certain specific style, it does exactly the same thing.

We still find a few Gothic churches built after the manner of the fifteenth century. But they become rarer and rarer. Finally they disappeared altogether. A new generation with new ideas and new ideals began to wonder why they had ever been built at all.

# The End of the Gothic Period

*The emancipation of the artist and the appearance of several new techniques within the field of the pictorial and audible arts*

THE ART of the first six hundred years of the Middle Ages was an anonymous art. The architects built anonymously. The painters and sculptors and miniature makers never bothered to sign their works. It is difficult to imagine such a state of affairs in our age of exaggerated publicity when we build vast and complicated reputations around a name and when it sometimes looks as if painters invariably begin by signing their canvases and then add the picture later as a sort of afterthought.

Today the main purpose in the life of every cub reporter is to get his stuff signed, though it may only be the story of a dog fight or a speech by a candidate for the town council. But the men responsible for the *Nibelungenlied*, the *Chanson de Roland*, the Eddas or the tales of King Arthur have left scarcely a trace of their existence in any of the contemporary chronicles. They were content to provide their neighbors with five hundred years of entertainment and asked for no further honor.

Most of the artists of that day worked either directly or indirectly for the Church and we are therefore apt to attribute their anonymity to a becoming sense of humility. That may have had something to do with it but that was by no means the only reason.

In the first place, few of these men had a surname of their own. Even in Chaucer's day it was not the custom for the common people to be known otherwise than as George of the Algonquin or Alf of Kansas. In the second place, once their apprenticeship had come to an end, most of these artists hardly stirred from the city or the monastery in which they were employed. And everybody there and for miles around knew all about them and about their work. In the third place, life was simple and those good craftsmen had no fancy notions about their own place in society. They knew their jobs. They realized that they knew their jobs and they were decently proud of the fact. But in the days of the guilds everybody had to be a good craftsman if he ever hoped to qualify as a full-fledged *Meister*. It probably never

entered into their minds that anybody a thousand years hence would bother to go through all the volumes of the receipted city bills of the cathedral of Reims in the hope that somewhere he would find some such item as "paid to Master Godewinus, three shillings, two pence for his statue of St. Fiacre over the central entrance to Notre Dame."

And furthermore and finally, these artists were still very greatly restricted in the ways they could give expression to their artistic impulses. The Romanesque world needed many architects and stonemasons, a few sculptors and painters, still fewer miniature painters, and a minimum of goldsmiths and jewelers. But times changed and one of the most interesting results of this change of the times was that the artist began to lose his anonymity and became an individual with ideas and idiosyncrasies and a style and a name of his own. When that happened, we can speak of the end of the Gothic period.

I mentioned in the last chapter how the vertical streamlining of the Gothic churches and the introduction of the pointed vault deprived the fresco painters of the wall space formerly at their disposal. Especially in northern Europe, where in the winter the days are gray and somber, it was necessary to make the windows very large. As a result, the northerners were forced to devise some new medium with which to paint on wooden tablets long before the need of such a method was felt in Italy. It was Flanders and not Italy which gave the world the invention of painting with oil.

We know that in modern New York every time a fashion changes, hundreds of thousands of people are suddenly thrown out of work and then have to switch from lace to feathers or from artificial flowers to Heaven only knows what. We know that when Monsieur Daguerre invented a way of capturing Grandpa's stern looks on a sensitive plate and of holding it there for all time, the old perambulating portrait painters thereupon either starved to death or became professional photographers, which may well account for the superior quality of most of these early likenesses.

In the same way, when soon after the discovery of oil painting it was found that a painting representing a statue was much cheaper than the statue itself could ever hope to be, the sculptor lost out but the painter got a great many new orders.

However, the painter also had certain troubles of his own. For he could only work very slowly and for a very restricted market. Once his picture was finished it could be hung in the local church and the neighbors could come and look at it but that was as far as its influence

would go. There was no way in which the scene he had depicted could be made to reach a larger number of people.

Now, among the strange baggage which the Crusaders had brought home with them from the Orient there were a few exotic-looking woodcuts, undoubtedly of Chinese origin, for the Chinese were making very beautiful woodcuts as early as the seventh century, and the textile manufacturers of northern Italy learned that the patterns on the brightly colored cottons which were imported from Persia had also been made, not with a brush but with bits of engraved wood.

We have no idea when or where this new process was first tried on the European continent, but it was a wonderful labor-saving device. Soon it was being used for quite a different purpose.

The Middle Ages with all their outward pretense of holiness were really a period of serious and intense gambling. Until the thirteenth century most of this gambling had been done with dice but the Crusaders had heard of a new way of losing their money in the Orient and it was they who had introduced playing cards into Europe.

Then one fine day some bright Italian lad, whose father may well have been a cotton dyer, thought of the possibilities of using the same wooden dies with which the pattern was applied to the cotton for the purpose of turning out playing cards. Judging by the formidable edicts against this wicked innovation which suddenly appeared upon the statute books of every land, the new pastime must have been a tremendous success. Europe became card-conscious.

It followed that if one could reproduce pictures of kings and queens and mere knaves by cutting their likenesses into a piece of wood, one could also cut the scenes from the lives of the saints into a piece of wood. Then all one needed was a little ink and a press to offer these pictures to the public at a fraction of what it would have cost to paint one single picture. I am not giving you definite facts, for we have none. But there is very little mystery about the way such things have always happened.

One of these early woodcuts may well have fallen into the hands of a German jeweler who was accustomed to engrave lines into his gold or silver for the purpose of adding a few adornments to the flat surface. It was quite natural that such a man must have thought of the possibilities of substituting copper for the much more perishable wood and then of printing the pictures from the copper plate. Very likely his first experiment was a failure but others carried on where he left off. About a century after the Van Eycks had given the world their new method of painting with oil, we begin to find early samples of copper

engravings and from that time on the painter had to reckon very seriously with the competition of the engravers, both in wood and in copper.

Soon another group of artists began to feel the competition of this new process of reproduction. The woodcutters were not contented with depicting the lives of the saints. For the benefit of the few who could read they had also added a few lines of text which explained the pictures. If one could engrave whole series of letters, one could also print letters individually. That must have been the line of reasoning of Johann Gutenberg when in the year 1438 or thereabouts he began to print circulars from something he called "movable type"—individual letters that could be placed together in any sequence that might be desired. A noble invention and of immense benefit to authors and printers, but one which spelled ruin to the artists who for centuries had supplied the market with their manuscript volumes and their beautifully illuminated stories of the Scriptures and who after the fifteenth century disappear completely from view.

All through the Romanesque period, all during the early Middle Ages (vaguely speaking, from the year 400 until the year 1200), the artist had depended for his living upon the good will of the abbot and the squire. He had had no private patrons, for there had not been any. When commerce and trade returned to western Europe, when money once more began to make its appearance as a means of exchange, wealth was at last diverted from the nobleman and the high clerical officials and began to flow into the pockets of the businessman.

The first thing one usually does when one gets a little extra cash is to buy a house. The people of the early Middle Ages also lived in houses but they were of the simplest kind. The furniture was such as one would have found in the wooden cabin in which Abraham Lincoln spent the first years of his career. The house of the second half of the Middle Ages was a tremendous improvement upon the hovel of the Romanesque period. There were tables in it and benches and occasionally even chairs and certain other luxuries for the benefit of the older people and all sorts of chests and cupboards to store away the spare sheets and the rich apparel which was worn on festive occasions. Chimneys were also being constructed in many of the newer houses and candles were now well within the reach of the average man, so that he was no longer forced to go to bed as soon as the sun had set. Furthermore, glass windowpanes were now being turned out for common use and so it was possible to spend a pleasant evening in one's own parlor without catching one's death of cold.

It is rather dull to look at plain wooden walls. Now that pictures no longer had to be painted on wet plaster, but could be smeared upon small pieces of wood, it was possible to go in for a little interior decorating. And behold our painter, transformed from a merely anonymous worker in the vineyard of the Lord, into a highly respected member of society, whose services were eagerly sought after by the rich in their desire to compete with each other in the splendor of their mansions!

And now still other fields of activity are opened to him. For once more he is allowed to paint portraits. The Romans and Greeks had painted pictures of living people and had made busts of them, but the Church had greatly disapproved of this heathenish custom. Indeed in the year 787 the Second Council of Nicaea, the one that definitely revived the veneration of holy images (and put an end to the image-destroying tendencies of the eastern half of the Church) had laid down the law that the "conceptions of pictures should not be the invention of the artist but should be governed by the rules of tradition and of the Church."

Under those circumstances it was a brave soul who would have undertaken to paint the portrait of a private citizen. But now many of these private citizens were as rich as the princes of the Church and money, then as now, meant power, and power meant freedom and independence, and so one could afford to take a risk. In Italy it was Giotto who took that risk when he asked his own friends to pose for the pictures of the bystanders in his lovely series of scenes from the life of St. Francis in the upper church of St. Francis at Assisi. One step quietly led to the next. With a return of the old prosperity and a growing disregard for mere tradition, the private portrait gradually grew in popularity until the new Van Eyck invention, combined with the economic independence of a new class of people (the businessmen), gave birth to something the world had not seen for almost a thousand years—portraits that had no connection with religion.

And since it made a portrait much more interesting to give it a little background of hills and rivers and lakes and houses, as already had been done in a few sacred pictures, the artist began to add a fitting piece of landscape, such as his patron's favorite garden or a view of his country house. These landscapes found great favor in the eyes of a people who were once more beginning to love colors. Soon a brave patron ordered a landscape without any saint or portrait.

Meanwhile, especially in those northern countries where the lugubrious and damp climate forced people to spend most of their time

*When an artist draws a rapid sketch he does not bother about the scientific perspective of his landscape. He sort of "feels" how it should look.*

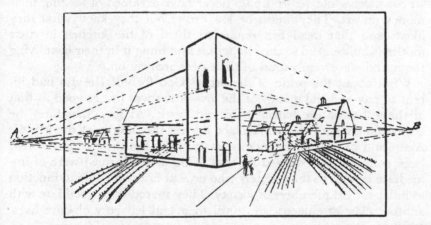

*As a rule he is quite right and the results are as they should be, but it takes years of constant practice to be able to make perspective an unconscious part of your artistic perceptions.*

within the four walls of their own home, the rooms were rapidly acquiring a much greater degree of cosiness. One was now rich enough to eat from tin plates and to cook one's food in brass pots and pans and to have a few flowers around the house in glass jars or in an earthenware vase.

It is only natural that a person should like to have some graphic reminder of those objects with which he has been surrounded all the

days of his life. And so a painter was asked to paint a picture of these selfsame pots and pans and other household utensils which nobody until then had considered fit subjects for such an experiment. But the result was pleasing. The still life was born.

Have I made the story a little too simple? I doubt it. I have too often seen with my own eyes how such still-life pictures come about. For one thing, they saved the average painter the trouble of going out to find himself a model. His wife most likely was going to have fish for dinner, anyway. Why not drag the old easel into the kitchen and paint these dead fish while the wife was getting the vegetables ready? And to make the picture more amusing, you could always add a lute or a violin. It is true that lutes and violins had nothing to do with fish, but they added a nice splotch of brown to the white-bluish foreground of the fish.

Best of all, such pictures found ready buyers among a class of people who a short while before would never have dreamed of wasting their money on art. They might be low-brows but they knew what they liked, and that dead fish reminded them of the kitchen in their mother's house. And so they bought it and hung it in their own living room and were very proud of their new acquisition.

What about the pride of the artist? God forbid! He also had his rent to pay and the money of the low-brows was just as good as that of the abbot or the baron in his old castle. At first, therefore, the economic changes that took place during the middle of the Middle Ages (and before the aristocratic taste of the last three centuries had been completely destroyed by that of the new patrons) were of immediate benefit to the painters who now at last were able to function as independent members of society. They shared their good fate with another class of citizens who until then had led very obscure lives. I refer to the musicians.

Music had been a very popular form of entertainment among the Greeks but the triumphant Christian church had greatly disapproved of it and had tried to suppress it and had only allowed such singing as fitted into those religious services where the whole of the community had come together to render praise unto God Almighty. This proved impossible. Singing, being as natural to man as breathing or laughing, could never be completely suppressed. It was therefore led into a different channel. It was made part of the regular religious services.

Now the earliest Christian communities, as was quite natural, were

mostly composed of Jewish converts, and they carried a great many of their ancient Jewish customs and ceremonies over into the newer form of worship. Among those ancient customs was the habit of reciting the Psalms of David in that strange singsong fashion still practiced by the Jewish cantors, whom you occasionally hear on our concert platforms. In the synagogue the priest used to read or sing (for their reading was really a form of monotonous singing) a few lines of the Psalms, and the congregation would thereupon respond in the same way. The Christians in their earliest public gatherings followed this example. But soon afterwards they were compelled to divide the congregation into two groups who responded to each other in an antiphonal way (just as we used to sing *Three Blind Mice* in the nursery). For that was the easiest way to teach the more recent converts those parts of the service with which they had not yet become familiar.

Gradually, however, the Church lost its original democratic, one might even call it communistic, character. Surrounded on all sides by a host of enemies, the Church could not possibly hope to survive unless it were a strictly disciplined organization. The clergy therefore got farther and farther removed from the congregation, just as the officers of a ship, as a matter of dire necessity, must form a class apart, far removed from the common sailors. The clergy then took over that part of the antiphonal singing, which until recently one-half of the audience had done, and the audience responded to the chanting of the officiating priest, as is done this very day in many of our Protestant churches.

In order to emphasize the exalted position of the clergy still further, their appearance before the altar was also emphasized by special hymns. It proved, however, a risky business to let this very solemn moment depend entirely upon the well-meaning but often rather inexperienced efforts of an audience of amateur singers. And so very gradually it became the custom to choose the best singers from among the worshipers and to unite them into a regular choir which grouped itself around the altar and led the singing. From there on it was only a step to exclude the congregation itself completely from the actual singing and have the responses sung exclusively by the priest and the official choir.

What they sang and how they sang in these early Christian churches we do not know. But it is to be feared that every organization arranged this part of the service very much as it pleased. Hence certain efforts made late in the fourth century by Saint Ambrose, the famous bishop of Milan, to bring a little order into this most regrettable chaos

of cacophonous sound. Ever since that time, Milan has been a center for this form of Ambrosian chant.

Two centuries later, however, under the influence of a large number of local choirmasters, there was again such a lack of unity in the services of the Church that under Pope Gregory the Great a definite form of music was prescribed for use in all churches. Modern criticism has thrown considerable doubt upon the claim that Gregory was actually the founder of this new form of music. But the name "Gregorian chant" for this particular form of plain song or plain chant has been so generally accepted and has been used for such a long time that we had better not waste any time in vague speculations about the person responsible for this far-reaching reform.

As for the reform itself, it was of the highest importance for all further musical development. This Gregorian style of singing you can still hear every day in the churches of our Catholic neighbors. You will sometimes like it and upon occasions it will strike you as rather monotonous, but at all times it is impressive and it is exactly what the name implies—a plain chant—a sort of musical declamation, rather than singing in our modern sense of the word. There are between twenty-five hundred and four thousand melodies in the Gregorian modes. A few probably go back to the days when the Jews in exile founded an independent synagogue of their own in Baghdad. The vast majority date back to the seventh and eighth centuries and a very few are modern.

The great difficulty when it comes to deciphering the older ones is the lack of any definite form of notation. The melody was either indicated by means of letters—a b c d e f g—or by means of so-called "neumes" which is a Greek word for breath and which suggests (as is still done in some very rustic Protestant churches) that every note took a man's full breath.

These neumes, a sort of musical shorthand, were then written over the words that were to be sung. But as every choirmaster of any importance had his own system of shorthand or neumes, they do not really make our task of deciphering such old manuscripts any easier. In short, notwithstanding the serious efforts of Ambrose and Gregory to make all Christian churches stick to one method of singing, chaos once more threatened to engulf medieval music until an honest and simple music teacher by the name of Guido, a native of the town of Arezzo in Tuscany (also the birthplace of our friend Vasari, who had his own peculiar ideas about the beauties of Gothic), hit upon the brilliant idea of placing his notes upon four parallel lines to which we

have since added a fifth one, and which he called a ladder or scale. Those notes higher on the scale or ladder were to be sung in a higher tone of voice than those lower on the ladder. Then at last, as soon as one knew the height at which the first note was to be sung (you have heard an orchestra tune all its instruments according to the A of the oboe) the rest followed automatically, and the same tune would be sung at the same pitch in every church.

The next development was the introduction of polyphony, which was the opposite of monophony or monody. Whereas monophony and monody meant a melody for a single voice, polyphony meant a piece of music arranged for several voices. But Gregorian music, being bound to certain hard and fast rules, could not indulge in very much freedom. Whether sung by one single voice or a combination of parallel-running voices, it remained really a sort of melodious declaiming. If ever harmony entered into this sort of singing, it did so entirely by accident, for harmony, as we now know it, did not come into general use until after the death of Bach, who still was a writer of polyphonic music.

During all these centuries it is perfectly possible that the country people had developed a few tunes of their own but if they did so, they have been lost and we know nothing about them. Whatever new developments took place, such as "strict organon" and "free organon" and "counterpoint," for instance (the music books of that time are full of such expressions), they only benefited the Church and did not at first spread among the masses. As for instruments, they were not yet being used, for they had been very popular in ancient Rome and were therefore taboo to all good Christians.

Even the organ did not escape this bar. When the King of France in the latter half of the eighth century decided to introduce the Gregorian way of singing among his Frankish subjects and thought it would be hopeless to do so unless he had some instrument which would enable the poor peasants and serfs to follow the tune, he had to send a special embassy all the way to Constantinople to ask the Byzantine Emperor to let him have one. He got his organ and it caused more excitement than the arrival of the first church bell in Moscow several hundred years later—that famous church bell which caused the simple Muscovites to attack it as the "voice of the Devil" and throw it into the river.

After a very long struggle the organ was finally tolerated, for the Church authorities recognized its value as a mass instrument (as do the managers of our big movie houses), but other forms of instru-

mental music were out of the question. And these conditions would have continued if it had not been for the influence of our old friends, the Provençal troubadours and the German minnesingers.

We know that the local Provençal poetry, long before the troubadours had taken it up as a serious art form, had already ceased to be a matter of mere meter (as Latin poetry had been) and was being written according to the principle of accent. Such poetry lent and lends itself easily, one could say almost automatically, to a musical form of interpretation. "Mine EYES have SEEN the GLOry of the COMing of the LORD." Read this line three times in succession and you will begin to sing it.

We are accustomed to this form of poetry, as most of our verse nowadays is written that way. But in this world, which had never heard anything but the monotonous droning of the voices of their Gregorian choir, this was something as new and quite as refreshing as syncopated music was to us thirty years ago.

Novelty is apt to make for popularity and it soon became evident that those troubadours were the most successful who were also most spontaneous in their way of delivery. Hence they did a lot of extemporizing, the sort of extemporizing you can watch the minnesingers do in the second act of *Tannhäuser*. They would come together at some castle and then they would be given a subject—any subject at all—around which they were expected to improvise a poem which they would sing then and there and without any preliminary rehearsals.

During many subsequent centuries this was to remain the favorite indoor sport of all musicians. Bach's great improvisation on a theme given him by Frederick the Great when His Majesty had invited him to come to Berlin and try out his collection of pianos is still well remembered. And as late as the days of Mozart and Beethoven, the great composers loved to indulge in this very amusing but quite difficult pastime. If I am not mistaken, the most renowned of all virtuosi, the great Franz Liszt, found great delight in improvising on a theme that was sung for him by one of the members of his audience.

Now that we have come to take our music, indeed all our arts, so very, very seriously—almost sadly—we don't go in for that sort of thing any more. Besides, it is very difficult, and although we are all very great artists, we are no longer perhaps as many-sided as the simple craftsmen of those long-ago days. But the next point I must discuss is this: When exactly did the accompanists—the menials with their little harps or fiddles—come into their own and cease to be mere

accompanists and become *Spielleute*, and when did they first of all combine into a regular orchestra?

The handbooks of music, depending for their conclusions entirely upon written evidence, fail to tell us, for of course there was no written evidence, as everybody took such playing for granted and did not bother to write the tunes down for future use. I have an idea how this came about. I offer it as a suggestion, though I know that I may be wrong.

In my younger days, while I was studying in Munich, I used to play a lot with the so-called *Schrammelspieler*, a small orchestra composed of a fiddle or two, a guitar, and perhaps an accordion. Almost any instrument could be added *ad lib.*, a flute or a clarinet or a tuba. Now when the regular performance was over and the guests had had their fill of beer and dancing, we used to indulge in the strangest forms of music, anything from the highest forms of superclassical to the latest popular air. Those were grand and glorious evenings and we used to play until all hours of the morning. Even today we sometimes have grand musical orgies of that sort right here in the house in which I am writing this, though I am afraid to give the names of the participants. It might hurt their reputations if the public knew that quite a number of their most highly respected soloists can go completely crazy, turning *The Big Bad Wolf* into a Bach fugue and a Beethoven symphony into jazz.

Well, I feel quite sure that when these hired men, these "menials" of the troubadours and minnesingers, were off duty and were drinking their sour beer in the mean tavern in which they had been lodged overnight, or in the kitchens of the castles in which their noble masters were partaking of a ten-course banquet, I feel quite sure that it was then that orchestral music almost unconsciously came into being. Passers-by must have heard these merry tunes. They must have struck them as something fine for a wedding or some other feast. And hopefully anticipating a few extra shillings, I am sure that these different instrumentalists were only too willing to oblige. Of course, they have left us no written music. In the first place, I doubt whether they could write their letters, let alone their notes. But in the second place, they had no need of a written score. They were craftsmen who had served many years of a very difficult apprenticeship. Why bother about writing the stuff down?

And, of course, the richer the burghers grew and the more they could spend on their own sort of plebeian entertainments, the more these fiddlers and lute players and flute players and drummers were

in demand. And when the minnesingers were finally replaced by the much more democratic (if infinitely less capable) Meistersinger, the *Spielleute*, too, benefited by this change.

For the guild of the Meistersinger was an important part of the social life of the cities of the Middle Ages. Almost as important as that of the jewelers or the butchers and bakers. And the Church was careful not to interfere too drastically with such powerful organizations. In this way, under the protection of the Meistersinger, the pipers and harpists and flutists and string scrapers finally smuggled themselves into a community which until then had regarded them merely as mountebanks and disreputable characters against whom one closed one's doors for fear of losing one's spoons and knives and daughters.

And so out of this strange mixture of troubadours and minnesingers and jugglers and minstrels and *trouvères* there arose the instrumental musician, the ancestor of our modern virtuosi. Some of them will hardly appreciate this little genealogy I have constructed for their benefit. Will Harold Bauer forgive me if I therefore repeat what he once told me?

"After all," he said, "what are we but a sort of *Spielmann*? We play our little piece. If we please our public, they throw us a handful of pennies. We gratefully gather them together, pick up our instruments, and go on to the next county fair."

To which the artists of the Middle Ages, who had at last emerged from their complete obscurity and anonymity, would chant a pious amen, a polyphonous amen, accompanied by chords on their theorbos, their rebecs, their vielles, their sackbuts, bombards, and doodlesacks.

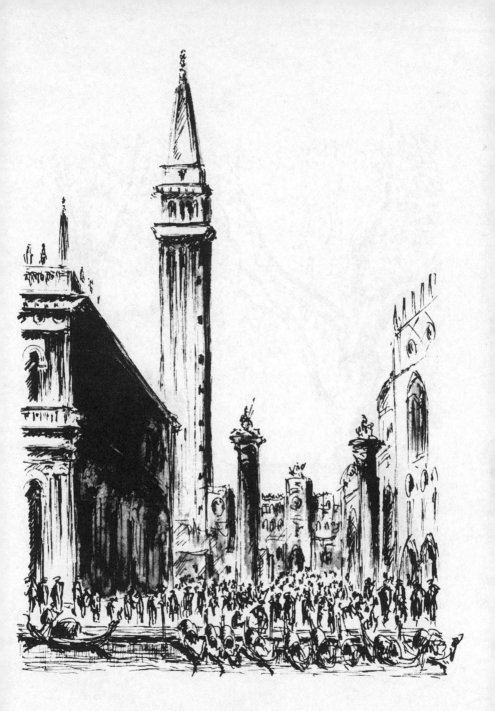

VENICE

THE TROUBADOUR

## The Spirit of the Renaissance

*The city-state once more becomes the center of the arts and the Renaissance style of architecture begins to spread throughout the world.*

THE WORD "RENAISSANCE" goes back to the sixteenth century. A very superior person, proud of what his own generation had accomplished and thoroughly contemptuous of what had been done during the period that separated the new civilization from the old, had briefly dismissed that stretch of a thousand years that lay between the two as a sort of Middle Ages, a period of hibernation for the human mind. After that interval had come to an end, there was a regular *rinascimento*—a "rebirth of the spirit of man," as people will remark on such occasions when they feel that they are watching the coming of a new dawn, about once every two hundred years. I am afraid, however, that this rebirth of the soul would never have got anywhere at all without a previous rebirth of the pocketbook.

That pocketbook which had shrunk to almost invisible proportions during the early Middle Ages was beginning to show signs of a slight bulge, and gold in the pocket will do strange things to a man's soul. In addition to the gold there now were certain little pieces of paper. They were connected with a mysterious new invention called credit. Such scraps of paper, attesting a man's credit, were even more powerful than ducats.

There was a great stirring of independence among large groups of people who until then had lived only by the grace of their spiritual and worldly masters. Liberty was in the air but nowhere did it fill men's lungs with such a feeling of pride and independence as behind the sheltering walls of some strongly fortified city.

And when you ask me what caused the Renaissance, I shall feel compelled to answer: The Renaissance was the result of the triumph of commerce (by means of money and credit) over the earlier medieval method of trading by barter.

There were a great many other contributory causes, but there never would have been any *renaissance* without the rapid increase in prosperity (and therefore in political and social prestige) of the middle classes. After they had definitely arrived and become the rulers of

225

their city, they rather liked to forget that episode during which they had ceased to be peddlers and had become regular merchants. And then, when they presented their fellow townsmen with a new hospital, or a new church, these were evidences of their desire for learning, their respect for true scholarship, their love for beauty. All of which was very fine and undoubtedly true, but unfortunately the man who is economically dependent has little chance to practice such virtues as loving beauty or respecting scholarship. The breadline is not welcome in the museum or in the jewelry store. These lovers of beauty and respecters of scholarship had first of all to acquire sufficient power to snap their fingers at everybody else and to do as they pleased. They spent the thirteenth and fourteenth centuries organizing that power. They spent the fifteenth and sixteenth centuries enjoying it. That period of enjoyment was therefore called the Renaissance.

The Renaissance began in Italy because Italy was the first country to be touched by the new prosperity. It thereupon found its way to the rest of Europe, closely following the different trade routes. And the way in which it usually made itself first of all manifest was by an outbreak of a widespread interest in architecture.

It is impossible to define the Renaissance style of architecture as you can define and classify the flowers or the birds according to certain definite sets of rules: so many petals and so many stamens and all the rest of it. For architecture, which is that form of art in which the soul of a people best expresses itself, bears a very close resemblance to our trees. Trees are always the most conspicuous part of any landscape, but when you begin to transplant them into a different soil, all sorts of strange things may happen to them. Unless they are most carefully cultivated by a small army of picked gardeners, they will develop into something quite different from what they had been in the beginning.

It is the same with architecture. Two dozen countries will go in for the Romanesque or will decide to build according to the Gothic formula. They will start from the same general principles. They may even copy each other's blueprints. But during the actual process of construction, something always happens and the results are apt to be most surprising.

Take those Greek temples we have erected along the banks of the Potomac and many of which were built absolutely according to the Greek originals. They may have looked magnificent against a Greek

background, but it takes a lot of patriotism to accept them amidst their new surroundings.

The Italians must have felt something of this sort when almost instinctively they shied away from Gothic. They probably never reasoned it out and I am quite sure they had not the slightest idea why they should feel such a profound dislike for this product of a foreign clime. But people endowed with a great natural sensitiveness can often come to the right conclusion by a process of intuition while their much more logical neighbors, with all their slide rules and adding machines, get everything all wrong.

But the moment they were once more on familiar ground, the moment they were once more a nation of city dwellers as their ancestors had been before them, the Italians seem to have realized that the Romans' way of building was the best of all possible styles for their own social needs and for their own landscape. And so they returned to the classical style of a thousand years before and the moment they did this, Gothic was reduced to the second rank and Italy once more became the great artistic center of the Western World and Italy set the pace as it had done in the days of the Caesars.

Florence is the town in which you can study this new development better than anywhere else. The palaces of the rich merchants still retain many of the aspects of the fortress style which had been imposed upon them by the continual civic disturbances of the first half of the Middle Ages.

During the beginning of the Renaissance, that constant dread of being murdered in one's bed was still in people's minds and it gave the homes of the rich a sort of prison atmosphere, reminding one more of the U. S. mint than of a country house on Long Island. But soon we are able to observe certain very subtle changes. The outside walls are still as forbidding as ever and the windows are still comparatively small, so as to keep out robbers and brigands. But the interior, built around an open court, a sort of patio such as you will find in the old Spanish mansions in southern California—that interior now begins to resemble those houses of the Romans with which we are familiar from the excavations in Pompeii. And once more, as a thousand years before, the walls are being covered with paintings and these paintings, too, resemble those of ancient Rome. For now that every peasant could hope for a substantial reward in case his spade turned up some ancient statue, an entire civilization that had lain buried for almost

*The moment the Middle Ages had come to an end and people were no longer obliged to live cooped up in some eagle's nest on the top of a rock . . .*

*they hastened to build themselves comfortable homes in the plains where they could move about and no longer feel the restrictions imposed upon them by the medieval fortress.*

a thousand years was suddenly coming back to life at the very moment the people were once more able to appreciate it.

Most of the antiques of that day were in a deplorable condition. For the climate of Italy was not the climate of Egypt, where anything entrusted to the soil was safe for all eternity. But with a little soap and a great deal of water and sandpaper, one could often produce astonishing results. If you are curious to know how much was really found, visit one of the big Italian museums where these ancestral relics are kept and try to see it all. Two or three days will be enough to make you give up in despair. Then remember that there is at least one local museum of antiquities in every Italian hamlet and village and in many private houses. Then remember that in the eighteenth century, when every potentate wanted to turn his own two-by-four court into a miniature Versailles, he bought Italian *objets d'art* not merely by the cartload but by the boatload. The contents of entire country estates from Calabria and Umbria were moved to Saxony or the shores of the Neva. Then remember, furthermore, that until quite recently, when a law was passed forbidding the export of ancient works of art, all young men of fashion making their Grand Tour (which was supposed to give them a truly Rococo polish) deemed it their duty to return home with at least one or two heads and torsos of Roman emperors and Greek Goddesses as ornaments for their fathers' country estates in Yorkshire, Värmland, or Amstelveen. And when you have taken the trouble to remember all this, then you will at last be able to appreciate the amount of plunder that had come to Rome as the reward for four centuries of world domination and that came back to the surface of the earth during the Renaissance.

The Roman Empire, as you will then realize, had really been in a class by itself. Even in its ruins. From a spiritual point of view it had never ceased to maintain its ancient position as the center of Western civilization. Now it once more was able to dictate a new style of architecture according to which "modern-minded" people all over the rest of the world had to construct their houses and their office buildings or be deemed hopelessly old-fashioned.

For the new style became an object of fashion, just as Gothic or the style of the days of Queen Anne is an object of fashion among the philanthropists who today and every day give us our colleges. In the course of the next two centuries it penetrated into every nook and corner of the old continent, and its triumphant progress was most ably aided and abetted by a newcomer within the realm of the arts—the professional architect.

I know that already quite often I have used this word "architect," but I did so merely for the convenience of the reader who is accustomed to the idea that all architecture must necessarily be the result of the labors of an architect. The Middle Ages, however, had not known the architect in the modern sense of the word. Neither had the Greeks, although the word itself is of Greek origin. Their *Architektors* were merely master builders, a class of superior foremen whose practical skill was combined with a natural gift for bossing a gang of laboring men and who knew enough mathematics to keep their accounts straight. When such a superior foreman happened to be better than his colleagues, he was gradually promoted until he became the general superintendent in charge of a new cathedral. He would then receive more pay than the others, but his social status remained about the same as that of the stone carvers and slaters and plumbers (there was a terrific amount of delicate leadwork connected with the complicated roofing of these Gothic churches) and glass burners and carpenters and painters who were also busy on the same project. He therefore continued to live with them and among them and if they obeyed his orders, they did so because they knew that if it came to laying bricks, he could outlay the fastest of all the other bricklayers; that if a dangerous part of the roof had to be painted, he would know how to make the safest sort of scaffolding and would try it out himself before he allowed one of his men to go up; and that there was not a detail connected with the actual business of building which he did not know better than his subordinates.

During the Renaissance there was an end to this arrangement. The architect became an artist rather than a builder. Henceforth his only direct physical contribution to the work upon which he was engaged would consist of the muscular energy with which he sharpened his pencils. Such a change may not strike you as very important. Yet it had a far-reaching influence upon the further development of all architecture.

The art of the Middle Ages had had a childlike quality—an air of the unconscious and a complete absence of the self-conscious. After the Renaissance this was no longer true. The builder ceased to think in terms of Almighty God to whose greater glory he was erecting a new house of worship. He was much more occupied with "the rules and regulations for the perfect classical style." These had been laid down in the ten books on architecture written by the great Vitruvius, who had been superintendent of all Roman civic and military edifices under the Emperor Augustus, and who, after an absence of almost

*The most important part in the life of a cathedral or any other building is the moment the architect sees it in his mind's eye and hastily jots down the first rough plans on the back of an envelope or an unpaid bill.*

fifteen centuries, had been brought back to life through the discovery of his writings in the ancient Swiss monastery of St. Gall.

As a nation we are not very fond of intermediary colors. We like to see things in either black or white. Grays are not popular and what I have said so far about the art of the Renaissance may well make you ask: "That is all very interesting but what do you really think? Was it good or was it bad?"

The answer is the same as that which I would have to give about every other style of architecture, music, or painting. It all depends upon the way you look at them. In the hands of truly great men, such as Bramante or Michelangelo in Italy, Jules Hardouin Mansard and Jacques Gabriel in France (the men responsible for the façade of Versailles and the Place de la Concorde in Paris), and Juan Bautista de Toledo in Spain (who built the Escorial) or in those of a Christopher Wren in London (the architect of St. Paul's) or Jacob van Kampen in Holland (the creator of the old Amsterdam town hall), the Renaissance style achieves certain effects which are eminently fitting and pleasing.

But even these buildings suffer to some extent from the fact that they were not homespun but a foreign import. For when the French Renaissance architects were obliged to stick closely to their Vitruvius, they had to give their buildings flat roofs such as you will find on the Petit Trianon in Versailles. That had caused no difficulties in Italy where a small brazier placed in a corner of the room was enough to keep away the chill of a few cold days. But in northern Europe, where the winters were apt to be very severe and to last for four or five months, you had to have open fires and chimneys. As a result, most of us when we think of Paris think first of all of chimney pots—whole armies of chimney pots. They are apt to look incongruous because they are on the wrong sort of roofs. In Holland and London, on the other hand, you don't notice the chimneys because they fit in with the pointed roofs which are necessary in countries where it rains four days out of every seven. But because Vitruvius, in whose day northern Europe was still an unexplored wilderness, had worked with flat roofs, the Hildebrandts and Fischer von Erlachs in Vienna and the Pöppelmanns in Dresden had to build their court libraries and their Zwinger in the same way.

And then there was something else. That was the matter of ornament. Let me give you an example with which almost everybody is familiar—the Arc de Triomphe in Paris. The world has been full of such triumphal arches ever since the day Titus erected one in Rome

after the destruction of Jerusalem in A.D. 70. And most of them rather make you feel that the architects have somewhat overdone a good thing. In their desire to make these monuments tell the whole of the story about the lives of their heroes, they have been very apt to overload them with unnecessary details. Soldiers are committing mayhem on each other with swords and lances or they are dying most becomingly with a dozen hostile spears in their manly chests. Horses are prancing, bands are blaring, and special incidents are commemorated in special little medallions. The few square inches of space left blank were afterwards filled in with suitable arrangements of flowers and palm leaves. Sometimes they were not quite so suitable. But they were there and in great profusion, for the real purpose of the structure was to make the spectator gape and exclaim, "What a man! And how I do admire him!"

The artistic effect might suffer from such treatment but the heirs and assignees of this great general or statesman were not interested in architecture. What they wanted was merely a convincing piece of marble publicity.

This same desire to impress the multitude that had turned so many Roman buildings and monuments of the imperial age into caricatures of their former selves now once more made itself evident in a new style which was to dominate the world for several centuries— which had grown directly out of the style of the Renaissance—which always remained closely related to it and which even today (although in a slightly modified and disguised form) has a habit of making its appearance in some of the most unexpected places. It was called the Baroque.

Originally in Spanish a *barroco* had been a large pearl, but an irregularly shaped pearl, something very costly but not well proportioned and therefore bizarre rather than beautiful. During the course of the seventeenth century the name came to be given to all those new palaces and churches which fundamentally had remained faithful to the architectural principles of the great classical masters, but which under the stress of circumstances had acquired certain extravagant elements which were to give the whole era of the Baroque an air of restlessness and a touch of vulgarity which today we instinctively associate with the good city of Hollywood. And the two indeed had and have a great deal in common. For the Baroque and the Hollywood style were both of them born out of the same practical need to impress the multitude—to make the public gape with open-mouthed admiration at so much gilt, at so many unnecessary but expensive ornaments,

and to feel a pleasant glow of awe and admiration before such a magnificent waste of money upon wholly trivial matters.

There is a reason for this similarity, for the Church of the seventeenth century and the movie industry of the twentieth found themselves in the same quandary. In order to maintain their prestige, they had to impress millions and millions of people who were apt to judge a thing by the amount of money it had cost. Hollywood does this in order to get a decent return for the millions it has sunk into its mass products. The Church was obliged to do this in order to keep its spiritual hold upon that part of Europe that had been exposed to the perils of the great Protestant heresy. For the crisis which threatened her early during the sixteenth century was the most dangerous menace to her safety she had ever experienced.

A defiant German monk had forced an issue upon the authorities at Rome which they had not been able to settle according to the old and well-tried recipe of benevolent persuasion mixed with ruthless violence. The Reformation had brutally upset the medieval dream of a united Christendom. Part of the world seemed lost forever. Other countries were still in a doubtful condition. These must be brought back within the fold and since the Inquisition and the rack and the executioner's ax had failed, recourse must be had to the arts in this great struggle for humanity's ultimate salvation. Every single one of the arts, architecture, music, sculpture, painting, must be enlisted and must be fully utilized to impress the parishioners with the beauty and the power and the glamour and glory of the old Mother Church. Hence the fairly simple style of the Renaissance was taken thoroughly in hand and twisted into a hundred different forms and shapes until the final results were supposed to be irresistible in impressing all but the most obstinate and incorrigible of heretics.

There was no escape for these poor protesting dissenters, for they were also being attacked from another side. The endless years of religious warfare which followed in the wake of the Reformation presented a small number of competing dynasties with the chance for which they had been hoping and praying ever since the latter part of the Middle Ages. They wanted to increase and amalgamate their different holdings. They were no longer contented to manage small corporations. They intended to become large-scale executives. Here at last was their opportunity to do the thing and do it in a big way.

But in order to accomplish what they had set out to do, they were obliged to take certain very grave risks, for they must first of all destroy the power of the old feudal nobility and that of the semi-inde-

pendent city-states. They were furthermore obliged to combat that old Roman ideal of a superempire, which even after these many centuries of failure still spooked around in the minds of millions of good people who could no more imagine a world that did not (outwardly, at least) recognize one central source of authority than a universe without a Supreme Being.

In order to be successful they must therefore begin by selling their dynastic ideas to a majority of the people. I realize that this word "selling" may strike you as slightly undignified when used in connection with such distinguished historical characters as Richelieu or Mazarin, both of them princes of the Church. But they themselves would have accepted the expression as a compliment. They were, above all, practical men of business with no nonsense about the ideals of statecraft. They not only sold the people their royal masters in the most brazen fashion but they gloried in the fact and there was no trick of publicity which they despised to use. Their armies and their spies and their bribes and their secret dungeons could take care of their individual enemies but in order to get at the people in general they, like the Church, had to use more subtle methods. And so, quite like the Church, they enlisted the co-operation of the artists and told them to go ahead and never mind the expense.

There is nothing that sounds quite so much like music unto the ears of an architect or a painter or a musician as this verbal P.S.: "Never mind the expense." They were told to make the people forget the high cost of dynastic glory by providing them with a free show which should make them feel that they were getting something for their hard-earned taxes. Hence all those little imitation palaces of Versailles that arose in every capital of Europe—and please remember that during the latter half of the seventeenth century, Europe had some three hundred capitals. They were not all of them of equal importance but that did not matter. Heinrich XXXV of Klausenburg-Sondershausen-Dinckelspiel, whose domains were smaller than the space reserved for the exclusive benefit of the pet King Charles of Madame de Pompadour, intended to make his capital city of Pflaumenstadt (total population, 8,734 souls) just as much a center of civilization as the residence of the Sun King himself, or let his peasants die in the attempt.

We Americans have reason to know this better than any other people. For the poor Hessians who were brought over to our country to fight England's battles during the Revolutionary War had been sold to Great Britain for a round sum of sixteen million dollars. The

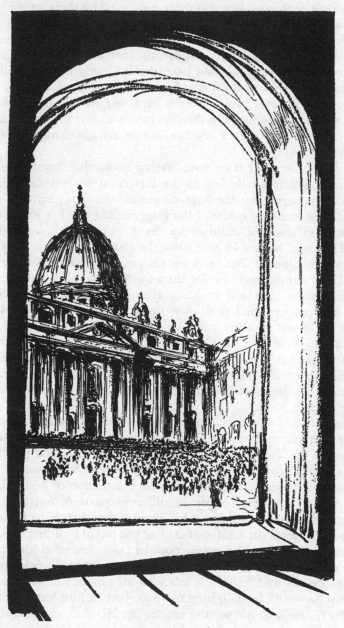

**SAINT PETER'S**

greater part of that money was thereupon used by their loving master
to make his palace in Cassel one of the showpieces of the eighteenth
century, something that even we ourselves could admire if we were
only able to rid ourselves of the feeling that all these lovely marble
halls and swimming pools had been erected upon the bones of those
poor slaughtered grenadiers who had died for a cause that was about
as far removed from their interests as a war on the planet Saturn.
However, that is one side of the arts into which it is sometimes safer
not to inquire too closely. For otherwise we are apt to make some very
startling discoveries.

You will remember from your history books that one of the many
grievances which finally led to the Reformation was the profound
indignation caused by the high-pressure sales campaign by means
of which the banking house of the Fuggers had tried to dispose of its
accumulated stock of indulgences. Such indulgences were nothing
new. They had been sold ever since the days of the First Crusade in
the eleventh century. But on April 18th of the year 1506 Pope Julius
II had laid the cornerstone for the new basilica of St. Peter's, which
was to replace that old building that Pope Sylvester I, early in
the fourth century, had built over the grave of the first of his pred-
ecessors. The old basilica had been in such a terrible state of repair
that already, half a century before, Pope Nicholas V had ordered the
Florentine architect Rossellino to draw up plans for a new building.
But before the walls were started, the Pope died and during the next
fifty years nothing was done at all, for the papal treasury was com-
pletely empty.

Then Julius II, another mighty builder before the Lord and who,
among a great many other things, was responsible for the magnificent
museum of the Vatican, sent for the great Bramante and told him to
revise the old Rossellino plans to suit the taste of the times.

Donato d'Augnolo was, like Raphael, a native of Urbino. After
many years of apprenticeship in different parts of northern Italy,
during which time he changed his name to Bramante, he finally was
appointed general superintendent of all the papal building operations
in Rome. Julius II, who became pope in 1503, inherited him from his
predecessor, Alexander VI, and told him to resume work upon the
new St. Peter's and finish the job with all possible haste. Bramante
said that he would be delighted to do so. Just let him have the money
and His Holiness would see the mortar fly. His Holiness consulted his
bankers. They in turn informed him that he was broke.

All this will sound quite familiar to many of our modern architects,

for most of our own church buildings, too, stand firmly founded on a mighty fundament of unpaid mortgages. But after the Borgias (Alexander VI had belonged to that distinguished Spanish family) even the credit of the Holy See was gone, and so in an evil hour for the Church it was decided to raise the necessary cash by selling several million dollars' worth of indulgences.

That was the beginning of the strangest sales corporation in the entire history of the Church. Since the Germans, accustomed to obedience, were considered to offer the smallest risk of resistance, it was decided to concentrate all efforts upon their unfortunate country. The well-known banking house of the Fuggers in Augsburg (they who enriched the language with the word *Thaler* or "dollar") obtained the concession for the distribution of indulgences throughout the German domains, and they in turn appointed a certain Dominican by the name of Tetzel to organize their sales campaign. He was a man of imagination and industry. Far and wide his subordinates traveled, offering absolution at the rate of six guilders for the comparative light sin of polygamy, eight guilders for murder, nine for sacrilege, and so on and so forth according to the nature of the crime that had been committed or that was still to be committed at some unknown moment in the near or distant future.

The intense indignation caused by this shameless exploitation of human fears and credulities was one of the chief causes of the outbreak of the Reformation. But Rome, which failed completely to understand the true nature of this spiritual rebellion, deeming it another unseemly row between two rival orders of monks, both of whom wanted all the profits for themselves—Rome did not even bother to read the letters of warning that came from many a northern capital. For a rich harvest of golden ducats was the result of Brother Tetzel's labor, and Bramante was at last able to resume labor on the greatest cathedral of Christendom.

Bramante superintended the building of the four mighty pillars that were to support the central dome and had begun the arches that were to connect them when he died. His two chief assistants were old men, not inclined to rush a job that would take at least another hundred years, and so the Pope entrusted the plans to the greatest living painter, a young man by the name of Raphael, who, like Bramante, was also a native of Urbino but whose delicate health could not stand the strain for more than six years, when he died (in 1520) at the age of only thirty-seven.

Then a number of indifferent architects were called in but (as so

often happens) each one had a pet idea of his own. They quarreled more than they worked until finally everything was entrusted to one Antonio da Sangallo, who decided that Bramante and Raphael had been all wrong and that the church ought to be built in the form of a Latin cross. Da Sangallo, however, was not a strong enough character to handle such an enterprise and progress was therefore embarrassingly slow until no one less than Michelangelo was forced to accept the position of chief architect and everybody else was told to keep his peace or resign his job. That happened in the year 1547, almost a century after Pope Nicholas V had decided to build this edifice and had given his approval of Rossellino's preliminary plans.

As Michelangelo is going to have a chapter of his own, we can be very brief about him here, and it suffices to state that he returned to the plans of Bramante (dead and gone for thirty-three years) but with certain additions of his own, planning among other things vast porches with columns and a pediment adorned with statues of the saints. He became fascinated by the problem of erecting such an enormous dome and so he reinforced the central pillars and then began the task of completing the dome itself, which was to have a diameter of 138 feet and reach a height of 437 feet. But everything connected with this church was on a truly Michelangelesque scale. Santa Sophia, the most important structure of the early Middle Ages, covered 8250 square yards of space. St. Paul's in London is only half the size of St. Peter's in Rome and Cologne Cathedral a mere 7340 square yards.

Michelangelo did not live to see his work completed, for he departed this life in 1564. The interior of the building was not ready for use until more than half a century later, in 1606. But by this time the Reformation had about wrecked the Church. A desperate effort was being made to bring the wandering Protestant sheep back into the fold and the straightforward plans of the Renaissance architects were no longer considered sufficiently impressive for the needs of the moment. Pope Paul V was then the reigning pope. He was a member of that famous clan of the Borghese who had started humbly enough in the little city of Siena but who, a few centuries later, owned the best collection of art in all Rome.

That collection, by the way, went through some strange adventures. Early during the nineteenth century it was sold to the Emperor Napoleon by one of the contemporary Borgheses, a certain Camillo who had married the beautiful Pauline Bonaparte, the Emperor's sister. It remained in French hands until the year 1815 when the Congress of Vienna returned it to the original possessors. There-

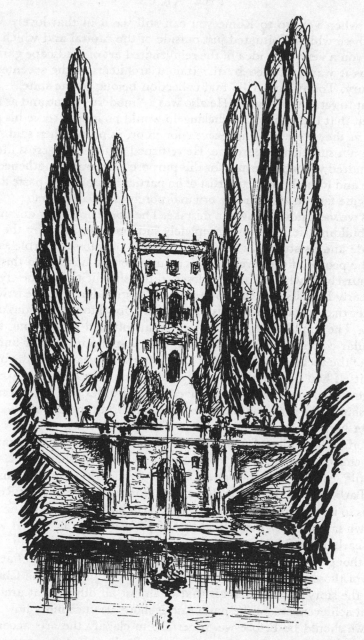

*During the Renaissance, the landscape artist, forgotten since
the days of the Romans, once more made his appearance.*

fore, when you go to Rome you can still see it in that lovely Villa
Borghese which is situated just outside of the capital and which will
give you a very high idea of the rejuvenated art of landscape garden-
ing as it was practiced by the Italian architects of the seventeenth
century. Today both villa and collection belong to the state.

But to return to Paul V. He also was a "modern" pope and as such
he felt that the plans of Michelangelo would no longer serve his pur-
pose as they were not impressive enough or, as people then said, they
were not sufficiently Baroque. He returned to the Latin cross idea of
a hundred years before and for this purpose he greatly lengthened the
nave and hired himself an artist of no particular ability to paste a new
Baroque façade all over the original porch of Michelangelo.

As we see it now, this was a mistake. The dome no longer dominates
the building. It is almost completely hidden from sight by the new
façade and its strangely assorted collection of colossal marble saints.

The people of the seventeenth century seem to have liked this, but
we ourselves, who are much closer to the simplicities of the style of
the early Renaissance than our great-great-grandfathers, are irritated
rather than impressed by this too evident appeal to the passions of the
mob. The unpleasant effect is somewhat softened by the long semi-
circular colonnades which Bernini, the Neapolitan sculptor and the
last of the architects of St. Peter's, added several years after the build-
ing itself had been finished and which seem to reach forth like two
outstretched arms ready to receive the multitudes that have come to
worship at the grave of Peter, the fisherman from the Lake of Galilee.

On November 18th of the year 1626, just thirteen centuries after
the original basilica of St. Peter's was supposed to have been founded,
the church was officially consecrated by Pope Urban VIII. This
pontiff, by the way, belonged to that famous Florentine family of
the Barberini, whose ruthless energy in plundering the ancient Roman
ruins to improve their own modern palaces had given rise to the well-
known saying, *Quod non fecerunt barbari, fecerunt Barberini*, "That which
the barbarians failed to destroy, the Barberini demolished."

I thought it well to give you this rather detailed account of at least
one of those enormous cathedrals that are the pride of the Church.
For the story of St. Peter's is that of almost all other great architec-
tural achievements of the past. And it shows us once more how care-
ful we should be before we undertake to classify the arts according
to certain definite schools or periods. In St. Peter's there are parts of
the original basilica of the fourth century. There are also several altars
that date back to the twelfth century. There are a number of sar-

cophagi carved by Roman workmen during the days when Rome was still the capital of the Western Empire. Then we come upon the labors of the architects who had been under the influence of the early Renaissance. These in turn are deprived of much of their effectiveness by a violent outburst of Baroque which in turn tapers off into certain much more pleasing effects of the Rococo of the eighteenth century when a world grown sick of religious violence returned at last to a more reasonable philosophy of life.

A style, whether in architecture, music, or painting, must always represent a mode of thinking and a pattern of living of some particular generation. But as the human race does not move forward in serried ranks but in a most haphazard and irregular fashion, a few small groups of courageous pioneers will always be at the head of the procession, with a horde of stragglers at the tail end. In between these two groups we find the rank and file that does not really care much whether they are going this way or that, provided they are definitely going somewhere and meantime get enough to eat and have a roof over their heads.

It is difficult for contemporaries to realize this because, like the soldiers taking part in a battle, they have no chance of ever finding out what is really happening all around them. We know only what occurs in our own little sector. But those who live a hundred years later are able to get a true perspective on all the charges and counter-charges. They are able to say, "That battle was fought the way we think it ought to have been fought," or the opposite. And so it is with the arts. We see the arts of the past in their true perspective and therefore we can judge of them as a whole, as an entity. But we should remember that to those who lived at the moment they were being created, they must have appeared in a very different light.

It always has been that way and it probably always will be that way. All we can hope to do is to study and compare and not be too hasty in our opinions, lest we ourselves be judged very severely by those who come after us. It may strike you as a little too complicated to be entirely satisfactory. But the beauty of the arrangement is this: There exists such an enormous variety of choice that each one of us must sooner or later find something that responds to his own particular artistic needs.

But be careful, when you visit a museum, to wrap yourselves well into your warmest cloak of tolerance and understanding. Otherwise you may catch a chill of disappointment, and if you really want to get the greatest enjoyment out of the beauties of the past that would be the worst thing that could possibly happen to you.

# *Florence*

*A chapter which not only tells you something about the famous old city on the Arno but also pays its compliments to good Saint Francis of Assisi and gives a short account of the life and work of that extraordinary artist whom we know as Giotto.*

ALL ROADS LEAD TO ROME."
That was what the people of the Middle Ages used to say, and they were right. For although no longer the center of a worldly empire, Rome was still a spiritual capital that dominated the mind of man. Hence every emperor and king, every bishop and priest and even the humblest of private citizens who had a favor to ask of the Holy See or a grievance that needed adjustment must sooner or later undertake the long and perilous journey to that ancient palace of the Lateran which had become the official papal residence in the fourth century. This meant that he must also pass some time in the city of Florence, for that was the spot where all the roads from north and east and west came together, where one prepared for the last stage of the journey and made the necessary final arrangements with one's lawyers and bankers.

The town was not as old as Fiesole on the near-by hills, but it was very conveniently located for manufacturing purposes. In the eleventh century it was already recognized as the leader in the wool business and in the silk trade. Silk had originally come from China where, according to tradition, the first silken robes had been woven several thousand years before the beginning of our own era. From the Celestial Kingdom it spread to Japan and to India and from there, via Khotan and Persia, finally reached Europe just in time to allow Aristotle to add the strange "horn-bearing worms" to his collection of natural curiosities. Silken garments, however, had not become popular in Rome until the days of the later emperors. The older generation of hardy Roman patricians disliked this novelty so strongly that they passed several drastic laws against the wearing of the "effeminate" material. These laws (as such laws invariably manage to do) only succeeded in making silk togas so expensive that all the rich people immediately insisted on wearing them. Whereupon the Roman mag-

SAINT FRANCIS

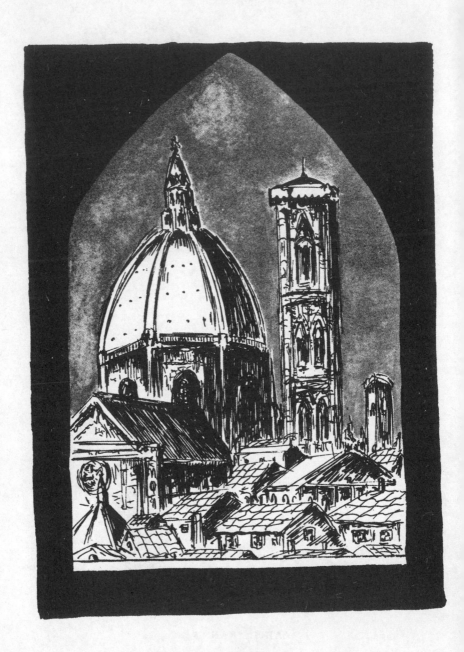

FLORENCE

istrates decided to make a few honest pennies out of the situation by converting the manufacture of silk into an imperial monopoly. For this purpose part of the emperor's palace in Constantinople was converted into a silk factory. But although the silkworms took kindly to the mulberry leaves of the West, the art of spinning and weaving was never quite mastered by the Byzantines, and until the days of the Crusades all the best silk continued to be manufactured by the Mohammedans who distributed their wares from Sicily.

This might have caused difficulties with the clerical authorities who as a rule frowned upon all such commercial transactions between the faithful and their Moslem enemies. But by this time the Church had begun to recognize the value of silken draperies as a suitable form of ornament for the cold and rather forbidding stone walls of the old Romanesque churches. The crusaders, too, now accustomed to the agreeable luxuries of the East, insisted upon dressing their womenfolk in something a little more exciting than mere linen or cotton.

The prospects, therefore, of doing exceedingly well in the silk business became so great that a number of manufacturers in Florence, Milan, Venice, and Genoa decided to invest some of their spare funds in this new enterprise. They used the plains of northern Italy to raise the necessary silkworms and trained a large number of young girls to work the looms. And in this way the silk and wool trade had contributed to make Florence one of the richest towns of medieval Europe.

Given a large surplus of both gold and silver, it was only natural that a few quick-witted citizens should thereupon have thought of the profits that might be derived from selling and buying foreign currencies. For every day of the year hundreds of pilgrims from all parts of the world passed through the town and all of them needed the right sort of money for their transactions in Rome. Soon the streets leading up to the city gates were lined with crowds of eager money-changers. who, sitting behind their low *banchi* or tables, were prepared to short-change every pious pilgrim to the very best of their almost unlimited abilities.

They could do this in complete safety. They were on familiar ground. They knew all the city officials and the pilgrim being an outsider was therefore a fit subject for plunder, an opinion not only held by the bankers themselves but also enthusiastically seconded by the local magistrates.

These profits, quietly accumulating year after year and century after century, finally made Florence the greatest money market of

Europe, a sort of London of the thirteenth century. As the Church did not allow the taking of interest and regarded it as a form of usury that should be punished with death, it was impossible to invest this rapidly accumulating capital in those "paper investments" which are the bulwark of our present-day prosperity. There were only two ways in which spare funds could be used. One could either convert them into land or sink them into the building of still more factories. But the very primitive machinery of the Middle Ages needed thousands of human hands to guide it. Hence a vast and quite sudden increase in the number of workingmen. These workingmen, in order to protect their own interests, established labor unions or guilds. These guilds, as was quite natural, took a deep interest in local politics and since numbers do count when it comes to either elections or pitched battles, the factory hands soon became the most important element in the civic life of a community where money rather than birth was being accepted as a standard of success.

Unfortunately the moment the workers had achieved their purpose and were given a chance to rule the state, they proved themselves to be even less competent and infinitely more corrupt than the noblemen and patricians whom they had replaced. Soon chaos reigned supreme. It was the time when all Italy was divided into two parties—those who wanted to see the country dominated by the Pope and those who expected salvation to come from a victory of the Emperor. Should you care to know with what bitterness that civil war was fought, read the works of the most famous of all the Florentine poets and politicians, Dante Alighieri. From his *Inferno* you will learn how, after the victory of one side or the other, five or six hundred families might suddenly be driven into exile to starve to death or spend the rest of their days living upon the charity of their neighbors. Should they venture to return, they would (as in the case of Dante) run the risk of being burned alive by the party that had driven them out.

What became of business and trade under such circumstances, I need not tell you. Finally, in sheer despair, the Florentines threw both Guelphs and Ghibellines out and thereupon the guilds (or the "Arts," as they were locally known) undertook to govern the city, and this time, as they loudly proclaimed, for the benefit of all.

A few years sufficed to show that good intentions alone butter no political parsnips. The more ambitious and energetic members of this new democratic society, as well as the less scrupulous and honorable, managed to get hold of all the more lucrative offices, while the others lost whatever they had and degenerated into a class of restless and

discontented proletarians. This led at first to outbreaks of discontent, next to street brawls, and finally to pitched battles. Of course, a city that had become the most important money center of the entire world could not afford to be at the mercy of a dozen political gangsters, each with a small army of henchmen and retainers. It was then that Florence experienced a rare piece of luck. A family arose which was not only capable of maintaining peace among these different hostile factions, but which at the same time was clever enough to avoid doing anything that might have made people suspect them of having ambitions that might be dangerous to the safety of the state.

The name of this family was De' Medici or Dei Medici. The Medici were of very ancient lineage, if one is to believe their own claims to genealogical distinction. In Florence, right in the heart of the city, you will see a large statue of Perseus holding high the dreadful head of the Medusa. That statue still stands where it was originally erected in front of the magnificent building where the representatives of the guilds used to meet. It was the handiwork of Benvenuto Cellini, one of the greatest scoundrels and at the same time one of the greatest artists that has ever lived, a man who shone as brilliantly on the battlefield (where he had at least some excuse for being) as in the boudoirs of his friends' wives (where he had no excuse whatsoever for being). He was one of those rare phenomena, a universal genius. In his workshop you would find everything from statues that were three times ordinary life-size to a simple little clasp made for a papal vestment, but of such enormous value that General Bonaparte, a fine connoisseur in the matter of loot, was willing to accept it as part of the indemnity that he extracted from the Pope when a minor French political agent was murdered in the streets of His Holiness's place of residence.

Maestro Cellini, who was not deeply interested in historical details (provided you paid him his price), was quite willing to connect the family of his patrons, the Medici, with the son of Zeus and of poor, unfortunate Danaë. Hence this strange image of Perseus as the earliest certified ancestor of the house of Medici. Modern historical investigation, I regret to say, has only been able to trace the Medici back to a doubtful ancestor who was a leech. Hence the three pills in their coat of arms, still so familiar to all authors and artists who have ever been obliged to entrust their grandfather's watch to the temporary care of the nearest "Lombard"—the nearest pawnbroker.

But somehow or other, during the first few centuries after their gradual rise to wealth and to power, all of the Medici managed to

retain some of the horse sense of those master craftsmen who had laid the foundation of the family fortunes. Even after they reached the point where they were able to have their sons elected popes and appointed cardinals, they (outwardly at least) remained plain, ordinary citizens of their native republic. It was not until several hundred years later, during the last quarter of the sixteenth century, that they became grand dukes of Tuscany and that their daughters were married off to members of the ruling dynasties, to play their fatal roles as the wives and mothers of kings.

That (although they did not know it) was the beginning of the end. When the last of the Medici died in 1737, the lovely land of Tuscany had been turned into a poverty-stricken and barren region—a land in which a useless nobility and an indolent and ignorant priesthood lived precariously upon the labor of a peasantry that was but little removed from the wolves that spent their nights howling outside their doors.

But we should not let these last two hundred years of decline blind us to the tremendous services which this extraordinary family rendered not only to the city of its birth but to the world at large in so far as that world was interested in the arts. Rich people have always bought paintings and statues and have always thought it necessary to surround themselves with the products of the more fashionable studios. It was as satisfactory a way as any other in which to give evidence of their wealth. A few at times have also cared for the things they acquired in this way, although to most of them a new Titian probably meant just about as much (and just about the same thing) as the ermine coats with which their wives could impress their neighbors' wives at the local opera house.

Once in a very long while, however, there have been exceptions to the old rule that "big money makes for bad art." Once in a very long while the patron of art has also actually been the lover of art. It was the good fortune of the house of Medici that for almost three centuries it produced both men and women who not only loved beautiful things but also knew them when they saw them. As a result, the city of their birth became so delightful a place in which to live that enforced exile from it (as in the case of poor Dante) was considered a more cruel form of punishment than death itself.

Having thus paid our respects to the Medici as a family of an unusual ability and responsible for much of the glory of their native city, we must now introduce another hero of this chapter. He will prove a very different type of man, though as far as his own background was concerned, he might just as well have been a member of

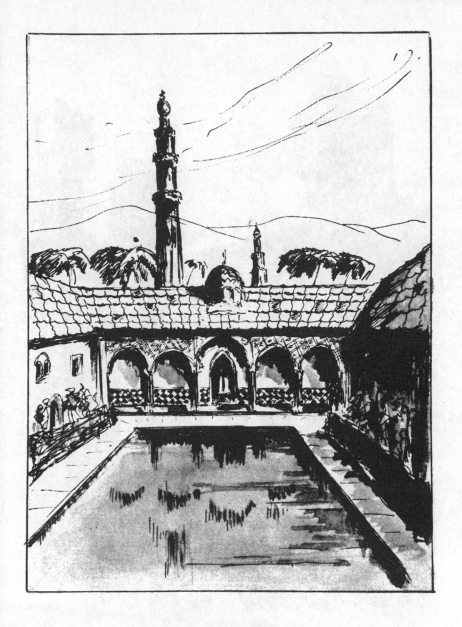

*After the Crusaders had made the acquaintance of a civilization where people lived among surroundings like these...*

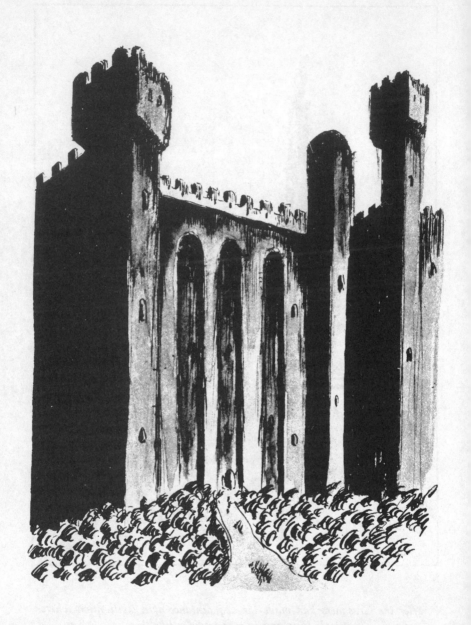

*they were not very eager to go back to their gloomy castles which were merely large stone caverns without any of the comforts and graces of life.*

the Medici family, for his people, too, belonged to that competent middle class which has given the world most of its great men.

They called him Francesco and he was the son of Pietro Bernardone, a well-to-do merchant of the city of Assisi, most pleasantly situated among the hills of Umbria just south of the Tuscany of the Medici. Old Pietro Bernardone was rich and Francesco was brought up to consider himself one of the bloods of his native town. But in the year 1202, shortly after he had attained his twentieth birthday, he fell desperately ill. When he had recovered, he was sent forth upon a military expedition to forget his recent discomforts. One day's march was enough to cause a relapse. When finally he regained his health, something had happened to him. He was no longer the proud and overbearing son of a rich father. He had become the humble brother of the poorest among the poor.

This being a volume devoted to the arts, I shall have to refer you to other works if you want to study the life of Saint Francis in greater detail. At the same time, it would be quite impossible to write a history of the art of the Middle Ages without devoting considerable space to that strange son of Pietro Bernardone and his far-reaching influence upon the civilization of the Middle Ages.

Francesco Bernardone, belonging to that class of people history has been obliged to classify as "exceptional men" (since they do not fit into any other category), started his career giving no particular evidence of his future greatness. Like all medieval children, he was born into a world that abhorred death while at the same time it despised life. Like most of the rich youngsters of his time, he was brought up in a sort of hit-and-miss fashion and depended for his learning upon such scraps of information as fell from the lips of a few casual visitors who were men of letters. When he died after a career of only twenty-four years (for during the first twenty years of his life he was exactly like all other Italian boys) he had brought something new into the lives of his fellow men. More than that, he had brought something new into the lives of all of us. For not only was he one of the few saints who survived the persecution of our Calvinistic ancestors and who skipped merrily from the Catholic consciousness into that of the Protestants, but his personality had been so all-pervading that none of us can quite hope to escape the influence of his teaching.

Then what did he teach? Here I shall have to proceed most carefully. I speak as a layman and not even a very good Christian. But in a world which had come to care so much more for the letter of the law than for the spirit, Francis suddenly appeared to show us with

refreshing vigor that being a Christian was not really so much a matter of what one believed as of what one did. And he therefore substituted the joy of being allowed to believe for the stern duty of being compelled to do so. In short, he belonged to that small band of people who have been mankind's most glorious benefactors—he was a laughing philosopher.

It would take me too far afield to tell you in detail how he changed the entire outlook upon life of the age into which he was born, but here is what he did to the arts. He put them back again where they have always belonged, in the streets of the cities, on the tops of the mountains, in field and in forest, in your own room and in that of your neighbor. Undoubtedly he was and remained until the end of his days a true son of the Middle Ages. Existence on this planet was merely a short period of preparation for the greater blessings that awaited us in the hereafter. But he showed us that in anticipation of this event, we might as well accept and enjoy the good things which the Lord in his wisdom has so generously placed at the disposal of his wayward children. All of which, revaluated into the terms of the arts, meant that the painter could once more open his windows, which had been shut tight these last thousand years, and could exclaim in childlike surprise, "What a glorious day and what a delightful view! I never knew the world was so beautiful!"

It meant that the musician once more could open his ears to the tunes of the birds and to the soft murmurings of the rapidly running brooks and find them more inspiring than the doleful Gregorian chant which had been his exclusive diet for so many centuries. It meant that the sculptor could now derive as much pleasure from contemplating his children dancing in the garden as he used to get from meditating upon the stern visage of an implacable Deity. It meant that after an absence of a great many centuries, mankind had come back to live on this earth and had found it good.

And now we come to the second name mentioned at the head of this chapter, the painter Giotto. According to the story which all good Florentines devoutly believed, he was the son of a poor peasant of Vespignano, a little village a few miles north of Florence. One day he was tending his father's sheep and amusing himself drawing the outlines of a lamb on a rock. A stranger passed by. He saw the boy at work and stopped to watch him. He recognized the child's genius, took him into his arms, pressed him to his bosom, persuaded his fa-

ther to let him become an artist, and so prepared him for a career that was to bring him both fame and riches.

What really happened was probably a great deal less poetic. All painters' studios of the Middle Ages were forever on the lookout for bright youngsters, for most of the preliminary work had to be done by the apprentices and it was difficult to find good ones. And so they used scouts very much as our modern universities use scouts to discover promising football fodder. Most probably one of the scouts of Maestro Cimabue had heard of a peasant's son in some little village somewhere and had hastened to buy the boy from his parents that he might come and work for this great Florentine master who was not only a painter of murals but also an architect and a worker in mosaics.

The life of such a youngster was not an easy one. His master undertook to feed him and clothe him (after a fashion, and a very poor fashion it usually was) and to teach him his craft in exchange for a dozen years of an existence that bordered very closely upon the life of a house slave. The apprentice had to cook his master's meals and mind his children, whenever he was not busy mixing paints or preparing a fresh layer of cement on which the great man himself could trace the figures for his next *chef d'oeuvre.*

Here I ought to add a few words about the teacher himself, for Cimabue was considered one of the greatest painters of his time. I regret to say that few authentic pictures have come down to us from this man whom the Florentines honored as the father of Italian painting. His chief claim to fame seems to have rested upon the fact that he was supposed to have painted the "biggest picture in the whole world." It is a curious touch which shows us that in the matter of popular taste, very little has changed during the last twenty-five centuries. For Phidias had gained great renown among the Greeks for having constructed the "largest statue in the world." And Nero is still remembered because his likeness—the most colossally colossal statue of all times—stood right near the Madison Square Garden of his day, which ever since has been known as the Colosseum.

But while the genuine Cimabues have almost all been lost we still have a great number of pictures that were either copies of Cimabue's own work or painted by his pupils. These are interesting, for they show that this artist, who died in Florence in the year 1302, was still essentially a product of that early medieval school of painting which today survives only in the work of the Russian icon makers. That is to say, he apparently never looked at nature but was guided only by

tradition; and tradition in his case was still the tradition of the worker in mosaics.

Now mosaics in the fourteenth century were beginning to be a lost art. In the first place they were much too expensive for any practical purposes. In the second place, they took an awful lot of time (try to hurry a picture puzzle that is ten by fifteen feet high and wide!) and, then as now, time meant money. In the third place, the material forced such absolute limitations upon the artist's genius that he looked eagerly for some other method that would give him a little more freedom of action.

He found this finally in painting *alfresco*. This *alfresco* method of painting (so called after the Italian word *fresco* which meant fresh or cool—in this instance referring to the fresh wetness of the plaster) consisted of the following: The artist smeared his colors, mixed with water, on a background of wet plaster. The water would soon evaporate and would bind the colors to the plaster, producing a hard substance which was almost timeproof. Being so much cheaper and easier than mosaics, the *fresco* method was at first held in low esteem, just as many people today will still prefer a tenth-rate painting to a first-rate photograph.

Giotto, too, appears to have begun his career as a worker in mosaics. But we know him only as a painter and architect. In the latter capacity he was a good craftsman, but no better than dozens of his contemporaries. But as a painter he was something very exceptional, for he gave us a fine broad highway where until then the members of his profession had always been obliged to follow a narrow and not very interesting track.

Here I should warn you that if you have never seen any of Giotto's works and should now, in anticipation of a few happy hours, rush to the library to get a volume of his reproductions, you may well experience a sense of profound disappointment. "Is that all?" you will say to yourself. "These wooden figures and these funny-looking houses and trees, all of them out of proportion and as flat as a pancake! Is that all?"

But that is not all. There is a lot more, but it may take you many years to learn to see it. In the first place, there are the unusual features. Remember that Giotto was not a painter in the modern sense of the word. He was a muralist. The work of a painter stands by itself, or at least is supposed to be able to do so. You can buy it in Rome and take it to Rio and if placed in the right light, it will be just as good in the latter city as in the former. But murals are expected to play a role

quite different from that of ordinary paintings. They are exactly what the word implies. They are a part of the *muri*, an integral part of the walls, and as such they perform an architectural purpose as well as an esthetic one. That may be one of the reasons why most of our own modern murals are so bad. The artists have thought of themselves only as painters and not as a species of artisans who were supposed to work in color instead of in bricks and mortar.

Had Giotto turned to a "naturalistic style," had he tried to give a true representation of landscapes and of the people standing in those landscapes, he would have defeated his own ends, for then he would have given his paintings a depth which would have distracted the eye and the attention of the pious from the building in which they were worshiping. He would have turned the church into a museum. Giotto sometimes came very close to such a naturalistic form of expression, much closer than any of his predecessors, but he was a good son of the Church and he remained faithful to the traditions of his guild.

That brings us to the second one of the objections you are likely to make. I now refer to the stiffness and awkwardness of the gestures of the figures, the wooden aspect of the gowns of his women and the cloaks of his men, which look as if they stood "outside" of the figures they are supposed to cover instead of hanging from their shoulders as they would do in a modern painting. There again, remember the difficulties which Giotto had to overcome. He was a true pioneer. He was the first man to try to do something that had not been done for such a long time that it had been completely forgotten.

If I were asked to paint a naval battle of the seventeenth century, I would have hundreds of other pictures of naval battles done by much better men than myself from whom I could politely "borrow" a few ideas. Poor Giotto had nobody to "inspire" him, as we are apt to call a little bit of stealing within the realm of the arts. He had to invent everything for himself. He had to fish all his ideas out of his own imagination. There were, of course, thousands upon thousands of religious pictures which dealt with the lives of Jesus and the saints. But they dealt with a world which time had completely encrusted in a heavy layer of tradition.

Saint Francis, on the other hand, was no saint who had been dead for hundreds of years. He was almost a contemporary. There were still thousands of people who in their early youth had seen him with their own eyes. Giotto therefore could not treat him as he would have treated Saint Peter or Saint Luke. There must be an air of authen-

ticity and aliveness to these scenes he was going to depict on his walls. Furthermore, as Saint Francis was to be the hero of all these exploits, Giotto must constantly keep him in the limelight, as we would say today. There had to be a certain amount of background and there had to be a background which would make it easy for the common people to identify their hero with whatever he was supposed to have been doing at the time. But this background must never be allowed to distract the attention from the main figures.

When you have studied these pictures for a few years (my recipe for this is as follows: Get a few good reproductions and hang them on the walls of your bedroom or your sitting room where you can look at them at odd moments without getting conscious of doing something unusual)—then you will begin to see for yourself how completely Giotto solved all his difficult problems. Suddenly one fine morning you will discover that these wooden figures are really not wooden at all. Within the limitations of the methods that were at the disposal of the artist, they are most tremendously alive and they completely fulfill the purpose for which they were made.

Saint Francis comes back to life. You follow him as he tends the sick. You listen to him as he preaches to his little brothers and sisters of the fields. And all this was as it should have been, for Giotto lived in an age when there were very few books, no pictures to speak of, no wood or steel or copper engravings, no movies, no means of pictorial communication except what could be shown in a few statues and on the walls and in the windows of the big cathedrals. The Franciscans, who had asked him to tell the story of their founder for the benefit of the multitudes who were now coming to the churches to hear these brethren preach (one of the many innovations of the great Francis), wanted to appeal to their disciples not merely through their ears but also through their eyes. Giotto was told to solve this problem and he solved it most successfully.

You will find his best pictures in the upper and lower churches of Assisi. You will find others in Florence and a great many of them are in Padua in a chapel built by the son of a famous moneylender who, when last seen by Dante, was having a very thin time of it in the seventh circle of Hell. Most of them show the signs of their great age and in another four or five hundred years they will be merely so many blots of color. However, quite a number of excellent reproductions exist and these will not only give you a great deal of pleasure, but if you study them the right way they will teach you one very important lesson. They will show you how few things a really first-rate artist

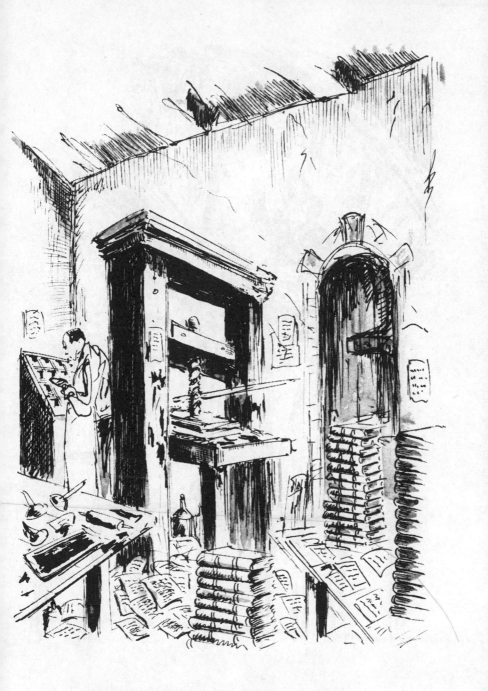

THE PRINTER APPEARS UPON THE SCENE

**MICHELANGELO**

needs to achieve his effects. Two or three figures, a bed or a chair, a window, a door, a wall, and the top of a tree, and the story is told so that everyone can understand it.

There have never been many people who could do this. The Chinese were very clever at it hundreds of years before Giotto was born. But as he had never heard of them and had never seen any of their work, no one can possibly accuse him of having been influenced by their example. He was just brilliant enough to discover all this by himself. His name is not as well known as that of a great many other Italian painters, such as Raphael or Da Vinci. But it deserves to be. For these other masters only followed where he had led.

Giotto died in the year 1337, sixteen years after his good friend Dante, who had been his guest in Padua while he was working on the frescoes for the Chapel of the Arena, which derived its name from the fact that it was built on the site of an old Roman arena. But before he was lowered into his grave, sincerely regretted by all who had known him and who were unanimous in proclaiming him one of the most lovable of men as well as one of the most important artists of all times, he had switched over from painting to architecture.

At the request of his neighbors he had agreed to act as superintendent of all public buildings within the territory of Florence. For the Florentines just then were engaged in building their glorious Duomo and they intended to make it outrival any other cathedral ever built in any other part of the world. Their famous cathedral of Mary of the Flower (thus named after the lily in the arms of Florence) still stands. It had been begun some forty years earlier but it was still far from finished when Giotto was made its architect. Also, the Florentines wanted a tower worthy of their most important church and as this had not even been begun, the plans thereof were left entirely to the new superintendent. It was finished fifty years after the master's death, but he lived long enough to feel convinced that it would be his tower and that no younger architect would be allowed to modify it, reshape it, or reconstruct it the moment he should have disappeared from the scene.

That is about all I can tell you about him in a book that is already so full of names. Perhaps I have even given him a little too much space. But that was unavoidable. For Giotto was remarkable in still another way. Not only by his work but in an equal degree by his personality and the dignity of his private life, he contributed mightily toward giving the artist once more that position in society to which he was entitled by the very nature of his services as a philosopher who thought in terms of color and line and sound.

# Il Beato Fra Giovanni Angelico da Fiesole

### The Saint Francis with a brush

GIOTTO HAD A GREAT MANY PUPILS but not a single one of them ever rose above a respectable mediocrity. While all of them most faithfully copied the mannerisms of the master, none of them was ever to equal him in his manner and in his style. Italy is full of these Giotto-esque pictures. They are as dull as the Christmas cards that the English royal family sends to its friends on the twenty-fifth of December, and by their very number (all the Italian museums are full of them) they threaten to make you lose all taste for the work of the older man himself. Beware, therefore, of these uninspired disciples and hasten to the rooms that bear the legend FRA ANGELICO. For there you will come face to face with another very interesting personality. There you will make the acquaintance of Fra Angelico, a brother who, if you treat him with respect and understanding, will prove an angel as well.

Giotto, although he had entered so closely into the spirit of holy Francis, had been a man of the world, a well-to-do and respected citizen of Florence, the father of three sons and three daughters. Fra Angelico approached his problem from a different angle. He lived far removed from all the temptations of the flesh. He divided his days between tending the sick and painting pictures. And finally he did something which even Giotto himself had not been able to do.

Giotto had always painted his hero from the outside. Angelico went one step further. He painted his hero not only from the outside but also from the inside. He managed to do this by training himself into another Saint Francis, but a Francis with a brush and a canvas and pots full of paint. The Church probably had this in mind when it declared the good *fra* worthy of holy honors and made him the only painter who had ever been allowed in the anteroom of the saints. We laymen, who are not qualified to judge of such high matters, must base our final judgment upon somewhat different grounds. Merely study the works of the honest friar and soon you will say, "This man was more than a painter of imaginary scenes. He must have been pres-

ent at all these events. He must have seen them with his own eyes. For how otherwise could he have achieved such a sense of reality?"

But the "reality" of the fifteenth century (Angelico was born in 1387 and died in 1455) was not that of our own school of realistic painters. It was a reality of the imagination rather than of fact, but it was just as real as the "reality" of the Knights of the Round Table, who are concrete and living characters to us although we know perfectly well that they probably never existed.

Like Giotto, Fra Angelico was of humble origin. He was born in Vicchio, a village in the neighborhood of Florence. At the age of twenty he became a novice in the Dominican convent in Fiesole, the small town that towers high above Florence and has one of the oldest Romanesque churches of northern Italy. Whether he had practiced painting before he took his vows, we do not know, but his style seems to indicate that he had learned his trade from one of those masters who had made the city of Siena a center of painting long before Florence became interested in that form of art.

Unlike so many other beginners, he did not have to spend many years fighting for recognition. His work found admirers from the start and he spent almost half a century going happily from city to city, painting altarpieces or whatever else was required of him, asking no other reward than the conviction that, to the very best of his ability, he had contributed to the greater glory of God.

His unselfish modesty became proverbial. Pope Eugenius IV offered to make him archbishop of Florence, but Angelico declined. He declared himself unworthy of such an honor and went on painting pictures and devoting his leisure hours to the care of the sick.

Let me mention one thing that is very characteristic of his work. I refer to his sense of color. Surely the Middle Ages had not lacked in color. Illuminated manuscripts and stained glass windows often make one feel as if a lot of bright children had been allowed to play with the rainbow and told to do as they pleased. In the paintings of Fra Angelico the color is also present and in great profusion, but it is much less harsh than in the stained glass windows of a more brutal age which liked its art as it liked its food—everything from meat to pudding mixed with spices and served with a liberal addition of mustard, pepper, or cinnamon.

It is always very difficult to reinterpret something that should be seen or heard into terms of words. But the paintings of this master give me the feeling that Angelico was very conscious of the oft forgotten fact that God is really a gentleman and that heaven may there-

fore be presumed to be populated by people of gentle instincts and tastes. That may explain why for so long a period of time and against so many rivals the Angelic Friar has been able to hold his own and even today appeals as much to the Protestant as to the followers of his own faith.

# Niccolò Machiavelli

### And the new patrons of art

IT IS A PRETTY FAR CRY from Saint Francis of Assisi to Niccolò Machiavelli of Florence, but history and the arts make strange bedfellows and so we shall have to give the founder of the modern conception of the state almost as much space as the man who tried to make that Machiavellian state unnecessary by turning its citizens into decent Christians.

Machiavelli does not enjoy a very good reputation these days. He was a perfectly well-behaved citizen, however, held in high esteem by his neighbors and enjoying the personal friendship of several of the popes. But his curious ideas of statecraft and his conception of the state as a sort of superhuman monster that was not bound by any of the ordinary laws of decent behavior and could do exactly as it pleased, that could murder and steal and cheat without the slightest qualms of conscience—they have made his name a byword among the liberals of the last two centuries for all that is wicked and iniquitous.

Why did this learned, cultured and on the whole very tolerant and amiable Italian gentleman, a great lover of the arts and as particular about his literary style as about his personal appearance—why did such a man preach a doctrine that might well have been conceived by one of our master gangsters in their lonely seclusion of Alcatraz Island? We must first of all realize the sort of world in which he happened to have been born. It was—incredible though this may sound at first—very much the sort of world in which we ourselves happen to live.

The Middle Ages had expected salvation from a universal state. During almost a thousand years people had had a lovely vision of a dual form of leadership. The pope was to be supreme in all the matters of the spirit, while the head of the Holy Roman Empire was to exercise the power of the Caesars of whom he was supposed to be the logical successor. This arrangement, which had seemed favorable when the strong personality of a Charlemagne dominated the world, degenerated immediately after his death into a vulgar brawl for

power and for spoils. It turned the pope into the sworn enemy of the emperor and from that moment on (rightly speaking, the middle of the tenth century) they never ceased to fight each other for that part of the world which would bring them the greatest amount of revenue —that part of central and northern Italy where all the big cities were situated. Most of these cities had acquired their wealth by means of commerce and industry. They could only hope to maintain themselves if they were able to act as independent units. They realized this very clearly but the cards were heavily stacked against them. Outwardly at least they were "democracies" and a democratic form of government in the days of Machiavelli meant anarchy.

Niccolò Machiavelli was no scoundrel, as so many people still seem to believe. He was an honest fellow and in his own way an ardent and unselfish patriot. As nationalism had not yet been invented, his love for his country meant his love for his native city of Florence. But he had traveled. He could look beyond the narrow confines of Tuscany. He realized that no salvation was to be expected from the bickering little democracies with their everlasting feuds and their jealousies or from the petty tyrannies of those little towns which had fallen into the hands of some local family of Capulets or Montagues. What Italy needed was a strong man, and Machiavelli set out to discover for himself an ideal prince, an ideal prince who would make an end to all this unworthy strife and give the people, not only those of his own community but of the whole country, a feeling of safety and security which they had not had since the last of the Roman legions had marched out of their city gates, never to return.

Two thousand years before, the mild and amiable Confucius had set out upon a similar quest for the ideal prince. I regret to say that both men were equally unsuccessful. But whereas the great Chinese reformer had hoped to find his ideal ruler in the land of Lu and afterwards in the land of Ts'i, Machiavelli stayed a little nearer home.

After a political career in Florence, which ended in the usual disaster, he cast longing glances in the direction of the neighboring city of Siena. This town, after many years of continual disorders, had at last been converted into a smooth-running tyranny by a completely unscrupulous but exceedingly intelligent gentleman by the name of Pandolfo Petrucci, and it was this Pandolfo Petrucci whom Machiavelli had in mind as his example of the ideal statesman when he spent the days of his exile in the year 1513 composing his famous book, *The Prince*.

And now, if you please, let us stop a moment while I show you why

I have mentioned a saint and a politician as being both of them responsible for a profound change in the contemporary arts. Pictures not only must be painted, but if the artist is to live they must also be sold. Saint Francis, by giving the world a new outlook upon life, had changed the contents of the pictures. Machiavelli, by idealizing the prince, now gave the artists a new kind of patron—the dictators of all those little cities in northern and central Italy who were even more lavish in their expenditures upon their palaces and pictures and statues and private choirs and orchestras than the Church had ever dreamed of being.

Siena is as good an example of this new development as one can hope to find. Like Assisi, it was situated upon a ridge of low mountains that had been a center of civilization ever since the days of the Romans. For there were music and gaiety among those hills and as a result, the painters and sculptors got rhythm and melody into their pictures and into their statues. Built in the land of the Etruscans, Siena had enjoyed the benefits of civilization at a time when its future masters, the Romans, were still heavy-footed peasants, painfully tilling their stony fields. Before the sudden rise of Florence it was Siena that had been the most important banking and manufacturing center of northern Italy. Drawn into the great quarrel of the Middle Ages, the fight for supremacy between pope and emperor, the city had wasted all its political energies upon these unceasing feuds between the Guelphs and Ghibellines, the latter being the supporters of the emperor while the former took the side of the Holy See. But it had retained a great deal of its former wealth and had therefore attracted both the literary folk and the gentry of the brush and the chisel, who are just as eager for three good meals a day and a pleasant roof over their heads as any other part of humanity.

Finding themselves in so merry a city and among so merry a people, they all of them reflected this mood in their work and ever since, the "gay school" of Siena has been famous all the world over, both for its perfection of color and for its emotional appeal.

We usually associate the idea of gaiety with liveliness and therefore we would expect to find in these Sienese pictures a close copy of those festive scenes which we shall afterwards observe in the works of so many of the great Dutchmen and Flemings. But the Sienese still had the blood of the old mosaic makers in their veins. Byzantium and Ravenna continued to guide their hands when they mixed their pigments and put them upon the wet chalk of their church walls. And when the failure of Siena to defend its liberties had made the city

part of the rapidly increasing Florentine domains and the city therefore had become more or less cut off from the rest of the world, the Middle Ages continued to linger within its ancient walls and Siena became a small island of medieval tradition lost in a vast sea of Renaissance experiments.

Strangely enough, the local sculptors and wood carvers and the makers of the famous Sienese pottery were far ahead of the painters in noticing the changing trend of the times. This was especially true of the sculptors, such as Niccola and Giovanni Pisano (father and son) and Jacopo della Quercia and Lorenzo di Pietro. Saint Francis had given them something new upon which to try out their talents. The Franciscans had introduced preaching as part of the regular church services. Whereas formerly the churches and cathedrals had been entirely bare of furniture, the central part was now filled with benches on which the worshipers could sit while listening to the sermon that was pronounced from the top of a pulpit. These pulpits, playing such an important part in the new ritual, became an object of great care, for the Church has always understood that it is just as important to appeal to a man's eyes as to his ears. Having no contemporary examples from which they could derive their inspiration (for until then there had been no pulpits) the sculptors went all the way back to the old Roman masters and thus introduced a Renaissance element into a community which was still predominantly medieval in its general outlook upon life.

As for the painters, most of them, I am afraid, will be mere names to you, for fresco painting is not an easy article of export. But one of them, Duccio di Buoninsegna, usually called Duccio for short, painted Madonnas of such tenderness and charm that they greatly influenced all his contemporaries, including the masters of the more robust Florentine school. Simone Martini and Lippo Memmi, his brother-in-law, and the Lorenzetti brothers turned their art into the same sort of graphic poetry which we so often encounter in the illuminated manuscripts of that day.

But after the city had ceased to be a miniature metropolis with a rich political and intellectual and artistic existence of its own and had become a colony of Florence, these painters and sculptors lost their old market. The architects, too, were forced to leave, for no new buildings were going up where there was no longer any money. The old families alone held on for a few years more. Then, unable to maintain their former palaces any longer according to the standards set by their ancestors, they either went to some other city where they

would not mind being poor and disinherited or they withdrew to their farms and got absorbed into that class which had given them birth, the class of the small peasant proprietors.

As for the town, which for almost two centuries had been one of the most interesting art centers of Europe, it settled down into perpetual hibernation. Grass grew in the deserted streets. The magnificent old churches became gathering places for beggars who would murder a passer-by for a couple of pennies and who were painfully kept alive by the charity of the few remaining monasteries. The city settled into a desultory museum of Gothic architecture and Gothic paintings, a sleepy village where the spirit of the Middle Ages had found a final refuge among the ruins of those proud and turreted homes from which, four hundred years before, a handful of haughty patricians had controlled the money markets of the world as Wall Street controls them today.

## Florence Comes Into Its Own as the World's Greatest Art Center

*And Paolo Uccello makes certain interesting discoveries
in the field of perspective*

OUR GREAT FOOTBALL AND BASEBALL PLAYERS and our movie stars, being very close to our hearts, are usually referred to by their nicknames. Whenever a certain group of people has become just so many nicknames to an entire nation, we may be certain that whatever these heroes happen to do means more to their neighbors than anything else.

In Florence it was the artists who achieved this curious honor. Everybody not only knew them but also knew all about them, where they lived, what pictures they had just finished (and had been paid for or not), what pictures they had just started (and how much they were supposed to get for them), whether they were bossed by their wives (or *vice versa*), whether their wives fed their apprentices decently (or let them starve), and other such important details which showed that the Florentines took a very direct and very personal interest in those matters which today are usually associated with Hollywood.

There was, to give you an example, Paolo di Dono, the son of a Florentine barber-surgeon. At the age of ten he was apprenticed to Lorenzo Ghiberti, the sculptor and worker in bronze, who made the famous doors for the Baptistery in Florence, that strange little octagonal building that stands close to Giotto's duomo. Afterwards he did some mosaic work in Venice and then turned painter. His hobby, however, was birds, and Florence therefore got to know him as Paolo Uccello or Paul the Birdman.

How Giovanni da Fiesole became Fra Angelico I have already told you. Then there was Donato, the son of Niccolò di Betto Bardi, like the Medici a member of the wool combers' guild. As a boy he was apprenticed to a goldsmith but after quite a long stay in Rome, whither he had gone with Ghiberti to study Roman antiquities, he returned to Florence and became so popular that his given name of Donato was gradually changed into the affectionate diminutive of Donatello, "our little Donato."

Another famous painter who suffered a similar transformation (but on somewhat different grounds) was Tommaso Guidi, son of a Florentine notary. His sloppy habits both in his mode of living and in his method (or rather lack of method) of paying his baker and grocer gained him the name of Masaccio, or "clumsy Tom," and as such all good visitors to the Brancacci Chapel in Florence admire him as the first of the great naturalists.

It is rather difficult to think ourselves into the mentality of these good Florentines of the fourteenth and fifteenth centuries. You would be entirely mistaken if you thought of them as a race of supermen who closed the doors of their studios at noon to spend the rest of the day reciting the sonnets of Dante and taking their children to observe the progress of Maestro Giotto's lovely campanile. They were just as much interested in making as much money as they could as any modern businessman. They traded and bartered, bargained and cheated and lied with all the gusto of a modern Italian art dealer trying to sell you a very poor copy of a Raphael as a genuine product of the Master's hand. Their political activities were of the order of the ward politics of our own country in the days of Boss Tweed. Dante to them was a fugitive from justice who had guessed wrong and had backed the wrong candidate. In dealing with their neighbors, they were guided by only one motive, to get just as much for themselves as they possibly could while giving no more than they were absolutely obliged to do. If they had been alive today, they would have been among the most ardent supporters of Signor Mussolini, who by and large is one of the most faithful and also most successful disciples of Niccolò Machiavelli. In short, in their politics and in their daily activities, these Florentines of the glamorous *Quattrocento* were not a whit different from their descendants of today, just as the Greeks of the days of Pericles were the exact counterpart of the Greeks of today when it came to plotting and scheming and putting their own interests above those of the state.

But it so happened that they combined this spirit of ruthless selfishness with a very deep and very sincere feeling for everything that was beautiful. If the true purpose of an education in the arts consists in giving people a sense of discrimination which enables them to recognize perfection and to reject everything second-rate as spurious, then we can say that the Florentines (and for that matter, most of the Italians of that day) were among the most civilized people the world has ever seen. The Medici, never faltering in their pursuit of the greatest of all the arts, the art of living, may have had something to do with

this. It is much easier to develop a good musical taste when from childhood on you have been exposed to only the very best of Bach and Beethoven and Brahms than when you have never heard anything but romance of the moon-and-spoon variety. But I don't want to be too dogmatic, for unless you have the eyes with which to see the beauty around you, it might just as well not be there. The modern Italians and the modern Greeks are still surrounded by these same temples and statues and pictures which inspired the people of the Renaissance. Yet they are the most hopeless artistic barbarians of modern times. They not only tolerate but actually admire things which the people of New York or Chicago would relegate to the ash-can. It is all very complicated and better men than I will have to find out how this happens to be that way.

During the period between the death of Giotto in 1337 and the death of Domenico Ghirlandajo in 1494, when Rome succeeded Florence as a sort of concentration camp for all artists (having meanwhile increased immensely in wealth), there were so many painters, sculptors, jewelers, goldsmiths, silversmiths, tinsmiths, coppersmiths, and glassworkers of all sorts in the city on the Arno, and they worked so diligently at their different trades that it is impossible to give you all their names or to tell you in detail about everything they did. But I shall mention a few to give you an appetite for the others.

First of all, Masaccio. His most important work you will find in Florence in the chapel that the Brancacci family built in the church of Santa Maria del Carmine. Originally Masolino da Panicale, a member in good standing of the druggists' guild (to which the painters who made their own pigments then belonged), had been entrusted with this work. Masolino never finished the job and it was given to his pupil Masaccio. These frescoes of Masaccio were the talk of the town, for they showed something entirely new and entirely different from the work done by Giotto. They definitely broke with the tradition that murals must be part of the architecture and should not pretend to play an individual role as paintings. They were paintings pure and simple. And as such they so deeply impressed the art world of that day that for several hundred years the Brancacci Chapel became the school where all young artists came together to learn their trade. The chapel fulfilled the role today played by our own academies of art.

Masaccio, who died before he was thirty, twenty years before his master Masolino, also failed to finish the chapel and so the rest of the

work was done by Filippino Lippi. This Filippino was the son of a certain Filippo Lippi, who, although he had also taken holy vows, was rather more careless in the observance of the rules of his order (he was a Carmelite) than his colleague, Fra Angelico. As a result he became the father of a boy who one day was to gain almost as great renown as his father. The child's mother is also known to us, for she posed for many of those charming Madonnas which were one of Fra Filippo Lippi's specialties. All this, of course, is not the sort of thing of which we would approve today, but Lorenzo the Magnificent, the supreme judge of Florence in all matters pertaining to manners and morals, worried so little about this slight irregularity that upon Filippo's death in the year 1469 he ordered a most imposing monument to be placed over his grave. There the old sinner still lies, the same man who had saved his own life while a prisoner of the Barbary pirates by painting the pictures of his captors, who was undoubtedly one of the greatest colorists of the fifteenth century, and who made his heavenly scenes so delightfully human that many people, for the first time in their lives, thought it might be rather nice to go there.

And now a few more names. There was Andrea del Castagno. He was known to his fellow Florentines as Andrea degl' Impiccati, or Andrew of the Hanged Men, because in the year 1453, after one of the eternal quarrels in Florence, he was commissioned to paint the pictures of all the leaders who had been hanged. The picture was intended for the Palazzo del Podestà, the palace of the chief justice, more commonly known today as the Bargello. Not a pleasant job, but his life was full of tragedy. He was seriously suspected of having murdered his rival, Domenico Veneziano, when he suspected that Veneziano had also got hold of the secret formula by which the Van Eycks were now preparing their famous oil paints. The story is interesting because it shows us what a tremendous sensation this Flemish discovery must have made among the painters of Italy when they were willing to murder each other so as to keep a monopoly that might bring them a fortune. Unfortunately the story is not true, for Domenico Veneziano died quietly in his bed, four years after Castagno.

Then there was Benozzo di Lese, known commonly as Benozzo Gozzoli (which may have referred to his having a *gozzo* or goiter). He started his career as an assistant of Fra Angelico and is best known for his endless murals (none too cheerful) which he began in the cemetery of Pisa but never finished.

There was Andrea Verrocchio, painter, sculptor, and goldsmith,

the teacher of Leonardo da Vinci. He fashioned the model for one of the finest equestrian statues still existent, that of the Venetian *condottiere* (Italian for leader of a band of mercenaries), the famous Bartolommeo Colleoni, as noble a type of gangster face as you will ever see anywhere and as fine a horse, too.

One name I have saved for the end, for the man who bore it is known to all of us. That is Alessandro di Mariano dei Filipepi, whom we know as Botticelli, or "the Little Barrel," because that was the nickname of his older brother, Giovanni, an honest broker who took care of Alessandro and educated him after the death of their parents. As he was not of very robust health he was at first apprenticed to a bookbinder to learn a trade which would not tax his strength too much. But when he showed extraordinary talent as a draftsman (as we can see for ourselves from his illustrations for Dante's *Divine Comedy*), he was apprenticed to the gentle Fra Filippo Lippi.

He got a lot of his master's style into his own work, but if I may borrow an expression from the fiddler's art, he got a great deal more of the *vibrato* into his paintings than any of his contemporaries. Now *vibrato* is sometimes necessary and it can be very pleasing, provided it does not last too long. It is apt, however, to give an emotional touch to the music which soon makes you ask for something a little more robust. It was entirely in keeping with Botticelli's nervous and unbalanced temperament. He always remained a rather sickly person, although like so many delicate souls he reached a ripe old age, dying in 1510 at the age of sixty-six. During the last years of his life he became a mystic and lost himself more and more in religious speculations. This probably accounts for his tremendous vogue with the English and Americans of the Victorian era. I seriously doubt whether we shall see quite as many reproductions of his *Birth of Venus* and his *Spring* in another twenty-five years as we do today.

And now, for good measure, our old friend Uccello, Paul the Birdman, for his name is forever connected with the discovery of the laws of perspective. Perspective, as you know, is that scientific method by means of which "we are able to present an object as it is seen from some definite point of view, and to give it a tridimensional effect while using only two dimensions." It may seem strange that the world had been able to get along without some scientific method of perspective during all the thousands of years people had been turning out those works of art which still delight our eyes. This statement, however, needs a certain amount of modification. Many artists living in the pre-perspective era had often placed their landscapes and their

figures in the proper perspective without in the least knowing what they were doing, but following their intuition. Many more, I am sorry to say, had committed all sorts of grievous blunders which they could have avoided quite easily if they had known just a little about vanishing points and foreshortening. It is also possible, of course, for a painter to know so much about perspective that he gives us merely a mathematical rendition of a landscape or a basket full of onions, in which case the result is just as deplorable as when he doesn't know enough.

The best painters, therefore, since the days of Uccello have done their work as a first-rate skipper does his, making use of all the scientific appurtenances that are at his disposal but adding a bit of his own genius to come to the correct conclusions. Once the secret had been discovered, all sorts of other artists, especially those with a mathematical turn of mind like the German Albrecht Dürer, slaved over this fascinating puzzle until today there is not a single problem, however complicated, from elephants turning somersaults to airplanes making nose dives, that cannot be expressed in such a way as to observe all the rules of perspective.

Today the Chinese and small children are the only ones left who do not bother about perspective. Perhaps that is what makes their pictures so attractive.

# The Putti

*The cheerful little Bambini which the Florentine sculptors brought back to life*

URING THE FIRST SIX HUNDRED YEARS after the fall of Rome, sculp-
D ture had almost completely disappeared from this earth and it
was not until the middle of the eleventh century that the stonecutter
once more came into his own. But he was not asked to study nature
and revaluate what he there observed in marble and granite. Rather,
he was told to stick closely to the example given him by the painters
and mosaic makers of Constantinople. Any deviation from the strict
rules which tradition had already imposed upon these Byzantine
craftsmen was viewed with great disapproval.

When the Gothic mood came upon the people of the Middle Ages,
when the people of the cities, set free from the drudgery of the peasant's
existence, began to listen to that "beautiful fairy tale told in a brutal
world" of which I wrote a few chapters ago, the stern and forbidding
statues of the Romanesque churches were gradually replaced by a new
type of figure. This figure was endowed with certain human qualities
rarely to be found among the images which only a short time before
had gazed down upon the heads of the departing Crusaders.

The new shape of the Gothic churches was also responsible for this
change. The Romanesque church with its heavy walls had offered
little opportunity for the sculptor. But an edifice consisting mostly of
pillars and a façade that was meant to delight and attract people with
an elaborate display of heaven and its inhabitants—such a building
could be covered almost from top to bottom with large and small
pieces of sculpture. The cathedrals of Reims and Amiens are still there
to show us to what heights of perfection this "singing in stone" could
be carried.

Then came the great rejuvenation of the Christian faith in the
thirteenth century. The same spirit of childlike gaiety Saint Francis
had carried into contemporary painting also began to make itself
manifest in sculpture. And, quite naturally, it was the city of Florence
where this new sort of sculpture was brought to its highest point of
development. I am not now referring to the work of Michelangelo

and the other great men of the later period of the Renaissance. They are in a class by themselves. They literally take your breath away when, for the first time in your life, you enter the hall where they wrought their stone miracles. What I have in mind is something much simpler, but something that goes straight to our hearts, something not seen since the days of the Romans who had also been very fond of processions of happily dancing youngsters.

I refer to the children and the saints of Luca della Robbia and Desiderio da Settignano and the versatile Donatello. Since these men had broken away from the dogmatic severity of their ancestors, they thought themselves at liberty also to work in a medium that had not been used for almost ten centuries—our old friend the terra cotta or baked clay.

During the tenth century it had made its reappearance in northern Europe, which is very rich in clay but very poor in other building materials. Then it had been used for building purposes in a number of their churches. Now in Italy in the fifteenth century, the sculptors borrowed the idea from the architects and began to make terra-cotta portraits, as the Greeks and Romans had done long before them. But they improved upon the old technique in quite an interesting way. They began to enamel their terra cotta as well as to paint it. But how this was done I cannot tell you, for it is one of the things I have never seen done. And I hate to write about such subjects from the outside in.

CHAPTER TWENTY-SEVEN

# The Invention of Oil Painting

*The brothers Van Eyck show their fellow craftsmen of Ghent
an entirely new way of mixing their colors.*

OIL PAINTING was no sudden revelation, but then very few inventions are. The Greek painters had struggled with the problem of finding a reliable medium with which to mix their colors so that they would stick indefinitely and not lose their brilliancy. Vinegar was tried and white of egg and all sorts of strange mixtures. But none of their experiments were successful. For hundreds of years this search continued and meanwhile the painters were obliged to stick to their clumsy *alfresco* technique.

For clumsy indeed it was, especially if you were not able to paint directly on a wall but had to make a picture that could be moved. First of all a piece of wood must be covered with linen. Then this linen had to be covered with a couple of coats of fine plaster of Paris, mixed with glue—what the Italians called *gesso*. Then the apprentices set to work (time being of no importance) to rub the surface of the plaster until it was as smooth as polished marble. Upon this surface a preliminary drawing or cartoon was now transferred, as pencil drawings are transferred to lithographic stone. As a rule a rough coat of green or brown pigment was used as an underpainting. This done (and it all took a lot of time) the real paints, also mixed with egg, were applied. But as is not the case with oil painting, everything had to "set" right away. There was no chance to scrape things off this stone-like surface nor could one cover over possible errors by applying a new coat of paint.

Another disadvantage was that underpainting in green and brown. After a while the real paint would begin to wear off and the whole picture got a greenish or brownish aspect which gave it a sickly, disagreeable look. However, there was no other way until in the thirties of the fifteenth century a rumor began to spread among the Italian workshops that in distant Flanders a completely new way of painting had been discovered which did away with all the clumsy intermediary stages of putting the linen on the wood and covering the linen thereupon with plaster. What it was nobody knew for quite a long time,

*The fresco painter in the Romanesque church had enough wall space for his work.*

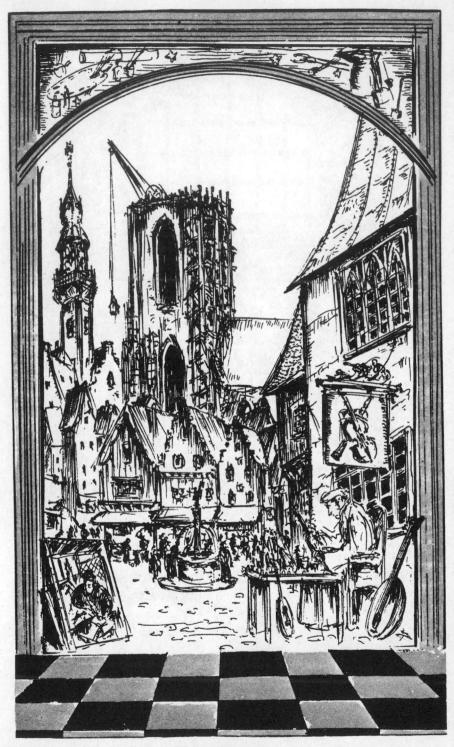

CRAFTSMANSHIP

for such secrets belonged either to individual artists or to the guild to which they belonged, and the guilds guarded such professional mysteries most jealously.

Finally, however, the name of the discoverer or rather the discoverers was revealed. They were two brothers by the name of Huybrecht and Jan van Eyck and they came from Maeseyck in Belgium. Huybrecht was the elder of the two (1366-1426) and Jan, almost fifteen years younger, had been his apprentice. Where they learned their craft we have never been able to find out, for they did not write for the papers. But we do know that they were products of a school of painting entirely different from that produced by the great artists of Italy.

The Italian painters had come up from the ranks of the mosaic makers, but these Flemings had originally been trained to make a living as professional illuminators of manuscripts. Such manuscripts had been in great demand in the southern part of the Low Countries. They were exceedingly expensive, but that was no hindrance to the burghers of Ghent and Bruges, for next to the Florentines they were among the richest people of Europe. These cities were connected with the sea but at the same time lay sufficiently inland to make them safe from attacks by any possible pirates. Being directly connected with the European hinterland by means of a number of big rivers, they were ideally situated to act as the middlemen between the British Isles and northern Europe.

England was then very far removed from the rest of the world. For hundreds of years it had been at the mercy of such Scandinavian and north German tribes as had taken the trouble to cross the North Sea. Finally it had been conquered by a Norman duke. This usurper had not only imposed his own language and laws upon his new kingdom but he had also introduced among his newly acquired subjects the architecture and the art of his continental possessions. Hence the cathedral of Durham, begun in 1093, just twenty-seven years after the battle of Hastings, had been Romanesque. But when it was finished a century later it had followed the changing fashion of the day and had become a Gothic structure. And ever after Gothic was the style in which all the big churches—Wells and Peterborough and Westminster—had been built, although considerably modified (as was inevitable in so remote a country) by the particular genius of the local architects.

In the matter of the arts, England did well enough after the Norman conquest but commercially it lagged far behind. Industries were impossible in a land so full of feudal quarrels. Generally speaking, Eng-

land during the Middle Ages had only one article of export—wool. Flanders at the same time was enjoying a period of comparative inner tranquillity and the Flemish made clever use of the predicament in which their English neighbors found themselves. On their own looms they wove that wool into blankets and cloth and sold the product far and wide all over northern and western Europe. In other words, they had a monopoly of the wool trade.

The Gothic cloth hall in Ypres, destroyed during the World War but now rebuilt, the cloth hall in Bruges, and many other civic buildings in different parts of western Belgium show how important that industry became. And just as in the case of Florence, once enough money had been accumulated to turn a few people into capitalists, these must needs invest their savings in all sorts of other ventures, for money hidden in a safe is of no earthly use to anyone.

International politics also played their part in deciding the fate of the land of Flanders. There was a strange country in the heart of Europe which has long since disappeared. It had really acquired importance when the son of Charlemagne divided his father's heritage among his own three sons; and it was known as Burgundy. It fell into the hands of an exceedingly capable and unscrupulous ducal family who intended to turn it into a kingdom that should run all the way from the Mediterranean to the North Sea. Such a kingdom, if it could have maintained its independence, would have been a godsend to the rest of Europe. Actually as a buffer state between France and Germany, it would have saved us all centuries of war. These plans came to nothing, but during the period of its greatest expansion, roughly speaking in the fourteenth and fifteenth centuries, Burgundy was way ahead of the rest of Europe in the general well-being of its citizens and was remarkable for the interest its rulers took in living just as luxuriously as their well-provided exchequer would let them.

Such tendencies run in streaks. Some of the ruling houses of Europe, with all the wealth of the world at their disposal, have always lived mean and dull lives because that sort of an existence happened to suit them to a $T$. Other princes, on the contrary, with very small means at their disposal, have been men of taste and discrimination, genuinely interested in all the arts and only happy when surrounded by their artists who were also their friends. The Burgundian princes, had they lived today, would have been very "social" but in the best sense of that oft misquoted word. They loved color and excitement. They were one of the few medieval families that really lived glamorously. In the end they were cheated out of their victory by one of the most

despicable and hateful characters that ever sat on the French throne. But while still on their way up, they accomplished a lot. If you should ever visit Bruges or Ghent, even today when for centuries they have been in a state of almost complete hibernation, you will easily be able to reconstruct the magnificent background against which these princes played their roles as the leaders of the medieval smart set.

This was the stage upon which the Van Eyck brothers made their appearance at the beginning of the fifteenth century. They came, as I said, from the village of Maeseyck, but they spent most of their lives in Flanders. They worked slowly and deliberately and their output was limited. They were so exactly alike in their style that it is impossible for us to tell where the elder brother left off and the younger one continued, after the elder one had died without having finished his famous altarpiece for Ghent's ancient St. Bavon's. Their abilities were for once fully recognized by their contemporaries. Huybrecht was court painter to the reigning Duke of Burgundy, who had his palace in Brussels, while Jan was first of all court painter to the Count of Holland (who spent most of his time in that famous hunting lodge which afterwards was to become the city of The Hague) and after the death of his brother succeeded Huybrecht as official painter to the Burgundian duke. Jan also took one long sea voyage. He accompanied the embassy that Philip the Good sent to Lisbon in the year 1428 to ask for the hand of Isabella of Portugal, and painted a picture of the future bride. Huybrecht died in Ghent in 1426. He lies buried in the cathedral in which you may still see his most famous picture, the *Adoration of the Lamb*, which he painted for one Jodocus Vydts. Jan died in Bruges in 1441 and lies buried in the church of St. Donat in that same city.

That is about all we know of them. But it is enough to make us see them quite clearly. They were straightforward craftsmen, contented to live as such but quite conscious of the value of their work and the respect due them as past masters of their trade.

So far so good. But what of the rest? How was it possible for them not only to invent a new process of painting but at the same time to achieve such virtuosity in handling the new medium that without any noticeable process of incubation they immediately rose to such a pinnacle of proficiency that their work has rarely been surpassed? There is only one possible explanation. I have already mentioned it. We know that the dukes of Burgundy during the fourteenth century owned the largest and most beautiful (as well as most expensive) collection of illuminated manuscripts in all Europe. We also know that

Flanders, after several French defeats which took place during the first fifteen years of the fifteenth century, had been flooded with expensive French manuscripts, sold by the wives of the great French nobles to buy their husbands out of captivity. In consequence whereof the entire manuscript industry had moved to Belgium. The Van Eycks, living in this atmosphere, came upon the idea of painting what were to all intents and purposes merely enormously enlarged manuscript illustrations. And somehow or other it was their good fortune that at this critical moment they bethought themselves of substituting linseed oil for the old white of egg and vinegar. This may seem too simple an explanation, but such occurrences are apt to be very simple.

In the beginning the Van Eycks painted only religious pictures. Soon, however, they left this narrow field and tried their hand at portraits. There again they triumphed, but such well-known works as the famous *Man with the Pinks* and the portrait of young Arnolfini and his bride bear very noticeable traces of having been conceived by people whose love for detail could only have been acquired in the workshop of a miniature painter. Their landscape and their still life are still parts of one general composition, but those incidental little bits of background have been so well observed and have been executed with so much love and understanding and such painstaking care for detail that they tell us more about life during the late Middle Ages than whole volumes of printed words.

The same held true for the other men who worked in Flanders, either at that time or shortly afterwards. There was Rogier van der Weyden, the town painter of Brussels, who was the first of the Flemings to visit Italy. There was Hugo van der Goes, who also worked for the Gobelin factories and for the stained glass manufacturers of Brussels and Ghent. There was Gerard David, the first Hollander to gain fame as a painter (he was to be the last of the great masters of the Flemish school), and another immigrant, that brilliant young German, Hans Memlinc, who after a short apprenticeship in Cologne moved to Bruges where he spent the rest of his days and where for the local hospital he painted that lovely shrine of St. Ursula that looks as fresh today as when it was painted in the year 1480.

One thing is certain, these early workers in oil knew how to prepare their colors in such a way that they have been able to defy both time and climate much better than pictures painted hundreds of years afterwards. Of course they worked under the best of all possible conditions. They had all the assistants they needed and could take their time. They could let their paintings dry without being called up on

the telephone five times a day to be asked whether that picture was not ready yet. And they still were craftsmen with a holy respect for those traditions of sound workmanship which had been hammered into their heads when they were mere apprentices and never forgotten.

The fame of these Flemish pioneers soon spread to every part of the world. It started a new enthusiasm for painting in Germany, especially in the valley of the Rhine. It caused the first pictures to be painted in the Netherlands, which soon afterwards were to play such an important role in that particular field. And in Italy it caused a veritable boom in painting which I shall describe in the next chapter.

Meanwhile in Flanders, the school of the great primitives ended as abruptly as it had begun. There was to be a great deal more of excellent painting in Flanders. The Breughels and Rubens and Van Dyck were still to make their appearance. But for the moment there was a lull in the artistic production of this small part of the world between the Meuse and the North Sea. The why and wherefore I shall explain just as soon as we have caught up with what was happening meanwhile in Italy.

# The Italian Picture Factory Gets Under Way

*"Send us a dozen prime Florentines and half a dozen
medium-priced Venetians"*

THE TITLE OF THIS CHAPTER may be slightly misleading. It sounds as if I had no proper respect for all these great masters of Italy's era of glory, for all these great names, these great schools, and these even greater traditions. I have the greatest possible respect for all of them. Some I like immensely. Many others I like fairly well. But an awful lot of them, if you must have the truth, bore me to distraction.

This is not an attitude I recommend to beginners. You will never learn your trade if you stick only to the high spots. In all of the arts there is a terrific amount of plain, ordinary routine work. There are no short cuts. If you really want to learn to play the piano or compose a sonata or sculpt a statue or to write decent prose, you simply have to do the same thing over and over again and for hours and hours and day after day and year after year, for an entire lifetime is hardly long enough to give you absolute perfection. And since taste is merely the ability to discriminate, you must have seen and heard everything there is to be seen and heard if you really want to qualify as a first-rate performer. Then, if the Good Lord has also been very kind to you, you may perhaps some day aspire to become a great artist. But it means work and then still more work, and the sort of work that would make a coal heaver or ditchdigger turn away in disgust.

Part of your self-imposed task will consist in looking at or listening to the things your predecessors have done. There is no help for it—you will just have to go through with it. Until, by the time you have reached my age, you can call it a day and go a little easier on your museums and collections and begin to live happily on your accumulated store of recollections.

Fortunately, as a rule, only the best things survive. Otherwise life on this planet would be impossible. Imagine a world in which all the fifth-rate pictures and all the sixth-rate symphonies had been carefully preserved! The prospect makes us shiver. But when a particular period has been very prolific in its artistic output, all the public buildings and all the museums are apt to be cluttered up with its

paintings, fully three-quarters of which might just as well have been relegated to the attic or the garbage can.

Since Italy has always been the happy hunting ground for the esthetically inclined and depends, even today, for much of its revenue upon the tourist industry, the shrewd natives of that industrious peninsula have most carefully preserved everything to which a date and a label could possibly be fastened. The result is at times rather appalling. But the blame should really be placed upon their ancestors, or rather upon those among their ancestors who were engaged in a trade that soon degenerated into a mere industry—the industry of providing the whole of Europe with genuine Italian masterpieces.

Many of those, of course, were not too "genuine," as we understand the word today. They were signed with names that make every modern artist hold his breath and whisper, "Ah, he was glorious!" But that did not always mean that the *maestro* himself had actually painted the picture. Why should he? It was not the custom. As in the case of the great Raphael, the *divino pittore*, the Master himself provided the sketch and blocked out the figures, but all the rest, the actual painting and finishing, he left to his apprentices, to the "ghosts" who filled his workshop and who in turn learned their trade with a thoroughness which has never since been surpassed.

The method of painting itself had a lot to do with this. In the first place, the old system of painting in tempera (the name we give to every process in which some other substance than oil is used to bind the colors to the background)—this old system that had been in vogue ever since the days of the Romans was still as a rule only a sort of "drawing with colors." You will grasp what I mean by thinking back to the time you got your first box of paints and your first painting book. In the painting book everything had been neatly printed in black and white. Thereupon you sat down to fill in the white spaces, according to the example on the other side of the page. The trees were filled in with green, the roofs of the houses were made a lovely red, and the sky, of course, was done in blue. When you were not very careful, the blue of the sky would run into the red of the roofs and give everything a startling purplish effect, like some little sketch by the late Vincent van Gogh, who did not care either what color his skies were as long as everybody knew them to be skies.

The other sort of painting, in which the color alone told the whole story and in which no use was made of any visible outline, was, as I just told you, a trick of the Flemings which the Italians did not really begin to practice until the Venetians had learned how to do it. And

they only learned how to do it after oil had become the universally accepted medium. That took quite a lot of time. A hundred years after the death of the Van Eycks, the Italians were still painting in tempera, using as a rule white of egg as their binding medium and giving their work merely a few touches of oil to heighten the general effect. For oil was much more shiny and brilliant than tempera and it gave the picture a brilliant aspect which made it much more attractive to the average customer and encouraged him to pay a higher price.

In the second place, the market for which these men worked was not as particular as we would be today. Italian paintings had become the fashion and the public wanted names. The few great names could never have begun to fill all the orders that came in from all over the world. Just as most of our jazz writers today are either too busy or too lacking in skill to do their own instrumentations (many of them cannot harmonize even the simplest tune) and therefore have a small army of professional harmonizers, who take their little songs and prepare them for the piano and for the orchestra, so the denizens of Paint Alley in the sixteenth century left the details to their assistants and contented themselves with a general supervision, just enough to make the average client feel that he had received his money's worth.

Here you might well ask me why I continue to talk about pictures and about sculpture as if there had been no other forms of art during the so-called era of the Renaissance. But the other arts were not very much in evidence during this time. For the rebirth of the arts was the direct outcome of the birth of a new sort of society and every new form of society seems to pass through a period when the pictorial arts are the only ones that really interest people.

Man, of course, needs shelter and woman needs ornaments, and therefore the architect and the jeweler are the first of the artists to appear upon the scene. But they are closely followed by the painter and the sculptor. And only after these have exhausted themselves in contributing to the happiness of the community is there a chance for the musician and the actor and the writer to get a hearing.

During the fifteenth and during the first half of the sixteenth centuries, the Italians were still entirely "picture-minded." It was only after the middle of the sixteenth century with the great composer Palestrina that the musicians began to count. Literature had meanwhile produced Petrarch and Boccaccio, who gave us the short story and reintroduced Homer to the Western World after an absence of

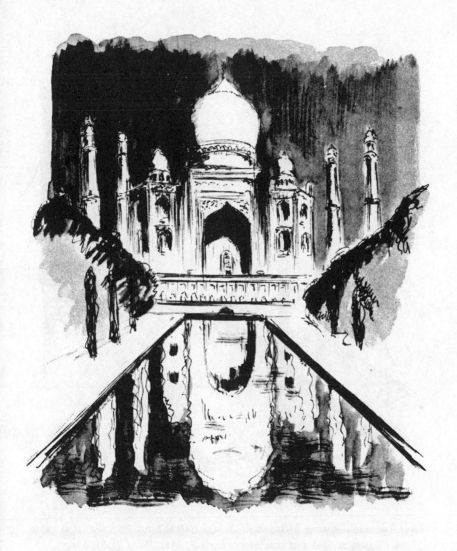

*The Taj Mahal is undoubtedly one of the most beautiful buildings ever devised by the genius of man...*

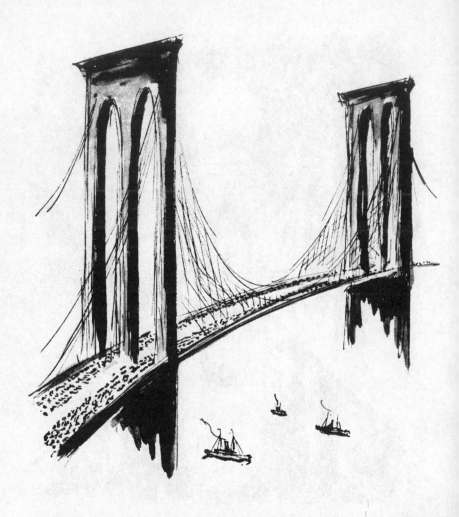

*but when you approach Brooklyn Bridge without any prejudice it is quite as beautiful and even more imposing than the Taj Mahal.*

almost a thousand years, but neither they nor all the thousands of scholars then engaged upon the immense task of reviving the learning of the ancients appealed to the mass of the people in the same way the painters did. It is impossible in a book of this sort to mention them all. But I can give you at least a glimpse of a few of the better-known ones. The others you will afterwards have to discover for yourself.

## Titian

His father was a soldier and politician by the name of Gregorio Vecelli. His own name was Tiziano Vecelli, but he dropped the Vecelli and the world has come to know him as plain Titian. We do not know in what year he was born. Like a great many other people who at the age of seventy are still able to ride a horse and run a mile and eat mince pie for supper and read without glasses, Titian made a fetish of his age. It became a matter of inordinate pride to him that he, who had long since outlived all his contemporaries, could still spend more hours in front of his easel than any young man of fifty. And soon he was adding a couple of years to his age whenever he had occasion to mention the subject to one of his patrons. In writing to King Philip of Spain in the year 1571 (the usual dun, for His Majesty never paid anybody), he informed the King that he was then in his ninety-fifth year. Modern investigation among the archives of the Venetian mainland seems to indicate that the *maestro* was a round ten years off in his calculations. Even so, it was a most enviable performance and we may easily forgive the old fellow his innocent little vanity.

He died when he was probably in his ninety-ninth year. The plague carried him off. Otherwise he might have had his wish and still have handled a brush on his hundredth birthday. That same plague also put an end to his family fortunes. Titian had always received large fees for his labors. During the greater part of his life he had maintained a noble mansion as behooved an artist who was also a count of the Holy Roman Empire and a knight of the order of the Golden Spur and who upon one notable occasion had been allowed to entertain no one less than the King of France at his own dinner table.

After he died of the plague, followed almost immediately by his son, his palace remained untenanted for two or three days. The rabble of Venice used the occasion to break into the premises and steal everything that could be carried away. Such were the customs of the times, and people thought as little of them as we do of the state's charming habit of entering the homes of our departed parents and helping itself to seventy per cent of all it can find.

Titian did considerable traveling but from early childhood on his permanent home was in Venice. He so completely identified himself with the life of that city that it is now as difficult to think of Venice without Titian as the other way around. For this grand seigneur of the paint brush represented the outward culture of his own community in such a perfect manner that if all written documents upon the history of Venice during the sixteenth century were lost, we could quite easily reconstruct the daily life of that town from the portraits and altarpieces that came out of this studio on the Grand Canal.

The story of Titian's career is interesting from a great many angles. Venice was the last of the big Italian towns to feel the influence of the Renaissance. The stern race of patricians who made their beloved city the heart of the greatest colonial empire of the Middle Ages was able to maintain itself without opposition until almost the end of the fifteenth century. Knowing the lighthearted tendencies of their subjects, the stern doges who lived in that vast palace just off the Rialto (their home since the year 814) realized how little it would take to make every day Carnival Day among the careless inhabitants of their prosperous lagoon. So these watchful guardians of the ancestral virtues passed a number of laws of such austere and efficient severity that public life within their bailiwick stood stock-still for almost three hundred years. And the artists, who feared the secret police of the doge as much (and rightly so) as the laziest beachcomber on the Riva degli Schiavoni, meekly continued to paint according to the Byzantine tradition the authorities favored and which therefore survived in this city on the Adriatic long after Constantinople itself had ceased to exist as a Christian town.

The school of painting which had been established on the island of Murano, that famous island that is still the center of the Venetian glass industry and which gave birth to one of those interesting artist families of the Middle Ages, the Vivarini—that school dominated the whole artistic scene and was opposed to all innovations. There was therefore no future in Venice for the moderns. Much smaller towns like Padua were able to attract all the brighter young men, such as Donatello and Mantegna, who otherwise would undoubtedly have opened studios in Venice.

There was bound to be a reaction. It came during the latter half of the fifteenth century. The older generation began to die off. The last of the stern tyrants of the old school was carried to his grave in one of the countless churches that dotted the hundred and seventeen small islands of which the city consisted. Immediately the children and

grandchildren emitted a loud and delighted "Oof!" They settled down to enjoy those riches which their dour fathers and grandfathers had accumulated during those many centuries when they dictated their will upon both pope and sultan and looked askance upon a doge who had actually died in bed instead of in battle.

From that moment on this loveliest of cities became the center of fashion and pleasure of all Europe. During the next two and a half centuries, indeed until the day when a corporal's guard of French revolutionists dissolved the ancient republic, Venice was what Paris has been during the last two hundred years and what New York may become tomorrow—the one spot in the world where everybody with a lot of money and a desire for pleasure knew that he could find whatever he wanted.

Such news travels fast and at once all the artists and near-artists of Europe hastened to these happy marshes. The painters and sculptors reaped as rich a harvest as the pastry cooks, the opera singers, the professional gamblers, and all those who in one way or another contributed to the comforts and pleasures of fashionable society.

Among the first of these happy arrivals was a lad from Sicily, a certain Antonello da Messina, who somehow had strayed to Flanders and there learned the new method of painting with oil. Soon afterwards local talent also made its appearance. This was—or rather, these were—the famous Bellini. They provided Venice with two successive generations of first-rate artists, the best known of whom was Gentile Bellini, a fellow with a most delightful sense of color. Like Giorgione and Carpaccio and many of the other great Venetians he was a past master at showing us the holy saints as distinguished ladies and gentlemen, much more interested in enjoying the sights of the town than in the dreary business of saving souls.

Such an attitude toward religious subjects was safe enough, for the Inquisition was not allowed to operate within the territory of the Venetian Republic. If there was any censoring of morals to be done, the doges intended to do it themselves, and they were powerful enough to defy the anger of the Holy See. And so the gay life continued and the artists reaped a rich harvest. Every young man who made the Grand Tour (that year of international travel which was a sort of social Ph.D. for all fashionable youngsters) returned from the city on the Adriatic with one or two pleasant products of the Venetian school. Indeed, the trade grew so brisk that even today there are probably more phony Venetian masters afloat in our museums than any others except products of the modern French school.

There you have the background against which Titian lived his long and busy life. He started in the usual fashion, serving first of all as an apprentice in the workshop of a mosaic worker and then going to two of the Bellini in succession (first to Gentile and next to Giovanni, the sons of Jacopo) to learn the painting business. Having got as much as he wanted from them, he entered into a partnership with Giorgione, who was his contemporary but who died while still quite young. Together they did a series of frescos for the warehouses of the German merchants living in Venice. After the Bellini were gone, Titian also finished the paintings which his former teacher had begun in the ducal palace.

That was the beginning of a career which in that day and age was quite a novelty. For Titian was the first among the great artists who was able to be entirely independent of a regular patron. He had of course a number of customers for whom at one time or another he did certain pieces of work. But he was never obliged to hire himself out for years at a time to some pope or prince and to act as their official "court painter." This was a most flattering title but in reality such a court painter was not really very far removed from the court cook or the court fool or the court musician. Titian, on the other hand, had his own workshop and there his clients, high or low, could come to look at his pictures and buy whatever they could afford. He was still enough a man of his time to feel a little self-conscious about his independent position, and when King Henry III of France visited him, he felt so deeply honored by the royal presence under his humble roof that he presented His Majesty with all the pictures of which he had deigned to ask the price and begged that the King would accept them as a present.

That, however, was just a little flareback to the days of his youth. The rest of his life he spent painting whatever and whomever he liked, following his own counsel in all he did, whether it pleased his clients or not—an independence few artists of that day could allow themselves.

As for the choice of his subjects, they covered every phase of life, both in this world and in the next. All of them, however, gave evidence of that same intense love of life which made these men of the Renaissance so different from their predecessors of the Gothic period. For good measure Titian finally added something that was entirely new. I would like to call it the psychological element. His faces may have been good likenesses or bad ones. That is something we never can tell about pictures made several hundred years ago. But the faces

of Titian's patrons are apt to reveal certain hidden traits so accurately that we would know the true character of these historical personages if we had nothing else to guide us in our judgment—no contemporary documents and no memoirs and no state papers.

Take his portrait of Pope Paul III and his two grandsons. They clearly show the tragedy of that old man, who had such terrific ambitions for everything that could add to the outward glory of the Holy See and who realized that he had not many more years to live and that his worthless grandsons would then destroy everything he himself had so carefully built up. Or take his picture of the Emperor Charles V on horseback. It shows the mightiest ruler of his time as the loneliest man among all his millions of subjects. And the portrait of Aretino is exactly what we would expect of a blackguard of that sort.

In short, Titian was not only a very great artist, but also a gentleman who by his own life added immensely to the respect in which the arts came to be held, once the artist had regained the right to his own identity. I may be entirely mistaken and perhaps the title really belongs to someone else, but I have always felt inclined to call Titian the Franz Liszt of the painting profession—with the exception that the Venetian knew infinitely better how to handle his women. And I am not merely referring to the women whom he made immortal by allowing them to appear in his pictures.

It is curious how often we have forgotten everything about a famous man except some insignificant detail which to himself was not of any particular importance. Everybody, for example, knows about Titian red in connection with that strange reddish glow of the hair of so many of the women who sat for him. That particular red, however, had nothing to do with Titian, who merely copied what he saw. It was a red that was prescribed by fashion.

As Venice was the great center of pleasure and luxury of the sixteenth, seventeenth, and eighteenth centuries, it was of course able to impose its own fashions upon the rest of the world. Now the Venetians seem to have had a decided liking for red-haired women, just as we, some twenty years ago, used to prefer blondes and went so far as to invent the platinum blonde. By what strange lotion of a contemporary beauty specialist they achieved this effect, we do not know. The formula has been lost. But the sun had apparently something to do with it, for the truly elegant ladies of that day used to spend hours and hours sitting patiently in the sun, their long tresses carefully

draped across an enormous straw hat with a hole in the top of it which allowed the hair to bleach while the ladies themselves were carefully protected against sunburn. For there must be no tanned faces. Tanned faces were not considered nice for ladies of fashion. A creamy complexion was supposed to go best of all with this reddish sort of hair, and so they all had creamy complexions or bribed the *maestro* to give them creamy complexions. Today they would spend an extra thousand dollars to be shown as if they had just spent a month basking in the sun of a West Indian island.

## Leonardo da Vinci

The second name on my Italian menu is that of Leonardo da Vinci. Here we are on more familiar ground, for we really know so little or so much about this venerable old wizard that we can give free rein to our imagination and we are able to turn him into anything that happens to please our own fancy. In a moment I shall give you a list of his accomplishments, as partially enumerated by himself in a letter which the Master addressed to Lodovico il Moro, Duke of Milan, when he offered his services to this rich patron of the arts.

This Lodovico, one of the most interesting of the Italian dictators of the fifteenth century, was a member of the famous house of Sforza which had attained great power since that memorable day, late in the fourteenth century, when the founder of the family, a certain Giacomo Attendolo, decided that there was more money to be made from the bandit business than from tending a dozen goats and sheep on a barren farm in the Romagna. The family had done very well for itself, and Lodovico, with the help and assistance of the King of France, was the recognized boss of Milan. His hold upon his new territories, however, was none too firm, and so he bethought himself of ways and means by which he might gain the loyalty and affection of his newly acquired subjects.

Giving the people something for nothing (or rather, giving it to them in such a way that they think they are getting it for nothing) has always been a very successful method of establishing one's reputation as a public benefactor. And so one fine day Lodovico let it be known that he was going to pull down the dreadful slums that were a disgrace to his capital and that he meant to replace these unsanitary hovels by miles upon miles of beautiful new tenements. He advertised for a competent city planner and civil engineer and Leonardo hastened to inform His Grace that he was the man. From his letter of application and from sundry other documents of a similar nature, we

can offer you a modest list of those accomplishments I mentioned a moment ago.

Among other things, Master Leonardo qualified as a painter, an architect, a philosopher, a poet, and a composer, as a sculptor and an athlete (broad and high jumping being his specialties), as a physicist and mathematician and practical student of anatomy. Furthermore he could not only play diverse instruments (the lute preferred) but he could also make them with his own hands and he was very clever at arranging formal parties and dinners whenever it was necessary to impress a distinguished foreign visitor with the wealth and good taste of his host. He had also dabbled a little in engineering and could claim to be the inventor of a new system of irrigating vast stretches of territory by means of mills and locks he himself had invented. But he was really most of all interested in flying machines and submarines and while working upon these plans he had devised a new method of constructing lifting machines and automatic drills. There must have been a few more things this incredible man could do, but I can't think of them just now.

Today when the specialist is the man we respect and the *homo universalis* is regarded with profound suspicion, such an accumulation of talents would hardly get a man a job. For we would hold that no one person could even begin to do half of all these things and hope to do them well. In the case of Leonardo that would be exactly the wrong conclusion. He was not only a painter and sculptor and musician and engineer but with the exception of his painting (which was perhaps his weakest point) he was equally at home within all those forms of art and science. How he found time to do all these things and do them so well is one of the many mysteries that were part of his character. Of course, like all universal geniuses, he was an indefatigable worker. He lived and slept in his studio but he seems to have been one of those fortunate persons who could do with very few hours of rest and was therefore able to devote twenty hours of each day to his endless mathematical calculations, to his geometrical puzzles, to his plans for his flying machines (the darned things would have stayed in the air, too, if only he had had a decent motor!), and to his eternal experiments with all sorts of pigments and building materials.

The one great disadvantage of his many-sidedness revealed itself in a terrific restlessness. No sooner had he begun work upon a gigantic equestrian statue than he would get sidetracked by the idea that he must construct a new type of siege gun. The gun had only been started when he would feel tempted to mix a better sort of oil paint than the

Flemish stuff then on the market. Forever driven by his restless brain, Leonardo never quite finished what he set out to do. He lived to be sixty-seven but his output, compared to that of other men who died at a much younger age, is almost ridiculously small.

There is the *Mona Lisa*, the portrait of the lovely wife of Signor Zanobi del Giocondo (hence her popular name of La Gioconda). Everybody knows that picture which is frequently held up as the ideal example of the Eternal Feminine. For does not the lady smile that wistful smile which betrays that she knew all the secrets of perfect womanhood? Perhaps so. Perhaps she also smiled because she was the third wife of a husband who was years older and whose will had made her the exclusive heir to his entire estate, so that some day she would have a chance to return to her native Naples as a beautiful widow with an unlimited fortune. And then again, that smile may have been due to Leonardo's inability to handle the lips, for with all his knowledge of practical anatomy, faces were not his strong point and the archaic smile that we know so well from the old Egyptian and Greek statues is apt to reveal itself the moment the old Master is defeated by a difficult mouth.

Whatever the cause, that face attracted more than usual attention, even when it was being painted. Pietro Aretino, the social columnist of the fifteenth century, still remembered for his attempt to blackmail Michelangelo and as fine a gossip scavenger as any of his tribe living today, pounced upon this picture with all the glee with which his tribe now welcome some stirring new revelation from Hollywood. He hinted that Leonardo had used this picture as an excuse to have the lovely lady sit for him for four long years. He told how the artist used to hire musicians to fill his client's heart with a soft glow of happiness which thereupon reflected itself in the luster of her drooping eyes. It made good copy but the only definite fact we know in connection with the picture is the price—four thousand golden florins—Francis I of France, whose portrait was painted by Titian, paid for it when he took it to Paris. There, as you will remember, it has remained ever since. A few years ago a patriotic Italian carried it away under his coat, to return this masterpiece to his beloved fatherland. But after a few anxious weeks it was discovered in his trunk and the *Mona Lisa* is back again in the Louvre, this time probably for keeps.

In the same museum you will also find his *Virgin of the Rocks* and the *Virgin and Child with Saint Anne*. As for the picture that perhaps gave him his greatest fame, it is the *Last Supper*, painted in 1494 for the convent of Santa Maria delle Grazie in Milan. Heaven only knows why,

some seventy years after the introduction of oil painting, Leonardo should have decided to do this work in tempera. But it seems that he was under the impression that he had discovered a marvelous new way of painting on plaster. It may have been "new," but it was also highly ineffective, for less than half a century after its completion it began to show signs of decay, and finally nothing remained but a wall covered with a sickly-looking layer of mildewed paint. As Leonardo (who loved to play the man of mystery) never told a soul what kind of medium he had used, the experts of the seventeenth and eighteenth centuries, who were called upon to restore it, decided to treat it as an oil painting and saturated the wall with oil in the hope that this would give the colors a new lease on life. As was to have been expected, the oil only made things worse. Thereupon the varnish specialists had their innings and they covered everything with heavy layers of varnish. These different quacks continued to torture the picture until finally, in the year 1908, Professor Cavenaghi succeeded in diagnosing the true nature of the medium Leonardo had used and was able to preserve at least enough of the original to make us understand how this painting had come to be regarded by Leonardo's contemporaries as one of the Seven Wonders of the World.

It is very difficult to start writing about Leonardo without being tempted to turn him into a book. Therefore I shall be very short in giving you the details of his restless career. In the year 1470, at the age of eighteen, this illegitimate son of a Florentine notary became a pupil of Verrocchio. Having learned his trade, he began to work for Lorenzo the Magnificent. But he soon got tired of this and, wishing to try his hand at engineering, moved to Milan where he remained almost sixteen years. Here he founded a very successful *atelier* where he taught painting and sculpturing when not busy with his blueprints and his drawing board.

To while away his leisure hours he began to work on the largest equestrian statue the world had ever seen. Before it was finished, the Pope and the King of France made an alliance for the purpose of dividing the duchy of Milan between themselves. Leonardo was obliged to leave the city. He sent his savings to the Medici in Florence for investment purposes but his equestrian statue (in its half-finished condition) remained where it was, and the archers of King Louis, in the playful way of French soldiers on foreign soil, used it as a target for their shooting practice. That it why we only know what it must have looked like from rather vague descriptions by a few contemporaries.

From Milan, Leonardo at first went to Venice where he meant to devote himself exclusively to his mathematical studies. But when he heard that his former patron, the unfortunate Lodovico, had been sold by his Swiss mercenaries to the King of France and would undoubtedly end his life in prison, he gave up all hope of ever returning to Milan and decided to make his permanent home in Florence. Three whole years he spent in Florence, painting pictures and occasionally engaged in some simple engineering problem, such as finding a method by which to stop a landslide that threatened half a dozen native villages in a near-by valley.

During this time he was also offered a chance to do a little sculpturing. He was presented with an enormous block of marble the city had somehow acquired and which proved to be something of a white elephant, for nobody knew what to do with it. Leonardo was told that he could turn it into anything he wanted. But as always his head was so full of ideas that he was never able to make up his mind. The block of marble remained therefore untouched, which was perhaps just as well, for three years later Michelangelo was able to use it for his *David*.

While Leonardo was engaged upon all these tasks, Cesare Borgia, the son of Pope Alexander VI, was trying very hard to found a dynasty of his own in the Romagna. Grabbing every available piece of land, he soon turned himself into a first-rate power. But he felt the need of a good military engineer and Leonardo, bored with Florence, gratefully accepted the post. This new sort of work carried him all over central Italy. Among other cities he also visited Urbino, the home of Raphael and of Bramante, where he himself once more got inspired to do some sketching and painting. But suddenly Cesare's father died and the outlook for his ventures was none too bright and so Leonardo returned quietly to the place of his birth. He arrived just in time to take part in a competition for an enormous battle picture which was to commemorate the victory of the brave Florentine army over their enemies in the year 1440. Michelangelo was to be his principal competitor. Well, Leonardo went at it in his usual thorough fashion and began by writing a formidable treatise upon the art of painting (which of course he never finished) in which at great length he discussed how such battle scenes should be made. It then took him two years to finish his cartoons—his sketches for the battle picture. Finally the people of Florence had a chance to compare the two complete sets of sketches, half of them made by Leonardo, the other half by Michelangelo.

Meanwhile he had been working on still another experiment in paint. It seems to have been some sort of tempera which was to be melted into the walls by means of heat. He smeared his paint on the walls of the council hall. He applied his heat. But the scheme did not work. The paint melted and ran, and during the next fifty years the Florentines had one of the walls of their council hall completely covered with a messy kind of brown bean soup. Then they got tired of looking at it and had the ruins covered over with frescoes by Signor Vasari, the well-known author of the lives of the great painters.

As for the sketches for the battle scenes, they seem to have been quite startling in the wild violence of both the men and the horses doing mortal combat with each other. Raphael studied them most carefully and said that he had learned a lot from them. So did many other young painters. But the souvenir hunter, then as now, was forever on the watch. These glorious cartoons were eventually cut up into small pieces and nobody knows what became of them.

In the spring of 1506 Leonardo obtained three months' leave of absence from his Florentine employer to go back to Milan and do some work for the viceroy who now ruled Lombardy in the name of the King of France. That three months' leave was extended several times until the year 1507 when King Louis XII personally visited his Italian domains and, with the consent of the Florentine magistrates, hired Leonardo as his official court painter and engineer in chief. But Leonardo's restless soul could not endure the restrictions placed upon him by his official duties, and he moved to Rome where Pope Julius II had finally started work on St. Peter's and was able to give steady employment to all the architects, painters, and sculptors of Christendom. Raphael, Bramante, and Michelangelo were already present, and now Leonardo joined them. When Julius II died in the year 1513 and was succeeded by Leo X, who as a Medici was a boy from Leonardo's own home town, his future at last seemed secure.

The poor man was soon disillusioned. He was sixty-one years old. Michelangelo was thirty-eight, Raphael eight years younger. The inevitable conflict between the older and the younger generations took place and Leonardo felt that he was no longer wanted. He was treated with sincere respect by his young colleagues but they went their own sweet way without paying any attention to his advice.

Fortunately, just in the nick of time, he made the acquaintance of King Francis I of France. This brilliant and many-sided monarch felt such tremendous admiration for the versatility of the old Florentine that he promised him everything he wanted if only he would

leave Rome and move to France to live at the royal court. And so, at an age when most of his contemporaries had already disappeared, Leonardo tried to start a new life on a foreign soil. He had already suffered a stroke of paralysis which had lamed his right arm but that meant nothing to him, for he soon learned to paint with his left one. And so we find him organizing marvelous feasts for his royal master, who, by the way, knew how to give a party much better than anybody else of that gaiety-loving age. We see him continuing his mathematical experiments and his anatomical studies. On the second of May of the year 1519 he died most peacefully in the arms of his gracious benefactor, who followed his remains to the cloister of St. Florentin, where Leonardo had expressed the wish to sleep his final sleep.

His vast collection of manuscript material he willed to his young pupil, Francesco Melzi. This noble youth preserved them with great care, but his descendants had not the slightest interest in them and they got lost or they were stolen, and nobody cared. A few short extracts from Leonardo's observations on the art of painting were published and that was all.

Came the revolution—the French one—and a general by the name of Napoleon Bonaparte descended into the plains of Italy to bring to the long-suffering subjects of the house of Hapsburg the blessings of Liberty, Equality, and Fraternity. General Bonaparte was a graduate of the artillery department of the military school at Brionne. He might not know much about art but he knew his guns. A man who was said to have invented a cannon that could be fired by means of compressed steam was a man after his own heart. Leonardo was supposed to have tried the experiment. Bonaparte therefore gave orders to send whatever remained of the Leonardo manuscripts to Paris. And so in the year 1796 the different manuscripts of Leonardo, in so far as they could still be found, were sent to Paris, care of the Institut de France. After years of deciphering, classifying, and editing the notes which (no great mystery after all!) had been written from right to left by one of the most famous left-handers of all times, the world began to realize what sort of man this Florentine had actually been. He not only had been one of the greatest draftsmen of all time, but everything from steam engines to airplanes, that were not to be put to use until hundreds of years later, had already been spooking around in the incredible brain of this old man, who (as he once explained) had tried to explore the whole of the universe that he might be able to add greater beauty to the products of his imagination.

### Raphael

Here is another close-up that is necessary to understand this age when the artist was a person of importance, a social necessity and not a superfluous luxury. It is the day before Good Friday of the year 1520. During the last week a terrible rumor has spread through the town. Raphael, the great Raphael Sanzio, the divine painter, has been stricken with a mysterious illness, a bad fever, and the doctors do not know how to help him. The patient is known to have weak lungs and the climate of the Holy City is dangerous to those who so easily catch a chill.

It is true the town is full of famous artists. Greatly upset by the news that has for years been coming from northern Europe, where all sorts of strange heresies have been rampant for quite a number of years and where a German monk has now most flagrantly defied the power of his spiritual masters, the popes have decided that the Church must regain her fast-dwindling hold upon the imagination of man by making the capital of Christendom a veritable City of God where the humble pilgrims shall feel that they have already entered the very portals of heaven.

Look at the names of the great masters called together to contribute to the honor and glory of the center of Christianity. Peruzzi is there, the famous engineer and painter, now busy on certain details of St. Peter's. Perugino, Raphael's beloved teacher, has also put in a short appearance. But feeling himself too old and too weak to paint the walls and ceilings of the new apartments of Pope Julius II (the so-called Stanze) he has left the finishing of the job to his pupil and has returned to Perugia to die at the ripe old age of seventy-eight. His place has thereupon been taken by another pupil and former assistant, Bernardino di Betti, better known as Pinturicchio, also a man of extraordinary talent but one who for many years is to be under a cloud, as Vasari (a most unreliable source, but the main one for the lives of these painters) will spread the rumor that the heads of his frescoes in the library of the cathedral of Siena have not really been painted by him but are the work of Raphael.

Venice is represented by Lorenzo Lotto and Lombardy has sent Giovanni Bazzi, who is better known by his nickname of Il Sodoma and who is said to have been the pupil of the great Leonardo. Leonardo himself has visited the scene for a short while but, finding so many youngsters engaged upon the job, he has decided that this is no place for him, and has again departed for his former home. A similar

fate has overtaken Luca Signorelli, who has also discovered that he is a little dated in the company of so many bright members of the next generation, and who has left Rome in disgust when he hears that the Pope has told Raphael to repaint everything he, Signorelli, had only a short while before started out to do inside the Vatican.

And then there is Michelangelo. Obliged to paint pictures when he really wants to be carving statues, he has given full vent to his disappointment and fury by covering the ceiling of the Sistine Chapel with a mixed collection of ancient heroes and sages. There they are, sitting high above the heads of the pious, brooding over their own pagan thoughts as if this were some heathenish temple instead of the House of God.

All these men have been, for a longer or shorter period of time, the daily companions of Raphael, the young painter who now lies stricken with his mysterious malady. If art criticism had been invented in the sixteenth century, I am sure that the night before Good Friday of the year 1520 would have been a very busy one for the local reporters, digging through the files of their morgue to get all the facts on the life of the great man, if perchance he should decide to die in time to catch the suburban edition. This is approximately what they would have written down in their notebooks:

RAPHAEL SANZIO, son of a certain Santi . . . also painter . . . but one who does not seem to have amounted to much . . . but did considerable work in his native village of Urbino. Born, April 6, 1483. Father had a job at the court of the Lords of Montefeltro, who then ruled the city. Died when the boy was eleven years old but seems to have started him in his own trade as soon as he was able to hold a brush. The boy was left to the care of his stepmother and an uncle who was a priest. They were bright enough to realize that he had quite a little talent and might some day be almost as good as his father.

When he was sixteen they sent him to Perugia to study with Perugino. Perugia seems to have been the best place for a young fellow just then to learn his trade. Center of the Umbrian school. Founded by this same Signor Perugino, whose real name was Vannucci. Began to do some work under his own name in or around 1500. Specialized in Madonnas. Went back home to Urbino for a while.

In 1504 goes to Florence. Gets there just when the competition between Leonardo and Michelangelo for the battle scenes was on and the whole town was talking art with a capital *A*. Spent a lot of time apparently in the old chapel with the Masaccio stuff. Learned all he had come to learn in a couple of months and then went back to Perugia. Next to Siena to help Pinturicchio make the sketches for the local library. Still specializing in holy scenes but begins to do a few portraits.

1506 back in Florence. Remains there several years. Paints a great many Madonnas.

In 1508 Bramante suggests that he come to Rome. In all practical matters those Umbrians surely stuck together! The Pope this time is working on his big church in all seriousness. The cornerstone was laid two years before. There might be a good opening for a bright youngster. He therefore had better hurry.

Bramante introduces him personally to the Pope. The Pope takes a liking to him and hires him on the spot. Must have had a great way with him, for soon he is dining with all the best families in town, painting their pictures, getting mighty good money, too. First job, however, is disappointing. The walls of the apartments in the Vatican, those built by the Borgias, are covered with frescoes by Signorelli and a lot of others. Present Pope doesn't like them. His Holiness tells his new protégé to paint them over with something of his own. The youngster does that, but, being a decent sort of fellow (everybody seems to agree that there never has been anybody like him when it came to doing the fair thing), skips the alcove painted by his own teacher, Perugino.

When this is finished, there is a lot of other work. The Vatican is soon full of his work and meanwhile he seems to have found time to paint a Madonna for almost every church in Italy. In January, 1513, Pope Julius II, his original patron, dies. His successor, a Medici from Florence, seems to have liked him even better than Julius and being a son of Lorenzo the Magnificent, he is a better spender.

All the rich bankers, too, hire him whenever he has five minutes of his own. Accounts for the work he did on the Farnese villa.

Anno Domini 1514 Bramante dies. Pope Leo X makes Raphael his successor as architect in chief of St. Peter's. Too bad he should have to die right now when he is sitting on top of the world. And on Good Friday of all days, when nobody will pay any attention. Well, we can save it for Saturday. In the meantime the art department can work on the pictures. There'll be a lot of them. Good for the Sunday edition.

More than four hundred years have gone by since the body of Raphael Sanzio, the son of Giovanni Santi of the city of Urbino, was laid out in state in front of his unfinished picture of the *Transfiguration*. All Rome passed by his bier to have a last look at his handsome features and wept when they thought of the girl to whom he had been betrothed and who would never be his wife. And during those four centuries his reputation has suffered as strange a series of ups and downs as ever has come to a man of his genius.

His friend and contemporary, Michelangelo, said that Raphael had succeeded as he did not so much on account of his superior talents as on account of his tremendous industry. The remark sounded polite enough but it was praising with faint damns. Giovanni Bernini, the

architect who constructed the famous colonnades in front of St. Peter's and who lived almost a century later, warned all young painters not to try to imitate the Divine One. It would get them nowhere, for Raphael was now *vieux jeu*, his paintings *passé*. Nobody cared for them any more. In Spain the great Velasquez voiced the same opinion.

When the *Sistine Madonna* was sold to the King of Saxony, the Dresden connoisseurs complained that the child on its mother's arm had a very "common" look. Winckelmann, the ponderous German who is usually referred to as the father of the science of archaeology, but whom we chiefly remember as the man who filled our museums with those dreadful plaster casts of Greek and Roman statues that are guaranteed to make you hate classical sculpture for all time, had a few words of praise for Raphael's ability as a sculptor but as a painter he rated him far below the contemporary German masters whose works today you could not possibly give away.

But all this changed a century ago with the beginning of the Romantic Period. After Goethe's sentimental drivel about the unhappy young Werther, it became very fashionable to die young and beautifully. Raphael had undoubtedly done this and his sweet-faced Madonnas reminded the readers of that time of Hermann's lovely Dorothea, the incarnation of all feminine charm. They compared his serene saints to the savage-faced Jeremiahs and Jonahs of his brutal contemporary, Michelangelo, and the comparison was not precisely flattering to the brooding prophets of the Sistine ceiling. Good Queen Victoria, who then set the fashion in all matters pertaining to the domestic virtues, thought Raphael a "delightful" and refined painter, and liked to be surrounded by reproductions of his pictures. Indeed, the only criticism that was heard came from that strange group of esthetes who sincerely believed that they would be able to set the clock of history back if they only tried hard enough and who, as convinced Pre-Raphaelites, had no use for the "hollow virtuosity" of Signor Sanzio. They found a most unexpected ally in the person of John Ruskin, who as a rule was heavily on the side of the moralities but who could never forgive an artist for having been born outside the era of the Gothic. Ruskin objected to Raphael's Biblical representations as being contrary to the truth. These lovely ladies and these stately gentlemen, so Ruskin protested, had nothing in common with their Hebrew prototypes. They were just so many beautiful bodies without any souls, etc., etc. Manet, the painter of the famous *Olympia* in the Louvre and as little of a moralist as ever handled a brush, was

even a little more outspoken in his comments. "Raphael turns my stomach," is the way he expressed himself with rare delicacy.

And today? I don't know. There is an almost incredible virtuosity in the work of Raphael, tremendous draftsmanship, a charming sense of color. There is not very much depth. But it is exceedingly difficult to put great depth of feeling into a picture that is meant to be seen at a distance of several hundred feet. After all, when you are going to give a concert in the Grand Central Station, you will hardly choose a harpsichord as the most suitable instrument for the occasion. Raphael was asked to paint pictures that were to be part of the stage setting of that new capital of Christendom that was being constructed for the sole purpose of impressing the faithful with the power and the glory of the Church. He did what he had been told to do and he did it supremely well. Isn't that enough praise for anyone?

### Michelangelo

And now one more name, Michelagniolo—as he wrote it in a script that is not quite like the handwriting of any other human being in its intimate sense of pride, defiance, and utter loneliness.

It will not be easy to speak of him, for all the usual figures of speech turn pale and meaningless when applied to this incomparable genius. Nor can you write about the school of Michelangelo, for there was no school—there could not be. Neither is it possible to make him the hero of a special chapter and call it the "age of Michelangelo," for there was no age of Michelangelo. He stood all alone and he dwarfed his contemporaries like a mighty mountain that arises unexpectedly from the surrounding plains.

All the good old stand-bys of "greatness" and "perfection" and "excellence," which fit ordinary human beings (the dictionary of quotations is full of them) suddenly lose their glamour and become slightly ridiculous, like the joyful hand clapping of some poor half-wit in front of the Taj Mahal, shouting, "Oh, isn't it cute!" The same thing holds true for his work. You simply have to see it for yourself to know what it is like. It is impossible to revaluate it into mere words. For in order to do so you would have to find certain points of comparison and there are no points of comparison. I could tell you that when, for the first time, you enter that room in Florence where so much of his half-finished work has been brought together, you will seem to be hearing Beethoven's *Death March* played by an orchestra of Titans. But unless you have ever heard the *Death March* played by an orchestra of Titans, that will not bring you much further, and all

our orchestras, alas! are composed of ordinary human beings and members of the Musicians' Union at that.

So all I can do is give you a short outline of his life and of his work. In his case, as in the case of all of the truly great, the two were identical. After sixty, Michelangelo found time for a few of those emotions which play so great a role in the existence of all ordinary human beings that most of us have no energy left for anything else. But even that all-overpowering love for Vittoria Colonna meant in his case merely a shifting of activities. For a while he slowed up a little on his painting and his sculpturing, but only to devote himself to an entirely new form of art, the art of poetry. He hacked away at his sonnets with that same imperious violence with which he had hacked away at that gigantic block of marble which was to reveal his *Moses*. And the sentiments he expressed were as high above those you find in ordinary poetry as the figures which he painted on the ceiling of the Sistine Chapel are above the heads of the spectators.

Here is a list of a few of the things he did during the ninety years he spent on this planet:

He was born in 1475. His family belonged to a class of society that then as now was only too common in Italy. They were people of gentle birth but they rarely got a square meal. They would have been able to support themselves quite nicely, of course, if they had been willing to work for a living, but that they could not do, for then they would have lost caste. Michelangelo's father was a perfect specimen of the contemporary gentleman who would rather have starved to death than demean himself by taking wages for his labors.

This strange attitude did not prevent Michelangelo from feeling a very sincere affection for his shiftless parent. After he had reached the stage when he began to get paid for his work, he forgot all the hardships of his youth and most generously supported his entire family. That family consisted of his father and a couple of brothers. His mother died soon after he was born. The child was thereupon sent to a wet nurse, wife of a stonecutter in a near-by village. This may have given him his passion for sculpture. He himself used to say so. Perhaps he meant it as a joke. In that case, it is the only joke history can credit to Michelangelo. He was much too busy to be funny.

His real career started at the age of thirteen when he was apprenticed to Domenico Ghirlandajo, the ex-jeweler who had turned painter and had one of the most popular studios in Florence. But long before that he had given evidence of his talents and as a mere urchin had already told the world that he intended to become a great artist.

The father, ever conscious of the genteel background of his family, resented the choice of such a career as entirely unworthy of the name of Buonarroti. But since he had nothing better to offer and since nothing better offered itself, he made the best of this sad blow to his parental pride. Some very nice people had been artists, he undoubtedly told himself, and sometimes they had even gained great wealth. What more delightful prospect for a man of his type than to anticipate the day when his son should be famous and able to restore the family fortunes!

But all that was still a long way off. First of all the young angel must learn his trade. Like the rest of the Florentine students of the gentle art of painting, Michelangelo began by copying the works of the great Masaccio in the Brancacci Chapel. One day he had a quarrel with a fellow student. The fellow student hit him and broke his nose. The damage was never repaired. It gave Michelangelo's face that strange expression which made it possible for his enemies to start the rumor that he had Negro blood in his veins.

From Ghirlandajo's workshop he went to the art academy that the Medici had established in that part of their gardens in which they kept their collection of ancient statuary. This institute was presided over by a venerable old gentleman who had spent so much of his time among the old Gods that he himself had become a complete pagan. He turned his art school into a sort of literary academy where the name of Plato was much more often heard than that of Saint Paul or Saint Augustine. This shows how completely the ideas of the humanists had come to dominate the minds of the men of the Renaissance. Nobody was any longer shocked by such goings-on. The Vatican itself was beginning to look like the palace of an old Roman emperor. And so it was possible for a disciple of Plato and Anaxagoras to devote seventy years of his life to the pictorial propaganda of a completely pagan faith and to die peacefully in his bed at the age of eighty-nine, unsuspected of any heresies and honored and lamented as one of the stanchest pillars of the Church.

Unfortunately, the great Lorenzo de' Medici died in 1492. His son Piero was a fool and under his feeble rule conditions in Florence grew so uncertain that Michelangelo decided to leave the city before the people began to build barricades in the streets. Why did he so suddenly make up his mind? Because this curious bundle of contradictions was convinced that he was endowed with the gift of second sight. Quite suddenly and without any apparent reason for such a fear, he would throw away his hammer and his chisel, break forth in

a terrible sweat, and say to himself, "Something terrible is going to happen to me if I stay here another moment!" Whereupon, without bothering to pack his slender belongings, he would buy a horse, gallop away, and not come to rest until he had reached some other city, hundreds of miles away.

It happened for the first time in 1492 but it was to happen time and again as we shall now see in this short summing-up of the seventy years during which the master worked at his chosen trade with scant respect for union hours.

After his first great panic drove him from Florence, he proceeded to Bologna, where he made a couple of statues for the local church. But a year later he got news that he was one of the artists who had been appointed to build the assembly hall for the Great Council of Florence. And so he went back home, and it was during this period that he took part in the great hoax, which sounds so modern that it might have happened right here and only yesterday.

Then as now, everything that was old was considered much better than anything that was new and everything that came from afar was of course infinitely better than what came from near by. An indifferent statue, two thousand years old, was much more interesting than a perfect piece of work made by a contemporary. Michelangelo, who had a sour sort of humor, knew this and therefore made himself a Cupid in the true Roman style. It was sent to an expert in the noble art of faking masterpieces and amidst many delighted "ahs" and "ohs" it was sold for a barrel of money to a cardinal who was very proud of his knowledge of the ancient masters. But the thing leaked out, as such frauds are apt to do. The cardinal wrote angry letters and demanded his money back. He got it, but there was a sequel which also shows that the art collectors of the sixteenth century and those of the twentieth have a great deal in common.

When Michelangelo shortly afterwards suffered from another attack of fear and once more felt that he could not possibly remain another moment in Florence, he decided to go to Rome to visit the cardinal who had bought his phony Cupid. "For," so he said to himself, "if this man really knows something about art, he will have been able to appreciate the technique which allowed me to make something which everybody so unanimously accepted as a genuine piece of work from the third century B.C. and he will receive me with great honors."

He did go to Rome but the reception he received was hardly what he had expected. The cardinal was not at home when Signor Buo-

narroti called and never deigned to receive him, for hell holds no fury like a connoisseur fooled.

However, the cardinal was not the only man in Rome who took an interest in art. There were thousands of others and soon Michelangelo had more orders than he could ever hope to fill. He remained in Rome from 1496 until 1501. Then his father lost the little political job that had kept him alive (some sinecure in the customs department), and Michelangelo returned at once to Florence, for he was a most dutiful son and brother. He took care of all his worthless relatives until the day of their death and then, very much like Beethoven after him, concentrated his affections upon a young nephew who was a boy without the slightest talent.

A short time afterwards he was called to Siena to make plans for a memorial for Pope Pius II that was to be built in the cathedral of that city. He finished the two main figures. Before the other two were done he was back in Florence to work on that tremendous statue of David which still exists. But it has since then been moved indoors to protect it from the rain. This is a pity, for in order to be truly appreciated it should be out in the open. Nevertheless, it is a tremendous piece of work. Forty years before, the city of Florence had bought this large piece of marble for the benefit of a sculptor by the name of Agostino d'Antonio. But poor D'Antonio had got stage fright and there that useless marble mountain had lain until Michelangelo finally gave it form and breath.

During these years Michelangelo also made the Madonna which finally found its way to Flanders and which you can still admire in the church of Our Lady in Bruges where it looks quite out of place— a piece of Renaissance sculpture in the stronghold of the early Flemish primitives.

It was also during this period that he went back to painting and engaged with Leonardo in the competition for those battle scenes that were to have been painted on the walls of the new council hall. The pictures were, as I told you, never finished but the sketches of Michelangelo survive. They are known as the *Bathers*, for they show the Florentine soldiers as they were surprised by the enemy while swimming in the river.

Then a letter came from Rome. The Pope asked Michelangelo to return and to start work on a vast memorial which His Holiness hoped to erect for himself during his own lifetime.

Rome, however, was full of studio politics. Bramante, the architect of St. Peter's, did not in the least like the idea of having so great an

artist so near at hand and he was very envious of the favors Julius II showed his Florentine rival. He therefore suggested to the Pope that Michelangelo could be used to better advantage if he were asked to paint the ceiling of the Sistine Chapel. In the first place, it was well known that Michelangelo greatly preferred sculpturing to painting, and he might refuse. In the second place, if he accepted, it would keep him out of the way for at least five or six years. In the third place (entirely my own idea, but I have spent a great deal of my time among the delightful followers of the Muses and know how sincerely they love each other)—in the third place, there was always a chance that a man working on those rickety scaffolds would break his neck. Michelangelo must have shared my suspicions. He had another attack of panic and when next the Pope heard of him he was back in Florence.

This was not at all according to the plans of His Holiness, who seems to have been very much aware of the genius of his rather trying servant. People have often remarked that his admiration for the Florentine master cannot really have been so very great, as he habitually forgot to pay him. That, however, proves nothing. Doctors and artists (including literary men) have always been supposed to keep alive on whatever provender it pleases the ravens to bring them. Why pay them when, somehow or other, they never seem to die of hunger? In spite of his fears, Michelangelo was finally persuaded to return. Duly provided with all the necessary safe-conducts, he set out for Rome.

The first job that awaited him there was a large statue of the Pope himself. It had to be done in bronze and was to be placed over the door of the main church in the city of Bologna which His Holiness had only recently added to his domains after a campaign which had been exceedingly disastrous for the people of Bologna. This incidentally explains why this statue no longer exists. As soon as the Bolognese had a chance to do so, they expelled the papal garrison from the city and destroyed the statue which reminded them a little too eloquently of them.

Michelangelo, however, was to pay another visit to Bologna. In the midst of working on the pictures of the Sistine ceiling, which took him almost four years and which gave him a kink in his neck from which he never recovered, he was frequently obliged to chase after his employer to get at least enough ready cash to pay for his materials. Finally, however, the work was done, just four months before the death of Julius. Then Michelangelo began to hammer away at the statues for that memorial that was to be the biggest memorial ever erected to the memory of a man who was still alive.

If anybody still believes in the myth of the artist's glamorous existence, I recommend that they study the period of Michelangelo's life that now began. For as soon as the Pope had died, his relatives tried to beat the master down on every detail. "The monument must cost less," or again, "If you make it just a little smaller it can be done for half the price," and so on and so forth. In the end, Michelangelo finished only three figures—the two nude slaves now in the Louvre and the magnificent *Moses* in San Pietro in Vincoli in Rome.

But before any of these had been completed, Michelangelo was back in Florence. The newly elected Pope was a Medici who now appealed to his fellow townsman to return to his native town and do some work on the façade of his own church of San Lorenzo in Florence. The heirs of Julius said, "Yes," and temporarily released the sculptor from his contract, and he hastened to Carrara to get himself just the sort of marble he would need. But no sooner was he there, working like a dozen horses, than local graft gave the contract to the quarries of Pietrasanta. Well, the whole scheme came to nothing and all his endless labors came to nothing, too.

Meanwhile, he had refused a most flattering offer from the King of France to come to Paris, and another one from the magistrates of Bologna to do them a new statue, this time something they themselves wanted. And there was the Pope who wanted him to return to Rome to finish the work Raphael had left unfinished when he died. Michelangelo hardly knew which order to accept when Italy suddenly found itself in the middle of a great civil war. While the armies of the Emperor were plundering Rome, the Florentines quietly expelled the Medici. But soon thereafter the Pope and the Emperor made common cause and it was the turn of Florence to be attacked. Every good Florentine was supposed to rush to the defense of his city and Michelangelo was put in charge of all her defenses. As engineer in chief he devised all sorts of new and highly ingenious ways of strengthening the walls. But he suffered from another attack of panic and fled. When everything was over (the revolutionists as usual had made an effective defense impossible by their everlasting quarrels) he went back to Florence and continued to work on the monuments which the Medici had ordered for their mortuary chapel in the church of San Lorenzo. One of these is known to all the world, for it contains those famous reclining figures which have become known as *Night* and *Day*.

There were to be a lot of others but before these were finished Michelangelo decided to return to Rome to fulfill his contract with the heirs of Julius II. The heirs, however, were obliged to wait, for no

sooner had he set foot in the Eternal City than the Pope ordered him to paint a new set of pictures over the frescoes Perugino had made on the wall right above the altar of the Sistine Chapel, and which were no longer to His Holiness' taste. Michelangelo consented and thus gave us his *Last Judgment*. Even while it was being finished the picture was severely criticized by some of the more pious inhabitants of the Vatican. The papal master of ceremonies especially was most severe in his denunciations. If you want to know what this papal master of ceremonies looked like, you can find him at the bottom of the picture. For Michelangelo painted him as Minos, the judge of the shades in Hades, and he is right there in Charon's boat.

But there were others, much more powerful and therefore much more to be feared, who also felt that this battle of the Titans hardly belonged in the very citadel of the Christian God. Indeed, Pope Paul III almost ordered the whole picture to be destroyed and was only persuaded to modify this sentence when it was pointed out that a few protecting robes painted upon these nude figures would serve the same purpose and at much less cost. A certain Daniele da Volterra, quite a mediocre artist, was found ready to commit this first sacrilege and almost two hundred years later a second coat of paint was applied to the few remaining spots of uncovered human flesh. Today the pious pilgrim no longer runs the risk of being shocked. Centuries of candle smoke and incense have so completely covered it with a heavy layer of soot that both saints and sinners have become almost unrecognizable.

The *Last Judgment* was finished in 1541. Michelangelo lived for another twenty-three years, working day and night, now as a sculptor, then as a painter, then again as an engineer and architect. The world around him had grown very lonely. His contemporaries were gone. His immediate relatives were dead. His nephew Lorenzo was the only human being who had a claim on him and upon whom he centered all his affection. The only great passion of his life came to him after he was almost sixty years old, but it was an intellectual passion. For the subject of his devotion, the lady Vittoria Colonna, was a woman of deep religious feeling. One rather wonders, therefore, what she can have thought of those exalted hymns in which the wisdom of Plato, the truth of the Christian faith, and the mysteries of art were praised with equal warmth and vehemence. In the year 1564 when almost ninety years old but still working with complete disregard for his health and now engaged upon the Herculean task of converting the old baths of the Emperor Diocletian into a Christian church, the old

man suffered a stroke. A few days later he died, as he would have wanted to die. For he died in harness.

And now I, because I am writing this book, must scribble a few words to sum up the labors of a man whose work I can hardly approach without feeling a strange weakening of the knees and without a humility that God knows is quite foreign to my soul. Yet there is one thing I can say and which I think the old man would have understood.

Michelangelo's greatness lay in his divine discontent—not with others but with himself. Like all the great of this earth, like Beethoven and Rembrandt and Goya and Johann Sebastian Bach, he was of such mighty stature that he knew the meaning of the word "perfection." And like Moses, glancing longingly at the dim and hazy outlines of the Promised Land, he realized that it will never be given to any of us mere mortals to reach that which cannot possibly be surpassed. Hence that divine discontent, which is not only the beginning of all wisdom but also the beginning and end of all great art.

# America

*The Old World discovers the new one. The new one contributes nothing
directly to the art of the old one, but indirectly its wealth creates a new
class of art patrons who in turn influence the tastes of their times and so
help to put an end to the era of the Middle Ages.*

IN THE SPRING of the year 1493 Columbus returned from his first voy-
age to the Indies. This famous citizen of the republic of Genoa is
usually classified among the explorers and discoverers. But he was
primarily a promoter, a strange visionary, part mystic, part explorer,
who sold his pet idea to his royal employers as a profitable scheme of
making money and replenishing the exhausted Spanish exchequer.

When he returned from the Bahamas, he was still entirely unaware
of having stumbled upon a new and completely unsuspected continent.
It was true that the natives he brought back with him did not look
very much like Chinese or Japanese or Hindus, all of whom the peo-
ple of Europe knew from the descriptions of Marco Polo and the other
medieval travelers. But perhaps they were a species Marco of the
Millions had never seen, and it took many years before Europe began
to suspect the unpleasant truth that these islands might have nothing
at all to do with Asia, and gave up the hope of ever reaching the flesh-
pots of Zipangu by sailing in a westerly direction. And so most of the
contemporaries of Columbus lived and died without being in any
way aware of the existence of a new continent. If they heard of it at
all, they had done so as we ourselves occasionally read a news report
about thousands of square miles of valuable timberland said to be
situated in the heart of New Guinea. Very interesting, but who cares?

Some thirty years later the situation changed. For then Cortez
conquered Mexico, and Mexico was full of gold, and that was some-
thing Europe understood.

The rape of Peru some ten years later by Pizarro, the most despi-
cable of all the conquistadores, was another bit of welcome news.
Thousands of poverty-stricken adventurers hastened across the ocean.
They came to steal and the moment they had filled their pockets,
they returned whence they had come. Quite a number of centuries
had to pass before Europe discovered that the painted savages whom

the earliest visitors had usually described (and treated) as a sort of biped insect had also been highly expert craftsmen and had built themselves a lot of very interesting monuments completely overlooked in the original rush for gold and silver.

As basket weavers and as potters they had produced a number of articles which compared very favorably with the products of the Egyptians and the Babylonians. Unfortunately, very little of all this has survived. In Central and South America, the humid climate will almost immediately destroy anything left out of doors. In the north, where the glaciers seem to have lasted much longer than in Europe, there had not been enough of a population to create anything of lasting value.

But apart from the climate another influence had been at work to prevent the development of a great form of art. Except in a few parts of Central and South America, the Indians had never ceased to be nomads. As they had neither horses nor camels and had never invented the wheel, they could transport only such possessions as could be loaded on the backs of their womenfolk, for the men were warriors and therefore gentlemen who were not supposed to carry bundles. Everything therefore beyond a few weapons and their fishing tackle was considered excess baggage, and we have come across only a few pre-Columbian relics of Indian art which can truly be called prehistoric. For baskets and pots and pans could be made wherever there were reeds and wherever there was clay, and these two indispensable raw materials were to be found all over the continent. An Indian tribe was therefore under no obligation to be careful with its kitchen utensils when it moved from one place to another. The old pots and pans were left behind in the deserted camp and an entirely new set was made as soon as they had pitched camp in some other place. Baskets and pottery therefore tell us very little about the earliest history of our Algonquins and Mohawks and all the other small tribes who for some twenty thousand years were in complete possession of our continent. We must depend for our circumstantial evidence upon the buildings the Indians of Central and South America erected and which they built with such perfect skill that even tropical vegetation (the most destructive of all the forces of nature) has not been able to destroy them completely.

But as I already told you, these pyramids and temples are to be found only in those regions where the climate and the condition of the soil made it possible for large groups of people to support themselves without being obliged to move from one hunting ground to the

next. The political development of these regions greatly resembled that which had taken place in Egypt and Mesopotamia and all along the Mediterranean. The strong had conquered the weak and had organized a number of highly centralized empires in which the conquered races did the work, while the conquerors as a sort of local nobility lived on the fat of the land. We would know this even if the Spaniards had not seen the tail end of their imperial organization, for the Mexican and Peruvian temples could never have been constructed without a great deal of very careful planning and without an unlimited supply of human material.

As to the exact date when these Mexican temples were actually built, we are still pretty much in the dark. We now know, however, that they are of comparatively recent date. The Mayans do not seem to have taken possession of the Yucatan peninsula until the days when the Franks were being organized into a kingdom, which happened in the sixth century of our era. As for the Aztec conquerors of Mexico, they were probably contemporaries of William the Conqueror. The Incas, the people of the sun, apparently founded their great empire among the mountains of the Andes while Saint Francis was founding a somewhat different empire of his own in Italy.

That an ex-swineherd like Pizarro should not have been deeply interested in archaeological details is easy enough to understand. Hence it was quite natural that his followers should have spoken so glibly of the "thousand-year-old empires" which they had just destroyed. Had they really felt the need of a little more accurate information they could have found it in the calendars of the Mayans, whose priests had worked out a division of the year which in a great many ways was highly superior to the system we ourselves have inherited from the Romans.

Unfortunately the Spanish conquerors were accompanied by a number of holy men whose desire to save souls was fully as intense as the greed of the conquistadores for gold. In order to save the poor heathen of the New World from the consequences of their own wicked superstitions, these zealous friars carefully collected all the available written and painted evidences of the old native civilization, and burned practically everything amid the loud hosannas of the true believers. If they had only sent at least a few of these valuable manuscripts back to Spain, we would now (since we have recently learned to decipher these hieroglyphics) know all about the earliest history of that part of the world. But only a few of the old Mayan manuscripts escaped the destructive violence of these zealous missionaries

and as a result we shall probably never know very much more than
we do today.

Incidentally, the Mayans and the Mexicans, quite like the Romans,
never learned to build a true arch. They knew how to construct roofs
but were obliged to do so without using any vaulting. They made
their roofs in a curious way by means of overlapping layers of stone
which were then finally connected by one large slab of some solid
material. In doing so they experienced the same difficulties as the
architects of the Romanesque churches. In order to withstand the
outward thrust of the heavy roof, the walls had to be very thick. But
these walls were eminently suited for a display of the sculptor's art,
and some of the friezes of the old Mayan temples are quite as inter-
esting in their own way as those we have found on the temples of
ancient Greece or India.

As a rule these temples had no pillars. The walls also served as pillars,
but some of these walls (whenever they were not too wide) were given
the shape of caryatids and were covered with ornaments, only in this
case the ornaments were not in the form of Greek Goddesses but rep-
resented the serpent, the holy animal of that part of the world.

No mortar was ever used and this has allowed the roots of the trees
to cause great damage to almost all of these buildings. The roots of
a tree will dig their way through everything except a block of granite.
After the last of the original worshipers had been converted to Chris-
tianity, the temples were so completely neglected that we are now
obliged to dig them out of the primeval forest, just as we have had to
do in the cases of the Borobudur and Angkor Wat.

How these Indians were ever able to move those heavy stones or by
what means they got their very delicate sculptural effects, that again
is something about which we know very little. The people who could
have told us are dead or have lost all remembrance of their ancestral
glory. After the coming of the white man they adopted the white
man's technique. They copied his patterns and they worked them
into their own baskets and pottery, and often improved upon them,
but it was no longer a purely native art. For the native no longer was
master in his own house. He continued to live, but as a pariah, de-
pendent upon the good will of the white man for the right to exist.
A concentration camp is not an ideal place for the development of a
vigorous and independent form of art.

Within the realm of the arts, therefore, the New World contributed
nothing whatsoever to European society, but by completely changing

the economic structure of the older continent, America was indirectly responsible for those great cultural changes of the sixteenth century which of course were accompanied by far-reaching changes in all of the arts.

I do not mean to imply that if Columbus had never sailed, the medieval ways of painting and singing and eating and drinking and dressing oneself would not have come to an end at just about the same time. The Gothic era had outlived its own usefulness. And as invariably happens in such cases, it became a caricature of that which it had been during the heyday of its glory.

Gothic art had been the art of the perpendicular streamline. The pointed arch, of which we instinctively think when we hear the word Gothic, was merely one manifestation of the desire to get everything needlelike, peaked, cuspidal, arundinaceous (they are all of them in the dictionary)—a desire that finally manifested itself in every hat and cooking pot. It played around with this idea for so many centuries, it indulged in so many experiments with this strange reedlike style that all its possibilities became exhausted. Having run its normal course it was bound to disappear from the scene as soon as the last vaulted window had been made so high and so pointed and so narrow that it began to resemble a slit in the wall and as soon as the female headgear (after all sorts of weird experiments) had begun to compete with the towers of Chartres, both in height and cost of manufacture.

Something new was bound to make its appearance, but what that was to be depended upon economic conditions quite as much as upon anything else. Even a Phidias or a Michelangelo could not have hacked statues out of marble if they had been exiled to some village in Greenland. A Cellini in a little prairie village, far removed from customers able to provide him with the necessary precious stones, might have developed into a successful second-story man, but he would hardly have gained fame as one of the world's greatest jewelers. And this is where the New World played its decisive role. For the New World put money into the hands of a class of people who thus far had never had any, and that money allowed this new class of people to compete as patrons of the arts with the church of the Middle Ages and with the princes of the era of the Renaissance.

Such changes do not occur overnight. In this case they took considerable time. Nor did they manifest themselves everywhere at the same moment. In some countries the princely power was too strong to be broken down right away. In others the Church prevailed for centuries after the introduction of the new economy. But in the end

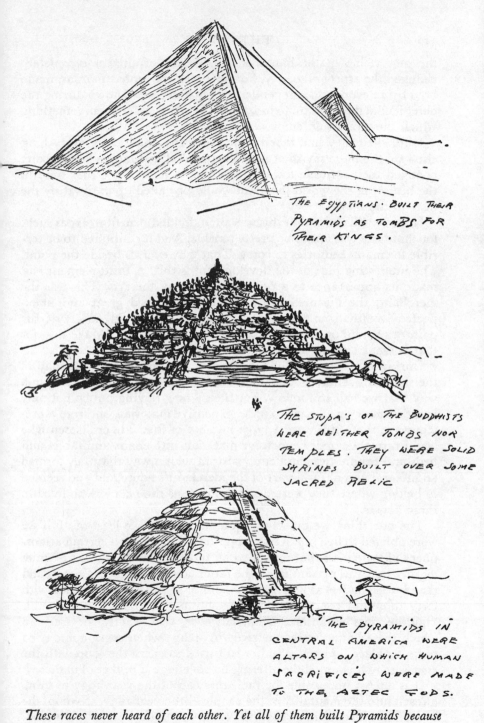

THE EGYPTIANS BUILT THEIR
PYRAMIDS AS TOMBS FOR
THEIR KINGS.

THE STUPA'S OF THE BUDDHISTS
WERE NEITHER TOMBS NOR
TEMPLES. THEY WERE SOLID
SHRINES BUILT OVER SOME
SACRED RELIC

THE PYRAMIDS IN
CENTRAL AMERICA WERE
ALTARS ON WHICH HUMAN
SACRIFICES WERE MADE
TO THE AZTEC GODS.

*These races never heard of each other. Yet all of them built Pyramids because
that was a natural way in which to get the necessary elevation.*

the new riches in the hands of a new class of citizens completely changed the aspect of society. For now even the more timorous, made bold by an economic independence they had never known during the older feudal days, began to insist that the artists make them something which they too could enjoy.

Until then they had taken their art as they had taken everything else—on the mere say-so of their "betters." Their money in the bank changed their attitude toward these "betters." For the first time in the history of the world the artist would be called upon to satisfy the taste of the masses.

Nobody will claim that this was an undivided benefit to art as such, for that taste was apt to be pretty terrible. And it continued to be terrible for many centuries to come. That, however, is beside the point. The interesting part of the development is this: A third element had made its appearance as a potential patron of the arts. This was the merchant, the businessman, who having derived great and unexpected wealth from his overseas transactions, could now visit the painter's studio or the architect's workshop and say, "Make this, for that is what I want, and I am able to pay you for it."

During the latter half of the Renaissance—during the last half of the sixteenth century—this "new spirit" began to manifest itself in a way that we can still follow. For then a new buying public not only had the money necessary to order expensive materials but from a previous age there still were a large number of first-rate craftsmen who could turn these more expensive materials into chairs and tables and beds and candlesticks and cupboards in such a way that they formed an integral and natural part of the merchant's household and seemed to belong where they were quite as much as the people who lived in these houses.

The one thing we ourselves probably would like least of all if we were obliged to live in a Renaissance house would be a certain atmosphere of stateliness that pervaded all those buildings—a sort of quiet dignity that was present in all the rooms and on all the staircases and that made you feel as if in another hour or so the King of France with forty thousand courtiers might possibly pay an official visit to this "middle class" mansion. That, however, was exactly the spirit in which these homes were conceived in an age when every home tried to be a palace and every waiter still tried to carry the soup with the *grandezza* of a young duke offering his sovereign a beaker of malmsey.

It is almost impossible for the American of the year 1937 to think himself into the mentality of the people of the year 1537, to whom the formal life still continued to be the only part of life that really counted.

*The miniature painters were such marvelous craftsmen that*
*we need not wonder . . .*

*at the extraordinary ability of the early Flemish painters when we remember they had grown out of the school of those miniature painters.*

We ourselves hate all formality so thoroughly that we have almost made something formal out of our very informality. In Europe that is not quite so. In Europe the conventional way of doing things, the conventional way of dying or getting married or entertaining one's guests has maintained itself in spite of all the many upheavals and revolutions of the last two hundred years. It is sometimes said that this was the result of the tremendous influence Louis XIV and the court of Versailles wielded over the minds of the people of the seventeenth century, the great century of the Baroque. I would like to suggest that it goes further back than that and that it is a survival from the days of the Renaissance. For then, during a short period of time, people actually lived as if they were forever on parade, as if they were forever being observed by their neighbors, and as if the slightest breach of etiquette (which is merely the French for a "ticket" or a formal label) would be part of tomorrow's gossip in every salon of the town.

Hence those dreadful *salons*—"reception rooms"—you still find in most European houses—those stuffy and badly ventilated rooms in which the windows are rarely opened and from which the curtains are never removed lest the rays of the sun discolor great-aunt Lucy's beautifully embroidered sofa pillows, and into which one is ushered with all due formality when one pays a first visit.

Of course, in the days when the ambassador from Poland called on the Conte di Casa Epsilon, a member of the grand council of the sovereign republic of Venice, his reception in the vast halls of the palazzo on the Grand Canal meant something. It was a fine and noble piece of mummery in which all the characters knew their lines and acted their roles with the utmost stateliness, offering as fine a sight as one could ever hope to witness. For then all these heavy chairs and ornamental sofas, which are so completely out of place in our modern flats, still played the roles for which they had been created with such great care and at such enormous expense. The elaborate mirrors reflected the light of candelabra that had been fashioned by the greatest of living artists. The clothes that were worn had been designed for the express purpose of giving the actors in this comedy the fullest possible measure of self-assurance.

Gone were the days of the slender Gothic garments. The horizontal streamline of the Renaissance had replaced the perpendicular one of the Middle Ages. Heavy silks and heavy velvets and heavy brocades hung heavily from the shoulders of both men and women. The women, in order to give themselves a greater appearance of *grandezza*, wore a thick roll of cotton around their waists.

I am not very good at describing this sort of thing. But perhaps

when you were a child and rummaging through your grandmother's attic, you came across a funny-looking pad hanging from a wire clothes model. Upon inquiry, you were informed that it was grandma's bustle and that as a young girl in the seventies of the last century she had worn it to give a becoming contour to a part of her body which today we try to keep as flat as possible. This preposterous embellishment, made into a sort of *roulade* that reached all around the hips, was the bustle of the sixteenth century. It forced the contemporary *couturiers* to use lots and lots of material, which was all to the good in a day when the owners of silk mills were among the richest and most influential politicians of their times. A few years ago the French dressmakers tried to reintroduce this fashion in order to give a little much-needed assistance to the industries of the city of Lyons. But the rest of the world refused to be burdened once more with these *disques*, which was the name for the rolls of cotton worn to make the sleeves about four times their normal size and which gave an air of distinction to even the most commonplace of women.

Our refusal to be so bothered was perfectly natural. This is the age of the young girl and the very young matron, whereas the Renaissance and the Baroque were an era when the woman of the more mature thirties stood in the center of interest. She knew it, too, and played her role as she was expected to, for she was the guardian of the *gravità*, of that weighty dignity upon which her future success, both as a wife and social leader, would depend to an extent which seems incredible to our modern minds. That race of people has now become almost as extinct as the dodo or the moa. "Ladies and gentlemen" has become an expression for radio announcers who do not quite know what sort of audience the program is likely to reach, and the blond Juno of Titian and his fellow painters of the sixteenth century has become a caricature of her former self and degenerated into a popular movie heroine.

Indeed, the entire world of the Renaissance has so completely disappeared from our planet that it sometimes looks as if it had never existed. But a few of the products of the great masters of that day have survived in spite of everything. And by some curious trick of history, these objects, pictures and pieces of jewelry (unless the owners are positively forbidden by law to sell them), are now finding their way to the New World.

It was the gold of the New World which made it possible for Europe to indulge in these substantial luxuries. Today that same gold is prying them loose from their ancient moorings and bringing them to the hinterland of America.

# New Ears Begin to Listen Where New Eyes Have Already Been Taught to See

### The age of Palestrina and the school of the great Netherlanders

O NE IS AT A GREAT DISADVANTAGE writing about music. When I compare the sculpture of the Parthenon and the Borobudur, I can first of all describe them to you, I can then show you photographs, and finally, if you still doubt me, I can say, "Very well! Take a boat and go and see them for yourself."

But music is a dead art until it is played. I know that there are people who can go to the library and read a score of a Beethoven symphony or some little item by Herr Strauss with the same relish and satisfaction baseball fans derive from studying a box score of a famous pitcher in 1879. But they are few and far between. Most of us have to hear the music actually played before we are able to form an independent judgment.

There are nowadays several excellent collections of phonographic records of pieces of ancient and medieval music. I have no doubt that the learned professors who have brought these Greek and Hebrew pieces back to life give us a most conscientious reconstruction of these old melodies. But that does not mean that we actually hear what the people in Delphi or Jerusalem heard, three thousand years ago.

Every age has its own way of expressing itself in everything it sings or paints or builds. No matter how hard we may try (and we have tried very hard) we can never hope to recapture the spirit of an art that belongs to a previous generation. If you want to know what I mean, the examples are all around you. We have complete plans of several medieval churches and where we have no such plans, we can go back to the original edifice and spend a couple of years measuring every stick and stone. Then we can come home and put these sticks and stones in exactly the same spots where we found them in the original. We get something that outwardly looks like a Gothic church but that inwardly remains so hopelessly modern that it looks as incongruous as a Dutch windmill in Hollywood. If we had money enough, we could undoubtedly reconstruct the whole of Oxford or Cambridge

somewhere in the heart of our prairies, but the result would be as terrible as those copies of "ye olde Paris" which one occasionally finds at world fairs or in a Broadway restaurant.

I suspect that music is even more deeply influenced by both time and place than the pictorial arts. With a sort of gruesome delight I have sometimes persuaded Hungarian bands to play American jazz and American dance orchestras to try their hand at a czardas. It was pathetic to hear how completely both of them failed to do something which—theoretically at least—should have been one of the easiest things in the world, for the notes were all there right before their eyes and the tempo had been carefully indicated. The players knew their instruments as thoroughly as all modern dance band musicians seem to do. But the *Truth about Dixie* became *A Lie about Budapest* and the *Broken Fiddle* was turned into the *Wail of the Ancient Saxophone*.

Therefore when it comes to the music of the real Middle Ages we find ourselves beset by all sorts of unforeseen difficulties. In the first place we, "the moderns" of the year 1937, live in an age dominated by instrumental music, whereas "the moderns" of the year 1337—of the *ars nova* of Guillaume de Machault—lived in a world in which the word "music" was still identical with singing.

There were only a few instruments. There was an organ one played with one's fists, one note at a time, but except for the improvised concerts of the *Spielleute*, the fiddlers and hurdy-gurdy players (a hurdy-gurdy was originally a string instrument) and the lute players and all the other members of that disreputable group of vagabonds, there was no instrumental music of any importance. But there was a great deal of singing and of a sort which today, despite all our efforts to revive it, has almost entirely disappeared in our Western World.

The people of the Middle Ages had one religion and lived everywhere under more or less the same social and economic conditions. Hence they were able to do something we no longer can do. They could experience common emotions and give common expression to them, whether it was in the form of their cathedrals, or their paintings or their songs. And they could afford to be honest about their emotions, without that sense of false shame which is a nightmare of modern life.

That same Guillaume de Machault, whom I mentioned a moment ago and who was secretary to John of Luxembourg (a member of that brilliant but slightly unbalanced medieval family which almost succeeded in establishing a central European dynasty which would then have ruled over both Germany and Austria)—he realized this as

early as the year 1350. For he gave us in one single sentence a rule of conduct which ought to be engraved in enduring stone over the entrance gates to all our art schools and all our conservatories of

The search for a definite method of notation

music. I give it in the original French, for it is rather difficult to translate it correctly:

> Qui de sentement ne fait
> Son dit et son chant contrefait.

We would say, "He who writes or composes without the true inner fire, without himself feeling the emotion he tries to describe, he had better not say anything at all, for he will always be a phony."

The Middle Ages, however, did not suffer in this respect. They were full of all sorts of very serious and deeply felt emotions. And as almost everyone could give expression to his feelings in song and only a few could ever hope to do so in paint or in stone (that took too many years of a highly specialized training) the people of the Middle Ages sang, and they sang right lustily.

It was not the sort of singing that would have appealed very greatly to our modern ears, for during the last two centuries we have become accustomed to harmony, and harmony was something only invented during the last half of the eighteenth century. But they sang their songs and they liked them, just as the people of Bali play the gamelan and like it, while they leave us wondering what it is all about.

When it came to the more formal singing in their churches, they were given no liberty of choice. The old Gregorian chant, the plain chant of the earliest days of the Christian church, was the only sort of music the clerical authorities would allow. But even there, without anybody probably noticing it, certain innovations from the outside world began to seep in. Some of the folkways of singing began to creep in, just as jazz is beginning to creep into our symphonic music and has completely conquered the religious singing of our more emotionally inclined colored neighbors. The old plain song of the Gregorian order had already been replaced (at least for worldly tunes) by the polyphonic method. The system of notation, devised by Guido of Arezzo, had been accepted everywhere and had done away with the old and cumbersome names. The written language of music had therefore become a sort of international vernacular which all the people of Europe could read with equal ease. And now several other circumstances, which had really nothing at all to do with music, began to make themselves felt in the further development of this particular form of art.

A number of powerful feudal chieftains were able to establish themselves as independent little sovereigns. Being in need of everything that could further the prestige of their princely courts, they deemed it a wise policy to establish special schools where promising young singers were trained to be singers in the royal chapels. At the same time the success of the troubadours and minnesingers had loosened up music to such an extent that it was beginning to become an art which attracted a great many people who until then had been rather frightened away by the forbidding solemnity of the music of the Church.

Now in the arts, just as much as in the sciences and in the humanities, the only school that is really any good consists of an inspired teacher on one side of a table and an intelligent pupil on the other. For everything depends upon the ability of the teacher to teach and the willingness and ability of the pupil to learn. Unfortunately, while the latter are fairly common, the former, the inspired teachers, are exceedingly rare. We know this because the moment such a one makes

his appearance, people will flock to his door, even if he lives in a spot
a thousand times more inaccessible than the home of Mr. Emerson's
perfect mousetrap maker or whoever invented that story.

The first of those inspired music teachers of the Middle Ages seems
to have been a certain John Dunstable, about whom we know nothing
definite except that he died in the year 1453 and was buried in Lon-
don. As his fame was much greater on the continent than in England,

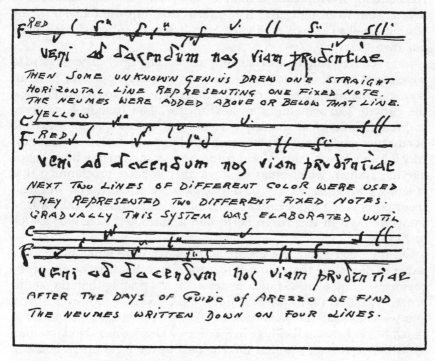

*The search for a definite method of notation*

he probably did most of his teaching on the continent. But as the
center of English politics after the defeat of the French at Agincourt
in 1415 had once more shifted from the British Isles to the mainland,
Dunstable was probably one of the many Englishmen who had fol-
lowed their sovereign to France when he married the daughter of the
French king and was recognized as heir to the French throne.

Contemporary historians were apt to refer to Dunstable as the
father of musical composition but this sort of fatherhood in connection
with any of the arts is usually of a very doubtful nature. There are

always too many men trying to do exactly the same thing at the same time to allow us to say of any one of them, "That is the man responsible for such and such an innovation and no one else." Dunstable, however, was one of the recognized pioneers in that new method of singing which was to give us our modern polyphonic music and which did away with the monotony and the bellowing that must have been so characteristic of the singing of the earlier part of the Middle Ages. His contemporaries realized that, for they came from far and wide to take lessons from him, and it is safe to call him the founder of the famous English school of singing which has maintained itself until our own times.

I am not referring to instrumental music. The English never seem to have cared much for mere instrumental virtuosity, but they have always maintained excellent church choirs. They do so today. Perhaps the climate had something to do with this. The Italians have given us greater individual singers, virtuosi with voices against which no northerner could hope to compete. The language itself had undoubtedly a lot to do with this. Vocal cords, accustomed to handle a tongue like the Italian, which sings itself whether you are proclaiming that *la donna è mobile* or merely buying a package of cigarettes, will lend themselves much more easily to a noble aria than the vocal cords of someone born in the frozen north and accustomed to handle Dutch or Finnish.

On the other hand, the people of the north were much more amenable to discipline than those of the south and that may be one of the reasons why they are so much better at choral singing than the southerners. I confess that I am only guessing. I do know, however, that if you want to hear the *Saint Matthew Passion* well sung, you can do so much better in a small village in Sweden or Germany or Holland than in Milan or Rome, whereas the *Pagliacci* at the local opera house in some hole like Bologna is apt to be much more exciting than the same opera given at some royal opera house somewhere nearer to the Polar Circle.

The Italians of the fifteenth century must have been aware of this too, for as early as the year 1400 we find them sending to the Low Countries for their choirmasters. At first they got their teachers from France where an excellent school of music under the leadership of Guillaume Dufay had grown up around the cathedral of Cambrai. They actually hired Dufay away from his job and brought him to Rome to instruct the papal choir, but in 1437 he got homesick and returned to his native city, to die there in 1474.

Dufay was succeeded by another native of the Low Countries (both Belgium and Holland in the Middle Ages were known as the Netherlands), a certain Joannes Okeghem, born in Antwerp but for many years choirmaster of the royal chapel in Paris. Okeghem was one of the first of the teachers who belonged to the so-called Netherlands school, which for almost a century and a half dominated the musical life of Europe. All of these men came either from Belgium or Holland, or like Josquin des Prés (the best known pupil of Okeghem) they were natives of that part of northern France where the Flemish race melts into the French and where both languages are spoken side by side with an equal disregard for the more delicate niceties of grammar and pronunciation.

Most of them, however, after they had received their training in their native cities, looked for wider fields of activity than those offered by some small Flemish or Dutch town. And so, all during the fifteenth and sixteenth centuries we shall find them in Rome, Naples, Venice, Augsburg, Nîmes, Paris, and even in the more important cities of Spain.

Shortly after the beginning of the seventeenth century their day of glory came to an end. Here and there we still run across the name of some old Dutchman as master of the royal or grand-ducal choir. But when these ancient worthies died, the vacancies were filled with Italians or Germans. That particular streak of genius in the Dutch race had worked itself out and when next we hear of the Hollanders they are painters. During those two centuries, however, when they had been the music teachers of all other races, they had made a few very important contributions to the musical arts.

What those contributions were—that is something else again and I shall find it very difficult to explain them without having a piano near at hand to let you hear what I mean.

Being methodical souls with an ingrained respect for law and order, it was only natural that these early Dutchmen should have done their best to make their little notes perform their task with much greater precision than they had ever done before. They did not give up the old polyphonic system for harmony, for harmony in our modern sense of the word was as yet to be invented. Rather, they introduced a new element into music, or more correctly still, they perfected an older idea, for quite unconsciously several of the composers of medieval folk songs had long since stumbled upon the idea of counterpoint.

Counterpoint is exactly what the word means—*punctus contra punctum* or note against note. The tunes which the voices must carry are

mathematically prescribed. The first voice starts on a certain note and the second voice starts on the same note, or a fifth higher and several measures later. The third one starts again on the same note as the first one and so on.

This is, of course, putting it very clumsily but it may give you a vague idea of what 1 mean. The point I want to make is this: That sort of music, being more closely related to a problem in mathematics

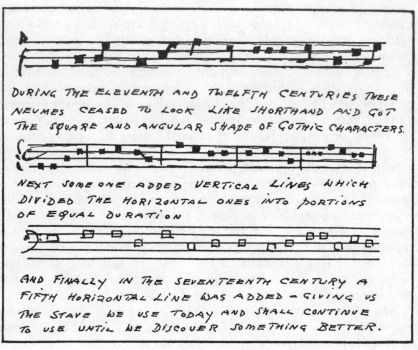

*The search for a definite method of notation*

than to one of the emotions, was ideally suited to the tastes of the Dutchmen and Germans and all the other people of northern Europe. These mathematical puzzles were a source of everlasting delight to their rather pedantic master craftsmen. For they could now "build" their tunes as an architect built his churches or an engineer constructed his bridges. Except that the architect and the engineer worked in materials that were hard and solid, whereas the composers had to content themselves with the human voice, the most brittle substance ever used to erect the most enduring monuments of all time.

In the end these masters of the great Netherlands school went the way of all intellectuals and began to suffer from the defects of their own superior qualities. They would, for example, take some simple air which everybody knew, some popular tune of the sixteenth century like that of the famous *Homme armé* (the *Music Goes Round and Round* of the year 1500). They would then use it and use it again and torture it and twist it around until it had lost all apparent resemblance to its original self—yet was still the old *Homme armé*, but now turned completely inside out.

The words of these songs were apt to suffer severe damage, for these composers in their mathematical zeal cared nothing at all for the meaning of the songs. They stretched their syllables or shortened them as it happened to suit their convenience. This gave great offense to all serious-minded churchgoers to whom the words meant more than the music and who were now no longer able to understand a word of the original text. But others, to whom a good tune meant much more than a dull text, took a great delight in these innovations. They recognized certain popular tunes which the composers had mixed in with the more substantial fare, and while the silver-tongued choir sang *Gloria in Excelsis*, the more irreverent members of the congregation could hum *Slumming on Park Avenue*.

Do you know how this was done? Have you ever played in an orchestra? If you have you will remember how it was possible to superimpose Rubinstein's famous *Melody in F* upon *Auld Lang Syne* and how Dvořák's *Humoresque* can be played through *Swanee River* and how a tune out of Carl Maria von Weber's *Freischütz* lends itself beautifully as an accompaniment to *Ach du lieber Augustin*.

Small wonder, therefore, that the Council of Trent, which (with a few interruptions) sat from 1545 to 1563 and which had been called together to reform the Church, was strongly opposed to all these musical innovations which threatened to turn the divine service into a vaudeville performance.

In the meantime some of the more serious-minded music lovers were getting increasingly annoyed at another trick that was very dear to the hearts of the mathematically inclined composers of that day and which threatened to have a very unwholesome effect upon the future development of the musical arts. I refer to the love of these fifteenth-century choirmasters of taking a perfectly nice and well-behaved little tune and making it do all the things a nice and well-behaved little tune never should do. Let me give you an example.

All of you know the old nursery rhyme about the *Three Blind Mice*.

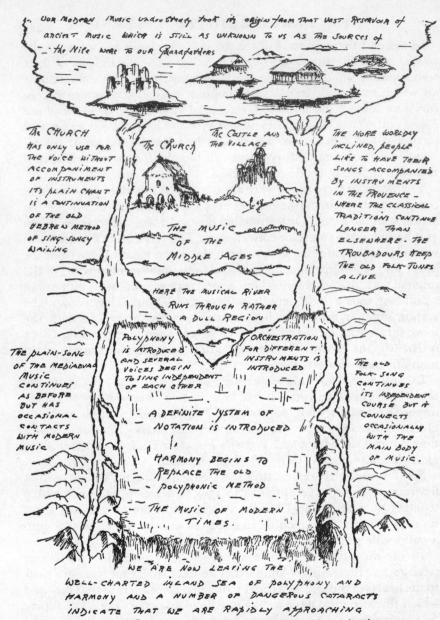

OUR MODERN MUSIC UNDOUBTEDLY TOOK ITS ORIGIN FROM THAT VAST RESERVOIR OF ANCIENT MUSIC WHICH IS STILL AS UNKNOWN TO US AS THE SOURCES OF THE NILE WERE TO OUR GRANDFATHERS

THE CHURCH
HAS ONLY USE FOR
THE VOICE WITHOUT
ACCOMPANIMENT
OF INSTRUMENTS
ITS PLAIN CHANT
IS A CONTINUATION
OF THE OLD
HEBREW METHOD
OF SING-SONGY
WAILING

THE CHURCH

THE CASTLE AND
THE VILLAGE

THE MORE WORLDLY
INCLINED PEOPLE
LIKE TO HAVE THEIR
SONGS ACCOMPANIED
BY INSTRUMENTS
IN THE PROVENCE —
WHERE THE CLASSICAL
TRADITIONS CONTINUE
LONGER THAN
ELSEWHERE. THE
TROUBADOURS KEEP
THE OLD FOLK-TUNES
ALIVE

THE MUSIC
OF THE
MIDDLE AGES

HERE THE MUSICAL RIVER
RUNS THROUGH RATHER
A DULL REGION

THE PLAIN-SONG
OF THE MEDIAEVAL
MUSIC
CONTINUES
AS BEFORE
BUT HAS
OCCASIONAL
CONTACTS
WITH MODERN
MUSIC

POLYPHONY
IS INTRODUCED
AND SEVERAL
VOICES BEGIN
TO SING INDEPENDENT
OF EACH OTHER

ORCHESTRATION
FOR DIFFERENT
INSTRUMENTS IS
INTRODUCED

THE OLD
FOLK-SONG
CONTINUES
ITS INDEPENDENT
COURSE BUT IT
CONNECTS
OCCASIONALLY
WITH THE
MAIN BODY
OF MUSIC.

A DEFINITE SYSTEM OF
NOTATION IS INTRODUCED

HARMONY BEGINS TO
REPLACE THE OLD
POLYPHONIC METHOD

THE MUSIC OF MODERN
TIMES.

WE ARE NOW LEAVING THE
WELL-CHARTED INLAND SEA OF POLYPHONY AND
HARMONY AND A NUMBER OF DANGEROUS CATARACTS
INDICATE THAT WE ARE RAPIDLY APPROACHING
UNKNOWN REGIONS OF TONAL EXPRESSION WHICH
UNTIL VERY RECENTLY HAD NOT EVEN BEEN
SUSPECTED. THE GOOD LORD ONLY KNOWS WHAT
AWAITS US THERE! LET US HOPE THAT HE WILL
BE KIND TO US

THE DEVELOPMENT OF MUSIC

A sixteenth-century Hollander would take this tune and turn it inside out until it became *Mice Blind Three*. His dear colleague in a near-by town must thereupon go him one better and he would boldly begin in the middle: *Blind Three Mice*. The next one, not to be outdone by his two rivals, and to show his own ability as a "master composer," would then make it *Mice Three Blind*, to be immediately overshadowed by still another brilliant melody maker who wrote the whole thing in such a way that one could either begin at the end and sing it backward or at the beginning and sing it forward—or begin it anywhere at all and still make it sound like music.

This sort of *Spielerei* continued well into the eighteenth century. Indeed, I remember my own immense joy when, as a reward for a month of faithful practicing, my fiddle teacher brought me a piece by either Haydn or Mozart (I think it was Haydn) which one put in the middle of the table and thereupon played as a duet, one person starting from the top and the other from the bottom and playing away for dear life until you came out where the other fellow had begun. It was perhaps not a very good duet, but a lot of fun when one was ten years old.

In the end that poor *Blind Mice* had been so completely pulled to pieces that nothing remained but the name of the song. Then even the wildest enthusiasts of the "new art" decided that things had now gone far enough and that the moment had come to call it a day. That was a blow for those who had made a reputation in that sort of thing, but it is an ill wind that does not carry at least one man's ship into a safe harbor. In this case the name of the man was Palestrina, who was now able to show the world that music need not be either solemn or gay but can be possessed of both those qualities at one and the same time.

Palestrina's real name was Giovanni Pierluigi but as he was born in the village of Palestrina, not far away from Rome, in the year 1526, he came to be popularly known as Palestrina. Trained in the chapel of his home church, at the age of twenty-five he became leader of the boys' choir of the Cappella Giulia in St. Peter's. In 1555 he got a job as a papal chapel singer in the Sistine Chapel but was curtly dismissed by Pope Paul IV when it was discovered that he was a married man. The blow almost killed him but his absence from the papal choir also came very near to killing that famous body of musicians. Palestrina, married or not, was therefore requested to come back and was appointed choirmaster of the chapel of St. John Lateran. From there

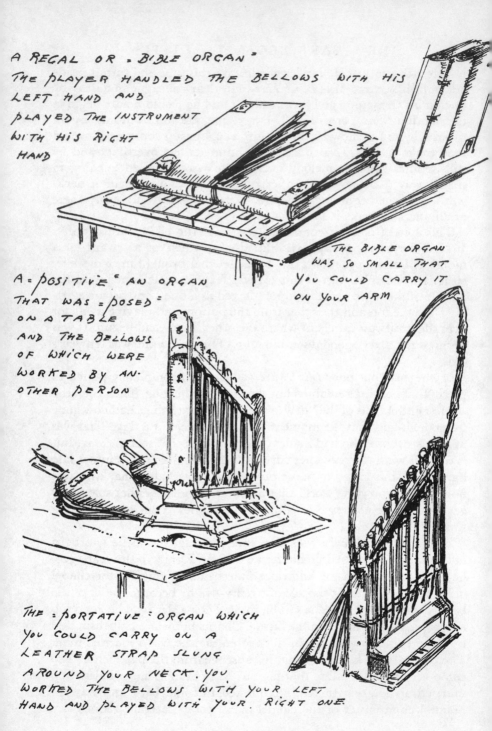

A REGAL OR "BIBLE ORGAN"
THE PLAYER HANDLED THE BELLOWS WITH HIS
LEFT HAND AND
PLAYED THE INSTRUMENT
WITH HIS RIGHT
HAND

THE BIBLE ORGAN
WAS SO SMALL THAT
YOU COULD CARRY IT
ON YOUR ARM

A "POSITIVE" AN ORGAN
THAT WAS "POSED"
ON A TABLE
AND THE BELLOWS
OF WHICH WERE
WORKED BY AN-
OTHER PERSON

THE "PORTATIVE" ORGAN WHICH
YOU COULD CARRY ON A
LEATHER STRAP SLUNG
AROUND YOUR NECK. YOU
WORKED THE BELLOWS WITH YOUR LEFT
HAND AND PLAYED WITH YOUR RIGHT ONE.

THE ORGAN

he was in the course of time promoted to the mastership of the choir of St. Peter's.

Palestrina, like so many of the great men of the sixteenth century, was a tireless worker. He did not perhaps compose as much as a Netherlander of that time, the famous Roland de Lattre, better known as Orlando di Lasso and head of the music school of Duke Albert V of Bavaria. The complete works of Orlando fill not less than sixty large volumes. But Palestrina was a much more important figure than Orlando di Lasso, for he saved music from the fate that would have overtaken it if the conservative Spanish party in Rome had been able to persuade the Council of Trent that the Netherlands school was a menace to the Gregorian style and therefore should be banished from all Church establishments.

There was a precedent for such a step. During the rule of Pope John XXII early in the fourteenth century, all works of contemporary composers had been banished from divine service. But that edict had never been taken very seriously and less than a century later everything was as it had been before and the living masters once more had just as good a chance as the dead ones.

The Spanish clique this time wished to take no chances. In order to prove their point, they took all the Spanish members of the papal choir to Trent that the members of the council might hear with their own ears what they were trying to prove and to what they objected in the new music. Fortunately for all of us, Pius IV was a very different man from John XXII. He liked the new music and, pretending that he could not take such a drastic step all by himself, placed the matter before the college of cardinals. The cardinals after years of deliberation decided that nothing but Latin might be sung during the church services and that everything "lascivious and impure" must be rigorously kept away from all sacred music. The Pope thereupon suggested a compromise. He invited his cardinals to listen to a composition that seemed to combine the old and the new in a most pleasing fashion. The piece he selected was Palestrina's Mass of Pope Marcellus —the famous *Missa Papae Marcelli*. It completely satisfied the demands of both parties and it was decreed that this particular mass should henceforth be the ideal example of what the Church expected of its composers in regard to the text as well as to the music.

This decision meant the defeat of the Spanish school that had been established in Rome by Cristobal Morales and Luis Tomás de Vittoria. It also caused a definite split between church music and worldly music. Since then many of the worldly composers, even some

who were not in the least interested in religion, have written excellent church music and the Church has wisely accepted their compositions and has sung and played them to the complete satisfaction of both the musicians and the congregations. But the Church has never again interfered with the development of the other sort of music which is meant to appeal only to the sense of beauty of its listeners.

It was a sensible arrangement. The Church no longer ran the risk of being turned into a mere concert hall. And the concert hall could run its own sort of entertainment free from clerical supervision. On the whole, this separation of worldly and religious music has been quite as beneficial to the two parties as the separation between Church and State, which was beginning to take place at the same moment.

# The New Prosperity Reaches the Heart of Europe

*Two master craftsmen, Albrecht Dürer of Nuremberg and Hans Holbein
of Basel, make the Italians realize that the barbarians across the Alps are
keeping up with the times.*

S LOWLY the heavy wooden carts carried their groaning burden of
barrels and bales across the dusty roads of northern Italy. Pack
mules, daintily stepping from stone to stone and nibbling at occasional
blades of grass, climbed the narrow passes of the Alps and, trotting
merrily through the village streets of cheerful little Tirolese villages,
delivered their precious cargoes to the heavily bearded men from the
north, who spoke a dialect which the Italian muleteers deeply de-
spised but who paid them for their services in silver coins that came
from the Joachimsthal in Bohemia and that had made the word *Thaler*
(or dollar) a guarantee of honest value in every part of the civilized
world.

And because this exchange of goods became more and more profit-
able, the people who lived along the roads that led from south to
north, trying to divert this trade to their own particular mountain
passes, were forever improving their roads and bridges, as modern
railroads in competition with each other will do their best to surpass
each other in comfort and service.

Since prehistoric times the Brenner Pass had been the main con-
necting link between northern Europe and Italy, so lofty and easy a
track that between the days of Charlemagne and those of Joan of Arc
(roughly speaking, six centuries) it had been crossed and recrossed
not less than seventy times by the rulers of the Holy Roman Empire.
Now this ancient short cut from north to south no longer enjoyed the
monopoly it had held for so many thousand years. It was still recog-
nized as the most convenient of all routes. Innsbruck and Augsburg,
the home of the Fuggers, the greatest banking firm of the Middle
Ages, and the other towns along this main artery of trade still show
in their architecture and in their art collections what a vast amount
of wealth must have been concentrated within their walls during the
latter half of the Middle Ages. As for Nuremberg, the great distributing
point for the whole of northern Germany, it had grown so rich and

powerful that it had been able to obtain that famous golden bull by which every newly elected emperor undertook to hold his first assembly in this traditional capital of the Frankish land.

But during the last quarter of the tenth century Saint Bernard of Menthon had founded a hospice on top of the pass that has since then borne his name. The new track (for none of these passes became real roads until the days of Napoleon, who needed them for his military operations) established direct communications between France and Italy by way of the valley of the Rhone and the Lake of Geneva.

To get part of these pleasant profits for themselves, the four cantons of central Switzerland, as soon as they had established themselves as an independent political unit, began to rebuild the old bridle path that ran clear across the mountain ridges of the St. Gotthard, but that had always been considered a little too dangerous for commercial purposes on account of the many avalanches.

This done, the cities of the valley of the Rhine became independent of their rivals of the Tirol and southern Switzerland, and the town of Basel, situated where the Rhine turns sharply northward on its course to the North Sea, developed into one of the main distributing points for the products of the Orient and the Mediterranean bound for the countries of the North Sea.

But when merchandise begins to move from one place to another, ideas are rarely far behind. Books and pictures take up much less room than bundles of nutmeg or Persian rugs. The medieval system of doing business, with its insistence upon long years of a most thorough apprenticeship, was forever shuffling boys from the Germanic north to the Latin south and *vice versa*. When these youngsters, after four or five years of service in Venice or Genoa, finally returned to the cities of their birth, to spend the rest of their days peacefully presiding over their fathers' warehouses and offices, they carried with them large quantities of that invisible baggage which no customs officer has ever yet been able to intercept and which is the most useful trophy one can hope to bring back from one's travels in distant lands. When they settled down and got married and decided to build themselves new homes, their houses and interior decorations showed unmistakable evidence of the styles among which the owners had spent the happiest days of their lives while learning the intricacies of double entry, that marvelous new Italian method of keeping accounts, then spreading all over Europe.

Should some misfortune befall their families and make it necessary for them to straighten out some slight misunderstanding with heaven

by means of a notable gift to the local church, then again the choice
of the picture or the statue that was to be given would be greatly in-
fluenced by similar works of art that they had seen in the cathe-
drals of the south. And should all go well and should they look for a
suitable teacher for their rapidly increasing brood of children, they
would undoubtedly give the preference to a slightly pagan tutor, well
versed in the polite tongues of Homer and Vergil, over one who might

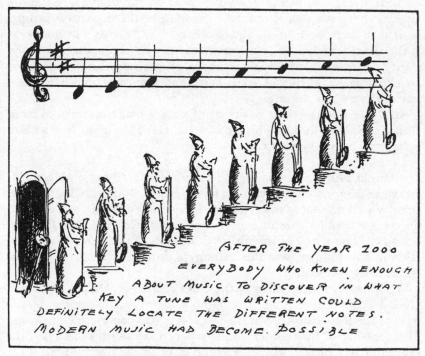

*What Guido of Arezzo did for modern music*

know his catechism forward and backward but who could not con-
strue a single line of Cicero without making at least five errors.

But this exchange of spiritual and artistic commodities was by no
means a one-sided affair. The Italians had undoubtedly made greater
advances in the field of gracious living. But in many respects the
northerners were better craftsmen, more careful in preparing them-
selves for their jobs, perhaps a little more formal and pedantic but
also a great deal more thorough, and so both sides accepted that ar-
rangement as something not only profitable but also of great mutual

benefit. It lasted for several hundred years until the religious wars of the seventeenth century made an end to this pleasant state of affairs and carried central Europe back to the days of the cannibals, when man was obliged to eat his fellow man for lack of other sustenance. (This is in reference to the cannibalistic feasts that were a result of the deprivations of the Thirty Years' War.)

However, when the two heroes mentioned at the head of this chapter were living and working, no one could possibly have foreseen the disaster that soon was to overtake the most civilized part of Europe. Both men were born in an age of plenty. Not "plenty" in our sense of the word which is so often synonymous with sheer waste, but the plenty which guaranteed every man a decent return upon his labor provided he was thrifty, worked hard, and was contented with plain fare and very few luxuries.

As Dürer was the elder of the two (being a contemporary of Hans Holbein, Sr., the father of his famous son, Hans Holbein, Jr.), we had better talk about him first.

Albrecht Dürer was the second oldest of a family of eighteen. He therefore came of a healthy stock, for his father, born in Hungary, was already well past forty when he decided to raise a family and married the daughter of his master who had only just celebrated her fifteenth birthday. The name of the girl was Barbara Holper and her father, Hieronymus Holper, was the leading goldsmith of the good town of Nuremberg.

We have several pictures of the elder Dürer. It was an age much given to portrait painting. The painting betrayed the new style, the style of the Renaissance, but the faces were still completely medieval. The drawing of his mother, made when that lady had reached the venerable age of sixty-three, tells the story of the martyrdom of the women of that time. The poor creature has been worn down to a mere skeleton by the burdens of childbearing and child rearing. The men, too, have the wild and distorted look of people beset by a thousand fears. Visions of the doom that awaited them in the hereafter must have been ever before their eyes.

Nothing shows the change that was coming over the world during that period as clearly as these portraits. Compare the apostles of Dürer in the Munich Pinakothek with the saints of Rubens, who was born less than fifty years after Dürer's death and you will see what I mean. But that is what makes the work of this earlier master so interesting. He was a living bridge between the old and the new. He was by no

means a rebel against that which had gone before. But quite uncon-
sciously he was a prophet of that which was to come so shortly after-
wards.

As a good son of the Middle Ages he learned his trade from the
bottom up. His father soon recognized the ability of his favorite son
and at the age of fifteen had sent him to the best known of all the many
Nuremberg artists, Michael Wohlgemuth. Honest Master Wohl-
gemuth was much more than a mere painter. He ran a complete
establishment in which all of the arts were both practiced and taught
and in which a small army of hungry apprentices worked day and
night to get their teacher's products ready for the market. A remark-
able fellow, Master Wohlgemuth, and a highly useful member of the
guild of St. Luke.

For great art is not a matter of a few virtuosi of the first rank. It is
the result of the labors of thousands of faithful craftsmen who know
that they are doomed to remain forever outside the gates of the Para-
dise of Perfection but who nevertheless will give the very best there
is in them because the work they do means more to them than any-
thing else in this world. They are the real tillers of the soil. The occa-
sional fruit that is born of their efforts fully repays them for their lives
of patient drudgery.

I shall have to mention these patient drudges again when we talk
of the music of Germany of the last two hundred years. In the days of
Dürer music had not yet come into its own. But the visible arts en-
joyed great popularity. And it was the intelligent and industrious and
simple Jack-of-all-trades of the Wohlgemuth type who was responsible
for the high degree of excellence that was so characteristic of every-
thing that left the German studios and workshops of the late Middle
Ages.

Often they were very strange customers when we compare them to
the artists of today. For there was as yet no deep abyss that separated
the artist from the rest of the world. A man could be a first-rate poet
and at the same time make a living repairing his neighbor's shoes, like
Hans Sachs. Sebastian Franck, my highly esteemed predecessor who
in the year 1531 wrote the first popular history of the world, was a
soap manufacturer. Lucas Cranach, Dürer's contemporary and fellow
Nuremberger, was a licensed apothecary who also on occasions prac-
ticed the recently discovered art of printing. As for Dürer, he never
had to struggle for recognition and he was much better paid for his
work than most Italian painters of that age and therefore he was not

obliged to make a few extra pennies as a barber or butcher or clerk in a lawyer's office.

But that did not prevent him from being thoroughly familiar with the technique of every sort of art, from oil painting to wood carving. It took him quite a long time to learn all these different trades but he was in no hurry and his father, who had become a prosperous man, was willing to risk a little money on this doubtful venture. Hence a number of *Wanderjahre* or years of traveling, that took the young student to many different parts of Europe.

We think that a modern artist or musician has done quite well for himself when after a few years in an American university he goes for a short while to London or Munich or attends the École des Beaux Arts in Paris or the Hochschule für Musik in Berlin. But what we do today is mere child's play compared to the everlasting wandering of the medieval student.

There were as yet few books. The poor fellows were obliged to learn everything (as one should really learn everything) by word of mouth and from some first-rate teacher. Most of them seem to have had a a fine nose for finding out just where these exceptional teachers were holding forth. And once they had made up their minds to attend their classes, there was no way of stopping them. Foot work meant nothing to them.

As a rule, such a wandering scholar was as poor as a church mouse, but that was the least of his worries. His worldly belongings he carried in a little bundle on his back, together with his sketchbooks and note-books. He slept wherever he happened to be, in a haystack or in the attic of some charitable citizen who remembered his own *Wander-jahre*. The Church still laid great stress on the importance of "good works" as a means of gaining salvation in the hereafter and in every town there were a number of houses where such a hungry youngster could count on a handout and occasionally on a small gift of money —a few coppers for which the local cobbler would then repair his shoes.

When he came to a city where they were building a cathedral or where some famous painter or goldsmith or coppersmith had estab-lished himself, the young man would hire himself out as a bricklayer or a stonemason or he would spend half a year mixing his master's colors and washing his brushes. Meanwhile he would use his eyes and ears and everything he saw or heard went down in his notebooks which afterwards, when he had set up as an independent "boss" (a word not then defiled by any political implications), became his text-

books and his daily guides in estimating the strength of wooden beams as compared to stone vaults and in trying to figure out how much carmine and gold he must order for a picture that was to be nine feet by twelve.

Dürer, a most methodical person who believed in having things down in black on white, has left us travel diaries of several of his journeys. I recommend them to all our own aspiring young painters.

As soon as he had finished his elementary training with the excellent Wohlgemuth, he left his father's roof and set forth upon his travels. It was his intention to spend some time with Martin Schongauer in the city of Colmar in Alsace, the borderland between the people of Germany and those of France. This Martin Schongauer was also the son of a goldsmith from Augsburg, the city so conveniently situated on the main road from Italy to northern Germany. He was born in 1445 and he had therefore learned his trade just when the works of the Flemings were beginning to find their way to that part of the world.

Colmar was situated on the main road from Strasbourg to Basel. It had always been a strong guild town, for as early as the fourteenth century the guilds had been able to acquire a share in the government of the city. That meant a high standard of skill, severely maintained by the masters of the guilds lest competition by inferior craftsmen cheat them out of their legitimate profits. All this is highly important as a background, for it explains to a certain extent why Martin Schongauer was able to become the first of the great contemporary painters who also took an interest in engraving. And once he had begun to play around with his copper plates and his burins—his boring tools—he decided that there might be more of a future in this sort of work than in using oils.

These, we should remember, were the days when the printing press had just made its appearance. Johannes Gutenberg was a citizen of Mayence, within easy walking distance of Colmar. Having got himself mixed up in a rather sordid quarrel about money with the city magistrates, Henne Gooseflesh (that is what his name originally had been), who like so many great inventors seems to have been a very poor financier, moved to Strasbourg. But soon afterwards this restless soul returned to his former home where in the year 1454 he presented the world with the first of its printed documents—an indulgence blank, a regular formula with spaces left blank for the amounts of money to be paid and for the name of the buyer and of the seller, the accepted medieval method of raising funds for good purposes (in this

**WOOD CARVING**

**ETCHING**

case a crusade to help the King of Cyprus kill Turks). Soon afterwards he started work on his famous folio Bible in Latin.

Schongauer therefore lived right in the heart of the most exciting experiments of the whole fifteenth century. That these took place in a part of the world which ever since Roman days had been the great melting pot for the East and West is hereby respectfully submitted to the zealots for the "purity of race" who just now are using Johannes Gutenberg's famous invention for the promulgation of their own strange ideas upon this most difficult of all problems. But everybody just then was trying to horn in on this new and highly lucrative business (though Gutenberg himself died in the poorhouse) of making books into a mass product instead of letting them be an expensive hobby for a few rich collectors. Schongauer was not interested in this particular detail of the venture but realized that the same presses that could be used for covering pieces of paper with ink from movable type could also be used for covering pieces of paper with the ink of a copperplate on which an artist had previously engraved a picture.

Until then engraving had only been done on blocks of wood. With blocks of wood you did not need a press to get an imprint. You could get just as good results with your hand or with a wooden roller. The new presses which had been built to handle metal were apt to be fatal to these blocks of wood. It was therefore necessary to find some other material. Gold was too expensive and silver was too soft. And so copper was selected.

The earliest copper engravings had been made for very practical purposes, for the wholesale manufacture of playing cards. The oldest ordinary engraving bearing a date goes back to the year 1446. That was exactly eight years after the word "printing" had been mentioned in one of those affidavits which were part of the ammunition with which Gutenberg fought his first three partners, Andreas Dritzehn and the Heilmann brothers, for a share of the profits. And then, all of a sudden, we hear of engravers not only in every part of Germany but also in many of the cities of the Low Countries.

As for the Italians, in the beginning at least they took hardly any interest in this new process of reproduction. This was after all quite natural because they worked for a different sort of market. The rich people of Italy lived in spacious palaces with a lot of wall space on which they could hang dozens and dozens of pictures. They could afford to live in that sort of house. The heating problem did not bother them. Except for one or two chilly days in December and January, they never felt the need of open fires. The people of the

north, on the other hand, were obliged to sit herded together in small rooms, closely hugging their tile stoves, for at least five months out of every year. Such houses offered as little room for paintings as a modern New York flat. But engravings were different. These you could keep in a portfolio, take them out, and look at them during the long winter evenings. Or you could have a few of them framed to break the monotony of the paneled walls of the living room. Besides, they were infinitely cheaper than paintings, whether in oil or in tempera, and that too was an advantage among these honest burghers who long before the days of Benjamin Franklin had realized that a penny saved is indeed a penny earned.

Engraving therefore reached a high degree of perfection in Germany and the Netherlands long before the Italians bothered about it. There was, however, one sort of engraving which the Italians practiced at a very early date. That was the sort of engraving we know as etching.

Etching (it is the same root as our word "eating") is done by means of acids. You first of all cover a copperplate or a zinc plate with a "ground" consisting of a mixture of wax and pitch and amber. You apply this when the plate has been sufficiently heated to make the wax melt. When this has been done you take a sharp pointed instrument (I use old phonograph needles) and draw your picture on that "ground" just as you would draw it on an ordinary piece of paper. You then put the plate into an acid solution, a mixture of hydrochloric acid and potassium chlorate, or whatever else gives you the best results. All of them are equally hard on the eyes and on the fingers and this so-called "biting" process takes as much time as it takes skill and patience. The acid eats away (or etches) that part of the copperplate which is not covered with wax—in other words, it bites away your lines. When you think that your lines have been sufficiently bitten, you clean the plate, remove the wax, rub ink on it (it takes only between twenty and thirty years to learn to do this well), and start printing.

The Italians were familiar with this process but for almost an entire century they used it only to engrave elaborate ornaments on pieces of armor without ever thinking of the possibilities it offered as a means of multiplying an original drawing a hundredfold.

During the fifteenth century the new etching technique finally crossed the Alps and was eagerly welcomed by the armorers of Augsburg, the birthplace of Schongauer's father. The jewelers tried it out on their precious metals, and then either a fellow by the name of

Hans Burgkmair or another painter of the Augsburg school decided to see what could be accomplished if you used an acid to get your lines engraved on your copperplate and were no longer dependent upon your burin and the physical strength of your good right hand.

Schongauer learned all these tricks from his father but in that day, when chemistry was still so badly understood, it was very difficult to get the right mordant, the right mixtures of acids, and he had remained faithful to plain engraving. When Dürer arrived in Colmar in 1492, Martin himself had just died, but three of his younger brothers were continuing the business, and it is there that young Albrecht must have learned the art in which he surpassed all his contemporaries —that of the engraver.

Engraving, like drawing, being more a matter of the brain than of the heart, was an essentially Germanic way of expressing the emotions. I can't think offhand of a single German painter who has been an outstanding colorist. Color was just not in their blood. But engraving took lots of patience and a great deal of careful planning. Yet it was a simple business, for which you did not need a vast studio but which you could do right at home and near your own kitchen fire so that you could always heat your plates without having to go to the extra expense of installing a furnace in your studio.

As for Dürer, he experimented with etching done on iron plates. But etching, being to such a great extent a matter of luck (regardless of the high skill you may bring to this enterprise), did not satisfy him. And for the rest of his days he stuck to engraving and a great many people prefer his work as a draftsman and an engraver to that which he accomplished as a painter. For his coloring never lost a certain harshness and always showed a decided lack of graciousness, but in his engravings we recognize the man who could draw a single violet or a single blade of grass as if they had been his close personal friends and as if he had learned all their innermost secrets.

These engravings have been widely copied. You can get them beautifully reproduced and for very little money. If you have a chance, try and buy a few of them and live with them where you can always see. them. For aside from all artistic considerations, they have a very important value as historical documents. They are the best pictorial introduction to the spirit of the Middle Ages. They are as Gothic as the name of Ravenna is Byzantine or the jazz of Gershwin is modern. They breathe the very spirit of an age that is now dead beyond all hope of redemption but out of which that state of society developed in which we ourselves happen to live. And unless you know your own

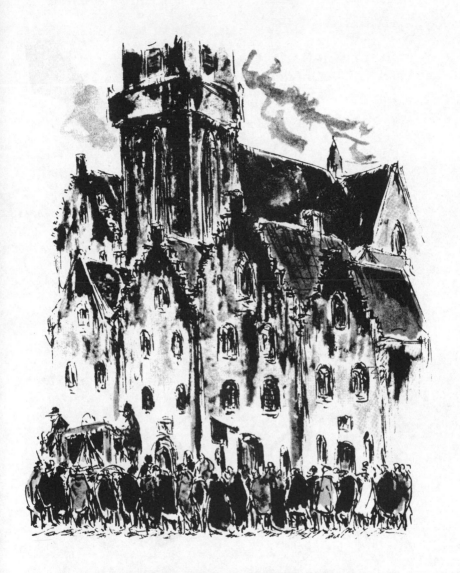

**THE GENTLEMAN PAINTER**

*Rubens leaves his native town on a foreign mission.*

*The beginning of the dance. The Indian witch doctor.*

past and know it thoroughly well, you can never hope to build soundly for the future.

The Holbeins of Basel, like the Bachs of northern Germany, were more than individual artists. They were members of a clan of craftsmen who for the greater part of an entire century were recognized as the undisputed leaders of their own particular trade. Hans Holbein the elder, born in 1460, came from Augsburg. His father was a master tanner, but as the civilization of the Middle Ages was a civilization of leather (just as ours is one of silk and cotton), a master tanner in those days was a personage of great importance, like the director of a modern silk factory. As such the elder Holbein was held in great respect by his fellow men and when the Emperor, on his way to Italy, paid his native town an official visit, the elder Holbein was there to receive him as a member of the official reception committee. Not perhaps in the first ranks. Those were reserved for the burgomasters and the aldermen and members of the local patrician families. But as "one of our leading citizens" and a man of character.

This old leather man had two sons, Hans and Sigismund. Both of them became well-known painters, and the elder of the two, Hans, in turn became the father of two first-rate artists, Ambrosius Holbein and Hans Holbein the younger. In due course of time the fame of the son so greatly overshadowed that of the father that we are sometimes apt to overlook the work of the older one. Similarly the fame of half a dozen Bachs has made us forget that at one time or another there have been literally hundreds of Bachs, each one of whom in his own humble way has contributed somewhat to the musical development of the German race.

In later years Hans Holbein the elder seems to have got into financial difficulties and that may have been the reason why his sons left Augsburg and moved to Basel. That happened in the year 1515. Four years before Erasmus, none too certain of the reception that awaited his dangerous social satire, had traveled from London to Paris to attend to the publication of his volume entitled *In Praise of Folly*. It was a tremendous success. So much so that his Basel publisher, Joannes Froben, decided that he could afford to print a new and illustrated edition, something amusing but well within reach of everybody's pocketbook. Young Holbein seemed the ideal artist for the job, and his illustrations have become as much part of the work of Erasmus as those of Cruikshank have become part of the novels of Charles Dickens.

The venture also showed the eminently practical side of Holbein's

nature. He was a most faithful portraitist. Nothing escaped his eye. The slightest details of both the face and the client's garments were most carefully put down. Holbein was no visionary who believed in art for art's sake! He had acquired a wife and she had presented him with several children. These children needed a home and an education and he meant to provide for them as best he could. Therefore, after having done a number of chores in Basel and near-by cities, specializing in decorating the walls of private houses and public buildings and having made quite a name for himself by the gruesomeness with which he painted those "Dances of Death" which were then as popular as Mexican murals are today (they showed Death dancing merrily with every sort of citizen from the pope and the emperor all the way down to the village idiot), he finally came to the conclusion that the local market had been about exhausted and that he had better look elsewhere for a few more remunerative orders.

In this decision he may have been influenced by the terrible depression that hit Europe around the year 1520. The sudden influx of all the many millions which Spain had taken out of the gold mines of the New World and carried to the old continent completely upset the simple economy of the Middle Ages. Everywhere prices rose skyward, while the buying power of the wages which were now being paid in money either decreased or remained stationary. Agriculture was hit worst of all and the discontent of the starving peasants greatly facilitated the labors of Martin Luther. For the Reformation, confiscating the wealth of all churches and monasteries, was a godsend to those unfortunate paupers and they were among the most ardent followers of the famous rebel from Wittenberg.

Basel, a distributing point for the merchandise from the Mediterranean, was one of the first cities to feel the depression. Artists have got to have patrons if they are to live, and Holbein, shrewdly anticipating the bread lines that soon afterwards were to form in every city of southern Germany, packed up his silverpoints and his colors and made for England. For in England, as he knew, there was law and order and while anarchy reigned supreme in every other part of Europe, the British monarchy, by placing itself at the head of the movement that demanded far-reaching ecclesiastical reforms, had been able to avert the threat of a civil war.

The first trip of young Holbein to England was an unqualified success. When you go to Windsor Castle you will find not less than eighty-seven drawings which Holbein made during that first visit and which are a veritable portrait gallery (and sometimes rogues' gallery) of all

the men and women who played a part during the reign of King Henry VIII.

In the year 1528 Holbein returned to his home town. His baggage this time contained a sketch of Sir Thomas More, which the latter had asked him to give to his old friend Erasmus, who was then living in Basel, the only city on the mainland where a man of his tolerant tastes could still hope to live in peace. It was the last time Erasmus was to behold the countenance of his generous protector. A few years later that noble head lay in the dust, cut off by order of the same sovereign whom the wise and broadminded Thomas More had served with such singular loyalty.

Our sturdy Swiss, however, was not interested in politics. He most carefully avoided doing anything that might arouse the King's ire. So in 1530 we find him once again in England, as busy as a beaver and gloriously basking in the favor of "good King Hal" who was a scoundrel and a rogue but who had certain essentially human qualities which greatly endeared him to the hearts of his loving subjects.

During this second visit Holbein finished a great many more pictures than during the first one. He had perfected his technique to a point beyond which no man could hope to go. While contemplating these pictures, one feels that if the people there represented had not actually looked the way he depicted them, they should have done so. His contemporaries appreciated his work at its true value and Holbein was able to provide houses and shoes for his wife and the kiddies as he had hoped to do when he set forth upon his perilous voyages. His own town honored him by making him the official town painter. The doors of England's mightiest mansions were wide open to him. But not a vestige of carelessness or indifference ever entered his work. Until the end he remained the faithful workman who intended to give his clients the best there was in him, just as his grandfather, the old tanner, had given his customers the best hides that money could buy and sulphuric acid could pickle.

In the fall of the year 1543 one of Hans Holbein's most popular series of woodcuts suddenly came to life. The plague broke out in London. And when the Dance of Death was in full swing, young Hans (he was only forty-six) was asked to join in the festivities. Before he could realize what was happening, the bone man had gaily trotted him off to the cemetery.

# A Mighty Fortress Is Our God

*Protestantism and the arts*

I T WAS THE THIRTY-FIRST OF OCTOBER of the year 1517. In the town
of Wittenberg (a little provincial nest in Saxony of which few peo-
ple in Europe suspected the existence) the good citizens were ready
to go to mass. But they stopped in amazement and perturbation
when they reached the front entrance of the church that was part of
the old ducal residence. For that which many of them had foreseen
and feared ever since their most distinguished professor of theology
had returned from Rome had now become a reality. Two pieces of
paper were fastened to the wooden doors, and these two pieces of
paper contained ninety-five formal complaints against certain clerical
abuses with which everybody was familiar but which nobody until
then had dared to mention in public. If you want to realize the emo-
tions provoked by these two sheets of paper in the hearts of all good
Wittenbergers, try and imagine how we ourselves would feel if the
president of Harvard or of Yale were to go to Washington and were
to inform the Supreme Court that our Constitution and our entire
form of government were in dire need of a complete reconstruction!

How this step of Dr. Martin Luther changed the entire course of
history I have already described in a previous volume. All I can do
here is try to discover to what extent the arts were influenced by
this act of open rebellion on the part of a stubborn German monk who
was firmly convinced that a single man with God and his good con-
science on his side could safely defy all the established authorities of
both Church and State.

It has been said (by a man with a deep knowledge of human na-
ture—the German philosopher Friedrich Nietzsche) that Luther's
professed hatred for the evil conditions inside the Church was merely
part of the general dislike he felt for everything beautiful that had
been created by the Church—for the statues and the paintings and all
the architectural details of the big cathedrals. I have no doubt but
this was at least partly true. The European peasant has always been
deeply suspicious of whatever he fails to understand and Luther was

**MEXICO**

*The Spaniards destroyed what the natives had wrought...*

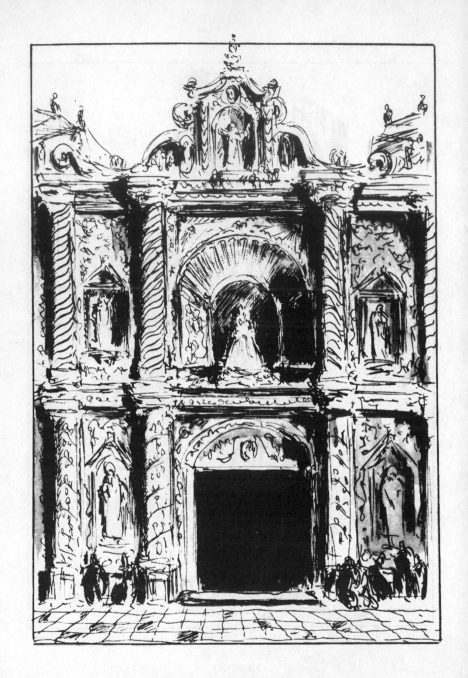

**MEXICO**
*and then gave them this in its place.*

(and until the end of his days remained) a simple German peasant with all the good and less agreeable qualities of his class.

According to all the available evidence, he was a forceful speaker of the evangelistic type. All his life he was in great demand as an orator. He must have seen the inside of most of the great cathedrals of his time, but he never with a single word mentions their beauty or the loveliness of their stained glass windows or their paintings and stat- ues. All he observed was that in some of the churches the acoustics were better than in others and that therefore in the cathedral of A you could get your audience much more easily than in that of B.

He did considerable traveling. In the year 1511 he crossed the Alps on the way to Rome to see the Pope. He passed through Florence, the most beautiful town of all Christendom. The only thing this practical German peasant noticed was the efficient public health service of the city. The hospitals, so it seemed to him, were much better run in Florence than anywhere else and that was a good thing for the people. He arrived in Rome just when the building and painting activities of the popes were rapidly transforming a collection of medieval hovels into a city laid out according to the plans of the greatest artists of the entire Renaissance. The conscientious German monk sat down on the piles of marble destined for St. Peter's and made mental calculations of how much of all the money necessary to erect this vast cathedral had probably come out of the pockets of his German fellow peasants.

He lived all his life surrounded by excellent painters of his own nationality. Lucas Cranach worked for many years in Wittenberg as court painter to the Elector of Saxony. One of his sons even became mayor of Wittenberg while the father not only painted the portraits of Luther's parents but also that of the great reformer himself, a pic- ture that seems to be the visible embodiment of the famous: "Here I stand. I cannot do otherwise. God help me! Amen."

Mathias Grünewald (who although a German was a startling colorist) was court painter to the rulers of near-by Brandenburg and in his immediate emotional appeal to the masses quite as much of a rebel as Luther himself. But Luther seems to have been completely unaware of the importance of these two men as artists.

His reading was just as limited. His ignorance of history was almost equal to that of Adolf Hitler, with whom, by the way, he had a great many points in common. Aristotle to him was merely a sort of human mule gathering useless information as a real mule will gather thistles along the road. He greatly preferred Cicero, whose work, so he claimed, was excellent for the purpose of teaching little German boys

their Latin grammar. Caesar was a trained monkey and the only Roman poets for whom the great reformer had any use were these moralizing fabulists like Aesop whose fables could inspire children to lead a righteous life.

Yet this same man, blind to all the arts that appealed to the eyes, was an ardent champion of all those that appealed to the ears. He loved music. Next to theology, he used to say, there was only one other thing of importance in this world and that was music, "that most wonderful of all of God's manifold gifts." He himself played the flute and the lute and on occasion he would even take pen and paper and compose a few hymns. His tune *A Mighty Fortress Is Our God* has become the national anthem of all good Protestants. And it was Luther who restored music to the place of honor it had held in the days of the early Christian church when every member of the congregation had been allowed to take part in this form of community singing.

So much for Martin Luther.

He was not an artist but a religious reformer. Yet in a curious way he seems to be responsible for the great change that came over the art of his own country. For after the beginning of the sixteenth century the pictorial arts that had started out with such high hopes in all the Germanic lands began to dwindle until finally they almost completely disappeared. There still were to be several good painters and architects in Germany but they were to give very few signs of originality. They became copyists of what had been originated abroad.

But at the very moment that the German painter disappeared from the stage his place was taken by the musician. And ever since music has been so much of a German specialty that German has been the *lingua franca* of the musical world.

Why this should have been that way, I do not know. I am therefore merely stating a fact.

# Baroque

*The Church and the State proceed to the counterattack
and how this affected the development of the arts.*

I F YOU WANT TO UNDERSTAND the century and a half which followed immediately upon the outbreak of the Reformation, I recommend the portraits that were painted during this period. They will explain the era of the great religious wars much better than all the books that deal with the subject.

They are able to do this for quite a variety of reasons. For one thing, there was the new weatherproof technique which allowed people to paint in oil. The fresco painters of the earlier half of the Middle Ages, with their fast drying backgrounds consisting of wet plaster, had always been obliged to do their jobs in too great a hurry to do a really good piece of work. Oil painting, therefore, had been of tremendous help to the portrait painter and although at first the Church had frowned upon the practice, the portrait painter had become a man of considerable standing in the community and was growing much richer than his colleagues who specialized in holy scenes.

But two things are necessary for a good portrait. One is an artist who knows his business. The other is a model worthy of his best efforts, and the sixteenth century was an ideal age for just the sort of faces a portrait painter would love to take on as his subjects. For it was an age of very outspoken and very strong characters. They were the only type that could hope to survive in an era of such unusual violence and fury, when war and pestilence were apt to reduce the population of a city or an entire country to one-tenth of its former size in less than half a year's time. The advantages of birth and breeding were reduced to a minimum. It was a question of kill or be killed and only those who were most fit to survive under these harrowing circumstances had a chance to maintain themselves.

Today the lower middle class seems to produce the strong men that are needed for the occasion but in the sixteenth century the leaders were born from among the peasantry or from the lower classes of the nobility, which except for its name was only one step removed from the earth animals among whom it spent most of its days. Peasants

started the revolution and peasants conquered the world. Peasants became the leaders of mercenary bands which made and unmade empires. Even the princes of that period gave evidence of a very peasanty sort of mentality. They were born in a castle that smelled strongly of gunpowder. They lived on horseback. Wherever they went they carried the smell of the stables with them. Their jokes were those of the village tavern. Their conversation reflected the atmosphere of the barracks where they felt really much more at home than in the apartments reserved for their womenfolk. A hundred years of almost continuous warfare made it possible for them to spend most of their time in some armed camp, a life that suited them to perfection. They preferred leather to satin and silk. Whenever they had to dress up for an official occasion, they appeared uncomfortable in very heavy brocades which made them stand apart from everybody else, like Luther in that telltale picture of Lucas Cranach—a heavy, square-toed yokel with both feet solidly on the ground. And the women were little better than the men.

The period of the Baroque was the ideal age for fat people. Perhaps it would be better to call them heavy. For most of these men led very active lives. The extra weight they carried about with them was not an evidence of physical laziness. It was the result of heavy living, heavy eating, heavy drinking, of deep slumbers after heavy meals. All of which contributed to make this an ideal age for the portrait painter.

A modern painter must spend a lot of time "draping" his subjects. In the sixteenth and seventeenth centuries the subjects had already draped themselves. Even when they were merely talking to a servant, they seemed to be posing for their portraits. For that was the way they were accustomed to live, doing things slowly, ponderously, and with solemn gravity.

Visit a Baroque palace and try to figure out how you could possibly turn it into a comfortable home. Medieval rooms lend themselves beautifully to being lived in by modern people. Once you get over a certain feeling of emptiness and a disgust with the lack of hygienic facilities, you will swear that you have never before experienced such a sense of peace and such perfect harmony between beauty and usefulness. A Rococo palace, whether big or small, as soon as it has been provided with a few modern conveniences, makes a delightful home. It creates an atmosphere in which you feel that you can be at your very best—in which you can be pleasant and polite even to people who bore you, and in which on occasions you can even be much wittier than you have ever been before. But Baroque palaces are only

fit for the people who built them and even with the best of modern interior decorators they will never be anything else but vast uninhabitable barns without a vestige of *Gemütlichkeit*.

The very name "Baroque" betrays the small esteem in which this style was held by the men and women of the Renaissance who witnessed the coming of these vast and dreary piles of stone. In Spanish a *barroco* was a huge pearl of irregular shape, a bivalvular affliction that somehow had gone wrong and looked grotesque rather than beautiful. It had not been meant as a compliment, any more than the sneering "Gothic" or "Hunnish" which the Italians had applied to everything that had come to them from the north. I have already mentioned the spread of the Baroque form of architecture throughout Europe. But I have said nothing so far about the Baroque attitude of mind and that, of course, in turn decided the sort of art that was produced during this period and was much more important than anything else.

It is difficult to give you any definite dates but I think it is safe to say that the Baroque started with the outbreak of the Reformation in the middle of the sixteenth century and ended with the death of Louis XIV, soon after the year 1700. In some parts of Europe it continued for a little while longer. In others it had already disappeared. But during these entire hundred and fifty years, the Christian world was primarily dominated by problems that either directly or indirectly were of a very decidedly religious nature.

Luther and Calvin had broken up the universality of religious experiences of the Middle Ages. Each man must now decide for himself which of the many new prophets of salvation offered him the best guarantee of future happiness. And soon Catholics, Lutherans, Calvinists, Baptists and Anabaptists, Supralapsarians and Infralapsarians, Latitudinarians and Limitarians, Trinitarians and Ubiquitarians, and a score of other conflicting sects were bidding against each other for domination over the minds of the millions.

Out of these arguments and disputes there arose a century of such strife as the world had rarely seen. It culminated in thirty years of a most disastrous form of warfare. Before these groups had been definitely convinced that none of them could ever hope to destroy all the others and that they must agree upon a compromise, the whole of Europe had been turned into one vast battlefield in which the Christian world was treated to the sight of Catholic generals leading Protestant armies and Protestant generals leading Catholic armies, of Protestant mercenaries plundering Protestant countries and Catholic

mercenaries despoiling Catholic countries, of a Catholic commander in chief offering to sell out to the champions of the Protestant cause and of a Protestant king accepting subsidies from a Roman cardinal.

The end was a complete stalemate. After thirty years of fighting (during eight of which the diplomats were preparing for peace) both sides agreed to a truce. A most disastrous truce, for it confirmed Article Three of the religious peace of Augsburg of the year 1555, by which each ruler had been given the right to enforce his own particular faith upon all of his subjects, regardless of the wishes of the majority.

As a result, all of Europe was to be henceforth divided and subdivided into an endless number of small principalities, each with a religion of its own and each one the sworn enemy of all its dissenting neighbors. And the Church of the Middle Ages was forced more than ever to play its classical role of the "Church militant."

It was one of the most far-reaching changes that have ever affected the civilization of Europe and it made a deep impression upon all the arts. For the painters and sculptors and architects and musicians ceased to be peaceful craftsmen who plied their trade to the greater glory of a universal God. They were forced to enlist in the different little armies that meant to reconquer the world for some tribal Deity. A picture ceased to be a picture. It became a piece of propaganda. A church ceased to be a house of worship and meditation. It became a meeting place for those who happened to belong to the same religious sect. And only such songs were tolerated as could also be used as battle hymns by the defenders of whatever "true faith" was the prescribed creed of their own little bailiwick.

In this terrific and merciless struggle, the Catholic South fought with the help of the visible arts, while the Protestant North depended more upon the audible arts. A strange catch-as-catch-can between painting and architecture on the one side and music on the other: Bach vs. Velasquez in ten rounds!

But I am trying to make things a little too simple, for there really has never been an historical period as hopelessly complicated as that of the Baroque. For another contender for honors had now appeared upon the stage. That was the dynastic state, the state in which all the power was in the hands of a single man, either a king or his prime minister. This dynastic state was not the result of the religious developments of that day. It had been born out of the need for a highly centralized form of government during an age when all countries

were fighting each other for part of the spoils of Europe and Asia and Africa and America.

Once founded, however, its rulers were forced to make common cause with the Church, for these princes, too, must be forever on guard not only against their enemies from abroad but also against those at home. Those at home might only be religious dissenters or potential dissenters, but they too if possible must be brought back into the fold of the faithful. And, borrowing a leaf from the Book of Conduct of the Church, the worldly authorities decided that nothing would serve their purposes as well as a deliberate campaign of splendiferous overawing. In consequence thereof the Baroque period became an era when both the Church and the State set out to impress the common man with their glory and their glamour and their power and their wealth until the poor subject was so completely overpowered by the majesty and splendor of his spiritual and worldly masters that he considered himself fortunate to be allowed to pay his taxes and share the least tiny little bit in this display of magnificence.

With so vast a panorama before us it is impossible to devote much space to the details. I can give you only a barest outline of what happened during this period to a few of the main actors in the tragedy of the Baroque. I must begin with the power that placed itself at the head of the Counter Reformation and that completely ruined itself in the attempt.

That power was Spain. Having spent eight hundred years fighting the Moors for the possession of their country, the Spaniards had worked themselves into a frenzy of religious zeal that made them the natural defenders of the faith the moment the Church, which had been their main support during this long period of martyrdom, was threatened by a new sort of infidel.

The Renaissance had not deeply influenced the Iberian peninsula. It had added an element of restlessness to the existing Gothic. This was called the Plateresque style. Like Baroque, the term was borrowed from the silversmith's trade. It implied that a highly complicated sort of architectural ornament had been superimposed upon the simpler outlines of the original Gothic. It never was very thoroughly developed in Spain because the Baroque soon afterwards overtook it and made an end to both the older and the newer Gothic. But in a modified form it reached the other side of the ocean and became responsible for those bizarre façades we find on so many churches in Latin America. And whatever chances it might have had to survive were destroyed by the coming to the throne of King Philip II.

A single man, holding all the power this monarch did, can make and unmake entire forms of art. This poor fanatic—the John Calvin of the Catholic faith—tried to express himself in one enormous and enormously dreary building—that vast dump of cold gray stone near Madrid known as the Escorial. But even his own devoted subjects could not follow him there and the Escorial remained a solitary example of a style which was eminently fit for the self-imposed prison of a religious maniac but not for human habitation. As soon, therefore, as His Majesty had descended into that crypt where he lay next to the son whose future wife he had married (for in that strange family all things were possible), the example of the Escorial was allowed to be forgotten.

But it would be an exaggeration to say that Spain thereupon became the leader of the Baroque style. The Spaniards were to contribute more than any other people to the spread of the Baroque spirit all over Europe, but their building days were over. For buildings cost money and Spain was bankrupt. A completely mistaken notion about the management of its foreign possessions, a racial pride that removed all non-Spanish elements (both the Moors and the Jews, the hardest-working members of the race) and that completely overlooked the importance of the small farmer in the economic scheme of things—such a country could not hope to survive even while owning all the gold mines of the New World.

But while economically Spain had ceased to count, it was still to have an enormous influence upon the spiritual life of the world through the sudden appearance of its most picturesque religious leader, the most noble Don Iñigo López de Recalde, better known to us as Saint Ignatius of Loyola.

I have mentioned that the era of the Baroque was dominated by men of peasant origin. Technically speaking, Ignatius was a member of the Spanish nobility and he even received part of his earliest training as a page at the court of Ferdinand and Isabella. But that ancestral castle of Loyola was about as much of a palace as the mansion in La Mancha where the most noble Don Quixote de la Mancha was to see the light of day.

Cured of all earthly ambitions by the misfortunes of his youth and crippled for life by a cannon ball at the siege of Pampeluna, this soldier of the king enrolled under the banner of the Cross and in due course of time became the most determined leader of the forces that were gathering together to reconquer the souls of men for the one and only Church. The Society of Jesus which he founded was a military

organization rather than a religious institution. It despised no weapon whatsoever in its warfare upon the infidels. And as the arts are a most powerful means of evoking and guiding the human emotions, the architect and the painter and the musician were all of them pressed into the service of God.

The architects might be Italians and pupils, perhaps, of the great Lorenzo Bernini, who had embellished St. Peter's in Rome with a fine Baroque frenzy and who in a way may be considered the father of the Baroque style in church building. But the men who approved of the plans and who provided the necessary funds were members of the Society of Jesus and whenever you visit a town in Austria or Poland or Portugal or Bavaria that shows the unmistakable characteristics of the Baroque, a restless desire to impress and overpower at all costs, you will probably discover that it was the work of a Jesuit and ten to one is still popularly known as "the Jesuit church."

But if Spain could no longer afford to build for herself, it could still find enough money to provide its artists with a little canvas and paint and those artists, too, became propagandists of the highest order for the cause for which their poor country was ruining itself.

The earliest and one of the greatest of them all was a foreigner, a Greek from the island of Crete, Dominicos Theotocopulos, known in Rome (where he arrived in 1570) as Domenico Theotocopuli, and called El Greco by the Spaniards who could never have managed that complicated combination of Greek syllables, but who never ceased to regard him as a "foreigner" with all that word implies.

Why, when, or wherefore he moved from Italy to Spain we do not know, but in the year 1575 we find him painting pictures for a church in Toledo and next we hear of him in Madrid, doing an altarpiece for Philip II which the King himself refused to place in his private chapel in the Escorial. El Greco had put high hopes on this work. He had been in constant trouble in Toledo for certain "improprieties" the clerical authorities had discovered in his pictures and such discoveries might lead to a very unpleasant personal encounter with the Inquisition. The King by buying a picture from him now extended his protecting right hand over the Greek master. But why he would not have it in his private chapel we do not know. Perhaps he did not like it and in that case a lot of people have since then shared His Majesty's feelings. For a love for El Greco is an acquired taste, like a love for the music of the Arabs or the Chinese. The coloring is unlike that seen in the work of any other man but you can soon overcome a slight feeling of monotony. The figures, however, will probably con-

tinue to trouble you for quite a long time. The usual explanation is that El Greco, being a Greek, must have been under Byzantine influence. Even though the Byzantine Empire had been destroyed fully a hundred years before Domenico appeared on the scene and his own city of Candia was a Venetian colony at the time of his birth, the ancient Byzantine traditions lingered on for several centuries longer. In Greco's case, however, they were greatly exaggerated by the fact that he seems to have suffered from some ailment which, especially during his later years, prevented him from handling his brush in any other way than that which produced his rather awkward and triangular figures. The sense of *folie de grandeur* which is so typical of everything he did, that upward sweep of a grand seigneur throwing ducats to the beggars outside his coach, would be entirely in keeping with this suspicion.

Such details are not merely a matter of idle gossip. They have often very considerably influenced the art of some great master. Rembrandt's rapidly increasing nearsightedness seriously affected all the etching of his later years. Beethoven's deafness influenced every composition he wrote after 1812. And Pascal would probably have been a much more cheerful philosopher if he had not suffered so severely from facial neuralgia.

However, whatever may have caused El Greco's drawing to look so completely out of gear, it did not seriously interfere with the general state of his health. He lived to a ripe old age and died as one of the most prosperous and esteemed painters of his day, deemed worthy of a funeral "as if he had been a nobleman instead of a painter," as his contemporaries so quaintly observed.

In this he had been only a little less fortunate than another great Spanish artist who not only had a funeral "as if he had been a nobleman" but who actually had been elevated to that rank before he ceased to paint and then on account of his most valuable services to the state. I now refer to Don Diego Rodriguez de Silva y Velasquez, Velasquez being his mother's maiden name by which, however, he came to be known, according to the pleasant old Spanish custom which allows the mother to be as important in producing offspring as the father.

Young Velasquez was trained for the law that he might succeed his father as one of the legal luminaries of Seville. But having shown marked talent for painting he was sent to a studio where, like most people of genius, he did not learn very much. His teachers, to give them their due, did not amount to a great deal either, but they were

good enough to give him a thorough grounding in the elementary principles of their art.

Like Leonardo and Michelangelo and indeed all great artists, he was a veritable mule for work. He lived to be sixty-one and for a great number of years occupied a court position which kept him very busy, the position of chief supervisor of the royal living quarters. This meant that he was not only responsible for the palaces the royal family occupied when at home but that he must also provide suitable rooms for the King and his vast retinue whenever His Majesty went forth upon one of his endless voyages. For the King whom Velasquez served did a great deal of traveling.

Some of it was rather complicated, too. There was the famous occasion in the year 1660, the year, by the way, in which Velasquez died. The daughter of the Spanish King was going to marry King Louis XIV of France. As neither sovereign apparently trusted his neighbor sufficiently well to be willing to set foot on the other fellow's territory, it was arranged that the ceremony should take place on a small island in the middle of a river that separated France from Spain. The royal tents and everything else necessary for this affair, which was the main social event of the century, were entrusted to Velasquez, and the world was full of praise for the way he handled everything. He had even been allowed to be present at the official dinners and receptions!

You have to know your seventeenth century very thoroughly to feel what such an honor meant when the recipient was a mere artist. It was just as if a modern debutante coming out at a million-dollar party at the Ritz should invite her caterer to come and join her at dinner. Of course, in the case of Velasquez there was one mitigating circumstance. The painter had been duly ennobled by his grateful master. But that operation too had been far from easy. For not only had Velasquez been obliged to prove that there were no traces of Jewish or Moorish blood in the veins of himself or of any of his ancestors, but also that there never had been a suspicion of heresy in his family. Finally—a typically Spanish detail—he must give assurance that none of his people had ever been contaminated by either trade or commerce. When all this had been settled to everybody's complete satisfaction and when it was shown that he himself had never actually sold a picture but had always worked for a salary (like any other court functionary), the patent of nobility was at last granted.

In the National Gallery in London you will see the benefit which this curious little transaction bestowed upon posterity. As a person basking in the royal favor and a nobleman in his own name, Ve-

lasquez could now afford to paint that marvelous *Venus and Cupid* which otherwise would undoubtedly have caused him several very uncomfortable interviews with the dignitaries of the Inquisition and which (even if he himself had escaped with his life) would have led to the destruction of the picture. But now he could not be touched, for he was protected by the favor of the King and even the Inquisition was obliged to make halt before his door and treat him with all possible consideration.

It was also the royal favor which sent him forth upon his second voyage to Italy to buy statues for the Spanish court. I don't know why, but the Spaniards were never very good sculptors. King Philip IV felt that he needed some statues for his royal palace and Velasquez was dispatched to Italy to see what he could get. Being primarily a painter, he acquired a great many works of Titian and Tintoretto and the other great Italians and when the doors of the Vatican were opened to him most graciously (such a close friend of His Spanish Majesty must be received with great politeness) he improved the occasion by painting a picture of Pope Innocent X which is as fine a portrait as any that was ever painted.

Most of his other pictures had to do either with the royal court or with scenes directly connected with that court—maids of honor, royal buffoons, and hunchbacks of all sorts (these poor little creatures were then kept by the rich as today they keep pet dogs and cats, but as a rule they were not half as well treated), successful generals in the act of conquering cities for their royal master (the famous *Lanzas* or the *Surrender of Breda*), a great many royal wives (the poor ladies had a most unfortunate habit of dying in childbirth), royal children (Don Baltasar Carlos on horseback), royal sculptors (Martinez Montañes), royal admirals, royal ministers (the Count of Olivares) and finally and perhaps the noblest of all his works, *Las Hilanderas*—the spinners of the royal tapestry works. Everything very "royal" as befitted a man who almost every day received a visit from his royal master in his studio in the royal palace and who (according to tradition) had taught enough painting to his royal master to allow the royal hand to smear the cross of the order of Santiago on the self-portrait that Velasquez had included in his picture of Philip's young daughter Margaret.

This picture I especially recommend to you if you want to understand the atmosphere in which Velasquez worked. Philip IV and his wife are both present, reflected in a convenient mirror. In the foreground lovely young girls, dressed in all the splendor and discomfort

of royal maids of honor, are trying to amuse the royal offspring, who already seems sadly conscious of the fact that "a Queen of Spain was supposed to have no legs." But as a final touch, and one which suddenly makes us realize that we are in the world of the Baroque, two most repulsive dwarfs, one female and one male, are standing right in front of the group of children. These were supposed to be ideal little playmates for a Spanish infanta, who some day might be called upon to rule half of the world. For the final results, consult your daily paper and read the news that comes to you from Madrid and Bilbao.

Yet underneath all these absurdities we can discover an idea, and an idea which seemed a highly desirable and an entirely practical one for the people of the Baroque. Murillo and Alonso Cano and Giuseppe Ribera were working to impress the multitudes with the glories of the Church. Velasquez from his side was bestowing such beauty upon everything connected with the court that all people must surely fall under the spell of the Royal Majesty. Yet somehow or other his pictures failed to accomplish this, for there was no letup in the violence with which the Dutch subjects of the Spanish monarch continued to fight for their political and religious independence. They had already so successfully defeated His Majesty's armies and navies that the northern part of their country had become one of the most powerful champions of the entire Protestant cause. The southern part, however, remained faithful to the Church. This division was to have great influence upon the art of the two countries, which was a curious development, for until then there had hardly been any artists in the north, and such young men as had been ambitious to learn the trade of the painter or the musician had invariably gone south to study with a Flemish teacher. From the middle of the sixteenth century it was to be the other way around. Surely the arts set us some strange puzzles!

During the fifteenth century Dutch art amounted to nothing and Flemish art was at the head of the procession. During the sixteenth century the two were almost equal, but the Flemings were still in the lead. During the seventeenth century the Dutch shot far ahead of their southern competitors. During the eighteenth century, neither of them amounted to anything. If you know the answer, please let me have it.

The fact that oil painting was invented in Flanders had given the Flemings a head start of almost a full century over their northern neighbors. The building craze of the Middle Ages had long since

spent itself. The old Gothic churches were slowly preparing themselves to serve as targets for modern artillery practice, a fate that seems to await all public edifices of the old continent. The prosperity of such cities as Bruges and Ghent was gone. The old, old story! Capital and labor fighting each other until, like the Kilkenny cats, they had completely destroyed each other. But a great deal of accumulated capital still lay hidden away in those ornamental chests with seven locks that had been the pride of every medieval household. And since pictures are one of the most concrete signs of a family's opulence, the painters were still doing a very nice business.

The pioneers of their new "method," the Van Eycks and the Memlincs and the Van der Weydens, to mention only a few, had long since descended most decorously into the vaults of those churches upon which their art had bestowed an undying name. Their places, however, had been most worthily taken by one of the most prolific families of artists of an age that specialized in those curious tribes in which the traditions of a certain craft descended from father to son and to grandson with undiminishing vigor. I refer to the Breughels, to Pieter the older and Pieter the younger and Jan.

I realize that until recently these honest Flemish peasants have been almost completely overlooked by many of our compilers of art histories. I also am bold enough to state (and in the most unmistakable terms) that especially the older Breughel was one of the greatest masters of all time, for he was so completely alive and so absolutely modern that it looks as if some of his pictures had been finished only day before yesterday. You will have to go to Vienna to see the old fellow in all his glory, for the Hapsburgs for one reason or another bought up most of his better-known works and transported them to their own capital.

Pieter the older was born in the year 1525 (?) in a village near Breda, which is now a city in the Netherlands but which then was considered part of Flanders rather than of Holland. His father was a peasant. So was his mother. So was he himself, as you will realize for yourself the moment you have noticed the love with which he recorded all the details of a village wedding, his fine feeling for the aspects of the different seasons, and the immense respect he showed for food. But talent was talent in the Middle Ages, and therefore a boy like Pieter, who showed such a remarkable natural bent for painting when he was still a mere child, easily found someone to give him money enough to go to France and Italy to learn his trade. After his return to the Low Countries he at first settled down in Antwerp but

later on moved to Brussels which then as now was the capital of the southern Netherlands. There he spent the rest of his days, painting and etching and educating his two sons. The elder one of these came to be popularly known as "Hell" Breughel, for he specialized in those fantastic pictures filled with absurd little devils and with self-blowing clarinets and all sorts of other absurdities which had already been made fashionable by his compatriot Hieronymus Bosch, another native of Brabant and the greatest master of such *diableries* until the blessed day when our own Art Young was born.

The younger son went to the other extreme, for he became known as the "Velvet" Breughel on account of the velvety quality of his roses and peaches and apricots. But regardless of their personal idiosyncrasies, the Breughels were marvelous craftsmen, deeply versed in all the tricks of the trade by which they made their living, and therefore they acted as a sort of connecting link between the painters of the days of the Van Eycks and those other great Flemings who shortly afterwards were to astonish the world with their genius. I refer to Jacob Jordaens (the least able of the three), to Pieter Paulus Rubens, and to Anthony van Dyck.

During the last fifty years Pieter Paulus Rubens has suffered a sort of eclipse. There has been a lot of criticism of his work. His women are too stout. His angels float through space in too open a defiance of the law of gravity. His Goddesses are a shade too healthy. But I have a suspicion that very slowly he is coming back into his own. The sort of women he depicted had undoubtedly never heard of the Hay diet and Hollywood would have spurned them with profound scorn. However, at certain times there have been other standards of perfection than those laid down by that strange village of celluloid make-believe, and the seventeenth century liked to know whether its women were coming or going. And as Rubens, the ideal Baroque artist, was supposed to paint pictures that would look well in churches and palaces of vast proportions he could not possibly follow the example of a Memlinc or a Dirck Bouts or a Quentin Matsys, whose work was meant to be shown in some small private chapel where a few worshipers could study it as carefully as if it had been a sort of miniature cut out of a Book of Hours and put into a gilt frame.

The wonder is that Rubens had the vitality to fill all those miles upon miles of canvas with paint and yet do as good a job as he did. Once upon a time when I was a little younger than now and therefore still addicted to the "believe it or not" habit, I took a piece of paper and by dividing the number of Rubens' pictures that have survived

by the forty-two years during which he painted as an independent master, I came to the astonishing conclusion that he had finished a picture once every twenty days. Even when we remember that most of the groundwork was done by his pupils, there still remain the necessary finishing touches and in the case of his gigantic canvases those finishing touches must have caused him quite as much labor as painting half a dozen small portraits.

But he was a Fleming. Like most of the people of that race, he had a healthy appetite for life. And such an appetite usually goes together with a tremendous capacity for work. The musicians have an expression, *con brio*. It means that something should be played with fire or with noise, if you follow the literal translation, and Beethoven used it in many of his sonatas as Tchaikovsky was afterwards to do in several of his symphonies.

That was the way Rubens painted—with fire. Take a brush and let her go! It is not a method I would advise to beginners or to inexperienced players or painters. But if they have a technique that makes them independent from a conscious consideration of what they are doing, the *con brio* tempo is a delightful variation from the monotony of everyday life.

There were other *con brio* painters. Frans Hals was one. Rembrandt occasionally. Goya, too, on a few occasions. Rubens was one of the few men who seemed to be able to keep it up forever. And that has given his pictures a quality that sets them sharply apart from the work of most other men. They live. At times they even live violently.

Rubens had an interesting career. He just escaped being born in jail and, as a matter of fact, his elder brother was actually born in prison. It is a complicated story.

The elder Rubens, one of the leaders of the Calvinistic party in his native city of Antwerp, was obliged to flee to Germany when the Catholics regained power. He settled down in Cologne and there became legal counselor and financial adviser to Anne of Saxony, the estranged wife of William the Silent—and crazy as a loon. Local gossip combined the names of this Flemish commoner and the daughter of the Elector of Saxony. In the year 1568 that sort of thing meant trouble and Rubens Senior was arrested by the local authorities and condemned to death. But his wife, a very superior type of woman, immediately joined him and asked to be allowed to share his imprisonment. This step undoubtedly saved his life. Eventually the whole family was allowed to go and live in Siegen, a small German town which belonged to the House of Nassau.

There the older Rubens lived until he died in the year 1587. Where-upon his wife, having returned to the Catholic faith, went back to Antwerp together with her four children. At that moment Pieter Paulus was ten years of age. Through his mother's family (she was born Maria Pypelincx) he got a job as a page with a noble family. But he wanted to paint and they sent him to the studio of a certain Adam van Noort, a man of considerable local reputation.

In the year 1598, Pieter Paulus successfully qualified as a master painter and a member in good standing of the guild of St. Luke. After that he rose rapidly from one honor to the next. For he was a *grand seigneur*. He had the looks and the manners and the bearing of a very great gentleman and upon several occasions when it was necessary to trust someone with a delicate diplomatic mission it was this hand-some young painter who was chosen to act as head of the delegation. It was a very intelligent arrangement and a very lucrative one for the artist. For instead of boring the potentates he visited with dull mem-oranda and other official documents, he offered to paint their por-traits and while they sat for him he could talk business. If his clients were satisfied they paid him well for his services. As a rule they were so charmed by his manner (for those were the days when "manner" still counted for much more than mere "manners") that they were apt to grant him everything he asked for. Ever afterwards they re-membered him. When we read that between 1637 and 1638 a hun-dred of his largest canvases were shipped from Antwerp to Madrid, we realize what it then meant to find favor with the head of the state.

All this made him a rich man but never did he become careless or slipshod. Whatever left his studio was finished and the quality of his work remained on a par with the quantity.

As for the man's own life, it was a happy one like that of most of his fellow Flemings. None of the deep introspective doubts that have al-ways been the curse of the people of the northern half of the Low Countries. A big house full of beautiful things. Two wives (the first one died quite young) both of whom he loved without any misgivings, as you can see by looking at the portraits he painted of them, espe-cially of the second one. And friends and neighbors who appreciated what he was doing and told him he was a great fellow and would go far.

Some wonderful things have come out of attics and out of fifth-floor rooms, the rent of which has not been paid for the last three years. And some wonderful things have come out of ateliers filled with the spoils of three continents. The moral is: You either can do it or you

can't and your surroundings are about as important as the paper you use when you sketch or whether you sit or stand while painting.

And now for one more great master of the Belgian school—Anthony van Dyck. Born in Antwerp, after many years of wandering in Italy he left his native country for good at the age of thirty-three and spent the remaining part of his life in London where he died in 1641, only forty-one years old.

The reason for this departure was the usual one—a better chance to make a living abroad than at home. The victory of Holland over Spain closed the harbor of Antwerp by making the mouth of the Scheldt a Dutch river. Antwerp was still a most noble city but grass was already beginning to grow in its erstwhile busy streets. At that moment the King of England offered Seigneur van Dyck a patent of nobility and an annual pension of two hundred pounds if he would become the official court painter. Van Dyck accepted, and why not? Even in his student days, the handsome youngster, the seventh of the twelve children of a not very rich merchant, had been known among his cronies as the "Sinjoor," the *grand seigneur*, on account of his beautiful manners and his luxurious tastes. He was not very strong, had trouble with his lungs. He could never hope to equal such men as Rubens in mere output and so he took the easiest way out and went to England and began a new career in the pleasant islands across the North Sea.

On the whole, a very wise choice. The English, not spoiled in the matter of painting (having produced very few good painters until then), were delighted with this newcomer. His excellent manners appealed to their love of good form. There was nothing grubby about him. He invited his clients to dinner so that he might the more carefully observe their idiosyncrasies over a glass of good port. He did not keep them sitting endlessly in uncomfortable chairs as so many of those other foreign artists did. Instead, as soon as he had finished the face, he let his client go. A professional model could then afterwards pose for the hands, a method which accounts for the unfortunate fact that in so many of Van Dyck's pictures the hands fail to fit the face. That a person's hands are apt to be even more of an indication of his character than his face was something these noble customers had probably never noticed. Why should Van Dyck have told them? They were satisfied. He saved himself a lot of time and trouble. Now if he had been Rembrandt! But he was not. He was Anthony van Dyck. He was received by all the best families. He had a title. He made his home in what in Belgium would have been called a palace. He mar-

ried the daughter of a lord. Is it any wonder that the rumor of his good luck soon spread abroad and that hungry artists from all over the world hurried to the fleshpots of the Blessed Isles on the other side of the English Channel?

A few of them, like Pieter van der Vaes (afterwards known as Sir Peter Lely), the son of a Westphalian soldier but trained in Haarlem, succeeded very well and were eventually given immortality in Pepys' diary. Others did only fairly well, lacking Van Dyck's gift for the noble gesture and Lely's gift for the languorous look. Still others became mere hacks or turned to etching, an art at which, by the way, Van Dyck himself excelled. But every one of them helped to establish that very typical English school of painting, of which, almost a century later, Reynolds and Gainsborough and Constable and Turner were to be the most noteworthy exponents.

They were a motley crew, these gentlemen adventurers of the paintbrush. But they repaid their new employers handsomely for whatever they got. And so there were no regrets. It was an honest bargain, with both parties satisfied.

# The Dutch School of Painting

*A strange epidemic of pictorial exuberance affects an entire nation.*

AND NOW we cross an invisible frontier (for the southern and the northern halves of the Low Countries are in no way different from each other in a geographical sense) and move over into the Netherlands, which to the people of the seventeenth and eighteenth centuries were more commonly known by the name of their most important province, Holland.

There conditions were entirely different. During the first hundred years after the outbreak of the Reformation, it seemed that the northern provinces were doomed to perish. The odds against which they were fighting were too great. A million and a half people, including the women and children, against the whole might of the Spanish Empire was a very uneven battle. But in the end the Hollanders not only were able to hold their own but actually turned the tables on their enemies to such an extent that Spain never quite recovered from the blow.

The terrific energy necessary to accomplish such a stupendous victory could not suddenly be subdued the moment peace was signed. Carried forward by its own momentum, this "desire to achieve" manifested itself in almost every other phase of life. Almost overnight Holland was turned into an economic, intellectual, and artistic beehive with thousands of little bees merrily buzzing around and carrying all sorts of fresh spoils to the domestic apiary. And none was as busy as the painters.

What the reason was it would be hard to say. Perhaps it was the magnificent scenery of the country. Of course, if you associate the idea of "scenery" with mountains and fast running brooks, then Holland has no scenery. The country is a large pancake of mud, floating placidly on the waters of the North Sea. But it has a sky and it has water and out of these two you can, if you have the right kind of eye for that sort of thing, construct every desirable sort of scenery. Indeed, I would go so far as to say that the Low Countries are one of the few parts of the world where every window becomes the frame for a very definite and exceedingly paintable little landscape, while inside the

house that strange light that sweeps across a sky washed clean by everlasting rainstorms, has a clarity and harsh brightness which turns even the most ordinary articles of daily usage—a tin plate, a brass pail, a tile floor, a dead herring, a can of beer—into mysterious objects that lose their commonplace character and begin to vibrate with all the colors of the rainbow.

I have no idea why this should be so, for here in Connecticut we also have the sea and the sky, but oranges remain oranges and tin plates lose none of their tinnishness. Put those same oranges and that tin plate in the kitchen of my old house in Zeeland and suddenly they come to life. It may be the reflection of that immense body of water which surrounds the country on all sides. Then again, it may be the thin layer of moisture, which even on the hottest days in summer clings closely to pots and pans and man and beast and makes rheumatism one of the natural ailments of this dampish land. But it is there, and given a sufficiently large number of people able to see things and a sufficiently large number of people willing to pay for the permanent record of what the others have seen, it is bound to cause a veritable outbreak of painting fever.

And it did. In such a way that it is almost impossible to give you the names of all the men who rose above mediocrity. During the whole of the seventeenth century the Dutch used to paint in very much the same way in which the Americans of the last hundred years used to invent things. I don't mean to imply that every American citizen of that period was another Edison or Henry Ford. Neither was every Hollander of the seventeenth century a Rembrandt or a Frans Hals. But the thing was in the air. Every village had its painter, as every American city of the nineteenth century had its mechanical genius who dreamed of some day giving the world a horseless carriage or a contraption that would fly.

And just like our mechanical putterers, the painters seem to have been much more interested in their jobs than in the money they might some day make out of them. Of course, if they should ever strike it rich—etc., etc. But most of them knew perfectly well that there wasn't a chance in a million of ever getting their money back. They went ahead just the same, because they were only happy while doing what they liked to do.

Under such circumstances it is almost impossible to divide these hundreds of artists into definite schools or to classify them according to their merit. Some had a great deal of talent and industry. Others had the talent without the industry. Still others had the industry with-

out much talent. But all of them, even the most mediocre, had one thing in common—they had learned their business and were experts in their own particular field. They might be lacking in imagination and in a certain superficial approach toward nobility which remained so characteristic of the Italian school until it finally disappeared for good. The choice of their subjects was often far from elevating. But the craftsmanship remained perfect. And it had to remain so because these Dutch painters worked for a very peculiar market.

Their customers were neither rich noblemen who wanted to embellish their palaces nor princes desirous of bestowing a costly gift upon a church. They were rich mercers (like that Six family which is now solely remembered because for a while it was allowed to be on friendly terms with Rembrandt) or rich wine merchants or wholesale dealers in wood or directors in some big colonial enterprise, spending their days among samples of cloves and nutmeg and pepper. When they wanted their portraits painted or when they decided to do something for that big open space on the wall of the sitting room, they bought their pictures as they would have bought their tables and chests and their kitchenware. They looked for quality and insisted upon getting their money's worth. As a result of this highly practical attitude on the part of the customers, the social status of most of the great Dutch masters was not much better than that of the greengrocer or fishmonger who sold them their cauliflower or that dead fish they needed in their still life.

Occasionally, when they had to deal with a Rembrandt, the son of a flour dealer in very moderate circumstances but with a mental attitude toward life of a *grand seigneur*, these penny-pinching patricians were inadequate to the situation. They never moved a finger to save him and quietly let him slip into bankruptcy, for that seemed the easiest way out. Yet somehow or other the arts did not fare badly under this arrangement although it was very hard on most of the artists. But it accomplished at least one good thing—it discouraged the rise of the second- and third-raters. You either knew your job or you got out. Sometimes, of course, conditions were so harsh that men like Hobbema and Hals were forced to stop painting altogether, and drifted into something else, going to the poorhouse, as Hals did, or taking a minor clerical job in the excise bureau of his home town, as Hobbema did, or hiring out as keeper of the city jail in Batavia, as Rembrandt's son-in-law afterwards did when he found that he could not make a living as a painter. But as a rule these men were too completely immersed in their work to surrender their palettes and their

etching presses. Regardless of the misery and penury in which many of them lived they continued to paint until, full of debts and gin, they were decorously conducted to their final resting place, at the expense of their guild brethren.

One or two examples, I think, will give you a fairly good cross section of the sort of lives these lusty fellows lived.

### Frans Hals

Frans Hals was one of the earliest of the great Dutch painters to make his appearance but, strictly speaking, he does not belong to the Dutch school at all. Like Teniers, Adriaen Brouwer, Rombout Verhulst, and a score of others usually identified with the Dutch school, Hals was really a native of Flanders. But again like these others, the victory of the Protestant and northern part of the Netherlands over the Catholic south forced him to emigrate; and he had gone north simply because there was a better market there for him than at home.

Hals, born in or near the year 1580, had some instruction in his native town of Antwerp before he moved to Haarlem. Then he studied with Karel van Mander, the Vasari of the Dutch school, the man who has left us a book in which he describes all his famous contemporaries of the easel and the brush. And after he had learned his trade, he let it be known that he was ready to take orders as a portrait painter.

A great deal of his work can still be seen right where it was made and therefore under the most favorable circumstances, just like the pictures of Velasquez. But what a difference between the careers of these two men! Velasquez spending his days at court, being treated like an equal by the sovereign who ruled supreme over millions of little brown, black, and copper-colored subjects, but whose palace was surrounded by almost as many beggars as flies. On the other hand, poor Hals, who after a lifetime of hard work, found himself at the age of seventy-two obliged to sell out to his creditors and being on that occasion possessed (according to reliable contemporary documents) of one table, one chest of drawers, three mattresses, and a few old blankets. Velasquez painting frail and delicate-looking royal children and Hals painting honest rotarians, bursting with health and life and cheerfully considering how, come next spring, they could get thirty per cent on their money invested in their colonial possessions instead of the usual twenty. But to give the Devil his due, these honest burghers of Haarlem were dealing with a very different sort of man. Hals most certainly was no Spanish hidalgo. If his friends, one and all, had suddenly decided to descend upon his studio to pull a party, all of the ten

little Halses would immediately have been dispatched to rush the growler and keep the whole assembly happily provided with beer bought at practically no expense as most likely it would never be paid for. That sort of thing did not go over very well in a country in which the nonpayment of one's bills on the first of each month was considered a much more serious crime than mere murder or arson. Nevertheless their High and Mightinesses, the Burgomaster and Aldermen, could on occasion be quite magnanimous. So when at the age of seventy-two Hals was left completely destitute, they provided him with his rent and his heat and on his eighty-fourth birthday they made him the recipient of an annual civic pension of not less than two hundred guilders. For this the old fellow was duly grateful.

If ever you visit (as I hope you will be able to do) Holland, you need not bother so much about those gigantic canvases on which, in his usual masterly fashion, young Frans (then only in his forties, fifties, and sixties) depicted the officers of the local boards of militia-men and sundry other groups of notables, but please spend an entire afternoon in that delightful and noble mansion which the good burghers of Haarlem had erected as a home for the aged. And when you sit in the utter stillness of those two small rooms that contain the final work of this very great master, you will contemplate something that is little short of the miraculous. Those honorable old ladies and gentlemen who composed the boards of regents of the "God's house" (as hospitals are called even today)—they might at any moment close the account books on which they have been engaged trying to locate that lost half-penny and walk out of their frames to go home and see that the cook had not used too much sugar for the evening's pudding of bread and raisins.

For surely it will be difficult to find other pictures as incredibly alive as these "regent pieces" painted by a man who at that time, if you please, was eighty-four years old! Look at the hands, look at the gloves, look at the lace collars of these old women. They are common-place, everyday articles of wear, but here they have been painted with a *brio* that makes them burst forth in a song of color as cheerfully triumphant over mere material considerations as that final paean of praise in the Ninth Symphony which Beethoven (another son of a man born in Antwerp) wrote in the days when he must have known that death was now merely a question of months or, at the most, a few years.

Most marvelous of all, this effect is not brought about by the rich-ness of the old man's palette, for at the time he painted these pictures,

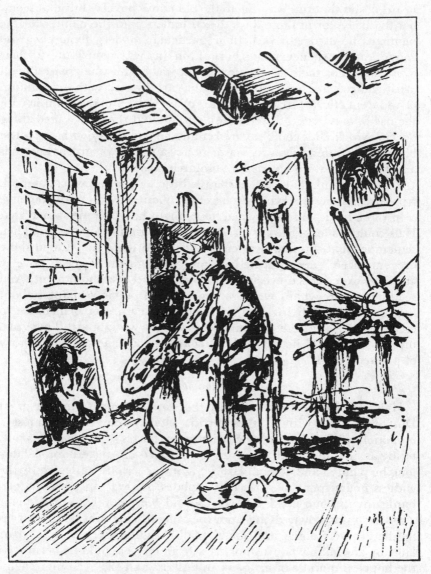

REMBRANDT

Hals suggested his colors rather than actually painted them. I have heard it said that this was due to the old man's poverty but that seems hardly likely, for in those days the customers paid the painter for the pigments he used and with these particular models, money was no consideration whenever money could in any way contribute to their own comfort or their own sense of what was fit. But the greatest of all artistic effects are invariably those that are created with a minimum of apparent effort. If Bach or Mozart could write immortal music with the use of only half a dozen notes, why should they have used three dozen? And if Hals could say everything he had to say with just a few blacks and whites, then why waste money and time on greens and reds and blues that were not really absolutely necessary?

You may think that I am perhaps a little too enthusiastic. After all, a picture is a picture. Why get so excited about it? Wait until you have seen those final paintings, when his eyesight had become so bad that Hals could no longer draw his figures in the right proportions. Then remember that this man was eighty years old when he painted these "regent pieces" and that he had gone through the bitterest poverty and had experienced every sort of sorrow and disappointment. And read once more what I wrote somewhere in a previous chapter about that sheer joy of living and that intense pleasure of being able to create, which is at the bottom of every great work of art. These pictures of Hals' will better explain what I mean than a whole library of printed books.

### Rembrandt

Hals died in the year 1666. At that same moment another great Dutchman, but without that terrific vitality that seems almost a monopoly of the Flemish race (whether in horses or in men) was puttering around in a small house on the outskirts of Amsterdam. All day long he painted and etched. His eyesight was seriously affected by the endless hours spent over his copperplates. He was an undischarged bankrupt and had no idea how he would ever be able to provide for a son who was slowly dying from the same disease that had killed his mother (tuberculosis) and for a small daughter born to him years later by a woman who was not his wife and never could be because of the hopeless muddle of his bankrupt affairs and the even more helpless puzzle as to what had become of the money the first wife had left to her son.

This man whose self-portrait (a mere scrawl on a piece of paper) shows how completely he remained the plain, ordinary middle-class

Dutchman even in the days of his affluence, was born in the city of Leyden, at that time the chief manufacturing city of the old Dutch Republic. There were still a great many people alive who had passed through that famous siege when the Dutch cut the dikes and turned an entire countryside into an artificial lake that they might man their ships against the armed camps of the Spaniards.

About his own immediate ancestors we know very little. They were just ordinary middle-class folk engaged in the flour business, grinding their own grain in a mill situated on the city's walls. Rembrandt had several brothers and sisters. None of them ever rose above a complete mediocrity. Most other great artists have had some link, however remote, that seems to connect them with greatness. The Bachs, the Beethovens, the Mozarts had fathers or grandfathers or uncles who were men of a certain ability. They themselves then represented the full flowering of the family's genius. A majority of the painters were the sons of jewelers or goldsmiths or were born into households where something else was occasionally discussed besides the prospects of next year's crops or the price of fish at the local fish market. But the enthusiasts for conditioning, who see every person as the result of his early environment, will have a hard time dealing with little Rembrandt Harmenszoon van Rijn. That "van Rijn" was added afterwards because the family mill stood on the banks of the "old Rhine," which in the days of the Romans had there lost itself in the North Sea.

When Rembrandt was born the family was doing fairly well. Since he seemed the brightest member of the flock, it was decided to give him an academic education. He was duly enrolled as a student in that university which had been given to the city as a reward for its heroic resistance against the Spaniards. But he showed little inclination for a career as a lawyer and so afterwards we find him learning the painter's trade in the studio of a certain Swanenburch, a local luminary who was held in great respect as he had actually studied in Italy. He remained with Swanenburch for three years. Then six months with Pieter Lastman and back again to Leyden.

The young man, whose ability was generally recognized, was offered a postgraduate course in Italy. He declined with thanks. He saw no reason, so he wrote to his patron, why a good painter could not learn everything he should know right at home. Traveling merely meant a loss of valuable time, so why travel? As a matter of fact, with the exception of a single trip across the Zuyder Zee when he went to Friesland to get married, and a walking tour to the near-by city of Utrecht (you can do it in a car in about an hour), Rembrandt never

stirred from the immediate surroundings of Amsterdam. He went to live there in the year 1631. He died there in the year 1669. He was also buried there but when his grave was opened half a century ago, it was found to be empty. Like Mozart, he seems to have preferred the same anonymity in death that had been his share so many years of his life.

I am careful, however, to say "during so many years of his life." For it would be entirely wrong were I to create the impression that Rembrandt never experienced a period of fame and considerable glory. During the first ten years of his career in Amsterdam he was the most popular and the most fashionable painter of a city which not only knew what it liked but which could afford to pay and to pay generously for whatever struck its fancy, whether it was Jacob van Kampen's new town hall (which cost the town almost nine million guilders) or a piece of real estate at the mouth of the Hudson River which they got for considerably less money.

But this attitude of "we know what we like and we will pay you handsomely if we like your stuff well enough to buy it" is no unmixed blessing for the artist. For it makes the man who holds the purse strings the final and sole arbiter in matters pertaining to something about which, as a rule, he understands nothing at all.

Rembrandt was to learn this from sad experience. As long as he was willing to paint his fashionable neighbors in a way which flattered their pride, he had more money than he could possibly handle. But the moment he reached the point at which such compositions began to bore him, when he began to paint his customers as they actually looked and not as they hoped that they might possibly look, he found himself without clients. They went to his neighbors who were not quite as "self-willed," as they called it, or "independent," as he called it. That was disappointment number one. But there was a disappointment number two which contributed even more to his downfall.

Rembrandt had fallen in love with a girl. She was a nice girl and we can even call her a very pretty girl, but his friends could have told him that marriage with her was not going to make his career any the easier. In the first place, she came of unhealthy stock and tuberculosis in that damp country (then, at least) was the equivalent of a sentence of death. In the second place, she belonged to a family that had seen better days, that had managed to maintain some sort of social position because of those better days, but that was now rapidly losing its grasp upon life.

A simple, middle-class boy like young Rembrandt was no match

for these pseudo aristocrats. The brothers and cousins of his lovely bride borrowed his hard-earned guilders for commercial ventures of their own that were failures in advance. And poor Rembrandt, probably very much impressed by the social superiority of his in-laws, now did what many a brighter lad has done under similar circumstances —he began to show off. He bought a house that was much too expensive for him. But he was the rich and fashionable painter of the richest town in Europe. To borrow money was the easiest thing in the world for one who not only was known to get more money for his pictures than anybody else had ever done but whose wife, furthermore, was said to have inherited forty thousand guilders from her father. Of course, thus far she had not yet got a penny. But the moment the estate was settled, she would have it—every cent of it!

Alas, when the estate was settled, there were no forty thousand guilders or even four thousand guilders. There was a lot of land, but land just then was not worth a stiver. Land never seems to be worth a stiver when you are trying to sell it! But in a short while it would undoubtedly increase in price. And Rembrandt, riding on top of the wave, went on a veritable buying spree—pictures and etchings and lovely Persian rugs and china—everything that appealed to him for its fabric and color. And he continued to dress his bride up in jewels and silks as if she were really a great lady instead of a shy little girl from a small provincial town where her father had been a magistrate, and therefore a man of great importance. In his dream of grandeur he would even disguise himself, the miller's son, as a fine nobleman who toasted his beautiful bride with a beaker of Rhenish wine (champagne, which of course it should have been, had not yet been invented) and who defied the world to show him a lovelier creature than that girl whom he so proudly called his wife.

The neighbors, of course, shook their heads and said that all this could not possibly last. They were right, as neighbors so often are under such circumstances. In the year 1642 Rembrandt was asked to paint a portrait of the officers of the militia company of Captain Banning Cock. Instead of grouping them around a festive table (the flashlight banquet of the seventeenth century), Rembrandt showed them as they left their armory at noon, bound for service on the city walls. This gave him a chance to show his virtuosity in handling lights and shadows, for the sun, then at its highest, would of course act as a spotlight, brilliantly illuminating those officers who had already left the premises while those who were still protected by the wide gateway moved around in a haze of darkness.

The picture survives. Not in its original shape. It was too large for the hall for which it had been intended and these excellent warriors therefore cut part of it off and burned it. They did not consult the artist and as a result of this vandalism what remained of the picture was thrown entirely out of gear. Then they hung it in a hall that was kept warm by means of a large open peat fire. The smoke of the peat covered the entire picture with a heavy layer of soot until it grew so dark that the people of the eighteenth century believed it to be a sortie in the dark. Hence the curious name of *The Night Watch* for a picture that was painted at high noon.

Today that picture hangs in a room all by itself. It seems to be vibrating with life as the bodies of Rembrandt's nudes seem to show the blood that runs through the veins just underneath the skin.

Rembrandt never told us what he meant and I doubt whether he was familiar with the word *chiaroscuro* which so often reappears in our art histories. Originally *chiaroscuro* (a strange word meaning light and dark, a sister word to pianoforte which means loud and soft) was a term which had to do with woodcuts. Some parts of the picture were printed from very dark blacks while others were printed from very light blacks to give the finished product a pleasant tone of contrasting lights and shades. Ever since the days of Leonardo da Vinci, *chiaroscuro* had referred to the way the painter had handled those atmospheric effects which allowed him to create the illusion that his subjects were on every side surrounded by space. In most medieval pictures the figures are too flat to please us. They seem to be glued to the background. After Leonardo, every artist did his best to pry his figures loose from that background and to let them stand "free" with space on all sides of them like an actor on the stage (provided he has a good stage manager who shows him how to do it).

Rembrandt was a past master at this sort of thing. In the case of *The Night Watch* you feel that you yourself could walk right into the picture and pass between the man with the flag and the little girl with her mysterious rooster without touching either. It is magnificent. That is to say, it is magnificent to us who have learned how to see such things. It was not at all magnificent to Rembrandt's patrons. They knew that although they had paid an equal share in having this picture painted, some of them seemed to have been pushed right into the foreground, while others (whose money was just as good) were hardly shown at all. These disgruntled citizens raised the cry of "No taxation without representation!" and they refused to pay.

The incident led to a lot of talk. It completely ruined Rembrandt's

chances to get any further orders for such mass portraits. In the midst of these unseemly quarrels, his wife Saskia died, a short time after she had presented Rembrandt with a son. She was deeply devoted to her swashbuckling husband and to show her affection and to give evidence of her complete faith in his honesty, she left Rembrandt as her sole executor in charge of the money that was to go to her son. It was Rembrandt's undoing. Left to himself he had to hire a nurse to look after his small son. Like the Japanese Hokusai he was "crazy with painting." If he happened to be interested in what he was doing, he would spend weeks at a time in his workshop, never taking his clothes off, having his food brought to him, now and then catching a few hours of sleep on a sofa. He finally found a young woman of honest peasant stock, unable to write her own name but able, in some primitive sort of way, to feel what was needed of her. She became Rembrandt's cook, housekeeper, nursemaid, model, but one day, to the horror of all the cooks, housekeepers, and nursemaids decently married to their employers, she became the mother of Rembrandt's child.

Amsterdam was horrified and delighted. "The woman caught in adultery"—the subject these painters so dearly loved to depict—had suddenly come to life. It was very exciting but not to be tolerated in a world of respectable Calvinist dominies. Hendrickje Stoffels was officially denounced from every pulpit in town. Then the storm broke, for now it was certain that Rembrandt would never have another customer.

The creditors, the usurers with promissory notes, the holders of first, second, and third mortgages swooped down upon their victim and in the year 1657 the house of the mighty Rembrandt, who thought that he could paint so much better than anybody else, was sold for debt, the furniture was sold, the paintings and etchings were sold. Everything that could possibly remind him of the days of his glory, when Saskia had been there to share his fame, was sold. The painter and his son Titus and Hendrickje Stoffels and her small daughter Cornelia moved to a cheap little house in one of the suburbs and there, living on borrowed money (for even Rembrandt's clothes and shirts and Hendrickje's pots and pans had gone under the hammer), they tried to begin all over again.

Rembrandt had now reached that important third chapter in his career which, if the sufferer has strength enough to survive his misfortunes, is apt to play such a very important role in the life of almost every great artist.

In the first chapter he is finding himself. The world is full of a num-

ber of things and there is nothing he cannot hope to attain. The second chapter brings him to the height of his fame. He is successful and triumphantly he cries, "Fate, I defy you! Now show me what you can do!" There is nothing Fate likes quite so much as that boastful dare and there are an awful lot of things Fate can do to any of us unless we are constantly on our guard. And so, one fine day, the blow strikes home and is apt to strike with such unexpected violence that the poor victim is knocked groggy, loses his bearings, and very often is unable to get back to his feet. But if he does, he has gained something that he could not hope to acquire in any other way. For now his bluff has been called. He has learned to see his success at its true value. From that moment on, stripped of all shame and pretense, he will do the greatest work of his career, for now there is only one person he has got to please—himself.

In that way the third and final chapter of Rembrandt's life came to its logical and glorious conclusion. The pictures he painted during the last twelve years of his life, the etchings he continued to make almost up to the hour of his death, have a spiritual quality which none of his former work had. Rembrandt was not a religious man in the sixteenth-century sense of the word. He did not go to church. He joined no sect. But the poor, the disinherited, the lame, the halt, and the blind, of which this country was still so full after almost eighty years of uninterrupted warfare—they became the faithful companions of his pencil and his brush. To give them a suitable background, to make them fit into the scheme of things of the world of his day, he clothed them in Biblical garb, bestowing upon them the dignity of those figures from the Old and the New Testament with which he had been familiar since the earliest days of his Leyden childhood. But even his occasional portraits show the change that had come over him. There were only a few orders now. The group portrait of the syndics of the clothmakers' guild, painted five years before the Master's death, was one of those few. It failed to satisfy his clients. It was queer. It did not look as if it had been "decently posed" and one had a right to expect that in so expensive a picture. Like *The Night Watch* it was allowed to gather dust until in our own day it was restored to life, and we could once more understand what Rembrandt had tried to tell us—the story of five honest drapers seated around a table and completely satisfied with a world in which nobody asked anything of them except that they should be honest drapers.

Thereafter, for lack of models, Rembrandt got into the habit of painting either himself or his daughter or his son or his wife. Most of

those pictures have survived. I don't know why. They were about the last sort of paintings his contemporaries would have cared for. I rather suspect they were a little afraid of them. That would not have been the first time such a thing had happened. There are pictures and statues and there is a sort of music that have so much personality that almost everybody feels a little uncomfortable in their presence, and these pictures had an inner quality which nobody before or since could create in quite that way by means of just a little paint and a piece of canvas. It is sometimes called the "Rembrandt light" and not infrequently it is described as an invention of the Master—some sort of clever technical trick. It is hardly that, although afterwards he reduced his light to a formula which was so simple that nobody has ever been able to copy it.

What was the secret of his famous formula? Merely the realization, suspected before by others but never yet put into execution, that darkness is merely another form of light and that every color is just as much subject to the law of vibrations as the sound of a note played on a violin. One of the last pictures he painted, a portrait of his son and his bride (erroneously called *The Jewish Bride*) which you can see in Amsterdam, is the final word he spoke upon this subject. It is no longer a painting. It has become liquid light.

And now for a few more names, names chosen at random, for the story of their works would fill many volumes. Not so the stories of their lives. Except for a few, like Gerard Ter Borch, who died a member of the Deventer town council (and who had been to Madrid and had seen the work of Velasquez and had actually been received by King Philip IV), they were merely craftsmen who were supposed to do an everyday job like a good carpenter or plumber. They no longer were obliged to join the wooden-shoemakers' guild, as had happened in the earlier days when as yet they had not been of a sufficient number to found a guild of their own. But few of them ever reached greater affluence or achieved a higher social position than that of a master blacksmith or master bricklayer. Their output, however, was large and of a consistently high quality.

There was, for example, Vermeer, the famous Vermeer of Delft, whose pictures are as lucid and clear as the music of Johann Sebastian Bach. When he died his widow, facing bankruptcy, tried to dispose of the twenty-six pictures that were still standing unsold in her husband's studio. The receiver in this case was a certain Anthony van Leeuwenhoek, another citizen of Delft and famous as inventor of the

microscope. But even this distinguished scientist and practical merchant could not persuade the creditors that they would be able to provide for their descendants by buying one of these canvases for a handful of guilders. In the end poor Jan Vermeer was so completely forgotten that during the next century his pictures were erroneously labeled as the work of Ter Borch or Rembrandt or Pieter de Hooch (another magician of interior light) or Gabriel Metsu, best known of the pupils of Ter Borch.

One of those who for a while at least fared pretty well was Bartholomew van der Helst. His militia pieces were greatly preferred over Rembrandt's *Night Watch*, and after Rembrandt's eclipse he became the fashionable portrait painter of all the rich Amsterdam merchants. Other painters whose work was much more popular than that of Rembrandt were Govert Flinck, a German who spent all his life in Amsterdam, and Nicolaes Maes, who together with Ferdinand Bol was one of the most successful of Rembrandt's pupils. Then there were Karel Fabritius, who died too young to have quite fulfilled the brilliant promise of his earlier years, and Gerard Dou, who tried to do what nobody has ever been able to do with complete success—to paint the effect of artificial light. And the irrepressible Jan Steen, an excellent technician and possessed of a Rabelaisian spirit which greatly pleased his contemporaries.

But few pictures of that period have a greater appeal for us than the landscapes. Many of these have almost become household gods in our parlors and dining rooms. There were Jacob van Ruysdael, who gave us his marvelous view of Haarlem, and Meindert Hobbema (the Hobbema of the famous trees) and Jan van der Heyde, a sort of Dutch Canaletto. The first three died in poverty. The last one, Jan van der Heyde, was more fortunate. He made quite a neat sum of money out of his invention of the fire engine. Incidentally, he was his own press agent, for he popularized his clumsy little contraption by a series of marvelous copperplates, drawn to show the advantage of the new fire-fighting machine over the clumsy methods used, until then, by the ancient and wasteful bucket brigades.

And, of course, in this country of water and sky, the seascapists did quite as well as the landscape specialists. Albert Cuyp and Jan van Goyen stuck closely to the shores of their native rivers. But the Van de Veldes (father and son and both of them called Willem) did their work on the high seas and they did it so well that their fame soon spread abroad and they were invited to come to England. Both Charles II and James II paid them each a regular annual salary of

one hundred pounds to draw pictures of those sea fights in which Their Majesties' ships were engaged and did not come out second-best.

Rembrandt died in the year 1669 and almost immediately afterwards the curtain began to descend upon this glorious chapter in the history of the art of painting. The Dutch school was coming to an end. For a short while Willem van Mieris, Adriaen van der Werff, and Karel du Jardin (a follower of Paulus Potter, the man of the famous bull—probably the best picture of an animal ever painted) carried on in the old traditional style. But the music had gone out of their work, as it is so aptly expressed in their own language. The divine spark was gone.

At first the fight for freedom had seemed so difficult that at times even men like William the Silent despaired of the final outcome. Then victory had been gained, but so unexpectedly bringing with it such a vast commercial expansion that nobody quite knew what to do with all this sudden wealth.

Following the path of least resistance, the younger generation felt no necessity of exerting itself. Their fathers and grandfathers had been at their best in their countinghouses, on the quarter-decks of their ships, in their studios, in some little godforsaken fortress on some distant island in the tropics where they were content to be what they were—plain, honest merchants, solid burghers with their two feet firmly on the ground, full of common horse sense but willing in a rough and ready fashion to live and let live and not ungenerous when their own interests were not too directly involved. Now their descendants bought themselves fine country estates, and their wives and daughters and sons tried to ape the lovely ladies and the handsome gentlemen whom they knew from the pictures of that elegant fellow, Sir Anthony van Dyck. When they had done all that, the results resembled those achieved by the Japanese or the Chinese of our own times when they endeavor to become the sort of ladies and gentlemen they have so enthusiastically observed in the pictures that come to them from Hollywood. Only in those days, Hollywood was called Versailles and all the roles of all the celluloid heroes were then played by a single man of exceptional histrionic ability.

His name was Louis and he was the fourteenth of his name to mount the throne of his ancestors.

# The Grand Siècle

*The arts, enrolled under the banner of the great King Louis of France,
help to bring about the final triumph of the principle of autocracy.*

OF THE GREAT LOUIS, most people seem only to remember that he
had a rather exaggerated notion of his own importance and
that by his personal extravagance he hastened the process of economic
deterioration which ended in that outbreak of violence the world
came to know as the French Revolution.

There was, however, considerably more to this gentleman than a
vast periwig, a pair of red-heeled slippers, and an air of sublime
elegance. Otherwise he would never have been able to accomplish
what he did when he made his own century, the so-called "grand
century," the school in which all of us who lay a certain claim to
civilization have learned our manners and our general way of living.

Louis was born in 1638.

He died in 1715.

And he occupied the throne for seventy-two consecutive years, a
record that has rarely been beaten, for even Queen Victoria, a close
runner-up and his exact counterpart in the influence she exercised
upon her environment, could boast of only sixty-four years of actual
government.

Of course, at the age of four, even a child as precocious as this
brilliant young monarch could hardly have been expected to take a
close personal interest in affairs of state. But as soon as he had reached
manhood, which in his case was at a very early age, he let it be known
that he intended to be his own master. Few sovereigns have ever lived
up to their early promises with such consummate skill and tenacity
of purpose.

It has been said (and it seems to me with a great deal of truth) that
the great things in life do not come to those who wait for them or to
those who deserve them, but to those who happen to be in their way.
For the consolation of all good moralists, I must add that those who
have prepared themselves carefully for a possible encounter with
Dame Fortune will probably make better use of their opportunities
than those who have left everything to chance. But to be on the prem-

ises just when the fickle Goddess passes a given spot at a given moment is still most important of all.

In the case of Louis XIV everything happened according to schedule. His father, Louis XIII, had been a man of weak character, more than willing to leave the management of his kingdom to his prime minister, the Cardinal de Richelieu. This exceedingly intelligent but completely unscrupulous dignitary had destroyed the power of the feudal nobility and had bestowed upon the French Crown such influence as no reigning dynasty had ever wielded before. After his death, his work was continued by Cardinal Mazarin. When Louis, at the age of twenty-three, became King in his own right, he found himself the ruler of a prosperous state, defended by an army that had never been beaten, administered by civil servants who were sincerely devoted to the Crown, and so well favored by nature that it was the envy of all its neighbors.

The nobility, after the great palace revolution of the Fronde, at last recognized that the cause of feudalism was lost and that all further hope for advancement now lay with the handsome young man whose smile meant a career and whose frown meant death. Not that Louis XIV was a particularly bloodthirsty tyrant. On the contrary, compared to his predecessors, he was a mild and amiable prince who sent few of his personal enemies to the scaffold. He had other means of realizing his ends. His public disapproval of one of his officials was sufficient to make that unfortunate victim take to his bed and die of a broken heart. And the others he gained over to his side by his personal charm.

For even his worst enemies were obliged to confess that His Majesty had a way with him. And history bears them out. Louis not only liked playing the part of the Grand Monarch but he brought to this role a talent of the first rank and a willingness to take pains which almost makes him deserve the rank of a genius. It is, of course, possible to argue that a genius for being a first-rate autocrat is not a desirable quality. From a purely democratic point of view, this is undoubtedly true. But the world of Louis XIV was not a democratic world. It was a world which believed, and believed most sincerely, in all those things that Louis represented. And as he represented them better than any of his contemporaries and much better than most of his ancestors, he was not merely feared but also honored and respected and almost until the end of his days was served with a devotion the like of which the world had rarely seen and which bordered closely upon an adulation rarely bestowed upon a mere human being.

A man who could so completely put his own stamp upon the political and social life of his day was, of course, to leave an equally important mark upon the arts with which he surrounded himself. For this particular monarch did not merely live in a palace with a few pictures on the walls and a few chairs and sofas standing here and there and perhaps a bust or two of his ancestors, all of them in the worst possible taste and inherited from his papa and mamma. Nor was he contented to sit through the musical soirees and the pantomimes his grand master of ceremonies arranged for him, that the guests might sober up sufficiently after an eighteen-course dinner to remember how much they had lost at baccarat or écarté.

None of that for handsome young Louis. He realized that he was the star performer in a tremendous drama which was called The State. The court was the stage on which the different scenes were enacted. The country at large was the pit in which the citizens were huddled together to partake of the festivities.

Now King Louis was an extraordinarily good showman. As such he realized that he could only hope to keep his audience by giving them their money's worth. They had to pay and they had to pay through the nose for the privilege of attending the spectacle. There was only one way to make the poor devils forget that fifty per cent of their income went for the upkeep of the royal mummers. Make them feel that the money was well spent and also make them feel that in a way they were part of the performance.

I know nothing about the art of play writing. It is a mystery to me and will always remain so. But the boys and girls who have a gift for that form of literature tell me that the most successful pieces are those in which the audience feels itself to be identical with the performers—those in which even the most average of average citizens can say unto himself, "Why, that very same thing might have happened to me if only I had had the chance, for I too would have behaved in exactly the same way that man in the brown coat did!"

The Parisian pastry cook who had only seen His Majesty once, and then at a distance of half a mile when His Majesty deigned to walk his pet poodle dog on the terrace of His Majesty's palace of Versailles, knew perfectly well that that was as near as he would ever come to the mighty potentate. But he could find consolation for his humble position in life in the thought, "If I had been the King, I would have walked my poodle dog with the same grace; I would have bowed to the gardener with the same condescending amiability; I would have answered with just as gracious a gesture to the plaudits of the multi-

tude." And the German princeling, invited to one of His Majesty's more exclusive entertainments (together with only two thousand other guests), would return to his father's *Schloss*, fully intent upon repeating the French King's example the moment his dear father should have been permanently removed to the ancestral vault. He would spend all the intervening years carefully preparing himself for the role of becoming another Grand Monarch, albeit on a little less expensive scale.

In short, the son of Louis XIII and Anne of Austria supplied a definite standard of perfection for the benefit of all the people who lived during the last fifty years of the seventeenth century and during the first fifteen of the eighteenth. And he did this so effectively that even we today are still greatly influenced by the example of the "grand century" and are still in many respects disciples of the great Sun King.

It was he who taught us how to live and in what sort of rooms. It was he who showed us how to eat and what and when. It was he who provided us with our code of manners. Our very ways of amusing ourselves—our theaters, our musical entertainments, our operas, our ballets—they can all of them be directly traced back to the court over which Louis XIV presided.

You probably would not have liked the plumbing at Versailles. You would have found it very difficult to keep clean with no further bathing facilities than a small washbasin and you would have been obliged to follow the example of your fellow courtiers, who hid diverse personal odors by means of those lovely perfumes, which have ever since been a specialty of His Majesty's erstwhile country. Neither would you have liked the eternal presence of a certain kind of fauna which has now been completely removed from our premises by our efficient exterminating companies, but which in the days of the Grand Monarch flourished so powerfully that people were obliged to keep their heads close-shaven and to wear wigs for fear that otherwise they might become walking insectaria.

And there would have been certain other aspects of the life at His Majesty's court which would not have appealed to you the least little bit. There was the hopeless overcrowding of the royal palace, which obliged even very high dignitaries to sleep somewhere in a little alcove underneath a staircase, separated from the rest of humanity by a silken curtain. There was the cold and the clamminess of these enormous barracks, situated right in the heart of a very marshy country. Even with all the fires burning full blast, it was not always possible

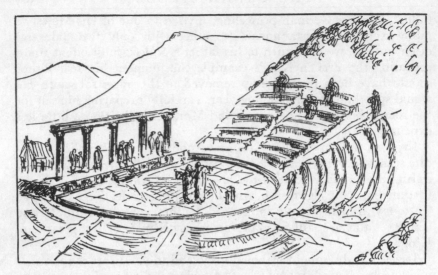

*The Greek theater was out in the open.*

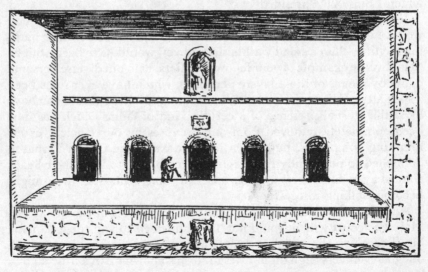

*The Romans placed a cover over the stage and the traditional Roman stage had five entrance gates in the rear.*

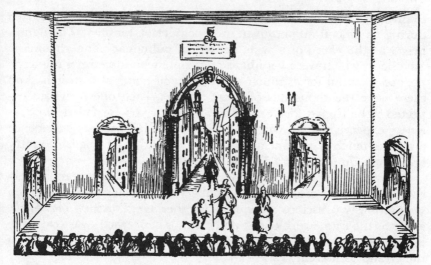

*In the sixteenth century that center entrance gate was greatly enlarged and showed the perspective of a street.*

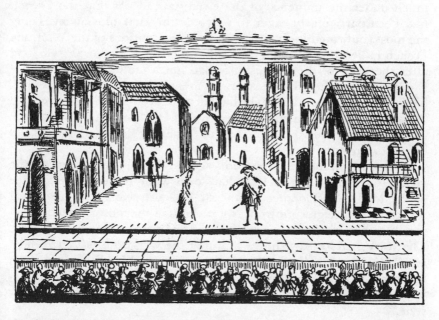

*Gradually that center entrance became larger and larger and the street it showed became more and more elaborate. Today that center entrance has become our stage and the perspective has developed into our modern scenery.*

to prevent the stewed fruit on His Majesty's table from getting frozen during an official dinner given in December or January. The dampness was the cause of a wide variety of pulmonary and rheumatic afflictions, which were very hard on people who sometimes might be obliged to stand for as much as six or seven hours at a stretch. And there were the thousands of court flunkies, each one of whom expected to be tipped for everything he did for you (or failed to do)—a very expensive detail which made a visit to His Majesty's residence almost as much of a financial trial as a week end at an English country house or a dinner with a Dutch family.

But except for these minor inconveniences and a certain stately rhythm of the life around you, I doubt whether you would have been very seriously conscious of living in another age. For the *Grand Siècle*, as far as the framework of our daily lives is concerned, was really the beginning of our modern era. In a way we are all of us still guests of the Grand Monarch.

At the time of King Louis' birth, the art of France was still very much under the influence of the Renaissance. Not that the French had been particularly eager to welcome this new movement. Being the most confirmed individualists among the nations of the West, the French patiently continued to build in their own medieval style long after the ideas of the Renaissance had got a foothold in the rest of Europe. But although the average Frenchman never left his own bailiwick unless he absolutely had to and even when he moved to Paris stuck closely to a colony of fellow citizens from his own province (which he still calls his own *pays* or "country"), the French kings began to stir about a bit.

During his infamous expedition against Naples and Rome in the year 1494, King Charles VIII had for a while occupied the palace of the Medici in Florence. Francis I had also learned a great deal about life in foreign countries. Not perhaps in the most agreeable way possible, but his long sojourn abroad as prisoner of the Emperor Charles V had at least shown him that the world did not end where one lost sight of the last church spires of Paris. By inviting such men as Bramante, Cellini, and Leonardo da Vinci to come to Fontainebleau and there work for him, he showed his preference for the new style.

This new style showed itself first of all in the architecture of the country. As the rise of the central power had made an end to the old feudal quarrels, it was no longer necessary to turn every private man-

sion into an armed camp. Walls and moats therefore began to disappear. The walls went first of all. The moats continued for a little longer, for it was useful to have a little water near to one's home. Friday was fish day. Many other days were fish days and in those leisurely moats the carp grew to the size of small crocodiles, as anyone who has ever visited Fontainebleau will remember.

Of course in certain other respects, the French palaces had to be different from their Italian counterparts. They needed pointed roofs to gather the rain water, which was the only safe source of water supply in those days. And they needed fireplaces and chimneys and, above all things, windows—just as many windows as possible, for in the winter the days were very short. But a few hours at such well-known châteaux as Blois and Chambord, Amboise or Chenonceaux, will show you the inconveniences from which the occupants must have suffered even there and which may well account for the terrific death rate among the women and children.

In our modern society the idea of "representation" has almost completely disappeared. The purpose, of course, was to "present" oneself and one's family and, above all things, one's own social position in the best possible light. As the idea of a fixed social position is entirely foreign to us (from shirt sleeves to shirt sleeves in three generations is our motto), it is difficult for the average American to understand how, until this very day, that strange ideal of representation has influenced all European life and art. Especially in the southern countries and in such cities as Rome and Madrid (if that city still stands when this book appears) whole families will pathetically starve themselves for generation after generation and will continue to shiver miserably in their high-vaulted rooms that they may maintain one vast reception hall, musty and cold and cheerless and used only three or four times a year, but necessary to impress the neighbors with the glories of their family tree which goes back to the days of Romulus and Remus.

In northern Europe that ancestral reception hall has shrunk down to the dimensions of the "best room" or the "parlor," that ghastly cubicle with its hideous and uncomfortable furniture and pictures of Grandpa and Grandma on the walls and artificial flowers from the Paris Exposition of 1889, which all modern architects have tried to destroy in vain as a menace to the health of the family. For it occupies space that should be lived in and instead of being used for that eminently sensible purpose, it forces whole families to live, cook, wash, and sleep in insufficient quarters. But the average middle-class family

of Europe would as soon think of surrendering this last stronghold of "respectability"—their right to be treated with esteem and respect—as an Englishman would dream of giving up his umbrella on a sunny day in Los Angeles. And I suspect that we shall continue to drag this survival of the sixteenth century with us for a good many years to come.

In one respect, at least, we are much better off. The automobile has taken the place of the horse. The French château had its stables right underneath the kitchens and the living quarters of the family. As all the world soon began to imitate the French example, this happy arrangement was introduced all over Europe. What the horseflies could do to man and food in an age that knew no screens of any sort, I shall have to leave to your imagination. But it was all in the day's work. People accepted it—and no wonder. Just as a hundred years hence, our grandchildren will wonder that we were contented to live in cities filled with evil-sounding noises and to drive along lovely country roads disfigured by hideous billboards.

The French Commune of 1871, which destroyed so many parts of old Paris, did away with several of the relics of this time, but the Louvre, which was the royal residence of the rulers of France until converted into a museum, the Hôtel des Invalides, and the Institut de France, which housed all the different French academies—they all of them still stand erect. And they show you the sort of official edifices that were being erected while the kings of France were trying to make their capital the show place of the civilized world. It meant lots of interesting problems for the architects of that period—for Perrault, who built the Louvre, for Le Vau, who was responsible for the Institut de France, and for Libéral Bruant, whose influence is noticed in all of these buildings.

Curiously enough, while the architects were doing such wonderful work, the painters showed very little originality. This may have been due to the affection the French bestowed upon their Gobelins, their tapestries. The Gobelin family, a famous dynasty of wool dyers from the city of Reims, had moved to Paris in the middle of the fifteenth century and had done very well for themselves. One of them especially, for he had discovered a new sort of scarlet, that scarlet that has always been the envy of all painters and dyers. In the early part of the sixteenth century, when the demand for tapestries to be used as wallpaper suddenly increased (on account of the new way of building, with larger living quarters), the enterprising Gobelin family opened a weaving establishment as an annex to their dyeing plant. They

made so much money that soon they were able to buy themselves high-sounding titles of nobility. After that they could not be expected to pay much attention to business and therefore their establishment was bought by the shrewd Colbert (financial dictator to King Louis XIV) and has survived until today as the French state factory of carpets.

I mentioned the enormous dimensions of the reception halls in the new type of castles and houses. They provided many new opportunities to the sculptors, as did the formal gardens which now became fashionable, in imitation of those of Rome. But they also were a great boon to the furniture makers who began to turn out very elaborate pieces of furniture, all of them very heavily gilded, all of them very expensive-looking, and about as useless as those malachite vases the imperial Russian family used to bestow upon its unsuspecting relatives in western Europe.

But to return to the painters. There were hardly any who were the equals of the Pugets and the Desjardins (born plain Van den Bogaert) who supplied their Majesties with the marble effigies of their ancestors.

Jean Cousin and François Clouet had painted portraits for the Valois. Their successors had been obliged to content themselves with Claude Lorrain and Nicholas Poussin, both of whom might just as well have been Italians in the way they looked at the world and painted their landscapes. And then, of course, there were the three Le Nain brothers, whose works it is so difficult to keep apart, but who were not very likely to find favor in the royal eyes, as they preferred to depict very drab and dreary peasant families instead of going in for dashing young cavaliers or beautiful ladies of the court.

It is true that French painting soon afterwards was to lead all the rest of the world. But before that could happen, the scene had to be set for their activities and it was being set just as fast as the royal contractors, working in Versailles with thirty-six thousand men and six thousand horses, could drain the near-by marshes, level the ground for the surrounding parks, and construct the necessary aqueducts (some ninety miles in length) which were to conduct the water from the river to His Majesty's fountains and waterworks.

As for the famous palace itself, nobody quite knows what it cost. The figures that are given are so fantastic that they mean nothing. The amount mentioned is a hundred million dollars or more. I once spent a whole month in the town of Versailles and during that time I tried to visit every nook and corner of the royal park. But at the end of that month, I would still discover entirely new spots, containing

open-air theaters or complicated arrangements of statues and orna-
mental benches and ancient fountains.

As for the interior, you will get some vague idea of its dimensions
when I tell you that under Louis XIV more than ten thousand people
used to inhabit this palace regularly. Yet all this splendor had begun
modestly enough. All the French kings had been great hunters. And
so Louis XIII had begun by building himself a small hunting lodge
right here in the heart of the forests. That was in 1624. Louis XIV,
being a perfect showman, soon discovered how beautifully this spot
lent itself to open-air parties of all sorts, to musical performances, and
to the new plays of his fantastic actor-manager-playwright, Monsieur
de Molière, who had begun his career as Jean Baptiste Poquelin, *valet
tapissier* to his Majesty, King Louis XIII. But it was not until several
years later—in 1668—that Louis XIV decided to leave Paris for good
and to establish himself definitely at a convenient but safe distance
from his turbulent capital.

Versailles, therefore, was intended not merely as a royal residence
but also as the seat of government of an entire kingdom, and above
all things as the fitting center for the greatest, the richest, the most
powerful, and the most glamorous monarchy of all times.

The artists heard of this. They also were informed that there was to
be no limit to the available funds. They hastily packed their meager
belongings and hastened to the fleshpots.

The central figure of this entire episode was a man whose name is
known to all of us because it survives in the expression of "a mansard
roof," a high and curved sort of roof which slopes up on all four sides
and each face of which has two slopes, the lower one being steeper
than the higher. The famous Mansard unfortunately was not the
actual inventor of this sort of roof. He merely revived it, for it had
always been very popular among his thrifty fellow Frenchmen who
used the generous attic space provided by this sort of construction to
provide sleeping quarters for their servants, *sans* air, *sans* sunlight, and
*sans* heat, but very economical.

Let me also add that contrary to the general impression, Mansard
was not the only architect responsible for the plans of the château of
Versailles. Like St. Peter's in Rome, Versailles took such a long time
to get finished that it was hardly reasonable to expect one man to live
long enough to do it all. Louis Le Vau, who had already done con-
siderable work on the Louvre, drew up the first plans which were ex-
pected to provide for several new buildings to be "suitably combined"
with those Louis XIII had already begun. Several other architects of

less importance also contributed a few ideas. But it was Mansard who drew up the plans for the chapel (he had then just finished the dome of the church of the Invalides) and for the famous Galérie des Glaces in which in the year 1871 Bismarck proclaimed the King of Prussia as German Emperor and in which in the year 1919 the Allies forced the Germans to sign the peace which put an end to that same Empire.

Mansard also completed the central part which served as the royal residence and he built the Grand Trianon, which was to serve as a place of refuge for Louis' second wife, a lady about whom I shall tell you something more in just a moment. The Petit Trianon, by the way, which is near by, was not erected until some seventy years later, and this in turn was used by Marie Antoinette whenever she wanted to get away from the maddening crowd at the Grand Trianon. If the French Revolution had not intervened, these French monarchs would probably have been obliged to climb a tree in their search for solitude!

But I am anticipating. We had only got as far as Jules Hardouin Mansard, who was born in 1646. His father was a painter and one of his father's uncles had also been a well-known architect who had built quite a number of churches and small country houses. As for young Jules, as soon as he reached the proper age, he was apprenticed to Libéral Bruant, the architect, among other things, of the Hôtel des Invalides. Somehow or other the young man then attracted the attention of the King, who ordered him to build a château for the Marquise de Montespan.

This lady was the mother of seven of the King's children and must have been a very intelligent woman, for when she resigned her rather singular position she not only got all of her daughters and sons legitimatized but she also obtained for herself a pension of half a million francs a year. This allowed her to continue to support such promising young artists as Racine and Corneille and that delightful Monsieur de La Fontaine, many of whose charming little fairy stories were written for her brood of princelings.

Incidentally, the education of the Montespan offspring was entrusted to an austere dame of high moral principles and a strong pillar of the church, a certain Françoise d'Aubigné, who had spent her childhood days in the island of Martinique, a trivial detail but which shows that Napoleon's Josephine was not the only American who played a role in French politics. Left behind without a penny after the death of her father, poor Françoise had been married to Paul Scarron, the most popular dramatist and wit of his time. As he was

twenty-five years older than his wife, Françoise soon afterwards found
herself a widow. But a pension from the King's mother allowed her
to continue her famous literary salon and, furthermore, she was se-
lected as governess of the King's children by Madame de Montespan.

For a while this was a very pleasant arrangement until the mother
discovered that the King was getting to be much more interested in
the governess than in her employer. This led to scenes and these
scenes ended in the usual way. The Marquise de Montespan dis-
appeared from the court and her place was taken by the widow
Scarron, who by this time had become the Marquise de Maintenon.

I am not telling you all this to revive an old scandal. I am merely
trying to make you see this world which provided us with one of the
most interesting chapters in the history of the arts.

Françoise d'Aubigné, as I said a moment ago, was a very pious
person and she was firmly determined to be the "good influence" in
the King's life. Even His Majesty's dull and drab Spanish wife, whom
he had been forced to marry for reasons of state, declared that the only
happy part of her life had been those years when Madame de Main-
tenon was the King's official mistress. And when the time came for
her to withdraw from a world that had not been very kind to her, she
died contentedly in the arms of the woman who was supposed to be
her rival.

Two years later the little Martinique girl had her reward for all her
loyal services. In such great secrecy that the actual documents have
never been discovered, Louis XIV married Françoise d'Aubigné and
during the next thirty years she was not only his wife but also his most
dependable adviser. Before a minister of state called on the King, he
invariably consulted Madame de Maintenon. As a rule, before the
King made a final decision upon any act of state, he first talked mat-
ters over with "the first lady-in-waiting of his royal daughter," which
was the title under which this unofficial queen lived at her own court.

However, titles did not interest her. Nor was she fond of outward
power. She had only one overpowering ambition. She wanted to
stand firmly for the decencies of life. She was as rigid in her condemna-
tion of immorality as good Queen Victoria herself. Realizing the hard
life of decent French girls who possessed no dowries, she established
a special school for them at St. Cyr, a few miles from Versailles. To
train these children in dramatics, Racine at her request wrote his
famous tragedies called *Esther* and *Athalie*. When they grew up she
looked after their interests with the same care she had bestowed upon
the children of Madame de Montespan.

She did not succeed in persuading the King to leave the crown to his illegitimate son, the Duc de Maine, who had inherited his father's ability. As a result, when Louis died the power fell into the hands of the completely worthless and dissolute Duc d'Orléans. But even he, one of the most accomplished scoundrels of an era that specialized in wickedness, had such a genuine admiration for this righteous old woman that he granted her full royal honors and a most liberal pension until, a few years after her husband, she died in her beloved school of St. Cyr. (This Napoleon, who had the usual Italian contempt for "educated women," suspended as soon as he became emperor and converted into that military academy which ever since has been supplying France with its officers.)

As for the excellent Mansard, who was responsible for so much of all this loveliness (and the parks of Versailles, especially in the fall, are of a surpassing beauty and charm)—he was quite an extraordinary fellow, a man of great parts, a terrific worker, and able apparently to do anything that came up in the course of ordinary business. His speed was enough to make most modern architects blush with shame. But then, he had only one employer and that employer, having decided that Mansard was the man best fitted for the job, left him alone and did not bother him with hundreds of questions, interruptions, and foolish suggestions. But even a Mansard could not do everything by himself. He therefore had a number of very capable assistants, not only for the buildings but especially for the parks. These therefore became the exclusive domain of André Le Nôtre, one of the most famous landscape architects of all time.

The ancients, who had lived an out-of-door life, had been very fond of their gardens, and even in the Mycenaean age the Greek kings surrounded their palaces with elaborately planned gardens. The Roman gardens of Hadrian's villa at Tivoli were one of the wonders of the old world, and the murals on the houses of Pompeii show clearly that gardens played just as great a role in the lives of the suburban Romans of that day as they do in the lives of our own suburban populations.

During the Middle Ages, when lack of personal safety forced people to remain inside the walls of their cities and castles, only the monks had cultivated a few gardens and then exclusively for the purpose of raising medicinal herbs. But that brilliant Persian civilization, which had shown the European barbarians of the crusading days once more how to live like human beings, caused a wide revival of gardening interest, especially among the Moors of Spain. Between the ninth and

fifteenth centuries they turned the whole of southern Spain into one vast park. From Spain this new interest moved to Italy. The gardens with which the rich merchants of the Renaissance surrounded their recently built country houses still show us how thoroughly the contemporary architects had learned the difficult art of establishing a perfect balance between that which nature had already created and that which man was obliged to modify according to his own needs.

When early during the sixteenth century it became known that the French monarchy was going in for rustic existence in a big way, many of the leading Italian landscape architects left for France. They in turn trained their French colleagues so that by the time the parks of Versailles were to be laid out, the work could be entirely entrusted to a number of Frenchmen. And the greatest of these was that André Le Nôtre whom I mentioned a moment ago.

Versailles was not the only job he did for the King. He also laid out the gardens at Fontainebleau and St. Germain and St. Cloud and did quite a lot of work for the electors of Hanover.

These seventeenth-century artists certainly were a hardy race of men. They disregarded all laws of hygiene. They ate the wrong things and drank the wrong things and worked sixteen hours a day and never took a holiday and yet, like Le Nôtre, were able to spend half a century in the service of one of the most exacting masters and die peacefully in their beds at the age of eighty or ninety.

Le Nôtre, like Mansard, could not do everything by himself. While laying out the plans for Versailles, which took him all of eleven years, he had over a hundred sculptors working day and night on the statues that were to be part of the waterworks and were to line the artificial ponds, among others the well-known *bassin* that was dug at the foot of the great staircase which led from the palace down to the gardens and which in a hazy day gives you the feeling that the park does not really come to an end but merely loses itself somewhere in space and goes on forever.

Louis XIV was a person of orderly mind but he had a habit of doing things on a grand scale which prevented him from becoming a martinet like Philip II of Spain or Francis Joseph of Austria. His preference for not leaving anything to chance also showed itself in his general attitude toward the arts.

There was already an institute which was supposed to watch over the purity of the French language. Why not have similar establishments to establish a few definite principles for the conduct of painters, sculptors, singers, dancers, and all the other craftsmen who labored

so industriously for the greater glory of France? The first one was erected in the year 1662 when the tapestry factory of the Gobelin family was converted into a royal furniture factory. A year later in 1663 the King founded a royal academy of painting and sculpture. Next came a subdivision which eventually was to develop into the well-known French academy of inscriptions. One year later again he founded the tapestry factory of Beauvais in northern France. Two years later he founded the French Academy of Rome, a subsidized French school in Italy where young French painters and sculptors could study the old masters in their original home. At the same time an academy of science was established in Paris. Four years later an academy of architecture was added to train young architects and engineers and road builders, and it was then that France began to be the one country in all Europe that had decent highways and reliable bridges.

Realizing that by establishing all these schools in his capital the rest of France was left without any schools that could look after the local needs, the King then drew up plans for a number of smaller academies of art in the different provinces. In 1672 there followed an academy of music. In 1674 His Majesty also played with the idea of an official school of dramatic art, but this was never realized. The unfortunate outcome of most of his foreign policies kept him too busy with other affairs. But all these schools and academies and institutes show the importance in which the arts were held as welcome and most useful allies in His Majesty's efforts to make the court of France the center of the civilized world.

And in this highly laudable ambition (from the point of view of France, at least), King Louis was entirely successful. As a politician he blundered badly. His attempts to put a French prince on the Spanish throne and to grab part of his father-in-law's inheritance (that father-in-law was Philip IV of Spain) got him into trouble with all the other European powers and although his generals repeatedly marched all their men up the hills of every possible sort of battlefield, they also invariably were obliged to march them down again and with very considerable losses. In the end it was these endless years of warfare rather than his building mania which so completely depleted his treasury that he had to call it a day and cease to add to his beloved Versailles. And when on the first of September of the year 1715 he died, he must have felt that as a statesman he had been a complete and thoroughgoing failure. But being far from dull he must have sus-

pected that he had other claims to fame. His ideal of the good life may have been an absurd one but he had lived up to it with every ounce of strength of his tough old body. In his youth he had set out to be a great king and he died as the one monarch who has never been surpassed for his intelligent benevolence to the arts.

# Monsieur de Molière Dies and Is Buried in Sacred Ground

*King Louis XIV makes playgoing once more fashionable.*

THE EMPEROR CONSTANTINE, one of the most despicable of all the Roman emperors, ruled alone from the year 325 until 337. During his reign two events took place which were to change the whole history of Europe. Rome ceased to be the capital of the empire, and Byzantium, or Constantinople as it was thereafter called, took its place. And officially Christianity became the favored religion of the empire.

The new creed at once set about to put its house in order. Every vestige of the old state of affairs was drastically suppressed. Since theatergoing had always been one of the most popular pastimes of the masses, it was one of the first to suffer the wrath of the new clerical authorities. All the civic theaters were closed and the actors forbidden under pain of death to practice their profession. As there was nothing else these poor devils could do, they were forced to go under cover and it is from that moment that the acting profession was degraded to a sort of bootleg trade of wandering vagabonds who strolled from village to village and from town to town, giving an occasional show in some hidden cellar or deserted barn whenever they were sure that the police would not raid the place and clap them in jail.

But so great was the love of the people for this sort of entertainment that all during the early centuries of the Middle Ages these unfortunate mimes were able to continue the traditions of an art that already had a history reaching back for more than a thousand years. And when the fury of victory had at last spent itself, the Church, too, began to recognize that in destroying the stage it had deprived itself of a form of public propaganda which under proper guidance might be of immense benefit in spreading some of those doctrines which the people at large were very slow to accept because they had never been quite able to understand them.

And so, as early as the tenth century of our era, we detect signs that the stage was slowly coming back, albeit in a form which was

very different from that which had flourished in the days of Sophocles and Plautus. This was especially true of England where pious nuns and monks now turned playwrights and by means of their little mystery plays made the churchgoers familiar with the lives of the saints and martyrs and gave them a glimpse of the miracles these holy men and women had performed during their stay on earth.

But on the Continent, too, the drama once more began to show signs of a new life. This did not mean that the professional actor was once more tolerated. He remained the poor, downtrodden zany, on a par with circus performers, trained dogs, and wandering fiddlers, for all the acting was now done by the priests themselves and the church was the scene of their activities. Gradually these performances became more and more elaborate until on Easter Sunday and on the Feast of Fools, which came in midwinter, complete shows were given, often interspersed with snatches of sacred songs.

In order that such entertainment might lose nothing of its unworldly character, the language used was Latin. But early during the eleventh century in France, Latin was dropped in favor of the native tongue and as the attendance at such performances increased from year to year, it was no longer possible to give them inside the church building. A low wooden stage was thereupon built just outside the church doors and there the priests went through their miracle plays and their so-called "moralities," an abbreviated sort of drama like the famous *Everyman*, given every year by Max Reinhardt in Salzburg—a play of Anglo-Dutch origin, wherein it is clearly shown that a life of holy works and saintly contemplation is greatly to be preferred to one of selfishness and sin.

Once more France took the lead in this new and interesting form of art. Just as the Provence in southern France had been the first to return to a crude form of musical entertainment, so did the whole country now welcome the reappearance of the professional actor as a respectable and useful member of the community. The clergy still exercised a definite supervision over all such performances but secular authors were once more allowed to write the plays, and university students and private citizens began to take the place of the priests who formerly had filled all the roles. Gradually these secular players gained such importance that they dared to compete with their clerical rivals. And when they noticed that an occasional bit of funny "business" mixed into the sacred text was sure to bring the house down with applause, they began to elaborate upon their nonsensical impersonations. Before anybody quite realized what had happened, the

French audiences were once more holding their sides while watching the farces enacted before their delighted eyes.

But it was in England and not in France that the religious play was eventually transformed into a regular drama, which no longer bore any resemblance to the old moralities. This apparently happened during the same period when the new music was being developed out of the old Gregorian chant. Both of these changes were undoubtedly caused by that new mentality which in turn was the result of the collapse of the medieval mode of thinking and living and of the rise of a commercial middle class, no longer dependent for its livelihood upon the good will of either the Church or the local landowners.

A certain John Heywood seems to have been the genius who did for the stage what Josquin des Prés had done for music. He set the drama free from the old religious restrictions. Borrowing heavily from his French predecessors, he no longer contented himself with the old and doleful stories about saints and martyrs but replaced them by ordinary men and women, such as one might meet at any time of day or night in the streets of one's own home town.

Meanwhile in Italy the general revival of interest in everything connected with the ancient world had also drawn people's attention to the existence of a vast body of theatrical literature that for more than a thousand years had lain hidden in the libraries of a few monasteries. Already during the first half of the fourteenth century a certain Albertino Mussato, a native of Padua, had used the stage as a means of warning his fellow Paduans against the attempts upon their liberties which they had to fear from the side of Can Grande della Scala, the friend and protector of Dante and a man of great power in the rival city of Verona. In this he was merely following the example of Petrarch and of Pope Pius II, who before he was elected to his high office was said to have dabbled a little in writing rather amusing comedies.

But just as within the realm of painting the highest technical skill was developed right at the beginning, so within the domain of the theater the greatest of all dramatists made his appearance immediately after this form of entertainment had once more been recognized as a legitimate branch of the arts. I refer, of course, to William Shakespeare.

Not that his immediate predecessors had been bunglers. On the contrary, several of them, like John Lyly and Christopher Marlowe and Thomas Kyd, were men of great ability. However, they were still conscious of living in a country in which an official act of Parlia-

ment declared all common players to be rogues and vagabonds and
not to be tolerated unless they were in the service of some lord.

Fortunately, many of the lords were enthusiastic lovers of a good
show and several of them had even gone so far as to combine forces
for the purpose of building a regular playhouse, the Shoreditch Thea-
ter, erected in the year 1576 and the predecessor of that famous Globe
Theater in which all of Master Shakespeare's own plays were after-
wards performed.

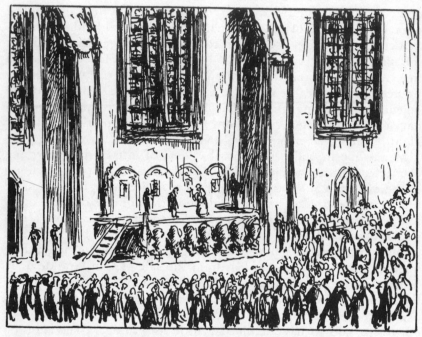

A MEDIEVAL STAGE-SET JUST OUTSIDE A CHURCH

Even so, the stage was still held in such profound disrepute that no
woman was allowed to become an actress. All the feminine parts had
to be played by young boys, a fact which may account for the many
roles in the plays of that day in which the heroine makes her appear-
ance disguised as a handsome young man.

Then came Shakespeare and it is to his everlasting credit that by
the sheer force of his genius he lifted both tragedy and comedy from
that low esteem in which they had been held ever since the fall of the
Roman Empire. He raised them to a point of perfection at which al-
most unconsciously they began to gain the admiration and good will

of everybody whose point of view had not been entirely warped by his religious prejudices.

But the men who once more made the mummer's profession truly "fashionable" were a triumvirate consisting of three Frenchmen, Corneille, Racine, and Molière; and the greatest of these was Molière. Not so much on account of what he wrote as on account of what he did for the dignity of his profession.

If today the art of the actor is among those most highly respected by the public at large, it is chiefly due to the untiring efforts of Molière and to the co-operation he received from Louis XIV. His Majesty, who was so fond of the stage that on occasions he did a bit of acting himself, knew the risks he ran in so openly espousing the cause of his mummers and as he realized his own shortcomings as a literary critic, Louis took unto himself a sort of unofficial guide, mentor, and friend who was to help him decide what was good and what was bad. This was Nicolas Boileau-Despréaux. Boileau started life as a lawyer but had gradually drifted into the risky business of being a writer of political satire. A suave and diplomatic gentleman, he was able to bring himself to the attention of the King, who appointed him his official historiographer. This undoubtedly saved the poor scribe a lot of trouble, just as the ennoblement of Velasquez by the King of Spain kept that great master out of the clutches of the Inquisition. For although no one less than Bossuet, the eloquent Bishop of Meaux, denounced him as an enemy of religion, Boileau at the wish of the King was made a member of the French Academy and was never disturbed by the police.

Now, while himself not a talent of the first rank, Boileau, as the King's unofficial adviser on all literary matters, was able to exercise an influence which on the whole was very helpful to his colleagues. Like all good Frenchmen, Boileau was a fellow with an orderly mind. All he asked of art was that it make sense, and I have heard of worse standards to be applied to painting and to plays and novels and even to music and the art of politics.

Supported at court by this powerful personage, Racine, Corneille, and Molière could then go ahead with a boldness impossible in any other part of the world. To a man of the caliber of Molière, one of the bitterest critics of his own time, this meant an opportunity few people before him had enjoyed. The Archbishop of Paris might be able to keep his *Tartuffe* from the boards for a year and a half, but in the end a hint from the King would get it performed and all of Paris could thereupon enjoy this most subtle attack on the deadly sin of hypocrisy. And when his next play, *Le Festin de pierre*, suffered a sim-

ilar fate, it was again the King who solved the difficulty by elevating
Molière's theatrical company to the rank of the official *troupe du roi*
and who lifted the burden of debt from his playwright's shoulders by
granting him a pension of six thousand livres. Even the doctors, as
sensitive and often quite as narrow-minded a group of people as any
other body of men, could do nothing to stop Molière's delightful (and
useful) attacks upon their profession.

This not being a handbook of literature, I cannot go into a detailed
discussion of all of Molière's works. But I do want to show how tre-
mendously helpful the co-operation of an intelligent despot can be
when an artist is trying to say something that is new and that there-
fore must come as a shock to ninety per cent of his fellow men. For
Molière with the King behind him could get things done. Did he need
incidental music, Monsieur Lulli was there to provide it. Did he need
more elaborate stage settings, Monsieur Le Brun, the famous interior
decorator of the Versailles palace, was at his disposal. Did he need a
collaborator to work out some details of a ballet, let Monsieur Cor-
neille attend to it. Did he need some neatly turned verses, send for
Monsieur de La Fontaine. But the most significant episode, to show
how the actor and playwright had risen in the esteem of the populace
because the man who dominated the scene held a protecting hand
over them, took place when Molière died.

Molière was not a strong man physically but even when sick, he
acted, for it would have been unfair, as he used to say, to throw fifty
people out of work just because he himself had a stomach-ache. But
on February 17th of the year 1673 even his most hilarious laughs were
unable to make the audience unaware of the pain he suffered. After
the performance he went home and died—quite suddenly and with-
out having partaken of the sacrament.

The Archbishop of Paris was therefore entirely within his rights
when he refused to let this unrepentant mime be buried according to
the rites of the Catholic Church. Molière's wife appealed to the King,
and the Archbishop was forced to give in.

It was a very simple funeral. Only two priests attended, no public
to speak of, and everything done very quietly after sundown. But all
the same an actor had at last been buried in consecrated ground!
And the next day all of Paris knew the great news—an actor, without
having first solemnly renounced his profession and having received
pardon for his sin of having been an actor and a playwright, had
been buried in consecrated ground!

For the King had so willed it.

# The Actor Makes His Reappearance

*Of the sort of theater in which His Majesty's mimes performed their plays*

THE OLD GREEK THEATER had been held in the open air. As play-going was the popular out-of-door sport of the Greeks and the Romans, all of southern Europe is covered with the ruins of such primitive theaters. They were often quite big. In Arles in southern France the local theater was so big that during the Middle Ages it was converted into an apartment house of such vast dimensions that it became a small, independent community.

Came the twilight of the ancient Gods and the theater faded out of existence. When plays were revived during the Middle Ages, they were really church affairs and as such were given inside the church building itself or (after the crowds had grown too large) on a wooden scaffold erected against the church walls.

All this was completely changed during the Renaissance. The church ceased to be a theater and new theater buildings, especially designed for that purpose, arose on all sides. In this case, the architects had something they could go by, for Vitruvius, among other things, had left them detailed descriptions of the old playhouses. All they had to do was to follow these. But one thing had changed. The modern theater had to be indoors. The audience could continue to sit in their circular rows of seats, but the stage now became a square platform as wide as the building itself.

No scenery, in the modern sense of the word, had as yet been invented. The wall behind the stage also served as a backdrop. It therefore was provided with all sorts of pleasant architectural ornaments, but even that was nothing new, for you will find the same arrangement in the old Roman theater at Orange in southern France.

Then came the greatest theatrical innovation of modern times—changeable scenery. In 1580 the Italian Palladio hit upon the amusing idea of building what were then called "perspective views," supposed to give the audience a feeling of reality by making them suspect that there was something more behind that backdrop than appeared to the eye. It was meant to introduce an element of space. But the doors

at the back of the traditional Renaissance stage were too small to serve this purpose. And so, a short time later, a young architect (said to have been Inigo Jones, the famous English builder who was superintendent of the royal buildings to King James I) bethought himself of the possibilities of so greatly enlarging the central entrance gate that it gave him a chance to erect an entire avenue of stately buildings right behind the entrance gate, and by this simple trick of perspective he hoped to create an illusion of immense distances.

The next step, this time taken in Parma, went still further. That elaborate central gate of the backdrop became the stage proper. The rest of the old Greek *skēnē* was thereupon turned into the proscenium and it was separated from the actual stage by means of a heavy curtain. At the same time the semicircular disposition of the seats was replaced by a *V*-shaped arrangement. This left some space open in the center where the ballets, which were then becoming exceedingly popular, could be danced without interfering with whatever went on on the proscenium or on the stage.

As the spectators were completely satisfied with the way things were run, the stage did not again change its appearance for several hundred years. A balcony might be added to the wall behind the stage with a special upper entrance to allow Juliet to contemplate the moon and to bewail her fate. And this was all the Shakespeares and the Molières ever had to achieve their effects. The real stage settings —the cardboard trees and the red autumn leaves of paper, painted on a very visible net, and the heavy granite pillars which shook every time anybody sneezed—all these did not come until well toward the end of the eighteenth century. They grew out of the attempts made by the composers to make their operas look a little less absurd than they would have done otherwise, rather than out of a desire for more realistic surroundings on the part of the playwrights and actors. But once they had been introduced, the stage people were obliged to follow suit. During an entire century, the poor public had to stare at this make-believe world which fooled no one.

Until some forty years ago when a new crop of stage directors grew up who have given us our present stage settings—a combination of movable and nonmovable scenery. It was an enormous step forward, but it was only a step. We still have several miles to go.

# The Opera

*The court of Versailles is treated to a few novelties of a musical nature.*

TO MOST OF US TODAY the name of Jean Baptiste Lulli means nothing except a few violin arrangements made in recent years by Fritz Kreisler and Willy Burmester. Perhaps the doctors are still interested in him, for his death was due to one of the queerest accidents on record. While conducting a *Te Deum* in the year 1687 he injured his foot with his baton (which in those days was apparently as long as a walking stick), developed what Molière's doctors diagnosed as a "cancer," and died of blood poisoning a few days afterwards. But to the contemporaries of King Louis he was a very great man. For he was acclaimed as the father of the French school of opera, and just then that strange Italian novelty called "opera" was the musical rage of the age.

Everywhere at their two-by-four courts, the little princelings of central Europe were erecting opera houses, which meant that the King of France, the unofficial head of everything pertaining to royal grandeur, must of course support the biggest and best of all opera companies. It may not actually have been the biggest but it was undoubtedly the best. Money was no object. When you die leaving a debt of over two billion francs, a few millions more or less spent on pretty melodies really make very little difference. And so France got its first opera house and the court of Versailles went decorously enthusiastic about the tunes of those charming women who saw in an operatic career a social future thus far reserved only for their rivals of the legitimate stage. As we ourselves may see the end of opera as such (it is the least democratic of all the arts), the subject deserves a chapter of its own.

I have told you of the tremendous outburst of musical activity that took place during the end of the Middle Ages. The Church ceased to be the exclusive purveyor of all musical delights and the public at large once more began to sing tunes of its own, motets and madrigals and all sorts of complicated songs constructed faithfully and entirely according to the rules laid down by a large group of English and Dutch composers. The Church at first had tried to stem the tide but,

recognizing the futility of such an attempt, had accepted the "new music" as a welcome adjunct to the old Gregorian chant.

And so at last the field of musical experimentation was wide open. Everybody could now take his lute or fiddle in hand and compose to his heart's desire. And just as the modern orchestra seems to have grown out of the impromptu performances of the lute players and harpists of the Provençal troubadours and the German Meistersinger, so many of the new musical forms were first of all tried out among small groups of talented amateurs, both men and women, who were not inspired by any hope of professional gain but who practiced their art entirely for their own amusement and delectation—who did it just for the fun of it as all the arts should really be practiced.

Among these innovators who helped to make our modern music what it is there was a very curious figure—a sort of Christian Socrates, who spent his days wandering through the streets of Rome, drawing strangers into conversation, and, thereupon, by pleasing conversational tricks, showing them that they were hopeless frauds who had better hasten to a truly Christian mode of living lest sin overtake them and they die an unrepentant death. However, he was more fortunate than his poor pagan predecessor, for as "Apostle of Rome" he not only died in an odor of great sanctity but was actually canonized by Pope Gregory XV only twenty-seven years after his death, which was more or less of a record when we remember how long it has taken most other saints to reach this high honor.

In the year 1548 this Filippo Neri, more commonly known to the Anglo-Saxon world as Saint Philip Neri, founded a society to look after the needs of the poor and the pilgrims within the walls of Rome. For this purpose he obtained the use of one of the city's hospitals, and there on several evenings each week he conducted prayer meetings. Everybody was welcome but knowing (he seems to have been a very wise and witty man) how little is ever accomplished by mere sermons, Saint Philip did not try to convert his hearers merely by means of oratory but used to ask his musical friends (Palestrina was one of them) to come and delight his audiences with scenes from the Biblical stories accompanied by music.

This was such a tremendous success that soon all Rome was talking of these musical exercises at the hospital of San Girolamo della Carità. And as the meetings were held in the oratory of the hospital, in the hall set aside for prayer, this new form of musical entertainment became known as the music of the oratorio or an oratorio.

Ever since the end of the sixteenth century, most of the best-known

composers have at one time or another tried their hand at such oratorios. They were really nothing but the old medieval mystery plays set to music. And since all acting was taken out of them and there was nothing left except the music, these oratorios were also considered highly suitable for the Protestant church. In the hands of the great Protestant composers they were to become veritable citadels of the reformed faith.

Now at the same time another influence was at work which also was to play a considerable role in the future development of music. I refer to the so-called "masks" which reached a high degree of popularity during the latter half of the fifteenth century and which became quite the rage during the reign of Queen Elizabeth.

In ancient times the Greek and Roman actors never appeared in their own faces. They always wore masks. The size of the theater made it necessary for them to do so, for otherwise the customers in the back rows would never have been able to see whether the actor was weeping or laughing or merely yawning. In the beginning these masks were made of painted canvas. But after the actors had increased their stature by means of the cothurnus, the heavy-soled boot that gave the wearer a few extra inches of height, these simple masks were replaced by quite elaborate contraptions. These were made of clay. They covered the entire head and they too added a couple of inches to the actors' figures, but on the top side.

With the coming of Christianity the mask went, together with the actors, but during the latter half of the Middle Ages, when people were beginning to realize what terribly dull lives they were living, they often organized masked balls to which all the neighbors were invited to come "suitably disguised and wearing a mask," so that the delightful element of suspense and surprise might be added to the other pleasures of the evening.

Now a person will do a great many things wearing a mask that he would never do if everybody knew who he was. People who do not know a B flat from a G sharp will cheerfully join in the "Anvil Chorus" or will volunteer to sing the love duet from *Lucrezia* the moment their faces are covered with a piece of black satin. What is much worse, they will even insist upon doing so in spite of all the protestations from their more musically inclined friends. To the clodhopping and rustic nobility of the fifteenth century, the mask came as a gift of the Gods. For now at last they could really be themselves without first drinking themselves into a stupor, a detail which made such parties a great deal pleasanter and easier for their lady friends. And

they could also take part in little improvised plays without feeling that they were making fools of themselves.

As you will know from your own experience upon such occasions, there is always at least one bright lad who has a gift and a love for theatricals and who runs the whole show. It was not different four hundred years ago. Such amateur managers would organize a regular performance on the spur of the moment. Those who were good at music could play the necessary tunes. Those who could sing would render a topical song with very witty allusions to the peculiarities of some of the less popular guests. The girls could do a little dance and they might even dress up for the occasion, pretending that they were nymphs or naiads and very beautiful and therefore very dangerous. The young bucks would thereupon put vine leaves in their hair and, shouting like satyrs, come stampeding upon the stage, doing whatever satyrs were supposed to do.

Whenever the amateur has started something, the professional is never very far behind. Soon we find some of the best professional playwrights writing regular libretti for a royal or princely "mask." In this way Ben Jonson made his early reputation, and Chapman and Fletcher also earned many extra sovereigns writing for the mask market, for during their days the mask was much more popular than the regular stage.

Now you have had them all and out of this combination of minstrelsy, oratorio, and masks there grew that strange new hybrid form of musical entertainment that we know as the opera.

Who first had the idea for an opera and what sort of an opera it was—those are questions which nobody as yet has been able to decide, for the event attracted very little attention. It was the work of amateurs who had no idea that they were doing something historical. They were merely looking for a new way to amuse themselves, just as several hundred years later a great many youngsters were to play around with funny-looking little cigar boxes and electric lamps and all sorts of other odds and ends which they put together until at last they could hear the dots and dashes of some distant wireless station. Yet out of these makeshift experiments grew our modern radio, and a century from now there probably will be a very lively debate among the writers of scientific handbooks to determine who invented the radio receiving set.

Of one thing we are certain. Opera was the result of a number of experiments, conducted at the same time in a large number of Italian cities, although Naples and Florence should probably get most of the

credit. In Naples it was the palace of that talented musician and amateur murderer, the Prince of Venosa, which served as a meeting place for the local musical enthusiasts, and it was the poetry of Torquato Tasso which they used as a base for their experiments. For the author of the famous *Jerusalem Delivered* also used to write poems which were to be used for madrigals—a sort of song written for several voices but not accompanied by instruments and eminently suited for operatic entertainment.

Tasso, in turn, was a great friend and admirer of Palestrina, and the latter seems to have discussed the possibility of orchestrating some of his villanelles. This Torquato Tasso was one of the most restless men of the Renaissance and, being much too outspoken for his own good, was forever getting into trouble with his employers. However, as he had one of the most brilliant minds of his time, he never lacked an occupation for very long and so in the course of his wanderings, which included a seven-year enforced rest in a madhouse, he also paid several visits to Florence.

There, too, a group of young men were trying, with that eagerness so typical of serious amateurs, to discover what could be done with the new sort of music. In their case, the "new music" was still the "new music" that had been developed during the latter part of the Middle Ages, for Florence was the only town that had never succumbed to the lure of the Netherlands school. It was too cut and dried for the people who lived in the gay city on the Arno. These Florentine music lovers, most of them belonging to the leisure classes, many of them noblemen, used to gather regularly at the house of a certain Giovanni Bardi, Count of Vernio, a member of an old and very rich family of bankers. Giovanni Bardi, like so many of the rich and fashionable young men of his day, was an enthusiastic supporter of all these new ideas which together were to give us the Renaissance. A new Greek statue dug out of the soil, a new Roman manuscript pockmarked by the labors of countless generations of industrious bookworms, meant as much to him as the victory of his own polo team means to the son of one of our Wall Street banking dynasties.

Some poor penny-a-liner must have made him acquainted with the charm of the old Greek tragedies. So for a while Bardi dropped everything else to give the world these long-lost masterpieces, done most faithfully in "the original manner." That meant that the choruses must be accompanied by music, for that was the way they had been spoken or rather chanted in the days of Euripides and Sophocles. When you remember that today, after all the painstaking researches

of hundreds of scientific musicologists, we still know nothing about the way the Greeks actually sang their choruses, you need not ask what a sad hash these Florentine amateurs made of their "genuine" Greek tragedies "done in the original manner." But that is not the point. These young men were deeply interested in what they were doing. The meetings of their *Camerata* attracted the attention of all the people of their own class and in the fashionable world everybody was delighted that now at last the true classical spirit had once more been brought back to life.

Now as all of my readers who have ever played in an amateur orchestra will remember, a few days before the final concert you were always obliged to bring in a number of professionals, for amateurs who can actually play the oboe, the French horn or the bull fiddle are very rare. It was the same in Florence during the last decade of the sixteenth century. Bardi always employed a number of professional musicians to give a little solid background to the well-intentioned but often rather feeble efforts of his amateurs. And soon (it all sounds so very modern! indeed it might have happened only yesterday) there were two groups present at the weekly gatherings of the *Camerata*, thus called after the vaulted hall in which these youngsters used to meet.

The academicians were all for sticking closely to the accepted music of their day, the polyphonic music, several voices either singing together or woven together into a neat contrapuntal arrangement. The amateurs, on the other hand, wanted something perhaps a little more advanced, something with more melody to it, and therefore much more agreeable to Italian ears than those mathematical problems that had been forced upon them by the barbarians from the north.

The amateurs happened to include some very distinguished citizens. One of them, for example, was Vincenzo Galilei, the father of Galileo Galilei, a famous mathematician and enough of a composer to set parts of Dante's "Inferno" to music for solo and an accompaniment by the viola da gamba, that small violoncello which when played was tightly held between the *gambe* or legs of the performer. Since the amateurs paid the money for the performance, they won out and it was decided to give a performance of a real Greek tragedy in which the polyphonic arrangement would be replaced by a homophonic one.

Don't be scared by these big words. It merely meant that part of the time, at least, the leading melody was being sung by a single voice, thereby creating that effect which today we call a "recitative"

and which must be familiar to all of you who have ever heard an ora-
torio, in which these recitatives are used with great dramatic effect.
A certain Jacopo Peri, a Florentine composer and very popular in his
day, was finally told to write something that would show what could
be done along this line. He set to work and combined his arias (those
melodious solos which have always been the most important part of
an Italian opera) with a number of recitatives, during which a single
voice in a sort of declamatory singsong explained those parts of the
proceedings which had been left in the dark by the arias. This was all
entirely according to the best classical precedent, for in the Greek
drama, too, the chorus had been present to explain the actual story.
Those of my readers who are old enough to remember the beginnings
of our movies may remember that something very much like it was
done in our prehistoric movie houses where a gentleman with a lusty
voice acted as a one-man Greek chorus to make the less quick-witted
understand the motives that impelled the heroine to shoot her hus-
band, or the other way around.

Ottavio Rinuccini, another member of the *Camerata*, a professional
poet, wrote the libretto for this strange hodge-podge. It was called
*Dafne* and was supposed to be the story of Daphne, the unfortunate
Greek maiden who had been changed into a laurel tree when her
mother, the Goddess of the Earth, feared that she might fall under the
spell of the seductive Apollo.

The first performance of this piece was given in the year 1597 in the
Palazzo Corsi in Florence. The delighted audience went home under
the impression that it had assisted at a genuine revival of the ancient
Greek drama. As a matter of fact, it had been listening to the first
opera.

News of this great event spread far and wide, by which I do not in
any way mean to create the impression that it was also an immediate
popular success. The populace only heard about these goings-on, as
the people in our slums may hear of the coming-out party of a rich
young debutante. For instruments cost a lot of money and the profes-
sionals had to be well paid for their services. The costuming and the
candlelight were also very expensive items. Hence this sort of music
was only for the well-to-do and, to be perfectly honest, it has always
remained a pastime for those who, in the jargon of today, are referred
to as the "overprivileged." Except that the overprivileged of the
Middle Ages and the sixteenth century did not content themselves
with just sitting and listening. They took an active part in the proceed-

ings. They studied their instruments very seriously and learned their singing from the best teachers available.

It has become a habit of our schoolbooks to refer to this entire era as one of "aristocratic indulgence." It is true the music and the theater of that day were only for the rich. But let us remember that the rich also made that music and did most of the singing and the acting and the dancing. No one less than the great King Louis did not think it beneath his dignity to dance in some of the ballets that were given at his court as a partner of young Signor Lulli, who was the son of an obscure Italian pastry cook and who had begun his career washing the dishes in the kitchen of Mademoiselle de Montpensier. Can you, in the wildest fancies of your imagination, see New York's leading banker dance a *pas seul* in pink tights and with ostrich plumes on his head (the costume of King Louis) in a performance of the American Ballet at the Metropolitan Opera House?

It was just a different sort of time with a different sort of people. But at least they practiced what they preached and took an actual and intelligent part in the musical performances of their day. Had you told them that it was not fair to keep all this beauty and loveliness for themselves and not share it with the common man, they would probably have answered you that the common man had a music and a form of dancing of his own which undoubtedly pleased and satisfied him infinitely more than the music and the dancing of his betters could ever hope to do. And no one, I am sure, would have more generously agreed with this opinion than the so-called common man himself. He did have his own music and he did have his own form of dancing and singing. As for the idea of making him listen to all that high-brow stuff of the Bardi mansion—God forbid! He would be so bored that he would never survive. So please let him stay where he was and sing the tunes he liked. And let the other fellows stay where they belonged and let them sing the songs that pleased them but let nobody try to force them to do what they did not want to do. And therefore, until we come to the nineteenth century, whenever I say that something was "so much of a success that it spread far and wide," I really mean that it spread far and wide but only throughout one class of society—the upper class.

However, among these fortunate young men and young women, the enthusiasm for the new operatic form of entertainment was so great that not less than two composers tackled Rinuccini's next libretto. Both Peri and Caccini wrote scores for his *Euridice*. The libretto of *Dafne* has survived but, except for one or two arias, the music has

been completely lost. Which is perhaps just as well, for otherwise someone would be sure to revive this first opera as a musical curiosity and judging by what we know about the score, it must have been pretty dull stuff. As for the *Euridice*, the music was actually printed, for in Venice there was now a publishing house which had invented a method by which notes could be printed just like letters. You can get this opera in a modernized version, but it will hardly interest you, for it was all still rather primitive and unsophisticated.

The "romances" of the Middle Ages are also interesting as a first serious attempt at some sort of "literature of entertainment," but try to read them today! For that matter, is there anyone present who can still get interested in the *Bride of Lammermoor* of Sir Walter Scott? Or who has been rash enough to try to wade through Goethe's *Werther*? But less than a hundred years ago these tales of Sir Walter were thought so exciting that people actually refused to die until they had finished the last installment of *The Fair Maid of Perth*, while Werther's sad fate inspired dozens of lovesick young men to get out of their miseries by way of Werther's suicidal pistol shot. And while *Euridice* would now cause you to cry out in despair at such uninspired mediocrity, it was so important to the Florentines of the year 1600 that when Maria de' Medici, the niece of the reigning Grand Duke of Tuscany (the Medici had done quite well for themselves since we last heard of them), bestowed her hand upon the King of France (Henri IV, the brilliant grandfather of the brilliant Louis XIV), the Florentines knew of no better way to honor the happy couple than by arranging a special performance of Peri's famous *Euridice* in the big banqueting hall of the Pitti Palace.

On this occasion every young man of noble blood who could either sing or play an instrument volunteered his services. The orchestra—and this detail should be especially interesting to our modern arrangers of dance music, who are forever trying to discover new tonal combinations—the orchestra consisted of three flutes, one theorbo (a double lute with twenty strings, eight of them being open and lying off the keyboard), three *chitarroni* (large guitars), and a harpsichord.

The score was written in that sort of musical shorthand which the Italians called *basso continuo* and which we call "thorough bass" or, more commonly, "figured bass." Originally it had been used only for the organ but it was such a convenient method of writing music that during the beginning of the seventeenth century it was used for all sorts of keyboard music. It was really a mixture of notes and ciphers. The notes were only used for the bass notes. The figures above indi-

cated the chords that were to be added. During the seventeenth and eighteenth centuries most composers contented themselves with some hasty outline of what they intended to say. But since all the fiddlers and guitarists and flute players were expert craftsmen, that sort of shorthand notation was quite enough, for everybody knew exactly what to do. Today, the walking delegates of the Musicians' Union would undoubtedly call a strike if their members were obliged to play from such a score. For that would presuppose a knowledge of their instruments which most of them no longer possess.

Once definitely established, the opera soon found its way across the Alps and made a new home for itself in Paris. There under the leadership of Jean Antoine de Baïf, a native of Venice, a regular academy of music was founded which would try to do for the French capital what the *Camerata* had done for Florence. Since poetry and music at that time were still closely connected, De Baïf was greatly influenced by the work of Pierre de Ronsard, the Prince of Poets (as his contemporaries proudly called him), who for a while had been a tutor in De Baïf's household. So great was the esteem in which this fellow was held that the king, Charles IX of France and himself quite a good amateur poet, asked him to come and live at his palace.

This sign of the royal approbation, by the way, caused a most terrific outburst of fury among the French Protestants who in the beginning had hoped that this distinguished poet would take their side. But here was another artist who instead of devoting his talents to the cause of the true religion (as revealed by Dr. Calvin) allowed himself to be bought by Satan and now placed his divine harp at the disposal of the Antichrist. When Ronsard went so far as to give encouragement to Étienne Jodelle, who in the year 1552 wrote the first French tragedy, *Cleopatra in Captivity*, their fury knew no bounds and they even tried to have Ronsard murdered. This little detail gives you an idea of how seriously people took their literature and their music during the first half of the sixteenth century.

As for Ronsard, he is merely a name to us. We rarely read him but indirectly we are still being influenced by the freshness and the charm of the meter of his verses.

It was this meter which De Baïf afterwards tried to introduce into music. And it may well have been through this attempt that we got another very important musical innovation—those measured bars which are so familiar to us that we take them for granted but which until then had been completely unknown. Already during the latter half of the Middle Ages musicians had been trying to discover some

way in which they could give definite expression to what they called the *musica mensurata*, in which the length of a note was not left to the lung power and endurance of the singer. Now at last they got rid of the elaborate system of dots and dashes, which for all the world looked like the queer figures you find in our modern timetables to tell you whether a train has a dining car or not or that it runs only on alternate Sundays in leap year. A single vertical bar across the four or five horizontal lines on which the notes were written now separated one bar from the next.

This new method was most eagerly adopted by those musicians who were just then engaged on the gigantic task of providing the newly founded Protestant communities with hymns that could be sung by the entire congregation. Under the new dispensation, the professional singer was banished from the services and every Christian was supposed to lift his own voice in praise of Almighty God. In the Protestant countries there was therefore such a tremendous demand for simple and practical hymnbooks that some of these early collections of hymns went through almost as many editions as the Bible itself. The publishers realized this and greatly encouraged the zeal of the musicians in their efforts to write a sort of music which every citizen, be he ever so humble, would be able to follow.

It was a risky business, for one of the most popular composers of that time, Claudin Le Jeune (the first musician to be appointed official composer to the king) almost lost his life during the night of the Massacre of St. Bartholomew because he was known to have set some of the Psalms to music for the benefit of the Huguenots. Fortunately his life was saved by one of his colleagues, Jacques Mauduit, the greatest lute virtuoso of his day and so stanch in the doctrine that no one could possibly suspect him. In this way Le Jeune was allowed to live a few years longer and this enabled him to co-operate with Mauduit and De Baïf in composing one of the first of the ballets about which we really have a few definite data.

That form of theatrical entertainment, in which no words are used but in which the story is supposed to be told merely by means of the dancer's art, has an interesting history. It probably is an offshoot of the pantomime, which as part of a religious invocation is one of the oldest of all forms of art, going back to the dim obscurity of prehistoric times. But in a pantomime, the participants gave expression to their emotions by means of both gestures and steps. And pantomimes were accompanied by music. In the ballet, dancing alone was used

to reveal what the actors felt or thought or intended to do. And this dancing has, of course, to be accompanied by music, for dancing without music is not only very difficult but it also has a tendency to grow very monotonous.

And now once more a heavy fog of ignorance descends upon one of my chapters, for nobody seems to know for certain at what moment the ballet first cut loose from the pantomime. I once more suspect the amateurs, for they have almost always been years ahead of the professionals, just as the philosophers have invariably anticipated the findings of the scientists by quite a number of years.

We do know, however, that Catherine de' Medici, the wife of Henri II of France, used to organize little ballet performances to prevent her weak son from getting too much excited about affairs of state. History does not tell us what sort of ballet was danced to make the poor boy forget the horrors of the Massacre of St. Bartholomew, which his mother ordered to rid herself of her Protestant enemies and during which fifty thousand Huguenots were killed in one single week. But we do know that the first official "ballet" was danced at the palace of the Louvre in Paris in 1581 and that it was such a success that for several generations it prevented the further growth of the opera on French soil.

When finally the opera attracted the attention of Louis XIV and was introduced by him at his court, it had made great strides from the days when it had been only a means of killing time for the fashionable world of Florence. Most of the improvements were due to a young man by the name of Claudio Monteverdi. Being a native of Cremona, the home of all the great fiddle makers, Monteverdi had quite appropriately started his career as a viola player. This is important, for all the other composers and teachers until then had begun as singers. But now at last a man of genius appeared in the musical field who, above all things, was an instrumentalist and who quite naturally therefore looked at music from the instrumental point of view rather than from that of the voice.

Monteverdi is often given credit for having laid the foundation for our modern instrumental music. This is true, but in order to write good instrumental music, one must first of all have decent instruments. They need not be perfect, for Beethoven wrote his symphonies and sonatas for orchestras and pianos that were decidedly inferior to those of today. Nevertheless, the instruments that were at his disposal were of sufficient quality to give him an idea of what he could make

them do. And that may also account for the success of Monteverdi. He undoubtedly had a great natural talent for the writing of instrumental scores. But he was also one of the first composers whose orchestras were provided with a highly improved type of instrument. They were important enough for us to give them a little chapter of their own.

# Cremona

*A slight detour to visit the home
of the fiddle-making dynasties of Lombardy*

M OST MODERN MUSICAL INSTRUMENTS are the result of the law of the survival of the fittest. The Babylonians, the Assyrians, and the Egyptians made themselves all sorts of harps or flutes or trumpets, and for all we know they had in turn learned the trick from other and more ancient races. The Greeks improved upon these older models and bestowed their instrumental heritage upon the people of the Middle Ages. But as there were no regular orchestras (in our modern sense of the word) there was also no demand for a standardized form of instrument.

Every fiddle maker experimented with new sorts of violins, vielles, alto viols and treble viols and violas, rebecs, violas d'amore, violas da gamba, bass viols, double bass viols, and dozens of other sorts, large, small, and medium-sized.

The manufacturers of wind instruments tried their hand at flutes, fifes, piccolos, oboes, bassoons, double bassoons, and *cors anglais*, which were not, as you would have supposed, "English horns" but *cors anglés* or slightly curved members of the oboe family. Next they turned their attention to bombardons and krummhorns and clarinets and saxophones (a substitute for the clarinet and going back to the Middle Ages, although greatly improved a hundred years ago by the Belgian instrument maker, Adolphe Sax). And all the keyboard instrument manufacturers promised themselves golden mountains from their monochords, hurdy-gurdies (which originally were by no means just street organs), and finally from their hundreds of varieties of pianofortes, the new and improved clavier that could be played both *piano* and *forte*.

About ninety-nine per cent of all these inventions and improvements came to nothing. They were tried out, found wanting, and were discarded and forgotten. Only the hardiest, the most useful, the most practical varieties survived.

In the case of the fiddle family, these were the violin, the viola, the violoncello, and the double bass. All the others were relegated to the

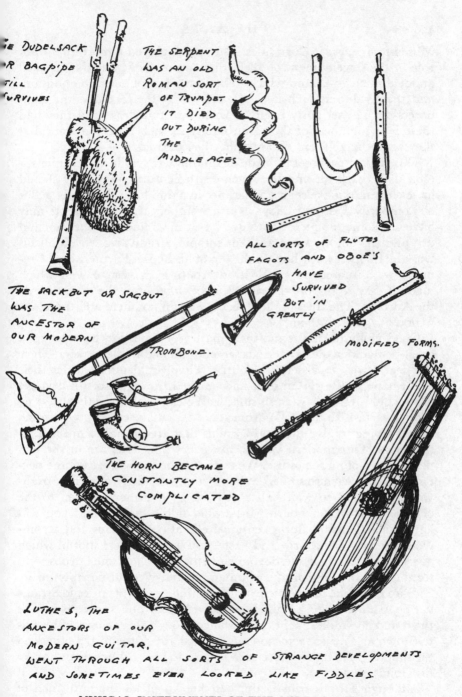

THE DUDELSACK OR BAGPIPE STILL SURVIVES

THE SERPENT WAS AN OLD ROMAN SORT OF TRUMPET IT DIED OUT DURING THE MIDDLE AGES

ALL SORTS OF FLUTES FAGOTS AND OBOE'S HAVE SURVIVED BUT IN GREATLY MODIFIED FORMS.

THE SACKBUT OR SACBUT WAS THE ANCESTOR OF OUR MODERN TROMBONE.

THE HORN BECAME CONSTANTLY MORE COMPLICATED

LUTHES, THE ANCESTORS OF OUR MODERN GUITAR, WENT THROUGH ALL SORTS OF STRANGE DEVELOPMENTS AND SOMETIMES EVEN LOOKED LIKE FIDDLES.

MUSICAL INSTRUMENTS OF THE MIDDLE AGES

Museum of Musical Curiosities. These four played a most important role in the development of all further music. Together they formed an ideal nucleus around which to build the rest of one's compositions and their value as such is clearly shown by the fact that the composers did not seriously begin to write for orchestras until they had these four members of the violin family in such a perfect state that they could make them do anything they pleased.

This happy event—the birth of the modern violin quadruplets—took place early during the seventeenth century. Why they should have chosen to make their appearance in a dull little city in the plains of Lombardy I do not know. I rather suspect that the climate may have had something to do with it. The air in Cremona is both hot and dry and this allowed a man like Antonio Stradivarius to do all his work in an open workshop on the top of his house. Furthermore, Cremona was situated on an old trade route from east to west which made it easy to import the right sort of wood from the other side of the Adriatic. The trees of the Balkans were in no hurry and there was nobody to disturb them.

Good violinmaking is mostly a matter of time. We have heard a great deal about the mysterious secret of the old fiddle makers. Their one secret was an absence of hurry. They could afford to let their wood hang in the sun until it had reached the right sort of dryness. They could let their varnish sink in. We can make exactly the same sort of varnish that the Guarnieri and Amatis used. But we are no longer trying to give the world violins that are primarily musical instruments. Our modern violins, like everything else, are in the first place pieces of merchandise. We cannot afford to waste the time necessary to let a varnish sink in. When a customer was in a hurry, Stradivarius told him to wait half a year or go elsewhere. Listen to the circular saws of a modern Mittenwald fiddle factory and you will know what I mean. But given ideal climatic conditions and a complete absence of all hurry and haste, you have an ideal spot in which a serious craftsman could devote his entire life to just one purpose—to turning out the best product human ingenuity could possibly make.

As an example, let me record the fact that the great Antonio Stradivarius, who lived to be ninety-three years old and spent seventy of them making fiddles, kept on working through three sieges of his native town and never seems to have noticed any of them. Let others do the shooting. He himself intended to stick to his workbench and make his violins.

Although Stradivarius is the best known of all the craftsmen of

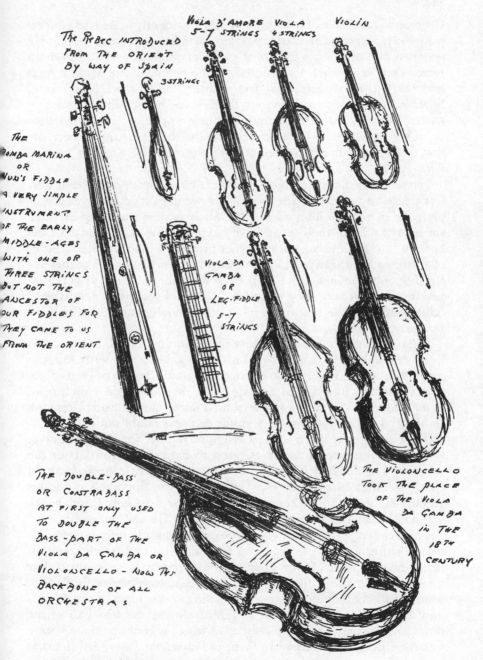

THE REBEC INTRODUCED
FROM THE ORIENT
BY WAY OF SPAIN

3 STRINGS

VIOLA D'AMORE VIOLA VIOLIN
5-7 STRINGS 4 STRINGS

THE
TROMBA MARINA
OR
NUN'S FIDDLE
A VERY SIMPLE
INSTRUMENT
OF THE EARLY
MIDDLE-AGES
WITH ONE OR
THREE STRINGS
BUT NOT THE
ANCESTOR OF
OUR FIDDLES FOR
THEY CAME TO US
FROM THE ORIENT

VIOLA DA
GAMBA
OR
LEG-FIDDLE
5-7
STRINGS

THE DOUBLE-BASS
OR CONTRABASS
AT FIRST ONLY USED
TO DOUBLE THE
BASS-PART OF THE
VIOLA DA GAMBA OR
VIOLONCELLO - NOW THE
BACKBONE OF ALL
ORCHESTRAS

THE VIOLONCELLO
TOOK THE PLACE
OF THE VIOLA
DA GAMBA
IN THE
18TH
CENTURY

THE FAMILY TREE OF THE VIOLINS

Cremona (his fiddles having a tone that is ideally suited to concert purposes), his contemporaries paid no particular attention to him. He was just one of a large group of violin manufacturers, all of whom were taken very much for granted, as the people of the Middle Ages had taken their stonemasons and painters for granted. They were, however, not quite so anonymous, for the label of their firm was neatly pasted in every instrument that left their workshop. We can follow them through the ages, and thus we know that the Amatis were the first of these mighty dynasties of the polished wood and the varnish pot.

These devoted craftsmen of the Piazza San Domenico lived in perfect peace and amity. They spent their evenings together over a simple glass of wine, telling each other about a new way they had discovered of mixing their varnish, of having changed the width of the bottom to eight and a quarter inches instead of the traditional eight, of bringing up the sides to one and seven thirty-seconds inches instead of only one inch as it had been done in the earlier days of fiddle-making. In this way they conducted a sort of unofficial academy of fiddle-building, the best of all schools for people who take their jobs seriously.

After the Amatis came the Guarnerius family. The founder of this lively tribe, Andrea, had learned his trade side by side with Antonio Stradivarius in the workshop of Niccolò Amati, the son of Geronimo. The Guarnieri had a sign outside their shop showing a picture of Saint Theresa. When one of the sons, Pietro, moved from Cremona to Mantua, he took the same sign for the new establishment.

They must have been a very religious family, for the greatest of them all, Giuseppe Guarnerius, used to inscribe the initials of the Saviour, I.H.S. (*Iesus Hominum Salvator*—the "Jesus, the Saviour of Men" familiar to us from the Catacombs), on the labels inside his violins. He came to be known as "Giuseppe del Gesù," and hence you will sometimes hear people talk about a "Jesus-Guarnerius."

This Giuseppe or Joseph was a queer and slightly unbalanced customer, suffering from fits of deep melancholia. In his brighter moments he was probably the greatest fiddle maker that ever lived. For no one ever made a little wooden box that would give forth such sounds. His contemporaries preferred the sweeter tones of the Amatis and the Stradivarii. But after Paganini, during the first half of the nineteenth century, had shown the world what could be done with a Guarnerius, the tide turned in favor of Giuseppe. Today I think that with all due respect to the average high degree of perfection of Stradi-

varius, the professional violinists agree that Joseph at his best had all the rest of them beat by a thousand bow lengths.

And finally, there was the great Antonio Stradivarius himself, who in 1666, when he was twenty-two years old, left the workshop of Niccolo Amati. In 1684 he began to make the larger and bolder models which have given his name its world-wide fame. He died in the year 1737. His two sons were also fiddle makers. But Carlo Bergonzi took the business over and continued it under his own name. Eight years later the great Joseph Guarnerius died. The family of the Amatis had disappeared some forty years before. By the middle of the eighteenth century, the great fiddle-making dynasties of Cremona had come to an end. The divine spark was gone. Their genius had at last spent itself.

Since then lots of other good violins and violoncellos and violas and base fiddles have been made—by Jacob Stainer in the Tirol, by Lupot and Vuillaume in Paris, by the Hill brothers in England. But none of these products has ever quite come up to the standards of the Cremona masters at their best.

But they had played their part and they had done their work. For the new sort of violins and violas and violoncellos and also the new bows (greatly improved after Corelli had established a definite technique of violin playing during the latter half of the seventeenth century)—these had turned the stringed instruments into an absolutely dependable backbone for all works of a purely orchestral nature. A regular sort of chamber music (music which was written for amateurs to be played in their own houses and without any thought of big public performances—a sort of music which until then had been restricted to the voice) now began to be written for quartets of stringed instruments. The announcement "fit both for voice and for violins" began to make its appearance more and more in all books of printed music.

At the same time came the tremendous improvement in the keyboard instruments. These had developed out of the medieval monochord that Guido of Arezzo used to teach his pupils the intervals between the notes. The monochord became the clavichord. The clavichord in turn grew into the more elaborate harpsichord, which in its turn gave birth to a whole variety of keyboard instruments in which the strings were still being plucked. These were known by all sorts of names, such as spinet, virginal, clavicembalo, or simply cembalo. All of them survived until late into the eighteenth century. These spinets and harpsichords, very small and light and therefore as easily trans-

ported as a violoncello, were incorporated into the orchestra and gave it a background and volume it had never had before.

Hence, just as the improvement in shipbuilding methods caused a tremendous outburst of activity among the navigators, so did these better and more dependable new instruments cause a veritable explosion of industry among the contemporary composers. Dance tunes that so far had lived only among the peasantry, and had always been passed along from father to son, were now written down for all sorts of instrumental combinations and were given a form that since then has become traditional, such as the saraband, the musette, the bourrée, the allemande, the courante, the rigaudon, the gigue, the tambourin, the passacaglia, and the chaconne. If this comes to you as a shock because it seems to make Bach a sort of Gershwin who wrote dance tunes, I am sorry, but it can't be helped. Most of the work of the great composers of the eighteenth century was really dance music, dressed up a little for the occasion, but dance music, nevertheless.

For the benefit of the more serious among the amateurs there were the sonatas. Originally in the sixteenth century, any sort of tune, anything that was "sounded" on an instrument, was called a "sonata" as opposed to the "cantata," a piece of music that had to be sung. On rare occasions the word "sonata" was also used for another novelty, the "sinfonia," which was really an ensemble for a large number of instruments. But as a rule it merely meant a simple piece written for only two or three instruments. These sonatas were divided into two groups, the *sonata di chiesa*, of a religious nature, and the *sonata di camera*, which originally consisted as a rule of a suite of dance tunes. Sonatas for the harpsichord alone were first written by Johann Kuhnau, who was Bach's predecessor as organist of the Thomaskirche in Leipzig. Old Kuhnau knew the mentality of his neighbors and respected their religious prejudices. Hence he used his sonatas to illustrate scenes from the Bible, as you will remember if you ever heard his witty *David and Goliath*.

But now we reach the age when all the world was beginning to write this sort of composition. Hence there is an end to our little detour and we return to the main road of our story.

# A New and Fashionable Form of Entertainment

### Monteverdi and Lulli
### and the beginning of the French opera at the court of Louis XIV

EVEN THAT GREAT TECHNICIAN of the violin, Arcangelo Corelli, the first of the tribe of wandering *virtuosi* of the catgut and the horsehair, held firmly to the opinion that the possibilities of his instruments were limited to the third position. What was higher than the D on the first string did not count. It did not sound right. It therefore must never be played. Corelli was born ten years after Monteverdi died, an event that took place in the year 1643. What Monteverdi therefore wrote was, technically speaking, fairly simple, although he had introduced several innovations, such as chords and pizzicato (the pulling of the strings with either the right or the left hand) which in the beginning had been very unpopular with his players.

But Monteverdi was responsible for something else that made him one of the most interesting composers of his day. I shall spare you further references to his use of monody and polyphony. They mean nothing to most of us, anyway. But it was Monteverdi who turned an orchestra into something resembling a well-trained army, a body of men who act strictly according to the will of one single leader and take no liberties with the score but play exactly what the notes before them tell them to play.

We happen to know exactly how many men he employed and what instruments they handled. His orchestra was made up of forty pieces, more than poor Beethoven ever had at his disposal several centuries later. These forty pieces consisted of two small organs (today we would probably use accordions), two clavichords, and a regal, also known as a "Bible regal" because it used to fold up like a book and then looked like a large Bible. Also ten *viole da braccio* (which being tenor violins, larger than the ordinary fiddle, gave the Germans the word *Bratsche* for a viola), a *viola da gamba* or leg violin ( a small violoncello), two *pochettes* (small pocket fiddles such as dancing masters used to carry in the pockets of their overcoats until a hundred years ago and which Thomas Jefferson carried with him whenever he took a trip), and two large lutes (the guitar of the modern dance orchestra).

The rest consisted of regular violins, flutes, oboes, and clarinets, but, as you will notice, no drums and no timpani, which add so much to the color of the modern orchestra.

Here at last was something with more body to it than any ears had ever heard before. Was it popular? A few people liked it. More did not. They declared that such an orchestra made too much noise and was an offense against the taste of cultivated gentlemen. They offered the same objections when Monteverdi introduced these enlarged orchestras into the opera house. As for his tunes, they accused them of being too "emotional" and their ears, accustomed to the monotonous evenness of the old harpsichords and the spinets, which had no pedals and therefore could not play any crescendos or diminuendos, were greatly shocked when Monteverdi began to create certain pianissimos and fortissimos by means of the violins and the oboes and the clarinets.

Monteverdi paid no more attention to these criticisms than any intelligent artist should do. He continued to compose until the year 1643 when he died in the good city of Venice, where during the greater part of his life he had been the choirmaster of the church of St. Mark's. But his new way of handling music, which seems to have struck many of his contemporaries as unpleasantly as Hindemith and Shostakovich happen to affect us (myself very much included), may really have accounted for the curious fact that the opera, after its first popular success, made such slow progress abroad.

In Italy it had already removed from the private palace to the public opera house, for as early as 1637 Venice established the first theater exclusively devoted to this form of musical entertainment. This venture proved so profitable that soon half a dozen other opera houses began to cater to the new popular taste, which did not care quite so much for pretty stories about ancient Gods and their lady friends, but which insisted upon such violent themes for their "melodrama" (the melody-drama, as the opera was originally known) that the name "melodrama" has survived for a peculiar type of stage performance in which a happy ending is sure to crown the noble efforts of the hero and heroine to escape from their predestined fate.

The French, who have always been very decided in their artistic preferences, meanwhile decided that Henri IV or no Henri IV, the opera was nothing for them. Jules Mazarin, the Italian cardinal who succeeded Richelieu as dictator of France during the minority of Louis XIV, had done his best to bring a few more Italian operas to Paris for purely political purposes. It was a well-known fact that this immensely rich statesman hated to spend money. Indeed, he was so

rapacious that he used to weigh all his gold pieces. Those that weighed the least, he would take with him when he spent an evening at the gambling tables, for in that way he would lose a few francs less. Nevertheless, when it came to his beloved opera, he wasted money with both hands, sent to Naples for the best of the *castrati*, hired the greatest living painters to do the stage settings, and engaged orchestras of Monteverdian proportions. All to no avail. The French obstinately refused to have anything to do with this "foreign" kind of amusement. It was too noisy, so they complained, and there were too many notes going on at the same time, the same objection the Emperor Joseph II, a century later, would offer to the music of Mozart. They remained faithful to their own ballets and carefully avoided those theaters in which the Italians held forth.

The great change did not occur until the middle of the seventeenth century. It came about this way:

In the year 1646 the Chevalier de Guise had somewhere come across a small Italian urchin who was a veritable wonder at dancing and inventing tunes. The child's name was Giovanni Battista Lulli. He had been born in Florence. His father was a useless sort of citizen. The poor child had had no education at all. He was now working in the kitchen of the household of Mademoiselle de Montpensier. This was the famous Grande Mademoiselle of the seventeenth century. Having been in turn affianced to Louis XIV and Charles II (she was immensely rich), she lived to be a most active and energetic leader in the rebellion of the Fronde and to end her days as the wife of a Gascon gentleman greatly her junior. This Gascon spent most of his time in prison until his ladylove had settled the greater part of her fortune upon His Majesty's brood of illegitimate children.

Little Giovanni Battista was a very bright boy, very clever, very observant, and very ingratiating in that eager-eyed Italian way that makes so many little Italian boys and girls look as if they could conquer the whole world if only they were given a pair of decent shoes and one millionth of a chance. His new patron meant to give him that chance. Little Giovanni was sent to a good fiddle teacher, and soon played the violin as well as he had played his self-taught guitar in his old Italian days. For here, so the child very clearly understood, was his great chance and he meant to make the best of it.

Therefore, when he began to write operas of his own and in a manner he hoped would please the French, he made a careful study of the way the great actors of the court declaimed their verses, for the French, even today, are much more interested in well-spoken verses

than in all the songs in the world. He then incorporated that method of reciting poetry into his music. But since all power came from the King, nothing could be done until he had first of all gained the favor of His Majesty.

In 1653 Lully (as he was then called, Lulli being considered a little too reminiscent of his Italian origin) composed the music for a new ballet and this the King liked so much that he made him superintendent of the royal music. In charge of the royal orchestra, he made

A SEVENTEENTH-CENTURY OPERA
*The scene shows the death of Phaëthon.*

the extraordinary discovery that note-reading had not yet been introduced among the royal musicians. They merely listened to the general melody they were supposed to play and then added their own parts as they liked. He taught these Frenchmen the useful art of reading a score and then set to work to make both a name and a fortune for himself.

In the meantime, Italian opera had made some progress in the French capital with the giving of Italian operas. In the year 1669 two

Frenchmen were granted permission to start a national academy of music which was to give performances of French opera (but in the Italian style) in all the cities of France. The venture was a success. Master Cambert and the Abbé Pierre Perrin earned enough from their *Pomone* alone (the piece ran for eight consecutive months) to build themselves a hall that was to be used exclusively for the new form of amusement—the first regular Paris Opera House.

This success had not gone unobserved by Monsieur Lulli who, meanwhile having been duly naturalized, was spending all his time writing and rehearsing and conducting those ballets in which His Majesty continued to take so much delight that he quite often took part in them. They were very stiff and very formal, as was everything during the era of the Baroque. But they were also very colorful, for not only did the actors appear in the appropriate fancy costumes, but the musicians, too, were dressed up to suit the occasion and Lulli, the director, would appear one night as a Turk and the next one as a Greek shepherd or an Italian fisherman.

But meanwhile the Maestro never lost sight of the opera which was making his rivals rich. Finally he prevailed upon the King to make him director of the National Academy of Music and to dismiss his two Frenchmen. By this time Louis was so under the influence of his clever Italian concertmaster that Perrin and Cambert were actually deprived of their office. Cambert moved to England, just when Henry Purcell was beginning his short-lived career (he died at thirty-seven) during which, in his *Dido and Aeneas*, he gave England its only seventeenth-century opera of any merit.

But alas, Monsieur Cambert's operatic days were definitely over. He found employment as bandmaster to King Charles II. An unexpected sword thrust put a sudden end to his career, while in Paris his hated rival continued to compose his operas and ballets and to bask in the royal favor with undiminished luster. Has there ever been a world of more jealousy and petty intrigue than that of the operatic stage? Compared to the way these charming people of the musical footlights treat each other, dogs in a kennel are examples of well-bred courtesy and mutual good will.

One detail should now be especially mentioned in connection with Lulli. He was the first director to let women dance in his ballets. Until then, all the women's parts always had been taken by young boys. But in Versailles ambitious ladies of the nobility volunteered their services and they could not well be denied the pleasure of thus bringing their pretty figures to the attention of His Majesty's curious

glances. Women therefore entered the ballet. But even Lulli was not powerful enough to use women for the soprano parts in his operas. He too had to content himself with those unfortunate boys who, for the purpose of retaining a high falsetto voice, had been subjected to a cruel surgical operation.

That, by the way, is one of the reasons why today none of those old operas are ever given unless they have first been completely rewritten. We no longer have the singers who can sing the parts. And I doubt very much whether Master Lulli's troupe would appeal to us if we should hear them in their original version. Our tastes, in that respect at least, have greatly improved. During the seventeenth and eighteenth centuries, however, and even during the first half of the nineteenth, there was nothing that would so fill the house as a very high falsetto voice. Even in England, which since the suppression of practically all of the arts during the regime of the Puritans had been rather decorous (for the spirit of Oliver Cromwell still hovered over the land) —even there the artificial male sopranos held the center of the stage for almost two centuries. The wife of James II imported the first one from Italy in the year 1687 and the last one, the famous Velluti, did not die until the year 1861.

It is a sad chapter, for it shows the ghastly poverty of the Italy of that day when parents were willing to have their children mutilated in the hope that perhaps (one chance out of a thousand) they might some day be great opera singers. But what else could they do? What other career was open to a musically ambitious Italian boy of the period?

The discovery of the new roads to the Indies and to America had turned the Mediterranean into an inland sea. For two centuries afterwards the Italians lived on the wealth accumulated during the Middle Ages when their country had been the distributing point for the merchandise from the East. Now that money was gone. Foreign princes ruled in northern and southern Italy. The papal domains, mismanaged to an extent it is difficult to imagine, were forever on the verge of starvation. At first those families who had inherited large collections of paintings were able to sell some of them to some rich English milord. But artistic taste varied from year to year. Many of the pictures, especially the very early ones, were not wanted. Others, like those of Giotto, were painted on church walls and could not be moved. The furniture went next. So did the family silver. At last there were only two products of the native soil that could be profitably exported. One was the business of the chimney sweep, for the agile little

*The strolling players, despised as so many mountebanks, enjoyed little esteem from the community at large.*

Italian boys were ideally suited for the job of creeping up and down the flues of the stately mansions of England and northern Europe. If sometimes—most unfortunately—they suffocated, there were always a lot of others to take their place. The other article of export was music. Hence the desperate struggles of all these poor devils from Palermo and Naples and Piacenza to get a foothold in every European capital, to establish a nucleus of singers and fiddlers which might in due course of time and with a bit of luck be extended into a regular *opera italiana* under royal or even imperial patronage.

But what pitiless battles had to be fought for every plate of spaghetti! The newspapers and memoirs of that day are full of them. In every city of some importance there were groups of those who would listen only to Italian opera, of those who vowed that they would rather be dead than sit through an evening of Italian tra-la-la, and who would spend their last penny on a performance at the French opera house, and finally (by the middle of the eighteenth century) of those who wished a plague on both the French and the Italians and who bestowed their most loyal affections upon the works of the German opera composers.

One of these encounters is still remembered in Paris. It became known as the War of the Buffoons and it took place some thirty-five years after the death of King Louis XIV.

Lulli, too, had gone to his eternal reward and had been succeeded by Jean Philippe Rameau, who although by profession an organist, had written a number of operas to texts by Voltaire and the other great literary men of his day. He had done more. He had gathered together everything then known about harmony and had written a book about it, the first regular textbook upon a subject that soon would be of very great importance. But just when he had more or less succeeded in establishing himself as a champion of the French music, an Italian troupe descended upon the capital with something entirely new, an *opéra bouffe*, a regular comic opera, something entirely different from all the old stuffy operas with their shepherds and their Gods, disporting themselves among the ruins of an ancient temple.

This was *La Serva padrona* by Giovanni Battista Pergolesi. All Paris took flame. The King was for the French opera. The Queen, the Polish Leszczynska, was for the Italians. When one took tickets for a performance, one was careful to ask for seats in the "King's corner" or the "Queen's corner," depending upon one's own musical preferences. All the great philosophers of that day, the Grimms and Diderots and D'Alemberts, neglected to work on their gigantic en-

cyclopedia (which was to set mankind free from the bondage of its ignorance) to rush to the support of their favorite arias.

The War of the Buffoons, which thereupon broke out between the two parties and turned every salon into a battlefield, divided Paris into two hostile camps. Jean Jacques Rousseau, the prophet of the "back to nature" movement that was so instrumental in bringing about the French Revolution, so far forgot his dignity as to compose a little opera of his own, *Le Devin du village*, which was written in the Italian style and was such a success when performed at Versailles that this great lover of mankind in "its primitive and virtuous state" would have been offered a royal pension if his contempt for royalty (as being against the laws of nature) had not made him refuse an invitation to the court. But in order that his position might not be misunderstood he wrote his *Open Letter on French Music* in which he most definitely took the side of the Italian school, adding in this way fresh fuel to the quarrel between the Buffoonists and the Anti-Buffoonists.

In the end, being on familiar home soil, the French party won out but the Italians had not given up the fight for good and only waited for an opportunity to reopen hostilities. They got support from a most unexpected quarter. Incredible though it may seem to our modern ears, the Italian peninsula had actually produced a libretto writer whose stories made sense! This was the famous Maestro Pietro Trapassi, who wrote under the name of Metastasio and who during an unusually long life (he lived during most of the eighteenth century) turned out not less than twelve hundred libretti. One of the greatest improvisators of his day (an art that has now completely died out), he had a very genuine feeling for music, which was of course of immense benefit to the composers for whom he worked.

In the end some sort of truce was declared and carefully observed until the day when Christoph Willibald, Ritter von Gluck, appeared upon the stage to conquer Paris for his Viennese opera. Then all the old bitterness flared up once more, but this time the quarrel was between the French opera fans and the German ones. Gluck had been the music teacher of Marie Antoinette before she had married the heir to the French throne. Having made a reputation with his *Orfeo ed Euridice* and his *Alceste*, he now tried his luck in *Armide* and the well-known *Iphigenia in Tauris*.

His arrival in the French capital at the request of the crown princess offered a most welcome excuse for an outbreak of political animosities. For all those who hated "that damned Austrian woman" (the name of most Frenchmen for the charming lady who soon afterwards

was to be their Queen) could now use the Ritter von Gluck's music to tell the world what they thought about the lovely Dauphine. She from her side fought back with all her usual energy and lack of discretion. The Anti-Gluckists imported Nicola Piccinni, who was asked to compose an opera on the same subject of Iphigenia in Tauris that Gluck had already embellished with his music. But although a man of great routine (he wrote some hundred and thirty operas), Piccinni had to work under such pressure, and the Anti-Piccinnists made his life so miserable, that he retired discomfited from the competition.

In the end, however, Gluck also lost out. In private life he was a most charming companion but he took his business so seriously that the moment he faced his musicians he became an Austrian drill sergeant, losing his temper at the slightest provocation and swearing at both singers and musicians in a way that is now almost completely unknown, except perhaps among some of our modern imports from La Scala in Milan. The musicians even insisted upon being paid overtime whenever they had to attend one of the master's rehearsals, so as to make up for the insults flung to them in a delightful mixture of Viennese and Parisian billingsgate. Finally the *Herr Kapellmeister* gave up the uneven struggle and went back to Vienna to die, leaving the warfare between Italian and French and Austrian music to continue for another half-century, not only in Paris but in every city from St. Petersburg to Madrid and wherever a few poor Italian singers and musicians and directors were trying to make enough money to spend the rest of their days in their native cities, swapping endless scandal about the courts for which they had worked and assuring each other that there was only one country—*la nostra Italia*—that really cared for the greatest of all musical forms of expression, the *bel canto* of a young and fresh Neapolitan voice which was all tone—all tone and no nonsense about declamative or dramatic effects—just a limpid, luscious tone!

From this lengthy discourse you may well decide that the seventeenth century was interested only in one thing—opera. Hardly that. The people went on living their lives very much as they had always done. But the operatic craze of the Baroque period accomplished one thing for which we may well be grateful. It made the world "music-conscious," as we would say today. It took music out of the church and the private concert hall of the rich. It sent music marching down the highways and byways. It made muleteers hum popular airs as they drove their obstinate charges down the dusty roads of Tuscany or

when they baked themselves in the pleasant sun of Naples. It invited the young gentlemen in Oxford and Cambridge to try their hand at Henry Purcell's charming melodies. It made even the Germans forget their contrapuntal exercises and the miseries of the dreadful Thirty Years' War to listen to an occasional tune of Reinhart Keiser, who started giving his operas in Hamburg just in time to teach young Handel something about the art of composition when he came to that city in the year 1703.

It encouraged thousands of enthusiastic young men and young women everywhere to learn to play the fiddle or the harpsichord or to learn how to sing, that they might spend the long rainy evenings of their northern clime improvising a *Night at Versailles*, when everybody did his best to sing and play as if he were acting right under the eyes of the Grand Monarch himself. It encouraged a large number of small German potentates to erect opera houses of their own where they could pretend (for the moment at least) that their own courts were in every way as important and as glamorous as that of their mighty cousin on the other side of the Rhine.

For music lent itself best of all to that sort of happy pretense. No one had money enough to build himself another Versailles as the concrete expression of his royal prestige. No one could hope to have his kitchens attended to by culinary experts like the Chevalier de Béchamel, the superintendent of King Louis' household and a most worthy successor to that unfortunate Vatel, the *maître d'hôtel* of the Prince de Condé, who threw himself on his sword because the fish he had ordered for a dinner given in honor of the King failed to arrive on time.

But everybody could somehow squeeze enough taxes out of his loyal subjects to maintain a band of underpaid German musicians and a troupe of picturesque although equally underpaid Italian singers. When this had gone on for two or three generations there was a very decided change in the popular attitude toward the arts. Until the end of the sixteenth century, the painter had always been the center of interest. After the beginning of the seventeenth century, the musician took his place, and he has held it ever since.

# Rococo

*The inevitable reaction sets in. After a century of artificial stateliness,
the world now strives after a new ideal, and little children are taught that
there are only three important things in life—to be natural,
to be simple, and to practice charm.*

THE MUSIC TELLS THE STORY. The era of the Rococo reminds one of
a minuet by Boccherini or Mozart's *Kleine Nachtmusik*. It was that
period of time between the death of Louis XIV in 1715 and the exe-
cution of Louis XVI in 1793 and it gave us the last of the *grands styles*,
not only in painting and architecture and music but also in the art
of living.

For styles are always born out of a unity of feeling on the part of
the whole of the civilized world. The French Revolution destroyed
whatever remained of the medieval concept of a united Christendom.
It proscribed internationalism as a foolish dream of impractical weak-
lings and gave us that particularly narrow and arrogant form of
nationalism that has turned every European nation into an armed
camp. And as a result, ever since the days of the Revolution we have
had a large number of local fashions but not a single universal style.

I am afraid that by and large the Rococo has never had a very fair
deal at the hands of our historians, for I am convinced that far from
being an age of frivolity and folly and superficial charm and extrava-
gance, it was in many respects the most thoroughly civilized epoch of
all history. The final and terrible collapse of this noble dream of
human rights and opportunities has made many people speak of the
age of the Rococo as if it were merely a very delightful but completely
futile intermezzo, during which a few well-meaning but completely
ineffectual ladies and gentlemen spent their time listening leisurely
to the music of Mozart and Gossec or discussing the woes of the poor
and bewailing the fate of the little servant girl who had broken her
mistress's favorite Meissen cup and saucer.

That is merely a convenient caricature drawn years later by those
who hoped that the terrible lessons of the Revolution had definitely
cured the world of putting too much faith in man's ability to cure

ROCOCO

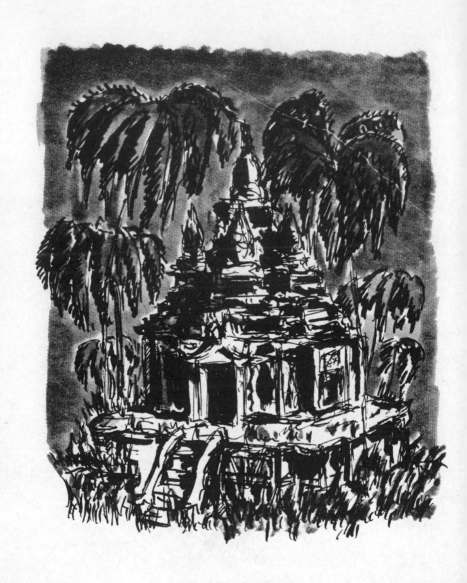

THE INDIAN SHRINE

himself of all his ills by an application of common sense and by what the philosophers of the eighteenth century called "enlightenment."

These critics, however, overlooked one fact. It was the very "humanity" of the people of the Rococo which caused their downfall. Had they been a little less enlightened and had they been willing to shoot down just a few of the ringleaders (feeling sorry for them perhaps, and pitying them on account of their lack of opportunities) there never would have been any Revolution at all. That puts us face to face with the question: What so completely changed the mentality of the upper classes that as a class they seemed completely willing to commit suicide for the benefit of another one? What or who started them so unceremoniously on the road to the gallows? There never has been a movement without a leader, but who was that leader who persuaded these men and women to substitute an illogical and unreasoning "sentimentality" for those well-balanced and practical "sentiments" which had inspired them to undertake the gigantic task of recreating our civilization upon a basis of "liberty, fraternity, and equality"?

The name of the man guilty of all this was Jean Jacques Rousseau. Like Saint Francis, almost six hundred years before, he put his mark so unmistakably upon the art of his day that he has to have a little space of his own, though I hate to give it to him.

Rousseau was a native of Geneva, that forbidding city in western Switzerland in which, two centuries before, Dr. John Calvin had established his new Zion. His father was a German watchmaker. His mother, who died at the time of his birth, was the daughter of a minister. Rousseau, like John Calvin, was never quite well. But their everlasting discomforts affected the two men in an entirely different way. They convinced Calvin that man was a pretty sad citizen, had started out all wrong, and probably never would amount to much. Rousseau held to the exact opposite. Man had started his career upon this planet in a state of natural virtue and goodness. Then he had gone wrong, for he had tried to civilize himself. Civilization was therefore at the bottom of all our ills. But Master Rousseau was there to show man the road back to his former perfection. It will be interesting to note briefly by what means Jean Jacques tried to accomplish this ideal for himself.

Brought up in a most haphazard way, snatching at little scraps of education as they came his way, the boy at first lived a hand-to-mouth existence as a law clerk, an engraver's apprentice, a flunkey, a student in a religious seminary, a hobo, secretary to a Greek archimandrite,

a music teacher, a musical copyist, a student of chemistry, a gigolo, a private tutor, the inventor of a new way of writing verse, secretary to a French ambassador to the Republic of Venice, a composer of operatic airs, and an irregular contributor to the famous French Encyclopedia. Yet he must have had something, for he ended up as the most powerful and influential publicist of the same century that gave us Voltaire.

As for the private character of this extraordinary creature, the less said the better. He twice changed his religious beliefs, both times inspired solely by the hope of private gain. While serving as a footman, he escaped imprisonment for theft by falsely accusing an innocent girl who worked as a cook in the same establishment in which he buttled. He engaged in a very unpleasant love affair with a scatterbrained female to whom he acted as secretary and gigolo, and cheated her scandalously. To balance things, he himself was most ludicrously fooled by a French servant girl with whom he lived for many years. Every time he threatened to leave her, the wench's mother told him of the arrival of a new baby which she had quietly taken to the nearest foundling asylum that the great man might continue to work without being disturbed by the howlings of his infant sons. None of these children were ever born. They were merely invented to blackmail Rousseau into giving further support to mother and daughter. Yet under these hopelessly unfavorable circumstances he was able to turn out a book that was accepted as the Bible of a new form of education by all those who believed that "enlightenment" alone could set mankind free from its ancient bondage. And while a sentimental world wept over his *Émile* and his famous *Confessions*, Rousseau spent his days denouncing Voltaire, who had been his most generous protector in the days of his need, or writing the most scathing letters to Frederick the Great, who had come to his assistance when he was destitute. He publicly told His Majesty to keep his filthy lucre which he had sweated out of his long-suffering subjects, but privately this lover of mankind would accept these gifts when nobody was looking.

He got in trouble with the French police, fled to England where he had been most hospitably received by Hume, the Scottish philosopher, and derived great personal satisfaction from depicting his benefactor as a menace to society. When a kind-hearted Swiss woman, who for years had let him live in one of her villas, went to Geneva for a visit, Rousseau repaid her generosity by hinting to all the world that "they probably knew the reason why."

In short, it will be difficult, within the whole realm of scoundrels, renegades, and liars of which history has so kindly preserved the record, to find a more perfect example of an all-around blackguard than this apostle of the new gospel of kindness, goodness, simplicity, morality, and virtue.

Voltaire, who even after his unhappy experience, continued to befriend the ungrateful wretch, was probably right when he summed him up as follows: "Poor Rousseau should have a blood transfusion, for his own blood is a mixture of arsenic and vitriol. He is the most unhappy of human beings because he is the most evil."

And yet this contemptible bounder became the most popular author of his time. For almost half a century he was the dictator who dominated the entire realm of politics, education, art, and morals. Why? For such people do not just happen. Because he preached the one thing to which a society that had lived a completely artificial existence until it could hardly bear the strain was not only ready but most eager to listen. He proclaimed the return to what was supposed to be "a natural life." The fashionable ladies and gentlemen who had gone to all the parties, eaten all the dinners, tasted all the rare vintages, been to all the first nights of all the new plays, listened to all the new operas, watched all the new ballets, not just for a year or a couple of years but for almost three generations, now experienced a completely unexpected thrill from doing the exact opposite of everything they had done for the last three generations. Rousseau was their guide, philosopher, and friend. No more parties in the overcrowded anterooms of Versailles but quiet evenings spent listening to the tunes of a shepherd's flute, happy afternoons associating with those unspoiled children of nature who dwell in rustic bliss in some simple little cottage, simple meals of dry bread and milk, eaten by the side of a babbling brook.

You can observe that sudden revulsion of feeling in the paintings and engravings of the period. Music does not change as easily as the graphic arts, for it takes a lot of time to break away from one musical tradition and to lay the foundations for another sort of composition. Therefore the new composers, such as Rameau, Leclair, and Daquin, continued to compose in very much the same style as the contemporaries of Lulli had done. But the painters and engravers created an entirely new sort of art—the art of the Rococo.

Just as Monteverdi was able to give us the modern orchestra because when he reached his own maturity the Cremona fiddle makers were ready to provide him with the sort of instruments he needed for his

elaborate ensembles, so did the painters of that period find a most welcome ally in a new medium eminently suited to the sort of work they were supposed to do. This was pastel. When it first appeared on the market it was called "crayon" but it was not really a pencil. It was pigment in its almost pure original form with just enough gum to make it stick. It suffered from one great disadvantage. It does not last and it is easily wiped off. It can be "fixed" with a fixative but such a fixative is apt to dull the colors, and the advantages of pastel lie in the charming color effects one can achieve with much less trouble than when one works in oil.

Pastel was not exactly a new invention. Something much like it had been used as early as the seventeenth century. But it did not come into its own until it was taken up by the French artists during the latter half of the eighteenth century and then for a while it almost eclipsed oil.

Incidentally, pastel gives us a chance to mention at least one Swiss artist, one of the very few, for these honest mountaineers have contributed very little to either music or painting. But one of the greatest pastel virtuosi, Jean Étienne Liotard, was a Swiss. He was called the "Turkish painter" because after a visit to Constantinople he always went about in Turkish garb. His popularity among Americans is due to the fact that his famous pastel of *The Chocolate Girl*, now in Amsterdam, was one of the first serious works of art to be used for advertising purposes. For the rest, we ourselves see very little pastel. It is lovely stuff to work with but very delicate and not at all suited to our modern tempo of living and working and getting things to the lithographer in a hurry.

As for French painting in general, it went through exactly the same struggle as French opera. There were those who preferred the Italian school and others who supported the purely native school. There was even a war between the two groups, greatly resembling the War of the Buffoons. With the Frenchmen's proverbial indifference to geographical details, the followers of the Italian school were called Rubenists (something which would hardly have pleased that sturdy Fleming) while the native painters were denounced as the Poussinists, after poor Nicolas Poussin, who had been in his grave for almost a hundred years. The Poussinists came out on top, and after the middle of the eighteenth century the French artists could paint as they pleased and were no longer obliged to imitate their Italian contemporaries.

Of course, in judging the art of that century we should remember that the last fifteen years of Louis XIV were very different from the

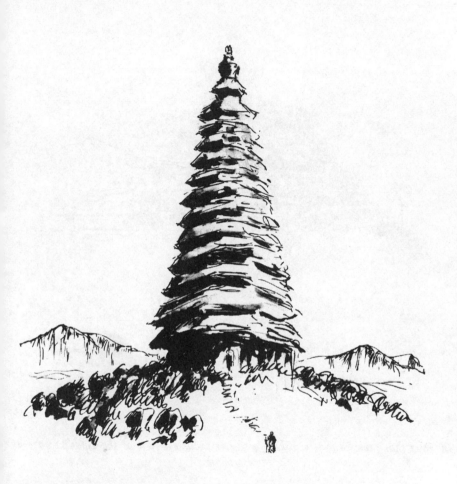

*In China the stupa became a pagoda.*

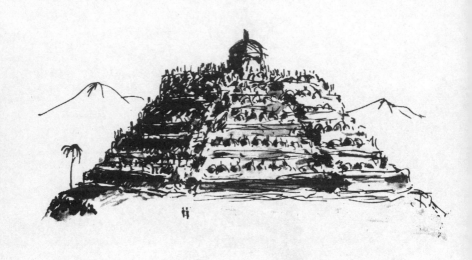

*In Java that same idea of building a shelter around a relic of the Buddha gave us the Borobudur.*

previous fifty. Under the influence of his wife, the old King became quite serious and a strange, almost Puritan quiet had descended upon the Palace of Versailles. The Italian opera singers were banished and those composers who wished to gain the royal good will had to devote themselves strictly to the writing of solemn masses and requiems. At the same time the painters received a hint that His Majesty had come to prefer large and elaborate battle scenes to the portraits of those lovely ladies who only reminded him of the less edifying days of his youth.

The French as a nation might pretend to approve of these serious tendencies at the court but when His Majesty finally gave up the ghost, they wept no tears but went forth to see the fireworks. But because Watteau, Lancret, Boucher, and Fragonard then burst forth with whole rafts of pictures full of color and gaiety, showing groups of laughing men and women, we should not rush to the conclusion that all of France now went on a sort of moral spree. The great mass of the people were very little affected by all this. They had looked upon Versailles as a magnificent show but they did not intend to let it affect their own home life. And even those on top had a sort of innate cultural reserve which prevented them from ever becoming offensive even in their least edifying moments.

Of course, those who insist that the good Lord, after he had created man, disapproved so mightily of his own handiwork that nothing must ever be shown of the poor creature except his face and his hands, will derive little satisfaction from Rococo art. They can, however, console themselves with the still lives of such masters as Chardin and with the sweet and innocent little girls (with and without broken pots) and the family scenes (with or without tragedy) of Greuze.

But in all these pictures, regardless of who painted them or what they represent, we can observe something of which I have perhaps made more of a point in these last few chapters than space warranted —the tremendous influence the long reign of Louis XIV had exercised upon every detail of life. The peasants and laboring men and their women of the sixteenth century had been ugly, ungainly brutes, dumbly staring at nothing in particular. But these same people in the works of the eighteenth century have attained a certain air of elegance. They still live in very simple, bare rooms, but the kitchen utensils around them and the tables and chairs have been fashioned after a good model, the clothes they wear are in a cottony sort of way a reflection of the lovely silken fabrics of the court. In short, there is more difference between the people of 1650 and 1750 than between those

of 1650 and 450, just as there is more difference between the interior decorations of an American home of 1937 and that of 1907 than there is between a home of 1907 and one of 1707. And this change was undoubtedly due to the influence of the royal court, just as in our own case the intelligent merchandising men of our big department stores have brought about the immense improvement in our popular taste which is so characteristic of the last thirty years.

In order to appreciate Rococo at its best we should not judge it primarily by its pictures or by its architecture, but rather by what it did in the field of interior decoration. The interior decorator had had little chance to show his ability as long as his customers spent all their time in the vast reception halls of their Baroque mansions. But the very name Rococo indicates something small and intimate. A *rocaille* was a shell and the word Rococo therefore was at first connected with the charming little gardens that replaced the older parks and in which one found small artificial rock gardens and narrow little lanes full of pebble work. When these made their appearance, they did so as every new style has done, abruptly and without any noticeable period of transition. Overnight it seemed that the older type of architects like the Tessins (who between 1700 and 1760 built that enormous royal palace in Stockholm that is one of the show places of the Continent) disappeared from the face of the earth, and then their places were taken over by other men just as able as their predecessors but possessed of an entirely different mentality, men who no longer saw houses as enormous façades meant primarily to impress the community at large but as a collection of rooms in which people were supposed to live pleasant and attractive lives without any undue desire for the admiration of the mob.

Because they were primarily interested in creating an intimate atmosphere, all their attention was centered upon the details of the interior, upon the way the walls were handled, upon the right use of mirrors (so as to make the rooms look brighter by candlelight), upon the cups and saucers and plates and the soup tureens the porcelain factories of Vincennes, St. Cloud, Sèvres, Meissen, Nymphenburg, Vienna, and Frankenthal were now turning out in happy rivalry with their English competitors from Chelsea, Derby, Bristol, Plymouth, and Staffordshire, the home of the Wedgwoods.

After they had attended to these, there were the spoons and forks and, above all things, the coffeepots, for the coffee bean had at last conquered the world and was now fighting a merry fight for suprem-

acy with its Mexican colleague, the cocoa bean. And when that had been accomplished, they could devote themselves to candelabra and chandeliers, for this was an age of essentially social people who sincerely enjoyed each other's company and who could spend a completely happy evening looking at the engravings of Daniel Chodowiecki, the Pole, or Hogarth, the Englishman. And many of them even went so far as to devise patterns for those satins and silks and cotton materials that lent themselves so exquisitely to the new sort of fashions, in which the heavy woolens and brocades of the Baroque period were replaced by a style that before all other things insisted upon a natural appearance and made a fetish of charm.

If it is the duty of all the arts to contribute to the ultimate and highest of the arts, the art of living, then the Rococo period came as near to perfection as any age either before or afterwards. The grave mistake—for an unconscious mistake is just as fatal a blunder as one committed on purpose—the error of judgment which finally destroyed this lovely house of cards was due to the complete disregard of these good people for even the most rudimentary principles of economics. They failed to realize, what we ourselves have only begun to suspect very recently, that no society can hope to survive when it is one-tenth rich and nine-tenths poor. In the case of the Europe of the eighteenth century, the proportion was even worse. And the gradual development of a rigid rule of caste, making it impossible for anybody of good birth to work for his daily bread and butter, doomed one part of the community to eternal drudgery while it condemned the others to a fate that was even worse—the slavery of an enforced idleness.

The final collapse of the world of the Rococo is known to all of us. Those same ideals of liberty, equality, and fraternity with which the polite people in their lovely Rococo parlors had toyed for almost half a century without ever taking them very seriously, those same ideals finally found their way to the basement where in obscure misery there lived those other millions who had been born to contribute to the comfort and happiness of their betters. And these others—these denizens of the kitchen and the scullery—they took the ideals seriously. Until one day the world of the Rococo was so rudely shaken out of its delightful complacency by a declaration of independence on the part of the farmers and merchants of a distant wilderness that it also tried to make some sort of reparation by issuing its own declaration of the rights of men.

But it was too late. The explosion had become inevitable.

# Some More Rococo

### The eighteenth century in the rest of Europe

Tradition are not easily destroyed. King Louis had made his capital the center of the arts but millions of people still felt that in order to be really good, their music and their paintings should come from Italy, just as today, in spite of an enormous amount of proof to the contrary, our women will insist that unless their clothes bear a Paris label, they are not really quite what they should be.

Hence when one fiddled or sang or composed operas, it was good policy to affect a vague sort of Italian atmosphere. Hence Heinrich Roesslen from Pfurzheim would disappear from his native haunts for a little while and would then suddenly bob up in the Dresden Opera House as the distinguished tenor, Signor Enrico Rossetti of Napoli. While simple Wilhelm Müller, whose father had played the trumpet in some obscure *Stadtstheater*, would astonish his family by beautifully printed programs which announced the forthcoming concert of Maestro Guglielmo Mullivari, fresh from his triumphs in the Teatro San Cosimo di Venezia.

But these were harmless little vanities that you can still observe this very day whenever the Metropolitan Opera Company publishes its list of singers engaged for the coming season. Of course, opera singers being what they are, the most quarrelsome people ever gathered together under the same roof, there was always a great deal of friction between the dear ladies of Teutonic and those of Latin origin. And in every city there were always groups of excited citizens who amidst veritable oceans of coffee would hold violent discourse upon the supposed talents of their favorite Giulias or Elisabeths.

A first-rate fist fight in the Café de la Régence between the Piccinnists and the Gluckists, during which the contestants lambasted each other over the head with chessboards—that was surely good for at least ten lines in the *Mercure de France*, and ten lines in a journal that had a circulation of almost thirteen thousand copies was a marvelous piece of free advertising. But on the other hand such incidents must not be overdone, for the really valuable and solvent patrons of the arts were not very fond of such "unnecessary noise," a term by which

until very recently they referred to every form of advertising. And so, by and large, the painters and fiddlers and singers and even the architects, although they might not like each other, lived very much apart from the rest of the world in a sort of independent Republic of Arts and Letters—a commonwealth that had its own laws, its own customs, and its own manners, but that has long since ceased to exist except in a few of the less savory suburbs of Paris.

In the eighteenth century this unity of interests had not yet been destroyed. Hence the last universal style, that of the Rococo. Hence a continual shuffling and reshuffling of all those painters and musicians which accounted for the fact that some of the best-known Frenchmen, like Alexandre Roslin and Nicolas Lafrensen (known in Paris as Lavreince) were really Swedes, that Liotard, another Frenchman, was a Swiss, and that Handel and Johann Christian Bach, who completely dominated the English musical life of the eighteenth century, were Germans. I could give you many more examples but these few will be enough to give you a picture of a world in which an artist was asked, "What can you do?" rather than, "Show me your passport."

And now a short review which will carry us from country to country in this period of enormous artistic activity. First of all, there was architecture. Contrary to what one would expect, there are many more buildings in the Rococo style outside of France than in France itself. Versailles too completely dominated the world of the French to leave room for any other style. And as every nobleman was obliged to spend at least part of the year at the court, he rarely had money enough left to do some building of his own.

In Austria, on the other hand, there was not only an emperor who was immensely rich but there also was a group of landowners who lived far away from the imperial court and whose estates were so enormous that if they wanted to,they could easily have outbuilt their Hapsburg masters. Not that the Hapsburgs were amateurs when it came to erecting those buildings they thought necessary to keep up with the Joneses from Versailles. By no means! Within a very few years there arose out of the ashes of a little hunting lodge, burned down by the Turks during the siege of 1683, a comfortable imperial country house which contained 1441 apartments and 139 kitchens. An Italian by the name of Niccolò Pacassi drew up the plans for this bagatelle of Schönbrunn. He was a good patriot. He made it just a few feet larger than Versailles.

Once it had got off to a flying start in Austria, the Rococo style became more popular than any other. It seemed somehow to suit the Austrian temperament. Even the Church in this intensely devout country fell under the spell of the new architecture. As soon as they could conveniently do so, the Austrian bishops and archbishops (who as a rule were quite as rich as the nobility) bade farewell to the heavy and ponderous traditions of the Baroque. They began to add such definitely Rococo details to their churches and monasteries that the visitor would not be in the least surprised if the cheerful-looking cherubs of the ceilings and balustrades should suddenly drop all further pretense of being what they are and indulge in a little minuet by Papa Haydn and dance most charmingly for the benefit of the delighted Christ Child and the stately saints on the high altar.

All through the valley of the Danube and all through southern Bohemia, from Jakob Prandauer's Benedictine abbey in Melk to the church of St. John which the Asam brothers erected in Munich, we find traces of that same lighthearted luxury mixed with a most genuine devotion which is so typical of the Catholic mentality of that fortunate part of the world. Pilgrims from the north sadly shake their heads and murmur that people who can derive spiritual satisfaction from such surroundings cannot possibly be good Christians. But those who remember that the Christ was capable of great gaiety (as all those who love children must necessarily be) will hardly be able to share this view. They will realize that a great deal of the music of Mozart was originally written to be played in just such an environment. And was there ever a better approach to the divine than that final requiem which burst into life as the master himself sank into a welcome death?

Somewhere in the beginning of this book I defined "mud" as being "matter out of place." The same holds good for the arts. Rococo in Austria, although one knows that it was imported from abroad, never gives one a feeling of being something that does not really belong where it is. For it plays a definite role in the national philosophy of life. Indeed, it may well be the Rococo spirit that has made Vienna survive in spite of all the mutilations it suffered at the hands of the terrible old men of Versailles. Just as I sometimes feel that the success of the Viennese waltzes and the Viennese operatic tunes, which have captured the entire world, is due to some spark of that Rococo gaiety which must have entered into the souls of Johann Strauss and Franz Lehár. Call them sentimental and lacking in depth and anything you

please and I will immediately agree with you. But the age of the Rococo, too, was sentimental and lacking in depth and this may well account for its universal and enduring appeal. Most human beings, of course, are rather sentimental and are very often lacking in depth. And so the two understand each other. They fit in with each other's virtues and shortcomings. At least, they do with mine. But it must be that vague drop of southern blood in my veins that makes me say this. As a good Dutchman I should never make such a confession. Imagine poor Vincent van Gogh drinking chocolate out of a lovely Frankenthal cup and not feeling ashamed of himself—drinking chocolate—not because he was hungry or thirsty but just because it is so pleasant to drink chocolate!

> Life is real! Life is earnest!
> And the grave is not its goal;
> Dust thou art, to dust returnest,
> Was not spoken of the soul.

What about Rococo in other lands? In Germany one can more or less accept it. The palace of Sans Souci in Potsdam, built according to the plans of Frederick the Great himself, in co-operation with his architect, Von Knobelsdorff, still bears some relation to its environment, and what his sister, married to one of the most notorious boors of all history, built in and around Bayreuth also had some value. The Saxon electors, always with one eye on the Polish throne, were of course obliged to follow the example of their potential allies and moneylenders, the French kings, and when Louis XVI added a little Rococo to his Versailles, they had to do likewise.

But the moment you leave Europe and cross over into the great Russian plain, Rococo becomes an absurdity, for here there was no possible connection between the buildings themselves and the soil on which they were being erected. Here everything bore the stamp of something "made abroad." When Peter founded his new capital on the Baltic Sea, he may have intended to turn it into something like Amsterdam where he had spent so many pleasant and instructive days. But His Majesty was a notoriously bad payer when it came to salaries he had promised to those willing to follow him into his distant wilderness. Few Dutchmen could be persuaded to leave their native marshes for those of the Neva. And so the work of laying out St. Petersburg was entrusted to a Frenchman, an Italian, and a German.

They found themselves in a country in which there were no arts in the European sense of the word. The only painters were those icon

makers who continued to work according to the best Byzantine traditions of hundreds of years before. Sculpture was completely unknown, for a nude statue would have been regarded with very serious suspicion by the enlightened Muscovites who only recently had drowned the first bell that had come to their country, suspecting it of being the voice of the devil. Peasant embroidery was the only native art of any value. But all this did not for a moment discourage the great Peter in his attempts to bring his country into line with the rest of the world. His first artistic gesture was the erection of a Russian Gobelin works, founded in St. Petersburg in 1717. This was followed by an imperial china factory. There were other plans but they never materialized. The natives were either lazy or indifferent. Thereafter when there was need of a painter or sculptor or architect, he was simply imported from abroad.

Among those immigrants there was a Florentine by the name of Carlo Bartolommeo Rastrelli. He was a sculptor who had learned his trade in Paris. He had a son, Bartolommeo Rastrelli and it was this son who was responsible for most of the large buildings erected in Russia during the eighteenth century—the Winter Palace in Petersburg and the Summer Palace at Tsarskoe Selo and many others.

These two Italians were the first of a long line of artistic adventurers who found their way to the land of the Slavs. For the Russians showed little inventiveness when it came to architecture. They had tolerated the monstrosities of Ivan the Terrible. They now tolerated the Baroquian-Rococo of Peter. But then, they will apparently stand for anything that anybody gives them. Their everlasting excuse is their youth. They are only just beginning. Suppose we let it go at that. It is the most charitable view to take.

In England there had been a curious development. During the first half of the seventeenth century, the court (except for Charles I and his Queen) undoubtedly had been completely immoral and hopelessly inefficient. But it had had a great love for beauty. The more serious-minded Englishmen therefore had begun to associate the idea of beauty with corruption, immorality, and inefficiency. They forgot that a great love of beauty is just as often accompanied by great nobility of character, by industry, and by a decorous way of living. They only knew that they disapproved of their King and all his works, and once poor Charles (the innocent victim) had been removed, they decided that there must be no repetition of such a state of affairs, and in order to prevent a return to the old order, the Puritans put a ban

upon everything that appealed to the senses. Henceforth the road to salvation must be plain and straight so that everyone at all times could see where he was going. Beautiful buildings and lovely pictures and statues were apt to obscure the view. Therefore away with them and let things be done in a simple, honest, and Christian fashion.

Fortunately the craftsmanship of the English carpenters and stone-masons was of so high an order that they continued to put considerable beauty into the houses they built and the furniture they made, even when they were supposed not to do so. But those arts that were not immediately useful went into a complete state of eclipse. Once again, as in the old Judea, the civilization of an entire nation centered around a single book and once more it was the Old Testament. Jehovah had frowned upon all foreigners. Therefore the Puritans did likewise. The Flemish and Dutch and French and German artists who during the last hundred years had made such an excellent living in England packed their easels and disappeared. A few local painters of no particular ability tended to the needs of the Puritan market. Occasionally there was a demand for the portrait of some great leader. That was all.

However, in one respect this period of neglect was really a blessing. Under the early Stuarts there had been a great deal of building that might just as well have been omitted. This has been due to the irre-pressible enthusiasm of one very great man, who had put his stamp upon all the architecture of that period (the first half of the seven-teenth century) and who in his love for everything Italian had hoped to turn his native land into another Tuscany.

His name was Inigo Jones. He was born in 1573 and he died in 1651. He was the son of a London clothworker and was apprenticed to a joiner, which in those days was a sort of superior carpenter, a maker of fine pieces of furniture. A rich nobleman saw some of his drawings, thought that the boy had talent, and sent him to Italy to study landscape painting. But he soon discovered that he was really much more interested in architecture than in painting, and so he proceeded to Venice. While there he discovered Andrea Palladio's famous handbook on architecture which had been published in Venice in 1570, and thereafter he became one of the great prophets of that new style which was intended to reconquer the world for the ideals of ancient Rome.

His first big job took him to Denmark where he erected the royal palaces at Frederiksborg and Rosenborg for King Christian IV. These finished, he returned to his native land where in 1612 James I ap-

pointed him surveyor general of all the royal buildings. His devotion to his classical ideals is perhaps best of all shown by the report which he wrote at the request of his royal master in the year 1620 upon the origin of Stonehenge. He conclusively proved that this old Celtic monument was really nothing but a Roman temple!

As was to be expected of a man so completely filled by one single idea, everything to which he turned his hand must assume at least the outer appearance of being Italian rather than English. When Charles I asked him to draw the plans for a new royal palace, Jones obliged by giving His Majesty the outlines of a vast structure to be done in the style of the Italian Renaissance. There were to be seven enormous courts and everything was to be on truly Roman scale. Unfortunately, after the first part had been finished, the banqueting hall of that Whitehall which still stands, several things happened to prevent the completion of the building. First of all, the King went bankrupt. Next the Great Rebellion, with a grim sense of humor, made His Majesty pass out of one of the windows of his own new palace to have his head chopped off.

As Inigo Jones had also arranged several of those masks which had always been so popular at the court of the Stuarts, the poor fellow was anathema to all good Puritans. They accused him of having been a "courtier" and he only escaped death by paying a very heavy fine. Having in this way lost every cent he had, he died in complete poverty in the year 1651.

But that was not really the end of his misfortunes. In September of the year 1666 the great London fire destroyed almost everything he had built during the previous thirty years. This fire, incidentally, would have been of great benefit to the worthy Londoners if they had been willing to listen to their King. For as soon as the ruins had cooled off he had asked a famous mathematician and astronomer by the name of Christopher Wren to draw up the plans for an entirely new city, built along modern and intelligent lines and doing away with all those crooked little streets that were an everlasting fire menace and shortened people's lives by depriving them of enough fresh air and sunshine. But these careful London shopkeepers would not hear of such a thing. Everything had to remain as it had always been. All the crooked little old streets and lanes had to be reconstructed just as they had been before the fire. Christopher Wren, who had now definitely deserted astronomy for architecture, was allowed to draw up the plans for a great many new churches, provided they would be rebuilt on the exact spot where they had always stood. This will

explain why, during your first visit to London, you experienced such great difficulties in locating most of Sir Christopher's masterpieces. Apparently you never discover them until you bump into them. They would have looked a hundred times better if they had been given a little space. But that is not the way they had built in the Middle Ages. Why build them that way now?

Even St. Paul's Cathedral, the work by which Sir Christopher is best known and which he rebuilt on the wreck of the older St. Paul's of Inigo Jones, is completely suffocated by the surrounding buildings. As for its interior and its general outlines, the building has so completely become part of English history that it is difficult to submit it to a criticism of a purely technical nature. It has a noble façade with a well-balanced arrangement of pillars and porticoes. But the two towers suddenly develop into some sort of Cambodian pagoda and there are other details not quite as satisfactory as they might be. However, the building is by no means as depressing as St. Peter's in Rome, and the interior is infinitely more restful than that of most other large cathedrals.

As for the other works of Sir Christopher and his contemporaries, such as the brothers Adam (John, Robert, James, and William), they still stand, and having been most solidly constructed, they are sure to stand for quite a long time to come in a country which has such profound respect for its traditions. They can best be studied in a number of vast and highly imposing country houses. For if Disraeli in the eighteen-thirties could say that England was a country "of the few— the *very* few," this was even more true of the England of the eighteenth century. Blenheim (the palace built for the Duke of Marlborough by a grateful nation), Hampton Court, and whatever their name—all have one thing in common besides their slightly Renaissance outer aspect: They were built to give expression to the political and economic power of their owners.

For this purpose the occupants were entirely willing to sacrifice their private comforts as well as that of their servants. In several of these famous mansions, when it was found that the servants' quarters in the attic would interfere with the lines of the roof, they stabled the poor wretches in the cellars. But they themselves were hardly better off in their vast and drafty halls, surrounded by all the lovely chairs and sofas and tables made exclusively for such privileged persons by the Chippendales, the Hepplewhites, and the Sheratons, and a great many of them constructed according to the specifications of Robert Adam, who was not only a great architect but who knew as much

about the carpenter's craft as the most experienced woodworkers of his day.

Now let me add something very curious and very typically English. While all this building in the new style went on—a great deal of Renaissance, a bit of Baroque, a few direct copies of the old Greek, and a dash of Rococo, the English as a race continued to have a very decided preference for that style to which they had been accustomed for almost half a thousand years—the Gothic of the Norman times. In consequence whereof England became the only country in the world in which Gothic continued as a living force and did not descend into something outmoded and outdated. Even today the English can live in the midst of such Gothic surroundings without making you feel that there is anything incongruous about this combination of the old and new.

It is a strange country. Perhaps it is so essentially logical that it strikes the rest of the world as completely illogical. For example, why at that precise moment should England suddenly have produced so many great painters? During the seventeenth century all the painting and most of the sculpturing had been done by foreign artists. Comes the eighteenth century and suddenly there are Reynolds and Gainsborough and Romney and Hoppner, ready to paint the portraits of all the loveliest women of that age and of all the most distinguished-looking men of that distinguished-looking era.

There is Hogarth to render a public and highly moral service (that, at least, is what he himself thought of his work) by depicting the wickedness of the society in which this strange pictorial Cervantes was born and lived his long and industrious life. There were Wilson and John Crome, the founder of the Norwich school which went in so strongly for water color, and finally there were Constable and Cotman and Turner, who gave the world an entirely new ideal of landscape painting. Turner, of course, does not really belong to the eighteenth century, for he was born in 1775 and he did not die until 1851. But although he lived long enough to give us about the only picture of a railroad train that reveals the soul of that useful monster, he was still essentially a man of the eighteenth century in his intense love of the soil of England.

And I think that there we have touched upon the very heart of the problem of all English art. The Englishman, once he has left his unspeakably ugly cities and industrial centers behind him and has reached the country, finds himself in one vast park, the like of which I for one have never been able to discover in any other part of the world. God

knows, I love our Connecticut hills and our old farmhouses, which were constructed by such faithful craftsmen that even the Massachusetts divines could not deprive their handiwork of its appeal to our sense of proportion and harmony. But England has achieved that which we ourselves may only hope to do in another thousand years. The English landscape, to borrow an expression from the musicians, the English landscape has been thoroughly *durchkomponiert*. It is no longer as the good Lord jotted it down when he rather hastily tried to create an entire universe in only six days. It has been revised and re-revised by every subsequent generation. At times it has been re-written as a courtly madrigal or a Puritan dirge. Queen Bess has danced across its greens in her red-heeled little slippers and Cromwell's men have trotted their heavily shod horses down its country lanes, chanting their gloomy psalms.

But generations after generations of men and women have lived here and have died here and have come back to this spot after exploring every nook and corner of the universe. This love for the soil seems to have affected the entire landscape. It acquired an inner spirit of its own, but that inner spirit seems to lend itself more easily to a literary expression than to a pictorial one. All other nations, the French and the Germans and the Italians, have produced poets and literary men of the very first rank. But Englishmen took to the writing of verse with the same ease with which the Hollander painted his pictures or the German wrote his music or the Frenchman designed a new fashion.

Nations are very much like children. Give each one of a number of children a quarter and one will spend it on candy, another will put it in the bank, a third will buy a ball, and a fourth will use it for the movies. Give each one of a dozen nations an equal amount of talent and one will squander it on painting, another on music, a third one on poetry, a fourth one on religious disputations, and a fifth one on the perfecting of its code of laws. It seems a very intelligent and interesting way of doing things.

A Goethe, a Rembrandt, a Johann Sebastian Bach, or a Mansard was a very useful national asset. But was anything the matter with Mr. Will Shakespeare?

# India, China, and Japan

*Europe discovers that it can learn a great deal
from these very unexpected quarters.*

I AM JUST OLD ENOUGH to have seen the tail end of the great Chinoi-
serie. When I was very young one would still occasionally find
one of the pretty little teahouses that stood by the side of a lovely road
on an even lovelier canal and that had been built in the best Rococo-
Chinese style of the middle of the eighteenth century. To this sacred
spot, so we were informed, our great-great-great-grandparents used
to withdraw on such rare afternoons when it was neither too hot nor
too damp to partake of a walk that must have taken them all of five
minutes.

Once arrived at their rendezvous, they would envelop themselves
in flowing robes of Chinese silk and solemnly partake of very expen-
sive Chinese tea. This was invariably drunk from the saucers of their
very beautiful Chinese cups, for to have drunk it directly from the
cup without first having poured it into the saucer would have shown
that one was painfully ignorant of the way in which the real Chinese
celebrated their tea ceremony. And not to know how things were done
in China was a plain but painful indication of a lack of good breeding.

Except for a few lacquer screens and the Chinese paintings on the
walls, there was little enough left of all this old glory when we ap-
peared upon the scene and used that humble edifice for the storing
of our fishing tackle. But the literature of the end of the eighteenth
century is full of romantic meetings in just such pagodas and they
were a favorite subject with the contemporary painters. It is therefore
quite easy for me to reconstruct this strange episode in the lives of my
very respectable and hopelessly commonplace ancestors. And that
was undoubtedly the reason why they had gone to all this extra ex-
pense. Being respectable and commonplace, they must do what all
their respectable and commonplace neighbors were doing. All of
them were playing at being Chinese. Indeed, the craze was carried
to such an extreme that in the end all these good Dutchmen (and
Swedes and Frenchmen and Danes, for the Chinese wave had swept
all over Europe) were talking to each other in some strange gibberish

that was supposed to have a very close resemblance to the tongue of the Celestial Kingdom—a sort of "allee samee likee soupee" effect which was not unlike the secret idiom we used to invent for ourselves when we were about seven years old.

Yes, that was the tail end of the great Chinoiserie, but it had begun much earlier, going all the way back to the year 1667 when King Louis of France at a court ball appeared dressed up halfway Persian and halfway Chinese and set the new fashion, which thereupon was immediately copied by every minor sovereign on the continent of Europe.

There is no use denouncing this as merely another indication of the snobbishness of the contemporaries of the Great Monarch. We ourselves are just as bad. Because the Duke of Windsor (Edward VIII of England, in case you have forgotten) was very fond of Austria and used to spend part of every winter skiing in the Austrian Tirol and go about in Tirolean garb, all of our fashionable and not-quite-so-fashionable women have now disguised themselves in Dirndl costumes, to the immense benefit of a very obscure Salzburg tailoring establishment. And our men have followed suit and they now wear Tirolean hats and peasant coats and leather pants, as if they had just come down from hunting the chamoix in Vorarlberg instead of having spent the day chasing a golf ball around the local links.

A hundred years hence, the historian who makes a specialty of the cultural development of the twentieth century will be quite as much surprised by the widespread popularity of this absurd *Tirolerie* of the thirties as we are about the Chinoiserie of the thirties of the eighteenth century. Except that in the case of the Chinoiserie there was an additional point of interest for the student of social affairs in the fact that while Europe was going crazy about China, China at exactly the same moment was going crazy about Europe. The Chinese pagodas and porcelain-covered houses of Versailles had their counterparts in the French Rococo palaces which the Emperors K'ang Hsi and Ch'ien Lung ordered to be built in direct imitation of Versailles.

All this, however, as we are now beginning to understand, was no mere coincidence. There was a perfectly good reason for this development. Both China and France were highly centralized monarchies. Both of them were ruled by potentates who hoped to make their capital cities the cultural centers of an entire continent. How thoroughly Rococo, in spirit at least, the China of the eighteenth century was you can see for yourself by looking at the pictures of that time and at the teacups and lacquer work and strangely carved pieces of

ivory and jade. All of them are gay and amusing, very worldly-wise and suggestive of a luxury that did not care how much money it spent or where that money came from, as long as it was there to be wasted. Also they betray a society in which women—and usually women of high spirits and considerable intelligence—dominated the political and social life of the upper classes.

From an economic point of view all this was of course entirely wrong. But it produced a great deal of very lovely art. We still have that art and the men and women who made it would have been dead, anyway. So we might as well accept whatever they gave us and leave the final judgment to Kuan Yin, the Goddess of Mercy, who was one of the most popular deities of a race that has survived longer than any other by carefully practicing a sort of rudimentary tolerance, apparently more effective than gunboats, dynamite, and bayonets.

Unfortunately, our ancestors in their beautiful Chinese draperies were completely ignorant of Chinese history and of everything Chinese. They eagerly accepted whatever came to them from that land of mystery without asking any embarrassing questions. This greatly pleased the wily Chinese merchants of Canton and Ningpo who were beginning to suspect that at last they had found the ideal customers. If these poor despised heathen did not know the difference between a genuine Sung vase and a hopeless modern imitation, why send them the original when the substitute would be just as welcome and would bring just as high a price? In consequence whereof the European market of the eighteenth century got glutted with such vast quantities of third- and thirteenth-rate stuff that it has taken all the scholarship of three generations of Sinologists to get rid of at least the worst part of it.

Today there is but little danger of a repetition of this unfortunate condition. Our experts know their Chinese art as they know their Delft china or their Greek coins. And even Chinese history is no longer the puzzle it was until half a century ago. Nevertheless there is still a great deal of misinformation upon the subject which persistently refuses to let itself be corrected. For example, most people seem to believe that the Chinese invented everything from the compass to the printing press several thousand years before the people of the West were clever enough to do so. That is hardly true. Reliable Chinese history is of comparatively recent date.

The Chinese love to let their earliest rulers go all the way back to the days of Cheops, but Fu-Hsi (so at least my Chinese historical friends inform me) is merely a mythical figure. However, he was an

**CHINA**

*The Art that merely suggested itself*

*If, like a Chinese artist, you would spend a lifetime painting nothing but this sort of thing you might eventually acquire the same skill.*

**INDIA**

*A holy city of the Hindus*

interesting personage and very different from the type of hero we find
in most other parts of the world whenever nations undertake to extol
the virtues of the founders of their race. For instead of slaughtering
his neighbors, he spent his days trying to set his subjects free from the
slavery of their own ignorance. He taught them how to hunt and how
to fish and how to domesticate wild animals. He divided them into
clans and established definite marriage rites. In order that they might
till their fields with greater regularity he invented the calendar, and
that they might preserve the accumulated wisdom of their own days
for the benefit of posterity he gave them a system of writing which,
however complicated and difficult it may seem to us, proved to be
entirely sufficient for all their needs.

To offset all these practical innovations with something of a spir-
itual nature, he devised a number of stringed instruments that men
and women might spend their hours of leisure dispensing sweet music.

Six hundred years later during the reign of the Emperor Shun, the
daughter of a high state official added the art of painting. Unfortu-
nately we have not been informed what the beautiful Lei painted or
what technique she used. The earliest Chinese pictures that we can
somehow date (they must have been made between 1800 B.C. and
1200 B.C.) are very crude representations of birds and people, scratched
on tortoise shell and quite inferior to the work of the cavemen of
Spain. And as the Chinese themselves agree that the brush was an in-
vention of the third century B.C., while paper only goes as far back as
the first century B.C., we are forced to the conclusion that Chinese
art, as we now know it, coincides with the beginning of our own era
when the Egyptians and the Greeks had already done a great deal of
first-class work as painters and draftsmen.

The true Chinese chronology does not contradict such an hypoth-
esis. The mythological part of its history came to an end with the
Ch'in period which lasted from 256 B.C. until 207 B.C. And this was
followed by the Han period which lasted from 206 B.C. until A.D. 220.
It is during the Han period that we begin to find the ancestral graves
covered with very simple line engravings, resembling the earliest pic-
tures of the Egyptian tombs. It was also during this period that the
first attempts were made at portrait painting.

Landscapes made their appearance during the so-called "period
of division" which lasted from 264 until 618 when the T'ang dynasty
came in. But the greatest art of old China did not develop until the
coming of the Sung dynasty. This lasted from 960 until 1279 and
was finally overthrown by the Mongol dynasty which conquered

northern China first and thereupon overran the southern part and made China part of its world empire that reached from the Pacific Ocean to the Baltic Sea.

This Yuan dynasty was succeeded by the Ming dynasty (1368–1644). The Mings were followed by the Manchu dynasty, which ruled China from 1644 until 1912 when democracy triumphed and China was split up into a number of small republics, which at the moment of writing are fighting a rather futile war to avoid being absorbed by their Japanese neighbors.

These few dates are entirely for your own convenience, for dealers in Chinese antiquities and directors of museums seem to derive great satisfaction from perplexing the laymen with their Ch'ing and Ming and Sung labels, knowing full well that most of us are even less familiar with these names than with those of our own Presidents.

It was—so at least it seems to me in my own great ignorance upon the subject—a very wise man who said that China represented a civilization rather than a country. If it had not been just that, the Chinese would never have been able to survive for as long as they have done. For nations come and nations go but civilizations may continue for thousands of years after those who gave them birth have ceased to exist.

Now you can hardly expect me in a few pages to give you a satisfactory and full description of a civilization that goes back so many thousands of years. I can only touch upon a few of the high spots. It strikes us immediately that the Chinese were fortunate in having been essentially a race of small farmers. There is apparently a terrific strength in living close to the land. Peasants, no matter how poor and miserable they are, invariably outlive our city populations and we ourselves are beginning to realize it. Every American today who can possibly do so, tries to get hold of a little piece of land. One hour's walk on the wet earth of the fields will give him more strength than a hundred hours on the asphalt of our streets.

In the second place, the Chinese were never subjected to one of those disheartening religions based on a consciousness of sin. The lower classes, like the lower classes everywhere, developed a pretty monstrous faith of their own, full of devils and evil spirits who have made themselves very apparent in their art. When a Chinese started to depict devils he was fully as good as Hieronymus Bosch, who lived in Holland five centuries before Art Young, who, Heaven be praised, is still with us to cheer us up with his nasty little imps.

The Chinese, being a people of great common sense, always seem to have realized that equality is merely a fit subject for Fourth of July oratory but that it has no existence in nature. Hence they accepted the fact that some people are born brighter than others and that it is as absurd to expect all of them to do the same things or think the same thoughts as to expect that all dogs shall be able to jump as far or be as graceful and dumb as a borzoi. They therefore let the peasant believe what pleased his rustic soul. They let those who had a little broader view of life indulge in whatever creed or philosophy suited their own spiritual needs. The idea of trying to convert one class of people to the faith of another never seems to have dawned upon them. Each man had to decide for himself how he was going to square things with his Maker. If he wanted to become a Buddhist, as millions of Chinamen have done, very well—that was his business. If he wanted to become a Christian, there was no law to prevent him from doing so. It all seemed rather silly and an unnecessary waste of energy and peace of mind but one must follow the dictates of one's own conscience. China as a result seems to be the only country that during the four thousand years of its existence has never suffered from a religious war. It has, however, experienced every other form and sort of conflict, so that that may have been just a way of squaring things.

Now among the upper classes of China—the literate classes in a country where it took half a lifetime to learn all the pictures of the written language—religion in our sense of the word, a hard and fast system of certain hard and fast dogmas, never seems to have played very much of a role. Its place was taken by a mixture of two main schools of thought. The older of these two was Confucianism, and the younger one is known as Taoism.

When Confucius appeared upon the scene, the Chinese people were only just emerging from that very elementary form of religion which still retained many of those cannibalistic features so typical of the earlier rites of all primitive peoples and which today only survive in parts of the hinterland of New Guinea and, perhaps, Borneo. They had, however, already ceased to kill their victims. They no longer shed blood or destroyed life but instead of sacrificing, let us say a cow or a sheep, they now sacrificed the image of these creatures.

The charming little earthenware figures of horses and all sorts of other animals and of men and women and bits of household furniture of the Han and T'ang period, go back to those early days when all funerals were accompanied by the slaughter of a number of animals and the sacrifice of one or two women who were walled up with the

deceased to tend to his needs and make him comfortable in the here-
after. It was into a world of this sort that Confucius was born.

It was the sixth century before the birth of Christ. China as usual
was full of corruption and political discontent. The rich were growing
richer and the poor were growing poorer and everything was as it had
always been and most likely always will be. Confucius, however, had
high hopes that he could change all this, at least a little, by trying to
reform society from the top. He realized that it was hopeless to try
and do so from the bottom. The bottom was too big to listen to rea-
son. The top might. And so, like Plato after him, he conceived of a
society that should be dominated by a superman. Not the superman
we know only too well, the little fellow in the big boots. The Chinese
had never had any admiration for violence. The soldier came last.
Indeed, the soldier in the eyes of Confucius came way down in the
scale of social values. But a superman who should be a sort of Public
Benefactor No. 1, a kindhearted, gentle, and honest patrician who
would spend all his days governing his fellow countrymen firmly
and disinterestedly and who should be the father of his subjects as he
was the head of his own household.

That such ideas must always be entirely too subtle and too spiritual
to satisfy the longings of the average man who wants personal devils
and saints whom he can approach and propitiate with promises and
bribes, seems not to have occurred to this benevolent sage who died
greatly disappointed at not having been able to achieve a few more
positive results. Nevertheless, a few scraps of his wisdom did find their
way among the masses. Although in a general way they remained
faithful to the older form of nature worship, they incorporated a great
many of the Confucian sayings into their own rather primitive phi-
losophy of life. All through their art you will run across the far-reach-
ing influence of this prophet who never became a God and whose
temples never contain anything but a tablet bearing his name.

Taoism, the other philosophy that greatly influenced Chinese life
and Chinese art, is often represented as being a sort of opposition
philosophy deliberately directed against the teachings of Confucius.
But it was hardly that. Unlike Confucianism it did not expect salva-
tion to come from breeding a perfect upper class. Rather did Lao-
tse, its founder, hope that he might make mankind a little happier
by beginning at exactly the other end of the ladder and by preaching
contentment to the masses and by telling the poor that they would
be infinitely better off if they accepted their fate with a smile than if
they tried to beat a game in which all the cards had long since been

*It is curious to reflect that while in Europe the kings of France were building themselves a royal residence of the incredible loveliness of Versailles . . .*

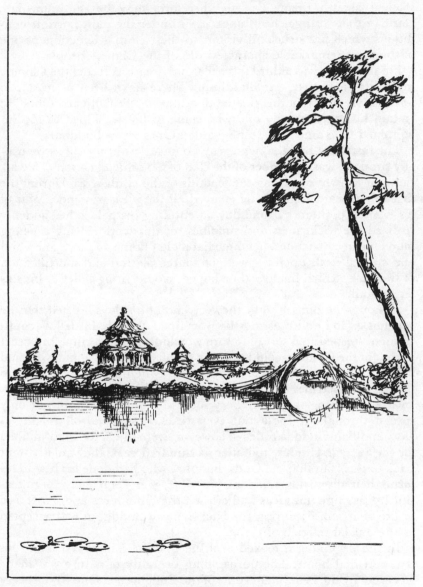

*at almost the same moment in distant China the emperors of the Celestial Kingdom were doing exactly the same thing though in a somewhat different and rather more subdued manner.*

stacked against them. Taoism, therefore, may be the immediate cause of that strange cheerfulness even under the most horrible conditions which has struck all visitors to the Celestial Kingdom as one of the most remarkable characteristics of the Chinese people.

Finally, there was a third force that has greatly affected the Chinese mentality, and that was Buddhism. There have been at least two dozen more or less authenticated Buddhas or "Enlightened Ones" in Indian history, but only one who came to be worshiped as *the* Enlightened One among the Enlightened Ones or *the* Buddha.

The historical Buddha, who is by no means as historical as we usually suppose, was a member of the clan of Gotama and a son of a warrior king who lived among the foothills of the Himalayas. During the first thirty years of his life he enjoyed all the pleasures and profits of his exalted position but one day on entering his palace he suddenly realized the wickedness and sinfulness of this world. Being a young man of firm convictions, he immediately left home and wife and child and started forth upon a career of contemplation and mortification of the flesh, which finally, so he hoped, would bring relief to his suffering soul.

Although he himself until the very end of his days insisted that he was not a God and must not be worshiped as such, his fellow countrymen, steeped in a sort of nature worship quite as brutal and cruel as that of the Chinese, could not take so lofty a view of a man who had lived so saintly an existence. They promptly deified him and began to preach his doctrines along the highways and byways of central Asia. In the beginning they were very successful and Buddhism not only spread throughout India but even reached such far-off islands as Java and Bali. Buddha's ideals, however, were much too high-minded for the average Hindus, and after six hundred years they quietly went back to their familiar old Gods. Buddha, who had done his best to reform their disgusting religious practices, was completely forgotten. But by this time his ideas had crossed the Himalayas and Tibet and in the year A.D. 67 during the Han dynasty Buddhism was accepted as the official religion of China.

In the beginning it looked as if the Buddha had at last found his true spiritual home. The unreasoning brutality of nature was made less cruel by the benevolent smile of the Enlightened One whose every word had spoken of mercy and compassion for all living beings. The arts especially were greatly influenced by the gracious spirit of this new prophet. During the T'ang period, Buddhism was the prevailing force in all literature, painting, and sculpture. But during the ninth

century that force apparently spent itself, and, except for such relics as have survived in the dry climate of the Gobi Desert, all the evidences of that early school of Chinese-Buddhistic art have now completely disappeared.

It survived, however, in other parts of Asia, notably in Tibet and Ceylon and in a highly modified form in Japan. But as an attempt to make the human race conscious of its divine possibilities, it was as complete and disheartening a failure as Christianity afterwards. The old Gods who reached all the way back to the dawn of civilization proved once more how strong a hold they had upon the average man. And soon the Indian was once more slaughtering his goats, burning his incense to his ancient idols, and doing all sorts of terrible things to himself to propitiate the evil spirits whom he feared much more than he loved the good ones.

This may explain why the first Europeans who visited India paid so little attention to Indian art that we hardly ever find it mentioned in their travel books. What they saw filled them with a feeling of horror and disgust, as well it might. Had they looked a little closer, they would have noticed that the sculptured figures of India bore a very close resemblance to those of Greece. Their general indifference and ignorance may have given rise to the notion still held by a great many people that the art of India was something mysterious that went back thousands and thousands of years, being even older than the Pyramids. That is entirely erroneous. We have a great deal of literature that was composed in the days of Homer but the earliest Indian architecture goes back only to the days of Buddha in the sixth century B.C. When Buddhism disappeared from India in the fifth century A.D., Buddhist art also came to a standstill. The old Hindu Gods were left in full possession of the field until the Mohammedans came to stay in the tenth century. The Moslems thereupon introduced their own art into India.

The great Mogul Empire, which existed for two entire centuries, covered western India with its own architecture and if you want to know how far their architects could go, there is the Taj Mahal to show you. It was erected in the middle of the seventeenth century and it is the tomb the great Shah Jahan built in memory of his wife, the lovely Mumtaz Mahal, the Exalted One of the Palace.

One would expect to find that Moslem art had put its stamp upon the native arts but the average Hindu remained stanchly faithful to his own temples, with their wide inner courts and their bathing reservoirs and their gilded towers, covered from top to bottom with statues

of their myriad Gods (a practice no Mohammedan would ever have tolerated) and their dark caverns (which look for all the world like rock tombs) and the whole nauseating collection of sacred animals and not-quite-so-sacred Deities and their very unappetizing female relatives.

Those vast temples, covering entire city blocks and making our own Gothic churches look like very simple and modest little affairs, are rarely pleasing to the European eye. Most of them, unless seen from a long distance, when they remind one of Manhattan seen from the distant Jersey hills, fill one's heart with a sense of imminent doom, and seem to preach the utter futility of all human effort against the implacable forces of nature. The bathing pools, which are full of light, would form a pleasant contrast to the interior if one were not conscious all the time that the gold smeared all over the roof and the jewels stuck in the holy images could be so much better used if spent upon hospitals to cure at least part of the deformed humanity that creeps through these dismal sepulchers.

As for the sculptures that are all over the place, they have been twisted and tortured into figures that seem created for the express purpose of repelling at least the casual spectator. The technique of the sculptures is often above all reproach. But the subjects, the Brahmas and Vishnus and Sivas and their endless cousins, uncles, brothers, and sisters, seem only very little more attractive than the nasty-minded holy monkeys and the half-starved holy cows which infest the premises.

All this changes the moment we come in contact with Buddhist art. I have been told by reliable authorities (being myself grossly ignorant upon the subject) that the Indians did not really learn the stone-cutter's art until they came in contact with Greek civilization as a result of Alexander the Great's march to the shores of the Indus River. And, indeed, Buddhistic sculpture did not really begin to flourish until several hundred years after the death of the Buddha himself, when Asoka, his devout disciple, was ruling over the Punjab. It was then that the traditional image of the meditative figure with the crown of live snails—live snails which had crawled all over his head to prevent the Enlightened One from getting a heat-stroke when he had lost himself in thought where there were no trees to give him shelter—was developed. Then, also, the lobes of the ears got that curious elongation which hints at the weight of the jewels the Master had worn in his prosperous younger days. It was then that that mark on the fore-

head was added to symbolize the third eye—the eye of the inner spiritual vision.

Until then—until the time the people of Hindustan saw the statues of the ancient Greek Gods which Alexander carried with him on his expedition—the figure of the Buddha himself had never been represented in any form whatsoever. But he had been shown in some of his former incarnations, as a bird or an elephant, and sometimes he had been shown as a strong flame, a symbol of his self-perpetuating ideas.

Once, however, the Buddhist sculptors had learned their art, they not only made pictures of the Buddha but, like the painters of Italy in the thirteenth century, loved to depict every possible scene from the life of their savior. The best example of the work they did is to be found in two of the greatest ruins of Asia, and Asia, remember, is the continent par excellence for ruins. Both of these, the Borobudur in central Java and the temple of Angkor Wat in Cambodia, are covered from top to bottom with a variety of sculptured scenes which for their fidelity of expression and clearness of observation have never been surpassed by our Western sculptors.

Angkor Wat was probably built in the twelfth century by a people who had come from Indo-China and who had established the so-called Khmer kingdom. This flourished in the twelfth century of our era and lasted until the fifteenth century when it collapsed as mysteriously as it had arisen and left us with these vast ruins which seem to have been begun under Buddhist influence but to have fallen afterwards under the influence of the Hindus who, after they had driven out the Buddhists, dedicated the place to the worship of Vishnu. We have no idea when they were deserted or whether some small group of faithful monks did not live and worship there during all the centuries these gigantic buildings lay in isolated splendor among the green foliage of the Cambodian jungle.

The same holds true for the Borobudur. When the Portuguese reached Java early in the sixteenth century, the whole structure was so densely covered with trees and shrubs that nobody suspected its existence until much later. It was not really brought back to life until a few years ago when it was realized that what had been mistaken for the top of a hill was really a vast Buddhist shrine consisting of gallery over gallery of sculptured walls and hundreds and hundreds of statues of the Buddha.

Exactly when these endless bas-reliefs dealing with the adventurous lives of the early Buddhist missionaries and converts were made, nobody knows. They must have been there, however, long before the

Mohammedans conquered Java and that would make the Borobudur a contemporary of Charlemagne. When you look at the work that was then being done in this distant land and compare it to the clumsy efforts of the Carolingian architect and sculptor, our own ancestors cut a very poor figure and their descendants seem to have learned very little. Otherwise, would they have built a hideous little Christian chapel right between this acropolis of the Buddhist faith and the silent figure of the Master which for over a thousand years has been sitting patiently in the semidarkness of his temple of Mendut a few miles away?

However, I suppose it really does not make very much difference. The princes by whose commands all this was done are gone. We do not even know who they were. The millions of worshipers who gathered together on this spot, carrying their gay baskets full of flowers and fruits, they too are gone and their dust has long since mingled with that of the near-by volcanoes.

All that remains is a great silence, a profound loneliness, a smile of patience and understanding, and the bicycle of the priest who is going to say Mass in that whitewashed wooden shack just at the other side of the Mendut and who has stopped to light his cigar.

The Hindu temples, by the way, were not churches in our sense of the word. They were like the temples of the Greeks and the Egyptians, the residential quarters of the Gods. The priest alone was supposed to enter their Holy of Holies (as he had done in Jerusalem) and a bare little room sufficed for this purpose. But the Buddhist stupa bore even less resemblance to a Christian church than the Hindu temple, for it was not a temple at all. It was a solid structure and unlike an Egyptian pyramid, it did not even have a small room hidden in its interior anatomy. As a rule, as in the case of the Borobudur, it was a small mountain or, in case no convenient mountain was available, a man-made hill overlaid with masonry and statues. But in order to become a regular stupa, this mass of earth or rock must contain at least one sacred relic of the Enlightened One, a hair of his head or a piece of his thumb or a tooth or something like that. Such relics, however, must never become an object of veneration like the collarbone or toe of a Christian saint. It must be present, but its exact location should not be known. The faithful must know that it lay hidden in this sacred building and that was enough.

Originally, quite like the Pyramids, the stupa had probably been nothing but a small mound built over a grave. And then, like its

Egyptian counterpart, it had grown and grown until at last it sometimes reached fantastic proportions. But there was no hard and fast rule about this, for a stupa need not be out in the open. It could be built within a regular temple, and we have found rock temples in India containing small stupas. And finally, the stupa was not restricted to any one particular form. In China, for example, the stupa becomes a pagoda. Those strangely roofed Chinese pagodas which so greatly fascinated our ancestors of the eighteenth century were really nothing but stupas, made out of wood or stone but serving exactly the same purpose as the dome-shaped stupas of Ceylon or the square and squat stupas of Tibet or the steep and pointed ones of Siam. But like all other Chinese architecture, the pagodas never fail to reveal their humble wooden origin. During the Sung dynasty they arose to mighty heights and were covered from top to bottom with colored tiles, but we have never found a round one. Wood did not lend itself to the rounded pattern and the Chinese artists were hardly the sort of people to try experiments. For they worshiped two ideals—faithful craftsmanship and tradition.

To this we also might have added a typically Chinese virtue—patience. For especially in their bronzes and their jades and in their enamels and their porcelains and earthenware the Chinese were possessed of a patience that could only have been born out of a complete lack of any sense of time.

The same holds true for their pictures. Not that it can have taken very long to write one of those pictures; for their painting, having grown out of their calligraphy, it is only fair to say that they "wrote" a picture as they wrote a letter. A few minutes must have sufficed in contrast to the oil paintings of the West, upon which one could spend weeks and months. But it must have taken a lifetime to acquire that particular dexterity with the writing brush which allowed the artist to say as much with a few lines as a Western artist could say with a barrel of colors and with a thousand different shades of darkness and light.

Every form of art is, of course, the direct result of its own technique. When you draw a picture with a match on a coarse piece of paper you get an effect different from that produced by a fine pen and a block of Watman hot-press and your best bottle of Higgins' ink. Therefore if you really want to understand what these marvelous landscape artists of the Sung and Ming periods tried to say (and lovelier work than that has never been done, even by the best of the European masters) forget all about your pens and ready-made inks and

get yourself some Chinese brushes and a stick of solid Chinese ink, which you yourself have to rub on a piece of wet stone to get the right shade, and then go to it. You will learn more about Chinese painting (which was the art in which the Chinese have achieved their highest results) in five minutes of actual work with one of their brushes than from a couple of years spent in a museum.

Incidentally, you will often hear that the Chinese painters suffered from the fact that they were not familiar with the science of perspective. That is true, but in the first place they were very fond of painting their scenery from the top of some low hill, thereby avoiding the necessity of having any perspective at all (perspective is much more important in pictures painted in flat countries), and in the second place they got the right effects just as well without ever bothering about a vanishing point. But then, Bach got harmonious effects without ever having been trained in our modern science of harmony. In the hands of real masters, all such details amount to nothing at all. The others, however, had better beware!

If you have never seen any Chinese paintings, do not expect too much at first, for you may be sadly disappointed. Don't look at too many of them at the same time. You will only go home with the recollection of a vast blur. And everything will seem rather monotonous. You must remember, in viewing all Oriental art, that ideas about "interior decorating" in the East and in the West are about as different as they possibly could be. Most people live in a world of gadgets, and we clutter up our houses with all the accumulated rubbish of two or three other generations and on our walls we hang all the pictures that belonged to our grandparents. The Chinese and the Japanese are willing to manufacture all the cheapest and most horrible *objets d'art* for the markets of the "foreign devils" but in their own houses they prefer to practice moderation. Even if they have a dozen pictures, they hang only one of them on their walls while the others remain neatly tucked away in their boxes in the storeroom. They do the same with their flowers. One rose or one tulip if placed in exactly the right position can be infinitely more effective than three dozen roses or a thousand tulips dumped in a lot of vases all over the piano and the cupboard where they do not really belong.

But the greatest difference between East and West is probably to be found in their respective ideals of what constitutes a truly great piece of painting. The Europeans (except the very modern ones) insist upon a careful and minute representation of the subject. The Chi-

nese and Japanese of the classical period were contented with a mere suggestion of a few of the basic facts, caring nothing for those details which mean so much to us. Not that they despised what we usually call "detail," for on occasions they could be the most minute of observers. But when an Englishman paints Mount Everest, all the other Englishmen who have ever seen that mountain will severely criticize him if he has omitted a crevasse here and a peak there. And they will base their criticism upon the contention that the artist has not told the whole truth.

The Oriental, being essentially an unscientifically minded person (one to whom our Western science means just exactly nothing except in so far as he needs it to make a cheap automobile), will think such objections just silly. The spirit of the mountain is there. Everybody who has ever seen it will at once recognize it. So why worry about another flake of snow on the right slope or the lack of a small black rock on the left slope? After all, it is not meant to be a map of the geological survey, intended to show prospective climbers how to reach the top. The picture is a sort of spiritual reminder of a bit of landscape that someone loved and wanted to have near him all the time. But he wanted a suggestion—not a photographic reproduction. If he had wanted the latter he would have bought himself a beautiful hand-colored photo of Mount Ranier that his fellow countrymen were manufacturing by the million for the benefit of the American market at a profit of one penny per gross. Those were lovely photos and just right for the American market, but as for himself, for the moment at least he would remain faithful to those few strokes of the pen on a piece of rice paper. Unless someone offered him a nice new picture of Greta Garbo or Clark Gable! That, of course, would be different.

I am afraid that it would!

In the sixth century of our era the first Buddhist preachers set foot on the soil of Japan. Until then it had been an unknown island beyond the pale of civilization. Something like the Ireland of the pre-missionary days. Even then relations with the mainland remained rather restricted. Not that the Japanese were exactly hostile to foreigners. They were just legitimately suspicious. Their experience afterwards with the Christian missionaries who came to convert them from their Buddhistic fallacies was a case in point. These Christians immediately and with sublime arrogance undertook to show the Japanese how they should run their own country. The Japanese resented this greatly and threw all foreigners (including the Christian missionaries) out of their country and forbade them to re-

turn. At about the same time one of the shoguns, who until then had been merely a military commander, made himself the real ruler of the country, completely eclipsing the emperor. And since the shogun's family proved to be better fitted for the job than the family of the legitimate ruler, they maintained themselves in that position for several hundred years. It was during this period, the Tokugawa period, which lasted from 1603 until the reopening of Japan to foreign influence in 1868, that a new form of art made its appearance which has exercised a much greater influence upon the art of the West than anything ever produced by the painters or lacquer workers of China. I mean the popular woodcut, the penny print of no great consequence, which anybody could afford to buy.

In the beginning these pictures were done only in black and white, but gradually a few colors were added. The prints were no longer made by hand as they had been since the beginning of time but they were reproduced by means of a mechanical press. Finally this system of reproduction was so greatly perfected that the artists could use any colors they liked.

Now, it was these cheap little penny prints rather than the costly Chinese paintings (which the Chinese themselves valued much too highly to let leave their country) that gave the artists of Europe their first knowledge of the art of the Orient. And they were delighted. They had learned almost too much perspective. They were being drowned in an ocean of academic detail. Here was a breed of painters completely ignorant of the laws of perspective and yet able to express every sort of emotion, to reveal the nature of every sort of landscape, and to do all this with a minimum of apparent effort and wasting no foolish money on expensive canvases and paints.

It is, of course, more than likely that their long seclusion from the rest of the world had been of the utmost benefit in allowing the Japanese to develop a style of their own and to forget some of the things their Chinese masters had taught them. But one thing they retained in common with their Chinese teachers: their great love for nature. During the latter half of the eighteenth and the first fifty years of the nineteenth century, the great Japanese draftsmen—Utamaro, Hokusai, and Hiroshige—took their brushes in hand and mixed their colored inks and thereupon drew literally everybody and everything that came under their observation—endless landscapes, birds, flowers, bridges (they seem to have been almost as much fascinated by their bridges as our own medieval artists), roads, waterfalls, waves, trees, clouds, and their holy mountain, the snow-covered peak of Fujiyama

*Where our heart is, there also is our art. The sailors of New Guinea who had never seen a piece of metal had spent just as much effort on the prows of their beloved canoes (which meant their daily bread and butter to them) as . . .*

*the European sailors who discovered them in their own search after bread and butter and a little jam. They came from the opposite ends of the earth but the urge to beautify that which meant most to them was the same in both cases.*

rendered a hundredfold and from every possible angle, and actors and actresses and little boys flying kites and little girls playing with their pet puppies—indeed, whatever the Gods had created was most welcome grist to their busy mill.

With a little training, almost everyone can get the "feel" of these pictures. They are, of course, entirely different from Western painting but that makes no difference. You can learn to understand them as you can learn to appreciate the music of the Balinese gamelan. It is all a matter of good will and patience and, as always when you are dealing with the arts, go to the originals if you possibly can. Do not read about them. See them and then compare them. Take, for example, a landscape by the elder Breughel or Patinier or Nicolas Poussin and put it next to a winter scene by Fan K'uan who lived four hundred years earlier and was a contemporary of William the Conqueror. Or compare a flower by Korin (Ogata Korin, 1661–1716) to a flower arrangement by the Dutchman D'Hondecoeter or the Frenchman Renoir, or one of his ravens to one of the rare bird pictures of a Dutch master of the seventeenth century. Or compare Hokusai's well-known wave to the wave of the Frenchman Gustave Courbet or our own Winslow Homer. You will then realize how essentially the art of China and Japan was an art of suggestion, and you may well begin to wonder whether Admiral Perry was really such a benefactor of mankind when on that famous fourteenth of July of the year 1853 he insisted that the Mikado receive the letter from President Fillmore and listen to the latter's proposal to open up his empire to the nations of the West.

Perhaps he was right and such developments are unavoidable, for we must have progress!

Must we have art, too?

Yes, we must.

But we shall have to fight for it as we shall have to fight for all the best things in life and fight as hard as we can.

# Goya

### The last of the great universal painters

PAINTING, of course, did not completely come to an end during the latter half of the eighteenth century. Even today there are some thirty thousand painters in Paris while, judging by the statistics of the W.P.A., there are at least a dozen times that many in the city of New York alone. Furthermore, during the last century, enough pictures have been painted to cover the Sahara Desert with a rich layer of colorful canvases. But when the arts and life parted company, the painter ceased to be the interpreter of certain definite ideals which all the people of western Europe could understand and feel because they were part of their common spiritual and social heritage.

The Reformation had been the first step in this direction. But although Protestant and Catholic were now each other's bitterest enemies and frequently slaughtered each other with an efficiency which was only surpassed by the wholesale murder of the Great War of recent date, they continued to live the same sort of cultural existence, to paint the same sort of pictures, to build the same sort of houses and palaces, to wear the same sort of clothes (perhaps a little more subdued in color for the Protestants than for the Catholics), and to compose the same sort of music.

Of course, the palace of the Catholic ruler contained a private chapel where Mass was said according to the Catholic rites, whereas the palace of the Protestant prince harbored a private chapel from which all trace of the former faith had been most carefully removed. But the proverbial visitor from Mars, not familiar with the details of such religious quarrels, would hardly have noticed any differences at all when he passed from northern Europe to southern Europe or moved from Versailles to Potsdam. European culture was still a universal culture, a carefully constructed economic and social pyramid, with a broad substructure of peasants who in most countries were worse off than the medieval serfs, a small layer of slightly better-off merchants and manufacturers, and a top consisting of an aristocracy who lived on the labors of their serfs, and way up above all this, and lost in the clouds, that block of priceless alabaster known as the King.

The French Revolution was to upset this ancient structure and was to cause such damage that no efforts at repair have ever been quite successful. It was to substitute the principle of nationalism for that ancient ideal of a cultural internationalism of which Goethe, the great German writer and scientist, was the last and the most brilliant champion and exponent.

Music remained the only form of art which sometimes succeeded in tripping merrily across the red and green and purple boundary lines that now appeared on the map of Europe and which divided the ancient continent into a hundred mutually hostile armed camps. But painting, being less easily transported and speaking a language that had a less universal appeal, was less fortunate in this respect and was reduced to a sort of national dialect which could not be understood, and was not really meant to be understood, by anyone outside of its own native bailiwick.

Goya was at least as Spanish as Velasquez or El Greco. No one could ever mistake him for a Fleming or an Italian. But at the same time there was a quality in his work that made him a representative of all the cultural manifestations of his age. You can call him a Baroque artist and I won't be able to contradict you. You can point to Rococo elements in his paintings and they undoubtedly are there. Nevertheless, the desire for a true and faithful copying of Nature-as-she-is and not as we ourselves would like her to be, an artistic ideal which went back to the Dutch school of the seventeenth century and which had become widely popular during the last half of the eighteenth century—that naturalism has rarely found such a faithful expression as it did in some of Goya's portraits. And that "impressionism," which we have always acclaimed as one of the great artistic achievements of the nineteenth century, is so brilliantly present in such paintings as that which depicts the wholesale executions in Madrid in the year 1808, that we shall some day have to revise our theories upon this subject and give the credit for its discovery to this great Spaniard.

Not that he himself would be much interested. He belonged to that old type of artist who slept with his clothes on and died with a palette in his hands. He spent eighty-two years on this planet and most of them were difficult years. For although he was appreciated by his contemporaries and enjoyed the beautiful title of Court Painter to His Most Catholic Majesty, and never had to pawn his clothes in order to buy food, he was temperamentally too much like Michel-

angelo and Rembrandt and Beethoven to find peace this side of the grave.

The time in which he lived bore a close resemblance to our own. A brilliant beginning. The dawn of enlightenment had appeared above the distant horizon. The brotherhood of man was to inaugurate an era in which freedom and an absolute equality of opportunity were to be the birthright of every child. *Allons, enfants de la patrie!* But something went wrong. The procession, instead of arriving at the foot of the Statue of Liberty, must have taken the wrong turn somewhere along the road, for it suddenly found itself facing the steps that led up to the scaffold. *Le jour de gloire est arrivé!*—and so, citizens and citizenesses, if you will kindly step forward, we will quickly and skillfully cut off your heads and dump your bodies into a pit of quicklime! All for the sake of that earthly Paradise which Citizen Robespierre, the true friend of virtue, intends to establish upon this earth according to a little blueprint of his own. You can see it sticking out of his back pocket together with a few other sheets of paper. Those other sheets of paper are not blueprints. They contain the lists of the names of those who tomorrow will kiss Madame Guillotine.

While all this was happening in Paris, Goya in Madrid was painting the portraits of the Spanish royal family. After a rowdy childhood in Fuendetodos, where he was born in 1746, and Saragossa, where he had learned his trade, he became a hobo, wandering all over Spain with a company of strolling bullfighters and ending up in Rome without a penny in his pocket and far from well. But his iron constitution carried him through this little contretemps. He kept on painting, won a second prize in a competition for something or other in Parma, and finally scraped together enough money to return to Saragossa.

In the meantime that unfortunate street brawl in which three young men from a neighboring village had been killed and in which he was suspected of having taken an active part had been conveniently forgotten. The indictment against Goya was quashed and he could go wherever he pleased. He tried his luck in Madrid where Raphael Mengs, a German Jew born in Czechoslovakia of a Danish father, was covering the walls and ceilings of the royal palace with those Greek Gods and Goddesses which made him one of the most popular artists of his day but which fill our own hearts with a sense of irrepressible boredom.

Through Mengs, who was a terrible painter but a decent enough fellow and willing to help a poor devil down on his luck, young Goya, now married to the sister of his teacher José Bayeu, got a job making

the designs for a number of tapestries which were to be woven in the royal Gobelin factory (director: Raphael Mengs). Together with his father-in-law Goya then lost himself for several years in the routine job of depicting popular scenes for a new set of wall coverings for the palace of the heir to the throne. These cartoons, a little too much in the Mengs style to be really great works of art but very pleasing in a decorative sort of way, attracted the royal attention. From then on Goya's career was easy. He was appointed director of the Royal Academy of Art and a short time later appointed painter to the court.

What he thereupon did to his royal master and his royal wife and their brood of royal children is really one of the most scandalous incidents in the whole history of art. Of course, a portrait painter must have a little leeway in exposing some of the less amiable qualities of his patrons if those patrons happen to disgust him. But Goya, in one single picture, a portrait of King Charles and his family, did more to destroy the royal prestige than all the diatribes of the gutter journalists of the early days of the French Revolution. What makes this incident so very deplorable is that the court was so dumb and so completely devoid of any common sense that nobody, neither the King nor Queen nor any of their ministers, seems to have recognized the brutal betrayal of the ideal of divine right of which this portrait had been guilty.

It is a marvelously clever piece of work. But then, Goya knew his business from $A$ to $Z$. Two or three hours was all he asked of his customers and behold, their picture was finished. A quality which, according to a widespread tradition, stood him in good stead on that famous occasion when he was supposed to have painted a nude portrait of the Duchess of Alva. Her husband upon being informed of this outrage announced that he would visit the painter's studio to assure himself of the correctness or incorrectness of this rumor and in case things were as he had been told, he would avenge the honor of a Spanish grandee in the way, etc., etc. But when the next day he arrived at the studio, behold! there was his wife's picture but showing the lady decently dressed. In one single night the versatile artist had painted the second portrait to appease the wrath of the infuriated husband.

I mention this pleasant little tale because it is so very much like almost all the other stories about the great artists of the past which have survived and have become common knowledge when nobody remembers any of their works. The Duchess of Alva may indeed have been Señor Goya's lady friend. But that second picture, the one that

had been painted at such short order to save the painter from the fury of His Grace the Duke, was painted when the Duchess was a widow. This interesting incident therefore never took place. And the only excitement *The Maja Nude* ever caused was in the year 1928 when the Spanish government, in order to celebrate the centenary of the great master's death, reproduced this painting on its postage stamps. This so greatly distressed the good women of our own country that they actually tried to prevent these stamps from being allowed in the United States. If it had not been for the International Postal Convention, they might well have succeeded, and thus at last the honor of the poor Duke would have been avenged by the descendants of those same Puritans whose complete eradication had been the lifelong ambition of his own most notorious namesake.

Meanwhile in France events took their normal course. The *Marseillaise* had given way to the *Marche de l'Empereur* and in the year 1808 Charles IV abdicated the throne in favor of Joseph Bonaparte, the brother of the Emperor. This led to years of civil war in which the loyalists were vigorously supported by an English army under Sir Arthur Wellesley, who after his victory over the French at Talavera had been created Viscount Wellington. Goya, for some mysterious reason, at first took the side of the usurpers and continued in his position as court painter. But what he really felt about all this was expressed in a number of paintings and in a series of etchings which will ever remain a most violent indictment of the follies of war. The etchings, especially, I would hardly recommend to people who are subject to nightmares, for most of them are exactly that—pictorial nightmares filled with a ghastly quality that forever haunts us once we have seen it. The pictures are as fresh as the day they were drawn, for they have an uncanny resemblance to the photographs which almost every morning we can see in our newspapers—heaps of corpses and mutilated bodies that are the inevitable results of civil war.

In the year 1822 when he was well past seventy, Goya suddenly left his native land, crossed the Pyrenees (all alone), and went to live in Bordeaux. There he met most of his old friends, for the restoration of the Bourbons after the fall of Napoleon had forced thousands of Spaniards into exile. Not because they had supported King Joseph but because, as true patriots, they had agitated for a constitutional monarchy and had opposed that despotism of the Crown and the Church which was responsible for the sad state of their nation and which had turned the erstwhile prosperous possessions of the Moorish caliphs into a howling wilderness.

Goya died in Bordeaux in the year 1828. During the last years of his life he turned completely deaf but his eyesight remained clear to the end. And what those eyes had seen, his hand had most faithfully revealed on canvas or on paper, leaving us a complete and painstakingly accurate picture of a society that had died because it had not known how to live up to its own ideals.

# The Picture Book Gives Way to the Music Book

*Music succeeds painting as the most popular of the arts, and the center of gravity of the musical life of Europe is moved from south to north.*

THE ART of the Middle Ages was the picture book of those who could not read. Every painting, every bit of sculpture, every illuminated manuscript, every piece of tapestry was created for the single purpose of making the illiterate masses familiar with some further detail of the stories of Holy Writ.

When the Church started out upon the well-nigh hopeless task of changing some fifty million barbarians into rather crude and rudimentary Christians—but Christians nevertheless—it discovered very soon that a mere appeal to people's ears was not enough. They had to see in order to believe. And so the Church overcame its earlier prejudices against the arts as part of the pagan inheritance. It enlisted the services of the painters and sculptors and the workers in brass and gold and copper and silver and silk and wool and bade them set to work and tell the story of the Good Shepherd and of His wanderings upon this earth in such simple pictorial forms that nobody could fail to understand their meaning. This accomplished, music was added as a method of propaganda, and during the end of the fifteenth century music, as we have already seen, escaped from the bondage of the Church and started upon a career of its own.

Once back among the people of the market place and the country fair, music developed by leaps and bounds. It was a much greater source of satisfaction to the average citizen than the pictures that hung on the walls of his chapel or the granite saints that looked down upon him from the roof of his cathedral. For this new music he could carry with him wherever he went. A tune, unlike a picture, was common property. Even the poorest wool carder, who could not afford a single penny print although he worked fifteen hours a day, had just as much right to an aria by Gluck as the rich Austrian nobleman who could afford to hire the composer for an evening of operatic entertainment.

In short, music was a much more democratic art than painting. And when at last the different instruments were so far perfected that

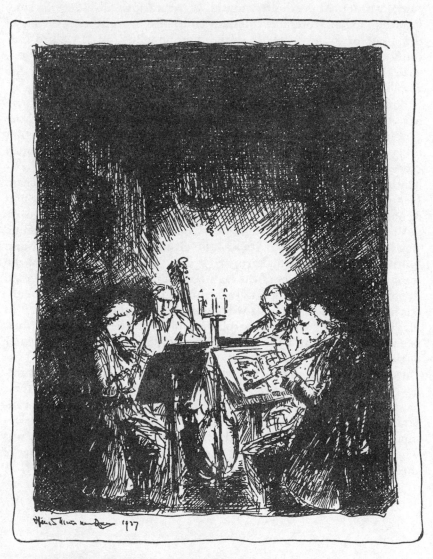

THE QUARTET

orchestral music, with its endless combinations and variations, became a practical possibility, music was victorious all along the line. Painting, exiled from all Protestant churches, fled into the privacy of the home or found a refuge in the museum. But music walked brazenly down the highways and byways of every civilized country and, with the help of the radio and the talkies, it bids fair to conquer the whole world.

But here is something to wonder about. Why should music have left the shores of the Mediterranean and moved northward in the general direction of the Atlantic Ocean? The answer is so simple that every reader will be able to supply it himself. The Mediterranean ceased to be the center of trade and commerce and, therefore, of civilization. The Atlantic Ocean then became the new world ocean. Hence the countries along the shores of the Atlantic grew richer and richer while those around the Mediterranean grew poorer and poorer.

Vienna was the last stronghold of the Catholic south. But Vienna was in a class all by itself. It was the city where north and east and south and west met. Furthermore, it was the residence of one of the most powerful dynasties of the eighteenth and nineteenth centuries, a dynasty which being essentially Teutonic in its administrative methods had been able to force its will upon a large number of ill-organized Slavic states and which, by exploiting them to the last pfennig, had been able to make its capital the economic, social, and cultural center of the whole of central Europe.

I think I have already succeeded in convincing you that the painters have always followed the full dinner pail. As soon as they got their chance, the musicians did likewise. They tucked their unpolished cantatas and sonatas under their arms. They left their unpaid bills behind them. They took the road that led to the north. For that was where the pot of gold awaited them, at the end of the rainbow of their high C's and their unlimited hopes and ambitions.

# Bach, Handel, Haydn, Mozart, and Beethoven

*The General Staff leads its army of humble music teachers
to a brilliant victory.*

WE HAD BETTER BEGIN with the greatest of them all. Here is his
statement of service as written down by his son:

*Born in Eisenach, A.D. 1685, March 23rd.*
1  *Court musician in Weimar at the court of Duke Johann Ernst.*
2  *Organist in the new church in Arnstadt, A.D. 1704.*
3  *Organist in the church of St. Blasius in Mühlhausen, A.D. 1707.*
4  *Chamber and court organist in Weimar, A.D. 1708.*
5  *Also concertmaster at same court, A.D. 1714.*
6  *Orchestra conductor and director of chamber music at court of Prince
of Anhalt-Cöthen, A.D. 1717.*
7  *From there went (A.D. 1723) to Leipzig where he had been appointed
choir director and cantor at the school of the church of St. Thomas.*
P.S.  *He died on July 28th of the year of Grace 1750.*

It is all very simple. There is nothing exciting or glorious about it.
It might be the obituary of any one of those thousands of "city mu-
sicians" who functioned during this period. But the P.S. at the end
happened to be by the hand of Philipp Emanuel Bach, and the man
about whom he wrote was his father.

## Bach

Sebastian (as his family called him) belonged to a family that had
produced so many musicians during the previous two hundred years
that in the central part of Germany where most of them were em-
ployed the word Bach had come to mean the same thing as a *Spiel-
mann* or musician. His father, Johann Ambrosius Bach, had moved
from Erfurt to Eisenach and there Sebastian was born in the year
1685. This little Thuringian city had played quite a role in German
history, for it was there that Luther, singing in the street for his daily
bread, attracted the attention of the Cotta family which did so much
to help him in his further career. Only a short distance away (a few
hours' walk) lay that magnificent Romanesque castle called the

Wartburg where early in the Middle Ages the minnesingers had held their famous singing contests (see Wagner's *Tannhäuser*) and where in 1521 Luther lay hidden while he completed his translation of the Bible.

Sebastian's father, Ambrosius, had a twin brother, Johann Christoph, town musician at Arnstadt, who not only looked so much like his twin that not even their respective wives could tell them apart, but who fiddled and composed so much like Ambrosius that it is impossible to say who composed what. These twins, together with all the other endless Bachs who during the sixteenth and seventeenth centuries held jobs as town musicians in many a village and hamlet of central Germany, were descendants of a certain Veit Bach, a baker and miller by profession, who had spent his leisure hours practicing the zither, an instrument he was said to have handled with great virtuosity.

Seeing a chance to improve his condition Veit had emigrated to Hungary. But when, during the Reformation, that country definitely took the side of the Catholic Church and all Protestants were forced to choose between recantation or exile, he packed up his little zither and returned to his native land to begin all over again. A rugged honesty and a complete inability to accept a compromise seem to have been the two chief characteristics of all the members of the Bach tribe. Several of them fell victims to the prevailing weakness of their age and ended their days as confirmed drunkards. But even in their cups they knew the difference between right and wrong in constructing a fugue as well as in closing a business deal.

Sebastian lost his father when he was ten. His oldest brother, Johann Christoph, took Sebastian and one of his other brothers, Johann Jakob, with him to the little village where he was organist. Here Sebastian learned to play the fiddle. And here occurred that famous incident which throws such a clear light upon the child's determination to learn his trade that it deserves to be mentioned as an object lesson to all children who take their music seriously.

Sebastian wanted to study the works of the great harpsichord masters of his day. His brother had them in manuscript form but would not give them to this child who was always asking too many questions, anyway. These works by Froberger and Pachelbel were kept under lock and key in a cupboard which had a latticed door; and brother Johann would not give Sebastian the key. So the boy used to sneak into the room every night when the others had gone to bed and with his tiny fingers pull the sheets of notepaper out of the cupboard. He

would copy them by the light of the moon (no candles for little boys in this careful German household!) and then tuck them away again when it had grown too dark to see. He spent six months doing this. Just when he was almost finished, his brother discovered him in the act of sneaking into the room, soundly spanked him, and deprived him of his treasures.

The brother got off easy. He is probably copying Sebastian's violin sonatas in one of the darkest corners of Signor Dante's Inferno. But poor Sebastian fared worse. He had so severely taxed his eyesight by these six months of scribbling that he grew blind long before he should have suffered from that terrible affliction. An operation was tried to restore his sight. It was not a success. Bach died blind.

I would much rather write about old Sebastian Bach than anybody else. But one either gives him three pages or three volumes. His musical output alone fills sixty volumes of the Bach Gesellschaft, founded a century after his death, when most of his works had been almost completely forgotten. This, however, was not the fault of the contemporary music publishers. Early in the nineteenth century, Breitkopf and Härtel (the firm, although founded in 1540, had been printing music for only half a century) had got out an edition of some of Bach's works. They could not sell it. In 1837 Robert Schumann published two letters of Beethoven in which old Ludwig congratulated another German publisher on his "forthcoming edition of the works of J. S. Bach." That plan too had failed. Thereupon the Bach lovers, under the leadership of Felix Mendelssohn-Bartholdy, founded their Bach Gesellschaft in imitation of the English Handel Society for the purpose of preserving the master's musical output.

They found it very difficult to get hold of all the manuscripts. Some had been sold, others given away, many more stolen or lost. The next time you hear the *Brandenburg Concertos*, remember that Bach himself never heard them played and that, after the death of the Elector of Brandenburg, they were sold for ten cents apiece.

As for the total output of J. S. B., as far as it has been rescued from the dust of many forgotten attics, it covers just about the whole of the musical field with the exception of opera in the modern sense of the word. During most of his life he enjoyed, of course, almost ideal conditions for the production of this sort of work. Our poor contemporary composers who are forever fleeing to isolated mountaintops of Pacific islands to "finish their opus No. 7" may well envy him the quiet of his surroundings.

By his first wife, his cousin Maria Barbara Bach, he had seven children of which four survived: one daughter and three sons, two of whom, Wilhelm Friedemann and Karl Philipp Emanuel, grew up to be excellent musicians in their own right. After fourteen years of a very happy but busy marriage, Barbara died. A year later Sebastian wedded Anna Magdalena Wülken, a young woman endowed with a lovely soprano voice and the daughter of a court and field trumpeter at Weissenfels. It was for her that Bach composed that charming little *Klavierbüchlein* with which all students of the piano are familiar.

Perhaps it was a reward for her secretarial services. For Bach was one of those lucky men possessed of a wife who could read his handwriting and who took a delight in copying his manuscripts. When not occupied with her husband's musical interests, Anna Magdalena was engaged in bearing him children, of which not less than thirteen appeared in very short order. But out of six boys, only two survived.

One of these, Johann Christian, the most colorful if not the most capable of all the Bachs, had an extraordinary career. He developed a gift for opera in the popular taste. He directed operas in Milan, in Naples, in Paris, in London. In the English capital, Signor Giovanni Bacchi became the fashionable music teacher of the nobility and gentry. He had his own carriage in which he drove from pupil to pupil. The charge for half an hour's lesson was half a guinea. For one of his Parisian operas he received ten thousand francs. The most his father had ever made in one of his best years when he worked only twelve hours a day at half a dozen different jobs was seven hundred thalers a year. Part of this came out of "special services" at weddings and funerals. During very healthy years (A.D. 1729 was a hard one for him) when people refused to die, his income was diminished by at least a hundred thalers.

As for those honors that meant so much in the unenlightened eighteenth century, the best Bach could ever do for himself was to be made court composer to the Elector of Saxony. It took him three years of constant effort and a series of letters of such abject humility that it hurts to read them. Yet—for such were the times in which Bach lived —this electoral title so greatly strengthened his social position that now at last he was almost victorious in his endless quarrels with his dreadful employers at the famous Thomasschule.

Bach was almost always in trouble with his superiors, usually about some absurd little trifle. When younger he was raked over the coals for allowing a strange young woman to play in the organ loft. Fortunately, on this occasion he was able to justify his act because "he had

warned the local pastor that the young lady was his cousin and his
future wife." Later on he was reprimanded for repeatedly overstaying
his leave of absence when away in some big city to hear the works of
one of the great contemporary masters.

But all these were as nothing compared to the difficulties that arose
after Bach left Cöthen, where he had been quite happy and com-
paratively well paid, to succeed Johann Kuhnau as cantor of the

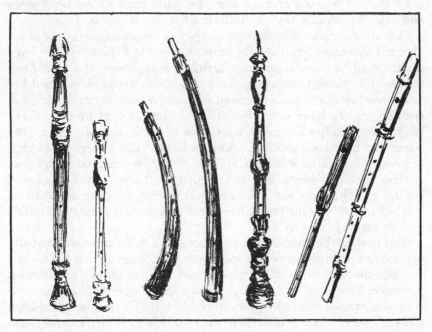

*These were the only instruments outside the harpsichords and the strings that
were at the disposal of the composers of the days of Bach and Handel.*

Thomasschule in Leipzig, where for the first time in his life he would
have a good organ at his disposal. So little did the worshipful magis-
trates and the good citizens of Leipzig understand his genius that they
noticed neither the *Saint John Passion* with which he opened his official
career in their town nor the *Saint Matthew Passion* which he wrote six
years later in 1729. A single contemporary critic remarked that it was
better suited for the concert hall than for a church, a fact which may
well have influenced him never to write another Passion.

But his minor works too failed to find favor in the eyes of his im-
mediate superiors. They never ceased complaining that he took "lib-

erties" with the music he was supposed to play during the church
services and were forever objecting to his "inexcusable habit of im-
provising in an unsuitable style." In order to show how thoroughly
annoyed they were, these little souls made it impossible for the music
teacher they had "hired" to reorganize his choirs along practical
lines by firing the incompetent singers and hiring only competent
ones. He had to do the best he could with the material they gave him.
If he did not like the arrangement, he could pack up his belongings
and take his small army of children wherever he pleased.

Did all this make him lose his temper or resort to outbreaks of in-
dignant violence? Hardly. He was too sincerely aware of his own
worth. And he was too good a Christian. If it pleased the good Lord
to send him these tribulations, he probably deserved them. And be-
sides, had he not been recognized by the greatest in the land? Had
not the mighty King of Prussia sent for him? Indeed he had! From
Bach's son, Philipp Emanuel, who was one of his court musicians, the
King had heard all about the famous father. The latter was bidden
to present himself in Potsdam. He was sixty-two years old at the time
of that famous journey. But he traveled all the way to the Prussian
capital and the King was informed that the old man had arrived and
was waiting to pay his humble respects whenever it pleased His Maj-
esty to deign to receive him.

And then a tremendous thing happened—a thing unheard of at any
royal court—almost as revolutionary and shocking as that time when
King Louis XIV allowed his good friend Molière to take a seat in his
presence. The King said, "Bring the old fellow right in!" and he wel-
comed him most cordially and showed him all his new pianos, which
were of course of great interest to the man whose *Well-Tempered Clavi-
chord* was to provide all future piano students with their Bible and
Book of Common Prayer. And thereupon, before all those present,
His Majesty provided the Saxon *Herr Kapellmeister* with a theme of his
own and asked him to improvise on it. And the *Herr Kapellmeister* had
done this so brilliantly that His Majesty and everybody else were de-
lighted, and the King actually refrained from giving a flute concert
of his own in order to spend the entire evening listening to the music
teacher from Leipzig.

And did the people of Leipzig hear about it? They did. And did it
change their attitude toward him? Not particularly. To them and to
most of his contemporaries Sebastian Bach remained just another
Bach, another church choirmaster on seven hundred thalers a year.

When, during the end of his life, his incomparable *Art of the Fugue*

THE ART OF DYNASTIC GRANDEUR OF THE XVIII CENTURY

BACH'S WORKROOM IN LEIPZIG

was published (one of the very few of his works actually printed during his own lifetime), only thirty copies were bought and the copperplates were sold for what they were worth—as copper. But few people have gone through life as serenely and uncomplainingly as old Johann Sebastian. Even fewer have shown such considerate kindness toward all beginners or greater magnanimity in forgiving their enemies. All his life long he remained the simple *Spielmann* of his earlier days, the little boy who had spent the moonlit nights copying the forbidden music of Pachelbel.

He was an indefatigable worker, an excellent harpsichord player, the most famous organist of his time, a good fiddler, a good viola player. And the number of his works that he wrote for the voice and for every instrumental combination is so enormous that one might feel inclined to doubt their authenticity until one begins to examine them. No matter how simple or how complicated, the Bach touch is always there. It is as difficult to produce a spurious Bach cantata as to fake a Rembrandt etching.

And now before I bid farewell to this man to whom I owe more than to all the great philosophers who merely tried to reveal Divine Truth by means of words, a few more random ideas. The fascinating part of life is its absolute unpredictability, its sublime lack of logic. It is undoubtedly true that once the northern part of Europe had grown more prosperous than the southern, the best artists and musicians of the south began to move in a northern direction. But Bach was born in the postwar Germany of the seventeenth century, the postwar period of that struggle of thirty long years during which the Teutonic lands suffered a setback from which they did not recover until fully two centuries later. And yet he and all his fellow musicians in their little towns and villages, living pitifully hard lives and getting practically no recognition, created a world of beauty that no country in the heyday of its glory has ever surpassed. Here and there a backslider like Handel or Bach's own son, Johann Christian, might fall for the fleshpots of London or Paris, but the others were quite content to remain where they were, to do the work their busy hands found to do, but at all times striving to further the cause that was nearest to their hearts—the cause of Music.

Bach departed this life quite suddenly on July the twenty-eighth of the year 1750. A few days before his death the blind man was dictating a choral for the organ to his son-in-law. At first the title he had chosen was *When in the Hour of Utmost Need*. But when he felt that the

end was near, he asked that it be changed to *Before Thy Throne, My God, I Stand.* And when he finally stood before that Throne, no man ever approached it who had so well deserved of the divine mercy as the old *Hochfürstliche Anhalt-Cöthenische Hof-Kapellmeister* and Director Choirmaster of the Church of St. Thomas in Leipzig, Johann Sebastian Bach.

The question is often asked: If Bach was really conscious of his own greatness, why did he accept the indifference of the public toward his music with such complete equanimity? For with the exception of Frederick the Great, he really received very little public recognition. And he must have realized that while he lived the obscure life of a "town musician," his rival Handel, who would not even take the trouble to meet him, let alone shake hands with him, was rolling up several comfortable fortunes and was becoming a man of such solid popularity that even the Hanoverian royal family (otherwise not famous for the delicacy of its feelings) trembled in its Hanoverian boots when their terrible *Kapellmeister* was in one of his tantrums. And while a truly great artist may be indifferent to the neglect he himself receives, the thing that is apt to hurt is to see others of inferior ability get away with all the laurels.

Well, in the first place, Sebastian Bach was much too great a man, and too sincere and honest a Christian in the most sublime sense of the word, to indulge in envy. That is why I have gone into such detail about his private life, for in his case, at least, the man and his art were absolutely one. But in the second place he was such an excellent musician, he knew his craft so well, that he must have realized that due to the conditions under which he lived he must necessarily be unpopular with the great masses of the people.

For Bach had the misfortune (which became our own good fortune) to be born in a sort of musical twilight zone between the old order and the new. The religious fury of the previous two centuries had spent itself. The inevitable reaction had set in. People were eager to listen to something that would take their minds off their troubles, the inevitable troubles of every great postwar period. The easy flowing and gay melodies of the Italian opera came to them as a tremendous relief. Here at last was something to which one could listen without bothering one's brain trying to solve some complicated contrapuntal problem. You could just sit down and let the music do the work.

Bach realized that there was no use fighting such inevitable reactions. Italian opera was the thing that just then happened to appeal to most people. Serious-minded German composers like Reinhart

Keiser and Johann Wolfgang Franck, who worked very hard to make Hamburg, the richest German city, the center of a truly German opera, ended their days in the poorhouse. Very soon after it had been founded the Hamburg opera was forced to close its doors. Italian music, the jazz of the seventeenth and eighteenth centuries, was in possession of the field and nothing was going to dislocate its hold upon the popular favor until a German musician who could and would compose in the modern manner should make his appearance. It was the tragedy of Bach that he was not that man.

In this respect he was entirely like that other famous citizen of the good town of Eisenach, Dr. Martin Luther. Just as Luther had not really been a pioneer of a new idea but the last defender of the faith of the Middle Ages—the last of the great medieval heroes—so Bach was not really a pioneer of a new form of musical expression but the last of the great medieval musicians. We are very apt to overlook this fact, and yet it explains everything. Bach's music, if we are not particularly serious students of the subject, strikes us as something refreshingly new—as something most agreeably suited to our modern ears. But Bach's music is only modern in the same sense that Giotto's frescoes or Jan van Eyck's pictures were modern. In reality, these were the final summing up and the highest flowering of a bygone civilization, but not in any way the forerunners of a new age.

When you look at the problem in this light it becomes clear why his contemporaries felt so indifferent toward this man to whom they used to refer as "the old wig," or, as we would say, "the old codger." The sort of wigs he continued to wear were old-fashioned contraptions with which no bright young lad, who kept up with the times, would care to be seen in public. And his music was like his wigs. It belonged to a past upon which most people had now deliberately turned their backs because it only reminded them of centuries of misery. They were all for the present. Although they realized that they were dealing with a musician of brilliant talents (for no one ever doubted Bach's genius, both as a composer and a practicing musician) they would have none of him. He was a "fussy old wig"—a man who had outlived his time.

We, who no longer share their prejudices and to whom their own much vaunted "modernity" sounds like terribly old-fashioned stuff, meager and without any true inspiration, can appreciate Bach for what he really both was and is—the most sublime exponent, the highest incarnation of all that was highest and noblest in the music of

the past—the broad foundation upon which the next generation would be able to construct the music of the future.

## Handel

Georg Friedrich Händel—or, after he became a British subject, George Frederick Handel—was born in the year 1685, the same year as Bach, but he died nine years after his famous contemporary, in April of the year 1759, and was buried in Westminster Abbey with all the pomp and circumstance due his exalted position as music teacher to His Majesty King George I.

His father, a barber-surgeon in Halle-an-der-Saale, had great ambitions for his bright young son. When he discovered that the boy wanted to become a professional musician, he flatly put his large Saxon feet down and said "No!" The son must rise a few rungs on the social scale by studying law. The scales of Guido of Arezzo would never get him anywhere. In the end, the father and son compromised. The son registered as a law student at the university and meanwhile spent a year as probationer-organist at the local church. After that year he got a definite appointment and at once bade farewell to the law.

His ability, however, attracted the attention of several serious patrons of the arts, and he was offered several subsidies which would have made it possible for him to spend some years in Italy to perfect his technique and learn composition. All such assistance Handel none too courteously refused. Not that during the earlier part of his career he was a young man of very lofty ideals. He had seen enough respectable poverty at home to give him an intense dislike for a diet of potatoes and boiled cabbage. But he was much too proud to sell out to some rich employer. Wherefore he carefully saved his pennies until he had enough of them with which to go to Italy under his own steam.

A fairly successful opera called *Almira*, performed in Hamburg in the winter of the year 1705, helped him to start upon his great adventure. He crossed the Alps and spent three years in Naples, Rome, Florence, and Venice. He had so thoroughly acquired the popular Italian style that Signor Giorgio Federico Handel, *il famoso Sassone* (the great Saxon), was everywhere received with enthusiastic acclaim.

It was during this visit that a little incident occurred which shows how far we have progressed in our instrumental technique from those very simple days. Corelli was playing the fiddle in a piece by Handel and came across a passage written in the seventh position. He ob-

jected. He refused to go that high. He said that the violin was in-
capable of producing a pleasing tone, once one went beyond the
third position. Handel took Corelli's fiddle and showed him that it
could be done. But ever after he carefully avoided the higher regions.
That is one of the reasons why Handel is so popular among all
amateurs. He does not ask too much of their technical abilities. Old
Bach does not care what he makes you do. He writes as he pleases
and it is up to you to learn to play what he has written or leave it
alone. But Handel knew his public. Handel died rich, Bach died
poor.

Not that his career was without its difficulties. He was considerable
of a plunger and his operatic ventures were by no means always suc-
cessful. After his return to his native land he accepted a post as
*Kapellmeister* at the court of the Elector of Hanover. Hearing of the
great possibilities that awaited a clever manager in London he asked
for a year's leave of absence, obtained it, and crossed the Channel. A
second visit to London proved to be so lucrative that at the end of his
leave of absence he flatly refused to return to Hanover.

This time his luck left him. Queen Anne died and Handel's
employer, the Elector of Hanover, became King of England. The
deserter might have fared very badly but, never at a loss and pos-
sessed of unlimited nerve, George Frederick Handel (now without
his umlaut) welcomed his former master with that famous composi-
tion which afterwards came to be known as the *Water Music*, as it had
been written for a royal water party on the Thames. Old George,
delighted with this composition, forgave his wayward *Kapellmeister*,
bestowed a pension of four hundred pounds per year on him (soon
afterwards increased to six hundred) and Handel could continue to
write his operas.

But the law of supply and demand functions just as nicely within
the domain of music as in that of trade and commerce. The English
people were willing to pay very liberally for light operatic entertain-
ment in the Italian style, and that fact did not remain a secret very
long. Behold, therefore, Signor Buononcini arriving upon the scene
with a rival troupe of singers! Thereupon there occurred that famous
battle of the composers which John Byrom made immortal in his
elegant poem which begins:

> *Some say, compared to Buononcini*
> *That Mynheer Handel's but a ninny,*

and which ends with this well-known phrase:

> *Strange all this difference should be*
> *'Twixt Tweedle-dum and Tweedle-dee!*

The way in which Tweedle-dum finally overcame Tweedle-dee is even more remarkable. Buononcini, quite a good composer in a light way, was exposed as having copied a madrigal (for which he had been given a prize) from a melody by Antonio Lotti, the organist of St. Mark's in Venice. Unable to offer a suitable excuse, Buononcini was forced to leave England.

Now the curious part of this incident was that Mynheer Handel himself was one of the slickest musical thieves that ever lived. It takes the superior abilities of a musical detective like our own good Sigmund Spaeth to discover where George Frederick got his plunder. As a matter of fact, he rather prided himself on his habit of stealing other composers' tunes and then sending them back to the stage bedecked with a few fine Handelian feathers. "Why not?" he used to ask with charming Teutonic bluntness. "The swine did not know what to do with them. I do." And he was quite right.

In the actual writing of his scores he was careless to a degree. For he had none of Sebastian Bach's careful methods of painstaking precision. The moment the music had been sufficiently "indicated" to allow the musicians and singers to make head and tail of it, he was satisfied. Everything else he considered a waste of time and energy.

Not that he was in any way lazy. The published works of the English Handel Society fill one hundred large volumes. Forty-one Italian operas, two Italian oratorios, two German Passions, eighteen English oratorios, five Te Deums, four coronation anthems, thirty-seven instrumental sonatas, twenty compositions for the organ—I shall spare you the rest, for the list is endless. Only a man with a coal heaver's constitution could have turned out so much work. He was not satisfied with merely writing all these operas and oratorios and conducting them and also playing the organ during the intermissions. No, he must also run the business end of his theaters and attend to all the details of a technical nature. Finally he so overstrained himself that he suffered an attack of apoplexy. This would have killed any ordinary man but it did not kill George Frederick Handel. He went to a watering place on the Continent and took the hot baths. He sat in these three times as long as any ordinary human being would have done but survived the experience. The moment he considered himself completely recuperated, he went back to England. Fearing that

another John Gay might write another *Beggars' Opera* and clown the noble Signor Handel off the stage, he now concentrated all his powers upon his oratorios, gave up Covent Garden and the opera, and concentrated on this form of entertainment at the Haymarket Theater until his restless soul bade him accept an invitation to go to Dublin, where he had never been and therefore had not yet been able to make any enemies.

That was the reason why the Irish were the first to hear his *Messiah* which, by the way, was not Handel's own favorite composition, for he preferred his *Samson.* But the *Messiah* was accepted by the English as their own most particular oratorio and ever since doddering old King George rose to his feet when the Hallelujah chorus was sung, it has been considered very bad form indeed to listen to this melody while remaining glued to one's seat. I have often tried to discover why people who can sit peacefully through Bach's Organ Fugue in G minor should feel that way, but I have discovered that many Englishmen seem to consider the Hallelujah chorus a sort of national anthem of Heaven. And about national anthems, as all of us know from sad experience, one should never start an argument.

Please do not construe this little aside as an indication of a somewhat superior attitude toward the music of George Frederick Handel. The man was endowed with such a vigorous genius for the art to which he gave all his lifelong efforts that regardless of his endless plagiarisms (but then, almost all other musicians of note have done likewise, and why not?) and his careless and hasty methods of composing, he belongs to the very greatest among the great. And he undoubtedly succeeded in making England music-conscious. He continued where poor Purcell had left off. He gave the English people a national music of their own.

Six years after his death, a wonder child who had been exhibited all over Europe dedicated one of his violin sonatas to good Queen Charlotte, and in a letter, dictated undoubtedly by his manager-father, the older Mozart, he expressed the hope that with Her Majesty's kind assistance he might some day be as famous as "Messieurs Handel et Hasse." Today, unless you have an excellent musical encyclopedia you will experience considerable difficulty in finding the name of Johann Adolf Hasse. But in the eighteenth century this clever German was considered the greatest of all composers of opera in the true Italian style. As a matter of fact, he bestowed upon the world more than one hundred Italian operas, not a single one of which is now

ever heard. It shows how music is almost as much the victim of man's ever changing tastes as the garb of the fairer sex.

It also shows how completely poor Sebastian Bach had been forgotten, less than twenty years after his death. Perhaps a few people

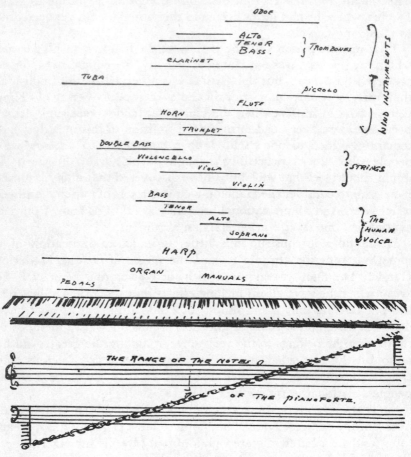

THE COMPOSER'S PALETTE

remembered that the distinguished-looking Signor Giovanni Bacchi, who performed his operas at the King's theater and was said to be a pupil of no one less than Padre Martini, had had a father who in his own small way was quite an expert at counterpoint and religious cantatas.

This Signor Giovanni had turned Catholic while organist to the

Milan cathedral. This was perhaps a little inconvenient in a country as much devoted to the Protestant cause as England. But one could not have everything. And besides, what harm could he do? For had not His Majesty's government, somewhat upset by all this musical to-do, taken the necessary precautions against further rowdyism of the Tweedle-dee Tweedle-dum sort by deciding that opera singers should henceforth be classified together with the regular actors?

Yes indeed, that is exactly what His Majesty's ever watchful government had done and from that moment on all opera singers were subject to the same regulations as their friends of the legitimate stage, which meant that in the eyes of the police they now became identified with mummers, vagabonds, and plain rogues.

### Haydn

Franz Joseph Haydn was born almost half a century after Bach and Handel and a quarter of a century before little Wolfgang Amadeus Mozart bestowed his first engaging smile upon this world. This great and good man therefore was a sort of bridge connecting the old music with the new. Few people as gifted as this simple Croatian peasant have ever played the difficult role of being a Grand Old Man quite as graciously as "old Papa Haydn." I don't know why he should always have been known as "old Papa Haydn," for when he died at the age of seventy-seven his spirit was as young as the day when, without a penny in his pocket, Franz Joseph was turned out into the streets of Vienna because the dignified director of the St. Stephen's choir school objected to the too lusty spirits of this gay young pupil. As for his uneventful career, here it is, told as briefly as possible.

Haydn was one of twelve children, three of whom made notable careers as musicians. His father was a poor wheelwright in Rohrau or Trstnik, whichever it is called today, a village on the border between Austria and Hungary. The Haydn family, however, was neither German nor Magyar but of Croatian origin. I could not find out whether Haydn spoke Croatian, but it is not very important, for whether he spoke the language of his ancestors or not, he became the man who for the first time introduced Croatian folk tunes into the music of the West. Just as Liszt was the first to make use of the folk tunes of his native Hungary, although he never learned to speak Hungarian with any degree of fluency.

At the age of four, little Franz Joseph was sent to a distant relative who was a schoolmaster and a musician and who trained him as a

choir singer. Thence he went to the boys' choir of St. Stephen's in Vienna. His voice broke, he got in trouble with the director about some silly boy's prank, and that was the occasion when he found himself on the street without a friend and without a groschen in his pocket. But somehow or other he got through the next few years of utter poverty. Being a lovable lad, he found many people ready to help him out with odd jobs, old clothes, and a nice, airy garret in which to sleep.

We recommend this part of his career to those who besiege our none too patient ears with the complaint that they too would have done all sorts of great things if only they had had the chance. Not that poverty and hunger, as the romantic school of eighty years ago seemed to believe, will invariably make a great artist out of a third-rate talent. But they never seem to have interfered very seriously with a boy of real ability.

Besides, Haydn enjoyed one enormous advantage over many of the musicians of a later date. He was of peasant stock. He was inured to hardships. He took them all in his stride and never allowed an empty stomach or a threadbare coat to interfere with his happy disposition.

Metastasio, that queer old libretto writer who pops up in the lives of almost all the musicians of the eighteenth century and always as the good fairy, met the boy in his boarding house and gave him a lift. Niccolò Porpora, the singer and the composer of diverse highly successful but completely forgotten operas and whose life reads like Thomas Cook's railroad guide to continental Europe, used him as his valet and taught him composition. And so between curling his master's wigs and pressing his coats, young Joseph learned his trade, until the Baron von Fürnberg, an immensely rich Austrian land-owner, hired him to conduct his private orchestra at his castle in the country.

From there he went in a similar capacity to work for a Bohemian aristocrat by the name of Morzin where he had an orchestra of fif-teen excellent musicians at his disposal, composing trios, quartets, symphonies, dance music—anything he was asked to do—and doing it in a hurry, which is the way a great many artists have always done their best work.

Two years later he left Count von Morzin to become general *Kapellmeister* to Prince Paul Anton Esterhazy, a Hungarian noble-man whose love for music was as far, wide, and handsome as the acres he could call his own. With the Esterhazy family, Joseph Haydn remained for almost thirty years.

In the meantime he had married the daughter of a Viennese hairdresser. This lady, according to all who ever knew her, was a *grande canaille*, an intolerable shrew, jealous, stupid, and forever riding herd on her poor husband. He never got rid of her. How could he in a country in which even today divorce is impossible? He supported her but lived his own life and did not allow his domestic Xanthippe to interfere with his good humor.

The Esterhazy orchestra was small but famous for the ability of its players. Haydn, relieved of all material cares, composed barrels of music: five masses, thirty piano sonatas, a dozen operas, forty quartets, one hundred symphonies for orchestra, concertos for every sort of instrument, and a whole sheaf of pieces for the baritone violin. The baritone was a *viola da gamba* with a set of sympathetic strings. It enjoyed a short popularity during the eighteenth century and Haydn's employer was very fond of it. Today you may find a few baritone fiddles in the better-equipped museums of musical instruments but they are very rare.

And now, please notice the appearance of a new note (no pun intended) in the announcements of the *Musical Couriers* of that day. Monsieur Haydn is referred to as the man whose music has been "published" all over Europe. That meant an almost revolutionary development in the lives of all musicians. We complain (I did it too in the last chapter) that Handel was a careless composer. We find it curious that Bach should have jotted down his noblest cantatas in a sort of musical shorthand, which is almost undecipherable to us and which seems to indicate—to our minds at least—that he put perhaps no great value on what he was doing. But why should the great musicians of the Middle Ages and the seventeenth and eighteenth centuries have done otherwise? Why should they have bothered? They knew perfectly well that as soon as their cantata was sung or their little symphony played, it would be dropped into an old chest of drawers, from where it would eventually move into the attic unless it were used to start the kitchen fire. There was not a chance in a thousand to get the thing published. Even if it were published, where was the public to buy it? There was none. Whatever they composed was written for a direct purpose and an immediate necessity. Once that purpose had been fulfilled, once the wedding had been celebrated or the funeral held or the third Sunday after Easter lived through, the music ceased to be of any further interest to anyone.

When Jules Landé, our own Hungarian fiddler, arranges the *Big Bad Wolf* for the delight of his lunching audience, he does not expect

that *La Storia del grande lupo cattivo*, op. 497 in G major, arranged for harpsichord, two violins, and contrabass, will thereafter appear in the catalogue of some famous music publisher between the works of Lalo and Orlando di Lasso. To compose his variations on the music to Signor Disney's libretto was just an incident in his life, no more important than playing a few scales through the waltz in *Die geschiedene Frau*.

Until the day when it became profitable and possible for them to have their music published, all composers knew that whatever they wrote would soon be as dead and forgotten as the *Big Bad Wolf* of the luncheon hour at the St. Regis. It was the realization of the fugitive quality of all their work that made them write the way they did. It also was the reason why they stuck so tenaciously to a regular job that guaranteed them and their families a roof over their heads and a piece of veal on Sundays. There was no other way in which they could possibly hope to make a living. The favor of a prince or a bishop or the vestrymen of some church was their only protection against the poorhouse.

The great change in their economic and therefore in their social status came during the latter half of the eighteenth century. Haydn was the first one to benefit by it but the Esterhazy family remained his main source of income. The royalties on his compositions at best provided him with a few extra glasses of Heuriger (that abstemious Croatian peasant never drank anything more dangerous) and toward the end of his life they made it possible for him to patronize a better tailor and wigmaker.

Mozart, poor impetuous youth, exasperated by the dull-witted Salzburg bishop who was his employer, broke away from this bondage and tried to make a living in the "new way" by supporting himself from his published works, but he failed and dropped by the roadside from sheer physical exhaustion. It was not until some thirty years later that Beethoven at last succeeded in breaking the bonds which until then had always made a composer dependent upon the good will of some particular employer. Beethoven was the first great musician who ever succeeded in supporting himself by the sale of his published works. In a way it was one of the most important changes that have come over the lives of all musicians since Guido of Arezzo gave them a practical system of notation.

So much for the economic background of Joseph Haydn's life. In his old age he did considerable traveling. He went to England twice

after the soil had been carefully prepared by Mynheer Tweedle-dee Handel. He was made a doctor of music by the University of Oxford. On his way home he was received with great solemnity in Bonn where he was welcomed with a cantata especially composed for the occasion by an unknown young pianist by the name of Ludwig van Beethoven. Papa Haydn thought so much of this work that he asked him to come to Vienna and be his pupil. He already had had one pupil who had made quite a name for himself, a lovable lad from Salzburg by the name of Mozart.

That was in 1792. From January, 1794, until July, 1795, he was once more in England. The rest of his days he spent in the Mariahilf suburb of Vienna, honored by all and loved by all, a musician of such international importance that when Napoleon's troops took the Austrian capital their commander in chief placed a special guard of honor in front of the house of the man who had composed the Austrian national anthem, that lovely hymn which you will also find in his "Kaiser" Quartet. In 1799 at the age of sixty-seven he composed his oratorio, *The Creation*. Two years later (for he got better the more he wrote) he wrote *The Seasons*. On May 31st of the year 1809, old Papa Haydn quietly dropped off to sleep and when he awoke again—behold! he had joined the immortals, both in this world and in the other.

What is Haydn's importance to us today? In the first place, there is the fact that he was the first composer who devoted all his energies to the development of the orchestra. In the second place, he was the first composer to discover the vast and hitherto unexplored field of folk music. Being a peasant himself he knew the ancient peasant tunes of his own Croatian people. In his operas and oratorios he still belonged to the old school and rigorously observed the traditional formulas of a bygone age. But within the field of the orchestra, Haydn was really the first of the great moderns. Philipp Emanuel Bach, Sebastian's gifted son, had tried very hard to do something along this line but he had never had a really good orchestra at his disposal. Haydn fared better. The Esterhazys had a fine nose for promising young talent and as they were people of unlimited wealth, Haydn was able to hire all the best fiddlers and flutists and oboists of his time.

Most of the Esterhazy concerts were private affairs to which they invited only a few intimate friends who happened to be music lovers. For these *soirées intimes*, Haydn would write a nice little quartet or a

trio, for that was by far the most satisfactory form of music for a small room and a small group of people.

At first the critics, who are usually twenty-five years behind the composers, bitterly objected to his habit of incorporating minuets and folk tunes into his symphonies and quartets. To them this was sacrilege, just as if a great modern composer, doing a little Ninth Symphony of his own in the best Beethoven style, should incorporate *Turkey in the Straw* into his third movement. But the innovation was a tremendous success with the public and most of all with his employers. There are, after all, certain undeniable advantages in working for a Serene Highness who gives you his full confidence. His

WHEN LITTLE MOZART PLAYED THE PIANO. . . .

Serene Highness can always tell the second footman to tell the third doorman to boot the critic out into the street.

Today Haydn is less popular than any of his great rivals of the eighteenth century. That may merely be a matter of a passing fashion, like our sudden enthusiasm for Van Gogh's pictures. A clever conductor or manager may change all that overnight. But even those who are not easily influenced by the activities of a shrewd publicity agent complain that Haydn's music is a little too thin for their ears. It well may be. But even if his music should entirely disappear from our programs (which the Muses forbid) we shall always have to remember old Papa Joseph as the father of the modern symphony and the modern quartet.

Others had tried their hand at diverse sorts of instrumental com-

binations which were supposed to produce symphonic effects. But Haydn was the first of all the great composers to do this with such brilliant results that the symphony soon afterwards became the *pièce de résistance* of all concerts, a position on the musical menu it has most successfully held until this very day. And I suspect that we are only at the beginning of the development of the symphony. Until now we have been too much influenced by the classical prescription which demanded that a symphony, like a sonata, must consist of just so many divisions—an andante, an allegro, a minuet or scherzo, a lustily galloping finale, etc., etc.

However, we are beginning to realize more and more that in music, as in everyday life, it is good policy to let the dead bury the dead. And some day one of our own composers may give us a new sort of symphony that shall have done away entirely with the old eighteenth-century divisions. A beginning has already been made by some of our composers who are graduated out of Tin Pan Alley. When these noble syncopaters finally turn their attention to the more serious forms of music, we may expect great things. And when that happens, that greatest of all syncopaters, Ludwig van Beethoven (what a fine tap-dance could be done on the finale of the "Kreutzer" sonata!) will undoubtedly lean out of heaven and gruffly shout his "bravo!" and "bis!" Undoubtedly this will again give deep offense to our professional critics, but was anything really good ever written with one eye on the score and the other on the critics?

Homer was blind. That may be one of the reasons why he wrote such excellent poems.

## *Mozart*

The first battle royal between Italian and German opera was, as we have already seen, fought in Paris in the days when Gluck, at the suggestion of his Austrian protector, Marie Antoinette, invaded the French capital with his *Armide* and his *Iphigenia in Tauris*. At that time young Mozart was only eighteen years old. When a few years later *Idomeneo*, the first of his better-known operas, appeared, the scene of the conflict had been moved from Paris to Vienna. And there it was fought out to the bitter end.

Not a very nice quarrel when one thinks that the unscrupulous Antonio Salieri was the leader of the opposition. For although it has now been conclusively proven that this hotheaded Italian, who for half a century was dictator of Vienna's musical life, did not actually try to poison his rival (as all the world then firmly believed), he un-

doubtedly succeeded in poisoning the minds of a great many people against Mozart and in this way had a great deal to do with the untimely death of the simplest and most lovable character among all the great composers of the past.

A great deal has been written about the illness that caused Mozart's death at the age of only thirty-six. As his body disappeared in a pauper's grave and was never found again, even the most eminent specialists within this field of post-mortem diagnosis, who can tell us what diseases were most frequent among the cavemen of Europe and among the mound builders of our own country—even they will never be able to help us out. But I seriously suspect that Mozart, never very robust, finally collapsed and died under an amount of work that would have killed a dozen ordinary people in less than half a dozen years.

Wasting no time in getting started, Mozart began to play the harpsichord at the tender age of three. A year later he made his first appearance in public, and on the program were some of his own compositions. His father, Leopold Mozart, a violinist in the service of the Archbishop of Salzburg, was his teacher. His sister Maria, the beloved Nännerl of his letters, also endowed with a precocious gift for music, shared these lessons. His faithful mother superintended the household, and it was a cheerful family, for both children took to their little piano as a thoroughbred poodle takes to tricks.

Salzburg, by the way, which now cashes in rather indecently on the reputation of this famous family (it did not particularly appreciate them while they were still living in their airless and dark third story walk-up of the Getreidegasse) was a queer little town. It was one of the few cities of southern Germany to escape the ravages of the Thirty Years' War. This had been due to the efforts of the prince archbishops who ruled the tiny state. During all these difficult years they managed to maintain a strict neutrality while selling everything their country produced with complete impartiality to both the Catholics and the Protestants and at such tremendous profits that they were able to convert their little city into a sort of miniature Versailles, one of the greatest show places of the era of the Baroque.

When the Thirty Years' War was over, these good shepherds bethought themselves of another convenient way of making a few extra thalers. They forced all their Protestant subjects to leave their territory but prevented them from taking any of their possessions with them when they went forth into exile. A great number of these

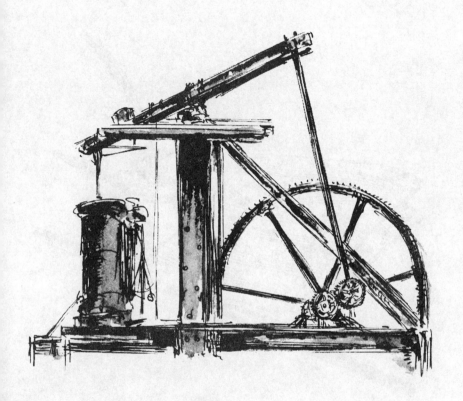

*We admire the first steam engine of James Watt for its logical simplicity...*

*but No. 1 of Bach's* Well-Tempered Clavichord *is beautiful for exactly the same reason.*

Salzburg peasants thereupon found a new home in Prussia. They were in luck, for the Brandenburg electors declared that such treatment of harmless citizens was an outrage against humanity and forced their Austrian colleagues to disgorge at least part of their plunder. Enough, however, of this stolen money remained behind in Salzburg to make it possible for the prince archbishops to add several pleasant Rococo touches to their Baroque establishment and to create an atmosphere of beauty and charm that has made this town an ideal spot for those annual musical festivals which are now the only source of revenue for most of its inhabitants. On these occasions the name of Wolfgang Amadeus Mozart smiles at you from every fence and billboard.

It is always interesting to see the sort of treatment such an "illustrious fellow townsman" received when he was still among the living. You should know Mozart from his works, of course, for it is the work of the artist that tells his story. But his career was so typically Rococo and he himself such a perfect representative of the Rococo spirit in all its good, bad, and indifferent qualities that it will be interesting to give you a short account of his career on our ungrateful planet.

In the year 1762 when little Wolfgang was six years old, dear Papa Leopold took him and his sister Nännerl, then eleven, on their first concert tour. Until then the world had not been called upon to deal with the problem of the infant prodigy, for it was only during the last half of the eighteenth century that the stagecoach connections between the different cities of Europe were sufficiently developed to let children go forth upon such exhausting expeditions without killing them off at the end of six months.

First of all the family went to Vienna. Good old sentimental Maria Theresa loved this charming little boy who was about the same age as her pretty little daughter, Marie Antoinette. The Emperor sat next to him on the piano stool while he played, and said that he was a fine little fellow—a veritable magician. The Empress, instead of scolding him for such a liberty, was delighted when, after he had played his little piece, the little boy climbed right into her broad, motherly lap and told her what a beautiful house she lived in. And when Marie Antoinette showed him how to maneuver the slippery floors of the palace without breaking his neck and the boy took her by the hand and said, "Oh, how pretty you are! When I am grown up, I will marry you," everybody thought it simply too charming for words.

Maybe that unfortunate princess thought of all this on that ghastly day in October, thirty-one years later, when she was carted off to the scaffold amidst the curses of her former subjects. If she had married that funny little boy who was such a wizard on the harpsichord, her life would have been quite different. Now all the world was singing his melodies. He himself had died two years before. She had heard about it during those terrible days when her whole world had collapsed around her. Marie Antoinette of Hapsburg-Lorraine or plain Frau Mozart? Life, indeed, was very strange. . . .

Now she was reaching the Place de la Concorde—right there before her arose the dreadful guillotine. It would all be over in a few minutes. . . . A little boy playing his little minuets on her mother's harpsichord in Vienna. . . . Yes, Sanson was ready for her. . . . The cursing of the mob was growing louder and louder. . . . There was that delightful air in *The Marriage of Figaro*. . . . How did it go? . . . Her brother had never approved of that opera. . . . And Beaumarchais had been a scoundrel, even if he had been such a close friend of that wonderful Monsieur Franklin who had told her such wonderful stories about life in the great American wilderness. . . . But she had been told that the opera, as little Wolfgang had written it, had been quite different from that evil piece of revolutionary propaganda of wicked Beaumarchais. . . . The text had been rewritten by old Da Ponte. . . . She remembered him too. . . . Yes, she had met them all . . . and where were they now? . . . The dreadful rebellion of the last five years had blown them all from their moorings. . . . The wheezy Da Ponte had been carried furthest of all, trying to make a living by organizing operatic performances in all sorts of queer places.

The plank was coming down. There was the *Marseillaise!* Captain Rouget de Lisle had been a soldier, yet he had written that terrible tune. The little Mozart boy would never have done that. He was a gentle child. . . . Now they were putting her on the plank. . . . They hurt her arms, but she was almost too numb to feel. . . . The crowd had stopped singing. . . . The silence was worse than all that noise. . . . Sanson was whispering something to his assistant. . . . The little Mozart child had hardly been big enough to reach up to the piano. . . . That was in her mother's home, the day she had almost tripped upon the slippery floor. . . . That crash was louder than any music she had ever heard. . . . The head of the widow Capet was being shown to the multitude. . . . *Allons, enfants de la patrie!* . . . The

drums of *The Marseillaise* had proved stronger than the fiddles of *The Magic Flute*.

A year after the performance at the imperial court in Vienna, Papa, Mamma, Nännerl, and Wolferl once more set forth to conquer the world. Upon this occasion the wonder child not only played the harpsichord but also performed on the organ and the violin. Furthermore, he sang, and at a moment's notice he would compose you a symphony or a sonata or just a little tune for the piano and flute—or six flutes. You just asked him whatever you thought would be very difficult and the child would immediately oblige and would kiss your hand while thanking you for the present you had made his papa.

But in spite of all the triumphs, gala performances at the court in Versailles, gala performances at all the embassies, the expenses of the trip ate up all the profits. So the four decided to try their luck in London. As everybody knew, Mr. Handel (and Frau Mozart thought her own little Wolferl infinitely better)—as everybody knew, that terrible German was said to have made an enormous fortune in that capital. England was very hospitable to the charming papa and mamma and their lovely and accomplished children. Little Wolferl was even allowed to accompany her on the piano when the good Queen sang a few songs, and he was very polite about it and said that Her Majesty had a lovely voice. Again a lot of medals and honors but very little profit.

So they next went to Holland where everybody was known to be as rich as Croesus himself. The same reception, even in this phlegmatic land. Little Wolferl played on the organ of the great Jan Sweelinck, founder of the modern school of organ playing, the teacher of Buxtehude and of that Johann Adam Reinken, who had so impressed Sebastian Bach that as a boy he used to walk several times a year from Lüneburg to Hamburg just to hear this Dutchman play. It was here in Holland that the small boy composed his first oratorio. But opera had to wait until later after the Emperor Joseph II, who was now on the throne, invited him to come to Vienna and write him an *opéra bouffe* for the Imperial Opera House. Alas, that opera was never performed. The Italian clique, forever on the lookout for new enemies after the success of the Ritter von Gluck, would not stand for it. The opera was postponed until finally it was taken off the repertoire.

This gave the Prince Archbishop of Salzburg, who for years had been quarreling with Vienna, his chance. He told Leopold Mozart to bring his son back to the home town and ordered the child's opera to

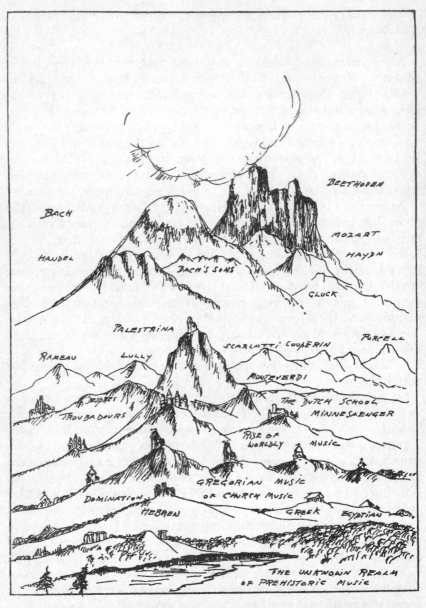

**THE MUSICIANS UNTIL THE DAYS OF BEETHOVEN**

*A very personal view of the landscape. Yours will probably be different.*

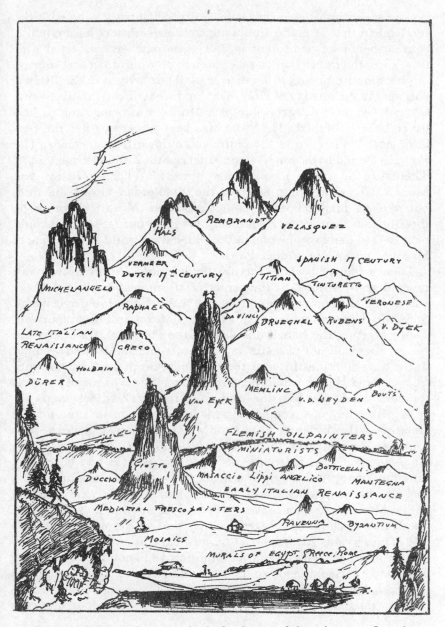

*And here by way of contrast is the landscape of the painters as I see it.*

be performed in his own opera house. So delighted was he with the boy's talent that he made him honorary *Kapellmeister* of his orchestra. A great honor for one so young, but as no pay was connected with this office, the father had to take the boy on a third concert tour.

This time Rome was to be their goal. They arrived in the Eternal City on the Wednesday of Holy Week and went directly to the Sistine Chapel. Gregorio Allegri's nine-part *Miserere* was being sung. It had never been published. The score was kept a secret. After the performance, Wolferl wrote the entire piece down from memory. The Pope, delighted by so much talent, knighted the little Austrian visitor. Thereafter he could have signed himself Wolfgang, Ritter von Mozart. Gluck, who had received the same order, always did that, but Wolferl preferred to remain plain Herr Mozart. Perhaps he thought that dear Papa would feel hurt if he put on such airs, and next to God there was no one in the whole wide world so deserving of his love and loyalty as dear Papa.

Then to Bologna where the old Philharmonic Academy was still revered and respected as the center of all musical erudition. There was a rule that no one under twenty years of age could receive an honorary degree from that institution but Mozart got his at fourteen. Padre Martini, the stanch upholder of the Palestrina traditions and the greatest collector of books on music (seventeen thousand volumes at the time of his death), took the boy under his protection. Not until he met Papa Haydn would he care so much for any human being as for the good Father Martini (and, of course, his own dear papa).

In Milan he got a commission for a serenade to be sung for the wedding of the Archduke Ferdinand which was to take place the next October. And so back to Salzburg to work quietly on the job for La Scala. But alas, Salzburg was no longer what it had been. The kind old Prince Archbishop was dead. His successor was a prig and a fool who hated music and who treated Mozart as if he were a lackey. When Mozart asked for leave of absence for another musical *tournée*, the Prince Archbishop answered curtly that he did not like to have one of his servants go forth on a "begging expedition." Mozart replied to this insult by resigning his commission as honorary *Kapellmeister*. His master cursed him for an ingrate and thereafter did everything to make his life miserable; and in those days a sovereign Prince Archbishop could do a great deal to make the life of a poor musician miserable.

Papa Leopold was forced to remain in Salzburg as a sort of hostage. Wolfgang and his mother went to Paris. Here they soon discovered

that a young man of twenty-one in long pants has no longer the same popular appeal as a child of six in velvet pinafores. And poor Wolfgang discovered that in spite of his genius he was human. He fell desperately in love with a German girl, Aloysia Weber, distantly related to Carl Maria von Weber, the famous composer. But her father was only a prompter at the Paris Opera House. Neither she nor Wolferl had a penny. From Salzburg dear Papa warned the son not to make the girl unhappy and to remember that he was a gentleman and a good Catholic. From Paris young Wolfgang answered that he was hopelessly in love but that he was too conscious of his duties toward God and Papa ever to do anything that was wrong.

A little later he had to write a different sort of letter. He had to break the news of his mother's death. Poor Mamma Mozart, after a long illness, departed this life in a none too comfortable Paris boarding house. Young Wolfgang buried her and went home alone.

And all the time, in hotels and while traveling in the shaky stagecoaches of that day, he worked. He left over six hundred and twenty-six different compositions when he died at the age of thirty-six. Compared to this, Beethoven was a mere beginner, for almost everything Mozart wrote was good. A great deal of it was done in a terrific hurry. Mozart worked like a newspaperman covering a great trial. Before the ink on his paper was dry, the manager of the opera house was having it copied so that half an hour later the musicians could begin to rehearse. In this way a few of the notes sometimes "fell underneath the table," as Mozart so quaintly expressed it, but like so many great artists, he was at his best with the deadline ten minutes off and three more pages to be done.

And so he worked and wrote and played and rehearsed eighteen hours a day. What did he gain by it? A pauper's grave. His position in Salzburg became quite impossible after the Prince Archbishop had fallen out with the court at Vienna, for his friendship with the Emperor cost Mozart half his salary. Then Mozart decided to relinquish his actual position at the Salzburg court as he had already given up his honorary position. He was going to Vienna to try his hand at free-lancing. He would sell his compositions to the publishers. Dear Papa Haydn, who had befriended him for years, would tell him how.

At first luck was with him. At the request of the Emperor he wrote an opera in the German language, the first of its sort, for tradition had been so strong that until *Die Entführung aus dem Serail* was given in 1782 the Italians had always been able to insist upon Italian as the language used. The reason was that they could not sing those difficult

German words. In spite of their opposition the *Entführung* was a tremendous success. Not financially, for Mozart was as helpless in monetary matters as he was brilliant in everything pertaining to his own art. The whole world now knew his name. Undoubtedly pupils would flock to him from everywhere.

And so he married the namesake of the heroine of *Die Entführung*, young Constance Weber, the younger sister of that Aloysia with whom he had fallen in love in Paris a few years before. The marriage lasted until his death. Constance was as bad a manager as her husband. They were always way behind with the grocer and baker and with all the candlestick makers of Vienna, for Mozart now worked day and night. Everybody loved him, everybody admired him, and everybody was some day going to do something really worth while for this brilliant young man—such a talent!—such a charming wife!—and such a good Catholic!—even if he were a Freemason and dreamed of a world in which all men should be brethren. But nobody moved a finger.

In 1789 Mozart went to Berlin with Prince Lichnowski. The King of Prussia offered him the post of conductor of the royal orchestra at a tremendous salary. Almost three thousand thalers, the equivalent of three thousand dollars today. Here was the chance of a lifetime. In Vienna the Emperor heard of it. "My dear Mozart," he said in his charming way, "surely my dear Mozart is not thinking of leaving me!" Touched by so much gracious kindness, his dear Mozart remained in Vienna and killed himself by overwork.

The director of a little suburban theater got hold of him, a kindly person full of bright ideas by the name of Schikaneder. Mozart began to work for him. The ideas were provided by the director himself but Mozart, composing at a terrifying rate of speed, reshaped them, changed them about, turned them into the fantastic fairy story of *The Magic Flute*.

Then another order from the court, this time an opera to be given at Prague for the coronation of Leopold II as King of Bohemia. His wife, the daughter of the King of Spain, had learned just enough of the language of her adopted country to express her opinion upon this lovely composition in words that could not possibly be mistaken. "Just some more German Schikaneder," said this exalted lady. But Prague loved it as it had loved *The Marriage of Figaro* and *The Barber of Seville* and *Don Juan*. Indeed, the Czechs with their genius for music appreciated this German master more than his own fellow Germans. The latter were forever letting themselves be influenced by

BEETHOVEN

MOZART

the cabals of the Italian opera clique under the great Maestro Salieri, whose hatred for his young rival went so far that upon several occasions he prevented him from getting an appointment that would have given him an occasional hour of respite in his endless labors. And all the little fellows, the incompetent ones, those "terrible weak" who in the realm of the arts are as dangerous as the "terrible meek" are in the domain of religion, envied and feared and therefore loathed this upstart boy from the provinces who never apparently knew when he was defeated; who kept on turning out operas, symphonies (forty of them or more), violin concertos, piano concertos—and all of them so infinitely much better than they themselves could ever hope to do.

Then came the final year. An ambitious nobleman, a certain Count Walsegg, an amateur musician of small merit, wanted to impress his friends with his genius. Through an intermediary he sent word to Mozart that he was willing to pay generously for a requiem which he would thereupon palm off as a composition of his own. Mozart, tired to death and constantly in a fever, got the *idée fixe* that the valet of this unknown aristocratic employer, who acted as middleman, was a messenger from heaven, come to announce his approaching end. That is the origin of the weird story about the mysterious black figure who knocked at Mozart's door during the last hours of his life to tell him, "Prepare ye, for the hour has come!" It was merely a flunky in the traditional black garb of his kind when off duty who, at the bidding of his employer, had called on the composer to ask when the goods that had been ordered would be ready for delivery. They were ready for delivery on December fourth of the year 1791. The next day Mozart's soul, too, was ready for delivery.

On the day he was buried it rained so hard that the few friends who wished to accompany him to the cemetery were forced to turn back at the city gate, for people going to the potter's field must not expect their relatives to be provided with carriages. The city gives them a coffin free of charge. Isn't that enough of an expense? Nobody followed Mozart to his grave except his dog, a faithful mongrel who sloshed through the mud and snow and was present when his master disappeared into the common grave of the poorest of the poor.

When a few days later, Constance came to the cemetery to pray at her husband's grave, nobody knew where he had found his final resting place. She was perhaps not everything Mozart had hoped her to be. But she was a loyal soul. She afterwards married a man by the name of Nissen. The two spent the rest of their days gathering to-

gether all of Wolfgang's music and preparing material for his final biography.

Not one but a whole score of final biographies of Mozart have since then seen the light of day. Monuments have arisen in all sorts of unexpected places. Vienna and Salzburg in the day of their need have cashed in most liberally on the reputation of their famous fellow townsman. But somewhere in the museum that has been erected in the apartment in which he was born there is a very indifferent little picture drawn by a very indifferent artist, but drawn in a spirit of humble reverence and devotion. It shows the little mongrel dog, sloshing through the mud to see that his master should not be entirely alone on his last journey on earth.

On the twenty-seventh of January of the year 1906 the city of Vienna celebrated Mozart's birthday with befitting ceremonies. In the afternoon there were music and oratory. In the evening the whole town was illuminated. The board of aldermen gladly appropriated ten thousand crowns for this noble purpose, and for ten thousand crowns one could do a lot of illuminating in the Austria of the good old imperial days. Half that sum would have sufficed to keep Mozart alive for at least another ten years. The other five thousand might have been used to provide an extra ration of leberwurst for the descendants of the poor bedraggled pup, who was the only gentleman on the day when Mozart was buried like a dog.

In the small towns and villages of the Tyrol and Salzkammergut and Carinthia, where the spirits of the north and the south have been blended for so many thousands of years, there live a people who are neither Italian nor German but a curious blend of both races. Their language, their manners, their entire outlook upon life are different from those of their neighbors. They have developed an art of their own. Their churches, regardless of the time when they were built, have a character that is so typical of these valleys that, once seen, they are never forgotten. Their local painters have discovered a way of decorating houses and furniture with patterns that are not found elsewhere in the world. Every village and every town has a market place surrounded by a few stores, an apothecary shop, an old inn. In the middle of the market place stands a fountain that provides the people with their drinking water, pure water from a near-by mountain brook.

All the best efforts of the stonecutter and the blacksmith have been concentrated upon this public fountain which is usually surmounted

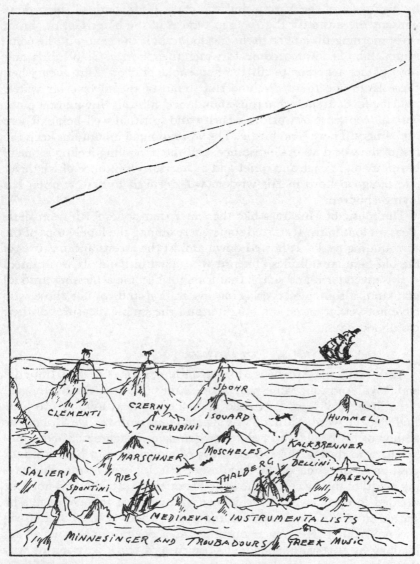

*For every reputation that survives and increases in stature there are hundreds of others that are lost and forgotten. Each one of these names (most of them now completely forgotten) meant as much to their contemporaries as those of Gershwin or Irving Berlin do to us today.*

by an image of the Virgin and the child Jesus, both of them done without the austerity that was so typical of the older Gothic. From early morning till late at night this fountain is the center of the communal life. Teamsters come to water their horses. Small girls and boys gather together to fill the household pitchers. But even when there is no one there, the cheerful sound of the silver-clear water, pouring forth in such generous abundance, fills this tiny market place with a deep sense of worldly security and spiritual well-being. There is no hurry. There is no bustle. The white-domed mountains keep the rest of the world at a safe distance, and the prevailing feeling is one of harmony and peace and quiet and a cheerful acceptance of whatever fate the good Lord in His wisdom will deem fit to bestow upon His loving children.

The music of Mozart is like the water that pours forth from these pleasant fountains. It started somewhere among the lonely tops of the surrounding peaks. It flowed down amidst the forests and pastures of the old familiar hillsides. Then it was taken in hand. It was tamed. It was given form and shape that it might become a blessing unto all mankind, a source of everlasting inspiration and joy for those who have not yet forgotten the laughter and the simple pleasures of their childhood days.

### Beethoven

After Wolfgang Amadeus Mozart, another subject of their Imperial and Royal Apostolic Majesties, by the name of Ludwig van Beethoven.

To little Wolfgang, Papa had always come next to God. To little Ludwig, the word "father" was synonymous with the Devil. For the author of his being was a shiftless, drunken, ill-tempered hack musician, who during the soberer days of his youth had held a minor position in the choir of the Archbishop Elector of Cologne. But having heard of the success of the little Mozart boy (as who had not?) he decided to do likewise with his own offspring. At the age of five he started to teach him the fiddle and got nowhere at all. For Ludwig was no Wolferl. He was as obstinate as a dozen mules, and all his life long he was as independent of spirit as a truck weaving its way through a post road full of flivvers.

These qualities were his good right. They had come to him as part of his racial heritage. I told you in a previous chapter what a great role the city of Antwerp has played in the history of painting. It has been either the birthplace or the home of Quentin Matsys, Frans Hals, Jordaens, Rubens, Van Dyck, and the two Pieter Breughels.

In the middle of the seventeenth century a little music was added to this rather unbalanced artistic diet. The family of the Van Beethovens made its appearance among the list of citizens.

It was Ludwig's grandfather who had moved from Antwerp to Cologne. He too had been a musician and so had his son, the tipsy tenor. And so his grandson was going to be, if blood and tradition counted for anything. The grandfather died in 1774 when Ludwig was only four years old, but he always remembered him kindly. He also retained happy memories of his mother. She had been a very simple woman, a servant in the household of the Elector. She too had deserted him when he was most in need of her love and her care. For it must have been dreadfully humiliating for a boy of his type, proud and independent and conscious of his superior ability, to feel that his father was an object of pity and contempt in the sight of his neighbors. In a little city like Bonn everybody knew everything about everybody else, and the fact that young Ludwig was entrusted with his father's wages because otherwise (as the authorities knew only too well) all the money would be spent on liquor must have been common knowledge in that old and gossipy city on the Rhine.

There were several other relatives. They played quite a role in Ludwig's life, for they became an everlasting source of nuisance. When they did well for themselves they never lifted a finger to help their queer brother. When in need, they unceremoniously dropped all their troubles in his lap and shrieked like hungry harpies for his support "because he must remember that he was their brother." And finally they left him with a nephew who was perhaps not quite as black a sheep as posterity has made him out to be but who was a dull and lazy fellow and therefore always in some sort of trouble. Nothing very wicked. Nothing very scandalous. Just annoying trifles, such as spending more than he should spend or marrying the wrong girl at the wrong moment.

But lawsuits and police-court proceedings do not go well with symphonies and sonatas. No one of the Beethoven family, however, seems to have worried about that. They had not the slightest conception of their brother's greatness. All they knew was that he was on intimate personal terms with some of the greatest names of the Austrian Empire. A man who had the entree, so to speak, of all the palaces of the imperial capital should be able to do something for his loving brothers and sisters. He need not live in a couple of shabby rooms in a shabby street and go about in shabby clothes with long, wild hair (he surely could afford an occasional visit to the barber!) and holes in the

soles of his boots. He could keep a servant so that his rooms would not look like a pigsty and that he might be fed decently and at regular hours. And above all things, he should use his influence to get favors for his own kith and kin. Those dedications to all sorts of excellencies and highnesses were all very well but cash in hand would have been much pleasanter.

A pretty sordid tragedy. But a very common one since that unhappy day when the arts and life parted company, which they began to do during the end of the eighteenth century.

I here must introduce a word which no American can ever hope to "feel" quite as deeply as a European. Compared to Europe we are still in that happy stage of our economic development where we can truthfully claim that we are not conscious of any definite "classes." Birds of a feather will always flock together. The man with an income of a hundred thousand a year will live a different existence from the man with only a thousand. But in America even today the road is not definitely blocked against the poor devil with twenty-five dollars a week. His chances may be very slim, but they exist. In the Austria (and for that matter, in the Europe) of the eighteenth century, there was no way of escape. All the lower middle class could hope to do was to maintain itself without losing ground and slipping down into the subbasement of those who were only *Volk*—just "people."

As the royal patron was rapidly going out of fashion, now that artists were beginning to deal in a commodity that was to be at everybody's disposal, a career as an artist meant a highly risky voyage into the realm of uncertainty. But uncertainty was the nightmare of all respectable shopkeepers and of all minor officials and of all the thousand and one groups whose trades or professions allowed them to cling to the idea of their still being *anständige Bürger*—respectable citizens. In Austria, where even today after a whole series of socialistic forms of government, the feudal system has survived for so much longer than anywhere else, an artist—a person blessed by the divine touch—could still occasionally be treated as an equal by his social superiors who ruled their fellow men by the divine right of having been born as their fathers' children.

As many of the aristocrats of the end of the Rococo period happened to be men of taste and discrimination, and as all of them were more or less tinged with a touch of the dangerous Rousseau doctrines about "equality," Beethoven had an easier time of it than those who came after him. Besides, absurd though it may seem to modern ears, that "van" made it a little easier to associate with him than with a

plain Herr Mozart. The "van" meant the same thing it means in my own name—just exactly nothing. But it could be abbreviated into a single small "v." A symphony by Ludwig v. Beethoven looked much more imposing than one by plain Johann Kuhnau. As you may remember, even poor Sebastian Bach had not been able to escape from the illusion that the title of a "royal court *Kapellmeister*" would help him in his struggles with the town counselors and church authorities of Leipzig.

The Beethoven brothers had the same name and yet, as you may well object, it did not do them any good. Of course not. They were just common, ordinary people. But a small "v." plus genius—that was a combination which meant a great deal in Vienna during the beginning of the nineteenth century. It even meant that Beethoven (who today would have been seriously suspected of leanings toward the Left) could get away with his rudeness and on occasions could even afford to be grossly and unnecessarily rude to a Royal Majesty without suffering any unpleasant consequences. "What do you expect? He's just poor old Beethoven, one must take him as he is. After all, he's a genius." And so the Austrian aristocracy tolerated the old fellow (who was not really old at all, but a man who had never been young) and were kind to him when he had been insufferably boorish and overbearing on account of some imaginary slight. When he died, they had to call out the army to keep order in the streets through which the coffin passed. Everybody was there. For it was he, old Ludwig, who had avenged all the humiliations which Austria had suffered at the hands of the Corsican usurper.

In his younger days, full of hope and enthusiasm for the cause of liberty and equality, he had written a symphony in honor of General Bonaparte, the prophet of these new revolutionary ideals. Then General Bonaparte made himself the Emperor Napoleon, and liberty and equality were removed from the battle flags of the republic. The will of a single capital letter $N$ was henceforth to be the law of an entire continent. Whereupon Ludwig van Beethoven, the old radical, took the manuscript of his symphony (the third one, as we now count them) and scratched out all reference to the Judas who had betrayed the cause of popular government. He scribbled across the cover: "A Heroic Symphony to Celebrate the Memory of a Great Man." And in this way, Napoleon's final obituary was written a dozen years before he suffered defeat at Waterloo.

Beethoven came to Vienna in the year 1792. He was sent there by

the Archbishop Elector of Cologne who wanted this talented young man to have the best training that was to be had. As Vienna at that time was the center of music, it was to Vienna that he must go. His teachers were old Papa Haydn, who just kept on living and working and smiling his pleasant smile, and Salieri, who had been such a bitter enemy of poor Mozart, now dead and buried in his nameless grave.

The reason why Haydn was chosen was a personal one. The old gentleman on his way to England had passed through Bonn and had there heard some of Ludwig's compositions. And the Archbishop had used the occasion to recommend his young protégé to one whom all the world then regarded as the founder of the "new music."

A word about that new music which introduces the (to me) hopelessly difficult subject of harmony. First of all, what is harmony? The accepted definitions will not help me very much. They merely substitute one set of terms for another. Here is the way one of the standard musical dictionaries defines harmony: "Harmony," so it writes, "as a general term means an agreeable combination of tones. More exactly, any simultaneous sounding of tones as opposed to melody, or concord as opposed to discord." If this were true, if harmony were indeed "any agreeable combination of tones," how ought we to define the music of Hindemith or Schönberg, both of whom are "harmonists" (for they do not belong to the contrapuntal school)? Yet neither of whom apparently is in the least little bit interested in producing tone combinations that are "agreeable" to the ears of most of their contemporaries.

I am not writing this in a critical spirit of disapproval, for I realize how rapidly we can attune our ears to what at first strikes us as an offensive combination of sounds. I am only too conscious of the fact that when I heard Debussy's *Cathédrale engloutie* for the first time it was quite as much of a torture as sitting through Stravinski's *Firebird*. Yet today I can listen to these compositions quite happily and they sound about as tame and inoffensive as an aria by Pergolesi or Rossini. If I live another thirty years I shall perhaps feel the same way about some of the latest products of the atonality specialists whose work now reminds me of a child of three or four in one of our modern schools, where the little darlings are supposed to "express themselves," hammering away at a piano with one hand and eating a piece of cake with the other. But I may learn. Besides, none of these problems, involving our personal tastes, can ever hope to be settled by the application of an esthetic slide rule.

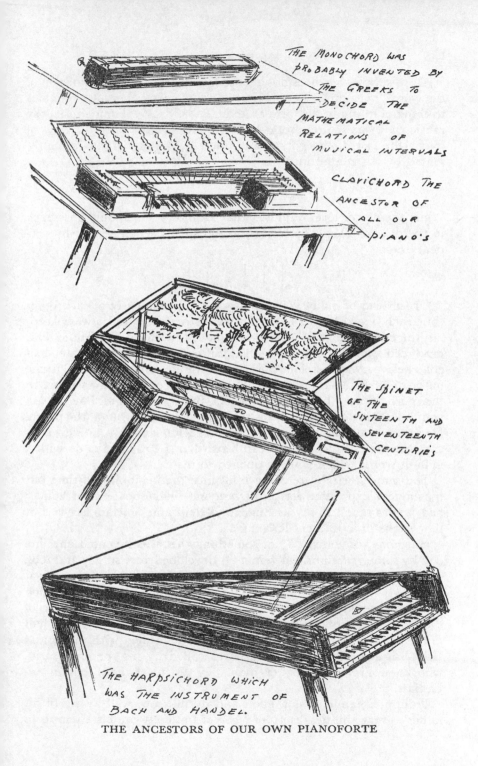

THE MONOCHORD WAS PROBABLY INVENTED BY THE GREEKS TO DECIDE THE MATHEMATICAL RELATIONS OF MUSICAL INTERVALS

CLAVICHORD THE ANCESTOR OF ALL OUR PIANO'S

THE SPINET OF THE SIXTEENTH AND SEVENTEENTH CENTURIES

THE HARPSICHORD WHICH WAS THE INSTRUMENT OF BACH AND HANDEL.

THE ANCESTORS OF OUR OWN PIANOFORTE

All this, however, does not get me any nearer to an explanation of the word "harmony." Let me try to do it this way. Try for a moment to think of music in the form of lines. The old polyphonic music, the music that was written from the beginning of time until the days of Bach (the last of the polyphonic musicians) would then be represented by horizontal lines:

———————        ———        ————

————————        ————        ————

While the newer form of music, that harmony which only goes back to the days of Bach's successors, would then be represented by vertical lines:

Or, instead of many voices that sang independently of each other (but each one adhering to certain very strict rules and always keeping the correct interval), they now moved in chord formation. This produced a fuller and freer method but not so pure as that which had gone before. And therefore there is something strict and formal in the music of Bach and Handel and all their predecessors which we miss in the music of the "harmonic" masters. But again I shall have to ask you to let some competent musician explain this to you on the piano. He can accomplish more in five minutes while giving you a few concrete examples to which you can listen than I can hope to do with a million words which you are obliged to read.

The same stories were being told since the beginning of time but the mode of expression was a different one. Shakespeare and Chaucer had just as much to say as Eugene O'Neill and Sinclair Lewis. But they spoke in a different language.

Harmony, of course, is not something that was invented one fine day by some great musical genius. It developed very slowly and took centuries to be recognized for what it was. Here and there in medieval music we occasionally hear something that sounds to us very much like a harmonic color effect. But harmony in our modern sense of the word does not really make its appearance until the latter half of the eighteenth century and it was then identified with the "great Bach" as Karl Philipp Emanuel was called by his contemporaries who knew him much better than ,hey did his father, Johann Sebastian.

Philipp Emanuel was a good and dutiful son, well aware of his father's great abilities, as proof whereof I offered you his attempts to

get the old man's *Art of the Fugue* engraved and printed—a disastrous publishing venture which ended with the sale of exactly thirty copies. His father had trained him to be a harpsichord virtuoso and as such he was engaged at the court of Frederick the Great to accompany His Majesty when he played the flute. From Berlin he went to Hamburg to succeed Georg Philipp Telemann as general director of church music, and there he died in 1788.

Many of his contemporaries hated him most bitterly, for he was the first man who had ever written a handbook on the art of playing the piano, in which the technique of that instrument (growing originally out of the technique for the lute or the violin) was now made the subject of certain definite laws of digital behavior, such as an equal development of both the left hand and the right, a regular way of playing scales, and numberless other little items which give children without talent such an intense dislike for that big black box in the front parlor.

This same Philipp Emanuel Bach is also often mentioned as the great prophet of the new "harmonic" school of composition, and his recommendations for this honor came from sources that are entirely beyond reproach. For Haydn, Mozart, and Beethoven, all three in great harmonic unison, sang his praises as the father of the new music.

We are perhaps a little less definite in our praises. No other art is subject to such sudden and unpredictable changes as music. Even if a certain style of painting loses popular approval, the paintings themselves continue to exist. You could of course burn them up or start a rebellion in the best Spanish style to destroy everything the last fifteen centuries have produced. But few of us are willing to go to such extremes and although such pictures may be relegated to the guest room (as was Van Eyck's famous portrait of Signor Arnolfini and his bride, when it was rediscovered by an officer in Brussels who had been wounded at Waterloo) or sent to the basement of a museum (all museum basements are chock-full of them) they can always be resurrected at a moment's notice. But music, unless it is being played, has no chance to bring itself to people's attention, for only one person in a hundred thousand can read a score just for the fun of it. And so entire regions that once upon a time were gay with the sound of voices and trumpets have become overgrown with a heavy underbrush of neglect and oblivion and have to be cleared off and brought back under cultivation like the forgotten pastures of the Maine landscape. Quite frequently we there come upon lovely old houses and

charming old gardens, all of them much the worse for wear but show-ing in an unmistakable fashion that not so long ago this neighborhood was inhabited by people of culture and taste.

Our musical explorers have achieved extraordinary results along this line of exploration. And as a result we are beginning to realize that the musical development of the fifteenth and eighteenth cen-turies was much greater than we had ever dared to suspect. We had always thought of the early development of music as a sort of triangle composed of Italy, Paris, and Vienna, with a polite bow in the direc-tion of the Flemish-Dutch school and that of medieval England. Then one big bright spot right outside that triangle, Leipzig and old Se-bastian Bach. Now we are coming to the conclusion that there were lots of other spots inside and outside that triangle, and almost as im-portant as Leipzig. There were Hamburg and Lübeck and Haarlem and, most important of all, Mannheim, where the great Bohemian, Johann Stamitz (1717–1757), founded an orchestra that was the New York Philharmonic of its time, wherein he introduced all sorts of new instruments that had never been allowed before, such as horns and clarinets. And we are now at last beginning to suspect that old Stamitz and his sons (the Stamitzes formed another tribe of musicians like the Bachs) may have had as much to do with the spread of the "new music," afterwards perfected by Haydn, Mozart, and Beethoven, as Philipp Emanuel Bach or any of the other candidates for the title of "Father of Harmony."

If you ask how this was done, how it came about, look at a list like this in which I shall endeavor to trace the strange wanderings of the people who had been directly influenced by this Mannheim school of music and who, like the pollen on some rare musical fruit, were blown all over the European landscape.

Stamitz himself, a Bohemian by birth, died in the service of the Elector of the Palatine. Georg Christoph Wagenseil, the music teacher of the Empress Maria Theresa, was an ardent disciple of the Stamitz method. So was Johannes Schobert, a Silesian who worked in Paris as harpsichord player to the Prince de Conti. So was Luigi Boc-cherini, who was born in Lucca in Italy and spent his days as court musician, first in Madrid, then in Berlin, and then back again in Madrid where he died in 1805, having been acknowledged as one of the greatest composers of his time by no one less than Papa Haydn. We recall nothing of him but his "Celebrated" Minuet but the man poured forth sonatas and quartets and symphonies like a fountain in the park of Versailles, and each one of these helped spread the new

gospel of the harmonic effect wherever they were heard. Another son of Bach, Johann Christian, the Milanese Bach or the London Bach of whom I told you, also worked in at least half a dozen countries, and all of his fifty-eight symphonies helped to spread the new style. So did the comic operas and symphonies of Karl Ditters von Dittersdorf, who moved from Vienna to Bohemia and who was a close rival to Haydn in the use he made of folk songs.

All of these composers and their orchestras were still essentially chamber musicians. Whatever they wrote was intended to. be given in the hall of some private house and it was not meant for the general public, which of course was never invited. But the audience held a large percentage of extremely capable amateurs and from them it percolated down into the lower departments and in that way it finally reached the general public. It may not have been a system of which we today feel that we could approve. It was entirely undemocratic but look at the results! Heavens above, look at the results and compare them to the situation today when the serious musician depends for his livelihood and appreciation upon the approval of the public at large by way of a radio sponsor who makes him play the Rachmaninov "Bronx" Prelude (C sharp minor) right after the finale of a Beethoven concerto.

Beethoven was fortunate in that he got a thorough grounding in both the old and the new style of music. In Bonn, his first teacher, Neefe, made him study Bach's *Well-Tempered Clavichord* until he knew that work by heart. Afterwards in Vienna, Salieri and Albrechtsberger, both of them excellent teachers, drilled him until there was no form of music, old or new, in which he was not completely at home. And so, in contrast to Mozart and other precociously clever children, he did not really begin to compose until he knew his craft and knew it inside out and outside in.

Like Bach and Kant and Rembrandt, he never felt the need of visiting foreign countries in order to widen his own horizon. He sometimes withdrew to one of the villages near Vienna that he might be able to compose without interruptions on the part of either welcome friends or unwelcome admirers. But for the rest he was quite content to "live within himself." This may explain the modern craze for travel. When there is nothing to explore at home, one must find solace in contemplating the scenery of distant lands.

The statistical data in connection with his life are very simple. He

was never very rich and never quite as poor as he made out to be. His brothers and sisters-in-law and afterwards his beloved but worthless nephew cost him a lot of money and, being a very bad financier, he was always hard up. Nor, I am sorry to say, was he himself always entirely scrupulous in dealing with his patrons, especially with his devoted and generous admirers in England. But his complaints about the neglect with which his contemporaries treated him, about his shabby clothes, about his days and nights without a crust of bread to still the pangs of hunger—all these belong to the realm of, let us call it, "musical license."

He was in his own manners, in his entire way of living, as shiftless as his drunken father. His rooms were always in a mess. Pianos covered with dirty dishes and manuscript sheets of the Ninth Symphony, a bed that had not been made for days or weeks, a washstand dangerously balancing itself on three legs, coats and shirts (none too clean) on the chairs and on the only sofa, more sheets of manuscript paper on the floor, scores of other people's music (sent to him for his approval) lying on top of the cupboard, covered with a heavy layer of dust, and rarely a window open for air, for the Master believed that fresh air was very bad for his bronchitis. Once in a while a slatternly servant would make her appearance to try to put some semblance of order into this mess. But old Ludwig would haggle with her over a groschen she was supposed to have wasted on his sauerkraut and the slavey would vanish again amidst a volley of loud vituperations, for like all members of his class (accustomed to that degrading miserliness which is the result of generations which have never had quite enough for their daily needs), Beethoven was never so angry as when he thought that someone in his employ had cheated him out of one of his hard-earned pennies. Meanwhile he himself squandered the pounds with a noble gesture of abundance—but only for the benefit of his own relatives. In his respectable little middle-class world, the family remained the beginning and end of all things.

Garrets are common enough in the history of the arts. Loneliness is part of the penalty every true artist pays for being different from the rest of his fellow men. But surely few people have lived as strange a life as this scowling and uncouth barbarian whose manners were those of a Flemish peasant, whose soul was that of a sensitive child, and whose genius created a new sort of music of such stark beauty and such vast dimensions that our own little everyday world seems to rattle around in it like one pea in a pod.

I shall not stress the fact that during the last dozen years of his

life he was stone-deaf and therefore never heard the last of his great works. As early as the year 1800 he had noticed that he was beginning to be hard of hearing. What caused this deafness, nobody knows. The ailments of Beethoven have never been correctly diagnosed, but after his thirtieth year he rarely enjoyed a whole month of good health and his deafness was only part of his suffering. He bravely

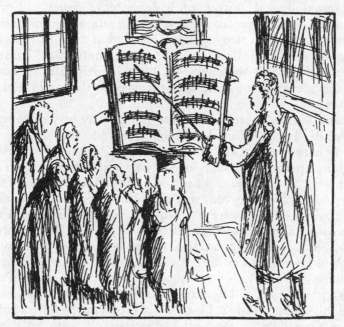

THE CANTOR
*The sort of work Johann Sebastian Bach
had to do to make a living*

fought this most terrible of all misfortunes, and it was not really until the year 1822, after that ghastly episode when he tried to conduct a dress rehearsal of his own opera *Fidelio* and had not the slightest idea of what was happening on the stage, that he refrained from attending any further public performances of his own works. However, there are a great number of musicians with perfectly good ears who never go to a concert out of their own free will. But in the case of a man as sensitive as Ludwig van Beethoven, it was his deafness that made him avoid the companionship of his fellows. By nature he was really a very congenial soul who liked to have his friends around him and who was very fond of going to parties and meeting people and who

(may Heaven have mercy upon his soul!) was particularly devoted to very poor practical jokes.

There are, in the former Royal Library in Berlin, a number of boxes that contain almost eleven thousand scraps of paper, covered with the pothooks and scrawls of L. v. B. For that was the only way in which the poor man could now communicate with the outside world, questions and answers on little pieces of paper—all of them jotted down by the nervous hand of a man who was constantly irritated by being cut off from society. The first of these little scraps go back to the year 1816. Beethoven did not die until 1827. During the last years of his life, therefore, he dwelt in perpetual silence. But out of this silence there arose such melodies as the world had never yet heard.

Perhaps Nature inspired him to write these by way of compensation. For Beethoven suffered as much as mortal man could bear. He fell in love repeatedly and every time was brutally rebuffed. Not through any particular cruelty on the part of the women upon whom he bestowed his affections. They sometimes liked him well enough, but the idea of marrying him was out of the question. It was all very well for an Austrian aristocrat to be on friendly terms with a personage whom all the world recognized as a genius. Their doors were open to Beethoven the composer, the piano virtuoso who by sheer strength of his ability had forced emperors and kings to listen when he spoke to them in his own language. But the very idea of such a man as a possible son-in-law was preposterous. His middle-class background, his drunken father, his dreadful brothers, the terrible nephew who was always under foot, his endless lawsuits with his sisters-in-law, his quarrels with his benefactors and, even worse, his everlasting suspicion of being slighted, his arrogant resentment of anything that might be construed as a reflection upon his greatness—all of these combined to make him a person whom one could admire and revere, but only within his own sphere.

Socially speaking, the Von Breunings and the Guicciardis and the Von Brunswicks would just as soon have given their daughters to their valets as to the man who in a most painful outburst of passion would dedicate one of his works to the object of his affections (the "Moonlight" Sonata bears the name of Giulietta Guicciardi) and who the next moment could be guilty of such a gross breach of decorum that everybody present turned pale with rage or wept with pity. No, it could not be done. And after Beethoven had lost his hearing, he realized that the case was hopeless. He still loved. But he had

learned discretion. From that time on his music spoke the words his lips dared not utter.

In most lives of Beethoven you will come across a threefold division. The first part begins in 1783 and ends in 1803. During this period he is still learning his trade and is entirely under the influence of Haydn and Mozart. He brings about certain innovations. Instead of the minuet which Haydn and Mozart had deemed a necessary part of their symphonies, he gives his hearers a scherzo, but for the rest his work does not yet bear any signs of that highly pronounced Beethoven style so typical of the works of the second period which comes to an end in 1815. Then there are several years during which it sometimes seems that he has fulfilled his destiny and that his self-appointed task has been performed. But in the meantime strange things are taking place in the soul of this man of sorrows.

Like all the people of his time who took a deep interest in the world around them, he had risen from the depths of despondency to the highest summits of hope, only to be cast back into an even deeper and darker despair by the rapid political changes that had taken place since the beginning of the great French Revolution. Had he been an ordinary human being, he would have turned cynical. He would have bade his fellow men destroy themselves in any way they pleased. But when he had recovered from the shock he was ready to do further battle. Like that great French general who was responsible for the final victory in the late war, his left wing had been broken, his right wing had been smashed, his center had given way, and he therefore made ready to attack. While all around him people bowed to the inevitable, Beethoven alone refused to surrender. Steeped in the works of the greatest of his predecessors, strengthened by the rugged courage of a Bach and a Mozart, he gave the signal to reassemble and in unmistakable terms reaffirmed his belief in the ultimate victory of mankind. And that is the way the Ninth Symphony came to be written.

No longer is destiny knocking at the gate as it did in the Fifth Symphony. No longer is the master concerned about the fate of his hero, his failure or success, as he was in the "Eroica." No longer does he occupy his mind with the beauties of nature as he had done in the "Pastoral" Symphony nor does he try to write the apotheosis of the dance, which found its fulfillment in the Seventh. He leaves all these common concerns behind him. In his Ninth Symphony the man who

has been recognized as the most versatile manipulator of orchestral effects goes back to the oldest of all instruments. He goes back to the human voice to give expression to his unshakable faith in that freedom of the spirit which all through his life had been his dearest and proudest possession.

# Pompeii, Winckelmann, and Lessing

*A little Roman city, recently arisen from its ashes, and two learned Germans combine to give new impetus to the so-called "classical movement."*

IN THE YEAR 1594 an Italian architect by the name of Domenico Fontana, digging a tunnel for an aqueduct in the neighborhood of Naples, came upon so many Roman statues and pots and pans and lamps and tools that he thought it necessary to report his discovery to his employers. But as all knowledge of Pompeii and Herculaneum had been completely lost during the Middle Ages, people believed that he had merely stumbled upon the remnants of some old Roman villa, and paid no attention. However, during the course of the next century and a half, so many other odds and ends of undoubted Roman origin were found on this same spot that it was finally decided to uncover the entire region and see what might lie hidden under this heavy layer of ashes and cinders.

These excavations began in the year 1763. They are still being continued and as a result we can now wander through the streets of an ancient Roman city which, except for the roofs of the houses, looks very much as it must have when the eruption of Vesuvius of the year 79 made an end to a town that had already been a prosperous village in the days of the Etruscans and that was beginning to play quite a role in the Roman history of the first century before the birth of Christ.

There was of course nothing new in the rediscovery of a few Roman statues and other works of art. The Renaissance had been very busy with the spade. But the excavating of the sixteenth century had been a haphazard sort of affair, a little here and a little there. Never before had the world seen anything like this—a complete city in full working order, exactly as it had been on that fateful morning when the inhabitants had either escaped by boat or had tried to find safety in these cellars. Now, after more than eighteen hundred years, they were discovered in exactly the same positions in which they had been suffocated by the gases that had poured out of the soil.

News traveled slowly in the eighteenth century, but it did travel. The whole world welcomed the elaborately illustrated volumes which told of the resurrection of the classical world in all its primitive beauty and glory.

Now at about the same time there appeared a very learned but well-written tome, a work that was greeted with the greatest enthusiasm by everybody who dabbled a little in the arts—and remember that the eighteenth century was the greatest era of the dabbler and amateur. The author of this noble opus was one Johann Joachim Winckelmann, a mere citizen of Brandenburg but such an ardent student of the classics that he took a job in Rome as librarian to a cardinal and even became a Catholic so as to fortify his position. His first essays attracted very little attention, but in the year 1764 he gained an international reputation with his famous *History of the Art of Antiquity*. Now that we have learned so much more about Greek art, we realize that these volumes were full of mistakes. Most of the statues Winckelmann accepted as examples of the best Greek style were rather bad copies made during the last two centuries of the Roman Empire, while those he rejected as too barbaric were the really good ones. Nevertheless, it was a most useful book, for it was the first serious attempt at art criticism on a literary rather than a sentimental basis.

As for the author, the unfortunate man did not live very long to enjoy the sweet fruits of public adulation. Four years after the appearance of his *History of the Art of Antiquity* he was murdered in the city of Trieste by a Levantine dealer in antiques with whom he had had a quarrel. But his book lived and continued to be regarded as the standard work upon classical art until the forties of the next century, when it was at last superseded by the studies of people who had actually visited Greece and who had not depended upon the plaster casts of the western museums for their knowledge of Phidias and Praxiteles.

It is true that Gotthold Ephraim Lessing, the most famous publicist of his time and the great apostle of the classics among the Germans of the eighteenth century, never set foot on Greek soil. Nevertheless his enthusiasm for the subject carried him further than any of his predecessors had ventured to go. A man of vast erudition and incredible zeal, he was able to continue the work where Winckelmann had left off.

This good Saxon, the son of a Lutheran pastor, had originally been educated for the ministry. But he felt little desire to spend

his days preaching the Gospels to the peasants of his native land and so, by way of the literary sciences, he finally drifted into journalism. Not as a reporter but as a serious writer upon serious subjects, for the European papers have always devoted a lot of space to these semilearned discussions which not only cover the entire field of literature, music, and painting but which are full of allusions to both history and philosophy.

As newspaper work alone could not keep him alive, Lessing spent the greater part of his life trying to get some small official position that would provide him with food and lodgings. But the Great Frederick, the man to whom he appealed, would not listen to his supplications, for Lessing, in one of his letters concerning the "new literature," had dared to say that Shakespeare was a greater playwright than Voltaire. And so Lessing drifted rather aimlessly from one town to the next until at last he found a patron and could write whatever he liked.

This is not the place to mention his purely literary and dramatic efforts, but no history of art can afford to neglect his *Laokoon* which began as a treatise upon Greek poetry and ended as a plea for a greater understanding of Greek sculpture.

And so, via Pompeii and Professor Winckelmann and the learned Dr. Lessing and the recently rediscovered temples of Paestum and Agrigentum, the eighteenth century at last undertook to make a scientific appraisal of the arts of the ancient world. That appraisal in turn led to a new movement, known as the "classical revival." Please do not confuse it with the real Renaissance of the sixteenth century. The Renaissance had been primarily an Italian affair, but this new classical revival was the product of the people of the north. It bore all the Teutonic earmarks of having been born in the stuffy studies of a number of learned Teutonic professors instead of having grown out of the soil of the Apennine peninsula.

Incidentally it was the first of the great art movements of Europe that affected our own country. For the Founding Fathers of the republic were ardent admirers of the classics. They loved to think of themselves as the legitimate descendants of the heroes of ancient Rome. They fancied themselves greatly in the role of Cincinnatus, who, as all the world knew, had only stopped his plowing long enough to smite the enemies of the commonwealth and who at the first opportunity had hastened back to his furrows and his simple meals of cornmeal mush and water.

Hence, as soon as the Fathers had gained their independence, they

laid the plans for a national capital that should be the visible expression of their belief in the superior virtues of classical Rome. There was to be no House of Parliament. That smacked too much of the tyrannies of the Old World. They meant to erect a regular Capitol, built upon a regular Capitoline Hill, and the structure was to look like a gigantic Greek temple with lots and lots of pillars, for in those days pillars were almost invariably associated with temples—and the more the better. They also meant to cover the new edifice with an iron dome, vaguely reminiscent of that of St. Peter's but crowned in this case with a statue of Columbia which bore a very close resemblance to the Pallas Athena that had graced the Acropolis of Athens.

The habit, once started, was hard to repress, and the city of Washington remains a strange hodge-podge of classical and semi-classical architecture. Wherever possible whole rows of columns have been added to buildings that would be infinitely better off without those superfluous ornaments. Poor old Abe Lincoln, who had begun life in a simple little wooden lean-to, sits Zeuslike in a marble Greek temple. The old gentlemen of the Supreme Court are safely tucked away in another Greek temple. The Treasury guards its sacred hoard behind the façade of still another Greek temple. Our banks all over the country have followed suit and everywhere Greek temples (provided, however, with a large number of entirely unclassical windows) invite the citizens to come inside and invest their drachmas.

But the craze was by no means confined to the cities alone. Far from it! Everywhere in the country there arose a new sort of dwelling that showed the very decided influence of the classical ideals. The simple little wooden houses of New England and the stone houses of the Hudson valley, built without benefit of architect but constructed according to the best traditions of the English and Dutch carpenters, were no longer considered sufficient for the needs of a nation that had now proudly taken its place among the ranks of the great powers of this earth. Again it was the unfortunate pillar that was called upon to add the necessary touch of classical dignity.

Now that we are at last beginning to have a little self-reliance and feel (as God knows we should!) that we are more than holding our own in the matter of all the arts, we can look back upon this era with an air of complete detachment. We sometimes wonder why our esteemed ancestors submitted so meekly to the dictates of Europe. But we should always remember that the first seven of our presidents had been born British subjects, and that the rich merchants of the

Atlantic seaboard thought of themselves not as Americans but as transplanted Europeans and got their books and their wives' clothes and their daughters' harpsichords from London or Paris, but never from a shop in Boston or Philadelphia.

Furthermore, the new classical style of Europe suited them much better than anything else they had ever seen. Baroque was too expensive for their slender means. Rococo was too frivolous for their sound Puritan tastes. But the plaster-cast Greece and Rome of the Winckelmanns and Lessings fitted in most neatly with their own ideals about a life of arduous duties and austere joys. Hence they swallowed that style—cornice, shaft, architrave, and all—and when they looked at the imperial eagle, proudly stretching his wings over the dining-room clock, they felt—in fact, they were convinced—that they had struck a most perfect balance between the old and the new and that Caesar, had he suddenly appeared on Capitol Hill in Washington, D. C., would have undoubtedly thought himself back in the city of his birth.

## Revolution and Empire

*The triumph of the classical style concludes with an attempt
to turn the artist into a political propagandist.*

JACQUES LOUIS DAVID, the dictator of art during the period of the
French Revolution and the Napoleonic Empire, was born in the
year 1748. When he was nine years old, his father was killed in a
duel. His guardian took him away from school and sent him to study
art with François Boucher, a painter of beautiful women in the most
charming Rococo style.

But since an artist, like water, will always find his own level,
young David soon afterwards moved across the street to the premises
of Maître Vien. Joseph Marie Vien was one of the founders of the
classical school of painting in France. He enjoyed enormous popu-
larity in his own time but is now so completely forgotten that in most
handbooks of art his reputation has shrunk to a mere note at the foot
of a page. But he was just the man for young David. When Vien was
appointed director of the French Academy in Rome, David accom-
panied him and landed in the heart of the paradise of his dreams,
what with Mengs painting his classical pictures and Winckelmann
developing his classical theories and all the museums full of classical
statues. Out of this Roman visit came the first large canvases in the
truly Davidian manner and with truly Davidian titles, the *Death of
Socrates* and *Brutus* and the *Oath of the Horatii*—ancient history painted
in the best Hollywood style and bearing about as much resemblance
to the actual facts as most of the products of that charming village
whenever it goes in for events of the past.

When David returned to Paris, he was predestined to play a lead-
ing role in the art life of that city. For in their reaction against every-
thing tinged with the mark of the beast (meaning the king and the
court) the people were now going completely classical. The women
wore garments that were supposed to resemble Greek tunics, and
hennaed their hair as the wives of the Caesars had done, and wore
sandals like Salome. Since there was no longer a minister of fashions
(Louis XIV had given the court dressmakers the titles of *ministres de la
mode*) to tell a proud and free people what to wear, and since the first

*In spite of what the academicians and the professors of art may say there is no definite way in which a picture should be painted. Let me give you a few examples that you may see this for yourself. During the four years I lived in Veere I saw literally hundreds of painters try their hand at the little harbor. To me it looked like this.*

*But to others it looked like this (with a polite bow in the direction of one of our greatest modern American artists—John Marin).*

of all fashion papers, the *Galerie des modes*, founded in 1770, had been suppressed (an energetic German by the name of Heideloff was continuing it in London under the name of *The Gallery of Fashion*), the Paris *couturiers* were now trying out all sorts of new ideas as the politicians were experimenting with all sorts of new forms of government.

The result was very curious. But the moment Robespierre, the one perfect disciple of Jean Jacques Rousseau, came to power there was an end to all those lovely Greek and Roman adaptations which had finally reduced the average female gown to an exact replica of the garment which Nausicaä wore on that lovely morning at the seashore when Odysseus discovered her playing ball with her handmaidens.

A world which had always tried to ape the aristocracy now went to the slums for its inspirations and dressed à la bum. To wear the trousers of the hated old oppressors in public was equivalent to a bid for the guillotine. Powder and soap were something no true patriot would ever touch. Instead of which, he now went about his business in a pair of dirty old long pants, which were considered the sartorial evidence of complete civic rectitude. These long trousers had originally been worn by the galley slaves. Indeed, it had been their only garment while pulling their oars. Afterwards, English sailors also patronized these wide long pantaloons, which were by far the most comfortable thing when you had to slop around on a wet deck, for they dried much faster than the tight trousers of the seventeenth century. They were called pantaloons because ever since the sixteenth century one of the characters in all Italian farces, by the name of Pantalone, had made his appearance in a pair of long trousers which had never failed to make the house come down in roars of laughter.

The upper garment for all men consisted of a loose blouse, the carmagnole, so called after the village of Carmagnola in Piedmont and brought to Paris by the cutthroats from Marseilles when they had hastened to the national capital to inject a little energy into the lukewarm activities of the legislative body. Hats, as smacking of too much refinement, were no longer tolerated. Instead of that, both men and women wore a loose cap which was supposed to be of Greek origin and was known as the Phrygian cap. As the Revolution had thrown France into a state of want and misery the like of which it had never before experienced (even during the worst days of the old regime) people wore any old material they could find. In order to keep one's head firmly on one's shoulders it was good policy to go in

for striped effects, repeating the new national colors—red, white, and blue—as often as could possibly be done.

As for the women, they too became *femmes du peuple*. Trains and artificial stuffings were gratefully sacrificed on the altar of equality. But as no laws, revolutionary or otherwise, have ever been able to make the slightest impression upon the desire of woman to look her best, she soon found other ways to accentuate her charm, especially by the arrangement of the little wisps of soft tulle which she wore around her neck. This of course was entirely in keeping with the times, for the neck had become the most valuable part of the human anatomy. One jerk at Citizen Sanson's fatal rope and the head, even the loveliest of heads, tumbled into the basket of Madame Guillotine.

While all this was entirely in keeping with the best revolutionary traditions, it found but little favor in the eyes of Maximilien Robespierre. Whatever else he may have been, Dr. Carlyle's "sea-green incorruptible" was no proletarian. Indeed, he was almost the only man who continued to dress himself decently and to appear well shaven and well brushed, while everybody else went about in the rags of the hundred per cent *sans-culotte*. As *culottes* had been the knee breeches of the old royalist order, the wearers of pantaloons were popularly known as *sans-culottes*, the "fellows who did not wear them."

And so Citizen Robespierre approached Citizen David and suggested that he, the great master of the classical style, now provide the French nation with a strictly classical garment which should show all the world that the old austere days of the Roman Republic had returned to this earth. David set to work with all his irrepressible enthusiasm, and a few weeks later showed his friend Maximilien the plans for his *costumes à l'antique*. His male costume was never a success. Most men felt that they looked like fools in these tunics and togas and feather-covered hats, and, unless they were absolutely forced to do so to escape the displeasure of the dictator, they never willingly went in for this painful sort of masquerade. The women, however, were very grateful to Citizen David for setting them free from their proletarian disguise. For David had merely copied the figures which he found on the old Greek vases, and as a result the French women of the days of the Terror and all during the Directoire were allowed to go about in very little more than an exceedingly slender chiton—a sort of amplified chemise.

The rest of Europe did not take very kindly to this new fashion, with the sole exception of Germany, but then, of course, it was the

Germany of Winckelmann and Lessing which had most ardently espoused the cause of the new classicism. And incidentally, it was this fashion which introduced the shawl. For most of these ladies dressed *à la greque* or *à la romaine* were forever suffering from the cold. And as mantles could not very well be worn inside the house, they took to shawls. These shawls were of Indian origin. The first ones came from Kashmir but soon afterwards the English looms began to work for this profitable market, sticking, however, very carefully to the rich Oriental patterns.

Another innovation due to the scanty raiment of that day was the handbag. During part of the Middle Ages, when dresses had been very tight, women carried the little odds and ends without which they cannot exist in a so-called *aumônière*—originally a bag to carry alms. Now the *aumônière* returned as the reticule, which in turn became the handbag into which we dig when we have finished our own cigarettes and go after those of our wives.

All these extracurricular activities, however, did not prevent Citizen David from covering hundreds of yards of canvas with historical propaganda of a revolutionary nature and from taking a very active part in the events of the day. In the year 1792 he was elected to the Convention and was one of the three hundred and sixty-one members who voted for the decapitation of the King, that fatal decision taken with a majority of exactly one vote. He was such a violent supporter of the radical wing that for a while he even acted as chairman of the Convention. He managed to escape the fate of his friend Robespierre, and when Napoleon rose to power, he not only became the official painter to the imperial court but also carefully rehearsed the awkward little Majesty before he drove to Notre Dame to place the crown of Charlemagne upon his own vulgar head. The fall of Napoleon forced David to leave Paris. The Bourbons never forgave him for the part he had played in the legal murder of Louis XVI, and he died in exile in the city of Brussels in the year 1825.

No one can deny the fellow's tremendous ability, especially as a draftsman. And we can well understand how these pictures, glorifying the heroism of the ancients, must have impressed his contemporaries who lived in a haze of classical allusions and allegories. But his influence in other ways was most unfortunate. For he believed so strongly in the superior qualities of a world that had been dead for more than sixteen hundred years that he had no understanding of anything else. "Antiquity—and antiquity in the raw" was the

*In England the architecture better than almost anywhere else
fits in with the landscape.*

slogan which inspired him all his livelong days. In his fanaticism for this unadulterated antiquity he went so far as to suggest that all pictures of the Flemish and Dutch schools should not only be removed from sight but should actually be destroyed because they were so outspoken in their realism as to ridicule the human race. He also wanted to have a law passed forbidding all artists to paint anything except patriotic subjects. The only exception he was willing to make was for incidents mentioned in Plutarch's *Lives*. But for the rest, the artists must be made to work for the glory of the state or suffer the consequences—confiscation of their work and imprisonment or exile.

David was not the first to attempt this sort of regimentation and neither was he the last, for it is again being tried in Russia and Germany and Italy. And apparently no amount of failure along this line seems to make any impression on those honest patriots who believe that the Muses can be put into neat little uniforms and be made to goose-step with all the other bright little boys and girls in their brown and black and pink shirts and their toy popguns.

But David did something else which in a way was even more fatal to that art of which he was so brilliant an exponent. He was, as I said, an excellent technician. He knew all the tricks of the trade. And because he was so good he was able to make people like the sort of pictures of which the story is really much more important than the actual painting. In short, it was he more than almost anybody else who reduced all painting to a sort of colored illustrating. And as David, like so many of the actors in the sanguinary drama of the Revolution, was at heart a terrific puritan (a murderer who murdered to rid the world of sin) he insisted that the stories that were told be nice stories, moral stories, stories that taught a lesson of virtue or patriotism.

In the hands of a craftsman like Louis David, such pictures could still retain the qualities of a masterpiece. But in the clumsy fists of third-rate imitators they became a mere waste of good canvas, except that nobody would have dared to call them so because they would have immediately been exposed to the violence of the men they had criticized.

"Aha!" these mountebanks would have insinuated, "and so you don't like our pictures! Perhaps it is the subject of which you do not happen to approve? But that subject is above all suspicion. It is virtuous. It has moral rectitude. All right-minded people should approve of it. All good patriots should admire it. All citizens con-

scious of their duties toward the State should applaud our efforts. Suppose therefore that we ask you a few questions about your own attitude toward a number of things, for example. . . ." And then, "Off with your head!"

Louis David's name is not only associated with the period of the French Revolution but also with the era of the Empire. As a rule we associate the so-called Empire style with the brief era of Napoleon's rule from the year 1799, when the Directoire came to an end (small loss, artistically speaking), until 1814 when Napoleon was sent to Elba. Because so many of the chairs and clocks and beds and water pitchers that go back to the beginning of the nineteenth century are adorned with the imperial eagle or the letter *N*, we are apt to think that the Empire style was yet another invention of that universal genius who juggled with kingdoms, codes of law, armies, navies, peace and war as a dog plays with a ball. That, however, was not the case. Empire is in reality nothing but the style of the new classical movement which in the beginning ran parallel with Rococo and which finally replaced it altogether. It therefore goes back to the early days of Louis XVI who came to the throne in 1774. But it got its name of Empire because it was the favorite style of the Emperor Napoleon, who whenever he thought of himself (an occupation which kept him busy twenty-four hours a day) loved to imagine that he was the direct and spiritual descendant of the Caesars and who, if he had lived long enough, might even have made Rome the capital of his far-flung empire.

The classical style in the hands of the well-bred people of the eighteenth century had created articles of common use of great beauty. As such it bobbed up again in Germany and Austria immediately after the Napoleonic era where it then became known as the Biedermeier style. And as such it found a charming expression in almost everything that was made in England during the Georgian period.

But all the Napoleonic palaces give you the feeling of "Corsica come into a million dollars," and that is exactly what they were. A little, black-haired Italian boy had struck it rich and was going to show the world what was what. The result was far from pleasing to our modern eyes. But it satisfied the motley crew of ex-bartenders and ex-scullery boys and ex-washerwomen, who, dressed up in all their feathery finery, now crowded around the newly re-established throne of Charlemagne and whose idea of true luxury was best summed up in the words of one of them: "When you have got it, you have got to spend it too."

Since gold has always been an evidence of "having got it," everything had to be thickly covered with a heavy layer of gilt. When you ordered a writing table, you did not want one with a plain wooden top. That was much too cheap. You must get one with a marble top or some other expensive stone. It might not be very handy for the purpose of writing, but why waste your time writing when there were so many infinitely more important things to be done? Besides, the marble would not spoil quite so easily when you dropped your wet gloves on it or your pistols or your saber or your dirty boots.

The best thing one can say about the Empire style is that it did away with a great many other innovations that were even less pleasing. For during the first great outbreak of classical enthusiasm people actually lived in houses that were a direct copy of the recently discovered mansions of Pompeii. Of course, no pictures were allowed in such rooms, for the walls were covered with frescoes done in the best Pompeiian style and the furniture was such as one would have found in the home of a Pompeiian patrician of the first century of the Christian era.

After the outbreak of the Revolution, when France started upon its struggle for life against all the rest of Europe, the classical mode was given a decidedly martial turn. Everybody—that is to say, every able-bodied man—was either at the front or had just returned from the front or was just about ready to go back to the front. And the home folks, not to be outdone in their warlike ardor, began to drape their rooms with all sorts of soft materials that gave their living quarters the appearance of a tent. Their beds became campaign beds, their clothes resembled uniforms, their children played only with tin soldiers and miniature cannon. Such pictures as were tolerated were those of brave generals exhibiting their superb horsemanship amidst a deluge of shot and shell.

The return to the classical style of the Napoleonic era was therefore an improvement upon the classicism of the Revolution. Political events, however, continued to influence the arts. After Napoleon had returned from Egypt with the first reliable accounts about a country that had been practically unknown for the last sixteen hundred years, Egyptian details began to make their appearance among the purely Greek and Roman ornaments that had held sway until then. The Sphinx began to smile mysteriously from sideboards and griffons lent their claws to assure stability to chairs and tables. And then came the bee—the famous bee which Napoleon had chosen as his trade-mark—

the bee that represented the idea of industry and constant application toward one final purpose—the glorification of the common hive. During the last years of his reign the capital letter $N$ began to replace the $B$.

Were there any musicians of importance during this period? They existed but they were not found at the imperial court. The Emperor did a lot for the improvement of his military bands but there is no evidence that he knew one note from another.

How about the arts? They were none of them considered quite as important as the contributions of the military tailors who submitted sketches for new uniforms. There were a few exceptions. Antonio Canova, Marquis of Ischia by the grace of the Pope, and technically one of the best sculptors of the last five centuries, found favor in the imperial eyes and found one of the imperial sisters willing to pose for his statue of Venus. Gros painted his familiar war scenes. Prud'hon continued his dull allegories and Ingres, the ex-fiddler (and a very bad one) and now a pupil of David, was beginning to draw those marvelous portraits which have rarely been surpassed for sheer beauty of line and which were so greatly superior to his work in color.

Incidentally, and to show you the hold the classical ideal had upon the people of this era, when Ingres painted his *Apotheosis of Homer* (you can admire this advertising poster of the Greek travel agencies in the Louvre) he was most careful to omit Shakespeare and Goethe from the crowd of the "moderns" who were doing homage to the blind singer from Chios. For these two had not been completely sound in their "classical tendencies" and so were sent into exile. It was the old, old story of the arts reduced to a formula which in turn was part of a political program. It has never worked. It will never work. But there is one thing that can be said in its favor. Invariably it has caused its own reaction, and after a period of suppression the arts have always experienced a rebirth of life which has carried them farther than they had ever been before.

# Chaos: 1815–1937

*Art and life part company.*

GOETHE WAS RIGHT. He happened to be present at the famous battle of Valmy. It was hardly a battle at all, as we now measure that sort of systematic slaughter. But it was the first conflict in which the unorganized hordes of the French Revolution were able to hold their own against the highly trained troops of imperial Austria and royal Prussia. It was the first time the forces of reaction were fought to a standstill by a mob of half-starved, badly armed civilians whose officers had only recently been recruited from the ranks and whose members had been horribly decimated by dysentery and despair. On the evening of that day when the imperial and royal forces withdrew from the encounter, along the rain-soaked roads of Verdun, Goethe wrote in his diary that a new chapter had been started in the history of the world.

I cannot go into a detailed description of everything that happened during the twenty-five years that followed in the wake of this eternally famous cannonade of Valmy of September 20, 1792. And so I shall have to begin this chapter on June 18th of the year 1815 when Napoleon was defeated at Waterloo. No sooner had the news reached Paris than the wearers of the *culotte*, the gentlemen of the elegant short knee breeches that had been typical of the old order of things, rushed back into power. They realized the importance of sartorial details and in several countries the wearing of the long pantaloons was made a penal offense. But these efforts were soon given up. There were more important things to be done. For while one half of the people remembered Maximilien Robespierre only as a monster of cruelty and depravity, who had met with his deserved end, the other half still regarded him with ill-concealed affection and felt that he had died a martyr to a holy cause.

They were very careful, of course, not to proclaim such a belief too loudly. The antirevolutionary forces were in full command, and the spies of Metternich, the conductor of the great European concert of reaction, were present in every home and at every public gathering. Nevertheless, the old revolutionary creed was by no means dead.

It had merely gone underground. Like many a forest fire that was supposed to have been completely extinguished weeks and weeks ago, it would suddenly flare up in all its former fury the moment nobody was looking or the moment it reached some neglected corner so completely overgrown with dried-out trash that it would go up in flames at the slightest touch of a match.

The emperors and kings assembled at Vienna constituted themselves into a sort of political fire brigade, the Holy Alliance Hose Company No. 1. They not only promised each other to observe a truly Christian charity toward all their neighbors (a written guarantee of peace eternal) but to protect those dearly beloved subjects which almighty Heaven had entrusted to their care against a repetition of the crimes and horrors that had been committed in the name of Liberty, Fraternity, and Equality.

Alas! Never in all history (and history is pretty full of very sad disappointments) has a generation suffered from such a horrible disillusionment as that which followed upon the Congress of Vienna. For no sooner had the last of the imperial, royal, and grand-ducal stagecoaches rumbled out of the gates of Vienna (leaving behind a city that never quite recovered from the ruinous cost of entertaining all these fine gentlemen and their womenfolk) than all these noble vows and promises about "peace eternal" were promptly forgotten. No constitutions were granted. None of the promised civic guarantees were ever realized. None of the old privileges and prerogatives were surrendered. The dearly beloved subjects were relegated again to the position they had held before the year 1791. They retained, of course, a certain value as taxpaying animals and as pieces of potential cannon fodder. For the rest, they were expected to obey their betters and to obey them with alacrity and a smile on their lips.

During the first ten years they accepted their humble role with unprecedented meekness. They consoled themselves with the idea that no matter how badly off they might be under the new dispensation, they at least enjoyed the benefits of a lasting peace. But when their rulers betrayed them and showed that during all these many years of exile they had forgotten nothing and had learned nothing, the patient subjects began to think back to the days of their youth. The French might have been stern taskmasters but they had (for a while at least) made them feel a certain pride in themselves, had encouraged them to stand up before other men and assert their basic human rights. And now the poor devils must once more goose-step before every black-and-white-striped royal Prussian guardhouse and every state official must be approached with a deep obeisance.

To make matters worse, a great change had come over the world, although very few people were as yet conscious of what this would mean to them in the immediate future. Some thirty years before, a Scotchman by the name of James Watt had brought about certain improvements in the cumbersome old steam engines (fire engines as they were then called) which made it possible to let a single one of these machines do the work of a hundred men. So a hundred men, who during the simple agricultural arrangement of feudal society had always been certain of a roof over their heads and a piece of black bread in their hands, were now thrown out of employment. They had become workingmen deprived of their tools. These modern tools called "machines" were so expensive that only people with a lot of money could buy them. They, of course, did not intend to work themselves but since they had enough spare cash to pay for these costly tools they experienced no difficulties in hiring others to do this for them and at such wages as they were pleased to give. As for the man who thereupon went to labor in the factory, he either had to accept what he was offered or starve. There was no choice.

Now this new arrangement reflected itself in a number of mysterious ways which were not at all pleasing to the people who remembered the old order of society. They had been thoroughly drilled in their respective catechisms and therefore knew the world must always be divided into the rich and the poor. It had been so in the beginning of time and it would continue to be so until the end of time. But until then, being rich had carried a great many obligations with it and obligations which no rich man, be he ever so selfish, had dared to disregard.

For one thing, he was expected to spend his money enjoying himself. But this new class of society (and heaven only knew where these new rich people came from!) did nothing of the sort. They accumulated wealth for the sheer joy of the accumulating. They did not follow the age-old example of spending their ducats upon collecting lovely paintings or hiring bands of musicians or endowing beautiful churches. They hardly knew that such things existed. When they were brought to their attention, they showed in unmistakable fashion how little they meant to them. They were, of course, dominated by a great deal of vanity and were always eager to impress their neighbors with their superior wealth. But they had no respect for the traditions. They were willfully ignorant of such matters. All they cared for was that their houses and their womenfolk and their meals should be substantial and should cost a lot of money. For the rest, they had few ambitions to play the Maecenas. That they impoverished whole

cities by this cruel method of exploitation—that they turned the quiet countryside into an eyesore, that they reduced an entire class of formerly self-respecting citizens to the rank of paupers—all this never seemed to penetrate into the minds of these new rulers who had all of the vices of the old masters but none of their virtues.

During the last fifty years our attitude upon this subject has completely changed. We have now learned that the machine, far from being a destroyer of beauty, can on the contrary bring beauty at a ludicrously small cost into the homes of millions of people who have never in all their lives owned a single thing with the least claim to an attractive outer appearance. A machine has no preferences in such matters. It will just as soon turn out a very good-looking tumbler, which afterwards retails at a nickel, as a bad one. It all depends upon the man who draws the original sketches and then makes the machine do his bidding. We have these men, but a hundred years ago they did not yet exist. Hence the beginning of the nineteenth century was an era of bad taste that has never been equaled in history. For the old order was not quite strong enough to destroy the new order, and the new order was not quite strong enough to destroy the old order, and both of them were at the mercy of a force which neither of them knew how to handle because neither of them had had any experience with it and because it was the result of something which nobody as yet understood—the steam engine applied to the problem of mass production.

You may well be curious to know how the artists fared under these new economic conditions. The answer is very simple—they fared exceedingly badly. For until then they had always given expression to certain emotions that had been common to all men. Now such a common experience no longer existed. The universality of the old cultural ideals was destroyed and the artist was left to grope for himself, like a sailor at sea without compass or sextant. No longer able to give expression to the common thought, the artist was now, for lack of better, forced to give expression to his own individual ideas. His old patrons were gone, his old outlets closed to him. The product of his brush or his pen had become a mere piece of merchandise. Because there was nothing left for him in which to believe, he had to invent a new creed, far less satisfactory than the old one. He must now either believe in himself or work in a void. And by and large, these unfavorable conditions have prevailed until this day. We are only now beginning to see the coming of a new dawn in which life and art shall once more become welded into one.

# The Romantic Period

*The great escape into the realm of the ruined castle and the
brokenhearted poet in the checkered pantaloons*

THE CIVILIZATION of the early part of the nineteenth century was
at least honest about its likes and dislikes. It told the painter and
the musician in just so many words: "You are a useless member of
society and we shall be better off without you." Then these young
men knew what to expect, but as they had no other way of making a
living than by their brush or their pen, they did not have the vaguest
idea of where to go. And so, like the lost souls in limbo, they wandered
all over the landscape. singing their little tunes to keep up their
courage and painting their little canvases to adorn the far from cheer-
ful walls of that drafty attic where they lived with their dear little
Mimis and Musettes in that picturesque squalor made so familiar to
us by the mellifluous works of Signor Puccini and Jacques Offenbach.

In the end, where did it get them? Nowhere in particular unless
they were fortunate enough to be forgiven by their parents (for the
economic sin of having become painters) and were able to spend the
rest of their days in their fathers' hardware business or selling insur-
ance to their more solvent friends.

For the arts were in the doldrums. After the excitement of the
Napoleonic era the world needed a period of rest. But stagnation is
something different again and not so good for either the soul or the
body. In Germany there was a great stirring within the fields of
literature and music, but the painter did not profit from this spiritual
boom. He became an illustrator who worked on canvas and who was
supposed to tell pretty stories for the nursery or to extol the virtues
of a truly domestic existence.

In France, painting had since the days of David been recognized as
a form of government propaganda. David was gone but the propa-
ganda remained. As one government succeeded the other with almost
indecent haste (even for France where they are accustomed to such
things) a large number of painters were kept alive by providing the
new rulers with the necessary pictorial excuses for their most recent
*coups d'état* or by depicting them in some act that should do credit to

their truly Christian impulses, such as feeding the hungry or opening new drainage canals or (worst of all) exhibitions of contemporary paintings.

As a result, the French artists of this period turned out endless miles of paint-smeared canvases. But if ninety-nine per cent of this rich harvest of the romantic generation should be lost overnight, nobody would know the difference. It would be good riddance and would make room for the younger fellows who really have got something to say. Fortunately, the contemporary paint manufacturers took care of this problem in such a way that the extinction of most romantic paintings will be almost completely painless. The paint they put on the market was so bad that most of the pictures of that era are slowly decomposing into a rather drab brown soup that even the loving descendants can no longer recognize as the countenance of dear Grandpa or his beloved spouse in her crinoline that took forty yards of real silk.

A similar fate awaits a great many of the works of art which our grateful nation has placed upon the walls of its executive mansion and upon those of that shrine of civic virtue where its statesmen meet to debate the fate of our republic.

The Egyptians were better at that sort of thing than we. The pictures on the walls of their mausoleums are still as fresh as the day they were painted.

Somehow or other I always associate the Romantic Period with gaslight, with stuffy rooms full of stuffy furniture and stuffy people. It may have been the pictures of Daumier that gave me that impression. Gaslight the way we knew it just before the arrival of the electric light was rather nice. But the gaslight of the thirties and forties was a terrible comedown after the candles of the Baroque and Rococo. It tried to make an impression of something very progressive but only succeeded in creating an atmosphere of flickering uncertainty, an atmosphere which quickly penetrated into every department of life. Small wonder that the painters finally arose in revolt against the helpless shallowness and artificiality of the existence they were supposed to depict and opened the windows of the stuffy studios and said, "For heaven's sake, let us have a little light and air!" The musicians had done so years ago. Now it was the turn of the gentlemen of the brush.

# Revolt in the Studio

*The realists refuse to find further safety in escape and start
a counterattack of their own.*

WHEN GUSTAVE COURBET, on account of his radical tendencies, was
refused admission to the Paris World's Fair of 1855, he opened
up a show of his own. Over the door he boldly painted the word
REALISM. At a time when nothing was real, when women were sup-
posed to exist without legs, men to go through life without a con-
science, and children to enjoy sermons, this signboard was an act of
defiance for which he deserves our respectful admiration. Soon he
had quite a number of followers and by the middle of the century, the
rebellion he had started was in full swing.

First of all the landscapists packed up their easels and brushes and
bade farewell to the city to paint nature as it was without benefit of
gaslight. For the artificial atmosphere of that period had almost made
the artists forget that "in the beginning, there was light." Now this
great gift of God, bestowed upon us on the second day of creation,
was rediscovered by such men as Corot and Millet and Daubigny and
Dupré and Harpignies and Rousseau (the Frenchman who came so
close to the Dutchman Ruysdael) and Diaz, the former porcelain
painter of Sèvres.

As Paris had nothing to offer them and they felt that they on their
side had little enough to offer Paris, most of them moved into the
country. The pleasant village of Barbizon, just on the fringe of the
forest of Fontainebleau, offered them shelter, for their needs were few
and most of them were quite willing to live like peasants provided
they could work as they pleased and without being obliged to make
concessions to the prevailing lack of taste. They had some slight
respect for the Englishmen, Constable and Turner, but they lived in
open warfare with the Academicians, who every year filled the official
salon with their miles upon miles of uninspired canvases. The
Academicians on their part (being only human) returned the compli-
ment and let their colleagues in Barbizon starve, to the great detri-
ment of their health and that of their wives and children.

The men of Barbizon, however, were soon joined by other groups

of rebels. In Paris a group of youngsters—authors, painters, sculptors, musicians—who did not have even the few sous necessary to take them into the country began to show signs of unrest. Balzac had already started upon his gigantic catalogue of every social type that went to make the great French nation what it was. Victor Hugo, violent enemy of all dictatorship, was living in exile on one of the Channel Islands, doing his best to expose and smash the false pretenses of the shadowy empire of Napoleon III.

And there were others, thousands of them, who felt there was something decidedly unhealthy in the whole fabric of this curious society based entirely upon the accumulation of inanimate objects and which would have to be destroyed before any real progress could be made. Some agitated against it by writing comedies, others by drawing caricatures, still others by running clandestine newspapers that were printed abroad. Many of them merely spent their days going from one café to the next, talking, denouncing, exposing, and meanwhile getting drunk on their own rhetoric as well as on their friends' cognac.

There has rarely been a society so full of intrigue and counter-intrigue, but, strangest of all, the man in the Elysée was really in secret harmony with those who had sworn to destroy his empire, and if possible, to send him and his Spanish wife to the farthest islands of the Pacific. He had seen his elder brother die while both of them were fighting for the freedom of Italy. Afterwards he had led two disastrous expeditions against two kings of France who occupied the throne he desired for himself. At long last he had been successful. But he was a person endowed with a shrewd gift of seeing himself as others saw him. He knew perfectly well that he had betrayed the cause of revolution. His new job demanded that he play the conservative. His instincts told him to do the exact opposite. It was really very embarrassing. So he smoked another one of his interminable cigarettes and said, "*Tiens, tiens,*" and poked fun at his wife who was as beautiful as she was dumb and who thought Géricault and Delacroix great painters.

There was that annoying incident of the year 1863. Every year one great exposition of pictures was held in Paris, the so-called Salon. The jury, which had to decide who should be admitted and who must be kept out, was invariably composed of stodgy old academicians. Any young man who failed to yes them had as little chance of having his work exhibited as Stalin of being elected an honorary member of the

Union League Club. Every year the old academicians flatly refused to give the youngsters a chance and every year this led to endless quarrels in all the cafés and salons on both sides of the river. In 1863 ensued the same old story, only that on this occasion the jury was even more narrow-minded than usual. Whereupon the Emperor decided to take a hand in the matter. With typical Napoleonic sarcasm he suggested a *Salon des refusés*, a rival exhibition where those who had been refused admission by the academicians could show their work to the public and leave the final judgment to the populace.

A great many of the paintings that were thereupon exposed in this Gallery of the Refused Ones were of very poor quality. That will always happen on such occasions. But there were several pictures which made the eminently respectable Parisians of that day gasp. There was a queer thing, a mysterious portrait in white by an American of whom nobody had ever heard, a certain James McNeill Whistler. Of course, one could expect anything from an American! But that a Frenchman could be guilty of anything quite as scandalous as that *Picnic Lunch* of a certain Édouard Manet (a picture showing two undraped females lunching in the forest with two gentlemen fully dressed)—that was something of which the whole French nation should feel thoroughly ashamed.

This was the same French nation on which Émile Zola would soon give us his not so flattering report. But by this time the forces of the attacking party were pretty well organized. Now it became a pitched battle, with the headquarters of the defense established in the editorial offices of the *Figaro* and the other conservative newspapers, while the opposition made merry in the Café Guilbert or in the studio of Courbet, who in order to show his contempt for the academicians, dismissed all his models and let his pupils draw a live cow instead of the conventional nude. But having ridiculed and lampooned the enemy to their hearts' content, they returned to their jobs, for as a group they were composed of hard-working young men and a few middle-aged and ancient fellows like Courbet and Corot, who now at last were beginning to make a few sales.

Not that the public really understood them, but the art dealers had discovered at last what could be done with a cleverly handled publicity campaign in some of the more respectable newssheets. France, of course, has always been a very sensible country in the matter of criticism. There is a fixed tariff according to which the critic gives your book or symphony or your concert an A, an A-1 or an AAA rating. It seems to be the one racket we in America have overlooked. I

wonder why? We have the racket of the art dealer and the concert
manager. But our literary critics keep aloof from these perfectly le-
gitimate business activities. Well, perhaps they will learn.

But these new rebels completely upset the equilibrium of the staid
old critics. They openly declared that the followers of Courbet and
his realistic disciples had only one purpose, *épater le bourgeois*, to step
on the toes of their enemies, the greengrocers and the other middle-
class middlemen. They may have been right, for when Manet in the
Salon of 1866 exposed his *Olympia*, the painting had to be protected
by the police against the violence of the public, just as sixty years
later the pictures of Van Dongen and Van Gogh had to be safe-
guarded against the umbrellas of the outraged burghers of their na-
tive land.

Four years later the empire of Napoleon III came abruptly to an
end. But the republic which succeeded it showed itself even less toler-
ant toward all innovations in the arts. Meissonier and his friends
now dominated the annual salons and were so resolute in their rejec-
tion of everybody who did not qualify as a true academician that they
forced Puvis de Chavannes, the famous fresco painter of the Panthéon,
to resign in disgust. And Courbet, who had been the protector of all
the youngsters, was living in Switzerland. He had done what no great
artist should do. He had got mixed up in politics. Now he was an
exile. His fortune had been confiscated. His pictures had been con-
fiscated. His home had been confiscated. He was completely ruined
and too old to begin again.

Then one of those strange things happened that are so typical of
the good city of Paris. In the early sixties a Paris photographer by
the name of Nadar had made himself quite a reputation as a balloon-
ist. He had constructed a gigantic bag containing two hundred
thousand cubic feet of gas with a car of two stories containing all the
comforts of home, like a modern Zeppelin. The thing had actually
left the ground with not less than thirteen passengers and the event
had made as much of a stir as the first flight of Bleriot across the Brit-
ish Channel. This same Nadar owned a photographic studio on the
Rue Daunou which he no longer needed. He told the painters, who in
the year 1872 were excluded from the Salon on the usual ground "that
their work was not up to the standards set by the Academy," that
they might use it. Among those who exhibited were several men who
since then have become world-famous: Manet, Monet, and Degas,
Cézanne, Pissarro, Bracquemond, and Renoir. And among their pic-

tures was a sunset by Claude Monet, done in a new style and entitled *An Impression*—nothing definite, just an impression.

This gave the *Charivari*, Daumier's old paper, a chance to poke fun at the new "impressionists." The name stuck. Today we talk in all seriousness about the impressionist school. We have forgotten about the roars of laughter with which that first exhibition was received by the good Parisians of the year 1874, who thought it terribly funny to look at such pictures upside down and then ask each other, "Tell me, what is it?"

Well, what was it? Nothing but an attempt to do something that upon a few occasions had already been done by Rembrandt and Velasquez and Goya—to make a figure or an object stand out from its background as if it were completely surrounded by light. In order to do this successfully, these painters like Monet felt that first of all they should know something about the true character of light. They realized that the mediums they used were different from the mediums used by the good Lord when he performed his miracles. Therefore they contented themselves with trying to create an "illusion of light." They thought that they could do so by breaking up the color of these pictures into small dabs of pigment. That was the "comic effect" which had so delighted their contemporaries and which has given the impressionists the reputation of being a group of lunatics. For such a picture must, of course, be examined from quite a distance. From near by it looks like a piece of Ben Day work (many of the illustrations in this book are in Ben Day) studied through a magnifying glass. But then, of course, nobody ever is supposed to look at such an illustration through a magnifying glass. You are supposed to look at it from a slight distance. The same held true for the paintings of the impressionist school.

This school began with Monet and ended more or less with Seurat and Toulouse-Lautrec, who used his paints as lightly as if they had been pastels. In the meantime other Frenchmen experimented with other ideas. Eugène Carrière came closer to the English Pre-Raphaelites than any other Frenchman, but being born of the people and feeling like the people, he retained a hold upon the actualities of life which is so completely missing in the work of his English contemporaries.

Then there was the strange case of Henri Rousseau, who was no relation to the landscapist, Théodore Rousseau, but an obscure little official in the French customhouse service, from which he was called the *douanier* Rousseau. He painted for his own amusement and died

without having the slightest idea of his own greatness. During the short-lived empire of Maximilian in Mexico he had visited that distant land. The tropical foliage that surrounded Maximilian's soldiers made a great impression on him and again and again it returned in his pictures.

It is very easy to laugh at the pictures of this funny fellow, but strange though it may seem, it is just as easy to like them. Indeed, I myself find it easier to like them than the work of another specialist in tropical scenes, Paul Gauguin. Maybe I know too much about the man himself to appreciate anything he did. But then, I know just as much about Richard Wagner (it is difficult to say which of the two had the more contemptible character) and I love his music. There must be another reason but as such reasons lie always buried miles deep in our subconscious minds I shall not even try to find out what it is. There are so many other pictures I can admire, so why bother?

Gauguin at once suggests the name of another man who might still have done a vast amount of beautiful work if Gauguin had not driven him into suicide at the age of only thirty-seven.

As a rule the Dutch of the eighties and nineties get the full blame for the tragedy of this poor man's life. But if he had been born underneath any other star, Vincent van Gogh would have succeeded just as brilliantly in squeezing the last drop of unhappiness out of every situation into which he found himself pushed by his love for self-torture. He lived in a country in which the great tradition of the seventeenth century had now completely disappeared. Such men as Breitner and Israëls and Weissenbruch could still paint as well as anybody was painting anywhere else at that moment and the Maris brothers, at least in their landscapes, showed that sky and water had not lost their old appeal to the imagination of the people of the Low Countries. And undoubtedly if Van Gogh had given the slightest promise of any sort of talent he would have been sent to one of the numerous art schools to learn his trade. But his earliest drawings and paintings were terrible. They still are terrible. Just as the work of his last years soars right over the heads of all his contemporaries. When he painted these landscapes and portraits and flowers that were afterwards found stacked up in those garrets and basements which had played such an important part in his life, he truly had been a man "mad with color." That, combined with his morbid love for the poor and the humble and the weak, was too much for any human brain to bear. The perfidious malice of Gauguin finished the job of destroying him. But we have those landscapes in which everything is vibrant with

sunshine and light and we can proudly recollect that once the poor fellow actually sold a picture—for all of twenty dollars!

What crimes have not been committed in the name of taste! While Van Gogh starved, another Dutchman was making a fortune in England with a sort of picture which today you could not possibly give away. His name was Alma-Tadema, in case you are interested, and the British knighted him for his services to the arts. Which will hardly surprise anyone who has ever visited the annual exhibition in London of the Royal Academy. Endless canvases representing animated full-dress uniforms with stars and garters in the original colors. It is a terrible experience, but the exhibition never fails to attract thousands of enthusiastic admirers, each one loudly drawing the attention of his friends to all those things that are completely nonessential. This may seem a very harsh criticism, but after Turner and Constable were gone, while the genius of the English people expressed itself brilliantly in literature, painting and music went into a severe decline. Everybody tried to paint portraits like Lawrence and, for all we know, that is what the English portrait painters are still trying to do today.

Then came the romantic writings of Sir Walter Scott and the esthetic sermons of John Ruskin, to whom art was something sacred but at the same time wholesome, like the Sunday roast beef and Yorkshire pudding. I do not want to belittle his influence and I like the man for his kindness to his friends and his generosity to poor artists. (This was a quality in which he was surpassed only by old Turner, who upon his death left the whole of his immense fortune to impecunious British artists—a most pious and laudable legacy which unfortunately never fulfilled its purpose, as his dear relatives went to court about it and got whatever money had not been pocketed by the lawyers.) But anybody who has ever taken the trouble to read the famous encounter between Ruskin and Whistler will remember how terribly restricted this most notorious of all British critics was in his outlook upon the art of his own contemporaries. Yet this was the man who dominated the artistic opinions of the English public for almost half a century. As a result, when some sort of outbreak finally occurred against the hopeless mediocrity of the academicians, the rebels did not ask for new worlds to conquer but contented themselves with a feeble attempt to reconquer a world that no longer existed.

The group responsible for this strange backward revolution called themselves the Pre-Raphaelite Brotherhood. The Brotherhood was founded in the year 1848 and originally consisted of seven young men who solemnly promised each other that they would try to recapture

the spirit that had animated the painters in the days before Raphael and that above all things they would endeavor to bring back those sound ideals of craftsmanship so typical of the Middle Ages. They were terribly serious about their mission and actually succeeded in ridding the England of the fifties of some of the shoddy stuff with which the manufacturers of that day were flooding the country. They lived as simply and unostentatiously as the master craftsmen of the Middle Ages had done. And they not only painted pictures but designed wallpaper and made cartoons for tapestries and they printed beautiful books (which were very hard to read) and they paid a lot of attention to furniture and to textiles and even relearned the difficult art of making stained glass windows.

One of them, William Morris, became the actual founder of that movement which tried to civilize the machine, and for this he should have our everlasting devotion and gratitude. Others, like Dante Gabriel Rossetti (the son of a Neapolitan political exile), slipped into painting via poetry and tried to change the London of 1860 into a replica of the Florence of 1360—a most worthy ambition but one foredoomed to failure. Still others, like Ford Madox Brown, fell in love with Gothic and spent all their days in a haze of *Ivanhoe* and small beer.

Altogether, the whole movement was a little bizarre. Costume balls are very nice but when they are over, we had better go right back home and put the coat of Lorenzo de' Medici, in which we had cut such a swagger figure, back into the moth balls where it belongs. You can, of course, wear it to business next morning but you will always run the risk that some ill-mannered little boy will shout, "Hey, mister! What's the big idea?" And you would be hard put to it to give him an answer.

There are other names I could give you—the moralizing George Frederick Watts and the sweetly sentimental, immensely popular Sir John Millais. But they have nothing to tell us that could possibly teach us anything or even excite our interest. And the same holds true, generally speaking, for the painters of most other countries.

The Hungarian Munkácsy, who tried to do for Holy Writ what David had done for the French Revolution, gained a world reputation which today has been completely forgotten. The Swedes had and have a number of excellent painters but practically all of them were influenced by Paris. They really contributed nothing new until the days of Liljefors and Anders Zorn and it was only recently that the

Stockholm town hall of Ragnar Ostberg became a nucleus for a very lively and interesting development of several of the minor arts.

For a short time, but only a very short time, we thought that salvation might come from the races of central Europe. Arnold Böcklin and Ferdinand Hodler, both of Swiss birth, had imagination and a fine sense for color. When I was young, reproductions of their pictures were to be seen in every European household and we all stood in awe before the *Island of the Dead*. Then they disappeared, never to return.

It was the same story in almost every part of Europe. Something was lacking in most of the painters of that day. They knew their trade but they had nothing to tell that interested anybody for more than a couple of years.

Segantini, the Italian who specialized in mountain scenery, was good in his day (he died in 1899), but we are beginning to forget him. Zubiaurre and Zuloaga in Spain, although quite modern, are rapidly going the way of their fellow countryman, Mariano Fortuny, who in the early seventies was supposed to be the logical heir to another great man by the name of Meissonier.

Not to forget Russia, where desperate efforts were made to found a national school of painting and where some very interesting work was done but work that rarely got rid of the atmosphere of the *Chauve Souris* of amiable memory. For art cannot become inspired by royal or imperial rescript. It either happens or does not happen. The French have a regular academy to encourage the practice of the belles-lettres, but the son of a tubercular little shoemaker in a small Danish village makes the whole world read his fairy stories. Rome is the center for the sculptor's art, but it is the son of an Icelandic wood carver who becomes the great sculptor of the first half of the nineteenth century. You will find them both in the index as H. C. Andersen and Bertel Thorwaldsen.

Yes, such things either happen or they do not. All you can safely say is that they are more likely to happen when there is a need for them than when they are merely a superficial luxury. During the nineteenth century the Muses were taken severely in hand and were told that they ought to be ashamed of themselves as they had never done a stroke of honest work, so would they please get jobs for themselves and become useful citizens. Is it any wonder that their former admirers no longer came around to see them and worship at their feet but hid themselves in all sorts of dark nooks and corners, cursing their luck and drinking away their despair at having lost those most

charming and admirable of friends? And isn't it just possible that if we go on neglecting them for much longer, they may die of sheer loneliness and misery?

For when all is said and done, the ideal of women "living alone and liking it" may be a very practical slogan for those who dwell in the hallowed halls of business, but somehow or other, it never seems to have worked on Mount Parnassus!

# Asylum

*The museum makes its appearance as a most welcome home for the aged
but is in no way fit to act as a place of refuge for the living.*

IN THE OLD DAYS the painting business had been one of "manufacturer to consumer." Those interested in the arts also knew where to find the artist. They visited him and dealt with him directly. The artist put a fair price on his merchandise. The patron was willing to pay a fair price. For art was a vital thing in the lives of most people, as automobiles and motor yachts are today. You don't go to the automobile show to haggle. You know what the price will be of the sort of car you intend to buy. But who today knows the value of a good piece of painting? And so during the nineteenth century a new middleman made his appearance. This was the professional art dealer.

It is a sad and depressing chapter in the history of all the arts, this role played by the dealer or (in the case of the musician) by the agent. For an ability to drive a sharp bargain is not very apt to go with a delicate sense of the finer things of life. There have been a few notable exceptions. There have been both men and women seriously devoted to the well-being of the unfortunate painters or musicians they represented. A very few of them were actually benefactors of these impractical children who entrusted their fortunes to their care. All glory to them and our deepest gratitude, for without them many an artist would have starved to death long before he had gained recognition. But by far the greater number of these middlemen were shopkeepers in the worst possible sense of the word—vulgarians who knew a dollar when they saw one but to whom a picture, like a statue or an old fiddle, was merely a piece of merchandise.

I am familiar with all their alibis—the risks they took and how once upon a time when so-and-so was completely broke they let him have the money to paint a picture (which two years after the artist's death they sold at a thousand per cent profit). I know all their alibis and I also know that the Greeks had a word for them—"Phooey!"

If this sounds bitter, make the best of it!

But in such matters I feel exactly the way Charles Philipon felt when he got Daumier and Gavarni and Gustave Doré together and

561

for almost thirty years fought the battle of the artist vs. a community which thought that it could live by bread and caviar and hoop skirts alone.

Just as today some of the pictures in *The New Yorker* are of great service in exposing the absurdities of our own form of society, so did both *La Caricature* (suppressed in 1835) and *Le Charivari*, which survived until the second year of the Great War, achieve a tremendous success in the bitter warfare upon greed and bigotry. This was partly due to the craftsmanship of Philipon's collaborators and to the profound gift for bitter satire of his chief assistant, Honoré Daumier. But some of the credit should also go to a German by the name of Alois Senefelder.

Senefelder, the son of a German actor in Prague, used to experiment with copperplates, but as a method of engraving these were too expensive and he puttered around with this and that and got no results at all. One day his mother came into the room in which he was grinding his ink. He did this on a slab of Solenhofen stone, a rather oily sort of stone that gets easily polished into a smooth surface. The mother asked her son to write down the laundry list for that week's family wash. He looked for a piece of paper, found none, and hastily scribbled the number of shirts and collars and socks down on his stone. What then gave him the idea of trying to bite this stone as if it were a copper etching plate, he was never able to tell. It was just one of those things. But he made his experiment and it was successful and he found that he could print that laundry list as if it had been an engraving on copper.

Out of this grew the art of lithography. In the beginning (the laundry list was reproduced in the year 1796) he had no idea that his new method of reproduction would ever be of any value to the artist. Senefelder believed that it would cause quite a revolution in the field of music printing, for until then all music had to be engraved on copperplates, a very slow and very expensive process which, as I told you, was responsible for the fact that the musicians of the seventeenth and eighteenth centuries had been able to publish so few of their works. The manufacturers of textiles too found it profitable to use lithography for their printed goods, but in the year 1806, when Munich had become the capital of a kingdom (by the grace of Napoleon rather than by that of God) and when a large number of strangers were visiting the city, Senefelder and his partner, a certain Baron Aretin, decided to make a reproduction of the missal of the Emperor Maximilian, originally drawn by Albrecht Dürer and preserved in

the Royal Library. This proved to be such a popular success in the days before the introduction of photography that soon a number of firms, including the famous old house of Hanfstängl, were engaged in making lithographic copies of all the old classics.

In France the Vernets and Raffet used the new method to popularize the Napoleonic legend, drawing endless pictures of all the events connected with the Grand Army of the Empire. That is the way lithography brought itself to the attention of Daumier and Gavarni when they began to work for *La Caricature* and *Le Charivari*.

While Gavarni specialized in what we might call the lighter vein, Daumier devoted himself to those miserable streets and hovels where the victims of the new order of society had found a most uncomfortable shelter. And while old Goya in his exile was learning the tricks of this new plaything, these two artists made their famous frontal attack upon the existing order of things with such logic and such violence that in spite of occasional imprisonments and fines the government feared them and their *Charivari* more than whole battalions of slum dwellers rushing to the barricades.

Neither of these two great artists grew rich from his labors, for they were the enemies of the only class of people who could afford to pay any money for pictures. And so they were obliged to do what the rest of their contemporaries did—make a living doing potboilers or trying to sell their works to a museum. Now, museums were nothing new. The Greeks had known them as "temples of the Muses" or places where literature and the arts were taught. We, alas, know them as places where many of our modern artists lie buried.

The collecting habit, practiced to a certain extent by the Romans, did not revive until the period of the Renaissance. So many things were suddenly being found that it was quite natural for rich people to try to acquire part of those spoils that they might have them right in their own houses where they could always see them and enjoy them. But almost every collector, then as now, had his particular hobby. This one went in for coins or medals, that one chose Greek vases or Roman busts or Etruscan pottery. Others again were known to buy only old manuscripts or natural curiosities, such as cats with two heads or four-leaved clovers or mandrake roots that looked like little men. In this way quite a number of private collections were made during the sixteenth century but the name "museum" did not come into use until the middle of the seventeenth century.

In the year 1682 a certain Elias Ashmole, an Englishman, had obtained a lot of curiosities from two Dutchmen by the name of

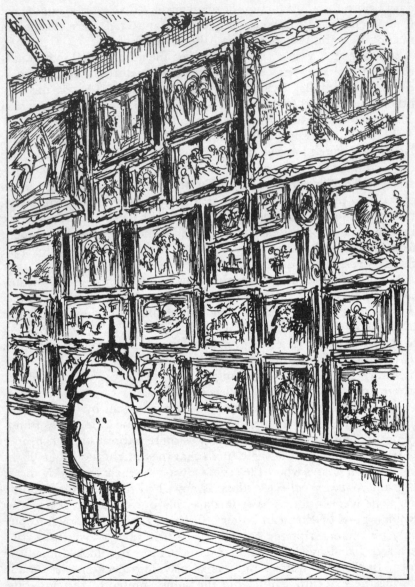

*The old sort of a museum where there was so much that one saw nothing at all*

*The modern museum, having discarded most superfluous rubbish, truly not only reflects the spirit of the times it tries to represent, but gives you a chance to enjoy the beauty of the past.*

Tradescant. The collection was known as Tradescant's Ark. Ashmole presented it to Oxford University where it is still known as the Ashmolean Museum. Some three-quarters of a century later two other large collections were in a similar way united to become the famous British Museum.

But the great craze for museums did not descend upon us until the forties and fifties of the last century. It was during the period when the world became education-conscious and when it was firmly believed that an ability to read and write and do simple sums, if only spread wide and far enough, would settle all our political and economic difficulties.

Since by that time art and life had definitely parted company, the museum became the place where you showed your children the arts, just as you took them to the zoo to see the wild animals. And so on Sundays (after church time) and on holidays, the hapless children were conducted to those vast and dreary halls that were entirely filled with dusty plaster casts of the old Greek Gods and Goddesses and with the less indecent pictures of the old masters, everything neatly labeled and tabulated so that you might know at a glance what school had developed out of what other school and when Giovanni di Cosa had been born in Potto di Vino and when Heinrich Schmalz had entered the studio of Albrecht Kupferstich to learn the engraver's trade.

Since then, I am delighted to say, enormous improvements have been made, not only in the actual architecture and arrangement of our museums but also in the way the different objects are shown. Well exhibited, they can be of the greatest possible value to those who want to make a serious study of painting and sculpture and who therefore ought to be familiar with all the best work that has been done by a previous generation. But at the same time the museum of today is not merely a safe storehouse for the homeless waifs of the past, for everything that has been stolen out of churches and palaces. It also threatens to become a regular receiving vault for the work of a great many people who are still alive and who would starve unless the museums occasionally bought one of their pictures or a bronze or perhaps a few of their etchings.

I know that all this is unavoidable but it really should not be. You probably know what happens to musical instruments that are kept in the glass case of some private collector. These poor fiddles are like pearls that are no longer worn but that are shown in the rooms formerly occupied by Marie Antoinette or Catherine the Great or some

other sovereign who once upon a time was a woman of real flesh and
blood. Such pearls die. I don't know why. Maybe nobody knows.
But unless once in a while they come in contact with a living human
body, they seem to lose their luster. It is the same with fiddles. Un-
less they are regularly played upon (which means that they get soak-
ing wet with the sweat of the master's hand—and do they drip after
a hard evening's work!) they lose their tone. Something goes out of
them. Something goes out of dogs that have been kept too long in a
kennel. Babies will die in a foundling asylum where they are well fed
and well aired and most marvelously taken care of, but where they
arc never fondled by human hands. The foundling asylums have
learned their lesson and kindhearted women therefore come to them
every day and just hold these babies and give the forlorn little crea-
tures the feeling that somebody really wants them.

This may sound a little absurd and perhaps a little too sentimental
but I can never help thinking of such things when I have spent a few
hours in a museum. A *Venus de Milo* or the Elgin marbles, even when
dusted twice a day by the careful *plumeaux* of a couple of old scrub-
women, begin to look like stone corpses. They were created to enjoy
the light of day, to give expression to something which was very much
alive at the time they were made, to be a part of the everyday life of a
Greek community. Now they are merely a number in a catalogue and
profitable subjects for the picture postal cards which the wife of the
concierge sells downstairs.

You might of course argue that if they were not where they are now
they would undoubtedly long since have been destroyed. That is en-
tirely true and it is really quite wonderful that they are so beauti-
fully preserved and are objects of the most tender care on the part of
the Minister of Fine Arts and the director of the museum. And, of
course, nobody would want them restored to those desolate islands
from which they were rescued just before a Turk or a Greek peasant
had decided to use these blocks of marble as a convenient doorstep
for his pigsty or as part of the pavement of a new road. That, of
course, would be utterly absurd. I can, however, end this otherwise
rather depressing chapter on a note of high hope. A new generation
of museum directors has made its appearance—young men of intel-
ligence and taste and understanding, who have realized that art must
be a living thing and has no business in a mausoleum.

I could explain what I mean but I would much rather let you
reach your own conclusions from your personal observations. Go to
one of our really modern museums where everything that is inferior

has been relegated to the basement and where everything that is really good has once more found the background for which it had been created in the first place. We are very apt to make a great fuss about those public benefactors who leave their collections to their home city. My own humble gratitude goes out toward that small group of men who had the courage to break away from an age-old tradition and who have dared to make their museums places of living beauty.

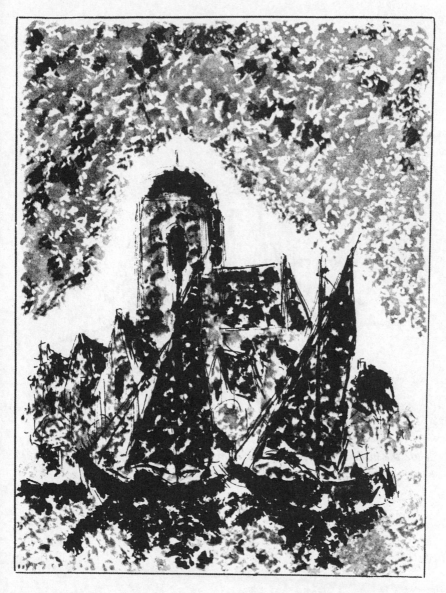

*The impressionists dissolved it into something like this, only they could use more colors than I can and therefore got a more brilliant effect. . .*

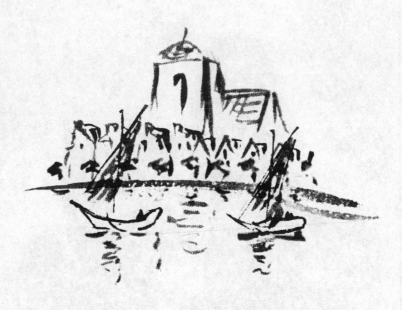

*while the modern realists wasted a minimum of paint and effort, yet obtained
the same general effect.*

# The Music of the Nineteenth Century

*Music captures the ground which the other arts have lost,*
*and bravely holds its own.*

THE CONGRESS OF VIENNA liquidated the affairs of the French Revolution in the year 1815. Napoleon died in 1821. Beethoven followed him to the grave in 1827. Three years later the last of the old-time Bourbons was driven from the French throne. The year before the first railroad for passenger traffic had been opened between Liverpool and Manchester and the enthusiasm for this marvelous new harbinger of progress was now so great that the Prince of Anhalt-Cöthen (a descendant of the employer of Johann Sebastian Bach) was heard to exclaim, "I must have one of those newfangled railroads for my own country, too, even if it should cost me a thousand dollars!"

Factories were everywhere destroying the old craftsmanship. The stock exchange, dealing in industrial securities, was making fortunes for people who did not know whether cotton grew on a tree or was dug out of the soil. In England hoards of little boys and girls were driven down the country lanes, bound for the mines and the factories, just as in a previous generation herds of cows and sheep had followed that same route, bound for the slaughterhouse. Here and there a voice like that of John Ruskin might utter a word of warning that all this was leading to chaos and self-destruction, but only a few sentimental old ladies and very young gentlemen listened. The world was hell-bent for progress and nothing could stop it.

The painters tried their feeble best and were rudely pushed aside. The authors (with a few exceptions like Balzac and Dickens) fled and sought refuge in the contemplation of a happier past. The sculptors starved to death. The architects were engaged in working out plans for ever larger and uglier foundries and mills. The reverend clergy, knowing on which side their bread was buttered, started a diligent search of the Scriptures that they might discover some text that would clearly demonstrate the Lord's approval of everything that was undoubtedly done for the best in the best of all possible worlds. Their kindhearted parishioners lulled their consciences to sleep by bringing

pots of soup and jellied pigs' knuckles to the men and women who had fallen by the roadside in a feeble effort to keep up with the new pace.

It was then that one small group of impractical dreamers stepped forward and created a haven of refuge and boldly engraved this legend above the entrance gate: "Come unto us, all ye that labor and are heavy laden, and we will give you rest."

These impractical dreamers were the musicians. Many of them paid for their rashness with their lives. Others survived only because their skin was tough as the hide of a rhinoceros and they had an almost unlimited capacity for going without food. A few of them actually gained a reputation while they were still alive and were sometimes able to pay their debts. But each and all of them, from Carl Maria von Weber to poor, nearsighted Schubert, who would have been happy if he had been able to qualify as a village schoolmaster—each and all of them contributed to the best of their abilities to provide the world with a convenient way of escaping from an unbearable reality. They sometimes went to strange extremes to achieve their purpose. They were very fond of leprechauns and nymphs and wood sprites and banshees. Weber filled most of his scenes with Puck and Oberon and Titania, and Rubezahl was one of his favorite characters. Having exhausted these pleasant subjects, such men as Meyerbeer (a hardheaded man of business) would betake themselves to the cemetery for their inspiration while others traveled to strange exotic lands, there to find some new materials they could work into their songs and operas.

We ought to give the operas the preference, for the first half of the nineteenth century was still essentially an operatic age. As a rule it was not very good opera. At least, not what we today would call good, for the orchestras were quite indifferent, the choruses were none too reliable, and the singers, both overworked and underpaid, often failed to hit the right note. But this form of art was still very much alive. Unlike painting and architecture and sculpture, it continued to satisfy a very essential need in the lives of thousands of people. As proof whereof I offer the tremendous popularity of so many of the songs that were composed during this period. We no longer recognize them as operatic arias, for they have so successfully incorporated themselves into the general repertoire of the street that we are now apt to mistake them for folk songs. When that happens to a tune, the tune has surely served its purpose.

In Germany three men were chiefly responsible for the romantic form of opera. They were Ludwig Spohr, Carl Maria von Weber,

and Heinrich Marschner. Of these, Spohr, although he left over a hundred and fifty compositions, among them fifteen violin concertos and half a dozen operas, is now chiefly remembered because he wrote a handbook on fiddling out of which four generations of unfortunate children have since been obliged to learn the rudiments of an art that is really much too difficult for the average layman. Marschner has been forgotten except for his *Hans Heiling* (which inspired Wagner to write his *Flying Dutchman*) and his *Vampyr*, which was one of the first of those ghoulish tragedies about ogres and harpies that ever since have been great box-office attractions, whether done in operatic form or as a movie.

Weber, however, is still very popular. Not perhaps in America, but in the matter of the opera we hold a very peculiar position. In our love for size and success, we will only accept the very largest opera house with the very best singers, or nothing at all.

It is a fact well known to all managers that the people in our small towns must have Kreisler or Paderewski or they will refuse to come to the concert. This is sometimes used as an argument to show how sincerely musical we are. I can't see that it proves anything of the sort. It merely shows that we will accept anything a clever promoter is able to talk down our throats with sufficient violence. We have greatly improved since thirty or even twenty years ago but we would be infinitely better off if we had a lot of regular repertory theaters and local symphony orchestras. These would give every boy and girl a chance to hear all of the world's greatest classics at least once or twice during the years they are at school. This is surely preferable to letting them grow up without such knowledge *because* (as we now claim) they must either have the best or nothing at all. The star system has killed the stage. There are hardly any theaters left where a beginner can get a thorough training, because a comedy or tragedy today is merely a financial venture combined with a speculation in real estate. And for lack of such training schools we shall wake up one fine day and discover that we have no more stars left because there were not enough ordinary performers from among whom we could choose our constellation.

It is the same with our opera. We have only one really first-class opera company in America. As a result, every farm hand and every shopgirl who has survived the jury at Fred Allen's amateur show insists upon trying his or her luck at the Metropolitan. Once in a bluish-green moon one of those candidates gets by (if only for a few

weeks) and all the others say to themselves, "Ah, there's where I too
will sing as soon as I have a bit of luck!"

All this makes interesting copy for our Sunday supplements but it
has very little to do with the development of the art of the opera. A
dozen fairly good opera houses spread all over the country would do
infinitely more good in spreading a knowledge of music and a love for
music than six dozen Esthonian and Lithuanian and Turkish prima
donnas and *primi signori* (why not, as long as we have these *prime
donne?*) imported specially for the purpose of giving the audience a

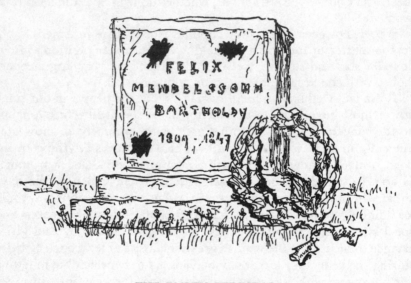

THE EMPTY PEDESTAL

new thrill and receiving salaries that would keep a dozen domestic
opera companies in a fair state of solvency.

As the work of Carl Maria von Weber does not lend itself very well
to the tricks of the box office, it is very unpopular among the man-
agers and is hardly ever heard. This is a great pity, for next to Wagner,
Carl Maria was undoubtedly the best showman of the operatic stage.
Born in 1786 in a village near the city of Lübeck, he belonged to a
family that had seen better days. His father had been a military
officer, his mother an opera singer. His father, more interested in
playing the fiddle than in drilling recruits, had drifted into the
musical business and traveled from town to town conducting or-
chestras or trying to organize new opera companies. In this he some-

how resembled the Mozart family with whom the Webers had several points of contact.

The boy, who was lame like his famous contemporaries, Lord Byron and Talleyrand, got a very thorough training in the elements of music, but as the family was forever on the move he had quite a number of teachers. Michael Haydn, the brother of Joseph, was one of them. So was Abt Vogler, who also trained Meyerbeer. So were all the singers and *Kapellmeister* to whom he listened when he was allowed to attend his father's rehearsals.

The story of his life is easily told. He had to work very hard for a living but unfortunately he still retained many of the ancestral characteristics of the *grand seigneur*, and these, as you well know, cost a lot of money. Furthermore, he was never in good health and, like Byron, suffered terribly from the consciousness of being a cripple. He did not live long enough to reach the full development of his powers but the *Freischütz* and *Oberon* and *Euryanthe* are sufficient to assure him an enduring position in the musical hall of fame.

To show you how difficult it is to decide a man's merit by the popularity he enjoyed during the heyday of his glory, have you ever heard the name of Gasparo Spontini? Not one person in a thousand, even among musicians, remembers who he was. Yet this man was the Toscanini of the Napoleonic era. The Emperor and his wife (especially she) thought he was the greatest musician that had ever lived. The Pope bestowed a title upon him, that of Count of St. Andrea. The King of Prussia asked him to Berlin to conduct the royal opera and gave him the order of *Pour le mérite*. The highest of all German universities, that of Berlin, made him an honorary doctor of music. He had a certain merit as the successor of Gluck and as the founder of a sort of grandiloquent operatic style which was afterwards perfected by Giacomo Meyerbeer, the great French composer who had been born as Jakob Meyer Beer, and who was the son of Herz Beer, the Berlin banker, and his wife, Amalie Wulf. But Spontini's work has been so completely forgotten that you would probably have to ransack the catalogues of a great many second-hand booksellers to find a single copy of his *Olympia* or *Ferdinand Cortez*.

This does not hold true for one of his most dangerous rivals, Gioachino Antonio Rossini. Occasionally we still play his *William Tell* and his *Barber of Seville*, just as now and then we still have a chance to hear *The Daughter of the Regiment* and the *Lucia di Lammermoor* of another popular composer of Rossini's time, Gaetano Donizetti.

But the works of all the Italians of this era are being more and more forgotten because, as I told you in a former chapter, we no longer have any artists who can sing them. The music of Weber, on the other hand, is eminently suited to our modern taste. He lets his instruments explain his dramatic situations. When he wants you to feel that you are all alone in a mighty forest, the oboes and clarinets and the French horns recreate the atmosphere that exists among the silent trees.

Beethoven had tried to do the same thing. But not quite as successfully for he had been obliged to do a little verbal explaining before the public realized that it was being taken for a walk through the meadows and would soon have to rush for shelter to escape the oncoming thunderstorm. In the *Freischütz* and *Oberon* we feel everything that is going to happen before we have actually seen it.

The *Freischütz*, by the way, was first given in Berlin on the sixth anniversary of the battle of Waterloo. By that time Weber realized that he was suffering from tuberculosis. He paid no attention and went on working. Five years later he went to London where he had been promised one thousand pounds for a new opera. On June fifth of the year 1826 his manager found him dead in his bed.

In 1844 his remains were taken to Dresden. Richard Wagner delivered the funeral oration. It is said that he spoke with great eloquence. I don't doubt it. The greatest of all musical showmen was paying homage to his immediate predecessor.

# Das Lied

*For which you can substitute the word "song," but it won't be quite the same*

I WONDERED whether the Oxford Dictionary would give the word *Lied*. It did not. And so I suppose I should not have used it at the head of a chapter. But what other word is there? Song? Yes, but a song is really something quite different from a *Lied*, just as a *Liedersinger* is not at all the same as a singer of songs or a *chansonnier*.

Singing, of course, is one of the oldest forms of musical expression—almost as old as the beating of a drum. But the world had to wait until the end of the eighteenth century before it got any *Lieder*. Like so many other words which we use every day it is very difficult to give an exact definition of a *Lied*. The troubadours, the minnesingers, and the Meistersinger had all of them used their voices as the instrument with which to give expression to their musical emotions, but none of them had ever really sung a *Lied*. The first time we discover something that is a *Lied* in our modern sense of the word is toward the end of the eighteenth century.

During the Renaissance every man or woman of education was supposed to know enough music to sing simple melodies or to play simple tunes on some instrument. Many of the great humanists and reformers were also amateur musicians. Erasmus was trained by the famous Jacob Obrecht of Utrecht who spent a busy life teaching music in every town from Ferrara to Antwerp. Luther played the lute and composed or rearranged a large number of songs. Zwingli, the Swiss reformer, played the lyre. Calvin, of course, neither played nor sang but was known to have expressed a guarded approval of music. The Emperor Maximilian, "the last of the knights," was even believed to be the author of one of the most popular songs of that day, *Innsbruck, I must now leave thee*. It was probably the work of a certain Heinrich Isaak, the director of the imperial chapel, ex-private organist to Lorenzo the Magnificent. But the populace insisted that their beloved Max had written it, thereby showing in what high esteem they held both their music and their Emperor.

But what we call a *Lied* did not make its appearance until during the latter half of the eighteenth century when Johann Adam Hiller, the author of a well-known German *Singspiel,* and Peter Schultz began to use folk songs for their miniature operas, which were much admired and sometimes imitated by no one less than Mozart.

But for once it was Berlin rather than Paris or Vienna which took the lead (no pun intended) in the development of this new form of art. The poets of northern Germany were the first to revive the old *Volkslied,* just as the composers of the north were the first to put them to music.

Goethe was a great admirer of this form of lyrical expression, though he completely failed to understand its musical possibilities. When Schubert sent him his setting for his poem, "Sah' ein Knab' ein Röslein steh'n," the sage of Weimar returned the package to him without a word of thank-you or comment. But it no longer mattered what a mere grand-ducal prime minister felt about these *Lieder.* Haydn and Mozart and Beethoven had taken them under their special protection and that was enough to assure their future.

Then during the early half of the nineteenth century, Robert Schumann, Franz Schubert, and Felix Mendelssohn-Bartholdy (who hereafter in the German edition will be known merely as Herr X.) turned their attention most seriously to the *Lied.* And for the selfsame reason which had made Monteverdi one of the first composers of instrumental music. Good instrumental music was impossible without good instruments. The *Lied* depended for its development upon a suitable instrument with which to accompany the voice. The lute was too difficult. The sound of the violin was too thin. The harpsichord did not have volume enough. Then the piano was invented and the problem was solved.

This most popular of all instruments, like its predecessors the clavichord and the clavicembalo, was a keyboard instrument, but its tone was produced by means of padded hammers which struck a tightly stretched metal string. In the older keyboard instruments the strings were plucked in the same way you still pluck the strings of a mandolin or guitar. Furthermore, the old instruments were not able to vary the volume of sound they produced. The new hammer piano, unlike the old plucked instruments, could play either very loud or very soft. Hence its name when Bartolommeo Cristofori of Florence invented it in the year 1709, the *gravicembalo col piano e forte,* "the clavicembalo that could play both loudly and softly." That

name was too long for practical purposes. It became the *pianoforte*, the "loud and soft." Even that was too complicated. Thereafter it became known as the *piano*. The *forte* was left to the player.

The invention of Cristofori did not exactly sweep everything before it. Another hundred years had to go by before the inner mechanism of the pianoforte was sufficiently simplified to make it an instrument everybody could handle.

The first real improvements were introduced by a certain Stein, an instrument maker of Augsburg. But in Berlin there was an enterprising instrument maker by the name of Silbermann who had more or less stolen Cristofori's idea, and it was Herr Silbermann who manufactured those new pianos which so delighted the honest heart of Johann Sebastian Bach when he was asked to improvise for the benefit of Frederick the Great. Some time after 1775 these Berlin pianos found their way to London and there a certain Broadwood started building them. By now all the great musicians were playing the piano and were expressing their preferences and their dislikes. They either went into raptures over the harder-toned English pianos or they would not touch a key unless they could have the lighter and more elegant pianofortes that were the product of the Viennese school. Mozart was a champion of the Viennese pianoforte. Clementi, the Italian who during the first thirty years of the last century taught all the best families of London their piano (as his contemporary Czerny was teaching those of Vienna), was loud in his praises of the Broadwood variety.

Soon afterwards Érard in Paris began to put a piano on the market that combined the best features of both schools. Since then we can say that Cristofori's invention has penetrated into more homes than even the toothbrush or the automobile. For in the New World, too, a certain Chickering began to build pianos of his own in 1823, and Steinway followed suit in 1853, and since then the number of different makes has run into the dozens.

For the piano successfully solved the problem of the one-man orchestra. Until the days of Schubert, all really satisfactory accompaniments for songs had had to be written for orchestra. The introduction of an instrument that could achieve all the tonal effects of a full-fledged orchestra and at practically no expense, had an incalculable influence upon the development of the song. Schubert and Schumann and Mendelssohn were the first to realize this. Hence their devotion to the German ballad.

## Franz Schubert

Franz Schubert was a poor devil who never had any luck. Meyer-beer and Offenbach, talking between themselves, would undoubtedly have called him a *Schlemiel*, for that is what he was from the day of his birth in 1797 until the day of his death in 1828.

His father was a small-town schoolteacher. There were thirteen other children. Nevertheless, the boy got some sort of musical educa-tion. How and in what manner the people of bygone times managed to give all their children a decent education, whether they had thir-teen of them or one, is one of those things that will probably always remain a mystery, like the smile of the Sphinx. When you compare our own facilities for turning out musicians with those of the days of Bach or Mozart or Schubert, we should graduate at least a dozen Beethovens every year. What we get is nice little girls who want to sing in grand opera and end by reading the comedy lines in a laxa-tive broadcast.

Not only did Papa Schubert teach his little boy the ABC of piano playing but the news spread that somewhere in one of the suburbs there was a child with brilliant musical abilities. Soon the scouts of the imperial and royal court chapel were on his trail and took him to Vienna, as today the football scouts of our leading universities would go after a sixteen-year-old boy who weighed a hundred and fifty pounds and had just brains enough to learn the signals.

Once in the school, young Schubert was given instruction in fiddle playing and composition by the best teachers the Austrian capital could offer, in return for which he was expected to sing in chapel.

But young Franz had seen enough of this world to know that he did not want to be a professional musician. Deciding to play it safe, he became a schoolteacher like his father, so that he would be certain of getting at least two hundred dollars a year by the time he was forty. He must have been a pretty poor sort of teacher, for he never obtained a regular appointment, which shows that there is a Destiny that watches over all human events. Having nothing else to do, he was more or less obliged to devote himself entirely to his compositions and in Franz Peter Schubert the fire of creation burned with such divine brilliancy that very soon the poor weak body was consumed to ashes.

During the years he tried in vain to get his little job as an "assistant teacher" (his hopes were not very high)—that is to say, between 1813 and 1817—he composed not only a number of large orchestral works

but also hundreds of songs, including the ever popular *Erlkönig* and the *Wanderer*. During the next six years he was able to make a few thalers by giving music lessons in the home of the Esterhazy family, a branch of that Esterhazy clan who had befriended Haydn for so many years. This obliged him to move to Hungary where he heard a great many Hungarian folk tunes which he afterwards used with great effect in his own work.

In 1825 he returned to Vienna and during the next three years tried desperately to get a chance to become the conductor of an orchestra. Again, no luck. He was an ungainly little fellow. He wore the wrong kind of clothes. In a city in which graciousness of living was elevated to one of the fine arts, the nearsighted schoolmaster with his rumpled coat and his coarse shoes would never do as the successor of the elegant Salieri. And so Franz Schubert never reached his goal; that "steady living," the final ideal of all the members of his class, an ideal for which they would go through every form of humiliation and hardship, remained forever out of his reach.

On the whole he seems to have resigned himself to his fate. He occasionally got a little money for his *Lieder*. His *Songs from Sir Walter Scott* actually brought him, if I am not mistaken, all of a hundred dollars. He had good and loyal friends who gladly overlooked his social shortcomings when they remembered that this man was, as Liszt called him, "the most poetical musician of all time." Occasionally they provided him with board and lodging. His wants were few —a bed to sleep in, a few sheets of paper, a pen, a bottle of ink, and a bottle of wine. The rest took care of itself, for one song was not finished before the next was on its way. This man was mad with music, as Hokusai, the Japanese, was mad with painting.

Every week from one to a dozen new songs were ready for the publisher (whenever there was a publisher) or ready for his friends (when no publisher had announced himself). In between his *Lieder* he wrote compositions of every sort—works for the piano, works for orchestra, operas, oratorios, quartets, and quintets, some of them finished, others never finished, but more finished in their unfinished state than the finished works of most other people. And six hundred (I repeat, six hundred!) songs, any one of which would have made a smaller man's reputation.

So that after all, his short life was not an unhappy one. Franz Schubert, in his awkward and shy way, was capable of deriving a lot of pleasure from a congenial social party. He delighted in those evenings, the famous *Schubertiaden*, when all the true music lovers of

Vienna came together at the house of Von Schober or Joseph von Spaun and sat around the piano and listened to the bespectacled schoolmaster accompanying his friend Vogl or some other singer who was going with him through his latest compositions. Moritz von Schwind has left us a delightful drawing of such a gathering and we suddenly understand Franz Schubert's nickname. It was "*Kann er 'was?*" or "Does he know something?" Whenever an unknown young musician was brought into the circle, Franz Schubert looked at him from behind his thick glasses and asked, "*Kann er 'was?*" For the honest fellow had only one standard by which to measure his fellowmen. Did they know their jobs?

In November of the year 1828 Franz Schubert was taken ill with typhoid fever. After a short illness he died at the home of his brother Ferdinand. When he arrived at the gate of Heaven, the recording angel took out a brand new goose quill and wrote behind his name, "*Dieser Mann . . . na, der hat 'was gekonnt!*"

### *Robert Schumann*

And now we come to another serious-minded German. His name was Robert Alexander Schumann. He was the son of a publisher. The fact may have given him his literary bent. For during the first twenty years of his life (he was born in 1810) he wrote only novels and essays, although in his leisure moments he also did a little composing. His father recognized his ability and urged him to drop everything to become a musician. His mother dreamed of a respectable career in the law. After the death of his father, his mother had her wish. Robert Schumann studied law in Leipzig and Heidelberg. But at Easter of 1830 he heard Paganini play. After that, the lawbooks were neglected. He too was going to be a great virtuoso.

Trying to make up for lost time, he strained his right hand and it never recovered. A pianist's career, therefore, was closed to him. However, even with one hand one could become a great composer. Schumann started work on his first symphony.

He fell in love with Clara Wieck, the pianist whose interpretations of his works were later to become so well known. The girl's father, Schumann's music teacher, refused his consent. It was bad enough to have a daughter who was a musician. To add a son-in-law in the same business? God forbid! The devoted couple waited a few years, then eloped, and got married anyway, letting Papa rave until he grew tired of it and once more became pleasant.

In the meantime Schumann had founded a magazine, the first

critical journal within the field of music. It was called the *Neue Zeitschrift für Musik*. It boldly championed the cause of several men who were on the verge of being forgotten. Among them were Mozart and Beethoven. The magazine also fought the battles of three others who were then struggling for recognition. Their names were Carl Maria von Weber, Frédéric Chopin, and Hector Berlioz. The magazine was a success. It never quite paid for itself but it was read by all intelligent music lovers and it definitely established Schumann's reputation as a critic.

The University of Jena bestowed an honorary doctor's degree upon him. Leipzig Conservatory offered him a professorship. It was the era when the romantic writers of Germany were in the heyday of their glory. Heine was composing his poems which were so much melody poured into a literary form. Schumann set them free from the bondage of their words. In a single year he composed over a hundred and fifty songs. The strain was too much. He began to suffer from fits of depression. The note A was forever sounding in his ears. All the phobias, since then so neatly classified by our learned psychoanalysts, gave each other rendezvous in the brain of poor Robert Schumann. In the end he could not stand it any longer.

They took him to Düsseldorf for that "change of environment" which is supposed to work miracles when everything else has failed. This time the miracle did not manifest itself. Schumann jumped into the Rhine and tried to drown himself. For now he not merely heard an A sounding in his ears but an entire orchestra. They fished him out of the river and sent him to a private asylum near Bonn. There he lived for another two years. On July twenty-ninth of the year 1856 death delivered him from his sufferings.

His wife survived him for another forty years. I have a recollection —a very vague one and one that may be wrong—that as a boy of ten I heard her play together with Joseph Joachim. I am sure about Joachim, who looked like my grandfather. I am not sure about Clara Schumann. But there must be a great many people who remember hearing her play. She was famous for the way she played Brahms and in his younger years that lonely man had dreamed of asking her to be his wife. But they were never married, which was probably a much better arrangement. Marriages between great artists are apparently not always made in Heaven. They are arranged for in that department of the nether regions where the Devil brews the bitterest of all his diabolical concoctions—professional envy.

### Felix Mendelssohn-Bartholdy

As I write this the newspapers report that the Germans have taken the effigy of Felix Mendelssohn-Bartholdy from its pedestal in front of the Gewandhaus in Leipzig and have melted it, probably to erect a statue to the composer of the *Horst Wessel Lied*. I wish them joy. But now that they have gained that great victory over a dead enemy, let them try something a little more difficult. Let them make a serious attempt to rid the world of the music of the grandson of Moses Mendelssohn, the *Midsummer Night's Dream*, the violin concertos, the *Elijah*, all the other oratorios, the pieces written for the organ, the chamber music, and, above all, the master's *Lieder*. For if ever they can do that, even I will say, "*Heil*, Hitler!"

If ever a man's music reflected his own innate character, it did so in the case of Felix Mendelssohn. A happy, useful, and well-balanced life. A marvelous mother who thoroughly appreciated the genius of the son and daughter to whom she had given birth. A highly intelligent father. Devoted friends. Early and universal recognition. A happy married life with the daughter of a French Huguenot minister. No possible worries about the next month's rent, as the Mendelssohns (although they had been baptized into the Lutheran church) remained connected with a very profitable Jewish countinghouse and did their universally high thinking on a plane of highly civilized living.

Then what caused this fortunate youth to work like a galley slave and burn himself out long before his time? What reason did he have to storm Mount Parnassus with such impetuous courage and so recklessly to defy the jealous Gods?

I think it was his magnificent loyalty to those of his friends to whom fate had been less kind. One of these he had never seen. For old Sebastian Bach had been dead more than half a century when Felix was born in 1809. At that time Hamburg was in French hands. The family, loyal in their devotion to their unfortunate country, refused to remain in a town dominated by a foreign despot. Shortly after the arrival of little Felix they moved to Berlin. Thereafter, although he did a great deal of traveling, Mendelssohn was identified with either Berlin or Leipzig, where he died in the year 1847, the same year in which he lost his sister Fanny, almost as talented as he himself. Indeed, it may well have been the news of her sudden death that gave him the shock from which he never recovered. The bond that

existed between the brother and the sister was so close that when she went he did not have the strength to go on by himself.

I mentioned the nobility of his character. Let me give you one example. This Jewish boy was a firm believer in the medieval code of chivalry which entrusted the protection of the weak and the unfortunate to those better prepared to meet the emergencies of life than they themselves. A moment ago I mentioned the name of Bach. When Mendelssohn was a youngster, even the name of the great Johann Sebastian was no longer remembered by most Germans. Then at the age of twelve young Felix came upon the manuscript score of Bach's *St. Matthew Passion*, one of the treasures of the royal library of Berlin. From sheer excitement he could neither eat nor sleep until his mother promised that she would have the manuscript copied. From this manuscript the first performance of this great oratorio was then given privately in the Mendelssohn home.

That was only the beginning. As long as he lived, Mendelssohn never let an opportunity go by to show his contemporaries the greatness of that humble choirmaster and organist of the church of St. Thomas. He performed a similar service for Schubert, or rather he tried to do so. For when he rehearsed Schubert's C major Symphony in London, the musicians thought the finale so utterly absurd that they could not go on playing. They roared with laughter and refused to take the thing seriously.

He had to console himself for this disappointment with the graciousness of his reception at court. Queen Victoria may have been a little old-fashioned in many of her views, and the Prince Consort may have been a good deal of a marionette, but the royal couple went out of its way to do honor to this young man who had the manners of a *grand seigneur* although it was his own father who had only recently set his fellow Jews free from the bondage of the ghetto.

Mendelssohn was blessed with a most excellent memory. Indeed, he was the first of the virtuosi to play without a score. That practice is now so common that it means nothing to us. When Mendelssohn played the Beethoven Concerto in E flat in London without the music it was first-page news. But during this same visit Mendelssohn played the piano part in one of his own trios. When the moment came to appear upon the stage it was discovered that the piano part had been mislaid. This really did not matter very much as Mendelssohn knew his own part by heart. But he did not want to hurt the feelings of the other two players by doing something which his colleagues might interpret as an attempt to show off. So he quietly reached for the

nearest book on the piano, put it upside down on his stand, and asked a friend to sit by his side and go through the motions of turning the pages. In a world in which most virtuosi have always behaved toward each other as if they were wolves sharing a common cage, this little incident deserves special mention.

It is very fashionable today to smile patiently at old Felix Mendelssohn. To show a slight contempt for his music is the sign of a superior education. Just like saying, "Oh, yes, Tchaikovsky! yes, poor old Tchaikovsky! He probably did his best." Even when it is impossible to deny the greatness of these two men, one can always regret that they were quite so sentimental.

I suppose that there is an answer but I must confess that I do not know it. I could, of course, suggest a suitable reply but I am afraid that it would not be a very nice one. So we had better let it go at that and leave the final judgment to history.

# Paganini and Liszt

### The appearance of the professional virtuoso
### and the emancipation of the artist

THE STAGECOACH was responsible for the appearance of the musical virtuoso. During the Middle Ages there had been wandering minnesingers and troubadours. But they went on foot or on horseback. Their comings and goings were therefore highly uncertain. But even if they had been punctual, there would have been no halls in which to give their performances. They had to sing at a castle or at somebody's private house. That was good enough for the ordinary *Spielmann* but not for the aristocratic gentlemen who then went in for music as their modern counterparts go in for steeplechasing.

Even after the economic conditions of the Continent had improved so far that the merchant could once more wander from place to place with his pack on his back, the musician remained bound to the place of his activity. Some other town or church or cloister might claim his services, in which case he would move from Paris to Florence or from Utrecht to Venice. But the perambulating virtuoso remained stationary until the end of the eighteenth century.

By that time the whole of Europe was covered with a net of stagecoach lines. They ran as regularly as our modern bus lines. They were perhaps a little cold and drafty in winter. But the stagecoach was, on the whole, a convenient and pleasant mode of conveyance and in northern and central Europe one could accept definite dates for a concert with a fair expectation of being there on time. It was, of course, impossible to give eight concerts in six days, as we can do today. However, nobody expected such *tours de force*. One concert a week was enough.

And since the artists were now available, every city had soon a little hall in which public concerts could be given. All that was now needed for complete success was the man endowed with exceptional ability or enough box-office glamour to shake the crowds out of their indifference and put the affair upon a paying basis.

That human element was provided during the first forty years of the nineteenth century. It appeared in the guise of the two gentlemen

whose names appear at the head of this chapter—Niccolò Paganini and Franz Liszt.

There exists an innermost belief among musical beginners that if they are only good enough and work hard and faithfully they will eventually be able to draw large crowds and break the records of Jenny Lind or Paderewski. I hate to upset the faith of the younger generation in the inevitable triumph of good intentions. Far be it from me to let them suspect, even for a moment, that anything can be accomplished in this world without a tremendous amount of hard work and a great deal of natural talent. But the history of the concert stage of the last hundred years seems to indicate that those qualities alone are not enough. One other element is just as necessary. It is not luck, though a little bit of good luck should never be despised. But what is needed for an overwhelming success is a combination of legitimate showmanship with a dash of what the Germans used to call *Bühnentalent*. It is not easy to give the exact translation of that word. "Talent for the stage" is a little too weak. It really means ability to put it over, that mysterious something that establishes an immediate contact between the public in the house and the artist at the other side of the footlights.

This *Bühnentalent* is something different in the case of every performer. It should not be identified with that streak of charlatanism or quackery that contributed so greatly to the world-wide reputation of Paganini. For Liszt, who was quite as famous as the Italian fiddler, never stooped to any of the tricks of his Italian contemporary, but he was even more of a popular hero.

How did they do it? It is very hard to say. How did Jenny Lind do it, whose voice (judging by all descriptions) was no better than many of those we hear at our Metropolitan today? How has Paderewski done it, who at the age of seventy-seven can still fill Carnegie Hall with delirious crowds of admiring worshipers?

Paderewski, of course, is a natural-born showman. He had a tremendous build-up by his piano manufacturers before he came to America for the first time, and as a professional Polish patriot he has, for more than half a century, been constantly in the public eye. But Fritz Kreisler is the personification of unassuming simplicity and he too can dispense with any advance notices about his forthcoming performances. A little announcement in the papers is all that is needed. Jan Kubelik was a mighty fiddler and a great artist. But he was not able to maintain his hold upon the public. Mere publicity will get an artist nowhere. It is a waste of time and money. It may give him a

moment's notoriety, like that of a Channel swimmer or a marathon racer. But such reputations are like a bonfire on ice. While it burns it makes a tremendous flame which is seen for miles around. The moment it collapses, it leaves behind an almost tangible darkness.

People with more knowledge of the subject than I possess have pondered it deeply and seriously, for it often means dollars in their pockets. They have got nowhere. Some of them are inclined to leave it to the good Lord. "He has either given one that rare gift of putting it across or he has not," they remark and ask no further questions. But that answer does not entirely cover the case, for a clever stage manager (and a few musical agents have also been exceedingly clever stage managers) knows how to assist the good Lord just sufficiently to make his client's performance a success.

Then what is it that they do? Hollywood can provide us with an answer. They are able to surround their virtuosi with a nimbus of glamour. They have, by some mysterious psychological sleight of hand, planted the seed of curiosity in the minds of so many millions of potential customers that the public is compelled to rush to the box-office and find out for itself or burst. This may sound very harsh and very brutal but I can't help it. For that, I suspect, is the secret which accounts for the final "appeal" of almost all our great concert pianists and fiddlers and all our great singers.

Jenny Lind appealed to her audiences because it was known that she was not only a very good singer but also an excellent and faithful Swedish housewife. That was her particular sort of glamour. But Sarah Bernhardt filled tents and theaters wherever she went, though nobody dreamed of associating her with any of the domestic virtues. As I write this they are burying good old Schumann-Heink. Well, the old lady would surely have agreed with me that there were better singers than she. But she was a cheerful soul with a tremendous lust for life and when she found herself placed in a most difficult and tragic position, she rose nobly above all her tribulations and thereby conquered the hearts of all her hearers.

I need not go any further. All of my readers will remember cases like it. And they will recollect that invariably it was some little bit of extra glamour that made it unnecessary to paper the house.

Glamour, according to the dictionary, means "a magical or fictitious beauty attached to any person or object—a delusion or alluring charm." Actual physical beauty has nothing to do with it. Tremendous intellectual ability is not in the least necessary. Absolute

mastery of the instrument is, of course, a *sine qua non*. Hard work and an infinite willingness to take infinite pains are also indispensable. But over and beyond this, there must be the gift of magic—the ability to make people feel that there is more there than they can see or hear

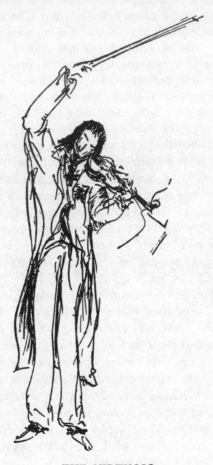

THE VIRTUOSO

—something that keeps them curious and interested and makes them look for an answer without ever being able to find it.

Paganini and Liszt! During the thirties and forties and fifties these two men filled as much newspaper space as the Hitlers and Mussolinis of today. When they arrived in a town to give a concert, a public holiday was declared. The horses were taken out of their carriages

and the delighted populace dragged them to their hotels where they appeared on the balconies to receive the plaudits of the multitude.

Of Paganini's playing we know only by hearsay but there are still a great many people among us who have heard Liszt. They all agree that even in his old age he had a phenomenal technical ability. Technical ability is something almost anybody can acquire but also there was his "tone," and it is the memory of Liszt's "touch"—of his "tone" —that has survived throughout these many years. Our present-day technique is undoubtedly better. Mechanically our pianos have made enormous improvements. But whether anybody will ever again have the Liszt touch—that is a question which now can never be answered. We can only wonder.

As for Paganini, we know that he too did not merely stupefy his audiences by his amazing staccatos and his left-handed pizzicatos. The *scordatura* of which he was guilty was nothing new. Other fiddlers and guitar players before him had tuned their instruments higher or lower than the regular concert pitch and had thereby been able to achieve strange effects which baffled the layman. His *pièce de résistance* of cutting three strings of his Guarnerius and then playing the rest of the piece on one string had been anticipated almost a century before by Bach and by others who had composed arias for a single string. Such rather contemptible devices as making his appearance on the stage by means of a contraption ordinarily used to make the Devil arise from the graveyard—even these would have failed to persuade some of his more serious listeners that he was by far the greatest violin virtuoso the world had ever heard or was likely to hear in the future.

Being a greedy and rapacious creature who as a confirmed and unlucky gambler needed large sums of money for his baccarat, he was not averse to any sort of publicity that could possibly increase the air of mystery with which he had been surrounded all his life. In his typically Latin fear of being cheated, he was always present in the box office while the tickets for his next performance were being sold. The moment the concert was over, he disappeared from view. A drab room in a hotel, and perhaps a little game of cards, and early the next morning off to another town, watching every penny so that when he died he would be able to leave a fortune to the son whose mother was the famous dancer, Antonia Bianchi.

The public at large was ignorant of this austere side of his private life. Besides, it would not have interested them. It was too common-

place. Popular belief insisted that the child's mother was no other than that noble lady with whom the fiddler had spent four mysterious years in a lonely castle in Tuscany and whom in a fit of anger he had strangled to death. There also was a rumor that he had killed his mother, and those who knew for sure that this was true added that as a result of his crime he had been cast into a dungeon and there had learned to play marvelously on one string because he had had no others.

All these stories were so much moonshine. Had they been true, Paganini would hardly have enjoyed the friendship of the Pope and most certainly would not have been ennobled by His Holiness. Nor would an ex-murderer have found such great favor in the eyes of Napoleon's sister Elisa, who as Duchess of Lucca had to keep up at least some pretense of respectability. But it brought in the crowds and it made Paganini rich. A strange person! After all his triumphant concert tours, he ruined himself trying to open a gambling house in Paris. The blow—the refusal of the police to give him a license—hastened his end. For years he had suffered from tuberculosis. In 1840 the disease killed him.

At that moment Franz Liszt was twenty-nine years old. Nine years before he had heard Paganini play in Paris. The performance made such a deep impression on him that he vowed to try to do for the piano what the Italian had done for the violin. It shows that Paganini, with all his cheap juggling, must nevertheless have been a very sound musician, for Franz Liszt was recognized as the greatest of all living pianists, and Liszt himself was too thoroughly familiar with all the tricks of the concert trade to have tumbled for a mere humbug. In every other respect the two men had absolutely nothing in common. Paganini was the born charlatan while Liszt was a *grand seigneur* by the grace of God and by his own devotion to the noble task of making the artist not only a useful but also a highly respected member of society.

Aside from all he did for the development of the technique of the piano and aside from his own compositions (which deserve a great deal more respect than they often get nowadays), Liszt was a truly great man who deserves the everlasting gratitude of all musicians for the way in which he fought for the honor of the artistic profession.

There had, of course, been exceptions to the rule that an artist could not be a gentleman. There had been painters who enjoyed the friendship of kings and there had been sovereigns who were happy to count playwrights and musicians among their personal friends. But until then the position of the artist had always remained rather pain-

fully uncertain. He had been the Greek at the court of the Roman emperor, the juggler in the palace of the sultan. Now do us a few handsprings or sing a song or tell us a funny story or do a couple of card tricks, but amuse us, damn your soul, amuse us, for that is what we pay you for!

The troubadour, belonging to the ruling class of society, was treated like a gentleman, but the troubadour's accompanist, his lute player or his fiddler, dined with the servants and came in and out by the kitchen door. During the seventeenth century a man like Bach could still be made to eat humble pie by a deacon of a Lutheran church. A Rembrandt could be forced to dun a Prince of Orange like a poor fishmonger asking for a little something on account of last month's bill. When a Louis XIV allowed a Molière to sit down in his presence, the court talked about it for the next fifty years.

It is said that in the old South the average planter treated his house slaves with a great deal of kindness and forbearance. I do not for a moment doubt it. But I also realize that if the owner happened to be a scoundrel he could order old black Joe to be tied to a tree and given fifty lashes. And because old black Joe knew this, he was never quite at his ease, even when he was being well treated. The average musician up to the days of Liszt was very much like old black Joe. As long as he worked for the Esterhazys, he had no reason for complaint. But he might also be obliged to work for the Archbishop of Salzburg. What then happened, you will remember from the story of Mozart.

It would take me too long to tell you in detail how Liszt succeeded in bringing about this change. He was, of course, a very fine musician. But his own life was really his greatest work of art. It will be remembered long after his music is forgotten.

Franz Liszt was born in the Hungarian village of Raiding, where his father managed the estate of one of the members of that Esterhazy family whose name is forever cropping up in the musical history of the time. The father was a Hungarian but the mother was an Austrian of German ancestry. As children in countries with mixed populations and languages invariably adopt their mothers' language, little Ferencz became Franz and went through life as a German rather than a Hungarian. He spoke the language of his native land a little. He never wrote it until late in life when his compatriots had turned him into the living symbol of their national greatness.

The point is not without interest, for although he was born a

Hungarian and brought up in a decidedly Teutonic milieu, it is difficult to associate Franz Liszt with any definite group of people. Like Goethe before him, he was a good European, willing to extend a friendly and helping hand to everyone in whom he recognized a spark of genius. As a result he influenced the lives of almost all his younger contemporaries. During his younger years he boldly put the compositions of Beethoven and Weber on his programs, although nobody wanted to hear them. And before he died he was recognized as one of the most valiant champions of Richard Wagner. For good measure he was also a stanch supporter of both Chopin and Berlioz and during the many years he was conductor of the grand-ducal orchestra in Weimar, he not only made that little German city the center of Europe's musical life but also the Mecca for all those ambitious young composers who felt that they had something to say, but who could find nobody willing to give them a chance.

If he had been an ordinary human being, we would feel that his life was full of incongruities. In the year 1835 he came to the conclusion (enthusiastically encouraged by the lady herself) that life was no longer possible without the constant companionship of the striking Countess d'Agoult, a lady who not only wrote books (very dull ones) under the name of Daniel Stern, but who also had a salon of her own where the whole of literary, musical, and artistic Paris used to gather to hear Heine recite his poems and Chopin play his nocturnes and waltzes. But of all places in the world he took the lady of his heart to Geneva, the home town of John Calvin, and the last city in the world where an artist would feel at ease.

There the Countess during the course of the next few years presented him with three children. One of these was to play quite a role in the musical history of the next seventy years. She not only resembled her mother in the brilliancy of her mind but also in her gift for being a most devastating shrew. Her name was Cosima. In 1857 she married her father's best beloved pupil, Hans von Bülow. He had begun his career as a pianist but developed into one of the great conductors of his time—"the best since Beethoven," as those who had heard both of them used to say. In that capacity Von Bülow rendered most valuable services to the cause of Richard Wagner when that great master began his forty years' war for recognition. Wagner was deeply grateful and showed his appreciation in truly Wagnerian style. He stole his friend's wife and in that manner became the son-in-law of the great Liszt.

After a few years the Countess, who was the living counterpart of her dear little Cosima, began to get most terribly on her lover's

nerves and in the year 1840 the two bade farewell to each other for all time. Liszt returned to the concert stage while the Countess found consolation in writing a bitter book of personal memories and recollections. When the book failed to interest people, she turned radical and became the head of a revolutionary salon in Paris. Her second daughter, Blandine, married Émile Ollivier, the minister of Napoleon III most directly responsible for the outbreak of the disastrous Franco-Prussian War.

Liszt, as you will probably have begun to suspect, was a man of parts. Whatever he touched, whether women or music, immediately acquired a certain radiation. Other men may have had the evil eye but "ce monsieur Lits," as the French used to call him, had the "glamorous eye." Other men must hammer away at the piano for three long hours before they can convince their audience that they are great musicians. Liszt merely appeared on the stage and smiled at his audience and they swooned away in pure delight. But they came back to life the moment he touched the keys, for his tone was like velvet.

Modern critics complain that his own compositions are rather shallow and that they lack depth. They either explain this or try to excuse it by pointing to the almost unbelievable strain upon the poor man's time, forever traveling from one town to the next, forever giving away all the money he had made to some poor deserving student, forever composing works of his own, forever arranging the works of others for the piano or the orchestra, forever answering barrels of letters, forever attending dinners and receptions, forever giving benefit performances for charitable purposes, and yet finding time to pay minute attention to his duties as a devout Catholic.

Liszt must have inherited a cast-iron constitution to be able to keep up the pace and yet reach the ripe old age of seventy-five. Other men would have been more than satisfied with just one Madame d'Agoult. But in the year 1848 Liszt fell into the clutches of yet another woman. This time it was someone who belonged to the class of people sometimes described as "strong characters." She was the wife of the Russian prince, Sayn-Wittgenstein. Thirteen long years Liszt spent with her in the little town of Weimar where (so the police reports show) the minor officials were duly shocked by this highly unorthodox arrangement but were powerless. They could not very well proceed against a private citizen whose waiting room was forever filled with half a dozen Imperial, Royal, or Serene Highnesses and whose letters to the reigning Grand Duke were such masterpieces of tact and diplomacy that even the slightest criticism of the Master's

private conduct would have been considered a very decided breach
of good form. The Russian court might express its disapproval, but
one letter from famous Franz Liszt and the sovereign state of Weimar
was ready to mobilize its entire army to defy the Muscovite hordes.

Those who are interested in genealogical matters might note that
by this time Franz Liszt had become Franz von Liszt. But with a
typical Lisztian gesture of "keep the change, my good man," he
handed the title over to a cousin who seemed to need it more than he
did. For what did an Imperial and Royal Apostolic patent of no-
bility mean to a man on whose passport the authorities had written:
"No personal description is necessary as the bearer of this document
is already known to all the world." Yes, upon occasions this simple
Hungarian child was more than a match for the haughty Austrian
and Hungarian magnates who felt that they must show him his place.

Upon one memorable occasion when Hungary was celebrating the
thousandth year of some famous victory over the Turks in which the
brave Magyars had saved the civilization of Europe (they were al-
ways doing it) Liszt was asked to compose the necessary music. He
did so. He came to Budapest with a boatload of musicians and singers,
specially trained by him for the occasion. In the evening a banquet
was given at the imperial palace. Every nobleman hastened to Buda-
pest to do homage to the common sovereign. The artist alone was not
invited. Did he feel slighted? Of course not. During the concert he
was just as affable as ever but when the evening of the imperial
banquet arrived, he arranged a party of his own on board the ship
that had carried him to the Hungarian capital. And there he dined
surrounded by his "fellow workers"—the fiddlers and singers and the
bassoon players.

Yes, it was dangerous to try to put this son of a former land agent
in his place. For he never lost his temper. He was always completely
in command of the situation and in this way was able to maintain his
exalted position to the end of his days.

During the latter part of his life he almost completely withdrew
from the concert stage. Gone were the years when he was continually
traveling from one end of the world to the other in open rivalry with
Sigismund Thalberg and when whole countries were divided into
bitterly hostile camps—the adherents of Liszt and the followers of
the nimble-fingered Thalberg—the only musician born in Switzerland
who ever made a world-wide reputation as a virtuoso. At the same time
he was beginning to grow tired of his fame. He had reaped enough
glory to satisfy the ambitions of a hundred ordinary human beings. In
the end, even the faithful (too faithful) Princess Sayn-Wittgenstein

began to pall upon him. At fifty it is no longer so pleasant to be told to wear your rubbers when it rains and please not to drink more than two cognacs after dinner, for that is bad for your digestion. Liszt therefore hinted at a separation, for as the Princess was now free to marry her commoner, he had to act quickly or be caught forever.

The difficulty was solved in a typically Austrian manner. Cardinal Hohenlohe (who for family reasons was strongly opposed to the match) arranged to have the musician ordained—very quietly and very unobtrusively but also very effectively. The Abbé Liszt, a man in holy orders, was now put apart from all further temptation. He remained the devoted spiritual friend of the good Princess, but there never was any more talk of a marriage.

For almost thirty years Europe was treated to the strange sight of a handsome elderly gentleman in clerical garb who divided his time between Rome and Weimar and Budapest, giving lessons to all those who deserved his attention but doing it for the love of the thing and never charging a penny for his labors.

As for his compositions, you can hear them so abundantly that I shall not offer any criticism. Make up your own minds, for that is all that counts. But it will be well for our modern musicians to remember what they owe to Franz Liszt. By sheer force of character he broke down the prejudices which for so many centuries had condemned the artists to live in a sort of social ghetto of their own, together with the acrobats and the trained seals and the other circus performers.

Beethoven in his crude and bumptious way had felt something of the sort when he refused to lift his hat to a visiting king whom he met on one of his walks through Vienna. "Am I not a king in my own way?" he had asked in a contemptuous tone of voice. No harm had come to him on account of this lack of good manners, for he was Beethoven, the old grouch, but the greatest genius of his age. Franz Liszt never refused to doff his hat to any man. But something in his general approach made the other man doff his hat first and with a suave gesture of extreme urbanity. Beethoven, the complete revolutionist, was always shouting, "Hey, you there! I am just as good as anybody else and don't you forget it!" Franz Liszt quietly assumed that this point had been settled long before and, having in this way deprived his opponents of their most powerful weapon, he was able to reduce the issue to an encounter in which talent was substituted for rapiers and in which genius took the place of genealogy.

Franz Liszt died in the year 1886. There never has been anyone like him. Almost, but never quite!

# Berlioz

*The beginning of our modern "popular music"*

PROGRAM MUSIC today threatens to become a form of musical enter-
tainment in which the printed program is vastly more important
than the music. For every bar we shall soon have two paragraphs of
solid literary explanation and for every eight minutes of an aerial sym-
phony we shall have to listen to nine minutes of verbal commentary.

Program music as such is no invention of recent date. The attempt
to let music unaccompanied by words give expression to nonmusical
ideas can be traced back to the middle of the sixteenth century.
Kuhnau's attempt to recreate the battle between David and Goliath
in terms of pure sound is perhaps the best example of what the seven-
teenth century could do along this line. His predecessor Sweelinck,
the Dutch organist, specialized in very realistic thunderstorms and
one of his colleagues was quite confident that by means of his arpeg-
gios on the same instrument he could make his audience visualize
Christ's ascent to Heaven.

The less violent composers of the age of the Rococo went in for
cuckoos and nightingales and the other beasts of the fields that made
funny little noises. Beethoven added babbling brooks and hailstorms
followed by rainbows.

When Napoleon rudely disturbed this earthly paradise, habitation
of the merry shepherds and shepherdesses of Jean Jacques Rousseau,
these unfortunate nymphs and their gentlemen friends betook them-
selves to the nearest woods and left the field of experimental music to
the rumbling noise of the imperial battalions and batteries. There
was an instant demand for battle scenes and the musicians hastened
to make a profit while the guns were roaring.

During the Congress of Vienna when the fine flower of European
diplomacy and aristocracy gathered in the Austrian capital, Bee-
thoven conducted a concert for the benefit of some five thousand
visitors. Did he play his "Eroica" or his "Pastoral" Symphony? Of
course not. The audience would never have understood them. What
he did play was his *Battle of Vittoria*, a tonal description of that famous
encounter in which Lord Wellington had so gloriously defeated Jour-

dan and the armies of Joseph Bonaparte, King of Spain. It was a tremendous success. It must have sounded a little like those performances of Tchaikovsky's "1812" Overture which I used to hear in Russia in the old imperial days when a battery of field pieces used to be fired all through the final part to accentuate the strains of the national anthem.

But tricks were the order of the day before some learned professor discovered that the purpose of music was to educate rather than entertain. And I sometimes wonder that conductors are still allowed to have a second trumpeter in the artists' room when they play the "Leonora" Overture, for such things are really not very dignified.

In view of the fact that the warfare between "pure music" and "program music" has now gone on for almost four centuries and has not yet led to any decisive victory for either side, I shall very carefully leave that problem alone. The discussion would be as futile as our endless and acrimonious debates upon the merits or the lack of merits of the different modern isms in painting—postimpressionism, surrealism, dadaism, futurism, and the rest of them. Some of them are probably good and more of them are undoubtedly bad. When a great master like Cézanne or Picasso prefers to paint that way, whatever he does will at least have a technical quality that gives it a certain distinction. When some incompetent little fool tries to do the same thing, the result is vile. When Richard Strauss tells me by means of his score what happened to Electra or gives me a tonal account of his ideas about death and transfiguration, I can follow him and I think that I know what he is trying to convey. Others who shall be nameless only make me look for the nearest exit and run, not walk. Even the *Don Quixote* of the great Richard Strauss has always remained a puzzle to me, which of course proves nothing, for I may grow up to it.

It is the same with humor in music. When Strauss or Mozart are funny, they are very funny to me and I enjoy their clowning immensely. The music of other composers who try to imitate *The Magic Flute* and *Tyl Eulenspiegel* only proves that they have not yet learned how to handle their material and should therefore leave humor alone. Better start out with tragedy. It is much easier.

Today we have a vast quantity of program music at our disposal. It runs all the way from Buxtehude's attempt to describe the "nature and character of the planets" via the organ to Debussy's far more successful experiment with the famous faun of his equally famous afternoon. Most of this music I sincerely believe would much better serve

its purpose if our commentators would only let the music do its own explaining. For if the music is really good, it does not need any outside assistance and if it is bad, why listen to it? When I eat mince pie I do not at the same time have to read a cookbook to tell me, spoonful by spoonful, how it was made. Then why do it for Respighi's *Fountains of Rome* or Schönberg's *Night Transfigured*?

All of which has here been mentioned as a suitable introduction to Monsieur Hector Berlioz, an eminent guitar player, the librarian of the Paris Conservatory, and also a composer who did so much for the development of this sort of music that he is often given credit for being the papa of all program music. Like kindly old Giuseppe Verdi, the greatest of all modern Italian operatic composers, Berlioz has suffered from the fact that during part of his life he was a contemporary of Richard Wagner. Wagner's ability was so colossal, so phenomenal, so behemothian (to give you all the polysyllabled Hollywood words of which I can think at the moment) that nobody had much of a chance to make himself heard while the *Götterdämmerung* din was going on. Furthermore, the self-assertive arrogance and the meanness of spirit of Richard Wagner were so supercolossal, so superphenomenal, and so super-superbehemothian that it was impossible for anybody else to have a chance, regardless of his merits. Wagner, who howled like holy murder whenever he himself was slighted, would have trampled upon the poor rival with all the wicked violence of his plebeian boots until the enemy was completely crushed. All the same, Berlioz, like the hapless Verdi, was really a very great musician whose work has stoutly maintained itself on our modern programs.

In contrast to Liszt, who learned so much from him, Berlioz' life was neither happy nor easy. His father, a country doctor, did not want his son to study music. As the son did not want to study medicine, he left home and shifted for himself as best he could, which I am afraid was none too good. But Paris has one enormous advantage over all other capital cities. It not only allows you to spend a million a week if you feel thus inclined, but it also lets you live on twenty cents a day if you only have twenty cents.

In the year 1830 Berlioz, then in his twenty-seventh year, won the Prix de Rome with a cantata composed on a poem written by his hero Lord Byron. *The Death of Sardanapalus* promised to solve his eating and sleeping problem for three whole years. But before two years were over the young student asked permission to return to his native land. Like all good Frenchmen he could not live without his Boulevards.

His case of homesickness was aggravated by his passion for an Irish actress, Henrietta Smithson, who was then in the French capital giving a series of Shakespearean plays. Berlioz was one of those persons born to be unlucky. He wooed the lady and he won her. They were married in 1833. But almost immediately the lovely dream of both of them contributing to the household expenses came to an end when Madame Berlioz had an accident which forced her to retire from the stage. Meanwhile her husband had written his *Episodes from the Life of an Artist*, which Paganini kindly publicized as one of the greatest works of art of all times, even better than his own *Carnival of Venice*. The public did not agree, and Berlioz (like Debussy after him) was obliged to make a living writing musical criticisms. He stuck to his irritating employment for twenty-six years and meanwhile composed the greatest of all his romantic works, his *Harold in Italy*, his *Romeo and Juliet*, his opera *Benvenuto Cellini*, and his *Requiem* in memory of the French soldiers who had recently been killed while conquering Algeria.

In 1840 he got rid of his beloved Henrietta and in the same year Germany discovered him. Robert Schumann became his champion in his *Neue Zeitschrift für Musik*, and as a result the Frenchman was invited to conduct his works in Vienna and Berlin and London and St. Petersburg. When he tried his luck with his *Damnation of Faust* in Paris, his compatriots merely laughed loudly but not at all politely. But the ever generous Franz Liszt himself extended a protecting hand to the master to whom he owed so much, and his *Childhood of Christ* was first performed at Weimar by that orchestra of only thirty-six men, the largest number of musicians the court of Weimar was ever able to place at the disposal of its famous *Kapellmeister*.

Today a third-rate radio station would feel ashamed of itself if it could not do better than that. But in the year 1850 that was all a small German court could afford to spend. When you realize, however, that a duchy like Weimar was not much larger than a middle-sized American county, these thirty-six men loom very large. What these tiny independent principalities of Germany did for the cause of music and of the theater during the first half of the nineteenth century deserves our fullest admiration and gratitude. To have played with Liszt at Weimar became a badge of honor just as some fifty years later it gave you a great deal of distinction to have acted in the theater of the Duke of Saxe-Meiningen. There were larger orchestras and larger theaters in the bigger cities. But there was no more intensive training than that which the beginner could get in one of those small

organizations. And the old adage, "Take care of the apprentices and the master craftsmen will take care of themselves," is a useful slogan, not only when applied to science but also in connection with the arts.

Why Berlioz should have had such a difficult struggle has never been quite clear to me. He had a great many ardent admirers and several powerful friends who pushed his work on every possible opportunity. He was not as badly off as César Franck, who was obliged to wait until a few years before his death before he could hear some of his greatest compositions played by the Paris orchestras, but just the same he had to overcome a great deal of opposition. In the case of Wagner we can understand this hostility, as he made enemies as easily as he wrote the score for a military march. Berlioz seems to have been a man of courteous and agreeable approach. His colleagues held him in high esteem and they were as generous toward him as he was generous toward their work. But he lived and died a sad and lonely man and soon he became a myth. Yet he is not really so very far removed from us. For in his later years he had a chance to marry Adelina Patti, and Patti was still singing for charity during the beginning of the Great War and died only a few years ago.

Perhaps he was born a little too late. He still belonged wholeheartedly to the romantic period. His music is full of masked strangers who abduct beautiful young princesses on dark, though moonlit, nights and take them away from their ancestral palaces in gondolas that slide noiselessly across the Venetian lagoons. It is all magnificently done but it smacks a wee bit too much of the poetry of Lord Byron. And therefore his music is as strange to our modern ears as the poetry of the hero of Missolonghi.

The dark handsome milord with the slight limp, an income of a million pounds a year, a private deer park covering two thousand acres, and a broken heart because he can't win the love of the one woman he wants, is gone. His place has been taken by the professor of economics who has a wife and two nice kiddies, who lives decently in a two-story house in one of the less expensive suburbs and is working on a new theory about the true nature of money. Why should this eminently practical member of society care whether Faust went to Hell or not? And as for Gretchen, if ever he gives her a thought, he will say, "She was a silly fool who got what she deserved." And then he will go back to solve the economic ills of our world.

As for myself, I am glad to say that I can still enjoy the Berlioz sort
'c. But then, I am so old that I remember the days when pro-

*In the middle ages the architects were forced to go up into the air for the sake of safety—for political reasons.*

*Today the architects are forced to build skyward for reasons of economic necessity.*

gram music was played without any literary comment and when the *Roman Carnival* was not explained to us by some such cryptic remark as this: "The scene is laid in Rome. Rome is the capital of Italy. It is carnival time. Carnival is a combination of two Latin words, meaning, etc., etc., etc."

# Daguerre

*The painter encounters a formidable rival in
Monsieur Daguerre's "heliographic pictures."*

THIS IS A STRANGE INTERRUPTION of the musical deluge which threatens to carry us completely away from the field of the graphic arts, but a very natural one. For when we reach the era of Berlioz and Liszt and Verdi we no longer depend upon anonymous oil portraits and stereotype copper engravings to help us out when we ask ourselves, "What sort of men were these mighty heroes of the keyboard and the composer's goose quill?"

A few elegant gentlemen like Christoph Willibald, Ritter von Gluck, could afford to have their pictures painted by a contemporary master of repute, just as Chopin, on account of his being a social success, could allow himself to be depicted by Eugène Delacroix. But the others, poor music teachers with a wife and a dozen children and six hundred dollars a year, were not able to go in for such unnecessary luxuries. At best, some traveling professor who did your face in half an hour and who went from country fair to country fair may have left us a portrait of the great man. This subsequently was stored away in the attic and not brought back to life until a hundred years later when the great-great-great-grandchildren discovered what a famous man their great-great-great-grandfather had been and decided to cash in on his reputation.

These honest peddlers of the palette were peacefully plying their trade when all of a sudden they were frightened out of their shabby boots by the news that a Frenchman had perfected a system by which you could now "take" a man's picture by means of a mechanical and chemical appliance instead of making it by means of paint. That was during the year 1839. Ever since 1814 another Frenchman by the frightful name of J. Nicéphore Niepce had been experimenting with all sorts of chemical solutions in an effort to capture faces and trees and scenery and "hold them in permanency," as people used to say. These experiments led to the invention of the diorama, a great popular success in all the European capitals of the early eighteen-

twenties and which was just as exciting to the people of that day as the movies were to us forty years ago.

Niepce never got as far as he hoped. The honor of having made the first actual photograph was left to his colleague, Louis Jacques Mandé Daguerre, a painter by profession and interested in chemistry because he hoped that it would help him reduce the cost of portrait painting by means of a few purely mechanical short-cuts.

Ever since the days of Daguerre people have been arguing about the exact status of photography. Is it an art or is it not? Of course it is an art, and some day very soon it may even become a great art.

It is interesting to observe that just as in the case of oil painting, the earliest photographers were also the greatest. There seems to be very little connection between the two but, as a matter of fact, they have many points of resemblance. The Van Eycks and the other great Flemish primitives had spent many years, ofttimes generations, illuminating manuscripts. When they started to work with the new medium of oil, they were graduating from one form of art that had almost reached its end into another that was only beginning. It was the same with the earliest daguerrotype makers. Almost all of them had started life as portrait painters who only became photographers because the new method offered them a much better chance of making a living. When they had died out, a new generation that had not gone through the long artistic apprenticeship of its predecessors succeeded them and these were often of very mediocre ability. It was their work which gave photography its reputation of being something merely mechanical and not fit to be counted among the arts.

We should remember that photography made its appearance just when the taste of Europe was at its lowest. Photographs have a better chance of surviving than pieces of furniture or ornamental vases and stucco statues, for everybody feels it would be an act of sacrilege to throw the pictures of Grandpa and Grandma in the garbage can. And so all of us are being constantly reminded by many of these family pictures of the outrageous clothes and hirsute adornments of our recent ancestors. As a rule we blame the photographer rather than the people who lived at the time the pictures were made.

But during the last twenty years the advance made in this exceedingly difficult form of art has been quite phenomenal. I am sure that the historian of art of a hundred years hence will have to devote as many chapters of his book to photography as to painting. For by then the rather snobbish attitude of so many of our contemporary artists, who still seem to feel that Arnold Genthe should not be in a book like

this while due mention should be made of every third-rate land-scapist of the seventies and eighties—that most deplorable attitude will undoubtedly have made room for the conviction that any method by which a person is able to reveal nature as he sees it through his own personality is really an artist, regardless of the medium in which he works. It is true that probably ninety-nine per cent of the photographs that are being made are completely worthless. But how about ninety-nine per cent of the stuff that comes out of our art schools? And how about the ninety-nine per cent who graduate from our musical schools?

In music and painting and architecture, it has always been the one per cent that counted. May I respectfully request the reader to visit some international photographic exhibition and to look at the exceptional one per cent and then tell me what he thinks about the argument that photography is not really an art?

# *Johann Strauss*

*And how dance music came once more to be composed
for the purpose of making people dance*

THE EARLY HALF of the nineteenth century was a very self-conscious age. The new rulers of society never felt entirely at ease. Hence they strutted in dignified manner from their pompous countinghouses to their equally pompous homes to spend the evening in dignified boredom with polite conversation and a bottle of port. Dancing as a popular form of entertainment was held in slight respect unless it was a slow and stately dance like the quadrille which was faintly reminiscent of the minuet as it was supposed to have been performed at the court of Versailles before the *Carmagnole* had hustled the fine ladies and gentlemen, together with their fiddlers and harpsichord players, to the guillotine.

I say "faintly reminiscent," for the quadrille was a dance which had an origin all its own. It had originally been a card game. How a card game could thereupon become a dance, we do not know. But stranger things than that have happened. As for the *Carmagnole*, it was danced to a very monotonous tune that is probably as old as the human race itself. In its original form you may still come upon the *Carmagnole* in the heart of Australia where the native survives in the unspoiled splendor of Monsieur Rousseau's noble savage. In a slightly modified fashion you may now and then observe it when our own Indians celebrate one of their age-old festivals. They do not dance in our sense of the word. They move their bodies up and down in endlessly repeated rhythm until the monotony of their movements and the monotony of the drum causes a state of semi-unconsciousness during which they feel nothing, remember nothing, and are capable of the most terrible acts of cruelty.

But we need not go so far afield. You will find exactly that same dance in the peasant weddings by the elder Breughel and many of the seventeenth-century Dutchmen. For that rhythmic expression of the emotions is so old that we share it with many of the animals. Cats, baboons, birds—they all dance the *Carmagnole* on occasion.

Quite naturally, being part of our primitive instincts, it came to

the surface during those terrible days of the French Revolution when fear of foreign invasion had turned human beings into wild beasts. As soon as the First Empire succeeded the revolutionary government, all such dances as the *Carmagnole* that were even remotely reminiscent of the hideous days of the guillotine were forbidden by the police. Even the harmless country dances that Bach and Haydn and Mozart had incorporated in their music were no longer regarded as quite nice. The result of this suppression was the exact opposite of what had been expected. The square dances and round dances disappeared but the infinitely more wicked and licentious waltz took its place.

We got our word waltz from the Germans. They in turn had got it from the French who used to call it the *volte*, and the French had borrowed their *volte* from the Provençals who called it *la volta*. So that we are back once more in the ancient land of the troubadours which, as the last stronghold of the old Roman civilization, had acted during all these many centuries as a sort of connecting link between the civilization of the ancients and that of our own.

It probably was the gay and elegant King Henri IV (himself a southerner) who introduced the *volta* at his court in Paris. From France it wandered all over Europe until, during the last quarter of the eighteenth century, we find it in Vienna being danced to the tune of *Ach, du lieber Augustin*, that merry melody which is as fresh today as it was a century and a half ago. By that time, however, it had lost its fashionable aspect and become a folk dance. It retained its popular character until toward the end of the Napoleonic wars.

In the year 1812 some brave spirits tried to introduce the waltz into London. They caused a scandal. The waltz was considered too utterly immoral to be tolerated in the ballrooms of polite society. But in 1815, when all the world gathered in Vienna for the Congress that was to make an end to all wars, *Der liebe Augustin* was too much for these gay young men who during the last twenty years had done nothing but shoot at each other. There was such an outbreak of what the contemporaries called a "dance mania" that, as the witty Prince de Ligne wrote in his diary, "The Congress danced but did not take a step forward."

After the Emperor Alexander of Russia, the savior of civilization, had actually danced the waltz in London, and in a public place at that, nothing could stop its triumphant progress. The people were going to dance and they were going to dance to a regular tune that allowed them to swing their partners. And as soon as these tunes had been written, the waltz and shortly afterwards the polka (a folk dance

from Bohemia, imported via Prague and Vienna) started people on a dance craze which can only be compared to the earlier days of the one-step and fox trot some twenty years ago.

And now we can once more observe (what we have already noticed several times before) that the moment there is a definite demand for a particular form of art, that demand will be supplied by some artist who thereupon makes a reputation (and often a small fortune) out of giving the people what they want. In the case of the waltz, three Viennese musicians, Joseph Lanner, Johann Strauss, Sr., and his son Johann Strauss, Jr., were found ready to give it a suitable musical background. These three formed a sort of trinity. For none of them could have accomplished alone what they were able to do together. It is true that Lanner worked under more humble circumstances than the two Strausses. He started out as a fiddler in some little coffee-house along the Prater while Johann Strauss *père* became imperial and royal court-ball music director to the Emperor of Austria. Strauss's son, following in Liszt's footsteps, carried his famous orchestra from one end of Europe to the other, creating an outburst of enthusiasm that made people forget everything else, even their wars and politics.

They were a simple type of men, these great waltz kings, for even with all their glittering orders and all the fuss that was made about them, they never forgot where they had started. The Strausses, like Lanner, were of the people and by the people, and that is probably the reason why they could so successfully write music for the people. I do not know what Lanner's father was, but the *lieber Papa* of Johann Strauss had been a member of the Viennese glovemakers' guild, and the dynasty (which I believe still survives) never lost touch with the class that gave it birth.

On the occasion of the elder Johann Strauss's last visit to London in 1849 (he was then forty-five years old and died soon afterwards), he was escorted down the Thames by a procession of barges in one of which a band played his tunes. It takes considerable composing to make the English nation so far forget its native dignity and bestow such recognition upon a man who has only written a lot of music in three-quarter time and who has never added a single square inch of territory to the British Empire. Upon this occasion they apparently threw all discretion to the winds.

As for the musical value of the works of the two Strausses, especially the son (the author of the *Blue Danube* and the *Fliedermaus*), all the great composers of the last eighty years seem to have agreed that the

work of these men was as perfect as anything composed by the so-called "classicists." Especially in their introductions, which should no more be omitted than we should omit one of the parts of a Beethoven symphony (radio sponsors, please take notice), the two Johanns showed a delicacy of feeling and an imagination which take us right back to the heart of the Rococo.

The great tradition of the waltz continued to exist in Vienna for almost an entire century and all attempts, even by such competent musicians as Waldteufel, to transplant the waltz center to Paris came to nothing. Early during this century Franz Lehár made all the world dance to the tunes of his *Merry Widow* as the Strausses, three-quarters of a century before, had made them twirl around to the pleasing melodies of *Wien bleibt Wien* and *A Thousand and One Nights* and all the other hundreds of their lancers, waltzes, and polkas. In his *Rosen-kavalier* still another Strauss (the mighty Richard) showed that he could probably have done as well as his namesakes had he tried to make people dance instead of contenting himself with letting them listen.

Today the glory of the old imperial Vienna is gone. The palaces stand deserted. The armies that followed the double eagle have been shattered. The Hapsburg dynasty no longer exists. Another hundred years and people will ask each other, "The Hapsburgs? Let us see . . . the Hapsburgs. Oh, yes, they were those funny old fellows with the side whiskers. Of course, we remember them now! Johann Strauss used to play his waltzes for them when they gave a party."

# Chopin

*The originator of the modern nationalistic "blues"*

THE *Harlem Blues* are really nothing new. They are the wails of self-pity of the old Hebrew psalmists put to music. Undoubtedly they are even older than that, for wailing is a natural expression of pain and discomfort, common to animals as well as human beings. But self-pity as a form of frustrated nationalistic pride was first of all brought to our Western consciousness by the builders of the Temple. It was even incorporated into their music, as anybody familiar with Hebrew melodies, both old and new, will probably realize. But as the Western World for almost fourteen hundred years after the fall of Rome failed to feel "nationalistically," but on the contrary was inspired by the ideals of an international superstate (the Emperor looking after the worldly interests of all people while the Church attended to their spiritual needs), there was not really very much opportunity for the development of what we now know as "national music."

There had been regional developments. A Flemish peasant looked different from a Spanish peasant. He ate different food. He wore different clothes. He spoke another language and lived in another sort of house. And as a result he expressed himself in a different way when he painted a picture on the walls of his house or when he played the *Dudelsack* at his daughter's wedding. He did not paint his picture or play his *Dudelsack* as a Spaniard did. But if he felt conscious of anything at all it was of being a peasant and not a gentleman and therefore making "folk music" instead of gentleman's music. And although the Reformation had destroyed the religious "universality" of the world, and a Lutheran hymn or a psalm set to music by a Calvinist was something very different from a melody by Palestrina, the directly national appeal did not enter into any of the arts until after the days of Napoleon.

For such a struggle as that which in the year 1812 caused the Prussians to rise against the insufferable arrogance of the French, a citizen like Goethe who openly declared that he would just as soon be ruled by a Frenchman or a Chinaman as by a German was of little practical

use. The cause of internationalism was deliberately wrecked by the lack of imagination of its own adherents. It is all very well to be a lover of nature, but you are not going to make yourself very popular among your neighbors if during a flood you refuse to handle a wheelbarrow or a spade, insisting that water has just as good a right to exist as the dry land on which you have built your house.

It was nationalism which had set Europe free from the tyranny of a foreign usurper. But the poor heroes who had so bravely sacrificed life and limb to gain their national freedom soon discovered that they had only succeeded in hoisting themselves out of the frying pan into the fire. For the delegates to the Congress of Vienna of the year 1815 gave evidence of being just as obstinately ignorant of what was really happening in the minds of their subjects as the old men of Versailles of the year 1919. As a result these shortsighted statesmen greatly furthered the cause of nationalism by putting all sorts of ethnological groups together which the Gods in their wisdom had long since put asunder. And a year after they had concluded their deliberations, everywhere in Europe Italians were groaning under the rule of an Austrian master, Catholic Belgians were fulminating against the blunders of their Protestant Dutch magistrates, Poles were cursing the brutality of their Russian viceroys, Greeks were swearing vengeance upon their Turkish pashas, and the whole of Europe had been turned into one vast caldron of mutual hate and detestation. There would have been an immediate explosion if Metternich and his reactionary henchmen had not been present to repress with their shooting squads and their executioners even the most reasonable demands for a certain amount of self-government.

Frédéric Chopin was born just in time to be an eyewitness to the most deplorable phases of this desperate struggle for national self-determination. Frédéric's father was not a Pole but a Frenchman who hailed from Nancy, had settled down in Poland, and there married a Polish lady by the name of Justine Krzyzanowska. As almost always happens in the case of such a mixed marriage, the boy took after his mother's people and became a Pole rather than a Frenchman.

When he saw the light of day in the year 1810, the Poles still lived in great hopes that Napoleon, for whom they had made such great sacrifices, would "do something for their country" and that he would bring about the re-establishment of the old and independent kingdom of Poland. They were to be deeply disappointed. Napoleon was completely indifferent to their sufferings. He plundered their country. He used its man power to fight his battles in Spain and Germany and

Russia, but he never moved a finger to undo the crime of the Polish division of a generation before. After his fall the Congress of Vienna settled the matter definitely by giving the western part of Poland to Russia. As a result, young Frédéric Chopin grew up in a country that was most bitterly resentful at having been betrayed by the very man whom they had worshiped with such blind and loyal devotion.

His first teacher was an ardent Polish patriot. So was his mother. So was everybody with whom he came in contact. A high-strung boy with a head full of chivalrous notions about the glories of the old Polish fatherland, Chopin fell an easy victim to the myth that Poland was the savior of Christianity and that it had lost its independence because it had not known how to be as selfish as all its neighbors.

The other side of the story, the sad lack of any sort of national discipline, the absence of an enlightened patriotism among its ruling classes, all that, of course, was either overlooked or conveniently talked away.

In the year 1829 Chopin went to Vienna for a series of concerts. A short time afterwards the great Polish revolution broke out. Two years later the victorious Russians abolished the last vestiges of Polish independence and the country started upon its final Calvary, being submitted for almost an entire century to every form of indignity that could be devised by the dull-witted viceroys who represented the house of Romanov in Warsaw.

Every Pole who could possibly do so (and who had escaped being hanged by General Paskevich) went to live abroad. The sympathy of liberal Europe was entirely with the Polish insurgents and in every Western capital there were colonies of Polish exiles and their native admirers.

Several of the old Polish noble families, having estates in the Austrian part of Poland, retained the greater part of their ancient wealth. As a race they had always had a great flair for a truly magnificent way of living. They now turned their palaces in Vienna and Paris and London into centers of Polish propaganda and it was in this atmosphere that Chopin lived and died. Here he developed his peculiar art which was to disturb the conscience of Europe much more profoundly than all the hundreds of thousands of written protests and all the white papers and green papers and brown papers which the different chancelleries were in the habit of sending each other upon the sad subject of Russian misgovernment along the banks of the Vistula.

When the Cossacks were let loose on Warsaw after the first outbreaks of disorder, they knew how greatly they had to fear this musical agitator, for they broke into the house where Chopin had lived and threw his piano out of the window and used it for kindling wood. It did them little good, for Chopin was already in Paris.

Seventy years later, in the hands of his great compatriot, Ignace Paderewski, his compositions full of his nationalistic ardor were to become one of the most eloquent arguments for the re-establishment of an independent Polish nation.

I may be all wrong in maintaining that the arts have always played a decidedly "functional" role in the development of our civilization. But by and large I feel inclined to think that I am right. No art that was merely made for art's sake has ever been any good. Whereas the art born out of a necessity and created to fulfill a definite purpose seems to live forever.

The private life of Chopin is so well known that I need not dwell upon it in any great detail. As a social and artistic success, the young Pole was a second Liszt. He was adored wherever he went. His music was played wherever people owned a piano and in the forties of the last century many people owned such a piece of furniture. Unfortunately, both for himself and for all of us, the defenseless young man fell into the hands of the famous Madame Dudevant, who under the pseudonym of George Sand had for quite a long time been shocking the European public with her very outspoken and modernistic novels. Amandine Lucile Aurore Dupin (Chopin could have turned her name into a nocturne!) undoubtedly meant to do well by her dear Frédéric, but, like the black widow of the spider family, the famous Madame Dudevant was in the habit of consuming her lovers as soon as she tired of them. As a rule she grew tired very soon.

Chopin, full of high ideals and six years her junior, was an easy prey to this imperious female. In order to give him a better chance to work undisturbedly (and also probably to have him entirely to herself), she dragged this poor consumptive all the way down to the Balearic Islands. She got a lot of useful copy out of it which she published under the title of *A Winter in Majorca*. But all Chopin gained was a plot in the cemetery of Père Lachaise several years before he needed to have died. For he did die in the year 1849 when only thirty-nine years old.

As a result of his untimely departure (although Pergolesi, Mozart, Schubert, Mendelssohn, and Bizet also died quite young) his output

was rather small. Except for his two piano concertos, he carefully refrained from writing for the orchestra. In this, however, he showed great wisdom, for the piano was first and last and all the time his own most particular instrument. His piano was to him what his pony is to a cowboy. He had grown to be part of it. He knew exactly what he could do with it, how much it would stand, how far and how fast he could drive it without forcing it to collapse. Having mastered it until it would obey his slightest whim, he used it—consciously or unconsciously—for but one single purpose—to give expression to that love which bound him and his fellow exiles to their native soil.

Such an all-overpowering emotion is a dangerous thing. It can very easily lead to an extreme of bigotry and intolerance which becomes a direct menace to the peace and well-being of the rest of the world. For then it ceases to be a matter of inspiration and degenerates into an obsession. As this world is now arranged we cannot all of us be Poles or Hungarians or Irish or Germans. Other nations, too, have a right to exist, a fact which the composers of such purely nationalistic blues were very apt to overlook in their devotion to the land of their affection.

And then there is something else I should here bring to your attention. It is always very difficult to decide whether it was the artist who created the national atmosphere or whether the national atmosphere had actually made the artist. Our most typical negro songs were written by a white man, Stephen Foster. What we call typical Hawaiian music was really written by a Prussian bandmaster. Most people associate *Carmen* and the *Bolero* with everything typically Spanish, but Bizet and Ravel were Frenchmen. The best tangos have been written not by Argentines but by Germans, and Dvořák, a Czech, wrote the best known of all purely American symphonies.

Furthermore, when you know the geographical background of a country really well, you soon come to the conclusion that this purely "national music" does indeed express the general atmosphere of the landscape to a most astonishing degree, but that you are sometimes fooled by a mere name. *Finlandia* with some other title might not immediately draw your attention to the lakes and forests of Sibelius' homeland. It might remind you of northern Maine. By the same token, if you did not know that the composer's name was Edvard Grieg, *Peer Gynt* might just as well have been a Greek as a Norwegian.

All the same, there is in most of the really good "national music" of the last hundred years an unquestionable strain of something reminiscent of the atmosphere of the country that gave it birth. Tchai-

kovsky does not depict the spirit of the African veldt or the Kansas prairies but that of the boundless plains of Russia. And the same can be said of the music of Borodin and Mussorgsky and Rimsky-Korsakov. Even such completely modern composers as Scriabin and Stravinsky have something in their compositions which instinctively makes you say, "This must be Russian," although you may not in the least know why you feel that way. Others like Rachmaninov or César Cui have elements in their work which is West European rather than Russian, but none of them can quite escape their original Slavonic background.

The Czechs have always been an intensely musical people. The city of Prague loudly applauded Gluck and Mozart and Weber long before anybody else was willing to listen to them. Within the domain of the graphic arts, these good Bohemians produced nothing of any value. But with Dvořák and Smetana they contributed mightily to the musical development of the last seventy-five years and in an essentially "national" way, for no matter how many years these two famous composers spent abroad, everything they wrote always had a decidedly Czech quality.

The same holds true for Hungarian music, although in that case it was a half-Hungarian, Franz Liszt, and a hundred per-cent German, Johannes Brahms, who made the whole world conscious of the existence of a purely Hungarian form of music. Of course, that purely Hungarian form of music may not really have been of Magyar origin, but may well have been invented by the illiterate *Zigeuner* fiddlers of Bessarabia. It makes very little difference, for we run across the same thing in an entirely different part of Europe. Albeniz and Granados wrote in a musical dialect which everybody immediately recognizes as Spanish, but then again, the typically Spanish rhythm was a dance rhythm with which the Moors and the Gypsies had had quite as much to do as the native Christian population.

When we go to the extreme north, we find that Grieg and Niels Gade spoke just as eloquently in a vernacular that was essentially Norwegian, while right across the Sound Christian Sinding did the same thing in Denmark.

Not to forget the little island of Bali where the gamelan gives utterance to the voice of a Hindu tradition that is thousands of years older than our own civilization.

The subject is intriguing. But this book is getting to be very long. I shall therefore let you solve the puzzle for yourself.

CHOPIN NOCTURNE

RICHARD WAGNER

# Richard Wagner

### The father of the Germany of Adolf Hitler

RICHARD WAGNER died in the year 1883 and the Third Reich was founded in 1937. Yet it is the musician who to a very large extent is responsible for the founding of the modern Germany that now so frightens us with its clamor for a new war.

I realize as well as anyone that the World War and the treaty of Versailles also had a great deal to do with it. Old Clemenceau, too, bears part of the blame, and the shortsighted vindictiveness of all the other Allied peace commissioners was another important factor in bringing about this most unhappy solution. But the entire tragedy is dominated by the spirit of Richard Wagner.

The French of the revolutionary era conquered the world to the tune of the *Marseillaise*, but Germany now steps forward to meet its final destiny while the orchestra plays the strains that carried Siegfried to his doom. And that music was composed by someone whose immediate ancestry was very possibly not of that purely Aryan variety without which no one is supposed to be able to understand the true inner spirit of the Teutonic race.

I am sorry to mention this little irregularity in Wagner's family tree. But the fact that he may well have had Jewish blood in his veins could explain another characteristic which has so greatly endeared him to the present-day Germany. Like so many people of mixed Hebrew-Gentile origin, Wagner always resented the Jewish part of his make-up, which in his case was undoubtedly responsible for his almost incredible musical virtuosity. He gave expression to this sentiment in the same brutal fashion with which he attacked everything that either displeased him or that seemed to stand between him and the final triumph of his ideas. And being one of the most accomplished virtuosi of vituperation who ever wielded a pen, he reached heights of meanness and abuse in his letters and in his articles which have rarely been surpassed and which (whenever they were directed against some Hebrew antagonist) have made Richard Wagner one of the most popular heroes of modern Germany.

I might here add a great many details about this man's life which

would bear me out in a statement which a desire for truth alone compels me to put down, for truly it is never pleasant to say such things about someone to whom you owe some of the most marvelous moments of your life. But why drag all this in? So many volumes have already been devoted to this very painful subject.

For Wagner has been dead a great many years, more than half a century. All the people whom he cheated or abused or worse, lied about or persecuted with his hate, have long since joined the great majority. The quarrels in which he engaged have been forgotten. But his music remains and that music is as sublime, as moving, as superlatively interesting today as when it was composed, seventy or eighty years ago. So why don't we just accept what he gave us and forget everything else? A rose will be just as beautiful whether it grows out of a well-tended flower bed or out of a rubbish pile in a neglected farmyard. And as Mr. William Shakespeare said quite a long time ago, it will smell just the same, no matter by what name we prefer to call it. So peace be to Richard Wagner's ashes!

For if he sinned, he was also greatly sinned against by all sorts of inferior little fellows who had no conception of this man's stupendous ability, who deliberately and willfully misrepresented everything he did, who sneered at him, who hooted the greatest of his works from the stage, and who in many instances have even carried their hatred beyond the grave.

Other men, less convinced of their own greatness, would have broken down completely under the endless blows and disappointments of which he was the victim during all the days of his life. Indeed, his stubbornness and his legendary arrogance may have been the very qualities that saved him. The elephant who lives in the jungle surrounded by thousands of relentless enemies needs a thick skin in order to survive.

Wagner had such a skin.

He survived.

That is really all we need to know.

Wilhelm Richard Wagner was born in Leipzig on May 22nd of the year 1813, a few months therefore before the so-called Battle of the Nations which made an end to all further Napoleonic ambitions. His mother's husband was a minor police official—a totally obscure fellow. But there seems very little doubt—at least Wagner himself hints at it repeatedly—that his real father was the man whom his mother married a very short time after her husband's death. His

name was Ludwig Geyer, and he was an actor and painter and playwright of considerable ability.

It is interesting to note that young Richard followed closely in his stepfather's footsteps. At first there was no mention of a musical career. All the young man hoped to do (which in his case meant "expected" to do) was to become a second Shakespeare. His schoolbooks, therefore, were not filled with ideas for future symphonies and sonatas but with plans for a tremendous tragedy, cast in the form of an old Germanic drama.

Needless to say, like all the other good and obedient little German boys, Richard was taught to play the piano. But he showed very little talent and until the end of his days used to joke about the sad fate that would have awaited him if he had tried to become a piano virtuoso.

These lessons initiated him into the secrets of composition. Once he had learned to give form to the melodies that were in his head he felt that it was not enough to become the modern Shakespeare. He must also be the modern Beethoven and as a combination playwright and composer he would give the world a new sort of musical drama that would make all previous efforts along that line read and look like an amateur performance of *Norma* in a small town in the French provinces.

The world had been waiting quite a long time but now at last the man had arrived who was to prove that the text of an opera was quite as important as the music and that the acting and the stage setting and the stage management might be on a par with the singing.

Let me say right here that he succeeded most brilliantly. He did give the world a new and perfect form of musical drama. He broke completely with the older conceptions according to which an opera had been merely an opportunity for a few strong-lunged singers to show how they could juggle their high C's and pay absolutely no attention to the text. If you have ever taken the trouble to read the words of the average pre-Wagnerian opera, you will know how true this is. Even Beethoven and Mozart had squandered their genius upon a kind of story which would have been refused by one of our *True Romance* magazines as being entirely too mushy for the taste of their readers.

There is a great deal of agitation nowadays to have all operas sung in English. It does not seem to me to make very much difference in what language an opera is given, but as long as most texts are what they are, I think we had better stick to the original Russian or French

or Italian. Then the listener does not understand a word of what is being said, and he can keep at least some illusion of glamour. Besides, it does not really matter very much. Except in the operas of Wagner where it is impossible to do so, most of our singers would undoubtedly continue to sing "la-dee-la-dee-la" as they have done since time immemorial.

The Geyer family, like all actors' households, did a great deal of moving about, but in the case of young Richard this was an excellent arrangement, for it made it possible for him to hear all the best there was to be heard, both in Leipzig and in Dresden. Dresden especially was to play a very important role in his life, for there he was to become thoroughly acquainted with the work of Carl Maria von Weber. Richard Wagner as a rule was not a man to acknowledge a debt to another, whether it was a debt in money or one of a more subtle variety. But he invariably spoke of Weber in terms of the highest esteem. He acknowledged him as the man who had first of all shown the world what an opera should really be. And when Weber's mortal remains were brought back to Germany, he could feelingly speak of his predecessor, not only as his own master but as the founding father of the modern musical drama.

When that happened, Wagner had already gained considerable recognition as a composer. But in the meantime he had been obliged to make a living as a conductor. He married an actress by the name of Wilhelmina Planer and in the year 1837 moved to Riga to become director of the local German theater. But that little provincial stage, supported by the patriotism of the local Baltic Barons, was much too small to hold a man of Wagner's ambitions. Paris was the city for him. Paris, where Meyerbeer was packing them in with his elaborately staged and showy operas.

To Paris, therefore, the Wagners went, going by water and being hopelessly seasick and, according to the generally accepted legend, deriving inspiration for *The Flying Dutchman* from the awesome sight of the Norwegian fjords. If that is true, the captain of their ship must have been a very indifferent navigator, for the southern coast of both Sweden and Norway is about as imposing and as rocky as that of Long Island.

Meyerbeer, an amiable and easygoing man, received the Wagners with great kindness. But soon something happened. Something always "happened" when people were kind to Wagner. He found himself on his own, being very hungry and very cold and very uncomfortable until he got some potboiling jobs which kept him alive until

the year 1842 when he was called to Dresden to conduct the Royal Opera. During the next six years he had a chance to show what he could do. *Tannhäuser* and *Lohengrin* were written, and *Tannhäuser* was actually produced. But it was too new and too strange to have an immediate appeal. Part of the press denounced it as dangerous to the morals of the younger generation and so loud was this chorus of disapproval that *Lohengrin* was not given until much later.

Came the year 1848 and all the pent-up rage of a generation of disappointed men found expression in an explosion that shook the whole of Europe. Wagner, smarting under the neglect he had received from those little German princelings who could so easily have helped him and by this time a most devout believer in the greatness of the old Germany, the Germany of Wotan and Walther von der Vogelweide, was heart and soul in the movement to establish a united fatherland. But the patriots lost out. They were full of sound and fury when it came to making speeches but they knew as much about politics as the proverbial babes in the woods. When it was all over, Wagner found himself high and dry among the Alps, a political exile living on charity in the city of Zurich and with no hope for a better future. The period of his exile lasted until 1861. He used it to write the greater part of his operas and to engage in a war of words with all those who did not share his views about the musical drama of the future, as it was to be written by Herr Richard Wagner.

And then in 1864, that incredible stroke of good luck. Ludwig II, King of Bavaria, sent for the humble *Kapellmeister* and made him a sort of musical dictator of the good city of Munich. He bade him go ahead and do whatever he wanted, provided he made it possible for His Majesty to lose himself in those romantic daydreams which were so dear to the heart of this slightly unbalanced ruler.

Wagner arrived in the Bavarian capital as a conquering hero. He had visions that now at last everything he had fought for so long and so bitterly would come to be realized. But, proceeding to the attack with his customary lack of discretion, he soon found himself in open conflict with all those who could have helped him in establishing a national German opera shrine. Ludwig II had strange notions about his duties as a constitutional monarch. In his dreams of grandeur there was no room for a mere scrap of paper that could impose itself between a sovereign and his beloved subjects. The subjects, an easygoing lot, loyal to their dynasty and their church, were not inclined to complain about some minor and trivial irregularities in connection with the annual budget. But at the same time they hated to see their

hard-earned pennies being squandered upon all sorts of absurd operatic schemes in which stuffed swans dragged silver-clad knights down a river and in which maidens, weighing a ton each, went swimming in the Rhine, singing "holdereeho" at the same time and waving their bare arms in a most immodest fashion.

In less elegant language, the Bavarian parliament refused to pay the bills. Wagner, who as usual had succeeded in making everybody dislike him, went hastily back to Switzerland as poor as he had come.

During all these years he had been most loyally supported (both in a financial and artistic way) by quite a number of ardent admirers. Liszt, the friend of all those who were trying to say something new in a new way, had produced many of his works in Weimar. Hans von Bülow had played them all over Germany. These friends now formed Wagner societies and these Wagner societies collected funds. Finally there was enough money to make Wagner's great dream come true. In the year 1876 his national opera house was most solemnly opened in the little Bavarian city of Bayreuth. Wagner himself was present; so was his second wife, who was a daughter of Liszt and Madame d'Agoult, and who had been the wife of Hans von Bülow until she left him and took the composer instead of the conductor.

After that opening performance in Bayreuth, Wagner at last occupied the position to which he felt himself entitled. The adulation his work received assumed almost divine proportions. Nobody else was any good except the inventor of the *Leitmotiv*. Look at poor Giuseppe Verdi! Ever since the early fifties he had been composing operas in the traditional old Italian style. These operas had a tremendous popular appeal. But the Wagnerites now made a bitter war upon all his works, denouncing them as mixtures of brutal dramatic scenes and empty melodies, perhaps good enough for the mob in the gallery (the mob in the gallery most heartily agreed) but nothing for the true *cognoscenti*, for the true followers of the new gospel according to their one and only Richard Wagner.

Kind-hearted old Verdi bore no grudge, although upon several occasions his German colleague made no secret of his feelings toward this simple Italian peasant who preferred the cows and sheep of his model farm of Busseto to life among the mighty and who was so completely lacking in worldly ambitions that he used his rapidly increasing fortune to endow a home for poor musicians in Milan. When in 1871 *Aïda* (written for the opening of the Suez Canal and first of all performed in Cairo in December of the year 1871)—when in this opera Verdi showed that he too could break with the traditions of

Donizetti and could write musical dramas in the Wagnerian vein, the overbearing German may well have felt a moment of uncertainty. For when it came to pure melody, Verdi, who during his long life (he died at the age of eighty-eight) had never been at a loss for new and pleasing tunes, might have been a dangerous rival. But Verdi was too old then to care much one way or the other. He remained peacefully on the other side of the Alps, and it was Wagner himself who went south. Not to achieve further triumphs but to finish his *Parsifal* and to die in Venice on February the thirteenth of the year 1883.

Since then the music of Wagner has conquered the world. Whether it is played by the augmented orchestra which Wagner originated or by a three-piece orchestra in some obscure café in Buenos Aires or by the mandolin virtuosi of the Grand Canal in Venice, it is always and most unmistakably the music of Richard Wagner. Some countries like France, with its nationalism fired by the disastrous war of 1870, were perhaps a little slower to accept it than others. But even today when we have listened to the compositions of so many other men of true genius like Richard Strauss (who has shown even greater virtuosity in handling tone than Wagner himself) or Hans Pfitzner or Humper- dinck—or a Bruckner or a Mahler or a Reger—Wagner still remains the greatest of them all. That boyish ambition to become the second Shakespeare and the second Beethoven all in one was not really as foolish as it sounded. Part of the dream, at least, had been realized.

And now for the reverse of the medal. When one reads a Wagnerian text by the cold and brutal light of an electric lamp in the quiet of one's own sitting room where not a single strain of his music can penetrate, it is pretty sad stuff, bombastic, hollow, and quite often downright absurd. But in actual life, his slow-moving and ponderous heroes in their false whiskers, carrying their absurd spears and as- cending to their Valhalla amidst clouds of steam (from the boiler room in the basement) or sailing across turbulent seas whose waves are caused by the legs of three dozen little boys kicking violently at a large piece of painted tarpaulin—in actual life these texts are in- variably accompanied by a music that is so persuasive, so enticing, and at times so bewitchingly debauching that ordinary flesh and blood have no means of resisting its seductive appeal and find them- selves in a cave of enchantment from which there is no escape. And so, less fortunate than Wagner's Parsifal, there is nothing they can do but surrender to this Klingsor of the tantalizing orchestration. Once

outside the theater and behind a ham sandwich and a glass of beer, the victim of this aural delusion may soon regain his normal composure and once more realize that all he had experienced had been merely "theater," something artificial and phony and not to be taken too seriously.

In the present atmosphere, in an atmosphere surcharged with a poisonous sort of supernationalism, it is exceedingly dangerous for ill-balanced little boys and megalomaniac demagogues to see themselves in the roles of so many Siegfrieds and Hundings and Wotans and Lohengrins, moving irresistibly toward their fate and called upon to re-establish the kingdom of the great God Wotan.

Jean Jacques Rousseau wrote nonsense, yet he was able to cause that terrific upheaval which under the name of the great French Revolution carried the world to the very brink of self-annihilation. Richard Wagner is the Jean Jacques Rousseau of our modern times. But he is infinitely more dangerous than his predecessor of a century and a half ago. For he speaks to us in a language that vastly outstrips mere words. He speaks to us in the most glorious music ever conceived by the brain of man.

# Johannes Brahms

*The amiable philosopher who thought in terms of music*

THERE IS A PICTURE of Johannes Brahms which you must have seen, for it is to be found on the walls of many of our music lovers. It shows the Master in the full vigor of his early fifties, playing the pianoforte. There are no frills about him. What he wears would hardly qualify him to enter a competition for the best-dressed man, although he lived in Vienna where the average male has always been very particular about his personal appearance. There is, however, something sturdy about those baggy trousers and the provincial cut of his coat, articles of wear which he probably continued to order from his old tailor in Hamburg, the place of his birth. For Johannes Brahms was an orderly person and a creature of habit. So there would have been nothing unusual in his sending all the way to Hamburg for something he could have bought right around the corner from the walk-up apartment where he lived his lonely bachelor's existence.

I refer you to that picture because it will give you a much better idea about the man and his work than ten volumes of printed words. There he sits and smokes. For the moment, at least, he is completely at peace with the world, for he is playing the piano and undoubtedly he is playing his own music. Perhaps he is merely improvising, but that makes no difference, for all music must necessarily begin as an improvisation just as every picture must once upon a time have been nothing more than a sketch.

The only thing lacking in this lithograph is an audience, but that does not matter, for you yourself are part of that audience, and you feel convinced that whatever this man is playing must be good, honest music, of sound texture and craftsmanship and full of color and with here and there delightful flashes of wit. You will also know that this music has grown out of his native soil and that it is part of him, just as he himself is part of that soil. For there is something simple and earthy about this bearded Herr Professor, just as there was something sound and earthy about old Michel de Montaigne in his tower among the vineyards of southern France.

They had a great deal in common, this German composer of the

nineteenth century and the French writer of the sixteenth. The former expressed himself by means of sound and the latter by means of words. But there was a great similarity between the things they had to say. They spoke of everyday emotions and commonplace incidents in the lives of ordinary everyday people. Being artists by the grace of God, they never descended to the vernacular of the street. It is true that they never lost touch with life in their general approach toward the simple folk of the market place. But like all great artists they were (regardless of their humble origin) spiritual aristocrats. At least, they were democrats, but their democracy was not the one in which every citizen should be dragged down to the level of the lowest, but should be tempted to reach up to the highest.

Modern man does not eat his meat raw. He does not tear a living chicken to pieces with his teeth and his claws as his ancestors did (and not so very long ago, either). He prepares his food delicately and carefully so that it is appetizing to the eye as well as to the palate. Brahms submitted his folk tunes to a similar treatment, as Montaigne, three hundred years before, had done with the ideas he had overheard in the wineshops of Bordeaux. The result of their labors was a pleasant and well-mannered philosophical contemplation, with a complete absence of argument and strife.

Brahms at times could be very sarcastic but he reserved his bitter wit for his correspondence with his friends. He did not, in the terrible fashion of Richard Wagner, shriek his notions from the tops of the houses. When he was twenty-seven years old he got mixed up in a musical dispute. He signed a rather silly letter which a number of the up-and-coming composers and fiddlers and pianists of that time addressed to their compatriots. In this letter these eager young men, full of admiration for the past, protested vehemently against what they considered to be dangerous modern influences of such people as Franz Liszt. But Franz Liszt, who had personally befriended and encouraged every single one of the petitioners, showed his usual bigness of heart. He paid no attention to this document. If they felt that way, that was their good right and Franz Liszt, with the easy gesture of the *grand seigneur*, dismissed the whole incident as something not worth bothering about. Only Wagner used the opportunity to rush into print and have his little say, but the rest of the world has long since forgotten this incident, and I suggest that we do likewise.

That signature at the end of this juvenile protest was Brahms' only contribution to the polemics of his day, which were infinitely more bitter than they are in our own time. With such venomous critics as

Eduard Hanslick filling the newspapers with their attacks upon everything new, the sixties and the seventies of the last century resembled another Colosseum wherein the bright young disciples of the Muses were thrown to the wild beasts of the critical department to be destroyed with less mercy than the Christians had received from the lions and tigers of the Emperor Nero.

Brahms did not entirely escape this fate, although he was one of the few contemporary composers who found favor in the eyes of the terrible Hanslick. Leipzig had turned a deaf ear to his Piano Concerto in D minor when it was first performed there, and his works for the piano and his *Requiem* and his songs were by no means an immediate success. They penetrated very slowly, for there was nothing showy or spectacular about them. On the contrary, they belonged to that sort of art that is so completely unpretentious and so absolutely honest that it has got to move forward by its own momentum.

During the latter years of Brahms' life there were three other great composers in Vienna whose works suffered a similar fate and had to wait a long time for recognition. The first of them, Hugo Wolf, gave us a series of songs of rare beauty, for he knew how to identify the music with the words as no one else had been able to do since Schubert. The second of these was Anton Bruckner, who spent his many days on this planet fulfilling his task in a simple and sincere and somewhat ponderous way. The third was Gustav Mahler, whom we still remember over here from the days when he conducted the New York Philharmonic Orchestra and who was almost the complete opposite of the embittered Wolf (who realized his own genius as a composer but had to make a living as a musical critic) and the deeply religious Bruckner.

All three of them were finally able to get their works performed. The last two lived to see the day when their symphonies appeared regularly on the programs of all philharmonic societies. But as in the case of Brahms, they were obliged to exercise patience and to bide their time. If the public was slow in coming up to them, that was undoubtedly very unfortunate, but for the public, not for them. Even the humble Bruckner knew that what he had to offer was good. Let the audiences come and get it or do without.

The only disadvantage that came to Brahms from his inability to achieve success a little earlier in life was an economic one. He wanted to get married but he could not do so without a steady job. But when the job came, the girls had either changed their minds or had taken somebody else. These disappointments he accepted in his usual phil-

osophical way. And on the whole I think that he greatly preferred his bachelor's existence to every other form of life. For there was nobody to bother him when he worked and he was able to live quite decently on the royalties of his published works. He was no miser but he appreciated the value of money.

He had learned this lesson in the days of his youth. His father must have been an extraordinary man. He had begun as a contrabass player in a coffeehouse but had worked himself up until he was finally allowed to play in a regular theater orchestra. Anyone at all familiar with musical conditions in the Germany of eighty years ago will know that such a promotion can only be compared to that of a private in the regular army who dies as a field marshal. That early background put its stamp upon the whole of Brahms' life. Before his death in the year 1897 he had received all the honors that could come to a man who has been universally recognized as the greatest musician of his day. When he died, the flag of every ship in the harbor of Hamburg flew at half-mast. Brahms received his medals and his honorary Ph.D. but never let them interfere with his work or his peaceful and orderly existence.

He knew all the great musicians of his day. With the widow of Schumann, who was the first to play many of his compositions in public, he was on terms of a most sincere friendship, treating her with great tenderness and respect. With the other members of his guild he was on cordial terms, but compared to most of the other composers of the sixties and seventies he lived the life of a recluse. He had an intense dislike for social chitchat. It seemed a waste of time and time was something that should not be wasted. He felt that a serious workman should stick to his job, as indeed he should. He realized that in order to be a great composer, it was not enough to know all about one's own *Fach* but that one should also be familiar with what was being done in a great many other departments of learning. That could only be achieved by reading and so he stayed home and read.

There is not very much else to say. The music of Brahms is still as new and fresh as the day it was written. Beethoven is perhaps beginning to disappear just a little bit from our programs, but Brahms is still as popular as ever. He belonged to a civilization that no longer exists. But we still understand the language he spoke—the language of an honest fellow who had something to say, who said it as pleasantly and eloquently as he could, and who thereupon stopped talking.

# Claude Debussy

*The impressionist style moves from the painter's studio
into the workshop of the composer.*

T HE NAME "IMPRESSIONISM" itself was mere accident, the chance re-
mark of a critic who, somewhat puzzled by a picture of Monet,
*An Impression of a Sunrise,* had used the word to describe the entire
group of painters who were exhibiting at the same time. But as so
often happens, there was just enough truth in this nickname to make
it stick.

There were, during the seventies of the last century, a sufficiently
large number of artists who were trying to get away from the influence
of the older schools to establish a regular school of impressionism. As
an artist usually is quite contented to create something new and then
let posterity explain what he really meant (that is why critics are
born) those radicals of the sixties and seventies of the last century who
seem so tame to us today rarely told us what was in their minds. I
suppose that in ninety-nine cases out of every hundred they really
did not know. They were young men who lived in a new world and
who were therefore no longer satisfied with the old methods of ex-
pression. Out of their quest for something that should be more in
keeping with their own times, they developed that new method by
means of which they tried to re-create on canvas that "atmosphere of
light" by which the objects they had chosen to depict stood enveloped.

The objects in and by themselves were not enough. To them a tree
or a house or a woman sitting on a chair was something more than
that actual tree or house or that actual woman sitting on that actual
chair. They were part of the atmosphere that surrounded them. They
therefore set out to show how the tree and the house and the woman
looked in their own particular atmosphere. (These are very clumsy
sentences but if you will reread them a couple of times, you will prob-
ably know what I mean.)

To a generation which had thought in simpler terms, to which light
had been light and darkness had been darkness, this looked like a
serious heresy. Some twenty or thirty years had to go by before the
eyes of the rest of the world had been trained to see these things the

way Monet and Renoir and Sisley and Morisot and Manet (only during the end of his career) had been able to see them.

It was the old, old story which repeats itself in almost every chapter of this book. The true artist, like the true philosopher, is a pioneer. He wanders away from the beaten track; he often disappears from view for years at a time, while he is trying to find a new road. Quite frequently he is never heard of again. He has then been swallowed up by the wilderness and has given his life in an attempt to discover new heights. Sometimes his bleached bones are found surrounded by the pictures which he painted in his final desolation and loneliness. Whereupon the art dealers fight for the spoils as bitterly as dogs will fight for a bone and will sell their plunder for large amounts of money to a museum or a private collection.

Now while all this was happening and while all the young Frenchmen were experimenting with this impressionism, something of the same sort was apparently occurring in those garrets where a new generation of composers was working on what was then (in the eighties and nineties of the last century) called "the music of the future." Look at the dates of their births and you will find a whole crop of them. Puccini, the great Italian opera composer, was born in 1858. Wolf, the song writer, in 1860. Mahler was born in the same year. Debussy made his appearance in 1862. Richard Strauss in 1864. Busoni two years later. Pfitzner saw the light of day in 1869, Reger in 1873, Schönberg in 1874.

The eighties and nineties were therefore the time they began to express themselves. And it is during these eighties and nineties that we begin to hear a new sound in our music—a sound which bears a close resemblance to the impressionism of the painter's studio. For just as the painting impressionists had discovered a whole set of new "color notes" (to use the only expression that seems to make some sort of sense), so did the composers begin to make use of new tonal effects that until then had been absolutely forbidden as they gave offense to the ears of a public to whom harmony still meant "an agreeable sound."

Here again we stumble upon that difficulty that will always arise when we try to describe a picture or a piece of music or a statue by means of words. So you had better let the originals tell you. Put a record of one of Bach's *Brandenburg Concertos* on your phonograph and then play Claude Debussy's *Cathédrale Engloutie* and you will understand what those differences are to which I refer.

I myself lived through the era when Debussy's works were still be-

ing received with raucous laughter. Debussy knew this but did not care. He lived a retired and retiring life and he worked. As a young man he won the Prix de Rome but the compositions he sent home to show that he was not wasting his time were considered so inferior by his conservative teachers in Paris that they were never deemed worthy of a public performance. One of these, by the way, was his music to Rossetti's *Blessed Damozel*, which was not heard in Paris until almost a dozen years later. After Rome, Debussy went to Russia, which under the last forty years of the Czarist regime was a veritable haven of refuge to all those who were trying to say something new—provided they did not mention any novelties within the fields of politics or economics.

When he was forty years old, the Paris opera at last opened its doors to his *Pelléas et Mélisande*. Such a step was almost revolutionary when you remember that until then the musical life of the French capital had been completely dominated by such men as Vincent d'Indy, Chabrier, and Gabriel Fauré. These were eminently capable composers, far removed from the amiable banalities of Gounod and Massenet. But all of them spoke a language which the public could understand, appreciate, and enjoy. Even Paul Dukas, who occasionally seemed to address himself to his audiences with his tongue in his cheek, was tolerated. His fun was still good, clean fun, and we may even come to like him here unless the radio stations play his *Sorcerer's Apprentice* so often that it will affect us like the "Unfinished" Symphony and we ask ourselves, "Must we hear that again?"

But Debussy had other enemies who were almost more dangerous than those who disapproved of his lack of respect for the established tradition. Those were the eager youngsters who, delirious with joy that the ultraconservatives were at last beginning to lose ground, now undertook to out-Debussy Debussy himself by the outrageous cacophonies which they proudly called "the real new music." Debussy, like all true artists, had a profound horror of what he called "intentional disorder," and so he himself withdrew more and more from all actual participation in the musical life of his day. He died during the Great War. In a way he was fortunate. He never lived to see the complete breakdown of our common civilization.

# A Final Word

*A word of farewell and good cheer*

THE EARTH was without form, and void; and darkness was upon the face of the deep. And the spirit of God moved upon the face of the waters. And God said: Let there be light: and there was light."

I do not belong to the class of people who are foretelling the end of the world because one particular form of civilization is running near its close. I sincerely believe in the evolutionary process as the basis of all growth. Only my sort of evolution does not go upward and onward, like a spiral staircase. Nothing quite as simple as that. It is more like the waves of the sea. The wave starts. It gains in size and momentum. It reaches its peak and is lost in a cloud of spray. Then it descends once more to a lower level but immediately the process is repeated. It rises upward. It gains in strength. It reaches its peak, but when it bursts with a cloud of foam, it has proceeded far beyond the spot where it was a moment ago. Human civilization seems to be subject to a similar law of growth and decline, never standing still for a single moment, ever and relentlessly moving forward.

Those of us who are over fifty years of age saw that wave burst forth in a magnificent flash of color just before the Great War, which was a period of tremendous activity within every field of human activity. Now we are witnessing the decline. But that decline is absolutely necessary before there can be a new surge upward.

The arts are an even better barometer of what is happening in our world than the stock market or the debates in Congress. Already before the war they had registered the disintegration of the old and established codes of good and evil. I refer to the great era of the "isms." Many of them are now merely names to us, although we got very excited when they made their first appearance. There were the eighteen-eighties when all Europe suddenly grew tremendously enthusiastic about the Japanese color prints of a hundred years before, which were then acclaimed as among the greatest works of art of all time. There were the eighteen-nineties with Cézanne and Seurat and his neoimpressionism and Gauguin with his synthesism, whatever that may have meant. There were the nineteen hundreds when neo-

impressionism had given birth to cubism, which in turn was to develop into suprematism and constructivism, mostly names invented in some cheap Parisian café over the third glass of absinthe and with one eye firmly fixed on the snobbishness of a public that had not the slightest idea what all these queer pictures and statues might mean but which had been told by a "reliable" art dealer and his equally "reliable" henchmen, the art critics (in the pay of the art dealer), that you could double your money in five years by buying the works of Picasso and Zorach and Russelo and Severini and Marcel Duchamps while they were still going cheap.

Then came the discovery of primitive Negro sculpture and the art of the Near East and among a lot of other absurdities it gave us expressionism and expressionism begat dadaism and dadaism begat surrealism, just as cubism begat orphism and neoplasticism and purism, and neoimpressionism begat the queer style known as futurism.

Most of us had only a very hazy idea about these developments as they took place in Paris during the Great War, when a number of foreigners were stranded in their Montparnasse ateliers. Having lost all touch with reality they went from one strange ism to another, finally leading up to that strangest of all emotional expressions, the nonobjective art, which went so far in its reaction against everything that had gone before that it composed its masterpieces out of old matchboxes, chicken feathers, and the offal of the barbershop floor.

I may, of course, be entirely unfair to this last development and I expect to hear promptly from the protagonists of these completely abstract forms of art, who will undoubtedly accuse me of being a prejudiced, bigoted old fogy who had better stay in the museum with his Whistlers and his Sorollas. In all fairness to myself, I think that this is hardly true. I have a great respect for much of the work done by the impressionists. I have never doubted the sincerity of the entire group that rose in its might to defy the traditions of all the previous centuries and to insist that the living must give expression to those issues that truly interested the living—issues which they expressed in the manner that seemed best suited to the needs of the moment.

Matisse, Cézanne, Lovis Corinth, Kokoschka, and our John Marin and Maurice Sterne and Boardman Robinson and Biddle and our Mexican neighbors, Orozco and Rivera (to give you only a few names that come to my mind and that are familiar to all of us), were undoubtedly the prophets of a new age. If you tell me that you don't know what their work is all about and that you yourself could do just as well, I can only answer that in the first place you had better try

to understand them, because they really have something to say that you should know, and in the second place that you flatter yourself but that you are probably very much mistaken. All these men had gone through the mill. They had learned their trade and learned it thoroughly. They could achieve their new effects only because they were such first-rate craftsmen that they need not bother any further about mere technique, just as a great fiddler or pianist can rise completely above the mere technical details of whatever he or she happens to be playing.

I wish that I could say the same thing about those developments of the last fifteen years which led up to the appearance of abstract and nonobjective art. I make this statement with many misgivings. It never pays to be too cocksure about such things. At present I still feel that I have seen more interesting nonobjective drawings on the telephone pads of some of my friends and in the letters sent to me not infrequently by the inmates of our more popular lunatic asylums than in the museums which carefully preserve these spoils of our ash cans. Time alone can tell, but on the whole, I am full of good cheer.

Such strange excesses have always taken place during periods of transition. Time will take care of them. Time will take care of them in its own merciless way. Fifty years from now we shall undoubtedly know whether these mysterious products of our bewildered contemporaries were just so much waste of time or whether I was just as foolish as those who objected to Bach because his music was a little too elaborate for their taste. And that, I feel, is all I ought to say upon the subject of the art of the present moment. I have so completely lost my bearings that I have not the slightest idea whether our wave is still moving downward or has already started upon its upward swing. All I know is that whether we are going upward or downward, we are also moving forward and that is the only thing that counts.

That and our ability to keep the boat on an even keel while courageously steering for the land of our ultimate desire—a world that shall create beauty out of the sheer joy of being alive.

## On How to Use this Book

I DID NOT write this book to give you a lot of facts, for the facts I mention have all of them been known for quite a long time and they are to be found in any volume devoted to architecture or painting or music. I merely gathered them together because I thought that would be the best way to give the reader a feeling for the "universality" that underlies all of the arts. Neither did I write these pages to air a few of my own esthetic theories and hobbies. Some of these have, of course, crept in, but try and keep them out in a discussion of anything as completely personal as a philosophical contemplation of the arts!

Then why did I take the trouble to write this vast tract and why did I want you to read it?

Merely to invite you to join us and by "us" I mean all those who feel that we can occasionally do without dinner or breakfast, but that life without a few extra dishes of music or painting is hardly worth while.

Now that sort of statement (like all more or less rhetorical utterances) is apt to be most beautifully distorted and misunderstood. For it comes very close to that terrible old slogan of "art for art's sake," which has ruined more careers than I care to think of. The last thing I want to do, is to take you away from a comfortable and decent mode of making a living and then turn you loose upon a cold and indifferent world, to spend the rest of your days as disgruntled and indifferent pseudo artists, spending miserable days and nights in an uncomfortable old attic, subsisting on stale spaghetti and contemplating the glorious revolution that will at last bring you recognition. The revolution may come, but it will hardly bring you the recognition you so eagerly desire. On the contrary, it is more likely to put a pickax in your hands and to tell you to make yourself useful digging sewers for the benefit of your less fortunate neighbors. Of course, should you really have been touched by the divine fire and should the good Lord in His wisdom have chosen you among His anointed few, then the urge to create will be so strong that nothing between Heaven and Hell can stop you. In that case, the cold attic and the stale spaghetti are of no consequence. You will take them in your stride, for you are

kept warm by the fire that is burning inside your heart and a crust of bread, devoured before your easel, will taste better than all the delicacies of old Raymond Orteig's most excellent cuisine. That, however, is a matter you will have to decide for yourself and I carefully refrain from all advice.

But there is a sort of compromise and since all of life is bound to end in a compromise, I want to draw your attention to the way in which you can bring yourself much closer to the delightful garden of the Muses (and it is indeed a most delectable garden) than you had ever thought possible before this matter was brought to your attention.

There must be something you like to do and can do. You may like to draw or to sing or to play the piano or go in for dramatics. Is there any reason why you shouldn't do so if it adds to the fun of being alive? I don't know of any.

Provided that you realize your own limitations. We live, unfortunately, in a country of competition and publicity. I have known perfectly good, average tennis or golf players who could have derived great pleasure from playing a reasonably good game, but they were unhappy all their livelong days because they could not play their games as well as Bill Tilden or Walter Hagen. I don't know Hagen but I do know Tilden and he would be the last person in the world to encourage you in such a belief. He would tell you to go out and get the exercise and do as well as you could and not worry when you have to accept the brutal fact that that rather unpleasant Jones girl next door can beat you every time you give her a chance. He would even suggest that you might learn more from getting beaten, playing against a really good player, than by being victorious against a weaker competitor and coming home with a perfect score.

Now the arts and sport have a great deal in common. I shall never forget one evening in my own home when Ty Cobb and Knute Rockne got engaged in a discussion on some obscure point in the noble craft of base sliding and the two of them, in their eagerness to prove that they were right, went through a sort of slow-motion demonstration of their respective schools of sliding and the show they put on was as good as the best Russian ballet I have ever seen. And I am sure that I never quite understood the real beauty of Greek sculpture until I saw the Babe knock out a home run in the last inning of a very important game. George may not be particularly interested in the Elgin Marbles (he may even think that they are something he used to play with as a boy) but he came as close to being a living reincarnation of some of the best work of classical Greece

as anything that was ever brought to my attention. Perhaps the diving boys in the harbor of Honolulu were his nearest competitors for such high honors. I am not quite sure but then it really does not matter, for the point I want to make is this: you need not be as good as the best professional in any of the arts to be still a very decent artist in your own right, just as you need not be an automobile racer to get a lot of fun out of the old flivver. But you can and will lead an infinitely happier and fuller existence if you adopt one of the arts as your stepchild and you will be surprised how far you can get by devoting a few of your leisure moments to the practice of whatever art you have chosen, whether it be photography or cooking or painting or etching or making stage models.

Of course, keep this fact firmly in mind—in the arts (just as in Nature) there are no short-cuts. Success is not a matter of inspiration but a matter of patience and more patience and then still more patience. Without inspiration, you may never be able to scale the greatest heights, but all the inspiration in this entire inspired universe will not do you any good without a vast amount of very hard work and slow, painstaking and conscientious work, at that.

So much for the general theory and now for a few practical hints. In the first place, do not think it necessary to specialize. All the arts (as you must have learned from this book) have but one single purpose, to contribute to the art of living and therefore they are closely related to each other and support each other and help each other out, like the members of a well-balanced family. You will be a much better draftsman for knowing something about the structure of a symphony. At the age of fifty-five I still patiently play my part in an orchestra. It takes a lot of time but it is the most practical way for me to learn a great deal about the structure of some music with which I am not yet familiar, and that again helps me in understanding how I should draw my pictures.

For years I have had my etching press, just a small one but good enough for my own simple needs. I don't expect to become a professional etcher. I shall never sell any of the products of my press. But my own struggles with copperplates and with acids and with different ink mixtures make it possible for me to realize infinitely better than I could ever hope to do in any other way just what the most successful etchers of the past have tried to accomplish.

The same holds true for a personal and intimate study of the works of all the great masters of the past. I do not mean in a merely imitative manner. You may have seen the copyists in our museums

painting away at their pitiful daubs, and you may well have asked yourself, "What is the use of all this wasted effort? These poor devils had better go out and milk a cow or do something a little more useful!"

Again I agree, but that is not what I meant by "studying the masters of the past." You should do this merely for your own entertainment and instruction. Once you have taken the trouble to copy in your own way some drawing by Dürer or to dissect a painting of some very complicated artist like El Greco, you will (for the moment at least) creep into the skin of those incredibly competent craftsmen and then you may at last begin to suspect something of what was in their minds when they themselves struggled with the unwilling material and the awkwardness of the human hand.

You will tell me that you cannot do this because art books are very expensive and you cannot afford them. Who said that you should buy those twenty- and thirty-dollar volumes which look so tempting in the windows of our bookstores? You can get catalogues in museums for nothing, or next to nothing. A good picture postal card is often quite as instructive as an expensive reproduction.

The same holds good for music. Our modern phonograph records are about as perfect as anything mechanical can ever hope to be. Save those dollars which you would otherwise spend on something that is not really very important (you will be surprised how much cash you waste every day on useless gadgets) and start a collection of records of your own. And listen to them too, for if you want to be a good amateur musician, you should be thoroughly familiar with everything the great composers of the past have written, just as you should know a few of the gambits of Marshall or Capablanca, if you are a devotee of chess. Knowing their gambits won't, of course, make you a Marshall or a Capablanca, but they will make it possible for you to play a much better game than you had ever done before.

And now another practical hint. If you have taken one of the arts as your hobby, it is not enough to practice it once in a while, on alternate Saturdays and Sundays in Lent. You should make your hobby your steady companion as if it were a pet dog.

Let me give you an example of what I mean by this rather cryptic statement.

Somewhere in this book there is a picture of the old Brooklyn Bridge, proving that in its own way it is quite as beautiful as the Taj Mahal. You may never see the Taj Mahal but you probably catch a glimpse of the Brooklyn Bridge (or some other bridge or building) every morning you go to your office. In those days when I worked

downtown in New York I always traveled by the elevated. During a short twenty-minute trip I saw enough sights to provide me with ideas for pictures for at least an entire fortnight. I did not have the time to draw them in detail (no more than you) but this was no labor lost, for something remained behind of all those many impressions and something that I could use afterwards in any number of ways.

I realize that all this is not easy to do. As a nation we are rather self-conscious when it comes to any of the arts and I know business-men who carefully hide their love for music or for some form of litera-ture for fear that their neighbors will laugh at them. We simply shall have to get over that feeling or we shall never get anywhere at all.

You may not want to be a martyr for the good cause but if, for example, you are interested in drawing, do as I have always done. Carry a few small cards in your pocket and when nobody is looking, make a short pictorial note of what you have just seen. Those notes will never find their way to a museum, to be exposed next to the sketches which poor Rembrandt drew on the backs of his unpaid bills, but they will teach you an amazing amount of detail and will sharpen your powers of observation to a point you had never deemed possible.

And when you have a chance, experiment with all sorts of media, for every new approach (oil, pastel, ink) makes you familiar with an entirely different technique and it is really like visiting so many foreign countries. Don't be afraid of the expense. No need of buying yourself one of those sixty-dollar contraptions filled with all the colors of the rainbow and with brushes at a dollar per. You will be astonished how much you can do with the little box of pencils which your small son discarded as one of his less welcome Christmas presents (he really wanted a flying machine, just as next year he will want those pencils!), and water-color boxes, sufficient for your needs and within the reach of your purse, can be had in any toy store.

As for the amateur musicians, if possible they should practice every day with the same regularity with which they take their morning's exercises. Once they get into the habit (if only for fifteen minutes a day) those minutes will soon grow into hours. The piano is the handiest of all instruments because it gives you the best chance to study orchestral compositions. But the piano is not the only instru-ment in the world.

For example, should you be an amateur fiddler, you will discover that there is a lot of fun in nosing around in the hock shops. Some day you may really find something really good. The chances are about

one to ten thousand, but these are less than the chances you take when you put your money on a ticket in the Irish sweepstakes, so why not try?

I must not make this chapter any longer than I can help but I am sure you are beginning to realize what I am driving at. When it comes to the details of such a "plan of campaign" I cannot really be of any help to you or give you any definite advice. There are two thousand million people in this world and there are, therefore, two thousand million different tastes. You will have to decide what you want to do for and by yourself but whether you go in for making ship models or writing songs or spending your summer vacation painting the rocks of Maine or laying out a small suburban garden, enlist right away among the humble followers of the Muses. They are very exacting teachers. But they are the most satisfactory of friends, for in return for your devotion and loyalty they will occasionally let you stroll into their own private garden and then you will catch a glimpse of a world of such beauty and such perfection that those few moments will most fully compensate you for any pains you may have taken to become one of the elect who have come to understand the true meaning of life at its best.

*Lucas Point,*
*Old Greenwich, Conn.*
*May 8, 1937*

# A New Vantage Point in Time

*And a brief transition from one set of
eyes and ears to another.*

W E COME NOW TO A FEW CHAPTERS which were not written by
Hendrik Willem van Loon. In them, I—a new guide—hope to
acquaint you not only with those developments in the arts which
have occurred since Van Loon completed his original manuscript
in 1937, but also with some of the changes which have come about
in the way people regard the arts of the entire century.

Van Loon was born in 1882. He was raised looking at and listen-
ing to the masters born before him. As the preceding pages indicate,
this didn't prepare him for cubism, futurism, or all the other
strange, modern "isms" which began to proliferate in the art world
in the early years of the new century. He never got used to "non-
objective" art. In this, however, he was only reflecting the taste of
most educated people of the time. Modern art still didn't have any
wide following. Nowadays, it does. There are still people who can't
get beyond the Impressionists, but their number diminishes every
year.

I am confident that had Van Loon been born, as I was, in 1935,
he would have had a different point of view. He would have ac-
cepted and admired the most radical twentieth century masters just
as he did those of every other era. So I shall try to introduce you to
some of them much as he would have done.

PIRI HALASZ

## Artists in a Lot of Countries
## Confront the Machine Age

WE THINK OF PARIS around the turn of the century as a gay and peaceful, placid place. But to the people living then, it didn't seem comfortable or settled or solid at all. Instead, the world appeared to be full of confusing modern developments, what with the recent invention of commercial electricity, telephones, airplanes and motorcars. People still went to church, but they didn't believe in the Bible as they once had—not since Charles Darwin had knocked the stuffing out of Genesis by showing that we were all descended from apes.

People looked to a new faith, a belief in progress, scientific and social. They welcomed change, or at any rate were beginning to accept it as necessary and inevitable. In short, by the year 1900 or even earlier, people were beginning to live mentally in our modern era. Of nobody was this more true than the artists and the writers who formed what was known as "the avant-garde." Avant-garde is a military term, meaning the advance forces of an army. The term began to be applied in the mid-nineteenth century to certain artists, writers and composers who produced works so radical that it took people ten or twenty years to learn to appreciate them. The avant-gardists were, so to speak, in the forefront of cultural change.

Nowadays, we can look back and say that the avant-gardists were the first to recognize the significance of the technological revolution, especially as it applied to art. They were the first to find a way to express the turmoil and fascination of the machine era. But when they first presented their works of art to the public, they were laughed at and rejected.

The Impressionists began the battle to utilize and rise above the competition which the machine age had to offer. In the case of painting, the nineteenth century had outdated the traditional skills of the artist-craftsman just as decisively as the automobile was to make the skills of the blacksmith obsolete.

By this, I refer to the invention of the photograph.

From time immemorial, painters had been dazzling their fellow

mortals with their ability to reproduce nature. Particularly since the Renaissance, painters had learned how to render a human face or figure so that it almost seemed to breathe. They had mastered the craft of making objects appear to be three-dimensional on a canvas, employing the scientific rules of perspective discovered in Italy in the fifteenth century.

Now all at once here was a mechanical process which could do all of that. Not only could a photograph make a portrait more faithful to a sitter's likeness than Ingress or Velasquez, but it could capture objects in motion more accurately than the human eye.

What were the artists to do? They fought back by discovering new ways of looking at the visible world, and investigating new realms of the world that a camera could never explore.

Starting in the 1860s, Claude Monet, Pierre Auguste Renoir and Edgar Degas began to paint pictures of nudes and landscapes, railroad stations or ballerinas, all with a technique that was totally revolutionary. They used broad, loose, flickering brush strokes in a variety of colors that didn't blend on the surface of the picture, but only if you stood back and looked at it from a distance.

They succeeded in making picture surfaces that looked totally unlike a photograph. With those bold, visible brushstrokes and vivid colors, an Impressionist painting said triumphantly, "Look—I am the work of a human hand!"

For the next thirty years or so, avant-garde painters played with different ways of using color in a way no camera could match. But the artists also, intuitively, began to devise ways in which they could present unique forms as well as colors, and search out subjects beyond those which could be recorded through a lens.

In the south of France, that dour, tormented Dutchman named Vincent van Gogh was painting pictures of a world different from the world anyone else saw. Using blazing oranges and yellows so brilliant that they were almost hallucinatory, Van Gogh depicted sunflowers like exploding firecrackers and cypress trees writhing upward like twisting snakes.

A bizarre fellow, this Van Gogh. In an insane fit of depression, he even cut off one of his ears and sent it to a lady friend who had once jokingly asked for it. He killed himself in 1890.

Another innovator was Paul Cézanne, a crabbed little French recluse who was so shy of people that he would scream aloud with horror if a stranger brushed against him in the street. Cézanne painted rocky mountainsides with such firm decision that their hard,

angular outlines shone through like geometric forms. He painted still-lifes with apples as hard as rocks.

Taking their cue from Van Gogh, a school of painters arose in the early years of the new century whose colors were so strange, savage, different and wonderful that they duplicated nothing in real life. Henri Matisse was the leader of this school. Through a prim, professorial-looking gentleman, he could paint a portrait of a woman that gave her a face part pink, part ochre and part green. In 1905, a critic went to see an exhibition by this group of painters and, because of the wildness of their colors, called them "wild beasts," or in French *les fauves*. We still call this school the fauvists.

Ordinary people were slightly startled by the fauvists. But the man who really set Paris ablaze with argument and controversy was a fiery-eyed little Spaniard. His first name was Pablo, and his father's surname was Ruiz, but the Spanish sometimes use their mother's surname instead. Young Pablo chose to become the most famous painter of the century using his mother's surname, Picasso.

Picasso's father was a painter, too, one of the old-fashioned kind. Pablo learned the conventional style of painting in his father's studio, but so quickly that by the time the boy was eleven or twelve, his father gave him his own brushes and pallette and told the boy that he was now a better painter than his father.

Picasso kept on studying. He came to Paris at the age of nineteen, in 1900. He took a studio in a crowded rabbit warren of apartments on Montmartre and found a girl friend named Fernande. Though they were broke, he and his artist and writer friends found ways to throw uproarious parties and argue life and art in the Montmartre cafes, over a glass of wine or beer. Within a few years, Picasso had developed a way completely his own of seeing the world. He painted circus folk and common people, making them look like gaunt, attenuated ghosts in canvasses tinged with a poetic, melancholy blue or rose.

At first, even these pictures unnerved people a bit, but they did begin to sell. The man in the street wouldn't have welcomed one as a gift, to be sure, but living in Paris at this time was a rich American writer named Gertrude Stein. Miss Stein wrote in a spare, bewildering modern style herself, so she could appreciate what Picasso was trying to do, and she bought his pictures. So did a few other open-minded collectors, who were beginning to realize that the avant-garde had something to say.

Picasso wasn't satisfied, though. He was still developing new ways

of seeing. He admired the geometric hardness of Cézanne, who had exhorted a friend to "seek in nature the cylinder, the sphere and the cone." Picasso decided to follow these instructions to a point Cézanne never dreamed of. In 1907, he retired to his studio and painted what has been called the "first truly modern painting." It did for form what the impressionists and the fauvists had done for color.

The picture, quite a large one, showed five nude women—women who looked like none ever seen on land or sea. Their bodies are composed of flat, angular chunks of pink and cream-colored paint, making it look as though they are mechanized toys, put together out of crude hunks of wood or tin. One woman has a leg shaped like a meat cleaver. Another was squatting, back to the viewer, except that her head had been turned completely around on her shoulders. The face staring out was grotesque, very much like the carved wood, primitive African masks that Picasso had recently seen and admired.

One thing you had to grant these women was personality. They were a splendid, awe-inspiring if terrifying crew. Picasso called this picture, *Les Demoiselles d'Avignon*, Avignon Street being an alley in the Spanish city of Barcelona where a brothel was located. The "demoiselles" were prostitutes. In carefree Montmartre, that in itself wasn't outrageous. What was, was the way in which Picasso had ripped away the conventional ideas of how women look and substituted his own wickedly satirical personal interpretation.

The work was so daring that it upset even Picasso's artist friends at first.

"It is as though we were supposed to give up our usual diet for one of tow and paraffin," exclaimed the fauvist, Georges Braque. Yet Picasso's example was so stimulating that, within a year, Braque himself was painting landscapes composed of flat, angular blocks of color.

"Monsieur Braque reduces everything to geometric planes, to cubes," wrote one critic, reviewing his 1908 exhibition. The new style thereby received its name: cubism.

No matter how dismayed and amused the general public was—and it was both—cubism caught on with other Parisian artists like brushfire. All, or very many, began to model themselves on Picasso and Braque. Picasso himself experimented over the next few years, making portraits and still lifes. In each case, he analyzed the forms he was dealing with into their geometric components and laid these

atop each other to create a panoply of sharply edged, vaguely mechanistic forms. Through the pattern, you could still distinguish faces, hands, headlines of newspapers and bottle labels, but gone with the softness and roundness was any illusion of depth, or three-dimensional form.

The cubists could be humorous. Both Picasso and Braque began adding a touch of lightness by pasting actual bits of newspapers and bits of chair caning onto their pictures, to stand for the real object. Since the whole picture had become so artificial, why not return it to reality by using recognizable things? In so doing, they invented a whole new way of making pictures, the art of collage.

Within five years, cubism had spread to every corner of the Continent. Artists from Italy and Germany and Russia and the Netherlands and England and even America came to Paris to study the pictures of the cubists; then they went home, and devised their own variants.

Why? I suppose basically because in every country, artists and critics alike had been searching for some way to express the coldness, the mechanization, the hectic tempo of the times. Cubism seemed a magic key.

In Italy, the style which owed most to cubism was called futurism. In England, the movement was vorticism. Both the futurists and the vorticists published declamatory manifestoes, outlining their programs almost as though they were politicians.

In Russia, the rayonnists were those painters who most nearly duplicated the work of the cubists and futurists. However, a few really radical Russians took the whole thing a complete stage further. Picasso, no matter how many liberties he took with his subject, always *had* a subject to each picture. The Russians decided to do away with the subject altogether.

It was the birth of that momentous invention known as "non-objective" art. We also call it abstract art—which is perhaps a more accurate namet in hat it suggests that the form presented on canvas is abstracted, or derived, from some form in reality. The first Russian to paint abstractions was Wassily Kandinsky. He had studied in Munich and visited Paris. Around 1910, Kandinsky made his first non-objective paintings, filled with gaily-colored, irregularly shaped lines and blobs and curves. These forms had a tense, wiry kind of nervous vitality.

In Paris, also, from around 1912 onward, others painters were beginning to paint pure abstractions. However, none of them had

the particular kind of imagination or insight that it took to make people remember their canvasses. That is the deceptive thing about modern art, especially non-objective art. In terms of technique, not much skill may be required. But the artist, more than ever, has to have that certain something extra, a gift, a flair, a personality that he somehow emblazons forth in his creations.

# Dada and Surrealism

*A terrible war and a troubled peace lead to the discovery that accident, madness and dreams can become the raw material for art.*

IN 1914, THE FIRST WORLD WAR swept over Europe. Never before in history had the Continent known a conflict so cataclysmic. War had never been so devastating. Tanks and shells leveled the land and millions of soldiers died in the trenches. The whole civilized world seemed to be caving in.

Moreover, to a lot of the younger artists and writers, it seemed as though European society had brought the catastrophe upon itself. Many of them were inclined to be political radicals anyway. They looked at the official reason for the war's beginning, the assassination of Crown Prince Ferdinand at Sarajevo, and asked themselves if that was really enough reason to lay waste so many countries.

The answer was no. The assassination was only an excuse, a pretext for the rich factory-owners, the aristocracy and the military to engage in a struggle for world domination. The bourgeois world had gone mad with its pursuit of money and power.

So the artists and the writers dreamed up an art that would express this madness. The art was deliberately inflammatory. It cried fie on every bourgeois institution: fie on the idea of progress and hope for rational advance, fie on conventional morality, fie as well on the kind of art which had been created and venerated in the bourgeois, pre-war world.

Down with sense, up with nonsense. Down with artistic "truth" and "beauty." Up, instead, with a kind of ugly, whimsical art which its creators dubbed "anti-art."

Even the name of this new style of anti-art was a nonsense syllable. Two artists picked the word, "dada," out of a dictionary at random. It was originally a child's nickname for a hobbyhorse.

Dada received its baptism in Zurich, where a small group of its radical proponents had gathered to run a nightclub called the Cabaret Voltaire. At this cabaret, they staged "performances" which consisted of people dressed up in crude, painted-cardboard costumes debating mystifyingly about nothing at all, or declaiming

"poems" of incomprehensible gibberish. If the evening ended with the spectators fighting or arguing with each other, so much the better.

The dadaists celebrated chance or accident as the guiding principle in modern life—and in modern artistic creation. The way they went about things is clear in the following advice from a dadaist named Tristan Tzara:

> To make a dadaist poem
> Take a newspaper
> Take a pair of scissors
> Choose an article as long as you want to make your poem
> Cut out the article
> Then cut out each of the words that make up this article
> and put them in a bag
> Shake it gently
> Then take out the scraps one after the other in the order
> in which they left the bag
> Copy consecutively

A dadaist painter, Jean Arp, composed pictures by the same principle, arranging squares of paper to look as though they'd fallen by chance on a larger square.

It sounds silly—but it was meant to. Dada was a brittle, ironic jest on the meaninglessness of existence. It shocked and infuriated conventional people, but unlike the impressionists and the cubists, the dadaists were intentionally out to shock. They were trying to shock people into re-examining and criticizing the whole status quo.

In the 1920s, this attitude managed mostly to antagonize people. But in the 1960s, when America was all but overwhelmed by the chaos and the senselessness of the Viet Nam war, a lot of people were able to look back and see a lunatic sort of common sense shining through the dadaists' excesses.

I could write an entire book, just describing the crazy ways the original dadaists thought up to tweak the nose of the Establishment, in Germany and Paris, after World War I. There were more extraordinary performances, manifestoes, exhibitions. A clever Frenchman named Marcel Duchamp took a picture postcard of the Mona Lisa and added a mustache to it. He was telling people too many of them revered this famous painting like a religious icon, and that it deserved to be debunked. Duchamp sent a urinal to a sculpture

exhibition, calling it a "ready-made" piece of sculpture. He was trying to point out that a mass-produced porcelain plumbing fixture could have as much beauty as a sculpture—if only people could forget their bourgeois notions about what it was intended for!

Of course, it takes a Duchamp to carry off this kind of gesture. A lot of the dadaists' stunts were not as trenchant, mild fun for the moment and forgotten the morning after. Besides, everybody in the movement made such a fetish of being individualistic and anarchistic that in a very few years, dada as a school began to fall apart. But not before it had furnished inspiration and a point of departure for a great number of painters and sculptors, especially in its adventurous concept of using chance, or accident.

This particular idea appealed to those Parisian painters and sculptors and poets who were beginning to study the turgid prose of Sigmund Freud, the eminent Viennese psychoanalyst who had discovered that vast, hidden realm of human thought and emotion which he called the unconscious mind.

Freud maintained that there was, in truth, no such thing as accident. Instead, a person's unintentional behavior represented the fears and desires of the unconscious mind. If he made a slip of the tongue, pen or brush he was only revealing unconscious inclinations. Dreams, too, represented this other, hidden reality.

Eagerly, the painters and poets turned to works inspired by this secret region of fantasy and imagination. They became a group in Paris, formally incorporating the dadaists in 1924, calling themselves surrealists, which is French for super-realists. They were dedicated to presenting the super-reality which lies within men's heads.

There were many ways they chose to depict this subject. Salvador Dali, a flamboyant Spaniard with a handlebar mustache and flowing cloak, painted hypnotic visions of the kind of landscapes seen only in dreams, rocky mountains with women's heads or limp watches draped over the branches of dead trees. Pablo Picasso, who had become quite fashionable and celebrated, with a home in the south of France and a Russian ballerina named Olga as a wife, became something of a surrealist. Abandoning the pure, hard forms of early cubism, he painted frenetic visions of screaming, eel-like women and men with minotaurs' heads.

Some surrealists let the method, as well as the resultant picture, utilize unconscious drives. A quiet, modest little Spaniard named Joan Miro, who had come to Paris some years after Picasso, experimented with what was known as "automatist" painting. He

would smear a few daubs of paint on a canvas, or make a doodle with his brush, then look at it and try to figure out what his unconscious had wanted him to show with this automatic gesture. If the smear looked like the beginnings of a bird, then he would add a head and tail feathers to it.

In this way, Miro created a whole universe on canvas of quaint, curious, enchanting little dancing suns, moons and stars, funny little personages with round behinds and birds that fluttered with the joy of being alive.

The surrealists, too, went in for manifestoes and magnificently nonsensical *gestes*, or gestures. One surrealistic exhibition featured rows of department store mannequins, dressed in the most extraordinary costumes you can possibly imagine. At the premiere, spectators obligingly staged a riot. But then, Paris in the late 1930s was turbulent and worried: the Nazis were massing across the border and Generalissimo Franco was decimating the Loyalist government in Spain, in its civil war.

In 1937, German bombers in Franco's pay wiped out the Basque village of Guernica. To commemorate the event and mourn the village Picasso painted a passionate masterpiece of outrage—*Guernica*. Using the bizarre vocabulary of images that he had developed through surrealism, Picasso angrily and movingly portrayed the dead babies, sobbing women and gored horses of that tragic town.

Paris was not the only capital where artists were at work in the discouraging era between the two world wars. In Russia, right after the Revolution of 1917, a lot of the daring young men and women who had fought for the cause of the workers banded together and insisted that modern, non-objective art be taught in the new government's schools. They believed this new kind of art was the only kind of art that really represented socialism. They tried to put it at the service of the working classes by designing fabrics and posters and cups and saucers decorated with non-objective designs. One visionary Russian named Vladimir Tatlin drafted plans for a towering, non-objective monument taller than any skyscraper.

Lenin tolerated these artists, whom we call the constructivists. But Stalin, who came to power in the late 1920s, decided that what the workers really preferred was pictures of people who looked like people. One by one, the constructivist artists were driven out of their government posts or forced to change their style. Some artists even left the country. Abstract paintings were damned

by Stalin as "bourgeois decadence" and hidden away in storage vaults.

Germany, in the 1920s, had again been a country where artists were painting busily. In addition to the dadaists, Germany had developed a group of more conventional painters, whom we call expressionists. Somewhat like the fauvists, the expressionists painted real-life scenes, but with a twisted vigor to their forms and a garish, exaggerated spectrum of colors that made their pictures very expressive—of emotion, that is.

At a school of design called the Bauhaus, also in Germany, craftsmen working with engineers utilized modern art in practical ways by producing beautifully sleek and elegant chairs and tapestries and lamps. But Adolf Hitler proved an even worse art critic than Stalin. Hitler closed down the Bauhaus. He declared the paintings by the expressionists to be "degenerate" and had them taken out of the museums. Again, many artists fled.

# Emboldened by Winning a Great War

*a nation of pioneers develops
some vehement, some amusing
means of self-expression.*

THERE WAS, HOWEVER, one major country where artists were still free to pursue their particular hobbyhorse without hindrance. If they insisted on painting avant-garde pictures, they might not make much of a living from it, but at least they could work.

America had emerged as a world power after World War I, but it really took the second world war to give it the kind of self-consciousness which made it possible to exert leadership in art. All through the 1800s and the early 1900s, American painters went to Europe to study. They came back to paint and sell pictures done in European styles. By the 1940s, a number of younger painters in New York had begun exploring the possibilities of surrealism. These young painters mostly lived around Greenwich Village or painted in lofts in lower Manhattan. They had their bars and their parties, a little world not unlike that of the French artists at the turn of the century. And, like Picasso in 1907, they were not satisfied with just doing things the way they were being done.

Especially not satisfied was a shy, dreamy-eyed man from Wyoming who turned into a belligerent arguer when drunk. This young man, who had studied with the realist muralist named Thomas Hart Benton of Missouri, was himself baptised Paul Jackson Pollock (he dropped the "Paul" when he came to New York). Pollock started out painting moody, cloudy landscapes in Benton's style. Then, becoming interested in surrealism and Jungian psychology more or less simultaneously, he evolved into a painter of wriggling, mythical monsters and strange totemic symbols of psychological significance.

Pollock had always had a way of slathering on the paint so vehemently that its daubs and whorls almost seemed to have lives of their own. Finally, around 1947, he let the paint take over altogether. Borrowing the surrealist technique of letting his unconscious do a major part of the job, he rolled out canvas on the floor and, instead of using a brush, simply dripped and dribbled skeins

of paint from a stick or a can, creating a thorny thicket that spread evenly across the entire canvas.

More sophisticated people in Europe had gotten used to Picasso and dada and surrealism, but America was still a relatively innocent country. Cries of outrage went up when Pollock first displayed his drip paintings in public.

"Jack the Dripper," some journalists called him. "Chaos!" "Wallpaper!" screamed other critics. They claimed to be unsettled by the fact that Pollock's pictures had no recognizable subject matter, but of course non-objective paintings had been around since 1910 or thereabouts. What was really compelling about Pollock's paintings was their spiritual abandon, the way he projected his strident personality across with his rivers of paint: the expressionist quality of his abstracts, in other words.

Many people called this new style Pollock had invented, abstract expressionism.

Pollock wasn't the only young painter in New York developing a new, ultra-simplified idiom. An immigrant Dutchman, Willem de Kooning, could paint thickly-spattered pictures of monstrous bitch-goddess women that were almost as disturbing. Mark Rothko, a hulking, bashful fellow covered each of his canvasses with large, soft, dark squares of paint that sank in and made the picture look stained, a little like stained-glass, in fact. A viewer looking at a Rothko felt as though he were drowning in this somber well of color. And there were others who, with Pollock and De Kooning and Rothko, made up what we now call, "the New York school."

When these artists first started painting like this in the late 1940s and early 1950s, you could buy their paintings for practically nothing. Nobody wanted them. Jackson Pollock got so discouraged by his apparent failure that he began to hit the bottle more ferociously than ever. His wife moved out on him. In 1956, driving a couple of girls to a party on Long Island, Pollock accidentally rammed his car into a clump of trees and was killed.

Ironically, only a few years after his death, the works of the entire New York school began to command very respectable prices. These prices have gone up and up every year since. Today, it isn't only a Monet which goes at auction for a million dollars and upward. One of Pollock's masterpieces was sold to the National Gallery of Australia in 1973 for well over a million dollars.

Americans may have been square and naive about the avant-garde right after the war, but in the 1950s, they developed a lot

more open-mindedness. It was a time of peace and prosperity, when people had plenty of time and money to go to museums and read books and buy pictures to hang on the walls of their spacious modern homes. And a modern house calls for a modern painting. So Americans quite speedily caught up. They learned to appreciate cubism and surrealism and abstract expressionism. If they couldn't buy a big painting, they bought a smaller one. If they couldn't. afford an established master, they would take a chance on one of newer, less famous artists just coming up.

I think it's partly because Americans, as a matter of principle, have always been interested in anything new. They took to automobiles and airplanes and computers and television faster than anybody else. Indeed, they will buy any new scientific gizmo or gadget as soon as it is patented. Thus, when the Americans realized they were a little behind the times in the matter of paintings they learned to see what there was to see.

I don't mean everybody, naturally. But enough people so that the artists could begin to feel needed and wanted by society at large. In the 1960s and 1970s, this has come to be true outside of the United States as well. The Germans and the Japanese, in particular, have learned to be very respectful about, and eager to collect contemporary art. But in the 1950s, it was still mostly the Americans who were delighted to accept the vanguard.

This acceptance came as a shock—to the artists themselves, this time. After nearly a century of being outcast and rejected, the avant-garde had become fashionable and stylish. A painter didn't have to wait until his old age to sell his work; he could support himself when still in his twenties or thirties. Wouldn't you know what would happen? A whole school of younger artists in New York, in the 1960s, developed a style which both capitalized on this popularity and made fun of it. Instead of trying to paint serious pictures, full of profound emotion, like the abstract expressionists this new crowd made pictures—and objects—that were intentionally simple and amusing.

Andy Warhol, a slender young man who dyed his hair silver, made dozens of paintings of Campbell's soup cans. He explained that he thought the design of a Campbell's soup can perfectly beautiful, Roy Lichenstein painted pictures that looked like Flash Gordon comic strips. Robert Rauschenberg, a lanky Texan, put together what he called "combines," or assemblages: for example, a stuffed angora goat with a tire around its middle. Rauschenberg's com-

bines were supposed to make you think, or laugh, preferably both. Claes Oldenburg, a dour Swedish immigrant, sewed together a huge, fake, hamburger made of cloth.

Everything was so easy to look at, so easy to be entertained by that it became the rage at once. No wonder this school of art was called pop—though technically, the art historians will tell you, the name came from the fact that the artists used popular images taken from the mass media, from television commercials and billboard advertisements and glossy magazines.

The pop artists were poking fun at the way in which Americans had gotten caught up in the shiny, prosperous world of the 1950s and 1960s. There was a lot of dada in pop art, the same spirit of mocking revolution which had been prevalent during the first world war. The pop artists borrowed many tricks from dada and surrealism. They staged "Happenings," which were very like the dadaistic *gestes*, with nude girls and clumsy paper props and costumes and bewildering non-sequiturs of dialogue and action.

But Americans, by and large, weren't shocked. They loved the joke. Society matrons invited Warhol and Rauschenberg to their dinner parties. Television spectaculars were staged about Happenings. Teen-age kids all over the country bought pop art posters for their bedrooms.

Op art was an offshoot of pop, a style of painting abstracts with colors so mechanically dazzling that they played optical tricks on the viewer's retina. As soon as op came in, Paris couturiers began to use fabrics with op art designs.

Both pop and op became so popular in fact that some very pure and high-minded critics maintained that neither could possibly be classified as true avant-garde art. Others used its success to prove that the avant-garde, as a social phenomenon, was dead—that the lag between artistic creation and acceptance no longer existed.

Myself, I'm inclined to think it's a little of both. There were other younger artists, painting abstract pictures developed from Pollock's style, and their work never became as much of a fad as pop. But pop was avant-garde in the sense that it represented what some, at least, of the brightest and most daring young men were doing.

And the acceptance of pop was part of a much wider social trend, a total revolution in highbrow standards and taste. Until the 1960s, the kind of people who bought and talked about culture—the ones who considered themselves up to date not only on paintings but

also on books—had nothing but contempt for what was produced for ordinary people's use. China from a dime store was hideous to them, radio music obvious and banal. They called such merchandise *kitsch*.

But in the 1960's, they changed their minds. If a Warhol of a soup can might be art, then so might the soup can itself. People began collecting Mickey Mouse watches and Coca-Cola posters from the 1930s, even though they had sniffed at such items when they were originally made. *Kitsch* became frightfully chic.

# A Word About Music,
# and a Final Word

POPULAR MUSIC, TOO, became "art." In the 1950s, the highbrows had laughed at Elvis Presley but by the time the Beatles came along, the highbrows loved them. They commented on the sophisticated harmonies the Beatles had developed, and admired their electronic sound effects.

But to understand why these qualities made the Beatles seem like highbrow music, we need to know a little about avant-garde music in general in this century.

I haven't talked about music so far, because I think a considerable change of emphasis has occurred since Van Loon wrote. He felt that music had become more accessible and beloved by ordinary people than the visual arts, the change taking place along around 1500 or 1600. I'm not gainsaying the fact that music is a universal language, nor the fact that everybody loves show tunes and popular ballads. Nor would I deny the fact that in our transistorized world, more people can hear classical music on records or tapes than ever before.

Yet in spite of all of this, we have to ask, what about the music composed by the avant-garde, those serious musicians trying to symbolize and reflect the cacophony and complexity of our modern society in their work. Is it as popular as the paintings and sculptures in twentieth century modes?

The answer, in my opinion, is no. The century has produced a lot of avant-garde composers, who took off from Debussy and Wagner and carried their ideas as far beyond them as Picasso carried the ideas of Cézanne. But such composers still find themselves in advance of popular taste. It has taken the listening public fifty years to get used to Igor Stravinsky, that dynamic Russian who set Paris on its ear, literally provoking storms of catcalls and foot-stomping with the premiere of his daring ballet, "The Rite of Spring" in 1913.

Both Stravinsky and Picasso have died in the last few years, at ripe old ages. But where Stravinsky was mourned mainly by music-lovers, Picasso had become a celebrity whom everybody knew. It

wasn't only his many girlfriends, who changed with every decade, nor the fact that he'd joined the Communist party and painted a dove of peace for it, nor even the fact that in his eighties he could still astound his admirers with a raunchy series of erotic drawings. Picasso was a celebrity because so many people had learned to relate to the entire way he saw the world.

And yet *The Rite of Spring* was to the history of music what *Les Demoiselles d'Avignon* was to painting. In it, Stravinsky experimented with throbbing, intoxicating rhythms never before heard in a concert hall, but associated with factories, and the roar of heavy machinery, or jungles, and the primeval thundering of savage drums. Stravinsky used a lot of unusual instruments to create his effect; he also arranged the score so that the musicians were playing in several keys at once.

Now that represented the same kind of departure from tradition that Picasso had used in dispensing with three-dimensional perspective. For centuries, all Western composers had structured their pieces around the seven-tone scale you get if you play an ordinary piano from C up to higher C, or from F to a higher F. Using this scale, a composer produces the attractive harmonies and chords we are all familiar with, from folk songs to Brahms. But if you've been raised with that, and then you play an F chord and G chord on the piano simultaneously, it sounds at first as though you'd stuck your elbow on the piano by mistake.

Stravinsky made his music sound that way on purpose, and—as I say—with the passage of time most people have gotten so that they find it as moving and exciting as Stravinsky wanted it to be. *The Rite of Spring* and other early Stravinsky works have become part of the standard repertoire for major symphony orchestras. But what have not caught on to the same degree, or anything like it, are the compositions written since, which take up from where *The Rite of Spring* left off.

Arnold Schönberg of Vienna, by the 1920s, had developed a twelve-tone scale, which made harmony of the conventional sort impossible. He composed many orchestral works built around this scale, and inspired a school of followers. But Schönberg's work, by and large, never caught on with lovers of Bach and Beethoven.

Since World War II, some composers have tried to apply dadaist principles to the making of music, introducing the element of chance and improvisation. This is called "aleatory music." One French composer, for example, produced a score whose pages were

meant to be shuffled, like a deck of cards, before each performance. Then the musicians were supposed to play the work in the order in which the pages fell.

An eccentric American composer named John Cage goes in for musical performances which, sometimes, are closer to Happenings than anything else. In one *Theater Piece* by Cage, performed in Rome in 1963, one musician threw a dead fish into his piano. Another wandered around the stage, noisily dragging a chair behind him, while a third, dressed in a nightgown, handed out pizzas to the audience. Any music produced was pretty incidental!

A lot of fairly sophisticated music-lovers can't stand this kind of nonsense, any more than they like another way in which composers try to take advantage of what the twentieth century has to offer—namely, by using computers and electronic sound in their compositions. Computers can be used to program a score according to a mathmetical formula. Tape recorders can be used to produce either pure sound, or else sound derived from conventional instruments which has been amplified or distorted by the recorder. The tape can be speeded up or slowed down, played backward or spliced together. Some electronic music is written to be accompanied by regular instruments, but some is meant to be played all by itself—and not necessarily in a concert hall.

The Frenchman, Edgard Varèse, is considered the father of electronic music. As with Schönberg, he has inspired a raft of followers. One of the most admired, or at least best known, is a young German named Karlheinz Stockhausen. He uses not only electronic sound, but also chance and everything else new-fangled in his work.

Nevertheless, the kind of up-and-coming junior executive who might put a pop art poster or a modern abstract in his office is less likely to go home and listen to Stockhausen on his stereo. That is what I mean by the relative cleavage between music and the visual arts. Our eyes have gotten more accustomed to the twentieth century forms of expression than our ears.

The composers who have enjoyed the strongest upsurge in popularity in the past few years are the more conservative twentieth century composers, the ones who carried on the great romantic tradition of Brahms and Wagner and didn't add too many modern tricks. Gustav Mahler is an illustration. His dramatic, melancholy symphonic works have enjoyed a remarkable revival of interest in the past decade.

Sergei Prokofiev, Benjamin Britten, Darius Milhaud and Dmitri

Shostakovitch are other twentieth century composers who enjoy a good reputation with the critics. But none is really radical, and none bids fair to become a legend in our time. The string quartets of Béla Bartók, a lonely and brilliantly difficult Hungarian innovator, are considered by some cognoscenti to be the greatest compositions of the century—but they are rarely performed. People just can't hum along with Bartok.

To be sure, we have modern ballet, probably the most fertile form of musical expression today. With its vocabulary of rigorous gesture and the frenetic rhythms its choreographers borrow from jazz and rock 'n' roll, modern ballet at its best presents a kind of "total theater" unlike anything in any other century. Electronic sound, subway graffiti for stage decorations—if it's in a ballet, anything goes.

In the same way, the Beatles borrowed electronic sound and tonalities from Stockhausen, but they mingled his contributions with their own nice, familiar, even sentimental lyrics—"Will you still need me when I'm 64?"

Some of my readers will possibly consider me somewhat stuffy because I am ending this brief account with the Beatles and the pop artists of the 1960s. After all, they will say, we are in the 1970s now. What about the newer rock groups? Aren't they more radical and atonal? Perhaps, in some ways, but even the most zonked-out are still using fairly recognizable lyrics as the sugar coating on the pill.

In the visual arts, as far as that goes, there are also plenty of younger folks, experimenting with all manner of new technology: videotape, laser beams. But I'm not going to mention any names because I don't think any of them has as yet managed to distinguish himself from the herd. As in Van Loon's day, it still takes a few years for the wheat to separate from the chaff.

Our advantage is that, compared to Van Loon, we've had forty years more to let the sifting take place, forty years in which to get used to the pressures and tensions of our century. We are used to living with what is upsetting about modern civilization—and freer to enjoy the richness and variety it can offer us, as well.

We've learned that the only constant in this era is continual change; new machines will continue to make old ones obsolete, new wars will take place of Viet Nam and tomorrow's money will never be worth what yesterday's was. So we expect art continually to change, along with everything else. The fact that so many

schools have flourished and died since the turn of the century no longer seems to us a sign that the art produced was shallow or superficial. Instead, it is proof of the remarkable freedom and opportunities to express individuality that artists in this century have enjoyed.

Once, people expected their art to offer peace and solace, to provide an escape from the brutality and poverty of their world. Today, we look for another kind of escape: from the humdrum and the ordinary, from too much complacency and stodginess. And we find it in the wit, the terror, the splendor, the passionate emotion, the fantasy and imagination which animates the work of Picasso, Miro, Pollock and all the rest. These artists have shown us that an era of science and social revolution means not the death of artistic creation, but a new and inspiring rebirth.

# Index

# A NOTE ABOUT THE AUTHOR

HENDRIK WILLEM VAN LOON *was born in Rotterdam, Holland, in 1882. He learned Dutch at the age of two, and two years later he started to draw. At the age of nine he began a Universal Historical Encyclopedia which he discontinued two years later for lack of time and paper.*

*Throughout his childhood and youth his parents tried to interest him in the army, the navy, medicine, and the law. But in vain. He insisted on becoming a writer. And because English was the most difficult language to learn he determined to express himself in that rather than in French, German, or his native Dutch.*

*At the age of twenty he therefore set out for the United States. He attended Harvard and then Cornell, from which he received his A.B. degree in 1905. The next few years he worked with the Associated Press as one of its correspondents in Washington, Warsaw, St. Petersburg, and Moscow, but in 1911 he found time to take a Ph.D. degree at Munich and promptly returned to the United States where he lectured on history and art in various universities. But when the war broke out in 1914 he was back with the Associated Press again, covering Belgium.*

*By this time his first book,* The Fall of the Dutch Republic, *had made its appearance, and in 1915 and 1916 he lectured on history at Cornell, and in 1922 and 1923 served as professor of history at Antioch College. His first great popular success,* The Story of Mankind, *appeared in 1921 followed by* The Story of the Bible *two years later.*

# A NOTE ON THE PRODUCTION OF THIS BOOK

THE ARTS *is set on the Monotype in 11-point Baskerville, a twentieth century recutting of the type originally designed in the eighteenth century by John Baskerville, of Birmingham, England. Baskerville, who was first a writing-master and stone-inscription cutter, then engaged in the manufacturing of japanned ware, and became interested in typography when forty-four years of age. Nearly seven years were spent in experimenting with type before he began printing. His first book, the Virgil, in Latin, was finished in 1757, and established his reputation. Baskerville's roman and italic, the first English transitional face, shows the influence of his interest and practice of calligraphy, resulting in a rounder, more sharply cut letter than any heretofore designed. His italic, though narrower than the roman, is particularly graceful and composes into a very legible and beautiful page.*